FILM

X

Autochthonous
Struggles
Today

FILM

Autochthonous
Struggles
Today

Edited by
Nicole Brenez
Jonathan Larcher
Alo Paistik
Skaya Siku

SternbergPress

Contents

"What's the Point of Cinema?"

Struggles, Conviviality, and the Vivacity of Images

Nicole Brenez
Jonathan Larcher
Alo Paistik
Skaya Siku

What's the point of cinema? This question is neither moral nor fatalist. It is practical and concrete and was posed in 1966 by the medicine man Sam Yazzie, a political and religious leader of the Navajo (who call themselves the Diné), to Sol Worth and John Adair, who were among the first to suggest to an Autochthonous[1] community that they make their own films—in a context, of course, where they had suffered massive figurative defamation, especially in Hollywood westerns.

The anthropologist John Adair, who had already conducted research on the Pine Springs Reservation (Arizona) in Dinétah, explained to Sam Yazzie the goal of their project. Teaching filmmaking and how to use film equipment to the members of the community would allow to observe how the Navajo's relationship to the world could be made perceptible via the medium of cinema. While the anthropologists were imagining how films by Navajo filmmakers could break with the formal, temporal, and thematic conventions of documentary and ethnographic filmmaking, Sam Yazzie confronted them with a much more fundamental and practical question of what is the point of making films.

> When Adair finished, Sam thought for a while, and then turned to Worth and asked a lengthy question which was interpreted as, "Will making movies do the sheep any harm?" Worth was happy to explain that as far as he knew, there was no chance that making movies would harm the sheep.

1 We use the term "Autochthonous," rather than "Indigenous," which is more commonly used in English, to designate nations and peoples who have been part of a living environment since time immemorial, thus preceding the various subsequent waves of arrivals through colonization, conquest, settlement, migration, displacement, or other means, and distinguished by their social, political, economic, and cultural life. Depending on a linguistic, cultural, historical, or political context, various terms are used to convey this notion globally or regionally: First Nations, *pueblos originarios*, *peuples autochtones*, American Indian and Alaska Native, Aboriginal and Torres Strait Islander. This heterogeneous category should not conceal the diversity of self-designations (endonyms) and experiences of the peoples it refers to. In the internationalist perspective adopted in this introduction and elsewhere in this book, the use of the term "Autochthonous" is helpful for the clarity of argument and analysis of political movements and social mobilizations. To mark the contrast, we at times use terms such as "majority society" or "Global North," which we also acknowledge to have their potentialities and limitations. In our text, we don't replace established locutions, e.g., Indigenous internationalism or Indigenous futurism. The authors in this book have opted for terms that they deem most appropriate in the context of their contribution.

Translations appearing in this text are by the editors unless otherwise stated.

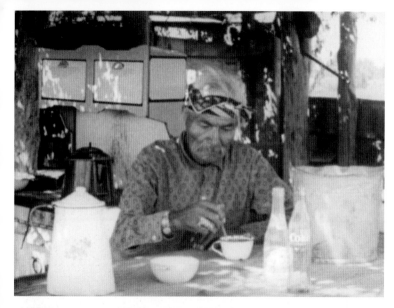

Still, Mary Jane Tsosie and Maxine Tsosie, *The Spirit of the Navajo*, 1966

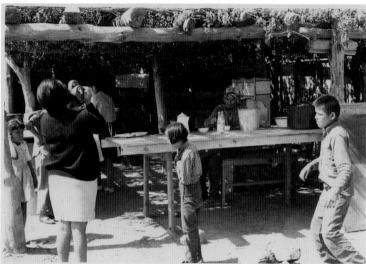

Mary Jane Tsosie filming her grandfather Sam Yazzie and sister Maxine for *The Spirit of the Navajo* (1966)

Sam thought this over and then asked, "Will making movies do the sheep good?" Worth was forced to reply that as far as he knew making movies wouldn't do the sheep any good.

Sam thought this over, then, looking around at us he said, "Then why make movies?"

Sol Worth and John Adair, *Through Navajo Eyes* (1972), 4.

Do we become the marionettes of a terrible ruse of reason by giving into the belief, indeed the hope, that the appropriation of audiovisual recording and distribution tools (film, video, digital ...) could be useful to Autochthonous peoples in their present and future struggles? Not to answer the question definitively, but to sustain it and shift it to the register of deontological preoccupations, let us consider several initiatives and summarize a few thoughts on this subject.

"What's the Point of Cinema?" Struggles, Conviviality, and the Vivacity of Images

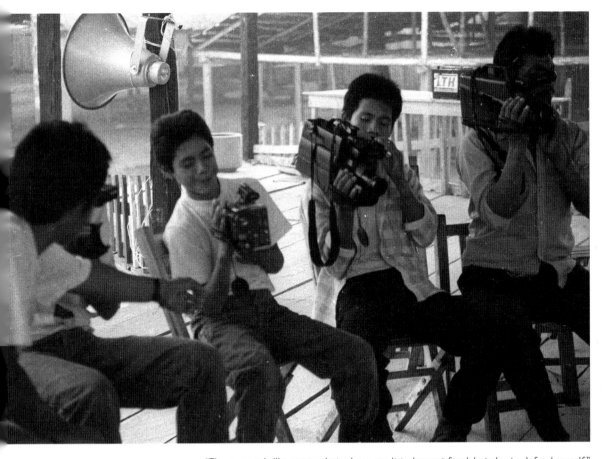

"The camera is like my machete, I can use it to harvest food, but also to defend myself."
"Bernal (right, with three other students), a Tojolabal peasant and a member of the La Realidad community (one of the Zapatista support bases in Chiapas), during a video workshop organized by the Chiapas Media Project (later named Promedios de Comunicación Comunitaria) in 1998. In the span of a week-long workshop, Bernal familiarized himself with the technical and visual possibilities offered by a video camera. The workshop in La Realidad, and in general all the workshops organized for the Zapatista communities, were training individuals who were appointed by the movement to become members of the communications team." [See also page 300.]
Francisco Vázquez Mota, personal message to the editors, 2023.

In early 1999, further south, on the high plateaus of Chiapas (Mexico, Abya Yala), Bernal, a Tojolabal peasant from the Zapatista movement seemed to formulate a response to Sam Yazzie's question and open a cluster of possibilities addressed by each of this book's contributions: "The camera is like my machete, I can use it to harvest food, but also to defend myself."

As the Zapatista uprising of January 1994 was met with violent repressions, an unprecedented military occupation, and forced displacements in Chiapas, the Zapatista support bases decided to set up an autonomous and alternative media infrastructure. Video played a central role in their media tactics. It served as a means to self-represent and to counter Mexican state propaganda, which was employed to frame its low-intensity war in Chiapas. Upon the initiative of the Chicago-based video maker and activist Alexandra Halkin as well as several Mexican, Autochthonous, and American filmmakers, photographers, and activists, the Chiapas Media Project (after 2002 called Promedios de Comunicación Comunitaria) trained and supplied the Zapatista support bases with video equipment

and satellite internet connection. Starting from early 1998, the first workshops were organized, launching a decade of intense and expansive use of video. In his contribution to the present book, drawing on his abundant photographic documentation, Francisco Vázquez Mota, one of the founding members of Promedios, gives an account of the organization of video and filmmaking workshops in the Aguascalientes (regional centers of the Zapatista movement). Through the adoption of video technology, the camera became a *convivial* tool for the Zapatista movement, as essential as the machete for serving the needs of its communities.[2] It allowed them to dissuade soldiers and members of the paramilitary forces, to exchange the knowledge and techniques of political, educational, and healthcare-related autonomy between support bases, and to inform the civil society.

In January 2021 in Nuevo San Gregorio, an autonomous Tzeltal community made up of half a dozen families faced numerous exactions. In the wake of the Zapatista uprising in 1994, several families had peacefully recovered more than 150 hectares of a former *hacienda* to collectively work the land and form a support base for the Zapatista movement. In the fall of 2019, the families in the village who did not belong to this autonomous community began using force—making threats, building fences, destroying shared crops, and perpetrating violence against livestock—while benefiting from the support of paramilitary groups and the government's social policy which promised a monthly allowance to all individual landowners. As the Covid-19 pandemic in 2020 interrupted the regular activities of human rights observation missions by national and international organizations (Doctors of the World, FrayBa, SweFOR, Promedios ...), a solidarity caravan carried out a humanitarian mission in Nuevo San Gregorio on January 10, 2021, both to observe and perhaps even hinder these threats. Faced with the encroaching capitalism in these rural regions, the autonomous community handed down to its youngest generations the use of the machete, the spade, and the camera. Throughout the day, Moisés, a young member of the local Zapatista community, recorded both the presence of the caravan in the pueblo and the daily activities of the members of the support base. This situation was also filmed by the representatives of the civil society who were part of the solidarity caravan. The purpose of this act of co-documentation was to demonstrate the peaceful and convivial character of the Zapatista support base and to counter the discourse advanced by the regime.

In just over fifty years, the interrogations of Sam Yazzie and the actions and answers of Bernal and the autonomous community of Nuevo San Gregorio have revealed the vivacity of film images—their effectiveness, the swiftness with which they are put to use amid adversity, and their ability to step out in defense of life forces.

2 We borrow the notion of "convivial tool" from the writings of Ivan Illich: "Tools foster conviviality to the extent to which they can be easily used, by anybody, as often or as seldom as desired, for the accomplishment of a purpose chosen by the user." The areas of use and of encounter of such tools are vast: technology, economy, domestic life and work, art. Ivan Illich, *Tools for Conviviality* (London: Fontana, 1975), 35.

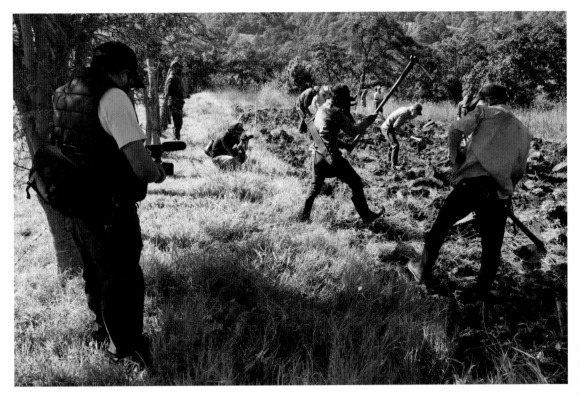

Solidarity caravan on a day-long observation mission in the autonomous community of Nuevo San Gregorio, Chiapas, on January 10, 2021. Several civil society organizations were present and documented activities at the Zapatista support base, which had been subject to a great deal of pressure, violence, and the dispossession of shared land. In 1994, during the Zapatista uprising, 150 hectares of land were claimed for the Zapatista community in Nuevo San Gregorio. Starting from 2019, over 95% of that land has been redistributed to small landowners under the aegis of neoliberal social policies of the Mexican state with the support of paramilitary groups. Moisés (in the middle, squatting), a young member of the local community, carrying a camera and machete, films families from the Zapatista community who work the fields and plant corn, as well as the visiting solidarity caravan. Francisco Vázquez Mota (standing on the left) of Promedios, part of the solidarity caravan, observes and films the local community.

For centuries, Autochthonous peoples have fought against every form of colonization, confiscation, and contamination of their lands and cultures. This long-running conflict has challenged the transmission of their imme-morial epistemologies and cosmologies, their relationship to living envi-ronments, their social structures, and their cultural and material existence. The arrival of filmmaking (employing first analog, and then digital film and video) in these situations of struggle is fairly recent. Although representa-tions of Autochthonous peoples have been part of cinema right from its inception, starting with the Edison Studios' 1894 short films *Buffalo Dance* and *Sioux Ghost Dance*, the vast majority of these have not been produced by nor for Autochthonous peoples. In the wake of political and cultural self-determination movements of the 1960s and 1970s, and with the gradual democratization and accessibility of the tools of moving-image making, Autochthonous peoples have tried to find ways to displace and renew cine-ma's forms and means of production, increasingly reclaiming their right for self-representation by way of film and video. How has film become a suit-able medium for retelling these multi-centennial histories of struggle? What are the conditions in which the medium can also extend them, support them, and intervene in them? Practiced outside of industrial conventions

and formats, does the art of filmmaking allow for the handing down, or even the reactivation, of something in these experiences and cosmologies by transposing the latter's principles of figuration onto cinema?

While Autochthonous filmmakers continue to carve out a space for Autochthonous themes and representations within the mainstream cinema, vibrant forms of moving images arise from within the communities, close to their existential concerns, their lived history and culture, and shaped by their particular material limitations and possibilities. Around the world, the forms find expressions in all spheres of moving-image media—between documentary, narrative, and speculative forms; with approaches ranging from pragmatic to poetic; coming in various durations; broadcast on Indigenous TV stations or national networks, live-streamed as activist video, or screened in theaters or at exhibition spaces or during community gatherings. Some of these works have traveled outside the communities and are inscribed in critical or historical treatments of media. Others, however, have remained local and transient, sometimes by design, sometimes unwillingly.

While the works of Autochthonous filmmakers are programmed at festivals, while *Indigeneity* is an increasingly visible theme in the contemporary art sphere, and while Autochthonous communities use various tools of visual activism, these different forms have rarely been considered as multi-sited phenomena. This book grows out of the wish to take a look at the diverse filmic forms made by and within Autochthonous communities in their quest for self-determination during the past decades.

The fruit of numerous exchanges between filmmakers and activists, members of Autochthonous peoples and their accomplices and allies from the majority society, this book presents the filmic experiences and forms resulting from the cross-pollination of the formal experimentations of political cinema and the visual (and sonic) epistemologies of Autochthonous communities. Our endless gratitude goes out to the contributors of this book who found the time and energy to relate their experiences and compose their contributions.[3] Autochthonous struggles and the filmic practices to which they give rise have become increasingly fervent and visible. The degradation of living environments—first and

3 We wish to clarify the positions from which we speak, and to give voice to the complementarity (and limitations) of our perspectives and experiences. For Skaya Siku, a scholar of Autochthonous education of Seejiq Truku descent in Nantou (Taiwan), the editorial work was an opportunity to revisit her previous research on several Taiwanese Autochthonous filmmakers, and to consider them alongside the various filmic histories and practices presented throughout the book. For Nicole Brenez and Alo Paistik, historians of images and filmic representations, this book is an opportunity to explore the articulations and forms of solidarity between the various international visual struggles across economic, political, and ideological terrains, and the audiovisual conflicts specific to the different Autochthonous peoples presented here. Jonathan Larcher, a visual anthropologist with no Autochthonous background, is indebted to his interlocutors for the generosity with which they opened their archives during his fieldwork. After all, as the Hopi artist Victor Masayesva Jr. once said, visual anthropologists are "a group from which [he] ha[s] previously sought a safe distance." (Victor Masayesva Jr., "Indigenous Experimentalism," in *Magnetic North*, ed. Jenny Lion [Minneapolis: University of Minnesota Press, 2001], 229.) We are aware of the long history of sometimes contrary and extractivist relationships that have characterized our disciplines' relationship with Autochthonous communities and their visual productions.

foremost those of which Aboriginal, Indigenous, and Native peoples and communities have been custodians for millennia—is an issue at the forefront of the social and protest movements of our time. The goal of this book is not to offer a panorama or cartography. This book makes no pretenses about being historically or geographically exhaustive. Its aim is to explore the propensity of these movements for inventing a multitude of singular filmic forms that cannot be reduced to one descriptive, narrative, figurative, or analytic model. We have greeted the contributions here as diverse and unique experiences and let each of them form an autonomous section, reflected in their makeup and layout.

In collectively contemplating how mothering moving images during struggle is possible, the reflections and images by filmmakers, activists, and scholars gathered between the covers of this book outline a shared historiographic territory and point to the potential that film holds for a contemporary Indigenous internationalism. In the book's second half, researchers, film scholars and curators, closely working with filmmakers or engaged in fieldwork, further extend, contextualize and analyze these first-hand experiences.

This book is also the result of exchanges with a larger circle of filmmakers and scholars in the years leading up to its publication, in particular in connection with a series of international colloquia organized by the editors in Paris in 2019. In addition to conversations with the filmmakers who ultimately contributed to this book, we are grateful to the enlightening conversations with the filmmakers and artists Rupert Cox, Aléssi Dell'Umbria, Myron Dewey, Sky Hopinka, Alanis Obomsawin, and Lisa Rave and Erik Blinderman. These colloquia and screenings were organized around a hypothesis that a particular global circulation of filmic forms as well as knowledge and practices, despite their diversity, are deeply interlinked through their shared concerns and the existential situations from which they emerge. Throughout the four colloquia, our focus was on the vivacity of film images and their role in the lived experiences of social movements and (sometimes armed) conflicts, produced by Autochthonous filmmakers as well as members of majority societies. Not unlike Indigenous internationalism, the films of Autochthonous struggles are at once radically local and particular, and interact with a global network of concerns, people, and creative forms.

Across the broad range of social movements and conflicts in which Autochthonous communities are engaged, several in particular have attracted our attention. The situations that we outline on the following pages are the current focal points of tension and active fronts of struggle, many of them the most recent transformations of deep-seated historical injustice, settler colonialism, and extractivist capitalism. They are also places where powerful forms of conviviality are being practiced and where vibrant filmic forms emerge. Parts of that territory have already been explored by filmmakers and scholars, some of whose publications are named at the end of this introduction. A number of these texts trace the individual strands of the formal and political inventions of the filmic history or show how the current fronts of struggle (protection camps, road blocks) often align with the same sites that in the past witnessed massacres, genocides, and forced displacements.

NEXT SPREAD
Shaney Komulainen, *Across the Razor Wire*, 1990. Photograph taken during the Oka Crisis, the subject of Alanis Obomsawin's *Kanehsatake: 270 Years of Resistance* (1993).

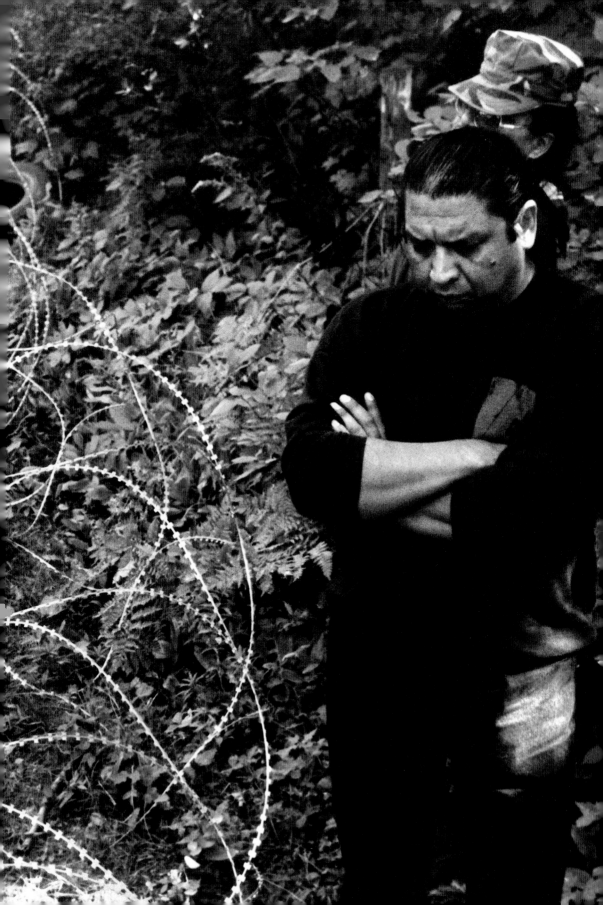

Situations

Political sovereignty and autonomy

Towards the end of the 1960s and at the beginning of the 1970s, in the wake of the decolonization movements launched in the aftermath of the Second World War, Autochthonous struggles were marked by the consolidation of local and international political movements to oppose the colonial dispossession of their ancestral territory. On Turtle Island, the Red Power movement took shape at the end of the 1960s, with dozens of local and then national organizations taking part in landmark occupations (Alcatraz, Wounded Knee). In the 1970s, a number of Autochthonous political movements in different parts of the world set out to claim sovereignty over lands that had been taken from First Nations and Aboriginal peoples. In Canberra, Aboriginal activists launched the Aboriginal Tent Embassy in front of the Australian Parliament—a protest occupation that is still ongoing, and which was the subject of one of the first films on Indigenous internationalism (*Ningla A-Na*, made in 1972 by the Italian filmmaker Alessandro Cavadini). In Aotearoa New Zealand, Māori activists occupied Bastion Point, a coastal land near Auckland, for 506 days (1977–78). In Sápmi, Sámi people and environmental activists launched the People's Action against the damming of the Áltá-Guovdageaidnu Waterway (1978–82), a founding event of the Čajet Sami Vuoiŋŋa! (Show Sámi Spirit!) political movement. In Eeyou Istchee (Quebec, Turtle Island), the mobilization against the James Bay dam project (from early 1970s onwards) left a lasting mark on the Cree nation. Taken together, these initiatives and movements formed the basis for the first Indigenous internationalism, and would contribute to the visibility and coordination of efforts for the recognition of territorial sovereignty and the political autonomy of Autochthonous nations. As has noted Kimberley Moulton, a Yorta Yorta woman and curator: "one could look at the global First Peoples community as a collective—the grand grouping of peoples who have resisted colonial empires for centuries and whose survivance is rooted in the connections to culture and country."[4]

This first Indigenous internationalism has opened up a possibility for a "'meta collective' of Indigenous people in a global context."[5] Embodied in numerous struggles for self-determination, this Indigenous internationalism has produced a multifaceted constellation of moving images. It was most likely in these political movements that contact points were formed between the Third Cinema, a territory charted in Fernando Solanas and Octavio Getino's 1969 manifesto, and the genesis of a Fourth Cinema, a term coined by Māori filmmaker and critic Barry Barclay in 2002. Barclay proposed the term to discuss the present and possible futures of the forms, economies of production, and reception of dramatic feature films

4 Kimberley Moulton, "One Mob, One Voice, One Land. The Meta-Collective," in *Mázejoavku: Indigenous Collectivity and Art*, Susanne Hætta, ed. Katya García-Antón (Oslo: Office for Contemporary Art Norway / DAT, 2020), 210.
5 Moulton, "One Mob, One Voice, One Land," 210.

"What's the Point of Cinema?" Struggles, Conviviality, and the Vivacity of Images

Stills, Myaw Biho's livestreams between April and August 2018

"February 23, 2017, marked the beginning of a formal occupation movement in front of the Presidential Office Building [in Taipei, Taiwan, of] an Indigenous occupation movement which has lasted for more than 1000 days and is regarded as the longest protest of its kind in Taiwan. During the occupation, Mayaw Biho strategically adapted to daily live streaming in order to reach a wider audience for their land claims. [Mayaw Biho, Panai Kusui, and Nabu Husungan Istanda] named themselves 'the Indigenous Transitional Justice Classroom' in order to examine and challenge the 'Indigenous Historical Justice and Transitional Justice Committee' led by President Tsai. [...] During their occupation, especially the first 300 days, they successfully raised awareness among the wider public and motived diverse Indigenous and non-Indigenous participants to support Aboriginal land claims by creating the popular slogan, 'Nobody is an outsider (沒有人是局外人).'"
Skaya Siku, "The Making of Indigenous Knowledge in Contemporary Taiwan" (2021), 57, 62.

made by Autochthonous filmmakers, which he counted as eleven, beginning with Sámi director Nils Gaup's 1987 film *Ofelaš* (*Pathfinder*). On the basis of archival materials that have been brought to wider consciousness in recent years, it appears that decades before the well-known works of Nils Gaup, Tracey Moffatt (*Bedevil*, 1993), or Chris Eyre (*Smoke Signals*, 1998), among others, Autochthonous activists, artists, and knowledge keepers who were engaged in militant activism produced, viewed, and distributed their own film and video images. As shows the film *Warrior Women* (2018), following the life and activism of American Indian Movement leader Madonna Thunder Hawk since the 1960s and making use of materials from private collections but also those of the AIM, these images—private, militant, communal—were an integral part of the self-determination movements and are now in need of renewed care and attention. These situations of struggle have been a training

ground for generations of First Peoples, Aboriginal, and Autochthonous filmmakers. Aboriginal filmmakers Madeline McGrady and Tracey Moffatt, for instance, began their long careers with the film *Guniwaya Ngigu* (*We Fight*, 1982), which follows the land rights protests and occupation of Musgrave Park in Brisbane, as it was reclaimed as Aboriginal Land in the leadup and during the 1982 Commonwealth Games.

Today, the repertoire of these actions—occupation, blockades, sit-ins—remains at the heart of the movements for political sovereignty of Autochthonous peoples. Digital platforms have not only multiplied the methods of archiving, counter-documentation, sousveillance and

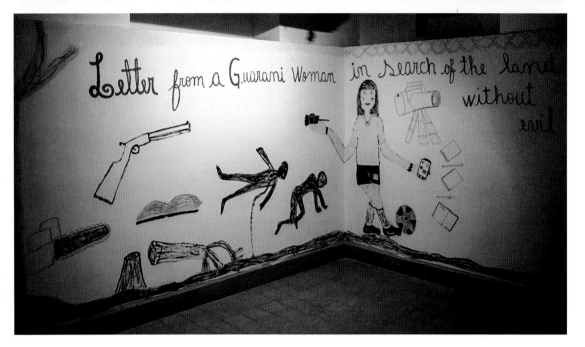

Mural entitled *Aguyjevete* (*Prelude*) at the entrance to Patrícia Ferreira Pará Yxapy's exhibition "Letter From a Guarani Woman in Search of the Land Without Evil" at S A V V Y Contemporary (conceived in collaboration with Forum Expanded at Berlinale) in Berlin, February 2020. The accompanying booklet reads: "Through presenting the sources of resistance and fragilities that have led Patrícia to choose the camera as a weapon to fight for a different narrative and exploring a means of healing from centuries of atrocities, we want to listen to and experience her expressions on the feminine, on spirituality, colonization, and the relationship to land."

intervention in the mediascape, they have also become the place of convergence for a new Indigenous internationalism. They contribute to the sharing of filmic practices, methods, and epistemologies between communities in struggle. From the Idle No More movement, in the lands now called Canada, to the Movement on the Road '96, in Amazigh territory, Morocco, a new generation of Water Protectors has been emerging since the early 2010s, using smartphones, drones, and digital tools to defend water, ecosystems, and the sovereignty of Autochthonous nations, and to confront head-on deadly hydropolitics (pipelines, mines, or the damming of rivers).

Sovereignty and autonomy can hold a variety of meanings within the context of Autochthonous struggles. Autonomy over one's thoughts, one's memories, one's body, one's language, one's culture, one's expressions, one's stories, one's histories, one's relationships—all battlegrounds in the face of majority cultures or states. It also means the freedom to determine the forms and trajectories of self-determination, whom and how does it touch, the beyond-human living and non-living, the multitude. Particularly fraught are situations where a nation or people are fractured between two or more states, with families and communities cut by international borders and politics. In 1968, with the support of the National Film Board of Canada, a team of filmmakers, including several members of the Indian Film Crew (IFC), documented the blocking of the road over the Seaway International Bridge by members of the Mohawk Nation at Akwesasne (or St. Regis Mohawk Reservation on the US side of the border). Following numerous treaties, their territory was reduced and located

"What's the Point of Cinema?" Struggles, Conviviality, and the Vivacity of Images

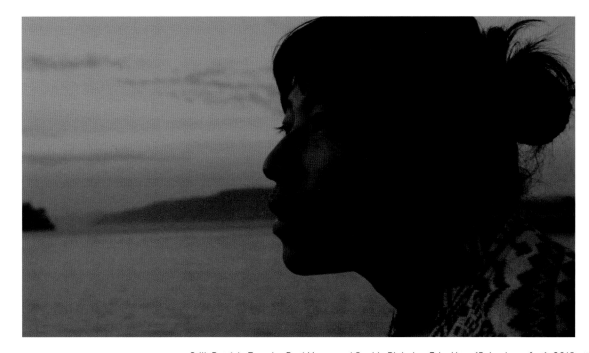

Still, Patrícia Ferreira Pará Yxapy and Sophia Pinheiro, *Teko Haxy (Being Imperfect)*, 2018

Porto Mauá, Uruguay River, on the Brazilian-Argentine border, July 2016.
Patrícia Ferreira Pará Yxapy, speaking in Brazilian Portuguese to Sophia Pinheiro: "For sure if I were to speak in Guarani the words would be much deeper. [...] Since you arrived, those that arrived, we are practically losing our things, the things that were left for us by the Nhanderu [creator being]. [...] It is difficult for us to do that which our grandparents did. To go walking, to go from one place to another For example, here, for us to go to Argentina or to return to Brazil if you don't have a document, if your document has the slightest issue, or whatever, you can't cross the border. You are barred because of paper. [...] I think that they really don't want us to exist. They really would have preferred that we weren't here when you all arrived, but we were here."
[Transcription of the film's English subtitles]

along the border between the lands now called Canada and the United States, subjecting the community to a regime of taxes and laws that were fundamentally foreign and unfavorable to them. This "guerilla filmmaking" resulted in a thirty-six-minute documentary *You Are on Indian Land* (1969), today credited to Michael Kanentakeron Mitchell, a trailblazing First Nations filmmaker and a Kanyen'kehà:ka (Mohawk) politician.

The Guarani homelands are sliced between Brazil, Argentina, Paraguay, Uruguay, and Bolivia, mounting sometimes invisible but no less effective walls between families and communities. These dividing lines have marked the life and creative practice of Guarani filmmaker Patrícia Ferreira Pará Yxapy, born near the Argentine-Brazilian border, who explores in her filmmaking the experiences of the Guarani in the continuing colonial reality, the relationship to the land, and the experiences and lives of Guarani women. After attending a workshop organized by Vídeo nas Aldeias in 2007, Patrícia Ferreira Pará Yxapy co-founded Mbyá-Guarani Cinema Collective, and went on to make a series of short-form documentaries, including, together with Sophia Pinheiro, *Teko Haxy (Being Imperfect)* in 2018. In this intimate and sensitive work, Patrícia Ferreira Pará Yxapy recounts the reality imposed by Europeans after their arrival in the Americas and the life of the Guarani in the borderlands.

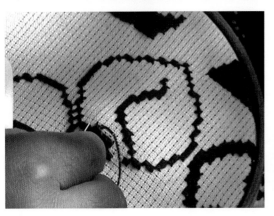

Passing down the ancestral knowledge

The transmission of ancestral knowledge has been a central concern for Autochthonous filmmakers and activists since the first forays into filmmaking in the 1960s. Film is seen both as a formidable medium for recording the stories and motifs that carry ancestral knowledge, and as a practice that plays a part in the subsistence economy of collectives. Formal inventions are thus conceived in symbiosis with forms of life. In Chiapas, Taiwan, Canada, and Australia, the transmission of ancestral knowledge through film is inseparable from striving for political autonomy, and vernacular and domestic economic activities.

In Canada, filmmakers and activists have seized every possible format and medium to convey the traditional knowledge and lived experiences of Inuit, Métis, and First Nations communities. At the turn of the 1960s and 1970s, First Nations filmmakers supported by the National Film Board of Canada took an active part in making documentary films to oppose the dispossession of their lands and the acculturation brought about by the boarding school system. From her very first films, *Christmas at Moose Factory* (1971) and *Mother of Many Children* (1977), Abenaki filmmaker Alanis Obomsawin made the transmission of ancestral knowledge one of the main thrusts of her narratives. This transmission of ancestral knowledge doesn't just rely on the spoken word; in Inuit lands, it also involves filmic techniques that borrow motifs and methods from vernacular activities (hunting, fishing, lighting a seal oil lamp …). This principle has inspired many of the productions of the Igloolik Isuma Productions collective, co-founded by Inuk filmmaker Zacharias Kunuk in 1990, as well as those of the collective Arnait Video Productions—originally Arnait Ikajurtigiit / The Women's Video Workshop of Igloolik—which was founded in 1991. Their films and videos thus don't only participate in representing the community to itself and in passing on ancestral knowledge to younger generations, but *talk back*[6] to the settler colonial

6 In a text studying Autochthonous media, Faye Ginsburg showed how Inuit and Aboriginal productions in the 1980s and 1990s "talk[ed] back" to "structures of power and state that have denied their rights" and to "the categories that have been created to contain Indigenous people." Faye Ginsburg, "Screen Memories: Resignifying the Traditional in Indigenous Media," in *Media Worlds: Anthropology in New Terrain*, eds. Faye Ginsburg, Lila Abu-Lughod, and Brian Larkin (Berkeley, CA: University of California Press, 2002), 51.

Stills, Promedios, *Xulum' Chon*, 2002

"In 2002, a *promotor de comunicación* of the Zapatista movement, in collaboration with Promedios, made a film about Xulum' Chon, a cooperative of Tzotzil women in the Chiapas highlands. Like many of Promedios's productions, the film shows how the daily, traditional activities of the Zapatista autonomous municipality San Juan de la Libertad, in particular the use of traditional looms (*telar de cintura*), are reinvested in practices of political and economic autonomy. In parallel, the cooperative's activities contribute to the transmission of ancestral knowledge since the embroidered motifs take up elements of the community's founding myth.

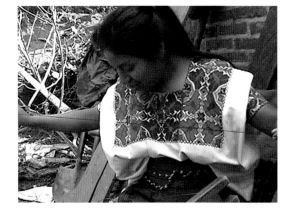

There was a time when the rain was falling constantly and the branches and trees started to clog a small stream above a huge rock. So, the Xulum' Chon, a mythological being in the form of a gigantic lizard, looked at the danger of the community living below the rock being overrun by floodwaters, and decided to carve a path for the water to escape. The animal was dragged away by the current and disappeared or perished, but its heroic action saved the community.

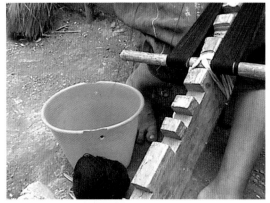

The women decided to name their cooperative Xulum' Chon because they consider themselves to act as this animal, they were opening a path for other women to be able to survive.

The motifs of the clothing echo elements of this myth. The film highlights the resemblance between certain details of the clothing and the crevasse on the mountain overlooking the community, seen as one of the traces of the providential intervention of this mythical animal [see the two stills above left]."
Francisco Vázquez Mota,
personal message to the editors, 2023.

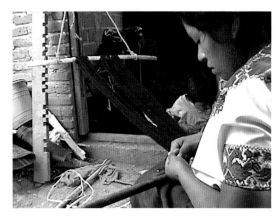

categories of representation. The filmic practices of Zacharias Kunuk and Igloolik Isuma Productions are fully in line with the subsistence economy of the community of Igloolik (Nunavut). The feature film *Atanarjuat: The Fast Runner* (ᐊᑕᓈᕐᔪᐊᑦ, 2001), is both the first fiction film in Inuktitut—an adaptation of a local oral story of love, jealousy, and murder—and a contribution to the economic, political, and cultural vitality of the Igloolik community. This emphasis on the concrete effects of image-making shows how, from the outset, Igloolik Isuma Productions had been conceived as an alternative video infrastructure (in a community that has opposed the broadcasting of satellite TV on their lands since the 1980s). In 2012, a new milestone was reached with the creation of an internet platform, Digital Indigenous Democracy (DID), hosted on IsumaTV, to coordinate the documentation of Inuit in low-bandwidth communities to counter the development of mining and extractive projects in Nunavut).

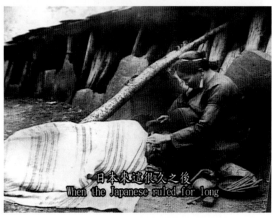

Stills, Pilin Yapu, *Tales of Rainbow*, 1998/2008

"When the Japanese reigned, they very soon noticed the tattoo was a token of Atayal's adulthood. The system that fortified the strength of the Atayal People is the social institution called Gaga. The Japanese spent ages researching, especially through professionals of anthropology and sociology, going to the tribe to learn the content of Gaga. Then they realized, tattoo was Gaga's visual symbol. Hence, if the Atayal tattoo could be taken out of the way, the visual symbol was in fact vanished from Atayal's Gaga. [There was only one reason behind banishing the tattoo,] they were anxious about the power of Atayal's Gaga force."
Voice of Walis Nokan, Atayal writer.
[Transcription of the film's English subtitles]

In Taiwan, Atayal filmmaker and educator Pilin Yapu has dedicated his work to the creation of filmic forms and school structures for the transmission of traditional Atayal knowledge: the Gaga. In *Tales of the Rainbow* (1998/2008), the filmmaker visits Atayal tribal elders, who bear traditional rainbow face tattoos. Rainbow, in the Atayal mythology, is the path that the deceased take on their way to heaven. The tattoos help the ancestral spirits recognize and welcome their own, they are signs of belonging and identity. The elders, some over a hundred years old, become mediators of generations and knowledge of the past, recounting how the tattoos became the basis of ostracization of the Atayal people under the Japanese and Chinese colonial regimes. They also show how the tattoos become elements of the renewal of traditional Atayal practices. Pilin Yapu uses the filmic art of transmission to revitalize rituals: the numerous screenings of *Come Closer to the Ancestral Spirits* (2002) to the communities helped reinvigorate the

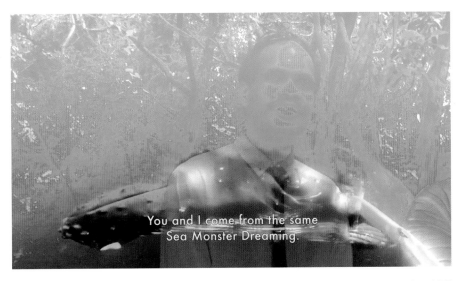

You and I come from the same
Sea Monster Dreaming.

Still, Karrabing Film Collective, *The Jealous One*, 2017

"We are doing films for a very particular reason. They allow us to act out the ancestral present, and they allow us to act it out without a script, because we have different levels of literacy and competency in ancestral languages, settler languages—that is English—and then creole, which we all share. So, making films allows us to intervene in settler narratives without being tied to settler literacy. Karrabing films are true with a little bit of story in them. Meaning, they are based on the lives we share and we know but we give them a little narrative order. [...] As Linda [Yarrowin] says, Karrabing films are based on true things, on their ancestral relations to their totems, to their lands, to the narratives that formed those lands. And these narratives are true, and we know, because when we go there, you can see how the geography has been formed by what the Barramundi Sisters did or what Tjipel, young girl dressed up as boy did, literally shaped the land."
Elizabeth A. Povinelli, *Cultures of Energy*, podcast, episode 204 (2022).

knowledge performed through their ancestral rituals. In 2016, Pilin Yapu founded an experimental Atayal school, the P'uma Elementary School, of which he is principal. The curriculum, in Atayal, is organized around the learning of ancestral knowledge and its modern adaptation.

In Australia, formed in 2009 in response to a state-sanctioned campaign of administrative and economic discrimination, Karrabing Film Collective has developed a filmmaking practice serving the basic needs of a community primarily made up of Belyuen Aboriginal Australians. The collective itself is an extended filmmaking family, a political community, of around fifty members who have made filmmaking an integral part of their way of life. They use decidedly low-threshold technology, which can be readily acquired and spontaneously put to use in situations which arise from the daily life. Interactions with the community and acting in the film flow organically between their daily life and the film world. Many of the films of Karrabing Film Collective address in image, sound, and word first and foremost the community itself. The works are at once proposals for reimagining human and non-human relations, and sound cartographies of ancestral territories for those who know how to listen to the ancestral presence. At the same time, the collective's films have become one of the most visible Autochthonous film productions in the international contemporary art scene over the past decade (helping to generate resources that are directed back into sustaining the life of the community).

Recomposing and questioning the history of colonization

The long history of colonization of Autochthonous ancestral lands is composed of painful chapters of the dispossession, pollution, and depopulation of living spaces. Official archives—regardless of their scale or location (national, regional, municipal)—rarely conserve an exact and detailed chronology of these events. To present and then represent this experience, Autochthonous peoples and communities have made frequent recourse to oral and visual traditions of representation and transmission. More recently, filmic tactics have joined them in recomposing and questioning the history of colonization, a few of which can be recalled here.

– Translating an artifact and its immaterial aura, as in the film *Kanehsatake: 270 Years of Resistance* (1993) by Alanis Obomsawin. To contextualize and revisit the events during the Oka Crisis from July to September 1990, when the Kanyen'kehà:ka in Kanehsatà:ke (Quebec, Turtle Island) opposed the construction of a golf course on a sacred burial ground stolen from them, the filmmaker reconstructs a long history of colonization using oral histories and a Wampum Belt that had sealed the treaty between them and the French in the early eighteenth century. The film's initial impetus was to document the unfolding Oka Crisis from the perspective of the protestors and from within the barricades blocking access to the area. Through its anti-authoritarian method and form, and by establishing a remarkable continuity between vernacular memory and the medium of film, *Kanehsatake* becomes a chronicle of a centuries-long injustice and resistance. In the years since its making, it has become at once a document of counter-representation in the context of biased media portrayals of the First Nations Peoples, and a potent pedagogical tool for studying the history of colonization. Obomsawin herself has remained an enduring presence as an Autochthonous activist, filmmaker, performer, and artist, and continues to generously accompany and mediate her works.

– Reclaiming the imagination and narratives of past and future through speculative audiovisual practice. The crop of films from the past decade making use of speculative narrative forms rather closely aligns with the concerns and questions posed in the field of literature, namely in the works of (and reflections on) Indigenous futurisms. The object of concern here is not merely the future, but a larger temporal horizon extending in all directions. Retelling the (colonial) past and radically readjusting the historical framing and narrator's or writer's position allows not only to revisit what was, but also to imagine alternative trajectories, redirected to another future. Moreover, the modes of Indigenous futurisms as identified by Grace L. Dillon—Native slipstream (developed from Gerald Vizenor's concept of slipstream); first contact narratives; Indigenous science and environmental sustainability; Native apocalypse, revolutions, and futuristic reconstructions of sovereignties; and Biskaabiiyang or "returning to ourselves,"—are ways to critically revise the dominant "Eurowestern" narrative tropes and to bring to the fore the Autochthonous perspectives and experiences. Jeff Barnaby's (Mi'kmaq) *Blood Quantum* (2019) and Danis Goulet's (Cree-Métis) *Night Raiders* (2021) are notable recent examples of letting the

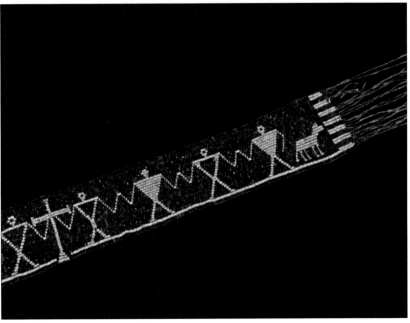

Stills, Alanis Obomsawin, *Kanehsatake: 270 Years of Resistance*, 1993

Voiceover: "Said Chief Aughneetha, 'You see this white line which shows the length of our land? The figures holding hands who rejoin the cross represent the loyalty which we owe to the faith that we hold. The body represents the council fire of our village. The two dogs on the outside are supposed to guard the boundaries of our land, and if anyone attempted to interrupt our possession, it is their duty to warn us by barking.'"

Alanis Obomsawin, voiceover: "For the Iroquois the Wampum Belt was a record of laws governing a five-nation confederacy ruled by a council of fifty chiefs. This system of government would influence the future establishment of a democratic charter in North America. As the years went by, every chief took up the struggle to have their rights to the land recognized."

Autochthonous experiences and cosmologies on Turtle Island shift and fuse with horror and science fiction. In Australia, several of Karrabing Film Collective's productions are carried by reenactments while retelling the past and drawing on speculative futures. In *Night Time Go* (2017), the film-making family restages the history of the deportation of their community's ancestors (Darwin, Northern Territory) during the Second World War to the war camp in the town Katherine, 400 km from their ancestral territory. The film's retelling of the escape of community members from the camp plants the seeds for a popular uprising that gradually spreads to the entirety of majority society. *The Mermaids, or Aiden in Wonderland* (2018) follows a young Aboriginal man in a contaminated world where only Autochthonous people are able to survive outdoors. Having escaped his white captors, who had experimented on him since his childhood, Aiden joins his family members and explores the different temporalities of his community.

– Restaging and reenacting the abuse experienced in the hands of the agents of the dominant society, most notably the moments of intense violence perpetrated by armed (paramilitary) forces. The various forms of reenactment that the affected communities have invented allow testimonies of abuse and impunity to be preserved and handed down

 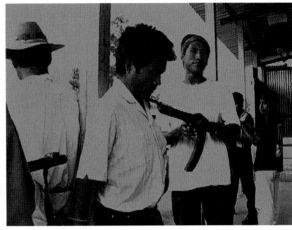

Stills, FrayBa and Promedios,
Caminando hacia el amanecer, 2001

Caminando hacia el amanecer, co-produced by Promedios and
the Fray Bartolomé de las Casas human rights center (FrayBa)
and directed by Nicolas Défossé, gathers testimonies and
interviews documenting the forced displacement of numerous
Autochthonous communities, particularly Tzotzil (Chiapas
Highlands) and Ch'ol Maya (North of the Lacandon Jungle),
in the second half of the 1990s. This effort to reconstruct the
effects of low-intensity warfare took the form of reenactments
of the violence perpetrated by the army and paramilitaries.

to younger generations. Sometimes, these tactics of transmission are
recorded on audiotape and film, for instance by the Tzotzil and Tzeltal
communities on the high plateaus of Chiapas who fled armed repression
in the late 1990s (*Caminando hacia el amanecer*, 2001), as well as by the
Yanyuwa people of Borroloola (Northern Territory, Australia) who used
acts of reenactment to assert their sovereignty over the territories from
which they were displaced (Borroloola Aboriginal Community with Carolyn
Strachan and Alessandro Cavadini, *Two Laws*, 1982).

Incriminating green colonialism

In Sápmi, the Sámi people's territory covering Northern Fennoscandia, and in the Isthmus of Tehuantepec (Mexico), Autochthonous communities are confronted with the most recent avatar of settler colonialism—insepa-rable from mining and fossil capitalism for three centuries. Since the early twenty-first century, energy transition infrastructures have been used to redirect the logics of appropriation, pollution, and land exploitation which continue to reduce Autochthonous nations to disposable communities.

Wind farms and new mining projects to extract resources for batteries—lithium, graphite, rare earth elements—are being built on territories that already bear the scars of a long history of exploitation, violence, and dispossession. In Turtle Island, The Fort McDermitt Paiute and Shoshone Tribe and the Algonquin from Long Point First Nation must protect their territory from proposed lithium mines after major deposits were discovered—at Thacker Pass (Nevada, USA) and around Lake Simard (Quebec, Canada) respectively. Around Kiruna/Giron, in Sweden's Sápmi region, several *sameby*—territorial entities where Sámi families have free grazing rights—are opposing an open-pit graphite mine that received the government permits in 2021. The infrastructure that would have to be constructed for the production and transportation of graphite would further fragment the winter grazing lands of reindeer. Throughout Sápmi, the experience of creating and maintaining wind farms has led reindeer herders to a similar conclusion (supported by several studies in animal biology): wind turbines and reindeer cannot coexist. In all these large-scale projects, energy and resources are never produced for the benefit of these present or future sacrifice zones, they are used first and foremost to power the industries and lifestyles of the majority society.

This green colonialism also instrumentalizes the ecological discourse in other ways. In the name of "environmental preservation," the Norwegian government has introduced limits on the number of animals per reindeer herd, which has a severe impact on the Sámi's ability to keep reindeer. In Finland, the government has similarly imposed quotas on fishing in the name of "biodiversity preservation." In summer 2017, a group of Sámi thus declared a moratorium on the island of Čearretsuolo. As well as being at the vanguard of the multiple fronts of environmental struggles, attested to by the growing number of Autochthonous activists murdered over the past decade,[7] Autochthonous peoples are thus also at the leading edge of the filmic, visual and sound forms that document and incriminate this green colonialism. The Sámi Pavilion at the Venice Biennale in 2022, and the mural art unfolding in the Isthmus of Tehuantepec are examples of the formal inventions and forms of conviviality being developed in affected communities.

7 According to Global Witness, a significant proportion of the 1,733 environmental activists mur-dered between 2012 and 2021 were Autochthonous, in particular in Mexico and Brazil. Global Witness, *Decade of Defiance: Ten Years of Reporting Land and Environmental Activism Worldwide* (September 2022).

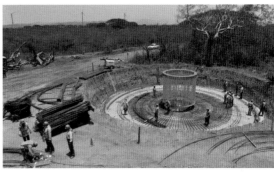

Stills, Alèssi Dell'Umbria, *Istmeño, the Wind of Revolution (Istmeño, le vent de la révolte)*, 2014

"A political documentary clearly takes sides in a war that is not officially declared—its aim is indeed to declare a war that exists anyway. For all that, this stance implies allowing another world to take shape in the cinematographic document. [...] In Mexico, commercial or political advertising takes the form of murals. But at Unión Hidalgo, another style of mural has been developing since 2010. These are giant portraits of community elders. [These] murals by our friends at Unión Hidalgo influenced our way of filming."
Alèssi Dell'Umbria, *Istmeño, le vent de la révolte* (2018), 14–15.

"To turn the landscape into an industrial site, one first has to clear the land. Magnificent trees are uprooted by the hundreds. [...] Deforestation goes hand in hand with territorial control: freedom of movement has simply disappeared."
Istmeño, le vent de la révolte, 33.

"The hundreds of concrete and steel bases in which the wind turbines are planted have disrupted the circulation of water in these lowlands, not only that of the canals and streams, but also that of the groundwater: each base is 28 meters across and 25 meters deep, which adds up to 360 tons of concrete injected into the earth at each site. And the water table is just a few meters below the surface."
Istmeño, le vent de la révolte, 32.

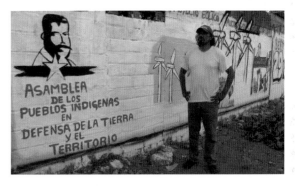

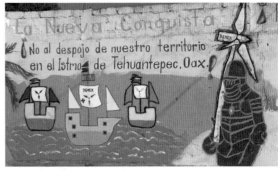

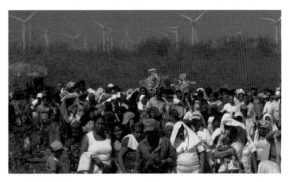

Parsing and affronting the colonization of the atmosphere

Is it possible to grasp a colonial politics whose territorial expansion is no longer horizontal, but vertical, rising into the atmosphere? If so, what media and filmmaking tactics can be mobilized to document and counteract these new forms of usurpation of the environment and living spaces?

Since the second half of the twentieth century, space exploration infrastructures have been constructed in places labeled remote and far too often presumed to be uninhabited. To the contrary, the Atacama Desert, the peaks of Hawai'i, and the boreal forest and tundra of Northern Sápmi are all homelands of Autochthonous communities. In Northern Sweden, the construction of the Esrange rocket launch center occurred concurrently with the establishment of a 5,200 km² impact zone encroaching on the reindeer pasturelands of several *sameby*. The currently unfolding advent of NewSpace—a conjoined commercial regime of communication infrastructure projects, the space launch market, and venture capital—on a site used until now for research in astronomy could further drive the colonization of the atmosphere above areas inhabited by the Sámi. This is the same logic that inspired the significant mobilization of Kānaka Maoli (Native Hawaiians) in opposition to the construction of the Thirty Meter Telescope at the base of Mauna Kea volcano on the island of Hawai'i. In the name of science and research into extrasolar worlds, aerospace engineers and astronomers have built very terrestrial infrastructures at the base of a mountain that the Kānaka Maoli consider sacred. The extension of digital telecommunications, environmental monitoring via satellites, and fantasies of discovering *new worlds* is based on these new practices of colonization. For long having operated beneath and along the ground, advanced capitalism now operates in the atmosphere.

This intertwining is happening along infrastructure projects that are traditionally seen to be confined to only one layer of our living space. The history of industrial catastrophes and displaced populations provoked by pipelines is one example of the great risks that this joining of extractivist and atmosphere capitalism engenders. The occupation of the Oceti Sakowin Camp in Standing Rock Indian Reservation (South Dakota, USA) in opposition to the construction of the 1,172-mile-long Dakota Access Pipeline (DAPL) shows that the use of subterranean infrastructures extends to the reserve's air space. Although the major police presence made it impossible to document the construction site, several Autochthonous activists and video makers—including Myron Dewey (Walker River Paiute Tribe) and Dean Dedman, Jr. (half Hunkpapa Lakota, half Diné, enrolled member of the Standing Rock Sioux Tribe)—bypassed the security cordons by using civilian drones to make daily video recordings. In the atmosphere, these Drone Warriors have displaced cop watching and counter-information practices, producing the materials needed to coordinate counterattacks led by DAPL opponents. The confiscations and signal interferences to which the drone pilots have been subject, as well as the establishment of a no-fly zone by the Federal Aviation Administration (November–December 2016), shows the degree to which the confiscation

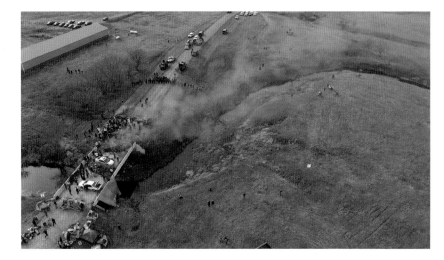

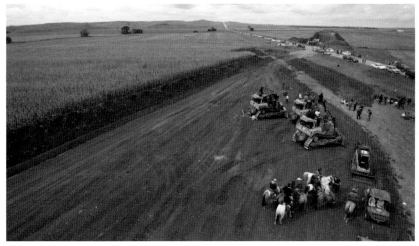

Stills, Josh Fox, James Spione, and Myron Dewey, *Awake, A Dream from Standing Rock*, 2017

Myron Dewey, voiceover: "On September 3rd, during the dog attacks, as I was reporting upon the hill, documenting that moment, the desecration of the sacred land, the Dakota Access Pipeline jumping forward twenty miles. It was hurting the people, hurting the women, hurting the elders, to see their ancestors' lands being desecrated. The goal is to educate and empower Digital Smoke Signals [...], not just only our Indigenous people, but also non-Native relatives that come in solidarity. [They] come to camp, they come to learn, they come to find their own spirit and the connection to the earth."

of the lands and waters of Autochthonous nations by fossil and mining capitalism now encompasses also air and space. As the Diné composer, performer, and installation artist Raven Chacon said during an artist talk, introducing his exhibition at Nordnorsk Kunstmuseum in Tromsø/Romsa in 2024, "we have to imagine our place in its verticality, with our ancestors below and above us." This view of the verticality of ancestral territories is at the heart of his two-channel video installation *Maneuvering the Apostles* (2024), which combines drone footage of a wind farm in Sápmi (Northern Norway) and a soundtrack of tremolo-effected bird recordings. Both images and sounds amplify these new, often hidden and invisible forms of green extractivism, sacrificing the same territories over and over again.

The futurity of visual sovereignty

"The gun/camera/computer are all aspects of the complete domination of indigenous cultures. From this perspective experimental films and videos can be defined by the degree to which they subvert the colonizers' indoctrination and champion indigenous expression in the political landscape. This act of protest and declaration of sovereignty is at the heart of experimental mediamaking in the indigenous communities."

Victor Masayesva Jr., "Indigenous Experimentalism," in *Magnetic North*, ed. Jenny Lion (Minneapolis, MN: University of Minnesota Press, 2001), 236.

In Canada, as in Australia, the first Autochthonous broadcast media productions appeared in the 1980s, as soon as access to satellite television infrastructures and programs was authorized, following years of mobilization by Autochthonous collectives. The production of television programs, often in several Autochthonous languages, played a dynamic role in the development of cultural policies and the revitalization of Inuit, Aboriginal, and First Nations languages. Since then, this proximity between film creation and the transmission of traditional arts and Autochthonous languages has been observed in many other contexts, including in light video productions. In this way, filmmakers and video artists have turned to their advantage media infrastructures that were once used for military surveillance (in the case of Canada's Distant Early Warning Line) or to transmit mass-media content to their communities. What's more, by giving a central place to Autochthonous languages and traditional arts, filmmakers and video artists have invented filmic forms that present the invisible worlds they embody.

Stills, Christophe Yanuwana Pierre, *Unti, the Origins* (*Unti, les origines*), 2018

In drawing on Autochthonous epistemologies, filmmakers and artists are breaking away from the dominant Western visual regime that has opposed animate and inanimate beings, landscapes and human figures. How to look at, manipulate, and interact with an object, when we take into account its immaterial aura? How to film the territory of a language? How to broaden the scope of a work's audience, to include both Autochthonous and majority society audiences, current and future generations? Sky Hopinka (Ho-Chunk Nation / Pechanga Band of Luiseño Indians), Nadia Myre (Algonquin member of the Kitigan Zibi Anishinabeg First Nation), and Christophe Yanuwana Pierre (Kalina) offer concrete answers to these questions, in the colonial context of North America and French Guiana but shared by many other Autochthonous artists and filmmakers, expanding the field of formal inventions fostered by the visual and sonic epistemologies of Autochthonous communities, all the while reminding us of the profoundly political nature of any process of figuration.

Nicole Brenez, Jonathan Larcher, Alo Paistik, Skaya Siku

Stills, Nadia Myre, *Living with Contradiction*, three-channel video installation, 2018

David Garneau (a Métis visual artist): "That's the main Indigenous critique of the Museum. It's that the Museum wants to own the objects, and replace the objects for the people, and so they don't see that knowledge has passed though the people equally with the drum or whatever object. So, this cult of preservation and conservation and its fear, I believe, of the living, a fear of the present, always projecting to the future tense, where someone might be able to take care of it better, when you think of restoration and so on. Whereas if you acknowledge that the knowledge is also in the body of the person, then you want those bodies around."

Suzanne Kite (an Oglála Lakhóta visual artist and composer): "Maybe when we will be able to make objects for the future, [...] we will be able to bury our old objects, and say, 'they've lived their life and we've learned all we possibly could from them.' And the other thing about that is that they are anthropomorphized, but beyond that, if we say that they have spirits in them, and [we] say, 'now it's time for the spirits to finally go back home.' Hopefully, we've stopped putting ancestors' bones in museums, but eventually that should happen with the objects."

David Garneau: "That fits with [the] critique of elders that came up earlier. At some point, some knowledge has to die because it is inappropriate to the new present."

Jackson Polys (a Tlingit Native visual artist and filmmaker): "We have to think about their makers [of the objects]. Were their makers indifferent to us, were their makers thinking in terms of deep time or long-term time, long span, in which they made them for us, they made them for our people who will come after us …."

Raymond Boisjoly (an Aboriginal artist of Haida and Quebecois descent): "Or the public may have been an ancestral public, that was their past. So, it's like, do we work in the same way, are we making works for the future? Is that our audience? Or can our audience be, sort of, before us?"

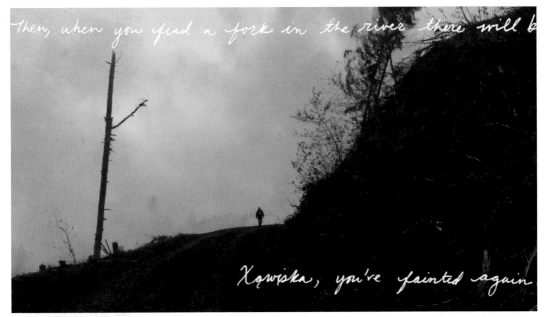

Then, when you find a fork in the river there will b

Xqwiska, you've fainted again

bǝt hayu pʰaɬ-ɬush ikta chaku, pi kʰǝltǝs..

TOP Still, Sky Hopinka, *Fainting Spells*, 2018
BOTTOM Still, Sky Hopinka, *maɬni—towards the ocean, towards the shore*, 2020

"I don't necessarily feel beholden to a canon or to these bigger ideas of what the history of cinema is in terms of reverence. I use them for my own purposes, making what a Ho-Chunk cinema, an Indigenous cinema, or a cinema of resistance would be, in terms of resisting these narratives that have plagued us for so long. But I do feel the burden of representation when it comes to non-Native and non-Indigenous audiences looking at these works: whether they might be familiar with certain concepts or whether they might be introduced to concepts that are entirely new to them, or foreign to a Western way of understanding what it means to be Ho-Chunk or the things that I'm working through in terms of landscape or language. [...] I lean more into myself as an individual who is trying to express my own position in this world, my own stakes in life, rather than feeling representative of an entire group of people, though I know that I will be viewed as such. I hope it generates more questions than an idea of knowing or a sense of certitude."
Sky Hopinka, interview by Andrea Lissoni and Filipa Ramos,
The Sun Comes in Whenever It Wants (2022), 52

Establish and preserve the filmic history of struggles

Around the years 2000 and 2010, Autochthonous political collectives became involved in an archival turn to preserve and extend the memory of the social movements that have marked the recent histories of their communities. For several collectives in Mesoamerica and South America, which filmed their productions on magnetic tape, this turn has acquired a particular urgency because of the fragility of the tapes, and the rarity of the equipment and knowledge that allow for their digitization and preservation. In the process, these collectives (the contributions in this book present the situations of the Promedios and Vídeo nas Aldeias—but the list is much longer) have invented new modes of cooperation while steering clear of salvage ethnography and the database fever, the inevitable byproducts of funding from national and state-sanctioned cultural and research institutions, and refraining from collaborations with institutions from the Global North, which reproduce the patterns of cultural extractivism that has marked the history of Autochthonous communities for centuries.

 This struggle for the memory of struggles has laid the groundwork for a historiographic territory that has been kept apart from the canons of film history. The projects that emerge from these concerns make possible the repatriation of archives to the communities and mobilize anew local and international networks of solidarity. Such is the case, for instance, with CEPAAC (Centro de preservación de archivos audiovisuales comunitarios / Center for Community Audiovisual Archives Preservation), an experimental

THIS AND NEXT SPREAD Stills, Christina D. King and Elizabeth A. Castle, *Warrior Women*, 2019

On land and children

Madonna Thunder Hawk: "I am Madonna Thunder Hawk, and I am an old AIMster gangster, way back, and I am not afraid of mics. It's the land, the *land* is priceless, and that's who we are. Once the land is gone, we're gonna be just a bunch of brown poor people. But, [what] we do as a people, everything is related, it's not one issue over here and one issue over there. If we can't save our children, why are we trying to save the land? That's our future. So, it is all connected and it is all important."

On Survival Schools

Madonna Thunder Hawk: "Survival School started out for my kids, and my nieces and nephews. And then it mushroomed on us, pretty soon we had all these kids coming to our door. Many of our students are children that have dropped out of the present education system. Not only dropped out, but have been forced out."

Marcella Gilbert, voiceover: "Survival School was just a big house that my mom rented and the young people who came there were the ones whose families were involved with the movement. They would come to hang out and then they just decided to stay. So, my education being an Indian person during that time, in the 1970s, it was a political education."

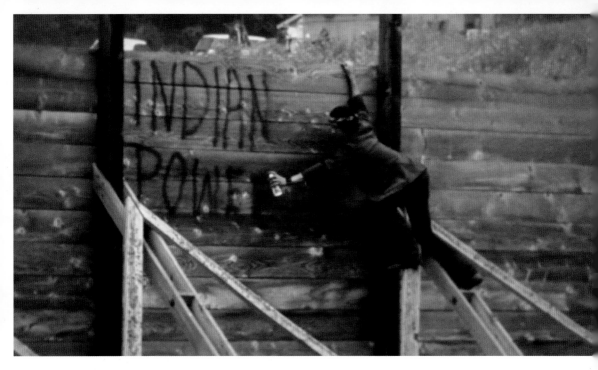

digitization and training center founded by Promedios in San Cristóbal de las Casas (Chiapas, Abya Yala) for the preservation of magnetic audio-video tapes documenting the Zapatista uprising of 1994 and the struggles that preceded and follow it.

The same understanding of archives and oral history is at the heart of the opposition to the North Dakota Access Pipeline, during the years 2016–17. Informed by over fifty years of film history of Lakota social movements at Standing Rock (in addition to the centuries-old struggle against settler colonialism), the Water Protectors have multiplied the ways of reworking and preserving the archive. Under the aegis of the Lakota People Law's Project, a media archive was set up to reconstruct the chronology of all Oceti Sakowin Camp activities.

With the film *Warrior Women* (2018), which centers around the life and battlefronts of the activist Madonna Thunder Hawk, and her daughter Marcella Gilbert, filmmakers Christina D. King and Elizabeth A. Castle have undertaken a compelling work of film and video archive reuse: from the American Indian Movement and its occupation of Alcatraz (1969–71) to Standing Rock, Wounded Knee (1973), and the Black Hills (1981). The film led to the creation of an eponymous collective, and a project to reconstitute the archive and oral history of the Red Power movement.

These initiatives show how these struggles—the American Indian Movement in the 1970s, internationalist solidarity movements following the Zapatista uprising of 1994, and the protests at Standing Rock in 2016–17—have not only produced film images but have invented entire alternative media infrastructures.

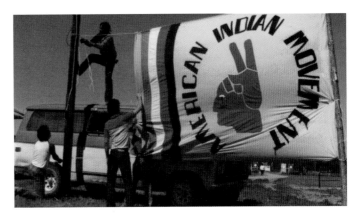

On Red Power

Madonna Thunder Hawk, voiceover: "There were several Red Power organizations, but they were mostly local or regional, specific to an issue. The American Indian Movement was the most dominant organization at the time. The American Indian Movement started in the late sixties in Minneapolis, as an answer to the police brutality that was going on. And then it just mushroomed and came to Indian country, mainly to South Dakota. We were the shock troops. When I refer to the Movement, I am referring to all those hundreds and hundreds of people that were involved wherever we went."

Marcella Gilbert: "She comes from the old Agency on Cheyenne River that's flooded. So, she can never really go home. So, I think that's why she's dedicated her life, because she can't really go home. When the Movement came, she was just like, 'Ok, this is my home.' She had somewhere where she belonged."

On Run for Freedom

Marcella Gilbert, voiceover: "There was a lot of the AIM leadership and membership that were being railroaded into prison. And so, we had political prisoners, and our Survival School was like, 'What can we do?' So, the first year of the Run for Freedom, in 1977, we went through all four seasons and as we ran, we prayed for our political prisoners everywhere."

Madonna Thunder Hawk, voiceover: "I was sent out around the country and also internationally, to get the word out."

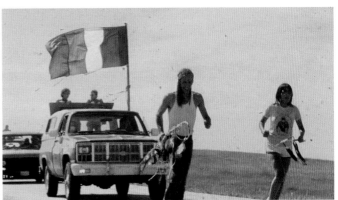

Nicole Brenez, Jonathan Larcher, Alo Paistik, Skaya Siku

Further reading

Texts by artists and activists

Barclay, Barry. *Our Own Image: A Story of a Māori Filmmaker*. Auckland: Longman Paul, 1990.

Barclay, Barry. "Celebrating Fourth Cinema." *Illusions* 35 (2003): 1–7.

Carvalho, Ana, Ernesto Ignacio de Carvalho, and Vincent Carelli, eds. *Vídeo nas Aldeias: 25 anos, 1986–2011*. Olinda: Vídeo nas Aldeias, 2011.

Cavadini, Alessandro, and Carolyn Strachan. "*Two Laws*: A Filmmaking Journey." *Screening the Past*, no. 31 (August 2011). http://www.screeningthepast.com/issue-31-dossier-u-matic-to-youtube /two-laws-a-filmmaking-journey/.

Gallois, Dominique Tilkin, and Vincent Carelli. "Vídeo nas Aldeias: a experiência Waiãpi." *Cadernos de Campo* 2 (1992): 25–36.

Go, Takamine. "I'll probably never know why I make films." In *Okinawa Dreams OK*, edited by Tony Barrell and Rick Tanaka, 54–65. Berlin: Die Gestalten Verlag, 1997.

Halkin, Alexandra. "Outside the Indigenous Lens: Zapatistas and Autonomous Videomaking." In *Global Indigenous Media: Cultures, Poetics, and Politics*, edited by Pamela Wilson and Michelle Stewart, 160–80. Durham, NC: Duke University Press, 2008.

Lea, Tess, and Elizabeth A. Povinelli. "Karrabing: An Essay in Keywords." *Visual Anthropology Review* 34, no. 1 (Spring 2018): 36–46.

Masayesva Jr., Victor. "Indigenous Experimentalism." In *Magnetic North*, edited by Jenny Lion, 226–238. Minneapolis, MN: University of Minnesota Press, 2001.

Sanjines, Jorge, and grupo Ukamau. *Teoría y práctica de un cine junto al pueblo*. Mexico DF: Siglo Veintiuno Editores, 1979.

Taiaiake, Alfred. *Wasáse: Indigenous Pathways of Action and Freedom*. Peterborough: Broadview Press, 2005.

Interviews

Borunda, Stephen N. "Mapuche Cosmovision and the Cinematic Voyage: An Interview with Filmmaker Francisco Huichaqueo Pérez (English Version)." *Media+Environment* 1, no. 1 (November 2019). https://doi.org/10.1525/001c.10788.

Dassonville, Aude. "Christophe Yanuwana Pierre: 'Être Guyanais, Amérindien et cinéaste? Cela me paraissait impossible.'" *Télérama* (October 29, 2019). https://www.telerama.fr/television /christophe-yanuwana-pierre-etre-guyanais,-amerindien-et-cineaste-cela-me-paraissait -impossible,n6480216.php.

De Beauvais, Daria. "Une conversation avec Barbara Glowczewski et Elizabeth A. Povinelli / A Conversation with Barbara Glowczewski and Elizabeth A. Povinelli." *Palais—Le magazine du Palais de Tokyo*, no. 33 (2022): 156–65.

Franco, Adrián, and Fernando Puerta. "La cámara: un tronco lleno de abejas. Entrevista con Iván Sanjinés y Marta Rodriguez." *Kinetoscopio* 13, no. 61 (2002): 70–78.

Gergaud, Sophie, and Thora M. Herrmann, eds. *Cinémas autochtones: des représentations en mouvement*. Paris: L'Harmattan, 2019.

Kahana, Jonathan, Alessandro Cavadini, and Carolyn Strachan. "Re-staging *Two Laws*: An Interview with Alessandro Cavadini and Carolyn Strachan." *Framework: The Journal of Cinema and Media* 50, no. 1/2 (spring & fall 2009): 61–81.

Khalil, Adam, and Zack Khalil. "Sky Hopinka." *Third Rail*, no. 10 (November 2017): 36–51. http://thirdrailquarterly.org/sky-hopinka/.

Lamche, Pascale, and Merata Mita. "Interview with Merata Mita." *Framework: The Journal of Cinema and Media*, no. 25 (1984): 2–11.

Lutkehaus, Nancy C. "'Excuse me, everything is not all right': On ethnography, film, and representation. An Interview with Filmmaker Dennis O'Rourke." *Cultural Anthropology* 4, no. 4 (November 1989): 422–37.

Rosenthal, Alan. "*You Are on Indian Land*: Interview with George Stoney (1980)." In *Challenge for Change: Activist Documentary at the National Film Board of Canada*, edited by Thomas Waugh, Michael Brendan Baker, and Ezra Winton, 169–79. Montréal-Kingston: McGill-Queen's University Press, 2010.

Monographs

Evans, Michael Robert. *The Fast Runner: Filming the Legend of Atanarjuat*. Lincoln, NE: University of Nebraska Press, 2010.

Hill, Richard William, and Hila Peleg, eds. *Alanis Obomsawin: Lifework*. Berlin: HKW / Prestel, 2022.

Murray, Stuart. *Images of Dignity: Barry Barclay and Fourth Cinema*. Wellington: Huia Publishers, 2008.

Randolph, Lewis. *Alanis Obomsawin: The Vision of a Native Filmmaker*. Lincoln, NE: University of Nebraska Press, 2006.

Toiviainen, Sakari. *Kadonnutta paratiisia etsimässä: Markku Lehmuskallion ja Anastasia Lapsuin elokuvat*. Helsinki: SKS, 2009.

Autochthonous cinema and Indigenous media

Ameríndias: Performances do cinema indígena no Brasil. Lisbon: Teatro Praga/Sistema Solar, 2019.

Bozak, Nadia. "Conclusion." In *The Cinematic Footprint: Lights, Camera, Natural Resources*, Nadia Bozak, 189–203. New Brunswick, NJ: Rutgers University Press, 2010.

Carréra, Guilherme. *Brazilian Cinema and the Aesthetics of Ruins*. London: Bloomsbury, 2022.

Claxton, Dana, and Ezra Wintor, eds. *Indigenous Media Arts in Canada: Making, Caring, Sharing*. Kitchener: Wilfrid Laurier University Press, 2023.

Crey, Karrmen. "The Aboriginal Film and Video Art Alliance: Indigenous Self-Government in Moving Image Media." *Journal of Cinema and Media Studies* 60, no. 2 (Winter 2021): 175–80.

Damiens, Caroline. "'Filming Back' in Siberian Indigenous Cinema: Cinematographic Re-appropriation Strategies in the Work of Anastasia Lapsui and Markku Lehmuskallio." *PROA: Revista de Antropologia e Arte* 11, no. 1 (January–July 2021): 100–29.

Davis, Therese, and Romaine Moreton. "'Working in Communities, Connecting with Culture': Reflecting on *U-matic to YouTube* A National Symposium Celebrating Three Decades of Australian Indigenous Community Filmmaking." *Screening the Past*, no. 31 (August 2011). http://www.screeningthepast.com/issue-31-dossier-u-matic-to-youtube/%e2%80%9cworking -in-communities-connecting-with-culture%e2%80%9d-reflecting-on-u-matic-to-youtube -a-national-symposium-celebrating-three-decades-of-australian-indigenous-community -filmmaking-2/.

Deger, Jennifer. *Shimmering Screens: Making Media in an Aboriginal Community*. Minneapolis, MN: University of Minnesota Press, 2006.

Devaux Yahi, Frédérique. *De la naissance du cinéma kabyle au cinéma amazigh*. Paris: L'Harmattan, 2016.

Dowell, Kristin L. *Sovereign Screens. Aboriginal Media on Canadian West Coast*. Lincoln, NE: University of Nebraska Press, 2013.

Ko, Mika. "Takamine Go: A Possible Okinawan Cinema." *Inter-Asia Cultural Studies* 7, no. 1 (2006): 156–70.

Gaski, Harald. "Nils-Aslak Valkeapää: Indigenous Voice and Multimedia Artist." *AlterNative: An International Journal of Indigenous Peoples* 4, no. 2 (2008): 155–77.

Gergaud, Sophie. *Cinéastes autochtones: La souveraineté culturelle en action*. Laval: WARM, 2019.

Ginsburg, Faye. "Indigenous Media: Faustian Contract or Global Village?" *Cultural Anthropology* 6, no. 1 (February 1991): 92–112.

Ginsburg, Faye. "Indigenous Media from U-Matic to YouTube: Media Sovereignty in the Digital Age." *Sociologia & Antropologia* 6, no. 3 (September–December 2016): 581–99.

Hearne, Joanna. *Smoke Signals: Native Cinema Rising*. Lincoln, NE: University of Nebraska Press, 2012.

Hokowhitu, Brendan, and Vijay Devadas, eds. *The Fourth Eye: Maori Media in Aotearoa New Zealand*. Minneapolis, MN: University of Minnesota Press, 2013.

Hu, Tai-li. "The Development of 'Indigenous People Documentaries' in Early Twenty-first Century Taiwan, and the Concern with 'Tradition.'" *Concentric: Literary and Cultural Studies* 39, no. 1 (March 2013): 149–59.

Igloliorte, Heather, Julie Nagam, and Carla Taunton. "Indigenous Art: New Media and the Digital." Special issue, *PUBLIC* 54 (Winter 2016).

Larivée, Camille, and Léuli Eshrāghi. *D'horizons et d'estuaires: Entre mémoires et créations autochtones*. Montréal: Éditions somme toute, 2020.

MacBean, James Roy. "Two Laws from Australia, One White, One Black." *Film Quarterly* 36, no. 3 (Spring 1983): 30–43.

Michaels, Eric. *The Aboriginal Invention of Television in Central Australia 1982–1986*. Canberra: Australian Institute of Aboriginal Studies, 1986.

Pace, Richard, ed. *From Filmmaker Warriors to Flash Drive Shamans: Indigenous Media Production and Engagement in Latin America*. Nashville, TN: Vanderbilt University Press, 2018.

Padget, Richard. "Hopi Film, the Indigenous Æsthetics and Environmental Justice: Victor Masayesva Jr.'s Paatuwaqatsi—Water, Land and Life." *Journal of American Studies* 47, no. 2 (May 2013): 363–84.

Salazar, Juan Francisco, and Amalia Córdova. "Indigenous Media Cultures in Abya Yala." In *Media Cultures in Latin America: Key Concepts and New Debates*, edited by Anna Christina Pertierra and Juan Francisco Salazar, 128–46. London: Routledge, 2019.

Siku, Skaya. *Vers une éthique de tournage endogène: Enquête sur trois documentaristes autochtones taïwanais*. PhD diss., École des Hautes Études en Sciences Sociales, 2016.

Singer, Beverly R. *Wiping the War Paint off the Lens: Native American Film and Video*. Minneapolis, MN: University of Minnesota Press, 2001.

Stam, Robert. *Indigeneity and the Decolonizing Gaze: Transnational Imaginaries, Media Aesthetics, and Social Thought*. London: Bloomsbury, 2022.

Stewart, Michelle R. "The Indian Film Crews of Challenge for Change: Representation and the State." *Canadian Journal of Film Studies* 16, no. 2 (Fall 2007): 49–81.

Turner, Terence. "Defiant Images: The Kayapo Appropriation of Video." *Anthropology Today* 8, no. 6 (1992): 5–16.

Wilson, Pamela, and Michelle Stewart, eds. *Global Indigenous Media: Cultures, Poetics, and Politics*. Durham, NC: Duke University Press, 2008.

Wortham, Erica. *Indigenous Media in Mexico*. Durham, NC: Duke University Press, 2013.
Zamorano Villarreal, Gabriela. *Indigenous Media and Political Imaginaries in Contemporary Bolivia*. Lincoln, NE: University of Nebraska Press, 2017.

Internationalist cinema and political video
Bonnemère, Pascale. *A Life Committed to Papua New Guinea: Conversations with Christopher Owen—Filmmaker*. New Guinea Communications vol. 8. Glienicke: Galda Verlag, 2022.
Brenez, Nicole. "For an Internationalist Cinema. Interview by Ryan Wells." *Cinespect* (March 2012). http://cinespect.com/?p=3090.
Brenez, Nicole. *Manifestations: Écrits politiques sur le cinéma et autres arts filmiques*. Réville: de l'incidence éditeur, 2019.
Dutto, Matteo. "A Migrant Filmmaker at the Aboriginal Tent Embassy: Alessandro Cavadini's Ningla A-Na (1972) as a Transcultural Space of Encounter." *Australian Historical Studies* 53, no. 4 (2022): 603–19.
Harris, Mark. "Wild at Heart." In *Wild at Heart: The Films of Nettie Wild, Mark Harris and Claudia Medina*, 77–101. Pacific Cinémathèque Monograph Series, no. 2. Vancouver: Anvil Press, 2009.
Larcher, Jonathan. "Visualité et imageries du pouvoir en Océanie. Dennis O'Rourke, un cinéaste des 'zones de contact.'" *Journal de la Société des Océanistes*, no. 148 (2019): 53–64.
Lee, Daw-Ming. "A Very Short Introduction to the History of Documentary and Experimental Films in Taiwan." n.d. https://docs.tfai.org.tw/en/news/5600.
Lourdes Cortés, María. "Cine y video en Centroamérica hoy." *La Pantalla rota: Cien años de cine en Centroamérica*, María Lourdes Cortés, 389–547. Mexico DF: Taurus, 2005.
Ma, Ran. "Okinawan Dream Show. Approaching Okinawa in Moving Image Works into the New Millennium." In *Independent Filmmaking across Borders in Contemporary Asia*, Ran Ma, 163–97. Amsterdam: Amsterdam University Press, 2019.
Miller, John, and Geraldene Peters. "Darcy Lange: Māori Land Project—Working in Fragments." In *Darcy Lange: Study of an Artist at Work*, edited by Mercedes Vicente, 143–55. Birmingham: Ikon Gallery, 2008.
Suárez, Juana. "Prácticas de solidaridad: Los documentales de Marta Rodríguez." *Chicana/Latina Studies* 5, no. 1 (Fall 2005): 48–75.

Situations: thematic bibliography

Struggles, conviviality, and the vivacity of images
Benjamin, Thomas. "A Time of Reconquest: History, the Maya Revival, and the Zapatista Rebellion in Chiapas." *The American Historical Review* 2, no. 105 (April 2000): 417–50.
Bosa, Bastien, and Éric Wittersheim, eds. *Luttes autochtones: trajectoires postcoloniales*. Paris: Karthala, 2009.
Gonçalves, Marco Antonio. "Intépidas imagens: cinema e cosmologia entre os Navajo." *Sociologia & Antropologia* 6, no. 3 (December 2016): 635–67.
Illich, Ivan. *Tools for Conviviality*. Glasgow: Fontana/Collins, 1975 [1973].
Illich, Ivan. *Shadow Work*. London: Marion Boyars Inc., 1981.
Le Bot, Yvon. *La Grande révolte indienne*. Paris: Robert Laffont, 2009.
Lewis, Randolph. *Navajo Talking Picture: Cinema on Native Ground*. Lincoln, NE: University of Nebraska Press, 2012.
Leyva Solano, Xochitl. "The New Zapatista Movement: Political Levels, Actors and Political Discourse in Contemporary Mexico." In *Encuentros Antropológicos: Power, Identity and Mobility in Mexican Society*, edited by Valentina Napolitano and Xochitl Leyva Solano, 35–53. London: University of London Press, 1998.
Pineda Arredondo, Noé. "ProMedios: Regards collectifs, regards contestataires." In *Cinémas autochtones: des représentations en mouvement*, edited by Sophie Gergaud and Thora M. Herrmann, 279–304. Paris: L'Harmattan, 2019.
Raheja, Michelle H. "'Will making movies do the sheep any good?' The afterlife of Native American images." In *Recasting Commodity and Spectacle in the Indigenous Americas*, edited by Helen Gilbert and Charlotte Gleghorn, 19–36. London: University of London, 2014
Worth, Sol, and John Adair. *Through Navajo Eyes: An Exploration in Film Communication and Anthropology*. Bloomington, IN: Indiana University Press, 1972.

Political sovereignty and autonomy
Bellier, Irène, Leslie Cloud, and Laurent Lacroix. *Les Droits des peuples autochtones: Des Nations unies aux sociétés locales*. Paris: L'Harmattan, 2017.
Blackwell, Maylei. *Scales of Resistance: Indigenous Women's Transborder Activism*. Durham, NC: Duke University Press, 2023.
Charters, Claire, and Rodolfo Stavenhagen, eds. *Making the Declaration Work: The United Nations Declaration on the Rights of Indigenous Peoples*. Copenhagen: IWGIA, 2009.

Coates, Ken. *A Global History of Indigenous Peoples: Struggle and Survival*. Basingstoke: Palgrave Macmillan, 2004.

Crossen, Jonathan. "Another Wave of Anti-Colonialism: The Origins of Indigenous Internationalism." *Canadian Journal of History* 52, no. 3 (Winter 2017): 533–59.

Crossen, Jonathan. "Safe Haven for an Indigenous Fugitive: Indigenous Internationalism and Illegal Protests." *American Indian Culture and Research Journal* 40, no. 2 (January 2016): 51–71.

Estes, Nick. *Our History is the Future: Standing Rock versus the Dakota Access Pipeline, and the Long Tradition of Indigenous Resistance*. London: Verso, 2019.

Estes, Nick, and Jaskiran Dhillon, eds. *Standing With Standing Rock: Voices From The #NoDAPL Movement*. Minneapolis, MN: University of Minnesota Press, 2019.

Inoue, Masamichi S. "'We Are Okinawans But of a Different Kind': New/Old Social Movements and the U.S. Military in Okinawa." *Current Anthropology* 45, no. 1 (February 2004): 85–104.

Johnson, Troy R. *The Occupation of Alcatraz Island: Indian Self-Determination & the Rise of Indian Activism*. Urbana, IL: University of Illinois Press, 1996.

Kino-dna-niimi Collective, ed. *The Winter We Danced: Voices from the Past, the Future, and the Idle No More Movement*. Winnipeg: ARP Books, 2014.

MacFarlane, Peter, and Doreen Manuel. *Brotherhood to Nationhood: George Manuel and the Making of the Modern Indian Movement*. Toronto: Between the Lines, 2020.

Manuel, George, and Michael Posluns. *The Fourth World: An Indian Reality*. Minneapolis, MN: University of Minnesota Press, 2019 [1974].

Moreton-Robinson, Aileen, ed. *Sovereign Subjects: Indigenous Sovereignty Matters*. London: Routledge, 2007.

Moulton, Kimberley. "One Mob, One Voice, One Land. The Meta-Collective." In *Mázejoavku: Indigenous Collectivity and Art*, Susanne Hætta, edited by Katya García-Antón, 207–25. Oslo: Office for Contemporary Art Norway / DAT, 2020.

Rademaker, Laura, and Tim Rowse, eds. *Indigenous Self-Determination in Australia: Histories and Historiography*. Canberra: ANU Press, 2020.

Rodríguez Bernal Adolfo, Claudio Pulido, Eduardo Prada, and Álvaro Rojas, eds. "Resistir para vivir: Una mirada histórica al movimiento indio del Cauca 1970–2000." Special issue, *Polémica*, no. 4 (2005).

Siku, Skaya. "The Making of Indigenous Knowledge in Contemporary Taiwan: A Case Study of Three Indigenous Documentary Filmmakers." In *Indigenous Knowledge in Taïwan and Beyond*, edited by Shu-mei Shih and Lin-Chin Tsai, 55–76. Singapore: Springer, 2021.

Subcomandante Marcos. *¡Ya Basta! Les insurgés zapatistes racontent un an de révolte au Chiapas*. Translated from Spanish by Anatole Muchnik. Paris: Éditions Dagorno, 1996.

Subcomandante Marcos. *¡Ya Basta! tome 2. Vers l'internationale zapatiste*. Translated from Spanish by Anatole Muchnik. Paris: Éditions Dagorno, 1996.

Wittenborn, Rainer, and Claus Biegert. *James Bay Project—A River Drowned by Water / Project de la Baie James—une rivière qui se noie*. Montreal: The Montreal Museum of Fine Arts, 1981.

Passing down the ancestral knowledge

Brasil, André. "Ver por meio do invisível. O cinema como tradução xamânica." *Novos estudos CEBRAP* 35, no. 3 (November 2016): 125–46.

Caixeta de Queiroz, Ruben, and Renata Otto Diniz. "Tikm'n-Maxakali: Cosmocinepolitics: An Essay on the Invention of a Culture and of an Indigenous Cinema." *GIS—Gesto, Imagem E Som—Revista De Antropologia* 3, no. 1 (July 2018): 62–106.

Colectivo Los Ingrávidos. "Matérialisme chamanique. 77 thèses sur l'audiovisuel." In *Expanded Nature: Écologies du cinéma expérimental*, edited by Elio Della Noce and Lucas Murari, 187–93. Paris: Light Cone Éditions, 2022.

Cox, Rupert. "Tremulous Images: Susurrations of Memory in Okinawa." In *Zawawa*, edited by Angus Carlyle and Rupert Cox. Berlin: Archive Books [forthcoming].

Feld, Steven. "Waterfalls of Song: An Acoustemology of Place Resounding in Bosavi, Papua New Guinea." In *Senses of Place*, edited by Steven Feld and Keith H. Basso, 91–135. Santa Fe, NM: School of American Research Press, 1996.

Ginsburg, Faye. "Screen Memories: Resignifying the Traditional in Indigenous Media." In *Media Worlds: Anthropology in New Terrain*, edited by Faye Ginsburg, Lila Abu-Lughod, and Brian Larkin, 39–57. Berkeley, CA: University of California Press, 2002.

Glowczewski, Barbara. "Beyond the Frames of Film and Aboriginal Fieldwork." In *Experimental Film and Anthropology*, edited by Arnd Schneider and Caterina Pasqualino, 147–64. London: Bloomsbury, 2014.

Kolowratnik, Nina Valerie. *The Language of Secret Proof: Indigenous Truth and Representation*. Critical Spatial Practice 10. Berlin: Sternberg Press, 2020.

Recomposing and questioning the history of colonization

Biddle, Jennifer L., and Tess Lea, eds. "Hyperrealism and Other Indigenous Forms of 'Faking it with the Truth.'" Special issue, *Visual Anthropology Review* 34, no. 1 (Spring 2018).

Dillon, Grace L., ed. *Walking the Clouds: An Anthology of Indigenous Science Fiction*. Tucson, AZ: The University of Arizona Press, 2012.

Lempert, William. "Decolonizing Encounters of the Third Kind: Alternative Futuring in Native Science Fiction Film." *Visual Anthropology Review* 30, no. 2 (2014): 164–76.

L'Hirondelle Hill, Gabrielle, and Sophie McCall, eds. *The Land We Are: Artists and Writers Unsettle the Politics of Reconciliation*. Winnipeg: ARP Books, 2015.

Melenotte, Sabrina. "Écrire (sur) un massacre: Acteal 1997–2008 (Mexique). Enjeux d'écriture, enjeux d'interprétations." *Cultures et Conflits*, no. 103–4 (Fall/Winter 2016): 111–29.

Monani, Salma. "Feeling and Healing Eco-social Catastrophe: The 'Horrific' Slipstream of Danis Goulet's *Wakening*." *Paradoxa*, no. 28 (2016): 192–213.

Nicholas, Clifton, and Pierre Trudel. "Sur la barricade à Oka/Kanehsatake." *Nouveaux Cahiers du socialisme*, no. 18 (2017): 90–97.

Remy, Lola. "Making the Map Speak: Indigenous Animated Cartographies as Contrapuntal Spatial Representations." *NECSUS—European Journal of Media Studies* 7, no. 2 (2018): 183–203.

Truscello, Michael, and Renae Watchman. "Blood Quantum and Fourth Cinema: Post- and Paracolonial Zombies." *Quarterly Review of Film and Video* 40, no. 4 (2023): 462–83.

Vizenor, Gerald. *Fugitive Poses: Native American Indian Scenes of Absence and Presence*. Lincoln, NE: University of Nebraska Press, 1998.

Incriminating green colonialism

Coates, Ken S., and Else Grete Broderstad. "Indigenous Peoples of the Arctic: Re-taking Control of the Far North." In *The Palgrave Handbook of Arctic Policy and Politics*, edited by Ken S. Coates and Carin Holroyd, 9–25. London: Palgrave Macmillan, 2020.

Dell Umbria, Aléssi. *Istmeño, le vent de la révolte: Chronique d'une lutte indigène contre l'industrie éolienne*. Paris: Collectif des métiers de l'édition / Les éditions du bout de la ville, 2018.

Duperrex, Matthieu. "Pipeline Songlines." In *Voyages en sol incertain: Enquête dans les deltas du Rhône et du Mississippi*, Matthieu Duperrex, 176–96. Marseille: éditions Wildproject, 2019.

Endres, Danielle. "Animist Intersubjectivity as Argumentation: Western Shoshone and Southern Paiute Arguments Against a Nuclear Waste Site at Yucca Mountain." *Argumentation*, no. 27 (2013): 183–200.

Feather, Paul. "Finding Ourselves at Peehee Mu'huh: An Interview with Daranda Hinkey." *CounterPunch*, (June 4, 2021). https://www.counterpunch.org/2021/06/04/finding-ourselves -at-peehee-muhuh-an-interview-with-daranda-hinkey/.

Finbog, Liisa-Ravna, Katya García-Antón, and Beaska Niillas, eds. *Čatnosat: The Sámi Pavilion, Indigenous Art, Knowledge and Sovereignty*. Oslo: Office for Contemporary Art Norway; Amsterdam: Valiz, 2022.

García-Antón, Katya, Harald Gaski, and Gunvor Guttorm, eds. *Let the River Flow: An Indigenous Uprising and its Legacy in Art, Ecology and Politics*. Oslo: Office for Contemporary Art Norway; Amsterdam: Valiz, 2020.

Howe, Cymene, and Dominic Boyer. "Aeolian Extractivism and Community Wind in Southern Mexico." *Public Culture* 28, no. 2 (2016): 215–35.

Kårtveit, Bård. "Green colonialism. The story of wind power in Sápmi." In *Stories of Change and Sustainability in the Arctic Regions: The Interdependence of Local and Global*, edited by Rita Sørly, Tony Ghaye, and Bård Kårtveit, 157–77. London: Routledge, 2021.

Kuhn, Gabriel. *Liberating Sápmi: Indigenous Resistance in Europe's Far North*. Oakland, CA: PM Press, 2020.

Kuokkanen, Rauna. "Ellos Deatnu and Post-State Indigenous Feminist Sovereignty." In *Routledge Handbook of Critical Indigenous Studies*, edited by Brendan Hokowhitu, Aileen Moreton-Robinson, Linda Tuhiwai Smith, Steve Larkin, and Chris Andersen, 310–23. New York: Routledge, 2022.

Öhman, May-Britt. "Gut la dån? Vem är du? Kukas sie olet?—Who are you?" In *Kiruna Forever*, edited by Daniel Golling and Carlos Minguez Carrasco, 237–46. Stockholm: ArkDes/Arkitektur Förlag, 2020.

Savard, Stéphane. "Les communautés autochtones du Québec et le développement hydroélectrique: Un rapport de force avec l'État, de 1944 à aujourd'hui." *Recherches amérindiennes au Québec*, vol 39, no. 1–2 (2009): 47–60.

"Securing Indigenous Rights in the Green Economy." Special issue, *Cultural Survival Quarterly* 46, no. 2 (June 2022).

Parsing and affronting the colonization of the atmosphere

Bidzííl, Shiyé [Dean Deman Jr.]. *Through Indigenous Eyes: The Story of the Standing Rock Movement as Told by a Local Drone Pilot and Visionary*. n.p.: Lulu, 2017.

Case, Emalani. "I ka Piko, To the Summit: Resistance from the Mountain to the Sea." *The Journal of Pacific History* 54, no. 2 (2019): 166–81.

Casumbal-Salazar, Iokepa. "A Fictive Kinship: Making 'Modernity,' Ancient Hawaiians,' and the Telescopes on Maunakea." *Native American and Indigenous Studies* 4, no. 2 (2017): 1–30.

Coplan, Alison, Katya García-Antón, and Stefanie Hessler, eds. *Raven Chacon: A Worm's Eye View From a Bird's Beak*. London: Sternberg Press, 2024.

Duarte, Marisa Elena. *Network Sovereignty: Building the Internet Across Indian Country*. Seattle, WA: University of Washington Press, 2017.

Haney, William M. "Protecting Tribal Skies: Why Indian Tribes Possess the Sovereign Authority to Regulate Tribal Airspace." *American Indian Law Review* 40, no. 1 (2016). https://digitalcommons .law.ou.edu/ailr/vol40/iss1/1.

Kaplan, Caren, and Andrea Miller. "Drones as 'Atmospheric Policing': From US Border Enforcement to the LAPD." *Public Culture* 31, no. 3 (2019): 419–45.

Parks, Lisa. "Vertical Mediation at Standing Rock." *LA+ Interdisciplinary Journal of Landscape Architecture*, no. 12 (Fall 2020): 32–41.

Parks Lisa, Ramesh Srinivasan, and Diego Cerna Aragon. "Digital Empowerment for Whom? An Analysis of 'Network Sovereignty' in Low-Income, Rural Communities in Mexico and Tanzania." *Information, Communication & Society* 25, no. 14 (2022): 2140–61.

Shorter, David, and Kim Tallbear, eds. "Settler Science, Alien Contact, and Searches for Intelligence." Special issue, *American Indian Culture and Research Journal* 45, no. 1 (2021).

Svonni, Lars Daniel, and Marit Anne Allas. *Talma Sameby: bosättningar, renbetesmarker, flyttvägar i ett historiskt perspektiv*. Älvsbyn: Älvsbytryck, 1999.

Uahikeaikalei'ohu Maile, David. "On Being Late: Cruising Mauna Kea and Unsettling Technoscientific Conquest in Hawai'i." *American Indian Culture and Research Journal* 45, no. 1 (2021): 95–121.

Walker, Janet. "Standing with Standing Rock: Media, Mapping, and Survivance." *Media Fields Journal* 13 (2018). http://mediafieldsjournal.org/standing-with-standing-rock/.

Futurity of visual sovereignty

Avron, Dominique. "L'arrivée d'une caméra en territoire animiste." *Melba*, no. 6/7 (1979): 10–11.

Betasamosake Simpson, Leanne. *As We Have Always Done: Indigenous Freedom Through Radical Resistance*. Minneapolis, MN: University of Minnesota Press, 2017.

Deloria, Vine Jr. *Custer Died for Your Sins: An Indian Manifesto*. Norman, OK: University of Oklahoma Press, 1988 [1969].

Escobar López, Almudena. "Ethnopoetics of Reality. The Works of Sky Hopinka." *Afterimage* 45, no. 2–3 (January 2018): 27–31.

Fowler, Cynthia. "Materiality and Collective Experience: Sewing as Artistic Practice in Works by Marie Watt, Nadia Myre, and Bonnie Devine." *American Indian Quarterly* 34, no. 3 (Summer 2010): 344–64.

García-Antón, Katya, ed. *Sovereign Words: Indigenous Art, Curation and Criticism*. Oslo: Office for Contemporary Art Norway; Amsterdam: Valiz, 2018.

Hennessy, Kate, Trudy Lynn-Smith, and Tarah Hogue. "ARCTICNOISE and Broadcasting Futures: Geronimo Inutiq Remixes the Igloolik Isuma Archive." *Cultural Anthropology* 33, no. 2 (2018): 213–23.

Hogue, Tarah, ed. *ARCTICNOISE: Geronimo Inutiq*. Vancouver: grunt gallery, 2016.

Hopinka, Sky. *Around the Edge of Encircling Lake*. Milwaukee: Green Gallery Press, 2018.

Jiménez del Val, Nasheli, and Anna Maria Guasch, eds. "Epistemologías indígenas e imaginación artística." Special issue, *Revista de Estudios Globales y Arte Contemporáneo* 7, no. 1 (2020).

Oikonomopoulos, Vassilis, and Flora Katz, eds. *The Sun Comes in Whenever it Wants*. Paris: Éditions Empire; Arles: LUMA Arles, 2022.

Raheja, Michelle. *Reservation Reelism: Redfacing, Visual Sovereignty, and Representations of Native Americans in Film*. Lincoln, NE: University of Nebraska Press, 2010.

Smith, Linda Tuhiwai. *Decolonizing Methodologies: Research and Indigenous Peoples*. London: Zed Books; Dunedin: University of Otago Press, 1999.

Establish and preserve the filmic history of struggles

Castle, Elizabeth. "The Original Gangster: The Life and Times of Red Power Activist Madonna Thunder Hawk." In *The Hidden 1970s: Histories of Radicalism*, edited by Dan Berger, 267–83. New Brunswick, NJ: Rutgers University Press, 2010.

Dekker, Annet, ed. *Lost and Living (in) Archives: Collectively Shaping New Memories*. Amsterdam: Valiz, 2017.

Larcher, Jonathan. "The Media Archivist International." *7th EYE International Conference* (31 May 2022). https://vimeo.com/718736949.

Lawson, Michael. *Dammed Indians: The Pick-Sloan Plan and the Missouri River Sioux*. Norman, OK: University of Oklahoma Press, 1982.

Thunder Hawk, Madonna. "Native Organizing Before the Non-Profit Industrial Complex." In *The Revolution Will Not Be Funded: Beyond the Non-Profit Industrial Complex*, edited by INCITE! Women of Color Against Violence, 101–6. Cambridge: South End, 2007.

Voigt, Matthias André. "Warrior Women: Indigenous Women, Gender Relations, and Sexual Politics within the American Indian Movement and at Wounded Knee." *American Indian Culture and Research Journal* 46, no. 3 (2023): 101–130.

Part I

Images and Sounds in Action

The Struggle
of Marginalized
Peoples Is the
Perfect Remedy
for an Ailing
Nation.

Okinawa,
Silenced by Japan

Chie Mikami

September 29, 2012. In Okinawa, an island group peppered with US military bases, a typhoon rages, ferocious enough to overturn cars. Here, a historical resistance is being attempted—a total blockade of a US Marine Corps base, to prevent deployment of the infamous new transport aircraft, the Osprey. Heedless of the storm, furious Okinawans[1] come together at the gate of the Futenma base, lining up their cars and sitting down in the midst of the gale to protest. This was to mark the first time that Okinawans, generally seen in Japan as obedient, had resorted to force and blockaded a base. But something else about this day was historic. One could no longer deny the cruel reality that the suffering of Okinawa, one of Japan's forty-seven prefectures, was not newsworthy to the other forty-six. Major Japanese media outlets, without exception, turned a deaf ear to what was happening. The only news people in Tokyo saw of Okinawa on this day was of the typhoon. Even now, most Japanese remain unaware of these events.

 I was a newscaster at a TV station (Ryukyu Asahi Broadcasting, QAB) in Okinawa for close to twenty years. Typical at such a small local station, I played many roles. I conducted research, was involved in documentary production, and reported the news both from the scene and behind the anchor desk. Okinawa Prefecture, located at Japan's southernmost tip, is composed of as many as 160 islands. The main island, Okinawa *honto* (literally "Okinawa main island"), is in the center, with the city of Naha as its capital. 15% of this island is occupied by US military bases. In my job, I discovered that Okinawan news was always dominated by the "military base problem," an issue that encompasses base noise, pollution, crime, and the "opposition movement." Although these dominated the local daily news, whenever a national network chose to carry a story from Okinawa, it almost never addressed the military base problem.

 Leaving aside the issue of whether foreign bases should even be hosted in this country, as they have been under the US-Japan Security Treaty since April 28, 1952, there is no reason for 70% of Japan's US military

All italicized quotes in the following text are from Chie Mikami's documentary *The Targeted Village* (2013).

1 This term refers to the people who live in Okinawa Prefecture, Japan. Okinawa is made up of islands. It was an independent kingdom from the medieval era up to early modern times, yet the ethnicity and language of its people are said to have the same roots as those of Japan.

base facilities to be concentrated in the southern part of the narrowest island. As you can well imagine, the location was chosen for its proximity to China, and—as they would be the first target in the event of an attack—its distance from heavily-populated areas, especially the capital of Tokyo. But that's still not enough reason to impose such a burden only on Okinawans. And although Okinawa has long implored the Japanese government to reduce or eliminate the bases, if anything the situation is worsening.

It is not enough to report just locally on the harmful effects of the foreign military facilities protected by the inequitable US-Japan Status of Forces Agreement (formerly the US-Japan Administrative Agreement, ratified on April 28, 1952). Nothing will change if all of Japan is not made aware of the situation. I and other reporters in Okinawa covering the military base problem need not only secure slots on local shows, we must also persuade news network directors centered around Tokyo to squeeze our reporting into their lineups, even though our experience has shown us it has little chance of being selected.

I and other people working at local Okinawan stations kept running into a wall—we wanted to report to the whole country about how Okinawa was being strong-armed into a cruel existence as a military fortress, and not about idyllic sea resorts or typhoons—topics that are more commonly covered. Since the news wouldn't tell the story, our next step was to make a thirty-minute documentary and put it on our network. We managed to get it passed at a planning meeting in Tokyo. In this way, we got three or four documentaries a year broadcast on national television, although they were only shown late at night or early in the morning in easily-overlooked slots. Was there no way to get the Okinawa base problem broadcast on prime time? We started entering our programs into one domestic contest after the other, and it was interesting to see the reasons given when they received prizes. Some praise included: "a masterpiece that closely follows historic Okinawan resistance," and that "there is true journalism here!" I suspect that such word choices might reflect a sense of atonement towards Okinawa on the part of the judges. Our station kept getting awards, yet still no program about the military base problem saw nationwide broadcast, not on prime time at least.

I kept asking myself the question: yes we were elated that prizes and money had been won for these documentaries from Okinawa—but what was the next step? Even though I worked in television, I was unable to utilize the television network. I had a number of works I wanted to show—should I make DVDs and bring them around the mainland on my days off, renting spaces to screen them? But I knew I would run into problems with copyright and broadcasting laws.

It occurred to me that we could re-envision our television documentary as a film for theatrical release. Might art houses around Japan show it then? In 2012, when the Osprey first arrived in Okinawa, only two local TV stations in Japan had ever released their documentaries theatrically. How was it done? Where would the money come from? How would we advertise it? How would we find a company to distribute it? Without a single connection to help me, I took a shot at contacting the producers at the

two stations. I found them to be passionate—unflinching when it came to putting together local news reports, and seeking to question society with works made beyond the confines of the network. By connecting with them, the road to getting theaters around Japan to show films that had been born as TV documentaries slowly materialized before my eyes.

Forging ahead, this led to *The Targeted Village* (2013, 91 min.), my first directorial work—in fact a television documentary reworked in two weeks. Although I was a completely unknown director, it showed in forty theaters nationwide, and before I knew it, at as many as 700 independent screenings, winning two awards at the Yamagata International Documentary Film Festival, and named Best Documentary Film of the year by the legendary and authoritative *Kinema Junpo* film magazine, among numerous other accolades. Many of those who saw it came imploring to me after the film, with tears in their eyes, expressing remorse towards Okinawa and saying, "I didn't know," "I can't believe something this important hasn't been on the news!," and offering me donations. I had mixed feelings. I was happy that the film had met with success and praise. At the same time, since my field was television, entrusting it to movie theaters after being refused by television felt like a defeat.

Nor did my company wish me to continue working in this awkward manner, using film distribution to compensate for the incapacity of television to do what I wanted. The film version of *The Targeted Village* might have brought the company praise and profits, but it's not as if my superiors at the station then went ahead and said, "Great, now let's see the next one!" I had a decision to make. Did I want to work on reforming the news system from within as a broadcaster, or should I concentrate on my work as a filmmaker, thrusting my oars into the rough seas of the freelance life? 2014 promised to be a turbulent year, with the construction of the Henoko base imminent—an issue that had plagued Okinawa for the past twenty years. Abandoning the struggle wasn't an option for me, and I made up my mind. Quitting my job, and with a small camera in hand, I began travelling to Henoko and Takae in my own car, with the barest minimum of driving experience.

NEXT SPREAD
Still, *The Targeted Village*, 2013. The US military's Osprey transport aircraft is accident-prone, having resulted in as many as forty-two fatalities (as of February 2021).

辺野古新基地計画
USMC Henoko Base Plans

辺野古弾薬庫 Armory

©Google

Still, *We Shall Overcome*, 2015. Map showing land marked for reclamation in the building of the Henoko base—a hotspot of abundant biodiversity and a unique habitat for numerous corals as well as the dugong, a Japanese national treasure. Voices against its destruction are being raised both locally and around the world.

Chie Mikami

Takae is the name of the mountain district that had taken center stage in *The Targeted Village*. With a population of less than 150, it vaulted into public awareness when a US military plan for helipads surrounding the village became public knowledge in 2005. And it was only a short time later that plans to deploy 100 of the accident-prone Osprey transport aircraft were revealed. Based in Henoko, the aircraft would be used for training in Takae, which was already in the middle of a jungle training ground. This history meant Takae already had fifteen unused helipads, far from any private residences. So why was it necessary to build six new ones, a mere 400 meters from the closest house?

Our village is a training target.

When a Takae villager said this to me, I honestly didn't get it at first. I'd covered the military base problem in various places around the prefecture, but I didn't take this view seriously, thinking of it as just some masochistic rhetoric—the people of Japan, a developed nation, couldn't truly be the training target of a foreign military. But I finally came to believe it after I began spending time in Takae, where I repeatedly had the mind-boggling experience of seeing low-flying US military helicopters suddenly emerging from the mountains with soldiers pointing their guns, as if they were on the set of a war movie. These were no pleasure flights—they would bound out from narrow gaps between the mountains, flying the turbulent air that hugs the ridges to avoid radar detection, aiming for the "guerrilla" villages in the valley to descend on and attack. Just one training drill encompasses Okinawa's mountains, rivers, and areas of inhabitance, not only today but also in the past.

Still, *The Targeted Village*, 2013. US military aircraft fly low over Takae, sometimes training their guns on the villagers. "Are we the targets of the training?" they ask in their suffering.

The Struggle of Marginalized Peoples Is the Perfect Remedy for an Ailing Nation

During the Vietnam War era of the 1960s, a facility called "Vietnam Village" was constructed here as part of an army training ground. Incredibly, they would use "Vietnamese-style" residents in "Vietnamese-style" houses, to be trained on by soldiers who would fly the next day to attack villages in actual Vietnam where the Viet Cong lay concealed. And the role of the Vietnamese, believe it or not, fell to the people of Takae. The historical fact of this "Vietnam Village" is at the core of why I chose to call the film "The Targeted Village." The elder inhabitants of Takae told me about that era.

Training in Takae, Higashison, at "Vietnam Village" as photographed in 1964 by the United States Civil Administration of the Ryukyu Islands (USCAR), which ruled Okinawa at that time.

> *Everyone went … women and children too.*
> *Because we'd get C-rations[2] in exchange. There was no pay.*

The last stages of the Pacific War witnessed intense warfare in Okinawa between Japan and the US, during which 200,000 people lost their lives. The Battle of Okinawa has been described as a gruesome event in which a variety of hells converged, being the only ground battle in Japan, and one in which the inhabitants also became engulfed. For the US military, it became a kind of symbolic "victory island," won after undue bloodshed by its soldiers. Separated from Japan and continuously occupied by the US military for twenty-seven years after the war, some former marines call these islands "war booty." Presumably little hesitation is needed to train on these "war booty" islands. From their perspective, they are just making use of the villages and their terrain as they happened to find them, and it's not as if they ever use live ammunition. They also think they are keeping Japan safe. Cooperation must seem a matter of course.

2 US military field rations.

PAGES 58–61
Stills, *The Targeted Village*, 2013

Residents in opposition were brought to court. The subject of the proceedings dealt not with whether or not it was right to build a US military base, but whether or not they had obstructed passage along the road. This kind of lawsuit is known as SLAPP (Strategic Lawsuit Against Public Participation), aimed at harassing those charged.

The US military surely believes this unapologetically. To land the Osprey, it is necessary to have helipads durable enough to withstand high temperatures, and they planned to build six more of these. The Takae villagers, already living with large helicopters crossing the sky over their heads, screamed that they couldn't take it anymore. They passed a resolution in Takae, bringing their petition to the prefectural assembly in Naha, a two-and-a-half-hour drive from the village. Initial news coverage was sluggish, and public opinion in opposition did not emerge. The first day of construction arrived, and the residents had no choice but to sit down and resist. And lo and behold, the Japanese government put fifteen Takae residents on trial for "traffic obstruction." These residents were issuing an SOS about how their lives were threatened by US military training, and the nation of Japan brought them to court for it. Moreover, among those on trial was the daughter, only seven at the time, of two of the protest's leading figures (a married couple). We countered in our news coverage that this was a SLAPP (Strategic Lawsuit Against Public Participation) suit, where the judicial system is used to harass people in order to silence them.

A seven-year-old brought to court by the state. In the aim of prioritizing the US-Japan alliance and for the safety and security of the majority, apparently it was okay to offer up the rights of some Japanese citizens. They were prepared to stop at nothing in tamping down opposition, even if it meant abusing the judicial system and taking advantage of children. Despite the revelation of such shameful acts by the state, the central media barely addressed the issues around Takae. While the Ministry of Defense announced that half the jungle training ground would be returned with helipads relocated accordingly, and that they hadn't heard about any Osprey deployment, the national media centered around Tokyo avoided investigating such claims or ever checking their veracity, holding firm to the stance that they couldn't report on the activities of a single opposing faction.

Japan continues to impose the burdens of national policy on this weak area on its outskirts. At the same time, the central media looks at us

The Struggle of Marginalized Peoples Is the Perfect Remedy for an Ailing Nation

This man and his young daughter were brought to trial by the nation of Japan for opposing deployment of the Osprey

On the day the barricade was broken and the Osprey was deployed, a little girl from Takae said to me, "If my parents ever get tired, I want to oppose the bases on their behalf."

who are there covering events as they unfold and says, "If there is opposition, it means there is also support. Those in Okinawa receiving government aid are accepting of the bases. If we don't provide the opinions of both sides, we endanger our neutral stance." But is that neutrality actually fair?

There are many people in the business community in Okinawa relying on government subsidies who take a position of approval towards the bases. Since the war, the art of compromise has become ingrained, as many people had no choice but to jump at the money offered by the government in return for the "burden of the bases." But what is so neutral about tracking down and broadcasting this dynamic of support and opposition in the remote regions of the country? Who are these people who are happy about Japan hosting an increasing number of Marine Corps bases and their deployment of new transport planes, irrespective of the onus it places on Okinawa? Doesn't the origin of the power to build the bases lie in the existence of a Japanese majority that has a vague fear of both China and North Korea, and a vague desire for both a US military presence and stronger Japanese self-defense forces? This group is on one side, while on the other is a family crying, begging for the bases not to be built. If, for example, this is the axis of opposition that needs to fit into a forty-second news report in

order for it to be broadcast, the day when Takae is broadcast into people's homes will never arrive.

It's the internet dwellers who fan the flames of fear and spread falsehoods about a Chinese threat, claiming that the opposition includes communist activists who fund the movement, when the reality is that citizens have come together of their own accord to protect democracy. Or could it instead be framed as those who want to get compensation since "the bases are going to be built anyway" versus those trying to overturn that very premise; or those who believe it should be Okinawans who decide whether to build the bases versus those who think that all Japanese should have a say. There are innumerable axes of opposition—it's not something that can be discussed via the dualism of pros and cons.

I have also long resisted the reasoning that says those in favor of the bases in Okinawa must be located and put on TV. It is not only an arbitrary way for those on the mainland to avoid looking at their own culpability, it also serves to sow more division in victimized areas of the country. But even though I understood that this "fair and neutral" approach rang a death knell for news from Okinawa, I was never able to solve the puzzle. This was the trigger for the three works I have made since quitting television.

Incidentally, no one in the Okinawan media ever interviewed that seven-year-old girl who was sued by the state. I had my own footage of her—I had been shooting her since she was six years old, but naturally I kept her face and name a secret. Her life need not be overwhelmed by the warped relationship between the nation of Japan and Okinawa, nor need she become a symbolic icon of that relationship's cruelty. Okinawan society is small, and everyone feels a kinship analogous to ties of blood or friendship.

The current base opposition movement began in 1995, with the assault of a schoolgirl. Twelve years old, she was raped by three soldiers. Then, too, the Okinawan media kept not only her name, but also her age and where she lived confidential. The mainland media had to be restrained from tracking her down at home. Okinawans strongly believe in protecting such a victim from further suffering.

Among the 86,000 Okinawans who came together around this issue at the Prefectural Convention, not one asked who the victim was, only raising their fists against her humiliation and repeated historical sadness as if it was theirs, vowing once again to reduce the bases and put an end to suffering.

In order to calm Okinawan rage, which was at a peak at this time, the US and Japanese governments announced that they would return the land on which Futenma Air Station stood. It later became clear that they were using this as pretext to build a "replacement facility"—really just an additional military base. The US and Japanese governments secretly coordinated to use this child's suffering and Japanese taxes to build an Osprey base, Henoko, with Takae as its training site. And so, the Takae helipad problem began. Henoko and Takae have become symbols of Okinawa's resistance to the burden of the bases, and that resistance continues unwavering to this day.

It was in September of 2012 that the Osprey was deployed to Okinawa, with Okinawans engaged in a historic blockade amidst a raging typhoon, as the rest of Japan turned a blind eye.

In the end, although the protesters linking their arms in the storm kept the US military base from functioning for an entire day, they were ultimately removed one after the other by Okinawa Prefecture riot police. The US military merely looked on at Okinawans clashing with other Okinawans, while the people on the mainland remained indifferent.

The Okinawa Prefectural Police removed other Okinawans, as though protecting a US military base

> *Isn't it the job of the Okinawan police to take care of Okinawans? Are you protecting America?*
> *None of you want to do this job, do you? I know it. Then one of you should have some backbone and say it! Tell them you don't want to fight with other Okinawans!*

The barricade was broken and the strange giants that are the Osprey buzzed in one by one, landing on Okinawa's main island. Looking at her dazed parents, twelve-year-old Mizuki said the following to me that day.

> *If my parents ever get tired, I want to oppose the bases on their behalf.*

I almost collapsed when I heard her words. Even though the press had fed off a twelve-year-old Okinawan girl's sorrow for the seventeen years since 1995, it was not only unable to stop the Osprey deployment, here now was a girl of the same age forced to speak words of such grim determination—how could I, an Okinawan adult, account for what I had done in those seventeen years?

Chie Mikami

Putting the documentary together was a painful process, since it meant reflecting upon the defeat of the press. After talking with Mizuki's family, we kept her in the film, and *The Targeted Village* was completed. These images in which I found despair gained a life of their own, and the work received countless awards. The name Takae became known all over the country, and the number of people supporting the base opposition movement in Okinawa increased.

In 2014, as the construction of Henoko airfield approached, hundreds of people were gathering at the base gates every day, and this had truly turned into an island-wide struggle. I remained a close observer of the Okinawans' buoyant and tenacious campaign, which was depicted in my second work, *We Shall Overcome*, released in 2015. In my third film, *The Targeted Island: A Shield Against Storms*, released in 2017, the outrageousness of the building of Self-Defense Force attack bases around Okinawa is met with supple opposition, through festival and song. Each film was a box office success, and I was able to bring images of Henoko and Takae to the entire country. And yet the helipads in Takae were completed, and the land reclamation of a vast swath of sea for the airfield off Henoko coast is proceeding apace. Regrettably, I have been unable to alter Okinawa's path towards being used increasingly as a military fortress.

In *We Shall Overcome*, once again twelve-year-old girls—twin sisters, wiser than their years—beg that the sea by their home not be reclaimed. It might be a coincidence, but twelve-year-old girls burdened with the fate of Okinawa often play an important role in my films. I can't erase the guilty feeling that we have put this unsolvable problem in the lap of each succeeding generation, but an old man from one of Okinawa's many islands said the following to me.

> *It's not important to win or lose. What's important is whether you fought or not. Adults around you fighting for the community. This is the greatest fortune we can bequeath to our children and grandchildren.*

PAGES 63–67
Stills, *We Shall Overcome*, 2015

You can find people all around Okinawa at the mercy of the country's whims, who have long fought an unwavering struggle with absurdity. Even if, in their adolescence they feel persuaded that it is useless to resist, once they become parents and have something to protect, they are able to find various methods of resistance. It might involve handing out flyers, standing on street corners, going to different places to petition for their demands, holding rallies, or writing a letter to the president of the United States. Not only actions of opposition, but also singing and dancing, making sure not to collapse in the process and leaving themselves enough energy to fight on. As children in Okinawa, they have seen the actions long taken by the adults around them, whose every wisdom is a fortune bequeathed to them that enables them to bring the struggle forward. On the other hand, children in places who have never seen anyone speak out will be unable to figure out how to do so themselves. This kind of fortune handed down to the next generation can never be taken away. And these twelve-year-old girls have already inherited it.

NEXT SPREAD
On the day Fumiko Shimabukuro was injured in a clash with the Okinawan Prefectural Police riot squad, protest leader Hiroji Yamashiro lashed out at the young riot cops, "You're Okinawans! And yet you protect the US military instead of the women of Okinawa?"

The Struggle of Marginalized Peoples Is the Perfect Remedy for an Ailing Nation

Fumiko Shimabukuro, aged ninety-two. Even now, in 2021, she continues to join in the protests against US military base construction. When she was fifteen, and Okinawa was a battlefield, she survived by drinking muddy water made bloody from corpses. She puts her life on the line to oppose the use of Okinawa for war—a symbol of the Henoko protests.

At the angry scene where Fumiko was pulled to the ground by riot police, a protester shows his grit by erupting into a display of karate—which originated in Okinawa. Screams of "Riot police! We'll give you hell!" turn into laughter. In Okinawan resistance, anger always goes hand-in-hand with singing, dancing, and laughing.

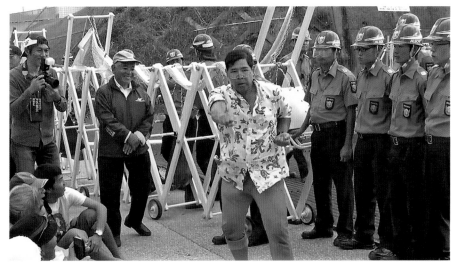

An Okinawan woman speaks quietly to the Okinawan Prefectural Police, forced to protect US bases, referring to the history of Okinawa, "Do you understand why the elder generation protests, after what they went through in the war? You can still stand there still knowing that?"

Chie Mikami

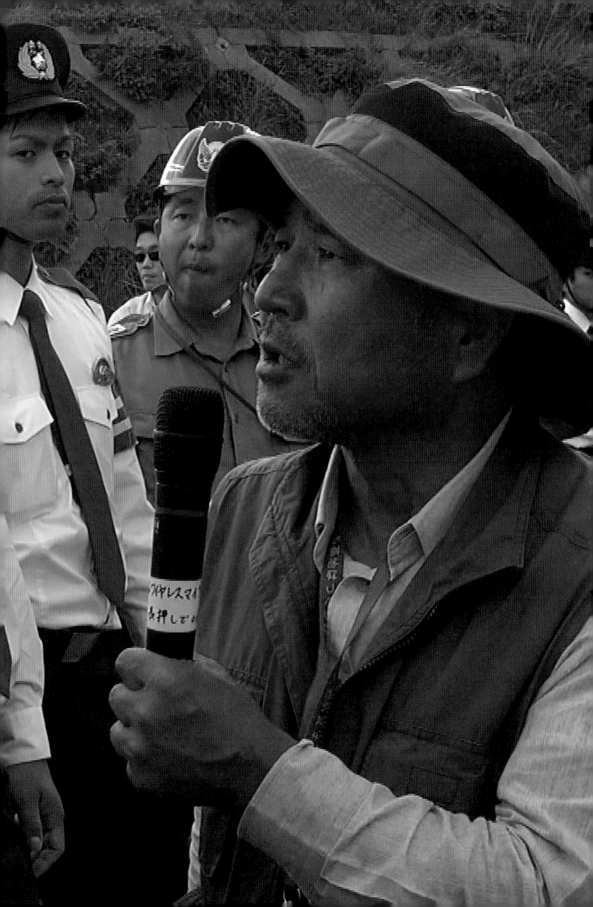

The women who went out by boat and canoe every day to the construction site on the water to prevent the land reclamation in Oura Bay had no choice on this day but to watch in tears as the first concrete block was thrown into the sea.

OPPOSITE
In 2015, huge concrete blocks were dropped one by one into Oura Bay, said to be among the most biodiverse coral reef hotspots in the world

The last ten years in Japan have seen the passing of a succession of pre-WWII style laws including the right to collective self-defense, the State Secrecy Law, and an anti-conspiracy law. In each instance, people feeling a sense of crisis rushed to the National Diet Building, but there was little variety in their protest, and no sense of playfulness. Among them, many came to Okinawa to find inspiration in the opposition movement here, in the people whose struggle with the structures of power commenced long ago. Okinawa's sit-down protest tradition has helped these citizens fight to forge a true democracy out of this nation of Japan. My films, which depict the struggle of Okinawa, have not managed to fully change the situation here, but it seems that they have succeeded in delivering skills and courage to others in their confrontations with power.

A country that exists only at the sacrifice of those who live in the peripheries, in depopulated areas, or of those belonging to minority groups, cannot nurture true democracy. In the case of Japan, one only need look at how this is being faced not only in Okinawa, but also by those who met with the calamity of the nuclear accident in Fukushima, to see the true face of the country. As such, a roadmap towards tempering and redirecting democracy may be found in the press reports, documentation, and accusations of those who have been disenfranchised. When the roots of a country are ailing, casting light on the struggles of marginalized peoples may serve as the perfect remedy.

Three films by Chie Mikami can be watched on Vimeo On Demand at the following links:

We Shall Overcome (2015)
https://vimeo.com/ondemand/weshallovercome

The Targeted Island: A Shield Against Storms (2017)
https://vimeo.com/ondemand/targetedisland

Boy Soldiers: The Secret War in Okinawa (2018)
https://vimeo.com/ondemand/boysoldiers

Walking the Path of Resistance with My Films on My Back

Mayaw Biho

I haven't made films for about eight years, so I can only share the documentaries I made in the past. This is why I named this lecture: "Walking the Path of Resistance with My Films on My Back."

Sharing past filmmaking memories feels like a topic for an older person, but I'm not even fifty years old, so I feel a little embarrassed to be here. I started making documentaries when I was very young, not because I liked filmmaking, but because filmmaking was the only thing I was good at. I really like the genre of documentary film, it expresses what people want to say. Especially when it comes to unhappy things, I can speak out on my own or help others to voice their troubles.

The very first time I held a camera was in junior high school. At that time, we had these so-called "dumb cameras." One day I stole my father's camera and went to the river to take pictures of the reeds. Before I knew it, I had finished an entire roll of film of thirty-six exposures, entirely of reeds. In that moment, I felt that the camera was a magical object. It can freeze beautiful things, condensing them into a single moment and leaving behind a lasting impression. It's not an easy thing to do.

Later, during my mandatory military service, I worked in the navy as an army photographer. Through my lens, I began to see many cases of social injustice against Indigenous peoples in the military. I completed military service in 1995 and went on study at Shih Hsin University in their Cinema and Broadcast Television Department. Despite the injustice I witnessed during my military service, I was still attracted by beautiful things. So, I photographed the rhythms, colors, and vibrant energies across Indigenous tribes.

But the summer before I started college, something happened that transformed my life and my photography from color to black-and-white. It was as if all of the colorful images I had taken before no longer existed. I saw a semi-professional Han photographer ask some Indigenous elders for permission to take pictures of them, offering two bottles of Paolyta-B[1]

This essay is based on a talk given by Mayaw Biho on January 18, 2019, at La Fémis, during a study day entitled "Genealogy and Cartography of Internationalist and Autochthonous Cinemas. Focus on Taiwan." Captions in quotation marks are taken from his talk. The essay has been edited for concision and clarity by Skaya Siku. The editor wishes to note that following president Tsai Ing-Wen's (2016–24) apology to the Indigenous peoples on behalf of the government on August 1, 2016, the Indigenous Peoples' Day in Taiwan, and since 2019, several policy and legislative reforms have taken place, in particular concerning the development of Indigenous peoples' languages and education. Mayaw Biho, Panai Kusui, and Nabu Husungan Istanda announced in May 2024 the end of the Ketagalan Boulevard protest for Indigenous land claims on its 2644th day, on May 20, 2024, coinciding with Tsai government's end of term.

1 Paolyta-B is a brand of alcoholic beverage with herbal remedy effects that is especially popular among Taiwan's working class. In 2014, it was categorized as a non-prescription medication and could only be sold in a pharmacy by the Food and Drug Administration of Taiwan.—Trans.

"During the summer vacation before college, my life went from color to black-and-white. It happened in the summer of 1995, during the Paiwan Maljeveq ceremony in the Tjuabal Tribe of Taitung. Two *vuvu*, Paiwan elders, happily accepted gifts from a Han photographer: two bottles of Paolyta-B and some Mr. Brown coffee, popular cocktail ingredients among Indigenous elders. After that, they were happy to be photographed. This made me feel very uncomfortable. I stood behind the *vuvu* to see how the photographer framed them, and then I stood behind the photographer to see how the *vuvu* had been shot."

in return. The elders gladly accepted the alcohol and agreed to be photographed. Watching this exchange made me feel deeply uncomfortable.

This incident made me think about the relationship between filming and being filmed. One of the reasons I felt so uncomfortable was that as Indigenous people, often we are arranged in poses or actions we don't like, in order to meet a photographer's requests.

The most painful part for me was that while it was a Han photographer making these requests, the children and elders being photographed seemed very happy with the situation and gladly accepted his demands.

This moment was a turning point in my life. From then on, I could no longer continue taking pictures of beautiful things, because all I could feel was a deep sense of injustice behind them. And so my world became black and white.

Walking the Path of Resistance with My Films on My Back

Stills, *"Chunri" is Our Name*, 1997.
Subtitles: "(Tseng Hsien-chiang, Crew member)
I want to represent ourselves.
We used to be hired hands for other people."

I filmed my first documentary, *"Chunri" is Our Name*[2] (1997, 40 min.), while I was at college, about the Pangcah youth from my tribe, Cr'roh, who competed in dragon boat races.

The reason the young people in my brother's generation wanted to compete with their own dragon boat was because the generation before them did not have the opportunity to compete for themselves. Instead, they were mostly hired as "mercenaries" by other, majority Han teams to row on their boats. Instead, they used their tribe's name to row for themselves and participated in the annual competition for the first time. In the end, they won first place in the national competition. At the time of filming, I didn't understand why Indigenous people loved dragon boats so much. I didn't know that Taiwan was recognized as the historic center or origin for the spread of Austronesian peoples. It wasn't until ten years after finishing this film that I finally learned this history.

2 The title of the film is sometimes rendered as as *"Spring Sun" is Our Name* or *"Chunri" is Our Name*.—Ed.

Walking the Path of Resistance with My Films on My Back

現在花蓮玉里春日的標手

三、二、一，奪標

或是我是山地人的名字啊

Subtitles: "C'roh Village Team's flag catcher.
3, 2, 1. We have winner."

沒有寫說花蓮、台東的名義

Subtitles: "Our aboriginal names have never appeared.
Our hometowns were never mentioned either."

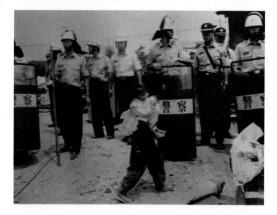

Shooting my first documentary was very natural, since the people I was filming were all my relatives. My second film (*Children in Heaven*, 1997, 13 min.) was more difficult to make. It tells the story of the children of an urban Pangcah community who lived in New Taipei City under the Sanying Bridge and whose homes were repeatedly demolished by the city government. You may wonder: what did the community do when their homes were destroyed? The answer is very simple. They just rebuilt them again and again.

This film took me three years to shoot but in the end I only edited a thirteen-minute short documentary. Because it was my first time shooting such a sensitive topic, I kept questioning myself without knowing the answers.

The question I asked myself most often was: why did I want to film these families? What was my real purpose in shooting this film? If my only reason was to win an award so I could have money to buy more negatives and other filming materials, could my film really do anything to help these children and their families?

When I couldn't answer my own self-doubts, I felt too embarrassed to continue shooting. And although at that point I was only taking photographs, which constitute an important part of the film, I was hesitant to do even that.

If my films or my other works today have some kind of "Indigenous character" [性格], I have to give credit to Professor Chi Lung-jen. He received a degree from the film studies department at Paris 3 University here in France. He often asked me: "Why don't you make this film in an Indigenous language?," "When you write your name, why don't you use your Indigenous name?," or "Why don't you let the elder speak for himself?" His teachings really changed me, and he encouraged and inspired me to develop my own Indigenous point of view.

Stills, *Children in Heaven*, 1997.
"The Pangcah people live by the Dahan River in New Taipei City. Whenever the government forcibly demolishes their houses every year, they gradually rebuild. It is a story of repeated demolition and rebuilding."

Walking the Path of Resistance with My Films on My Back

As I started to make *As Life, As Pangcah* (1998, 28 min.), I originally planned to base it on my own experience of returning to my roots. But then the leader of Makutaay, Lekar Makur, had so much he wanted to express, that in the end the film was filled with his words instead of mine.

That year he received an award from the Presidential office. When he found out, he was delighted and hoped to use this opportunity to discuss Pangcah affairs with the President. But all the President said to him was, "Congratulations."

Originally, he had prepared a lot of things he wanted to share with President Lee Teng-hui. Even though Lee Teng-hui was a leader of over twenty million people, and Lekar Makor was only the leader of a small tribe, they both shared leadership roles. He expected that they would meet as equals, with mutual respect. But Lee Teng-hui just offered his congratulations and went away. It left him deeply hurt.

After I heard about this incident, it was clear to me what it meant to have an Indigenous perspective. Even more clear was that Lekar Makor embodied this kind of Indigenous subjectivity.

So out of everyone I have met, he has made the greatest impression in my life. He was both confident and humble, with a clear understanding of his own indigeneity and a strong sense of responsibility for others.

During rituals, if it rained consecutively for several days, he would say, "The reason our ancestral spirits have not given us good weather is because of us, the elders of our generation, who have not served them well enough to earn good weather." He believed his generation of elders should take responsibility.

He also sang very well, with a voice that was clear and carrying. He could sing any song, but he only sang during ceremonies. It rarely happened on ordinary days.

When he was young, he hunted in the sea, when he was older, he hunted in the mountains.

Stills, *As Life, As Pangcah*, 1998.
Subtitles (third, fourth, and fifth still):
"The Mialaw master would go to collect bamboo.
How to foster Pangcah culture.
The culture of the Pangcah is a good culture."

Mayaw Biho

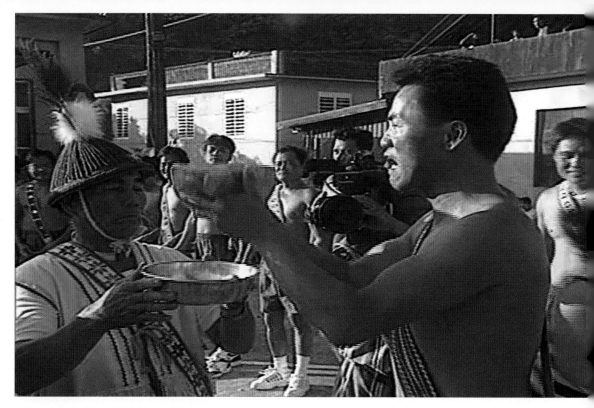

Still, *Dear Rice Wine, You are Defeated*, 1998.
"My first work after graduation, *Dear Rice Wine, You are Defeated*, was made for
Public Television Service. Actually, I only produced one documentary with the PTS.
I left after just two months to work at Super Television—I believed I could learn more
technical skills at a commercial television station. I also thought it would be a way
for a broader audience to see programming on Indigenous issues."

OPPOSITE
Still, *Carry the Paramount
of Jade Mountain on My
Back*, 2002

He stayed active and went up to the mountains until his nineties. I am very
happy to have met such a role model in my lifetime, it makes me feel proud
to be a Pangcah person.

During this time, I started to engage with more sensitive Indigenous
social issues in my films, such as education, housing, and
labor rights. I also made a film about Truku people's land
claim issue (*The Land in My Heart—The Witness Igung Shiban*,
1999, 24 min.). As I got more involved in issues of political
and historical injustice, I began to realize the world was
indeed not as beautiful as I had thought.

Mayaw Biho's films on the challenges of
urbanization (employment, housing, and
education) on Super TV:

1999 *Pangcah Mothers, Women Who
Build Houses*, 24 min.
1999 *Fast-Paced Life—Paong'ong Truck
Team*, 24 min.
1999 *Adaw's Footsteps—Being and
Nothingness*, 24 min.

The film won an award and I received some prize
money, which helped me buy more shooting equipment. But
I found that winning an award does nothing to resolve the
actual issues that are at stake.

The film's protagonist, Igung Siban, had suffered
many strokes and, like many elders in the film, she has since
passed away. Without their presence, the destructive and illegal mining
that was the subject of this film, is still in operation. After that, I won fewer
awards, probably because I chose to shed light on the darker sides of
society. Topics like this don't win awards in Taiwan.

 Walking the Path of Resistance with My Films on My Back

In order to address Indigenous name rectification issues, I filmed a four-part documentary series about Indigenous personal and place names.

Another theme that I have closely followed in my filmmaking since the early 2000s are the issues connected to Indigenous traditional territories and their land rights.

One of my films in this series, *Carry the Paramount of Jade Mountain on My Back* (2002, 46 min.), is about two Indigenous porters who were hired to climb to the top of Jade Mountain, the highest mountain in Taiwan, to install a bronze statue of a government official, Yu Youren, a key figure in the founding of the Republic of China.

As I filmed these injustices, I kept asking myself: could my films actually change anything? Even when my films won awards, they didn't seem to make a difference, and now my films were even less likely to be recognized. Was I just getting farther and farther away from social change?

In 2005, the English documentary filmmaker Dick Fontaine was invited to Taiwan for a film festival. He shared two ideas that resonated with me: "It is OK to compromise as long as you stay true to your original intentions," and "The public sector has some good people to collaborate with, so don't give up."

Mayaw Biho's films on Indigenous historical trauma:

Name rectification
2002 *What's Your "Real" Name*, four episodes, 25 min.
2005 *What's Your "Real" Name*, 48 min.

Traditional territories
2000 *National Bandit—A Beautiful Mistake*, 56 min.
2003 *Cilangasan: Stories on the Road*, 25 min.
2003 *From Kuangfu to Karowa*, 55 min.
2004 *From Fuxin to Piyaway*, 54 min.
2006 *Alishan Tsou*, 50 min.

Natural disaster
2001 *Painting 9½*, 45 min.

Ethnic histories
2001 *Coming and Going, Island of Tachen*, 111 min.
2002 *Carry the Paramount of Jade Mountain on My Back*, 46 min.
2005 *Taichung Underground*, 12 min.

Culture and customs
2007 *Malakacaway—The Rice Wine Filler*, 80 min.
2008 *Talanpo's Malapaliw*, 38 min.

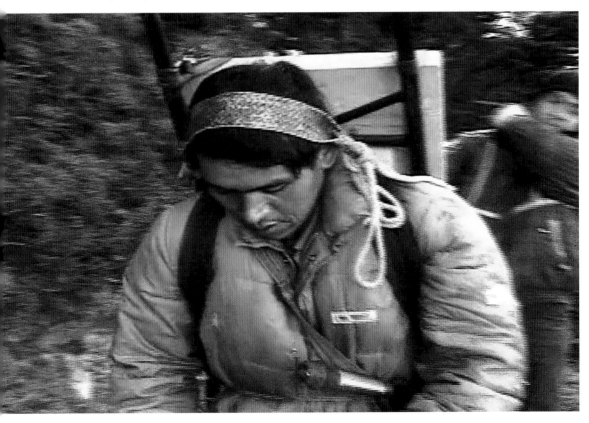

ABOVE AND OPPOSITE TOP TWO Stills, *Kankanavu Await*, 2010
OPPOSITE BOTTOM Still, *Light Up My Life*, 2011

In 2009, Typhoon Morakot hit Taiwan and brought heavy damage, especially to Indigenous areas in the mountains. For a year after the typhoon, no matter how many local residents pleaded with government officials, the government would not direct the state-owned petroleum company, CPC Corporation, to restore their supply in disaster areas; the state would not send gasoline up the mountain. But when we held a press conference in Taipei, gasoline was delivered the next day. From this we can see that the government thinks Indigenous peoples in the mountains are too far away to manage. So after the typhoon, they stopped gasoline supplies and refused to repair schools, as a way to force people to relocate off the mountain. Once everyone has left the mountains, it will be easier for the government to control Indigenous populations as well as natural resources. So, to fight these violations of Indigenous rights, I made three films on the mountain about the aftermath of Typhoon Morakot.

Mayaw Biho's films on Typhoon Morakot:

2010 *Kankanavu Await*, 94 min.
2011 *Free or fixed*, 55 min.
2011 *Light Up My Life*, 56 min.

During nearly two years of filming, I frequently asked people: is it the right decision to stay in the mountain? Is it a betrayal to leave the mountains? It seemed like those who chose to remain in the mountains were strategically abandoned by the government's passive policies. Those years on the mountain gave residents a profound sense of hopelessness and despair.

It is in this natural disaster that I saw how the government really treats Indigenous peoples. During that time, many people were so depressed that they were driven to drinking, or even suicide. But I did not want to give up, I wanted to change how things were, and so I took a next big step in my life.

Walking the Path of Resistance with My Films on My Back

聆聽

就是將部落的聲音

2000～2004年 連續辦了五次阿美影展

將影片帶回當初拍攝的部落

每年約有50場各地放映與座談

只是我拍紀錄片的另外一個開始而已

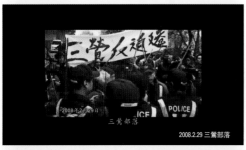

2008.2.29 三鶯部落

2008.2.29 三鶯部落

2011.12.17 台北公視

2011.12.17 台北公視

Stills from Mayaw Biho's campaign video for the 2012 elections, *Let's do the things right, we want change!* Mayaw Biho can be seen on the first and the two bottom images.

Without any party affiliation, without any institutional support, and without any money, I ran as an independent candidate in the Indigenous legislators' election for the Executive Yuan.

In the past, we believed that if we made a film, won an award, and held lots of screenings, then officials and public representatives would take on the responsibility to solve these problems.

But this was not the case. Public representatives were not addressing these problems, so we decided to run for office, to see if direct political participation would be a more effective form of social change than filming documentaries.

Our platform was: "We want change," and "Let's do things right." But the deposit required to participate in the election was around 200,000 NTD, and I had less than 20,000 NTD in my account. So, we set a new goal to raise money for the deposit by getting 1,000 Indigenous people to support us by donating just 200 NTD each.

But by the time polling day arrived, we still hadn't reached our goal. We hoped to inspire 1,000 people to action, but only 700 Indigenous people supported us. So our dream of collective funding was not realized.

That year, in 2012, we only received 4,000 votes, which was more than 10,000 votes short from being elected. There is clearly a long way to go. After the election I received a call from the Tainan City Government, asking me if I wanted to work in Tainan.

While I was hesitating, a friend reminded me, "Don't you love to criticize? You are always dissatisfied with the government ministries, you say they aren't doing enough. So, Mayaw, why don't you show us how it's done!" Three days later, I decided to accept the job as the chairman of the Ethnic Commission in the Tainan City Government.

Here we established the Ca'hamu Tribal University, which is very unique. We also set up a free, one-stop window in order to encourage Indigenous people across the country to come to Tainan and officially change their Mandarin name to their Indigenous name. This is part of Taiwan's Name Rectification movement, which

Walking the Path of Resistance with My Films on My Back

is typically a complicated bureaucratic process involving multiple government departments.

I worked there for around a year and a half and was very happy. I felt that I was able to use this platform to make significant changes and realize my past dreams. But then Taiwan Indigenous Television (TITV) suddenly announced a job opening for station director. So, I quit my high-salary government position and applied for the TITV opening. Out of eleven candidates, I was fortunate to be selected as the station director.

In this new position I put all of my past dreams and expectations into practice. I wanted to convey an *Indigenous perspective* and establish an *Indigenous subjectivity*. But even though I was the station director of TITV, above my position there was a CEO and a chairman. The station director's authority was disproportionately limited in matters of budget allocation. In addition to this, they kept trying to reduce my authority in other ways. In the end, I handed in my resignation as an act of protest, and left.

Mayaw Biho, third from left, standing for the second time in the Legislative Council elections, 2015

Like the Olympics, Taiwan's elections are held once every four years. When the time came, I ran again in the Indigenous legislative election as an independent candidate. This time our votes increased from 4,553 to 9,009, with the platform: "Become one's own master." But we were still 5,000 votes away from being elected.

Then on February 23, 2017, something significant happened for Taiwan's Indigenous land rights. At first we were only planning to camp out at the Ketagalan Boulevard in central Taipei for a month, but before we

The start of the Ketagalan Boulevard protest, February 23, 2017. From left to right: Lin Fei-fan, Han Taiwanese activist who led the Sunflower Student Movement back in 2014; Mosi Oroh, Indigenous activist from Koyo Tribe, Hualien; Mayaw Biho; Panai Kusui, Puyuma/Amis singer-songwriter who led the Ketagalan Boulevard Protest with her husband Nabu Husungan Istanda, Bunun land activist, and Mayaw Biho; Suming Rupi, Amis singer-songwriter.

Mayaw Biho's site-specific work within the larger work of the collective Indigenous Justice Classroom (consisting, besides Mayaw Biho, of musicians Panai Kusui and Nabu Husungan Istanda, and other artists and authors who are indigenous Taiwanese and of other ethnicities) at the 2018 Taipei Biennial, "Post-Nature—A Museum as an Ecosystem" (November 17, 2018 – March 10, 2019).

OPPOSITE
Still from Myaw Biho's livestream on July 31, 2018, detail. During the Ketagelan Boulevard protests, Mayaw Biho made extensive use of livestreaming to communicate with the larger public.

knew it, it had been 695 days (on the day of the talk). The day I arrived in Paris, I got a call from the police of Taipei City saying they were going to clear out our protest sites. The latest news is that everything will be removed in a week (at the time of writing, the protest is still ongoing).

On February 23, 2017, we formed a semi-permanent protest movement on Ketagelan Boulevard around Indigenous land rights. In her previous talk, Skaya Siku discussed how we mostly used livestream videos to communicate with the public and showcase what we were doing. Another unusual thing we did was organize a public lecture series at our protest sites, with 172 talks. We invited speakers from different political parties, different ideologies, and different areas of expertise to share content around the histories of Indigenous struggle. This Indigenous Justice Classroom was demol-ished by the Taipei City Government on March 31, 2018.

After our protest site was dismantled, my co-organizer Panai Kusui launched her concert tour to perform 100 concerts across Taiwan, while I started my 99 Lectures tour. Today in Paris is my forty-ninth lecture.

In Taiwan's three-year high school curriculum, of the 128 hours of required history classes only three focus on the Indigenous peoples. This means that Indigenous students don't know who they are when they graduate high school, and their non-Indigenous classmates also don't know anything about Indigenous peoples either.

In Taiwan, neither the Chinese Nationalist Party (Kuomintang, KMT) nor the Democratic Progressive Party (DPP) are willing to face the past 400 years of injustice towards Indigenous peoples, so we have to tell our own history. To this end, in 2018 we launched a series of lectures, and held forty-three sessions from May 10 to the end of the year. We spoke to adults, PhD students, and even elementary school classes. The younger the audience, the greater the impact.

After our protest camp was destroyed, we went on to hold lectures, perform concerts, and curate exhibitions. We worked with the Taipei Fine Arts Museum to curate a multimedia exhibit as an extension of the Indigenous Justice Classroom. Because all of this took so much effort, I didn't make films for eight years. It was not until the end of last year that I made two short films at the museum.

The slogan of our protests was "No one is an outsider." Our goal is to raise awareness and inspire everyone in Taiwan to accompany Indigenous peoples as they find their way back home. In some tribes, people can do it, but in many others it is complicated by the fact that a significant number of Indigenous lands are located within national parks, with access restricted by the Forestry Bureau. For now, our protests are largely ignored by the government, and it is hard to see what the future holds. But we will not give up, we will keep fighting.

Aide-Mémoire. Disinterring the Colonial Past in Service of the Present,
A Conversation with John Gianvito and Myrla Baldonado

John Gianvito
Myrla Baldonado

in conversation with

Ricardo Matos Cabo
Rupert Cox
Alo Paistik

With the diptych, *For Example, the Philippines*, which consists of *Vapor Trail (Clark)* (2010) and *Wake (Subic)* (2015), John Gianvito has produced an unprecedented nine-hour filmic fresco on the long colonial history of the Philippines that has scarred bodies, contaminated the soil and living beings, and erased the history of Indigenous resistance, replacing it with a falsified history that praises the cooperation between the Philippines and the United States. Throughout most of the twentieth century, the Philippines hosted two of the largest US military bases in the world— Clark Air Base and Naval Base Subic Bay—established in the wake of the Philippine-American War (1899–1903). Following the 1991 eruption of Mount Pinatubo, the nearby Clark Air Base was abandoned by the US military. The next year, after the breakdown of the negotiations between the US and the Philippines, the control of the naval base in Subic Bay was also ceded to the Philippines. Unknown to the public, during its occupation of the bases and before leaving, the US military had buried in the ground and sunk in the bay vast amounts of toxic contaminants. For decades, the nearby population has been directly affected, either through their employment at the bases, or by consuming contaminated water, produce, and fish. The volcanic eruption severely aggravated the situation, when communities living in the evacuation zones around Pinatubo, including the

Indigenous Aeta who inhabited the volcano's slopes, were relocated onto the territory of the abandoned Clark Air Base. What was supposed to be a temporary solution became for many a permanent and, alas, devastating home for subsequent years and decades. This is the site of John Gianvito's investigation, conducted over a decade starting in the early 2000s. Working alongside activist organizations (led by Myrla Baldonado and Boojie Juatco) that have been fighting since the early 1980s for the recognition of the suffering and injustice endured by the populations living and working at or near the US military bases, John Gianvito strives to give a voice to the individuals directly affected by the contamination, and connect their situation to the deeper American colonial and expansionist history in the Philippines.

The following conversation took place in Paris, at La Fémis, on April 9, 2019, within the framework of the series of colloquia entitled "Filmic Forms and Practices of Autochthonous Struggles." The conversation has been edited for concision and clarity.

John Gianvito: In 1999, I saw on the front page of my local newspaper an exposé[1] about the issue of toxic contamination in military bases around the world. Just by way of illustration, it put a spotlight on the situation in the Philippines. I was profoundly moved by this article and I felt that someday I should find out more about this story. A number of years later, I had been developing a project that was initially going to be a kind of a fictional documentary, hybrid, about a collective of young media activists who are doing their own independent journalism and putting it out on the internet. One character was going to be a Filipino-American who had never been to the Philippines and who would find out about the contamination around the bases, and travel there to investigate. I received a small grant to help with that part of the project, allowing me to travel to the Philippines and do some initial research. I first approached a grassroots organization located in Berkeley, California, called FACES (the Filipino/American Coalition for Environmental Solidarity), a group founded around the issue of the cleanup of toxic waste left behind at the former US military bases, hoping to work with them. They were the ones that suggested that I get in contact with Myrla Baldonado, as they felt that she and her organization had established the deepest connections within the community, having been working with these issues for about fourteen years. And so, in early 2006 I reached out to Myrla. My recollection is that I sent you one of my films [talking to Myrla], I think there was a process of building trust with one another before I travelled to the Philippines later that summer. Then, in the first days, after meeting so many people in such a dire situation, I just didn't feel how in good conscience I could pursue my initial film idea, no matter how

1 David Armstrong, "A Toxic Legacy Abroad: The Military Has Polluted in Ways That Would Be Illegal in the United States," *Boston Globe*, November 15, 1999.

Aide-Mémoire. Disinterring the Colonial Past in Service of the Present

interesting that film might be. At that point, I just decided to jettison this project that I'd been working on for about a year and began to see if I could tell this other story.

Myrla Baldonado: When John came, we were developing a strategy of coming up with the human dimension of the issue.

JG: There was a little book that Myrla and her organization had published, which she had sent me before I arrived, called …

MB: … *Inheritors of the Earth*.[2] With that book we took the decision that it will have to be the narrative, the stories of the people and how they explain it, that leads the campaign. Through these we would introduce to them the concept of toxics, the effect on the environment, and the health of the people.

JG: That book gave me a sense of the regions affected and some of the particular stories. But mostly, the decision of where to go and whom to spend time with was a conversation, a continuing conversation each year. I would ask them about certain things, such as the range of illnesses that people had that weren't being represented. And Myrla and the other lead activist, Boojie Juatco, would suggest people whom I might want to visit.

2 Aimee Suzara, Amy Toledo, Christina Leaño, and O'Lola Ann Zamora-Olib, *Inheritors of the Earth: The Human Face of the U.S. Military Contamination at Clark Air Base* (Quezon City: People's Task Force for Bases Cleanup, 2000).

Archival footage appearing in *Vapor Trail (Clark)*, 2010. Intertitle reads: "Mt. Pinatubo is part of a chain of volcanoes situated along the west coast of the island of Luzon, 55 miles northwest of Manila. Prior to 1991, the ranges around Mt. Pinatubo were densely forested and home to many thousand Indigenous people, the Aeta (Negrito), who had first fled there to escape persecution by the Spanish. Following a steadily increasing series of earthquakes beginning in March 1991, Mt. Pinatubo erupted on June 12 sending ash 14 miles into the air. Questioned at the time whether this was at last 'the big one,' observers from the United States Geological Survey replied, 'No, this is just a clearing of the throat.'"

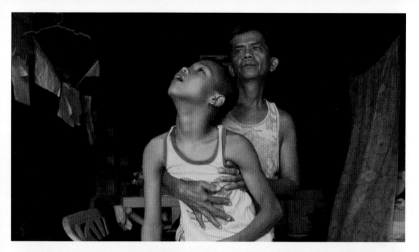

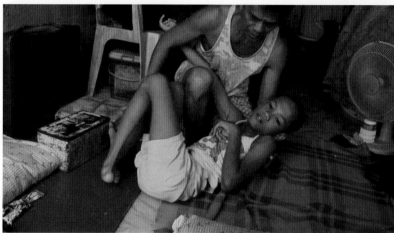

Stills, *Wake (Subic)*, 2015. Conversations with Nick Merino, whose son Samuel David was affected by cerebral palsy following the family's exposure to toxic contamination. Olongapo City, August 2007.

JG: This is a clip [presenting conversations with Nick Merino] from a series of sequences in the film where I decided I had to do interviews because you couldn't just observe people and know that they'd lost so many family members or had certain health issues. That became a necessary element. But I also sought to live with a family for a while and more intimately observe their lives dealing with children who had been disabled. I arranged to spend some time with the family of Nick Merino, who had worked inside the Subic naval base for fifteen years or so. He had two children who have cerebral palsy, which has been frequently connected to exposure to toxics. Only after quite a while knowing him did I learn that Nick had had a third child who had died. His son, Samuel David, who is in a way the central character in the second film, is a very bright boy but physically he is unable to use his hands, he can only use his feet. And he can't stand upright. He can't speak much. Sadly, he spends most of his time watching TV. And yes … Nick has passed away since the making of this film.

MB: Nick used to work in the naval magazine. It's an area where they handle weapons. He would forklift the containers with weapons, which contain toxic compounds that he was not aware of. When we traced his work history, there would be broken boxes, and the workers would carry

Aide-Mémoire. Disinterring the Colonial Past in Service of the Present

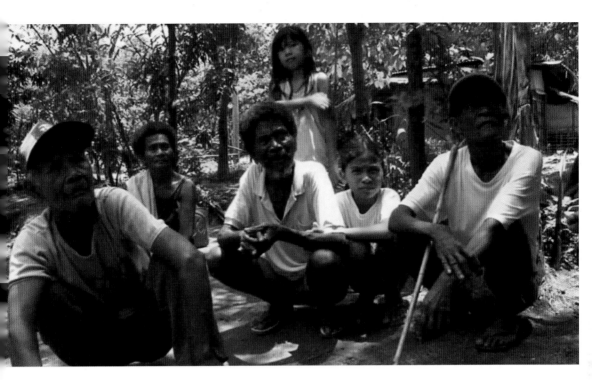

the weapons themselves, exposing them heavily to the hazardous waste. He had kidney problems and although technically it's very hard to prove the connection, the repetitive exposure and the types of jobs that they did was ...

JG: ... highly suggestive.

Alo Paistik: In the second half of *Wake (Subic)* there is a series of striking exchanges with one of the displaced communities, the Indigenous Aeta. They have been forced to store their communal drinking water in a huge water tank lined with asbestos. They are aware that it affects their lungs, causes coughing, and name many community members of all ages who have passed away in recent years. The discussion between the Aeta, Boojie, John, and Jade Timbas [an activist of the Task Force for Bases Cleanup] turns to the need to self-organize around the knowledge of the source of contamination and the need of all members to exert collective political power to bring about change. Can you speak more about this encounter and the Aeta's experience?

JG: The Aeta, one of several diverse indigenous groups collectively referred to as the Negrito people, live high up in the mountains not far from Mount Pinatubo in western Luzon. By the time of my first visit in the summer of 2006, the People's Task Force for Bases Cleanup had already established connections within the Aeta community and were working with community organizers. One of my recollections upon entering this area was an incident when we were first hiking up the mountain, we passed

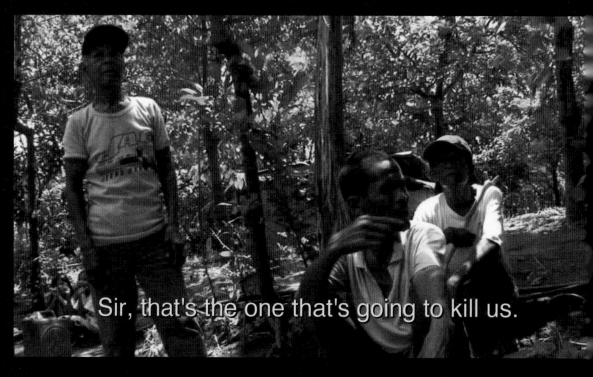

Sir, that's the one that's going to kill us.

PAGES 90–95
Stills, *Wake (Subic)*, 2015

Aeta man 1: Sir, that's the one that's going to kill us. That's why it needs to be replaced by the captain (village head) here.

Boojie Juatco [to the filmmakers]: The tank is made of asbestos. He demands that it needs to be changed. This is the social water for the whole community.

AM 1: It should be concrete, cemented … so that it would be nice. To change it because it affects our lungs. Up until now there are people dying from a lot of coughing. Because that thing hasn't been torn out.

BJ: So there are many people dying?

AM 1: Plenty sir, just recently. Young and old.

BJ: Did you take any action, did you write any petitions to reach those in power?

AM 1: None sir. Nothing sir.

Aeta man 2: The councilor and the captain should take action to change it, if they can.

Aide-Mémoire. Disinterring the Colonial Past in Service of the Present

BJ: As victims, you are being affected, many of you are getting sick? Will you just let it be like that? Do you have a plan for organizing? Do you have plans for ... to fight for your family, because you are getting sick? Did you ever think of giving contributions so that you could put it in new wells?

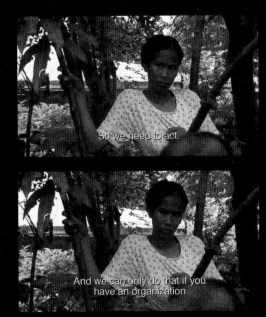

So we need to act.

AM 1: Sir, this is what should be done—to have a meeting, a general meeting involving everyone to discuss the problem. The people really haven't talked to one another. They don't know that *that* can kill, most here still don't get it, but most of us who have worked in the base know that. Even though four of us talk, it has no impact.

And we can only do that if you have an organization

BJ: So we need to act. And we can only do that if you have an organization that studies and investigates.

AM 1: Voices are lacking, lips are sewn, that's the problem here.

Woman off frame: Because there is fear.

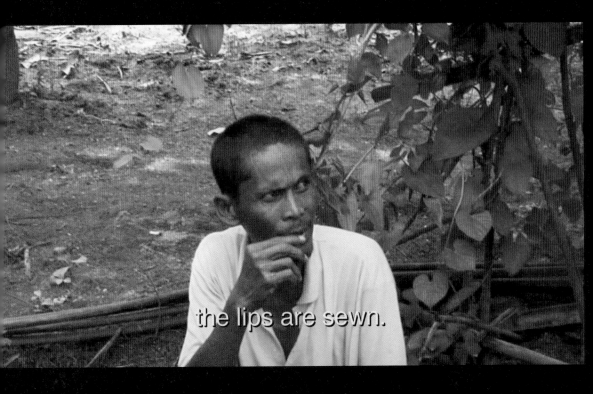

the lips are sewn.

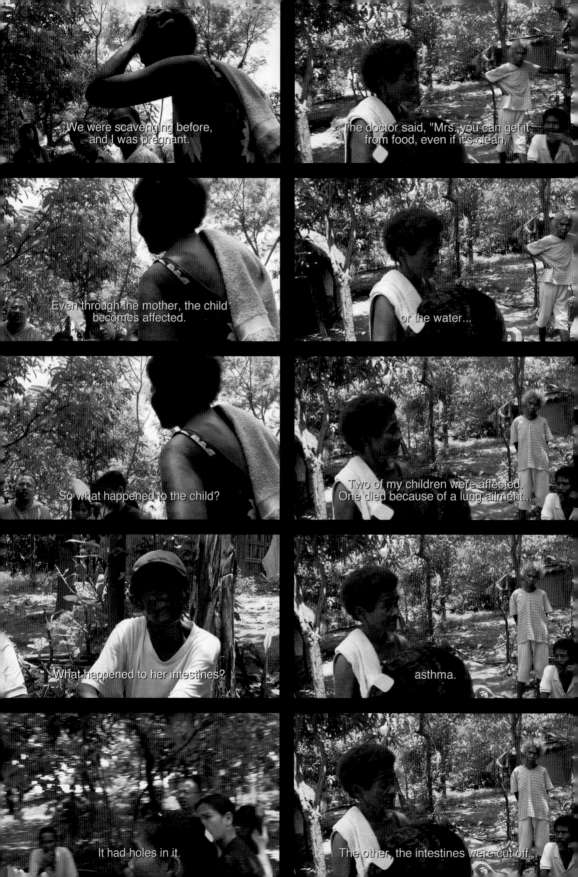

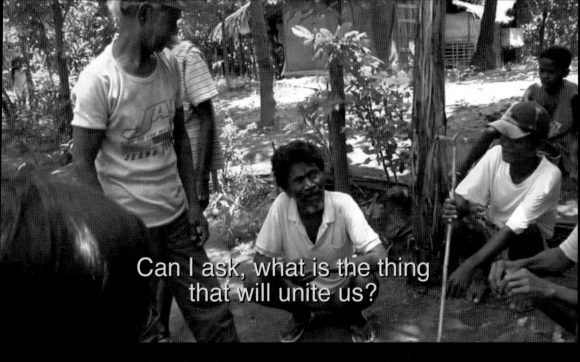

Can I ask, what is the thing
that will unite us?

BJ: You are afraid because you don't know what
to do. For example, if we were to walk across
a narrow bamboo bridge and that was the first
time you were to cross it, you would be afraid,
right? But once you know how you won't be
afraid because you already know what to do.
Since this is our problem, instead of pulling in
a leader from outside, then why not you be the
leaders? So what are we going to do? We've
talked and discussed now all problems, but we
are not talking about solutions.

AM 1: What we do with the problem sir, is to
publicize it on TV and let Mayor Bong watch it.

BJ: So who's doing it? Yes, that's right—publicize
in newspapers, go protest, but those who protest
must have an organization.

AM 1: Yeah, they should have one.

BJ: One can't protest and complain when
there's no unity.

AM 2: Can I ask, what is the thing that will unite
us?

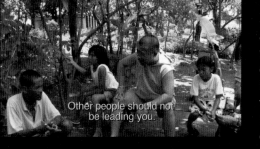

Other people should not be leading you.

BJ: There you go! First, there are people who believe and people who do not believe in what we are saying. Alright, sir, let's choose all the people who believe in this. Let's put together a small group first, until slowly it gets bigger and bigger. First of all, choose who they are. Second, now that you've chosen those who believe, all of them having the same beliefs, who amongst you here can stand up and be a strong leader? Who will be the primary contact with our office so that we both help and support each other? From people in solidarity ... therein lies the power. You don't need to be strong. Look at Apolinario Mabini, our hero, he was disabled, he was active in the revolution disabled, placed on a hammock, and carried by the Katipuneros. If you are not organized, you're all over the place, you are not going to be paid attention to by whoever it is. The poor are noticed when we are united and in large numbers. Because that's power, and those are votes. There's political impact. Later on—"to see is to believe" for those people who will say, "Oh, it looks like this is real. Let me join. I will try to get involved." So that's how it starts. That's when they believe, that's how trust is formed ... no more fear.

At one point during the sequence, a red arrow and a black text appear, to point out the asbestos water tank looming in the background

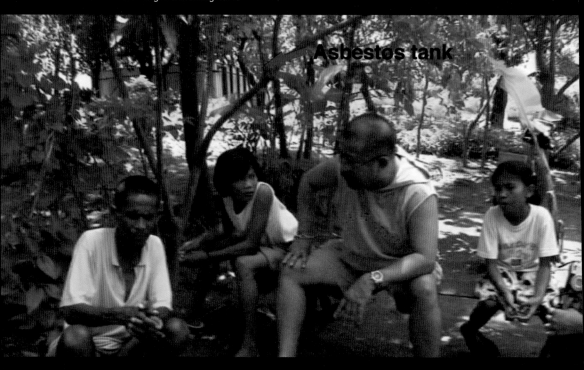

Asbestos tank

94 Aide-Mémoire. Disinterring the Colonial Past in Service of the Present

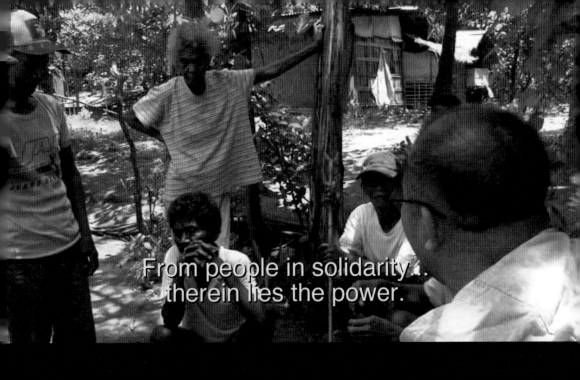

From people in solidarity...
therein lies the power.

Intertitle reads: "In February 2013, residents of the Iram Resettlement area
at long last succeeded in organizing to have their asbestos water tank full
dismantled and in securing a replacement.

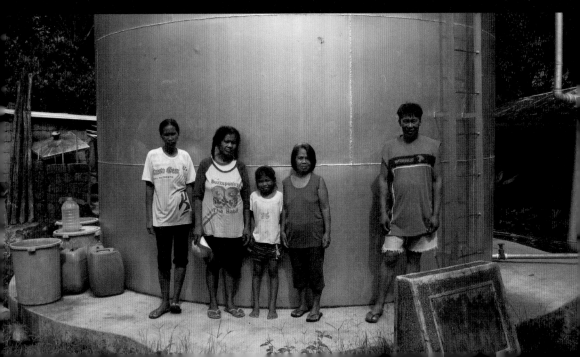

some young men and one of them shouted out to me, "Hey Uncle Sam!" Not only was I curious how they surmised I was an American and not from somewhere else, but I was almost pleased that finally there was a whiff of suspicion or even resentment of my presence as, knowing the history of the US's role in the Philippines, I was always surprised at how gracious and welcoming most folks had been to me. But that was largely the only such incident. Guided into the area by the local organizers, our dialogs, which you see through much of *Wake (Subic)*, were not markedly dissimilar to the other conversations we were having throughout the affected communities. There was clear awareness that too many individuals of many different ages were dying in abnormal ways. But access to better health care, resources, education, are even more limited both as a consequence of the Aeta's remote location and a persistent ostracization by the wider Philippine society. I felt a similar sense of resignation and dim hopefulness as I'd experienced in the city, though I came to respect that the daily pressures of just getting by often eclipsed the capacity to focus one's energies elsewhere.

AP: What transpires from these sequences is that there is a certain tension between the filmmaker's position and the position of the people that they film. There is this knowledge at the back of probably everyone's mind— yours, theirs, and the viewer's—that these people are bound to the situation that they cannot escape. One of the ways to break out of it is to create these images that travel beyond them. There is of course also this more contextual knowledge that these people have so little money that they're unable to even travel by bus to the nearest bigger city to get medical help, and if they do then they have to sacrifice something else, likely existential, in their life.

JG: You touch on a very important but difficult part of the making of a film like this. I was profoundly aware of the inequities of my situation. As I'm sitting in this home, I have a $5,000 camera with me. I'm staying in a very modest hotel, but again, by comparison far superior to their living situation. And I did decide to ... I felt that I had to give them some money, even though that was never supposed to be the arrangement in my discussions with the People's Task Force for Bases Cleanup, Myrla's organization. Eventually, I confessed to Boojie and Myrla that I had given them money. It was educational for me to understand why they didn't want me to do it, in the way that I was doing it, to just give it them directly. If I was able to give them money, I should give it first to the NGO, to the People's Task Force, because otherwise there was a risk that I was creating bitterness within this community—because everyone knows everything that goes on—and they would say, "Well how come that American got to meet those people and they benefitted from it."

MB: We wanted them to be empowered and not to compete with each other for material benefits. Rather, to work collectively in an organization to seek the US's responsibility for this, and to move our government to do something about it.

Rupert Cox: Your story resonates with the situations elsewhere and the work that has been done in Guam and in Okinawa around the US military bases. Are environmental impact assessments that the US military has to do a part of the conversation as well—the way these assessments are carried out and made public?

MB: There are two things. First, when the bases closed, there was a US General Accounting Office's report that recognized that there was contamination of Superfund proportions. So, this is an admission from the US government itself. But the Philippine government waived its right to have the area cleaned up. Second, we had a group of scientists, accredited experts at different levels, and also on advocacy level from the US, who called themselves the US Working Group. They demanded from the US all the documents that were available in the Air Force and regarding the naval base. And they did a study of those, which was not an on-the-ground study, but it would pass. They came up with a list of sites that should not be inhabited or touched. This study was never acknowledged by the Philippine government despite a preponderance of evidence and that if it were in the US, the government should have already started with the cleanup.

JG: As it's so expensive to do proper groundwater and air testing there, and to fund new or up-to-date research, the people in the States who cared about this issue had to use paper reports. The overarching issue here is that when the US opens a base somewhere, they've basically strongarmed the countries into an agreement, which says, "We're not obliged to do any environmental cleanup." So, legally, they don't have that obligation. And then, because we have something like 700 bases around the world, the minute we do start paying for what we've done there, all the other ones are going to say, "Well, how come you're not helping us?" which is why they have a strict policy of not taking responsibility.

RC: How do you go about communicating these results to the public and to your audience? Different contaminants call for specific ways of presenting evidence about their presence and effects. One can think of various ecological projects that appeal to different devices and ways of representation. How do you convey that through filmmaking, visualize people's relation within and to a contaminated space?

JG: I should say that many of the people in the community I met lived inside the Clark Air Base after the US was forced to leave. And when it was finally revealed that they were being poisoned, as a result of the improper disposal of various chemicals used on the base, there was enough outrage to force the government to relocate these people away from the base. Very minimally, modestly, but they did. The community I met with has no money for medicine and is around 90% unemployed. With poverty come other kinds of diseases. It's hard to always know, if they are caused by the toxicity or if the cause lies elsewhere. Besides, the effects of toxicity can manifest themselves over a long period of time. But what our research

showed was that the chemicals are leaching into the river system, spreading from inside the base eight miles further and going directly into the water the people are using. That is part of why we were showing the community maps of the river systems and how it was that so many of them were being exposed to contaminants. There's a scene in one of the films where you see them pumping water and all the stuff in it. People know that it smells bad, it tastes bad and it's greasy. They know it's not potable but they have no money to buy bottled water, they are forced to contend with it.

MB: There are chemicals that are very hard to remember, especially for a community that's not educated in science. We painstakingly describe these to them, and also our experts gave training sessions. American volunteers would come and they gave trainings and I was the interpreter. In the end, they also gave me a certificate. I was leading the campaign and I understood how the toxics would affect the communities. I met the Foreign Relations secretary of the Philippines and could at that point debate with him about the contaminants in the water. We knew that it was difficult, the US was stonewalling. Our only hope was that the people would demand for it. Evidently, the basic knowledge stayed with the community because of the strength of our media campaign. In fact, it became a historical campaign in the Philippines and a model for other campaigns against toxic contamination. Everyone would say, "Yeah, the toxics in Clark and Subic."

JG: One of the reasons for the length of the film grew out of seeking to find a way that I could prove that these people were sick from relations to the base, and not due to other factors. It's through exposing the preponderance of people repeating similar stories of the bad water that they were drinking, or the oily fish that they were consuming, or multiple stories of people talking about getting tested by the medical profession and then being refused access to the results of that test. I decided to keep all those stories in. Another motif in the film are cemeteries with endless buried children—you can tell it from the dates. I didn't know with certainty that every child in the tombs I was filming died because of toxic contamination, but there's just so many of them that I felt that, by and large, I'm making the case through such kinds of imagery and evidence. Besides the preponderance of evidence already established by the technical groups, what we were trying to do was to break through to the Philippine government and appeal to the political will to get the United States government to do something about this problem, which had not been happening.

Ricardo Matos Cabo: In the second film of the diptych [*Wake (Subic)*], John goes much deeper into historical evidence. He explores the history of US colonial violence against the Philippines, including those of extraction and the abuse of the population over not only of this specific period and on the specific issue of the military bases, but throughout a longer history. It works as another level of evidence, historical evidence, if you want, showing this continuous logic of injustice.

JG: My simple way of trying to find some future solution to this problem, which is so profound and overwhelming and hard for me to even know what could ever turn this around, was to simply posit the notion that if you didn't deprive people of their own histories, maybe you wouldn't get this result. If the people of the Philippines understood the role that the US had in robbing them of their independence, and murdering hundreds of thousands of their ancestors, I believe that they would have said "no" to the bases. They would have said, "Thanks, but no thanks." That was one idea of how things could eventually change.

RMC: Compared to the initial idea, your film ends up changing its focus and becomes a commentary on media activism itself. Can you say something about the process of your collaboration?

JG: Three years into the making of the film, travelling back and forth between the US and the Philippines, Myrla, Boojie and I had a particularly risky encounter at the Clark Air Base with a group of men involved in extrajudicial killings. Following that episode, it was the first time that Myrla and Boojie started opening up to me about their own lives as activists and how they had been arrested and undergone various forms of torture under the Marcos regime. At that point, I became as interested in their stories and their decision to commit the rest of their lives to helping the people affected by the contamination at the bases and decided I would open the lens wider and incorporate them into the film as well.

Before I completed the first part of the film, *Vapor Trail*, I had the ability to bring Myrla to Boston and what I specifically remember is her reaction after informing her what the running time of the film was. She told me how nervous that made her because she was anticipating a half-hour or a one-hour long film that would be a useful tool for her organizing work. There have been other documentaries made on this subject that she had used in the past. But what I remember her saying after the first projection of the film was, "Okay, maybe only 100 people will see this rather than 1000 people. But those 100 people are going to have such a deeper, richer understanding of this situation that maybe they'll be more moved to do something about the situation," compared to those films which move us but then we move on and they kind of evaporate. The other thing I remember you saying, Myrla, after the first viewing, was how moved you were by the eloquence of the members of the community, how much this indicated to you that the fourteen or fifteen years of community organizing had really paid off, allowing them to explain the circumstances of their condition.

MB: I think the other side of it is how you talked to them and treated them. You built the trust. And you waited for them to come up with their stories. I saw that because we were so used to having people from media organizations flying in, demanding quick access.

Audience member: Nicole [Brenez] spoke about how films made by activists can be *useful*. Have your films been useful to the causes you're describing?

After the fight at
nt Bud Dajo, Jolo, P.I.
March 7th 1906.

JG: I am sure Myrla might want to say something about this as well. It's very hard to have clear metrics on what the impact of one's work is. I called the two films together *For Example, the Philippines* because what the US did in the Philippines has been replicated in our relations with many countries throughout history. I feel that the lessons of the films are applicable to many people worldwide. The films have been shown in many parts of the world and various people have told me how much this has mattered to them. I need those sorts of affirmations that there's value in doing this work, but it is a struggle to believe that it might not be better to be just doing the sort of work that Myrla was doing and having a more immediate tangible effect on people's lives. It's not that I don't contribute money and do other things to help, but I have grappled with that many times.

MB: The beauty of having a film is that it lives beyond all of us, a film that can keep educating, a film that has captured the sentiment and the impact of the legacy of the United States military in the Philippines. During the Moro Massacre at Bud Dajo [1906], they killed close to a thousand people ...

JG: ... mostly women and children ...

MB: ... and the film makes us face the reality of the historical trauma that was robbed of our people, that was obliterated by miseducation, something we were all forced to forget.

JG: I still get emotional during this sequence, and I've watched it more than a few times ... this is the sort of finale to the history lesson that extends across the nine hours of the film. It is chronicling the evidence that there was a continuing resistance to the US occupation long after 1902 when Theodore Roosevelt declared that the war had ended. There was a lot of evidence that was able to be dug up to show that in many parts of the 7,000 islands of the Philippines the people had not agreed to submitting themselves to US rule. There's a strange irony that even a monster like Duterte knows this history. Early on, when he became president, he held up the photograph of the Moro Massacre and claimed that he wanted the US to apologize for this. But once Trump decided to be his buddy, that changed.

AP: The episode of General Leonard Wood shattering the only remaining photographic glass plate of the Moro Massacre in 1906, puts a finger on an important idea: we sometimes forget how fragile images are, especially the images that are contemporary to us, and how susceptible they are to being eradicated, destroyed, or buried under other images, and the effort needed to protect and contextualize them.

General Leonard Wood attempted to suppress the reports of the Moro Massacre—the killing of nearly the entire population of Tausūg villagers, one of the Moro peoples—perpetrated in March 1906 by the troops under his command. Although he shattered the only photographic glass plate taken after the massacre, the photographer managed to make prints of it beforehand, which were subsequently disseminated among the public.

JG: One of the things I struggle with is how to present this work in a way that you don't become numb to it. I think about the argument that Harun Farocki makes in his great film *Inextinguishable Fire* (1969), in which he says, and I am paraphrasing, "If I show you an image of suffering, you're going to

close your eyes to it because it's so painful. And then you're going to close your eyes to the memory of the image. And then you're going to close your eyes to the facts," and I need you to, I want you to, think about these things. The challenge is figuring out how to insert the most difficult images in a way that you can actually see them and not be totally overwhelmed.

Audience member: The occasional absence of images in John's films makes us understand the things that we don't see, that we don't even need to see. Is it a strategy for you to present voiceover over black screen, maybe because it adds more value to the images that you actually show?

JG: Yes, very much so. Because the information that I'm recounting is something I really do want you to understand and remember. I am cognizant of the fact that, in general terms, the eye is stronger than the ear. If I put an image next to everything that is being said, as many historical documentaries do, my feeling is that every time the image changes, even if it's for a microsecond, your brain has to process this new visual information and you're not quite listening as attentively as I want you to. Secondly, there weren't logical images that could accompany everything that I wanted to say. I would be forcing myself to fill up that space with visual wallpaper of some kind that I did not feel necessary. I am very conscious of the fact that structurally the film keeps surprising you with how long an image is held—sometimes very briefly, sometimes longer than is typical, sometimes it's an animation, sometimes it's an archival clip. My hope is that it keeps you active and engaged and that, while maybe unorthodox, the frequent use of black and the absence of images, employed strategically, is ultimately as cinematic as anything else.

RMC: Contextualizing archival images in this way is a call to fight against imperialism. This also applies to images of the landscape. After watching these films, we can no longer look at the images of these places in the same way as before. When we are aware of the historical and permanent damage that happened in there, a simple image of a river flowing through the landscape, an image of the sky or the land takes on a completely different meaning. The strength of these films also lies in their power to transform an image of a place into a landscape laden with the traces of history and ongoing violence.

JG: And I would just add to that, not only the environmental landscape, but also the human landscape. I feel that in the film the human bodies are themselves evidence of the deeper history of the people—that in a very literal sense history is being embodied.

Still, *Vapor Trail (Clark)*, 2010, detail. The evidence of the ever-permeating ground and water pollution: tainted water drawn from a well in the affected region around the Clark Air Base.

100 Tikis Souvenir.

O upu ua lele
i le matagi e

Dan Taulapapa McMullin

I'm standing among the old-fashioned vitrine displays in the Oceania room of the American Museum of Natural History, which were designed by anthropologist Margaret Mead. Groups of children continually run by shouting "Dum-Dum! It's Dum-Dum!" Curious, I turn the corner and they're gathering around what looks like an incomplete or fake Moai, an ancestor statue from Rapanui or Easter Island.

I'm editing *100 Tikis*, my video appropriation work that comments on the appropriation of Pacific Islander cultures by Tiki Kitsch, and does so by appropriating Tiki Kitsch images. I find a clip of the Hollywood film *Night in the Museum*, in which the security guard played by actor Ben Stiller is verbally accosted by a giant talking Moai who calls the security guard "Dum-Dum." I reflect on the English word "dumb" to be mute, silent, unable to speak, without language, and the other meaning of "dumb" to be stupid, an idiot, daft, unintelligent. And I reflect on the blackness of the Moai, its silence, and the possible fakery of the example in the American Museum of Natural History in New York City, upon which the Hollywood movie bases its depiction.

"Tiki" is a word I avoided much of my life, but to avoid Tiki Kitsch, that manufactured parody of our deity Tiki, may be to avoid the history of Tiki himself, the original ancestor. How can I say that Tiki Kitsch is not part of who I am, and indicative of something powerful in my life, that is, my political resistance and my creative process? If I look for authenticity, I might find that such a thing doesn't exist. From a certain type of village people painting with cubist elements that tourists collect the world over, to conceptual art pieces in international biennials that represent identity based on the visual moment of our colonization, to popular forms of Pacific art whose standards are set in the media, the world of Pacific art today is hybrid and complicated. Finding authenticity is not only about the objects of art, or "nostalgia for a lost economy" as American artist Mike Kelley expressed it, it can be about a way of living, almost religious in its overtones. Meanwhile most museum collections of Pacific art are rife with fakes; Tiki Kitsch began in the Western tradition of manufacturing fake Pacific art. If Western contact had happened a hundred years later than it actually did, I think our basic cultures today would each be different,

All the images in this contribution are stills from the film *100 Tikis: An Appropriation Video*, 2016.

because our ancestors were changing all the time. My life is Tiki Kitsch. And my life is Tiki.

My body of work on, or artistic research into, the history of Tiki Kitsch began with the poem "Tiki Manifesto" and ended with the film *100 Tikis*, but through this work my addiction to the archive increased—and it *is* a kind of addiction. After all, why not just write and make art with no research, as life happens wherever I am while I am living. Perhaps because the archive was always with us, it's in how we see things. I remember I was showing *100 Tikis* in Rochefort, France, and was on a panel with European filmmakers who made films about the Pacific Islands. One European filmmaker seemed to feel competitive towards my practice in terms of how Pacific Islander identity is portrayed in films. I said, I'm not really interested in how the world sees Pacific Islanders, I'm interested in how Pacific Islanders see the world. Really, how I see the world! Part of that is diving into blind spots in nature, among people's voices, and in the voices of the archive, as broken as they are.

I'm currently diving into the archives of three new(ish) themes or bodies of work: queer histories of Polynesia, flowers, and mushroom clouds.

Included in this memory, are four interconnected works: "Tiki Manifesto" (2011), a poem on Tiki Kitsch and Indigenous sovereignty;[1] "100 Tiki Notes" (2014), a text that began as an art gallery installation;[2] the "100 Tikis Script" (2016–17) for a forty-three-minute art film of appropriation art and Indigenous critique; and "Iki" (2021), an appropriation poem.[3]

1 "Tiki Manifesto" was first published in 2013 in my book of poems *Coconut Milk*, published as part of the University of Arizona Press's Native Sun Track Series. Dan Taulapapa McMullin, "Tiki Manifesto," in *Coconut Milk*, Dan Taulapapa McMullin (Tucson, AZ: University of Arizona Press, 2013), 11–12.
2 "100 Tiki Notes" was originally presented as a video text artwork in two exhibitions in 2014: "Biomythography," at Claremont Graduate University Art Gallery, curated by Jessica Wimbley and Chris Christion; and "Artspeak," at Commons Gallery, University of Hawai'i, curated by Moana Nepia. Dan Taulapapa McMullin, "100 Tikis Notes," *American Quartely* 67, no. 3 (2015): 585–94.
3 First created as a video art installation, *100 Tikis* screened at the Wairoa Māori Film Festival, and then on the opening night of Présence Autochtone in Montreal, Canada (both 2016).

Tiki Manifesto

Tiki mug, tiki mug
My face, my mother's face, my father's face, my sister's face
Tiki mug, tiki mug

White beachcombers in tiki bars drinking zombie cocktails from tiki mugs
The undead, the Tiki people, my mother's face, my father's face
The black brown and ugly that make customers feel white and beautiful

Tiki mugs, tiki ashtrays, tiki trash cans, tiki kitsch cultures
Tiki bars in Los Angeles, a tiki porn theatre, tiki stores
Tiki conventions, a white guy named Pupulele singing in oogabooga fake Hawaiian
 makes me yearn to hear a true Kanaka Maoli like Kaumakaiwa Kanaka'ole
 sing chant move her hands the antidote to tiki bar people
 who don't listen because tiki don't speak any language
 do they

Tiki bars in L.A., in Tokyo, in the lands of Tiki, Honolulu, Pape'ete
Wherever tourists need a background of black skin brown skin ugly faces
 to feel land of the free expensive rich on vacation hard working
 with a background of wallpaper tiki lazy people wallpaper
 made from our skins our faces our ancestors our blood

Yes it's all wrong but looks like my great grandmother's fale sort of
 except she isn't here and it doesn't really, her fale
 didn't have a neon sign blinking for one thing

And yes it looks like Polynesian sculpture sort of not really but what
 is the difference, the difference is this, we didn't make it
 or if we did it was someone desperate but probably not any of us
 just someone making a buck carving shit for drunks

The difference is this, our sculpture is beautiful, tiki kitsch sculpture is ugly
 not because they look so very different but because their shit
 is supposed to be ugly
 because we are supposed to be ugly
 and if we are ugly then they are beautiful
 American or European or Australian or Asian or
 a lot of us too and anyone can be beautiful and expensive
 as long as tiki kitsch is on the walls looking ugly and cheap

I like going to tiki bars sometimes and hearing island music or
 doing island karaoke and there are tiki bars in the islands sort of but
 there they're just bars and I'm here in Los Angeles or anywhere here
 in the so-called West which is everywhere
 and here, we are tiki mug people, my mother's face, my father's face
 my face, my sister's face

Our tiki sculptures are based on our classic carvings, which are abstractions,
 idealizations of beauty, our beauty, though in these bars they are …
Well, you get it

Can I remind us that Tiki
Whom we call Ti'eti'e and Ti'iti'i
Some call Ki'i, some call Ti'i

That Tiki was beautiful, jutting eyebrow, thick lips, wide nose
 brown skin in some islands
 black skin in some islands
 brown black deep, thick thighs
 jutting eyebrow, thick lips, wide nostrils, breathing

Lifting the sky over Samoa, lifting the sky over Tonga
 lifting the sky over Viti, lifting the sky over Rapanui
 lifting the sky over Tahiti, lifting the sky over Hawai'i
 lifting the sky over Aotearoa, and looking to, paying respects
 to Papua, to the Chamorro, to Vanuatu, to Kiribati
 lifting the ten heavens above Moana, not your Pacific, but
 our Moana

And now in tiki bars Chilean soldiers have drinks from tiki mugs after shooting
 down Rapanui protestors in Rapanui, not Easter Island, not Isla de Pascua
 but Rapanui, whose entire population was kidnapped and sold in slavery
 to Chilean mines in the 19th century, and whose survivors are shot
 on the streets of their lands still just a few days ago in 2011 in Rapanui

And American police drink mai tais in Honolulu bars from tiki mugs while
 native Hawaiian people live homeless on the beaches

And Indonesian settlers drink from tiki mugs in West Papua where 100,000
 Papuans have been killed seeking freedom after being sold down the river by
 President Kennedy so he could build some mines for his rich cultivated
 humanitarian friends

And French tourists drink from tiki mugs
 in Nouvelle-Calédonie and Polynésie française
 while native people are …

Where? Where are we?
In the wallpaper, on the mugs?

100 Tiki Notes

1. Tiki walked into a bar ...

2. The American bartender said, "Move over, Tiki, you are a Pacific Islander god/dess, you do not exist ...

3. "Your islands belong to us long time, since the first missionaries on gunboats squirted their diseased spirit over your fragrant seas ...

4. "Make way for tiki kitsch, and all kinds of cheap simulacra ...

5. "Accept your welfare check and stand down, we don't serve you anymore ...

6. "We serve up your image."

7. There's an avant-garde American artist in Los Angeles who makes a speciality of tiki kitsch assemblages ...

8. His tiki kitsch is in all the museums in LA—at museums where no contemporary Pacific Islander American art is ...

9. He grew up in a LA household with tiki kitsch, that's how he feels he loves it ...

10. A lot of connected artists in LA were saying, Dan, you should get to know him, you both deal with the same subject ...

11. He saw my work in my studio where I collaged a photo of a Polynesian wooden dildo that he fabricated in a homoerotic collage I made of *Hawaii Five-O* actors ...

12. I sent him Facebook friend requests, I think he reported me to Facebook, they shut down my account for a day.

13. There's a tiki kitsch artist in Orange County, California, who makes sixties' cartoons like paintings of Americans going wild with tiki kitsch abandon ...

14. At his show in the Orange County, California, art district, American patrons were saying to each other, "Let's go, there's all these brown people here now ..."

15. Meaning the Mexican Americans who had taken over opening nights in the art district ...

16. The American tiki kitsch artist and invited American patrons left after their own private preview at the gallery, before the zombies like me showed up for the public opening ...

17. I asked the university art students who were security, "Wouldn't you be insulted if this was a kitsch representation of your culture?" They looked puzzled.

18. I found a hot website of endless photographs of American women intoxicated worshipping giant Tikis ... tiki kitsch originated in pornography and alcohol ...

19. I was in a museum in Palm Springs and noticed a tiki kitsch photograph of American women in white bikinis on a volcano by a famous American conceptual artist …

20. What is location but concept? What is history but possession?

21. American soldiers back from World War II brought memories of the South Pacific, which to them represented women's breasts and getting drunk …

22. American Samoa women, because of the tropical heat, walked bare breasted in the 1940s, but American military saw this as a sexual invitation, leading to a first law against bare breasts …

23. Tiki kitsch begins with notions of paradise and ends with pornography, porn is about covering up the body.

24. Tiki porn begins with the Western patriarchal notion that females are savages and ruin paradise …

25. Tiki kitsch is religious kitsch in a bar, the great god Tiki is dead, drink …

26. After World War II, the first tiki kitsch bars opened in LA, and mass production porn industries began in LA …

27. Tiki porn and antiblackness, the notion that the devil is black images, and my ancestor Tiki is a devil …

28. Tiki porn is the notion that native people are sick and must be cured but cannot be cured …

29. Tiki kitsch is doubting that Pacific Islanders existed before tiki kitsch.

30. Tiki porn is the notion that the devil is everywhere, especially in black holes, the devil is a naughty Polynesian woman, and I am.

31. Tiki porn is Adam and Eve in Paradise for two weeks.

32. Tiki porn is any romanticized story of the kidnapping of native girls by explorers and soldiers and missionaries, silhouettes at sunset, private Hollywood.

33. Tiki is this list in search of this poem.

34. David Zwirner said of Jeff Koons, "He says if you're critical, you're already out of the game." If you have a reason to be critical, you're out of the game …

35. The question might well be, is my criticism of colonialism and appropriation part of my colonization? Well, of course!

36. This is an art work, a Tiki.

37. Tiki kitsch is when language becomes kitsch.

38. Tiki kitsch is the death of me. Tiki and I died in 1769.

39. Tiki is a girl named Sina falling in love with a strange white sea bird in an old story, Sina was her drag name.

40. Tiki is her brothers and the sea: Tiki lifting the sky.

41. Tiki porn in Shakespeare is the character of the savage in *The Tempest*,
 Caliban, child of an evil witch, voyeur naked to his own flood of perception.

42. Tiki porn was an American woman writhing in ecstasy before a wooden tiki:
 St. Teresa by a swimming pool.

43. Tiki kitsch is missionaries burning wooden gods and saving some for sale,
 commodities are not sacred …

44. Tiki porn was missionaries in Aotearoa–New Zealand cutting off the wooden
 penises of the gods …

45. Tiki porn is an archived box of these penises in a museum in Aotearoa.
 Tiki with cone around neck.

46. Tiki kitsch is when Polynesian music became lame and sweet after 1769,
 in mono.

47. Tiki kitsch is part of this work, tiki porn in searching for Tiki.

48. Tiki porn was the old missionary law that short-haired pagan Polynesian
 women grow long Christian hair …

49. Tiki porn was the old missionary law that long-haired pagan Polynesian men
 get short Christian haircuts …

50. Tiki kitsch is a race where a short-haired man chases a long-haired woman,
 history by the Department of the Interior.

51. Tiki is Herman Melville sleeping with black Polynesian men, Moby Dick and
 a black coffin, and the black and white sea for pages and pages.

52. Tiki is Paul Gauguin sleeping with Polynesian youth and turning into the red
 stray village dog.

53. Tiki is Gauguin running a fishing line from his second-floor studio into a well
 in his garden, where he kept his bottles of absinthe cool.

54. Tiki porn is fucking the missionary in the missionary position.

55. Tiki kitsch is the child of the missionary.

56. Tiki porn is for Adam and Eve.

57. Tiki porn is when my body. Disappears.

58. Tiki kitsch is when a native person represents a native person to a native
 person for the Department of the Interior.

59. Tiki kitsch is the notion that history is the same anywhere. That 1769 is the
 same anywhere.

60. Tiki kitsch came from Picasso's first cubist painting, *Les Demoiselles d'Avignon*.
 It's resemblance to any plastic tiki beer mug sold online is.

61. Picasso said Africa, Oceania, Native America did not influence his art. He slept around but on the down low.

62. Tiki is extremely difficult and lost in translation.

63. Tiki porn is a kind of genealogy, not mine, mind you.

64. Tiki is me, sometimes.

65. Tiki kitsch is a billionaire environmentalist burning down the fishing huts of local fishermen on his private island where they fished for ten thousand years.

66. Tiki porn is sometimes all that is left of history, but not according to Tiki …

67. Tiki porn is Margaret Mead writing about adolescent sex in *Coming of Age in Samoa* as a representative of the Department of the Interior and Hollywood.

68. Tiki kitsch is having a pixelated view of one's own life from the point of view of Hollywood and the Department of the Interior.

69. Tiki porn is watching Hollywood actors taking over Indigenous issues to promote Hollywood movies about Indigenous issues.

70. Tiki is sleeping with them.

71. Tiki porn is not sleeping with them. Hollywood is the notion that the audience is a big dead zombie, which it is.

72. Tiki kitsch is the notion that I am dead therefore I am.

73. Tiki kitsch is an international performance artist dressed as Papuan in mud with an artist statement that makes no mention of Papua, no history.

74. Tiki kitsch is the way history is erased by Hollywood and art because appropriation is sweet and pink and filled with stars.

75. Tiki kitsch is the way we search for meaning in 1769.

76. Tiki kitsch is the way art school can teach you about art school, and art about art.

77. Tiki porn is fine, it's just interesting, that's all.

78. Tiki porn is important tourists carried shoulder high and looking down between their legs on a sea of smiles and there's a jet waiting.

79. Tiki porn is Adam and Eve, and Hollywood, and Adam and Eve, and Hollywood, and Adam and Eve, and Hollywood, and Adam and Eve and Hollywood.

80. Tiki kitsch is the notion that the world can be saved by Hollywood. But for whom?

81. Tiki is not born yet.

82. Tiki is the summer I shall not see.

83. Tiki kitsch is the history of Easter Island by Jared Diamond and all American histories of Polynesia. Every kitsch drop of it, except the voice of Tiki.

84. Tiki kitsch is visible and invisible, Tiki is invisible and visible, the difference is inexplicable.

85. Tiki kitsch history was a post-WWII American porn photo-magazine that was called *Gaze*, really.

86. Tiki kitsch history was another post-WWII American porn photo-magazine that was called *Pagan*, which is kinda pagan.

87. Tiki porn is black & white photos of American women deliriously humping pagan idols, which is like burning wooden idols, which is kinda pagan.

88. Tiki kitsch porn is screaming Savage! to distract us from the privilege of screaming Savage!

89. Tiki porn kitsch is the notion that Daddy is black but baby is not, or how the body is appropriated as an object.

90. Tiki kitsch is the eternal return of Marlon Brando (as Captain Cook).

91. Tiki kitsch is Maori Aotearoa–New Zealand as the location for *Lord of the Rings*.

92. Tiki kitsch is Indigenous New Zealand Polynesian Maori in orc makeup, zombies.

93. Tiki kitsch is Sauron played by a Polynesian, the king of zombies.

94. Tiki porn is *50 First Dates* with an American actor playing a Hawaiian guy with cataracts for eyes while the American hero watches the same skin flick again and again.

95. Tiki kitsch is being a kid again, being a clown again, being a savage again, again and again.

96. Tiki porn is doing it for the first time again and again. Tiki is meaning.

97. Tiki kitsch is zombies everywhere!

98. Tiki porn is sexy zombies everywhere!

99. Tiki is everywhere.

100. :)

100 Tikis Script
An Appropriation Video

Waterfall scene from Hollywood film *South Pacific* with American actress Juanita Hall as Bloody Mary:

> BLOODY MARY: "Come to me.
> Here am I, come to me.
> Once you try, you'll find me,
> Where the sky meets the sea.
> Here am I, your special island.
> Come to me. Come to me.
> Bali Hai. Bali Hai. Bali Hai…"

Pathé documentary film on American Samoa educational television:

> AMERICAN VOICE: "Through television the people
> of American Samoa are solving their educational
> problems."

Hollywood film animation *Betty Boop's Bamboo Isle*, soundtrack of Samoan song from The Royal Samoans band being sung in deep voices by old trees. Betty Boop a girl with Bimbo a boy, both in blackface:

> TREES: "Samoa e. Samoa e.
> Ala mai. Ala mai."
> [Samoa dear Samoa!
> Arise, awake!]
>
> BETTY: "Don't be scared, Bimbo!"
>
> TREES: "Faia nei.
> Faia nei le faafetai.
> Le faafetai."
> [Say here, give now our
> thanks, the thanks.]

Montage of engravings and paintings of Tahitian traveler Omai, a Polynesian who discovered Europe.

Picture-in-picture: Hollywood film animation *Popeye's Pappy*. Popeye searches the sea to find his Pappy has become the king of a Cannibal island. To lure his father away to his ship, Popeye dances dressed as an island maiden. The Cannibals throw Popeye into a big black cooking pot. Popeye's Pappy eats a can of American spinach to defeat the Cannibals:

> PAPPY: "You land lubbers! Release my baby!"

Popeye and his Pappy punch big muscular black Cannibals until the Cannibals are all piled on each other against a fence

their arms outstretched like a cross. Pappy puts a sign on
them:

 TEXT: "CHEAPER BY THE DOZEN"

 PAPPY: "I'll show those savage kids who's king
 around here!"

Pathé documentary film on Samoa *tufuga fale*, with superimposed
images of Papua and Rapanui artworks:

 BRITISH REPORTER: "Men of the ancient builders
 guilds put the utmost of craftsmanship into the
 intricacies of roof structure.
 For the roof in Samoa is the house in this
 gentle climate where no walls are needed but a
 palm leaf curtain."

Documentary film of Hawaiian builders constructing a modern
aluminum dome similar in shape to the Samoan fale.

Montage of tiki kitsch in Hawaii, the US and elsewhere.

Song from German film *Die Blume von Hawaii* sung by German
actor Hans Fidesser playing the Hawaiian Prince Lilo-Taro in
brownface:

 PRINCE BROWNFACE: "Ein Paradies
 am Meeresstrand
 Das ist mein Heimatland
 Es duftend süß.
 Ein buntes Meer
 Von Blüten ringsumher
 Dort wo die schlanke Bäume rauscht
 Mein Herz dem Banjo lauscht.
 [A paradise on the sea beach
 This is my home country
 It's fragrant sweet
 A colorful sea
 From flowers all around
 Where the slender tree rustles
 My heart is listening to the banjo.]

Hollywood animation film *Toy Story*, Ken and Barbie scene.

Voiceovers from Hollywood film *Toy Story*, voiceover in Arabic:

 KEN: "Here's your bag, Barbie.
 You can put my luggage right here."

 BARBIE: "Oh, Ken, this is so exciting."

 KEN: "Picture! Say ice cream."

BARBIE: "Ice cream!"

KEN: "Perfect. Click, click!"

COWBOY VOICE: "Barbie? Ken!"

Self-advertisement of Australian Guru with golden muscular body sitting crosslegged on the grass in a garden in Hawaii:

AUSTRALIAN GURU: "Perhaps the most famous word
in the whole Hawaiian language, known all over
the world. It's the aloha-spirit. Alo-ha."

Advertisement for Disney resort in Hawaii, dancers in colored lights waving colorful flags:

DADDY: "What an amazing show. The whole
production, really."

MOMMY: "The songs were great. The dancing was great.
Really fun, and beautiful."

Self-advertisement for Australian guru in Hawaii:

AUSTRALIAN GURU: "So, who am I to define Aloha?
All I can do is, being a resident, on an off, in
the Hawaiian islands for almost twenty years,
all I can say is, the Aloha spirit is a spirit
of giving, of sharing."

Moai scene from Hollywood film *Night in the Museum* with Ben Stiller as Dum-Dum the Museum Guard. A giant Moai [deity statue] from Rapanui [Easter Island]:

MOAI: "Dum-Dum!"

DUM-DUM: "Yes?"

MOAI: "You give me gum-gum."

DUM-DUM: "I give you gum-gum?"

MOAI: "You new Dum-Dum, you give me gum-gum."

Self-advertisement for Australian Guru in Hawaii:

GURU: "We call these principles
the heart of Huna."

Hawaii news interview with haole tiki kitsch artist:

TIKI KITSCH ARTIST: "Actually,
a subcategory of that,
I'm actually Polynesian pop culture."

News interview with another tiki kitsch artist:

> ANOTHER TIKI KITSCH ARTIST: "All this detail
> disappears.
> So each mug, and it's usually me…"

Advertisement for Australian guru in Hawaii, he sits in silent meditation, then raises his head and blows a breath at the screen audience.

Picture-in-picture of entertainment news interview with haole actor Rob Schneider in brownface with fake cataract covered eye from Hollywood film *50 First Dates*, he uses character voice during actor interview:

> BROWNFACE MAN: "I'm going to be the hula in the
> movie. I'm going to be like best friend of Adam
> Sandler character Henry Roth. Now, Henry in
> Hawaiian is Hanalei, so sometime in da movie you
> gonna hear Hanalei not Henry. But you know, da
> kine, da Hawaiian."

Hollywood film *Mutiny on the Bounty* with Clark Gable: Two British explorers shirtless among a large party of Tahitians dancing.

US Naval film *Hello Hawaii*: A film made to introduce American sailors to Hawai'i and the Pacific Islands. It shows an American sailor in a hula skirt being bound and gagged by a group of American sailors, taken on a jeep and dumped in a field.

Montage of US Naval photographs of American men in hula skirts.

Lovely Hula Hands song sung by Hollywood haole actress Dorothy Lamour in brownface voiceover:

> DOROTHY LAMOUR: "Lovely hula hands,
> graceful as a bird in motion.
> Gliding like the gulls o'er the ocean,
> Lovely hula hands. Taulima nani e.
> Lovely hula hands,
> telling of the rain in the valley…"

Picture-in-picture from Hollywood animated cartoon *Popeye's Pappy* where Pappy is lounging on a throne while hula girls dance before the throne:

> PAPPY: "Oh, how I loves this life.
> Who needs a wife?
> Girlies by the score,
> who could ask for more?

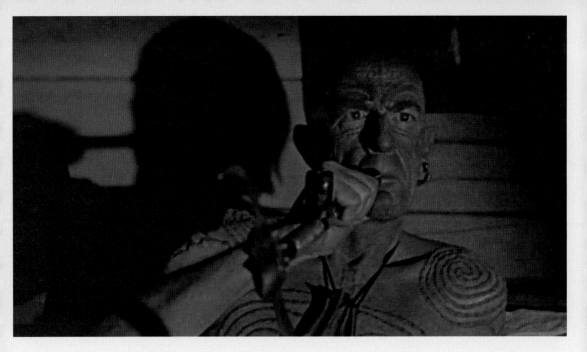

Popeye dressed as a hula girl attracts Pappy's attention:

 PAPPY: Say boy, you're new around here!"

US Naval film *Hello Hawaii* where the sailor dressed as a hula girl goes back to his ship but is insulted by the other sailors and jumps overboard.

Montage of fa'afafine of Samoa and American gay tourists in Hawai'i.

Montage of fa'afafine in Aotearoa voguing:

 FAAFAFINE: "Wow! Go girl!"

Lovely Hula Hands song sung by Hollywood haole actress Dorothy Lamour in brownface voiceover:

 DOROTHY LAMOUR: "…meaning of your hula hands,
 Fingertips that say Aloha.
 Say to me again, I love you.
 Lovely hula hands, taulima nani e."

Hollywood film *Moby Dick*: ominous music and thunder, Richard Basehart playing Melville character in bed in an inn room. Enter: <u>German actor Friedrich von Ledebur in brownface as Queequeg a Pacific Islander</u>, who puts a shrunken head on the fireplace mantel, lights a pipe, and gets in bed to sleep but finds Melville in bed with him:

 MELVILLE: "Oh no, wait, hold on!"

 QUEEQUEG: "Who the devil are you?

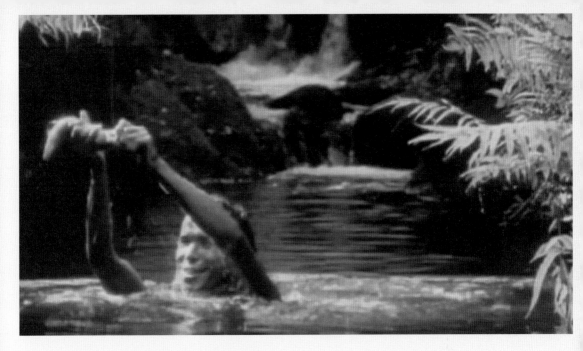

You never speak! I kill you!"

 MELVILLE: "Landlord! Peter Coffin!
 Coffin, save me!"

Innkeeper Coffin in nightgown Enters with candle:

 COFFIN: "Now, now, now, now.
 What is all this about?"

 MELVILLE: "Why didn't you tell me
 I was sleeping with a cannibal!"

 COFFIN: "I thought you knowed.
 Didn't I tell you he was around the town
 selling heads?"

 MELVILLE: "Landlord, tell him to stash
 that tomahawk there, that pipe or
 whatever you call it."

 COFFIN: "Well, pleasant dreams."

Aotearoa-New Zealand Pākehā film *Twilight of the Gods* with
Maori actor Greg Mayor and Pākehā actor Marton Csokas as the
Pākehā soldier who was left behind for dead after his battalion
destroyed the Maori village and killed everyone but one Maori
who was river fishing in the forest. The Maori man heals the
Pākehā man but despises him, and goes catching fish by hand.

Aotearoa-New Zealand-Hollywood film *Lord of the Rings* with Adam
Serkis as Gollum. Gollum in the secret forest grotto jumping
into water catching by hand.

Aotearoa-New Zealand Pākehā film *Twilight of the Gods*: the Maori catching fish by hand appears out of water.

Aotearoa-New Zealand-Hollywood film *Lord of the Rings*, Elijah Wood as Frodo calling to Gollum who is sitting on a rock in the water eating the hand caught fish:

FRODO: "Sméagol, Master is here.
Come Sméagol, trust Master. Come!"

GOLLUM: "We must go now?"

FRODO: "Sméagol, you must trust Master.
Follow me! Come on! Come.

 Come Sméagol, nice Sméagol.
 That's it, come on."

Aotearoa-New Zealand Pākehā film *Twilight of the Gods*—
Maori and Pākehā are now lovers and they kiss.

Fade to Black. Fade In:

Photograph of plastic tiki kitsch hula dancer.

Disney cartoon *Hawaiian Holiday* with Mickey and Minnie Mouse
doing the hula:

 MINNIE: "La, la, la, la, la, la, la, la…"

Social media post on how to do *Hawaiian Costume for Halloween*
with Hawaiian make-up techniques by Australian haole in
brownface.

 BROWNFACE GIRL: "Hey everyone, welcome back to
 my channel. So today's video is this Hawaiian
 costume, hair, and make-up that I thought would
 be really fun for Halloween. So I'm starting
 with my benefit for professional primer. Please
 excuse my crazy tan hands, I did tan for this
 costume, and I'm using my Bourjois healthy mix
 radiance reveal foundation."

Social media haole tourist bride doing a hula with Hawaiian
helpers to Music of Elvis singing "Hawaiian Wedding Song":

 ELVIS: "This is the moment."

CHORUS: "Eia au."

ELVIS: "I've waited for."

CHORUS: "Ke kali nei."

ELVIS: "I can hear my heart singing."

Montage of Hollywood photographs and artwork of Marilyn Monroe, Dorothy Lamour, and other American actresses in brownface.

Music from Hollywood film *Pagan Love Song* with non-verbal vocalizations.

Hollywood film *Dance, Girl, Dance!* Where American female dancers are auditioning to play hula girls on Broadway. Enter actress Lucille Ball taking off her fur coat to reveal that she's clothed in swimsuit and hula skirt:

LUCILLE: "The landlady told me the man was
having a hula audition.
So here I am."

MAN: "Can she really dance?"

LANDLADY: "She can, Mr. Katchourian."

Lucille Ball does a Broadway vaudeville version of hula kitsch.

Montage Hollywood photographs and artwork of starlets as hula kitsch dancers, followed by another Montage of naked American women dressed as hula girls worshipping Tikis, from American porn magazines.

TEXT: "Princess Luna loves the lushness of
her islands, the warm beaches and their lazy
contented way of life."

TEXT: "Poli is a perfect specimen of what
Polynesian beauties are pictured to be like, but
all too seldom are in real life."

Music from Hollywood film *Pagan Love Song* non-verbal
vocalizations.

Hollywood film *Hula* with actress Clara Bow performing hula
kitsch.

Montage of tiki kitsch magazines and <u>still from television
series *Nashville* of haole actresses doing hula kitsch with
watermelon bras</u>.

Hollywood film *Just Go With It* hula kitsch competition.

Picture-in-picture: montage of Pacific Islander women from
historical and contemporary photographs.

Hollywood television show *Entertainment Tonight* reporter
visiting set of *Just Go With It*. Actresses Nicole Kidman and
Jennifer Anniston doing hula kitsch.

BANDLEADER: "Let's go boys."

JENNIFER: "What? What's that?
Okay, a lot faster."

REPORTER: "The audience picks a winner!"

BANDLEADER: "You're in a side, somebody's
winning this."

JENNIFER: "We said last night, oh, this is
slightly, this…"

BANDLEADER: "I thought they were Hawaiian!"

REPORTER: "We're already a second day into
shooting the scene."

BANDLEADER: "How about this little girl right
here?
How about this little girl right here?
I don't know about you,
I got the best seat in the house."

REPORTER: "We'll see her next Valentine's Day."

Advertisement for tourist wedding in Tahiti, French couple on
beach being married, ceremony by Maohi priest and dancers,
flower petals falling around the couple to the music of Maohi
drums and singers.

Hollywood film *South Pacific* with actresses in Pacific Islander
brownface, African American actress Juanita Hall and Vietnamese
French actress France Nuyen singing to American actor John
Kerr, making hand movements to accompany the words of the song:

BLOODY MARY: "Talk about da boy,
sayin' to da girl,
Golly baby I'm a lucky cuss!
Talk about da girl, sayin' to da boy,
You and me is lucky to be us!
Happy talking, talking happy talk.
Talk about things you like to do.
You got to have a dream.
If you don't have a dream,
How you gonna have a dream come true?
If you don't talk happy, and you never have a dream,
Then you'll never have a dream come true."

UK Telegraph news video of Royal wedding couple Prince William
and bride Duchess of Cambridge on marriage tour in Tuvalu.
Royal newlyweds on thrones on a traditional Polynesian litter
being lifted on the shoulders of Tuvalu men.

TUVALU MEN: "Lua! Tolu! Ha!"
[Two! Three! Four!]

TUVALU WOMEN surrounding them singing *Tuvalu Pea
Uma*.
[Tuvalu Forever!]

Hollywood film *Tiara Tahiti* with actor James Mason; and actress
Rosenda Monteros in Pacific brownface as Tiara climbing a
coconut tree to get a coconut to make a cocktail for James
Mason.

 TIARA: "Thirsty?"

 JAMES: "Mm, yes!"

Picture-in-picture: Hollywood cartoon *Popeye's Pappy* where
Pappy is crowned king of the cannibal island, sitting on a
throne as a hula girl squirts seltzer water into his open
mouth.

Advertisement for wedding in Tahiti where blond bride lands by
boat onto a beach as Maohi drums play.

Cut to blond bride played by German actress Marta Eggerth as
fictional Hawaiian Princess Laya entering a savage pagan dance
to the sound of Native American drumming, in German film *Die
Blume von Hawaii*. She ascends a staircase as German actor Hans
Fidesser in brownface as fictional Hawaiian Prince Lilo-Taro
sings:

 PRINCE LILO-TARO: "Laya!"

 PRINCE LILO-TARO and PRINCESS LAYA:
 "Blume von Hawaii,
 ich liebe dich fürs Leben!
 Du schöne Blume von Hawaii,
 mein Herz gehört nur dir!"
 ["Flower of Hawaii,
 I love you for life!

You are beautiful, Flower of Hawaii,
my heart belongs only to you!"]

CROSS FADE TO:

Montage photographs of Pacific Islander women Indigenous
activists and images of Pacific Islands conflicts over the
centuries between European colonists and Indigenous Pacific
Islanders. Music of Tahitian Choir from Rapa Iti singing
"Himene Tatou":

CHOIR: "Himene tatou i te arofa o te ahu ma ia
tatou nei.
I te mana ha ma'ima'ili e rato e va i ma e mo.
E lele ahi to le o tahi i te fa'ana i te au nei.
E roro aho ia i me ora ia tatou ta na ma ta na i"
["Our hymn in the love at the altar all gather here.
In the holy spirit falling upon those there.
The fire that flies up quenches all our thirst.
The prayer given gives us life miraculous"]

FADE TO BLACK.

TEXT: "Part 2 or 2: Post-Post-Paradise or I was
in the Armed Slaveries"

Dance scene from Hollywood film *Mutiny on the Bounty* with Marlon
Brando and Tahitian actress Tarita Teriipaia flirting.

Picture-in-picture: montage of various Pacific Islander women
politicians and activists.

Montage of photographs of Gauguin paintings and subjects,
and of Picasso paintings and subjects, with a photograph of
a American Samoan woman soldier, and French Polynesian women
soldiers, and Hawaiian women prisoners.

Montage of American women in tiki kitsch, and US military
intelligence women in Hawaii.

Audio under montage of Gertrude Stein reciting her poem "If I
Told Him, A Completed Portrait of Picasso":

> GERTRUDE STEIN: "Would he like it if I told him,
> if I told him, if Napoleon.
> Would he like it if Napoleon, if Napoleon,
> if I told him. If I told him if Napoleon if
> Napoleon if I told him. If I told him would
> he like it, would he like it if I told him…
> One.
> I land.
> Two.
> I land.
> Three.
> The land.
> Three.
> The land.
> Two.
> I land.
> Two.
> I land.
> One.
> I land.
> Two.
> I land…
> Miracles play. Play fairly.
> Play fairly well.
> A well. As well. As or as presently.
> Let me recite what history teaches.
> History teaches."

Hollywood film *Aloha* (aka *Deep Tiki*) with haole actress Emma
Stone in brownface as a mixed-race Hawaiian resident:

> AIRMAN: "Morning Captain."

> CAPTAIN: "Morning Airman."

> AIRMAN: "Good to go."

Hawaiian men chanting and dancing for troops on American
military airfield as Emma Stone gives them slow clap.

Advertisement for US military tourists to Hawaii of military hotel resort:

> VOICEOVER: "Get ready for the vacation of a lifetime. Oahu Hawaii is home to the Hale Koa Military Resort. A seventy-two-acre tropical oasis completely dedicated to military members and their families."

Publicity photograph of *Dog the Bounty Hunter* in Hawaii reality show, which is about chasing down Hawaiian criminals.

Social media of Kanaka Maoli women activists in Hawai'i being arrested on Mauna Kea during a Kanaka Maoli protest. They are chanting "Kū Ha'aheo E Ku'u Hawai'i" (protest chant by Kumu Hinaleimoana Wong-Kalu):

> ACTIVISTS: "Kū ha'aheo!
> Kū ha'aheo!
> E ku'u Hawai'i. E ku'u Hawai'i.
> Mamaka kaua!
> Mamaka kaua!
> 'O ku'u 'āina…"
> [Stand tall!
> Stand tall!
> My Hawai'i.
> My Hawai'i.
> Band of warriors!
> Band of warriors!
> Of my land…]

Picture-in-picture: Disney TV show *High School Musical* with actor Lucas Grabeel and actress Ashley Tisdale in brownface as Hawaiian boy and girl singing:

> TIKI BOY: "A long time ago, in a land far away,
> Lived a pineapple princess Tiki.
> She was sweet as a peach,
> in a pineapple way,
> But she was so sad that she hardly speaky.
> Still, if you listen well, you'll hear her secret wish:"

> TIKI GIRL: "Aloha everybody, my name is Tiki!
> I long to free a truly remarkable fish:
> My sweet prince.
> Humuhumunukunukuapua'a
> Makihiki malahini-who,
> Humuhumunukunukuapua'a,
> Hawana waka waka waka niki pu pu pu!"
> [Humuhumunukunukuapua'a is a kind of Hawaiian fish, the rest is ooga booga.]

Hollywood film *From Here to Eternity* love scene with Burt
Lancaster and Deborah Kerr in bathing suits rolling in the
sand of a beach in Hawai'i, kissing as waves crash over their
bodies:

>WOMAN: "I never knew it could be like this.
>Nobody ever kissed me the way you do."

>MAN: "Nobody?"

>WOMAN: "No, nobody."

Silent Pathé film documentary of Bikini Island relocation for
nuclear testing by US military. First image a mysterious hand
appears around a corner and writes on the side of a ship:

>TEXT: "Kilroy was here"

Montage of images on Bikini Island just before the islanders
were relocated by the United States military. American soldiers
surround and cajole very young island girls. Bikini islanders
gather fish just before being forced onto barges with all their
possessions that they can carry.

United States military film of planes dropping atomic bomb on
Bikini Island. Sounds of planes and nuclear blast.

French singer Dalida singing "Itsy Bitsy Bikini" on French
television.

Cutaways from documentary on the history of the Bikini bathing
suit.

>DALIDA: "Sur une plage,
>il y avait une belle fille
>Qui avait peur d'aller prendre son bain
>Elle craignait de quitter sa cabine
>Elle tremblait de montrer au voisin
>Un, deux, trois, elle tremblait de montrer quoi?
>Son petit itsi bitsi tini ouini,
>tout petit, petit bikini
>Qu'elle mettait pour la première fois
>Un itsi bitsi tini ouini, tout petit, petit bikini
>Un bikini rouge et jaune à p'tits pois
>Un, deux, trois, voilà ce qu'il arriva
>Elle ne songeait qu'à quitter sa cabine
>Elle s'enroula dans son peignoir de bain
>Car elle craignait de choquer ses voisines
>Et même aussi de gêner ses voisins
>Un, deux, trois, elle craignait de montrer quoi?
>Son petit itsi bitsi tini ouini, tout petit, petit bikini
>Qu'elle mettait pour la première fois
>Un itsi bitsi tini ouini, tout petit, petit bikini."
>[On a beach, there was a beautiful girl

Who was afraid to go for a bath
She was afraid to leave her cabin
She trembled to show the neighbor
One, two, three, she trembled to show what?
It's an itsy bitsy teenie weenie tiny polka dot bikini
That she wore for the first time today
An itsy bitsy teenie weenie little polka dot bikini
A red and yellow bikini with tiny dots
One, two, three, that's what happened
She only dreamed of leaving her cabin
She wrapped herself in her bathrobe
For she was afraid of shocking her neighbors
And even to bother the neighbors
One, two, three, she was afraid to show what?
It's an itsy bitsy teenie weenie tiny polka dot bikini…]

Hollywood film *How to Stuff a Wild Bikini*, with theme song sung by beach boys to various beach girls:

BOYS: "In a thirty-six, twenty-two, thirty-six,
that's how you stuff a wild bi-ki-ni!"

One of the beach girls, a redhead, explodes in a puff of smoke.

United States military documentary footage of islanders on Enewetok Atoll near Bikini Island following most recent atomic test, they are surrounded by smoke and covered in ash as they crawl out of holes in the ground.

Tahitian Choir of Rapaiti singing:

CHOIR: Oparo e Oparo e!
[In the days of old
There was a war on Oparo
Oparo dear Oparo
The children woke up with this war.]

Montage of colonial paintings of Polynesia showing various scenes of conflict.

Picture-in-picture of Hollywood film *Island of Lost Souls* with Charles Laughton as Dr. Moreau, and Kathleen Burke in brownface as Lota the Panther Woman:

DR. MOREAU: "You're convinced that this thing on
the table isn't human."

ASSISTANT: "Its cries are human."

DR. MOREAU: "You know what it was when I began
with it?
An animal!"

Cutaway to White Woman in bedroom who screams when black sub-
human zombie appears in her window.

Whipping and animal zombie screaming.

>DR. MOREAU: "I'm not beaten! Ha-haha-ha!
>Get everything ready!"
>
>ASSISTANT: "For what?"
>
>DR. MOREAU: "This time I'll burn out all the
>animal in her!"
>
>LOTA THE PANTHER WOMAN: "No!"
>
>TEXT: "Paramount dares to give you
>the strangest story ever written…
>Island of Lost Souls."
>
>DR. MOREAU: "I'll make her completely human."
>
>LOTA THE PANTHER WOMAN: "No. No, no-o-o-o!"

Engravings of La Perouse battle in Samoa.

Picture-in-picture: montage of various Pacific Islander male
artists, politicians, activists, writers.

Picture-in-picture: montage of paintings and engravings
of the massacre of Captain Cook in Hawaii, followed by
scenes throughout the Pacific Islands from colonial history
of Indigenous and settler conflict, followed by images of
Indigenous renaissance in arts and navigation.

Picture-in-picture: montage of images of post-colonial Islander
men as cannibals, monsters, zombies, and Orcs played by
Polynesian actors.

>AUDIO: Tahitian Choir of Rapaiti singing "Oparo
>e Oparo e."
>[The children woke up from this war
>They became the warriors of Oparo
>Together they had one message
>Oparo dear Oparo
>With lamentations to live on our land
>Centuries after centuries
>Time after time]

New Zealand Hollywood film *Lord of the Rings* scene where Aragorn
encounters Orcs, many played by Polynesians in Orc makeup.
Noises of inhuman Orcs and battle sounds.

French military film of martial parade in Paris with soldiers from all over the Francophone world including Polynésie française.

<u>Tahitian soldiers in French military performing a Tahitian haka in a public gathering in Paris</u>.

Samoan soldiers in American military marching in training camp.

Samoans serving in Iraq and Afghanistan.

Samoan military parents receiving American flag signaling loss of a child that served in war

Samoan military marching in a field singing marching songs in Samoan and English.

 SAMOAN DRILL LEADER: "Left, left, left, right!"

Social media of American punk band The Angry Samoans in concert being introduced:

 CONCERT PROMOTER: "The Angry Samoans are great. Let's hear it for the Angry Samoans!"

 CROWD CHEERS.

Social media of Samoans in US military singing a Samoan hymn:

 SAMOAN SOLDIERS: "…ua ia faaola ia te aʻu
O laʻu lea pese fou
Pese! Pese pese
Aleluia! Aleluia…"

[…this gave life to me
This is my new song
I Sing! And praise!
Hallelujah! Hallelujah!]

Cutaway: Photograph of Samoan men and women warriors in 19th century.

Social media of Māori protest in the streets of Māori protest chant Aotearoa-New Zealand.

Advertisement documentary of the making of Aotearoa-New Zealand-Hollywood film *The Hobbit* with Maori actor Manu Bennett playing lead Orc monster:

> FILM ANIMATOR: "Casting is key. And Manu Bennett's muscular build and the heavy weighted mace prop gave his captured motions a weight and a feel that seemed both powerful and believable. It also helped that Manu gave just the perfect performance that fit into the design of Azog, the way that Andy Serkis fits into Gollum. Using our muscle simulation system allows us to get the base motions onto the character very quickly and gave us time to really work on the finer details of his character."

New Zealand military propaganda film of Māori soldiers preparing for World War II:

> BRITISH REPORTER: "Now, the legend history of a proud and virile people comes to new life as the Maori marches once again to war. The Maori

is an expert in the use of leisure, but here he
has an urgent job training to fight a new sort of
war. And he does it with Maori enthusiasm. His
lecture room is a hut built with nikau palms.
Out of doors, the Maori renews his skill with
many weapons old and modern, his favorite the
bayonet. Its use comes handily to men of the
race that chipped its weapons from the flint hard
greenstone."

Photographs of Māori leaders with moko facial tattoos,
including contemporary leader Tame Iti.

Advertisement documentary from Hollywood-New Zealand film *Lord
of the Rings* behind the scenes:

PAKEHA REPORTER: "Played by an actor named
Lawrence Makoare, an imposing gentleman even
when he's not in his prosthetics."

Hollywood-New Zealand film *Lord of the Rings*: fight scene between
Maori actor Lawrence Makoare. Music swells as Orc makes bestial
growls while fighting to the death with Aragorn Orc, and Pākehā
actor Viggo Mortensen as Lord Aragorn who cuts off the arm and
then the head of the Orc played by Makoare.

Advertisement documentary from Hollywood-New Zealand film *Lord
of the Rings* behind the scenes as Makoare makes a vogue pose:

MAKOARE: "Strike a pose,
and let's get with it. Whoah."

Māori protestors performing haka in the streets in Aotearoa-New Zealand:

Cutaways: Social media photographs of New Zealand police and Māori protestors.

 MAORI PROTESTORS: "Whakaporo toa!
 Tānga te unga!
 Tānga te aro!"
 [Make an end of it, warriors!
 We who stand expel!
 We the first guard!]

Hollywood animation film *Betty Boop's Bamboo Isle*: drum scene.

Cutaways: 19th century photographs of life in American Samoa, and a Hollywood photograph of Dorothy Lamour in brownface with a chimpanzee.

Cutaway: Toy replicas of American Samoa Fitafita police soldiers with Palagi leader, and Samoan veteran's house painted like American flag in American Samoa.

Betty Boop's Bamboo Isle with sound from The Royal Samoans band performing the slap dance Fa'ataupati:

 BLACKFACE: "Abbadee abbaday.
 Muzick!"

 Sounds of slapping and grunting ending with: "Hey!"

CROSSFADE TO:

Photographs of West Papua people and landscapes.

Video of West Papua performers in Jakarta, Indonesia.

Audio of West Papua traditional freedom song:

> [West Papua
> One people
> One soul
> Free West Papua.]

Photograph West Papuan prisoners of Indonesia.

Advertisement from Indonesia of tourists in West Papua at beach resorts swimming, jet boating, diving, partying.

Picture-in-picture: West Papua Indigenous peoples protesting Indonesian occupation of West Papua with flags and stones while being arrested and attacked by Indonesian military police with guns and tanks.

Picture-in-picture: tropical bird of West Papua, Western tourists and Indonesians partying at a West Papua resort in tourist advertisement. Music of British band Morcheeba used in Indonesian tourism ad:

> MORCHEEBA: "I left my soul there
> Down by the sea
> I lost control there
> Living free …
> And I, living, by the sea …
> Looking to the sea
> Crowds of people wait for me
> Sea gulls scavenge
> Steal ice cream
> Worries vanish
> Within my dream
> I left my soul there,
> Down by the sea
> I lost control here
> Living free …"

West Papuan exiled freedom leader Benny Wenda confronts American mining company Rio Tinto executives about their support of genocide by Indonesia of West Papua people:

> BENNY WENDA: "Your company supporting Indonesia, killing my people. This is like a secret genocide."
>
> RIO TINTO EXECUTIVE: "I mean, I certainly respect that fact that Papua is a part of the country of Indonesia. So we are certainly an

important part of the economy of Papua, we
are an important taxpayer, and we are also an
important economic engine to the region."

Picture-in-picture: Indonesian police and military arresting
and committing violence on West Papua protestors.

Advertisement from Indonesia of exotic tropical sea life in
West Papua seas; and Western and Indonesian tourists and resort
owners boating and diving, with Indonesian and West Papua
guides. Music of British band Morcheeba used in Indonesian
tourism ad:

MORCHEEBA: "A cool breeze flows
But mind the wasp
Some get stung
It's worth the cost
I'd love to stay
The city calls me home
More hassles fuss and lies on the phone
Left my soul there,
Down by the sea
Lost control here
Living free
Left my soul there,
Down by the sea
Lost control here."

Picture-in-picture cutaways: advertisements from Indonesia of
West Papua cultural dances but all the dancers are Indonesians
dressed in blackface as West Papuans dancing in tiki kitsch
versions of Pacific Islander hulas.

Dan Taulapapa McMullin

Picture-in-picture: <u>news report from Australian television covering violence by Indonesia in West Papua</u>:

 REPORTER VOICEOVER: "The Indonesian government has worked hard to clean up the image of its military since the excesses of the war in East Timor but these images tell a different story. One soldier swears and calls the men they've rounded up, "Dogs," then accuses them of supporting the separatists. One Papuan nearest camera says, "That's not true." And he is kicked in the thigh. People say the whereabouts of these villagers is now unknown. Other footage though is far worse, showing this elder trussed and…. The separatist struggle by Papuans might feel an obscure conflict…. The old man replies, "I don't know, I'm just an ordinary civilian…!" Shows not just the old man's abuse, but that of a younger man…. He's interrogated…. A plastic bag over his head…."

CROSSFADE.

Advertisement from Chile of Isla de Pascua [Easter Island] / Rapa Nui tourism.

Picture-in-picture: Rapa Nui tourist and song.

Photographs of Indigenous Rapa Nui sovereignty men and women, young and elderly protestors covered in blood from police beatings. Protest sign:

TEXT: "Independencia Pueblo Rapanui—
Ka Hoki Ki To Korua Hare"
[Independence for the Rapanui People—
Return our Home to Us.]

CROSSFADE.

Hollywood film *Blue Hawaii* with Elvis Presley, wedding scene
in Honolulu with canoes and flowers everywhere on the Ala Wai
Canal, where Elvis Presley and his young female co-star meet
their wedding:

ELVIS: "Blue skies of Hawaii smile
On this our wedding day!
I do."

BRIDE: "I do."

ELVIS: "Love you."

BRIDE: "Love you."

ELVIS: "With all my heart."

Cutaway: Glowing nuclear blast on Bikini Island.

TEXT: "Aloha :)"

FADE TO BLACK.

Iki

kitschen, to smear
süßer Kitsch, the art of the picture postcard
kitschen, to pick up garbage
den Straßenschlamm zusammenscharren, to pick up garbage from the street
verkitschen, to make cheap

England kitsch, Oxford, to render worthless, he dad
or precious and sketch Jane Austen give her life
West Indies bound life he dead, Caliban, Queequeg, Iki, Lilo
we was a small child and we neva growed up

French kitsch, chic, the queen of kitsch light
les demoiselles de Rochefort, d'Avignon, Loti, sailors, coconut milk smear
the first drawings of our hair, a long building for making rope,
an oval library of tropical diseases, royalty ballads

American kitsch, the American kitschonary, the queen mother of kitsch
Mrs Rockefeller on her farm as she received him from her bed, he noticed a real
 Picasso painting used as her headboard with tiny notes pinned on
 along the lower part of the painting
easy to market and effortless to consume, Modern Art, urban renewal
 and farm to table

tiny tiki village, miniature nu'u, vitrine, there I am walking in miniature,
 doing village things
the great hand of Margaret Mead picking us up when we didn't fit anymore,
 calling us perverts, deviants, birthed flappers American nudes
 worshipping giant alien invaders
disgusting she said on the phone in a drunken slur

what is the reality that kitsch opposes, denies? mispronounces
appreciated in an ironic or knowing way, stylish and full of class!
someone's first drawings, someone's missed pronouncements

o' Tiki progenitor
of fish of birds of wanderers
of reflections of worms and humans and flying clouds
of purple roots, dark life, the moon buried
behind nets

In a pool of reflections, smear of coconut

iki grimace, big empty smile open to the back of the head, Hollywood death
above its sister restaurant, a tropical escape in Washington DC
online, con iki, iki fleshlight
iki boat ride, board game, pineapple and coconut flavors
your unique citrus mix, cat food hotel, twirl, midtown hideaway, three levels of ultimate fun
island inspired bites, a taste of the tropics

copy of a copy, pixelated, the screen
life's too short for a normal tour, perfect venue on the water
drink the lake water of life, stowaway in the fashion district
located in beautiful Pismo Beach, panoramic, fresh coastal cuisine
popular spot, this one here, Polynesian delicacies in Medford, Massachusetts
book a private charter, elegantly prepared
forbidden island lounge, high roller boutique, mermaid boat rental yacht charter
exhilarating punch of juicy vibes, guava, pineapple, and orange

ideally located at the end of the pier over the ocean underground
the first in Akron, Ohio, featuring delicious noise-canceling technology
welcome, outdoor torches, Home Depot,
or Buy Online Pick Up in Store today in the Outdoors Department
major food group we for the oh gee goddess

an award-winning series about a magical cocktail lounge
with a gorgeous view of the largest selection of name brand sunglasses in the state
neat stuff, in business since 1993, mask leggings, happy hours, transparent flowers

chaos, the past
the peace of the savior, booking is easy!
don't miss the boat, select below, royalty hymns, we followed this why
the hiss of the evangelist in Shriner's Auditorium,
her rhinestone organist in sync to her voice
actors showed up in hospital beds, healed running between the paper buckets
the land of a billion auditions at the gas station

our Sunset Avenue location, double maitai, fun twist
Joe Captain Morgan miniature heads two men in a bed, rainbow warriors
please verify with your server a longing for the time

experience the tropical bars of the Hudson Valley
valley girl is my nickname
iki is making a comeback, the once popular
does anyone really know? order a flaming head for decoration at your next party
the flickering light, this unique experience a natural star
who gave birth, when it opened in Hollywood
the train along the river, winter is coming
one death per episode, at least
iki under the bed licking her arms down to the bone

what is this great gap between us
this great gap between us
fa'a to cause, the cliff we anchor to
smear or cast off

Still, *100 Tikis: An Appropriation Video*, 2016, detail.
The script reads: "West Papua Indigenous peoples
protesting Indonesian occupation of West Papua with
flags and stones while being arrested and attacked by
Indonesian military police with guns and tanks"
(see "100 Tikis Script" on page 136).

100 Tikis Souvenir. *O upu ua lele i le matagi e*

Karrabing,
Filmmaking for
Making the Land
and Its People

Karrabing Film Collective

...and forced people to say,
this land is just for that people and...

White people introduced the idea and forced people to say, this land is just for that people and certain people. And you end up with traditional owners for that little area and traditional owners for all kind of areas. Everyone's a traditional owner of a little bit of land. Then we get into big arguments, spear fights, everyone killing each other.

— Rex Edmunds, *The Riot*, 2017

Karrabing Film Collective began in the late 2000s as a wave of violence washed across their small community of Belyuen located just across the Darwin harbor, Northern Territory, Australia. About fifty adults and children, who would become the core of Karrabing, found themselves suddenly homeless and living rough. The social upheaval was unleashed by a state form of Indigenous recognition based on conservative social anthropological imaginary which differentiated families on the basis of traditional and historical residents.

Hello, Territory Housing out here.

You want to get broken down and stuck there?

Stills, *When the Dogs Talked*, 2014

Karrabing's first film, *When the Dogs Talked* (2014), sought to show how, within the collision of settler late liberalism's governance of Indigenous difference and capital markets, neither the romance of a traditional world nor modernity accurately captured the struggle to persist.

Cecilia Lewis: Show to other people how we've been struggling through life. In the movie I am the mystery, we decided that I play that role. Because everything I have my family [in town] I have to put them up in my house. And it's overcrowded and it's too much for me. Sometimes I feel like just walking out, going somewhere. Because it's too much stress. It's too many people.

ABC Interviewer: So is this your own story, Cecilia?

CL: Part of it, yes. It's all of us.

— Cecilia Lewis, ABC Radio Darwin, 2016

No one interferes, no one cares.
There's someone making money here.

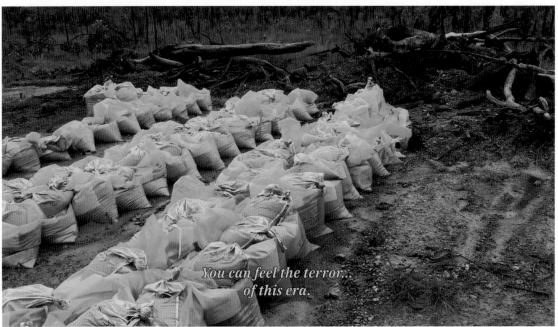

You can feel the terror...
of this era.

In *Day in the Life* (2020), Karrabing returned to these same romantic accounts of Indigenous futures. Set across five moments in a typical day at Belyuen, *Day in the Life* is punctuated with the song refrain, *Forward to the bush / But where's he going to go? / Back to the old lifestyle / The crush of lies / Leave them behind.* What seems at the beginning to be a manifesto for return, by the end is revealed to be a naïve settler sentiment. When the elder, Rex, brings his nephew out bush, they run into a lithium mine about which Rex rhymes, *How am I supposed to teach my kids / are digging on my lands?*

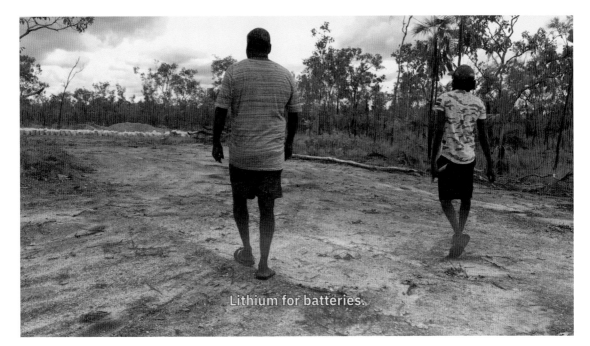

Lithium for batteries.

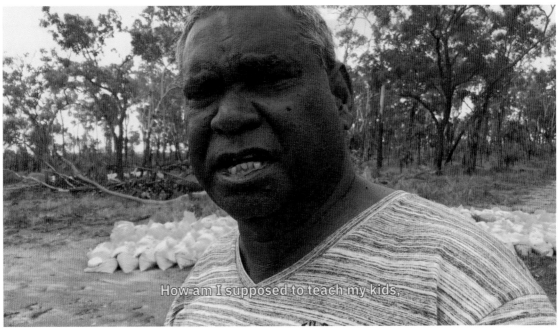

How am I supposed to teach my kids,

Stills, *Day in the Life*, 2020

Windjarrmeru (2015) focuses on the multiple intersecting economies of settler extractivism—mining, quality of life fines, epistemological dispos-session. Four young men find two of their relatives helping miners illegally blast near a sacred site in order to pay off fines before they are sent to jail.

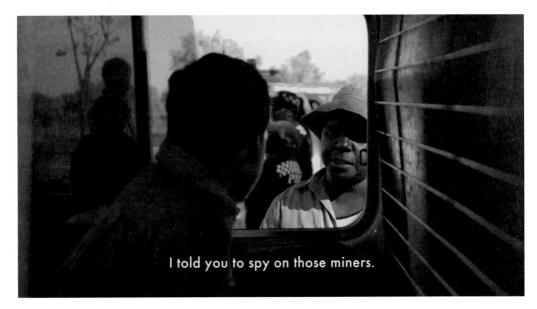

I told you to spy on those miners.

Trevor, how much in fines do you owe?

1300, and thirty two cents.

Stills,
ndjarrameru,
the Stealing
C*nt$, 2015

All place Indigenous people in a constant state of debt and liable to further state intervention and surveillance. *Wutharr, Saltwater Dreams* (2016) explores Karrabing persistence at the intersection of competing state, capitalist, and ancestral demands.

When I got on the plane to come here, I told the stewardess that the airline had put me next to my sister, and I cannot sit next to my sister from our law way, "Can I swap seats with my aunt so she can sit there and I can sit next to my cousin?" But the stewardess didn't understand why. "Yes, it's your sister so no problem." When I tried to explain she said, "I am sorry but there is no reason you cannot sit next to your sister. And besides airlines rules and regulations say you must sit where you are assigned." I want a world in which, when I move around, my law makes the rules of what goes next to what, why, and what for.

— Gavin Bianamu, Conversation among Karrabing Film Collective members, Gavin Bianamu, Rex Edmunds, and Elizabeth A. Povinelli, at Villa Empain, Fondation Boghossian, Brussels, 2017

...of paying off outstanding fines
with prison...

Otherwise you'll have to pay
the fine of $30,000.

We must have punished you...

Stills, *Wutharr,
Saltwater Dreams*,
2016

We're inside this radiation area.

Police won't come in here. We're safe.

Stills, *Windjarrameru,
the Stealing C*nt$*,
2015

Filmmaking and installation work allows Karrabing to share the ancestral present with each other in the lands and the actual networks of power that crisscross them.

When we started Karrabing the stories and knowledge was just one really thin thread.

Now it is a thick rope.

— Angelina Lewis, International Film Festival
Rotterdam, 2020

Remember when they were experimenting on you?

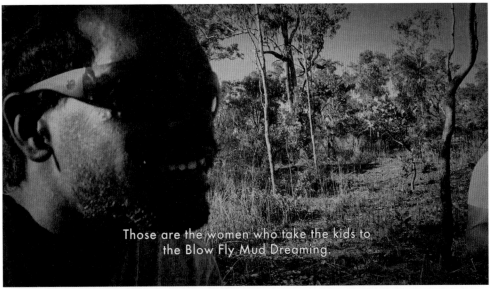

Those are the women who take the kids to the Blow Fly Mud Dreaming.

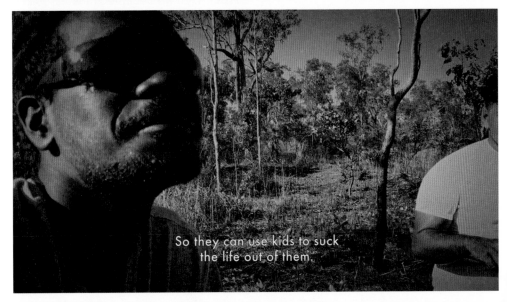

Stills, *The Mermaids, or Aiden in Wonderland,* 2019

So they can use kids to suck the life out of them.

Stills, *The Jealous One*, 2017

Elizabeth Povinelli: Youbela you were born at Belyuen and grown up Karrabing. Maybe we should begin by talking about what Karrabing means?

Natasha Bigfoot Lewis: The word means tide out—like low tide turning. But Karrabing is all the families around my grandmother side families and everyone married into it. We are all saltwater from the same coast—connected lands from the same coast.

EP: How did we start?

NBL: Well we became homeless in 2007 because of a really bad riot at Belyuen. We went south, along the coastline, to a place called Bulgul, and lived in tents there. Most of us in Karrabing were there. You were there too! And we lived there to about 2010 when my mum got a government house in Darwin. We started Karrabing before then—but we really started making the films after that really, around 2011.

EP: True.

Sheree Bianamu: And my dad always wanted to be a film star. His hero is Elvis Presley. True. But everyone said, we should just tell our own

Karrabing, Filmmaking for Making the Land and Its People

stories since government wasn't listening to the problems we were having.

EP: Ok, how old were all of you? I remember some of you were pretty little.

Ethan Jorrock: I was born in 2002, so I must have been five.

SB: I was nine.

NBL: I was fourteen.

Gavin Bianamu: So I must have been thirteen.

NBL: That's when Karrabing started.

EP: So, see youbela really grew up inside of Karrabing.

SB: Yes, as you can see from the first really first short film, *Karrabing, Low Tide Turning* to this film we making now, *Nighttimego (ngupelngamarrunu)*. From first, to second, to third, to fourth and now this new one, you can see us turning from kids to teenagers to adults, making movies.

— "Growing Up Karrabing" *unmagazine* 11.2 (2017)

Karrabing members in San Francisco. Bottom from left: Natasha Bigfoot Lewis, Angelina Lewis, Elizabeth A. Povinelli, Angelia Lewis, Rex Edmunds. Top from left: Shannon Sing, Kieran Sing, Gavin Bianamu, Aiden Sing.

We are getting stronger by living through our stories, and the stories we tell to our kids, and whose lands it is, and how we are connected to it.

We are acting in the realism of that story. But some thing we can add on.

— Angelina Lewis, Conversation among Karrabing Film Collective members, KADIST, San Francisco, 2019

Karrabing, Filmmaking for Making the Land and Its People

Stills, *Night Time Go*, 2017

We wanted to make films to be different to any other type of film you see in big cinemas.

— Rex Edmunds, Conversation among Karrabing Film Collective members, KADIST, San Francisco, 2019

Even though we have
different languages and land...

Karrabing seek to have their Autochthonous understandings of place deter-
mine their lives. They do not seek to be separate from each other, each
locked in their own little kingdom, but to be interrelated according to the
patterns laid down by their ancestral totems and relatives and sustained in
the matrix of micro- and macro-geological and -ecological conditions that
define their countries.

White people, or whoever, want to separate us
from each other. But we're still one. They can try
separate you, but you always have to remember
where you belong and where your country is.
That's what makes you strong.

— Cecilia Lewis, *How We Make Karrabing*, 2020

Karrabing, Filmmaking for Making the Land and Its People

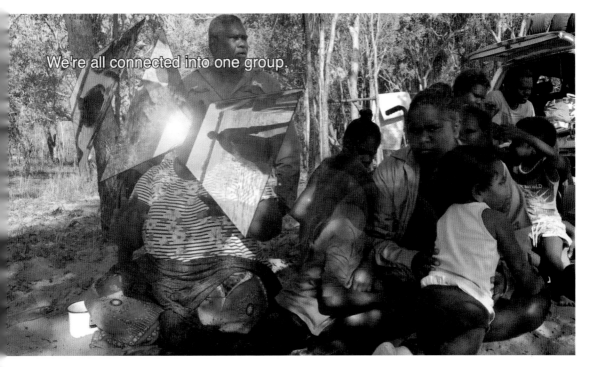

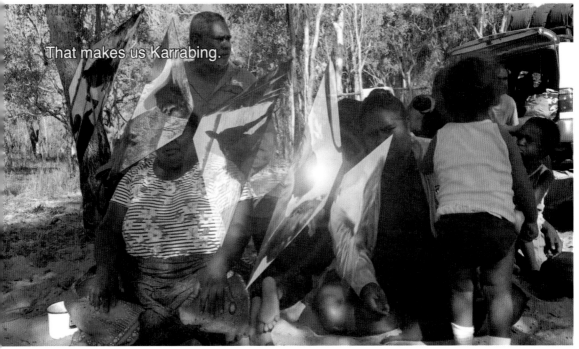

Stills, *How We Make Karrabing*,
2020. Presented during
"Medium Earth," Art Gallery
New South Wales.

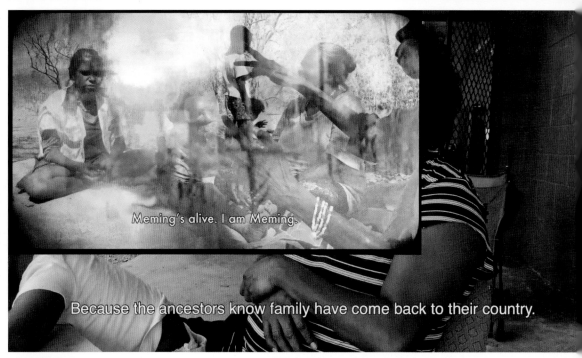

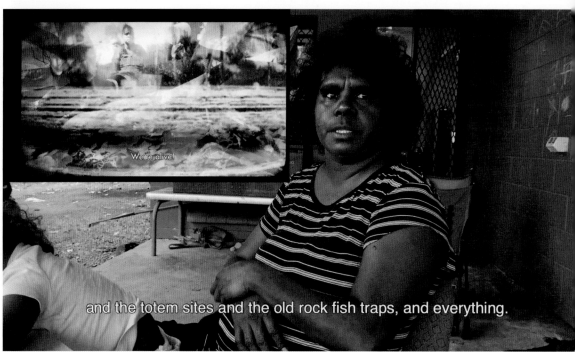

Thus, first and foremost, filmmaking and art is from and for the ancestral past, present, and future.

Linda Yarrowin. Stills, *Interview*, 2021. Presented during "The National 4," Carriageworks.

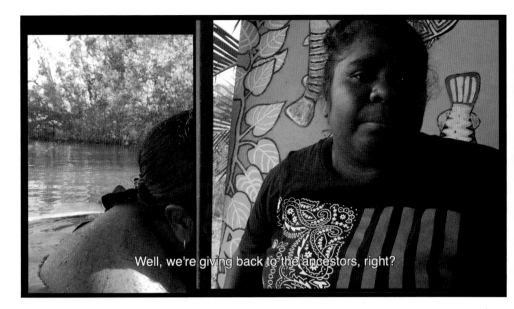
Well, we're giving back to the ancestors, right?

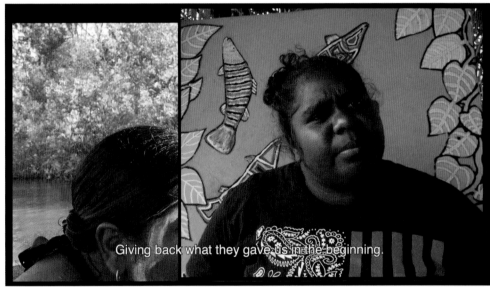
Giving back what they gave us in the beginning.

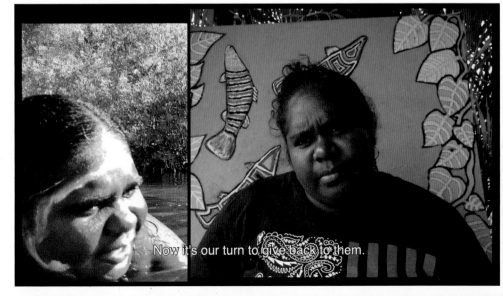
Natasha Bigfoot Lewis. Stills, *Interview*, 2021. Presented during "The National 4," Carriageworks.

Now it's our turn to give back to them.

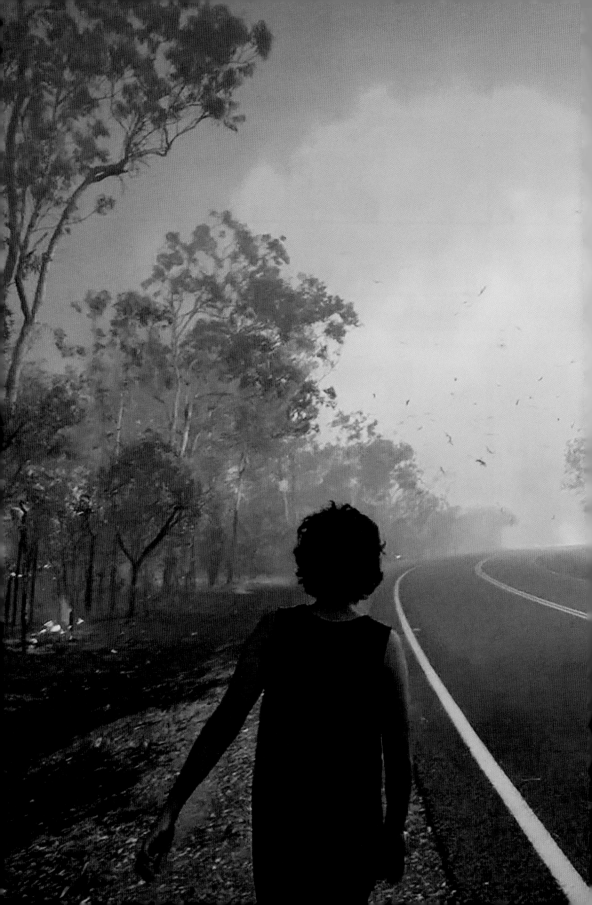

Karrabing Film Collective—Excerpts from Masterclass

Speakers: Elizabeth Povinelli, Aiden James Sing, Rex Sing, Linda Yarrowin

The following conversations took place in Paris, at La Fémis, on May 2, 2019, during a masterclass by Karrabing Film Collective. It was organized within the framework of the series of colloquia entitled "Filmic Forms and Practices of Autochthonous Struggles." The conversations have been edited for concision and clarity.

The beginning?

Linda Yarrowin: We decided that, we were just sitting around along the beach, when we've been homeless, sitting around and, "This is what we're going to try and do,"—and tried! We was talking to her [Elizabeth] that, "This is what we wanna do, we want to try make a little movie." Or make a film. Everybody all agree that we try to do something for ourselves, you know, and where're we at now, we *did*, we started up small but this is where we end up.

Elizabeth Povinelli: We watch a lot of television and movies, no doubt. But no, none of us knew how to make film. Everybody would say, like, we want to make real looking one, real, eh! And I said, "I don't know," I mean, "all I know is like …. Look, I could go get a camera and give it to everybody." And they're like, "No, we don't want that! We wanna look good!" [*laughter*] So, we've all learned together both why we don't want to do it one way, like with the production process, and how we want to do it together another way.

LY: We just wanted to do something for ourself because we was homeless. It's amazing what we have achieved now, for us. It's just more and more of that. We're not gonna stop. This is what we want to do. That we don't want a big film crew and all that. We just decided that we would do it our own way of making a movie with an iPhone.

EP: Usually, when perragut [white people] make a film, they say: "Okay, we're gonna make the film! When are we gonna make the film? We'll make it in May. Okay, we'll block off that six weeks." I don't know how it actually happens …, "Block off that two weeks for shooting. Okay?" Like that first time, savvy? That film cameraman's coming, "We got to do for one week that whole shooting," and then the shooting is done. Savvy? And way-way! And then they edit it. Do we do it like that?

Aiden James Sing: No!

EP: Where do we, when do we decide to shoot?

LY: Any time … any time, any place, anywhere!

Still, *The Mermaids, or Aiden in Wonderland*, 2018, detail

AJS: Aye, like she said, just, you can shoot anytime. [...] So, we, over time, for the last few films, we actually changed over to using just iPhones. So, reason why is because we think it's more, we say *easier*, or like something that was suited with us more. And because those [professional] cameramens—see, they're like more scheduled kinda, you know Our family, they're not really into those kinda schedules kind of thing, and like getting up early in the morning. And also, the fact that, we actually, doing repeated, you know, just repeating ourselves, doing the same part over and over again. Whereas with the camera, we do it ourselves. We actually go on our own time, so pretty much when we're available to go.

EP: Like when that, if that shot is there, we just have the cameras.

AJS: Yeah. And also, so with the iPhones, we actually can, we actually just capture the moment up like, just wherever, basically at any time. So, there's a ... I'll give you actually an example. My little brother is ... him, my little brother, and my nan, they were driving back and there was this massive fire going on. And so, they were just driving through it, and well, yeah, so my little brother was just like thinking, and then, I don't know what happened, he just like thought about it, he was like, he just thought about it for a second like, "Oh, wait! Nan! Fire!" And then, I mean, the nan reckons like, "Oh, yeah, it's a big fire, isn't it!" And then my nan goes like, "No, no! It's for the film, for the film!" So, it's like you just capture the moment right there, so that's something we can't really do with the [professional] cameramens, so you know, they're not always there and like with the iPhones it's really easier, so we can shoot it all the time.

LY: Yeah, it's just more easier, fast, getting up in the morning and we don't have to just put up with all them big cameras and people, you know them camera crew, they're telling you to get up and you have to be on time and we just didn't want to do that.

Rex Sing: Always wanna do it the way we wanna do it. Get up ready, and you know.

EP: We decided that the production process, if we're going to make Karrabing films, like films from the life that Karrabing were actually living, then why would we conform to a production process that came from outside with its own demands, its own forms and temporalities, its own logics of hierarchy. [...] Like Linda said, if we wanted to make films showing the life that they were living, then it couldn't just be one dimension of it. It couldn't just be: "Oh, we're homeless!" But also know about dreaming there, ancestors there, poison there, iPhones were there, technology's there. You know, the fences are there. It's all there! Right. It's all there. So, how do you manipulate the aesthetic surface of the film, the production time of film, post production time of film in order to make it conform to a world that it was never built for? Film was never built for *this* world. So, how can you deform the film so that it can better be formed through a different world? So, all that thickness absolutely is in there, it's all thought through. [*Turns to Linda*] Like the question of how do you make them ancestors, eyes everywhere. Like if you're in the bush …

LY: You see a blue light.

EP: Yeah, blue light. So, like how do we put blue light to, like, how do you signal that by using … because you can use film now to do that with special effects. So, everyone's like that, "We need special effect for this." Aiden, maybe you can just describe that scene where they jump into the waterhole and swim and how we put that, those images, why we put the images of the barramundi …

AJS: In *The Jealous One* there's one scene where my brothers, they jump in with my uncle. So, there's a, how they merge that image of that sea animal, the whale, and they put it like with the barramundis swimming with him, that represents their totem. There's my two brothers, or my brother is the muddy [mud crab] and that my other brother and his father is, that whale represents them so they're both sea animals.

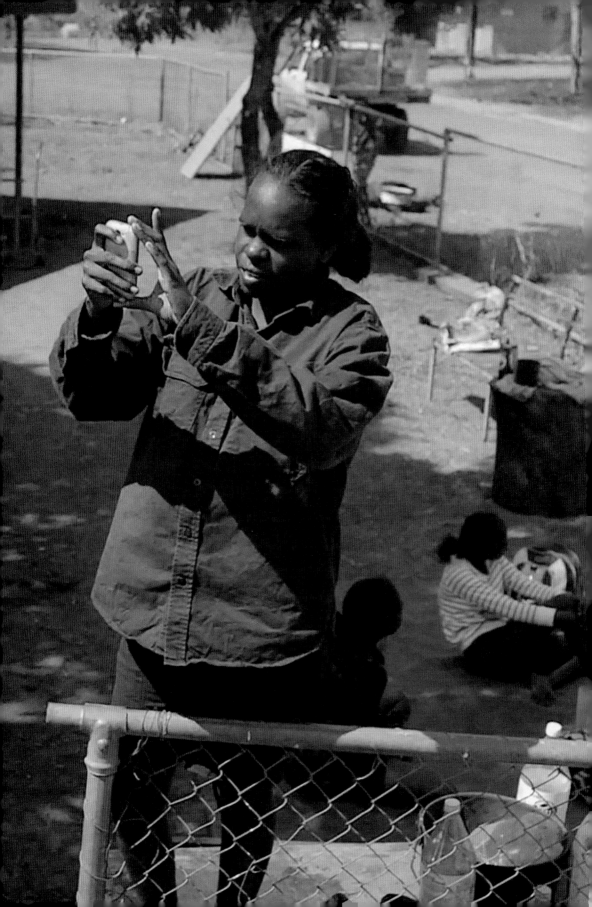

Where are the stories coming from?

Aiden James Sing: How we come up with movies or how we come up to make the films is us as individuals we come up with an idea and we share that idea with our family. And then maybe someone, like they come up with another idea and they share it with us and all those ideas we actually try combine them and actually use them in the story.

Linda Yarrowin: Well, there's no script to it, we just only act naturally.

Elizabeth Povinelli: So, we got the basic idea ...

LY: Yeah, just the basic idea and we, it's just we just put all together and just do it!

EP: Actually go.

LY: Yeah, it's just natural acting.

Still, *Windjarrameru,*
*the Stealing C*nt$,*
2015, detail

The composites?

Elizabeth Povinelli: And then for the images where there's those ... what do they say, overlays What do you guys call it in filmland? Composites? Yeah. So, we thought when we were going to show a clip [from *Night Time Go*] where you go back into Delissaville?

Linda Yarrowin: Back in time.

EP: Yeah, back in time. Like for perragut, there's like past, present, and future. But how are we working that image to argue how, where all that time is? Ancestors and dreaming and all that?

LY: It's just like our old people. They used to live back in those days. It's just how we go right back to our land, and knowing their dreaming of their sites, through coastal sites, as well. In the past, that's done and dusted, but then again, you gotta move forward.

EP: Like, when we go out, then the ancestors're there or dead?

LY: They're still there, they still remain.

EP: That's what we mean. Like when you go out hunting those ... like your mother and father, like we go along up to Fella Creek and your dad, what would he do?

LY: That spirit is still remain there ... show us sign and But you know that he's there, he's present there.

EP: So that images, all the images and sound, we've tried to figure out how to convey that to people that think time goes like that [*sweep of hand*]. So, like Daphne, Jojo's sister, was like, you know, white people don't get that dreaming is *there*. [...] All of this is in the sound and the image and the way it's constructed, trying to get an ambience, get a feeling without simply telling like an ethnographic explanation, because it's like settler colonialist explained it all to us but, how to, how to get it on the surface, what's true, without explaining it.

Still, *Night Time Go*, 2017, detail

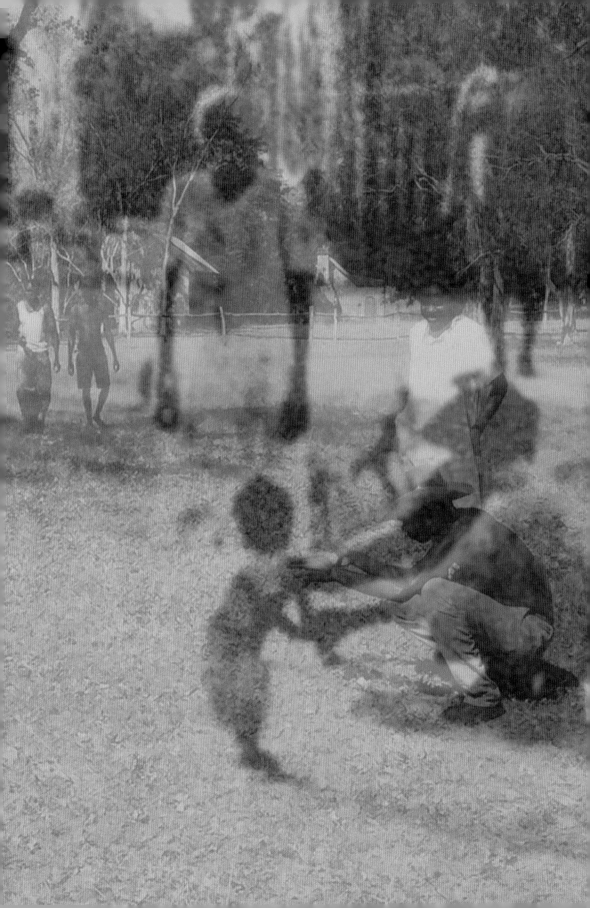

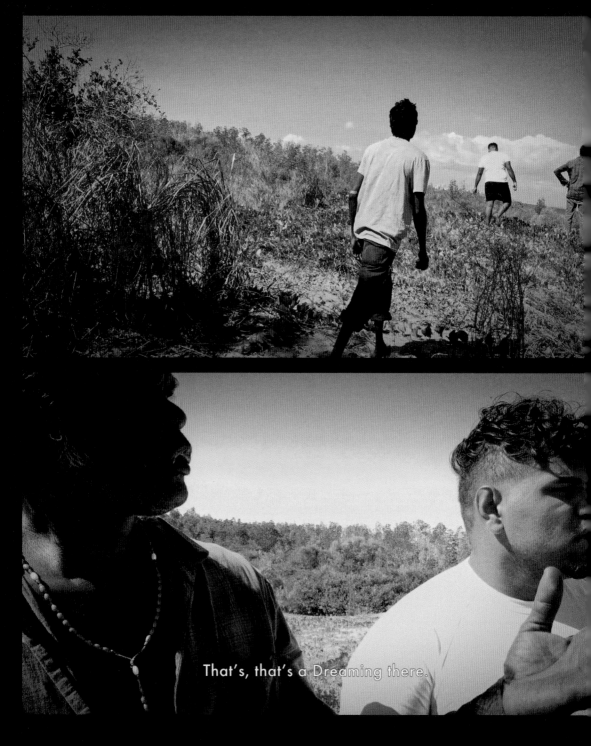

That's, that's a Dreaming there.

Stills, *The Mermaids, or
Aiden in Wonderland*,
2018

The sound?

Elizabeth Povinelli: To the sounds in the film, in the country, we know what all those sounds mean. Depending on who's seeing and hearing the films, you see and hear different ... you know different things, alright. So, like when we see, when you guys, when [in *The Mermaids, or Aiden in Wonderland*] you and the brother and that Gavin reached the beach, and you open your mouth to say [*mimics unutterable sound*], this sound comes out. *We* know what *that* means, eh? But I don't know if *you* guys [the audience] know what that means.

Audience [*collectively*]: No.

EP: No, you don't! And we don't bother telling you! *Voilà.* And it's a really thick soundscape trying to get like every character having that sound and then that overlay so that you hear that thick ... the actual thickness of meaning in the land that we listened to.

Linda Yarrowin: Like more in connection to the land and then more spiritual like our land is dying and animals and ... just dying from pollution. Yeah, so he [Aiden] knows all the animals and the land, even the land, the music, the sounds of it, it's just all dying. That's how we play their part of the music.

EP: Trying to get the thickness of that soundscape without So, it's not ethnographic, it's not like we're explaining everything, but we're *putting* everything.

Dreaming and ancestors?

Elizabeth Povinelli: One of the things your mom said when people would ask why we make the films and your mom said, Angelina Lewis said: before Karrabing that relationship between people in that country was getting thin, like the knowledge was getting thin, and abstract—perragut would say abstract—meaning like nobody ... they long way! The younger people never getting there and then him [Aiden] reckon that making these films has not only strengthened it but like spread it out into them young kids.

Aiden James Sing: So, you spreading, like teaching young kids about the stories or what's happened in the past. And so you're just keeping the culture strong. To teach our kids stories and stuff, you know.

Linda Yarrowin: It's just like our young ones when we take them out to country, they know that they got the feelings of the country, their ancestors they're there. So, when we go on a boat or go out taking our younger ones it's just they know that our people still remains.

EP: Like they, that dreaming and that ancestors see us there.

LY: It's just we know that we can feel it you know when we're on the land.

AJS: Dreaming's like, just, say, something that has happened back in the days, you'd say. There'd be stories of, you know, maybe the animal for or something like that and Those stories would, would actually connect to the land and connect to the coastals, to sea, and it connects back to us as well.

Still, *The Mermaids, or Aiden in Wonderland*, 2018, detail

Karrabing, Filmmaking for Making the Land and Its People

Of Megaphones, Cameras, and Songs.
The Films of Nadir Bouhmouch and the Moroccan Amazigh Movement on the Road '96

Nadir Bouhmouch
Omar Moujane
Marie Pierre-Bouthier

in conversation

edited by
Marie Pierre-Bouthier

Amussu (*Movement*) is a Moroccan-Qatari documentary which premiered in 2019 at the Toronto International Film Festival. Its author appears to be Nadir Bouhmouch, but a glance at the credits reveals that *Amussu* is also a collective production, a community film. It was indeed collectively produced by an Amazigh community, the villagers of Imider (South-Eastern Morocco, Tinghir province), calling themselves the "Movement on the Road '96 (Imider)." From 2011–19, this movement occupied a water pipeline on Mount Albban to prevent it from diverting their water towards a giant silver mine.

 The Imazighen are commonly known as "Berbers." They are the native people of Northern-Africa. They speak Berber languages (Tamazight), a branch of the Afroasiatic language family. Throughout history, these people have also been called Lybians, Mauri, Gaetuli, Numidians, etc., but they call themselves Imazighen (singular: Amazigh). More particularly, the villagers of Imider belong to the Ait Atta tribal confederation, who are renowned to this day for their fierce resistance against the French colonial armies: indeed, they were defeated in 1933 after the ferocious battle of Bougafer, in the Jbel Saghro mountains, a few kilometers from Imider. Ninety years ago, the free men and women were already struggling; they were already chanting their struggle.

The form and spelling of the name of the Movement on the Road '96 (Imider) has gone through variations over the years depending on the language and context in which it has been used: Amussu :Xf ubrid n 96 (Imider), Mouvement sur la voie '96 (Imider), ⵎⵓⵙⵙⵓ ⵅⴼ ⵓⴱⵔⵉⴷ I 96 (ⵉⵎⵉⴷⵔ), حركة على درب 96 إميضر, MSV96, and MOR96. In this publication, it is written as "Movement on the Road '96," unless originally written differently in quoted texts.

Opening titles of *Amussu:* "Imider Commune, Southeastern Morocco. Africa's most productive silver mine extracts 240 tons of purified silver per year using water taken from our villages' aquifers. When our farms began to dry as a result, we revolted."

The Movement on the Road '96 is like David against Goliath: a few shacks on a rugged craggy hill, resisting against the enormous outline of the mine not far away; a frail line of men, women, children, marching and singing, fighting against an army of helicopters, bulldozers, policemen, informers, and judges—and prison as a punishment, and diseases as a punishment, while mercury and cyanide infiltrate their land, their water, their skin.

Amussu's shooting was thus a clandestine, guerilla operation, from time to time compelling the Movement and the tiny shooting team to hide from informers or tread hidden routes to avoid police checkpoints. More significantly, it was decided from the very beginning that *Amussu*'s shooting should be rooted in the Movement's political and artistic customs. The decision to shoot such a film, to shoot such calm, slow, wide-angle images in order to leave enough space and time to frame the multiple heroes, the multiple deeds, the multiple speeches that constitute this Movement, and more particularly to frame its songs of resistance—this decision was taken collectively in Agraw.

Agraw is an Amazigh word which designates the village general assembly: an ancient form of Amazigh democracy that the Movement has updated by authorizing the attendance and freedom of speech of women and children. Women, men, and children assemble in a circle; a circle which reminds of an Agora. Another way of governing, of reaching decisions, another way of carrying them out. A political possibility: horizontality vs. verticality; collectivism vs. capitalism; margins vs. centralism; roots and traditions vs. extractivism; sovereignty and democracy vs. colonialism For the preservation of their environment, of their ecosystem, to which they fully belong.

Through the everyday songs of men and women, through the songs chanted by Yassin Madri, their Amdiaz (an Indigenous rebel-poet who documents the struggle), through the speech given in Agraw by various members of the community, through the multilingual reports written after each Agraw, and the manifestoes published for religious feasts or commemorative anniversaries of the Movement on social networks, one can easily conclude that speech is central for the Movement on the Road '96. Speech as a means of expression, speech as a means of

Of Megaphones, Cameras, and Songs

CALLING OURSELVES "MOVEMENT ON THE ROAD '96. WE SHUT DOWN AND
OCCUPIED A MAJOR WATER PIPELINE TO THE MINE ON MOUNT ALBBAN
WHERE WE REMAIN TO THIS DAY. SOME OF US ARE "IMDIAZEN," INDIGENOUS
REBEL-POETS WHO DOCUMENT THE STRUGGLE THROUGH SONG.

ⵉⵅ°°ⵓⵣ°ⵍ°ⵓⵓ°ⵉⵉⴼ «ⵅⵏ °ⴳⵓⵣⵄⵏⴳ96» , ⵉⵣⵣⵉ ⵣⵓⵏ⁄° ⵣⵏⵓⵏ°ⵉ ⵉⵍ° ⵏ°ⴽⴽ°ⵉ
°ⵍⵏⵉ ⵣ :ⵛⵏⵣⵅ ⵉ :ⵑⵅⵇⵅ ⵓⵅ ⵍⵏⵅⵀⵀ° ⵉ :ⵑⵀⵔⵀ°ⵉ ⵉⵍ° ⵅ ⵉⵓⵑⵀ ⵉⵅ° ⵣⵇⵣⵛⵣ °ⵓ
°ⵔⵔ°. ⵀⵀⵏⵉ ⵏⵣⵅⵉⵂ «ⵣⵛⵏⵙⵏⵅⵉ», ⵣⵛⵏⵙⵏⵅⵉ ⵣⵛⵏⵅⵣⵂⵉ .ⵔ ⵔⵔⵉⵜ°ⵛⵉ ⵜ°ⵂⵉⵔ°
ⵔ ⵣⵔⵅⵔ° ⵏ ⵜⵛⵏⵙ°ⵅⵣⵉ.

communication, speech as a poetic tool, but most importantly, speech as a
political space: a political proposition, utopia in itself.

This centrality of speech is the reason we chose to make this text
a patchwork—an *azetta*, to use the Amazigh word for carpet-weaving
using pieces of fabric—of pictures, texts, and words, in order to recreate,
to a certain extent, an Agraw on paper. At the same time, in doing so,
this chapter intends to provide an insight into the temporal depth of this
Movement and of this film, built on multiple layers of former and updated
speeches, songs, political or artistic manifestoes. This text assembles, in
a form of dialog, written testimonies by film director Nadir Bouhmouch
and MSV96 activist Omar Moujane, and intertwines them with many other
texts and images. Thus, this chapter bears evidence of the film's and the
Movement's rootedness in former political and artistic research, and of
their desire to pass on and update this heritage. Last but not least, by
mixing texts written in (or translated into) English, Arabic, and French, as
well as some lines written in Tamazight, this text also bears witness to the
situation of triglossia and linguistic colonization that most Moroccans still
live with today: people write in Classical Arabic, French, or, less frequently,
English—the languages they were taught at school—when their spoken,
maternal, home language is Tamazight or Dialectal Arabic (*Darija*).

In this way, we hope that this chapter will become one of these meta-
phorical spots, behind and beside the film *Amussu* itself, in which the spirit
of Agraw, of the Movement on the Road '96, and of Mount Albban Protest
Camp, can be preserved and carried on. Indeed, the camp was evacuated
in September 2019 by the exhausted militants, and it was immediately
destroyed by bulldozers. *Amussu*, the film, and its various screenings, thus
became the remaining location(s) where this inspiring resistance lives on—a
virtual, visual, living protest camp and manifesto. A fragile one, all the more
so as the circulation of the film was hindered by the Covid-19 pandemic. Let
us hope that this chapter becomes another of these spots.

Marie Pierre-Bouthier, May 1, 2021

Opening titles of
Amussu: "Calling
ourselves 'Movement
on the Road '96,'
we shut down and
occupied a major
water pipeline
to the mine on
Mount Albban,
where we remain
to this day. Some
of us are 'Imdiazen,'
Indigenous rebel-
poets who document
the struggle through
song."

Exchange with Omar Moujane, Movement on the Road '96 activist

Omar Moujane is a figure of the Movement on the Road '96. In the pictures taken by the Movement's Committee for Medias and Communication, in Nadir Bouhmouch's films (*Amussu*, 2019; *Paradises of the Earth*, 2017), at the screenings of *Amussu*, his are among the recurring faces and voices of the Movement. When I met him during a screening in Agadir, the precision of his knowledge of the history of the Movement and of the environmental and social consequences of the silver mine's establishment on his tribe's land, led me to invite him to become the representative of the MSV '96 in this polyphonic text. Representative, but not leader, as the Movement is proud of its ancestral model of direct, horizontal democracy. An activist in Imider, Omar Moujane is also one of its former political prisoners, as he was jailed from 2014–16. When the film project arose, and its shooting started, he was a member of the local production committee for *Amussu*. He is also a research student in sociology. (MPB)

Imider: The silver mine against the Indigenous farmers

In the Imider area, there is a gigantic mining project. This mine, the largest in Africa in terms of production, has experienced exceptional growth over the past fifty years. The mining activities result in the processing of 240 tons of 99.99% pure silver per year. The project has had disastrous environmental and social consequences, which led the neighboring population to come into conflict with it some twenty years after its installation in Imider, in 1969.

A fundamental rule for us is the community ownership of the lands that tribal dwellers traditionally occupy. This falls under the management of the Ait Atta tribe in the Saghro Mountains, for everyone's collective benefit. This principle was violated by the European colonizers. They passed laws on private property in order to be able to exploit and plunder Indigenous tribes' lands and resources. These old colonial laws (e.g., Law 19–19) are still in force today. For this reason, the mine has acquired and accumulated many hectares of land. Farmers oppose the acquisition of land and, more generally, this industrial model. They are attached to their collective ownership of land—both agricultural and pastoral.

Previously, more than 500 families used these spaces, for agriculture, livestock, and nomadism …. Daily life was based on farming activities. Suddenly, their way of life changed with the arrival of industrial-extractive activity into their rural environment. The company, which was set up to exploit the natural resources, did not take into consideration the perverse effects that its activities can have on life around the mine. It neglected the local inhabitants/farmers and saw no value in negotiating with them or talking to them. It resorted to the state's guardianship over tribal lands (via the colonial laws) to sign agreements without the participation or knowledge of the legal owners. From my point of view, this is the most

important point in the endless conflict in Imider between the three parties concerned.

Therefore, the problem is this model which appears in the form of industrial and developmental investment, while behind it hides the colonial reality. Fundamentally speaking, the conflict is about decolonization.

In 1996 the mine was privatized. Since then, extractivism intensified and mining activities expanded, to the harm of land, environment, and health of the population. This affected our food sovereignty as well as the economic stability of the rural farmers. More than 104 families left the region between 2004 and 2014.

In August 2011 the inhabitants of seven villages of Imider in the south-east of Morocco formed a social movement. Thanks to the Movement on the Road '96 (MSV96), the community succeeded in coming together in order to protest and to defend their rights. The conflict, at its core, has to do with the use and management of regional space. The mining company considers the land as a production space; for the farmers/inhabitants the land is a living space; and for the state the land is for exercising control and monitoring security.

"The state" does not play its role in this conflict: it never supports the villagers as "citizens" defending their just rights. On the contrary, it has intervened to support the neocolonial extractivist mode of production. This is a decades-long conflict between a capitalist model and the sustainable model of the local community, marked by a systemic marginalization of the villagers and a negation of Indigenous peoples' rights.

The movement succeeded in establishing a historic protest camp on Mount Albban for eight years, from August 20, 2011, to September 17, 2019. This involved peaceful protest marches demanding rights and respect for the environment, as well as cultural and recreational activities as means of struggle. In recent years the movement produced a documentary film, which constituted a possible alternative method for continuing the struggle. The inclusion of cinema in the battle came in addition to the virtual spaces used by the movement from the beginning. I will try though this interview to answer the following key questions: what is the influence of film on the struggle for farmers' rights and against extractive destabilization? Will the film help create local collective memory? Can cinema help liberate speech and culture from the controlling and monitoring empire and its elites? In sum, can the camera be a weapon for the trapped and the oppressed? (OM)

Omar Moujane's opening words and echanges with Marie Pierre-Bouthier were initially written in Arabic, then translated into English by himself. The English version was revised by Omar Berrada (who compared it to the original Arabic version for a better fidelity to Omar Moujane's thoughts).

Marie Pierre-Bouthier: How would you introduce your community, your tribe, and the Movement? What would be the main characteristics of the environment and history of the community, tribe(s), and villages of Imider, and of the Movement?

Omar Moujane: The Imider area is located in the southeast of Morocco and administratively belongs to the Tinghir region. The village of Imider comprises seven *Douars*[1] stretching over an area of 144 km². According to the 2014 census, its population is 4,420 people (627 families). In the 2004 census the population was 3,936 people (507 families). As for the 1994 census, we find 4,289 people (617 families). From the ethnic point of view, this area belongs to the Ait Atta tribes (the Ait Atta federation is a very large Amazigh tribe, occupying a semi-desert area of about 70,000 km²). The Ait Atta areas have special features in terms of climate and vegetation, as well as water networks, especially underground During major periods in the history of Morocco, these areas were isolated and managed independently from the central state authority—due to the weakness of the Makhzen[2]—and relied on a social organization based on custom. In the early part of the twentieth century, they stood as an impregnable barrier before the French colonial army. The Ait Atta and other tribes fought fierce battles with the French, the most famous of which was the Battle of Mount Bougafer in the Saghro Mountains, in February 1933.

The Imider tribe belongs to the Ait Ouahlim fifth and to the "race" of Ait Bouknifen.[3] Imider depends on irrigation and irrigated cultivation with a system of underground galleries called *khattaras*, in addition to grazing and transhumance. As for the topography of the region, it is a volcanic field formed in the Hercynian age. Therefore, it is rich in minerals, and is host to the world's largest silver mine, located on the northern face of the Saghro Mountains—specifically in the Targuit oasis.

The intensive industrial exploitation of the mine began in the 1960s, but the extractive activities date back to previous centuries—during the Middle Ages, between the eighth and twelfth centuries, in the time of the Idrissid and the Almohad dynasties. The advanced technical exploitation of the mine began in 1969, after the establishment of the Imiter Metals Company, the construction of the processing plant's foundations, and the development of drilling and extraction machinery. The exploitation of the mine is tied to the imposition of mining laws in the Dahir of April 16, 1951, which considered mines to be domain property, as well as Article 15 of a

1 In North Africa, a temporary or permanent, fixed or movable group of dwellings, housing individuals generally linked by a common ancestry.
2 "Makhzen" is an Arabic word, meaning a warehouse or a storeroom, which traditionally refers to "the governing elite centered around the king and consisting of royal notables, businessmen, wealthy landowners, tribal leaders, top-ranking military personnel, and security service bosses" (definition provided by Nadir Bouhmouch in his film, *My Makhzen and Me*, 2012), but it refers also to their controlling agents, representatives, and "eyes" on the field (the *muqaddem*, for instance—a mixture of informer and local government officer).
3 The Ait Atta confederation is divided into five fifths (*khoms*), which are themselves divided into sub-tribes or clans or "races," as Omar Moujane calls them here.

Of Megaphones, Cameras, and Songs

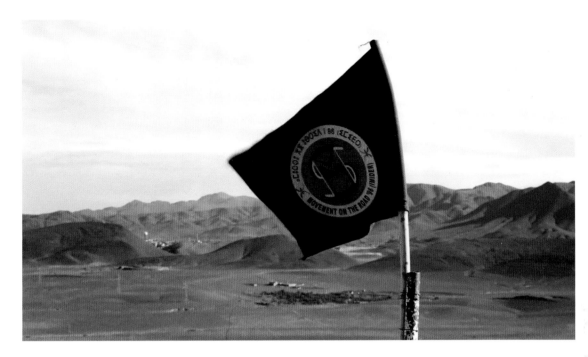

September 1923 Dahir, which considered mines a property of the state. Thanks to the legal arsenal left by French colonialism, the state was able to control the expropriation of lands from these tribes and pave the way for the exploitation of the mine.

The exploitation officially began in 1969, immediately following the topographical survey of the mine and the research conducted by the Office of Mining Research and Investments. This required the establishment of a new corporation, hence the birth of the Imiter Metals Company (SMI). Founded with the aim of exploiting the mine, it started as a limited liability company with a capital of 96,770,000 dirhams,[4] with the state's Office of Mining Research and Investments contributing 69% and ONA 31%. It began the process of drilling and extracting the ore, and is currently producing more than 240 tons of pure silver. The Office of Mining Research and Investments transferred ownership of the mine to the Managem group, which is part of the royal holding company, in three stages:

In 1996, the ONA Group bought 36% of the capital of SMI, which brought the share of Managem to 67%. In 1997, Managem bought 13% of the Office of Mining Research and Investments, and Managem's share became 80%. Privatization of the mine was achieved in 1998, as the mine is currently being exploited by the SMI company within the "Managem" group of the National Investment Company. On March 28, the name of the National Investment Company was changed to the name "Al-Mada," and in 2012 it achieved a volume of transactions equivalent to 1701.7 million dirhams, making Morocco the first in Africa and seventh in the world in terms of silver production.

Still, *Amussu*, 2019. Movement on the Road '96 flag, with the silver mine in the background (taken from Albban Protest Camp).

4 Approximately 9,100,000 euros in 2022.

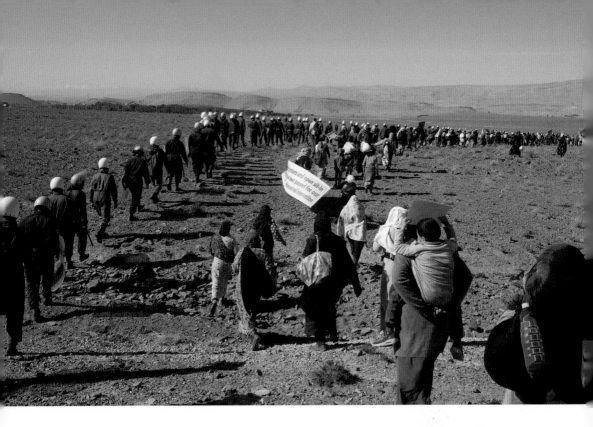

A heavily-controlled march on November 23, 2016

In spite of these figures and financial and monetary transactions, the local inhabitants (despite their small number) did not benefit from any activities related to the mining industry. Instead, they were negatively affected by the company's overexploitation of water resources. Subsistence farming, grazing, and overall production were damaged. Thus, the establishment of the mine did not have a positive impact on the region. Rather, with the beginning of the mining activities, Imider experienced transformations and an aggravation of social and economic problems. Unemployment appeared among the youth, the circle of poverty and marginalization expanded, in addition to environmental problems such as pollution, drought and water shortage, and land seizures. All of these problems led to the impoverishment of the populations, who did not remain silent about it. On the contrary, they adopted forms and methods of resistance that lasted for years, indeed decades—the protest camp of Mount Albban being the most prominent among them.

The exploitation of mineral resources caused damage to the environment and the oasis plantations, which turned into a dry area after the wells were drained due to the volume of industrial water pumped into the mine, while the use of chemicals in the mine also caused damage to the environment. All of which took place without proper infrastructure, including sanitation facilities, and the local population was systematically excluded from working in the mine. This social and economic exclusion, and general lack of development have formed the basis for protests against the mine for decades. This reflects a continuation of colonialism, which requires a continuation of the resistance.

Of Megaphones, Cameras, and Songs

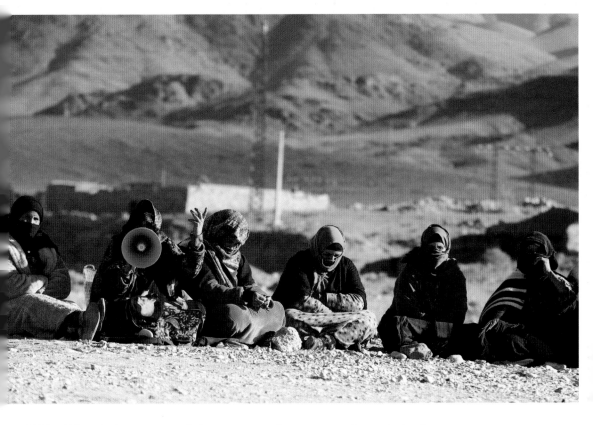

MPB: What is the cause and the purpose of your struggle, and who is or are the adversary or adversaries? How is your movement organized?

Agraw (general assembly) on January 29, 2017

OM: I defend the land because land is existence and I defend the water because water is life. I am not afraid of the company's power or of the state's hegemony, and I will keep struggling within the movement for dignity and for life for my comrades in struggle. I will fight to end all forms of colonialism.

I can say that the reason for my involvement in the movement lies in rejecting the culture of submission to control, and facing silence, social injustice and all forms of oppression; in other words, defending our rights, our identity, and our human dignity ("Dignity or death" and "To die for the earth in dignity or to be buried in it in martyrdom" are slogans of the movement). I have struggled on the side of the militants because the movement has provided us with a free space to express our positions in relation to the situation we are living in, and to work toward changing the situation for the better and fulfilling the demands that we presented in an official file. I was a member of the Dialog and Negotiation Committee, and I pleaded without fear in a direct confrontation with authority: the point was to confront the system face to face. I did not own anything that I might be afraid of losing; I was ready to face anything. For me, it is an existential position. When I was arrested March 1, 2014, I was not affected despite the physical and moral torture I suffered. On the contrary, I felt satisfied that I had done my duty. Being arrested for telling the truth is a reason for pride. My attitudes have not changed and will not change as long as the situation remains the same,

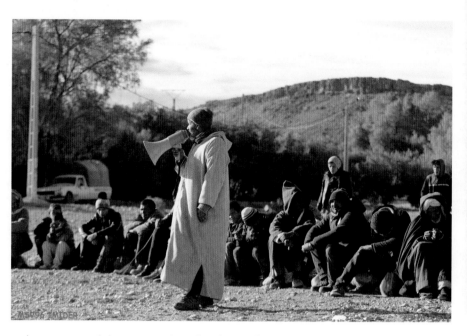

as long as our rights are undermined, our dignity is trampled upon, our land is plundered, our wealth is depleted, and the mining company continues its extractive activities that cause great environmental damage and depletion of water resources (a symbol of our stability), in addition to the increased risks due to climate change. In my opinion, the continuation of the mine requires the continuation of our resistance.

In official circles, collective memory has been excluded and neglected, but it has great importance in the organization of the movement and the embodiment of its discourse. Reviving memory and clinging to it is a form of resistance. As for the organization of the movement, we jettisoned all forms of vertical organization in which leadership roles are prominent. Instead, the movement adopted a horizontal organization represented by Agraw. "Agraw" is an Amazigh word that denotes a gathering of the population in the form of a public meeting in a space designated for it. They come together in a large discussion circle, which allows all members to contribute and take part in making a decision of interest to the community. It is similar to the Greek Agora, where public affairs are discussed. By reviving this institution that characterizes the Amazigh tribal organization, the movement has eliminated organizational forms that are easily infiltrated by the authorities—for instance, when a group of elders are in charge of the community. Here, the whole population is in charge, every member of the tribe or any person acting in solidarity has the right to participate and speak his or her mind publicly before all. In this way we uphold the concept of direct democracy. There are several committees within the movement, and they are all subject to Agraw as part of their decision-making processes. (See texts on pages 215–16)

MPB: Have you been supported by, or coordinated with, other local or global activist movements in Morocco / North Africa / the World?

Of Megaphones, Cameras, and Songs

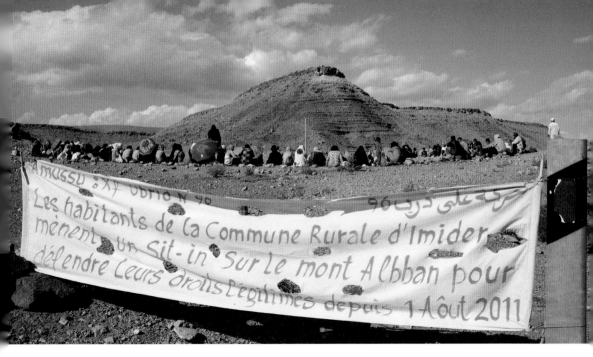

The COP22 (Conference of the Parties 2022), which took place from November 7–18, 2016, in Marrakech, was a particularly good opportunity to meet other environmentalist and/or native movements, but I believe that these contacts did not begin with the COP22.

OM: The protest camp of Mount Albban is a public space for all democratic voices in the world. Activists from different countries and nationalities visited us, and we had fruitful inter-actions with them. Before the establishment of the Imider movement, I was active in the Amazigh movement. As one builds an organization, one must understand the type of social relations that bring its members together before discussing the themes that will frame their common discourse. Any failure in social relations between the members can negatively affect the organization's prospects, and the better the social relations that link between them, the better for the life and the efficacy of the organization.

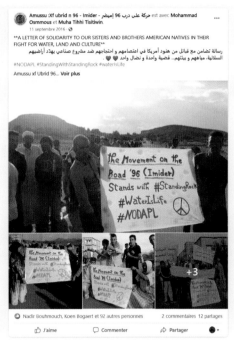

Letter of Solidarity of the Movement on the Road '96, published on Facebook

From the beginning there has been mutual support and I have had the opportunity to participate in discussions and meetings, and to host activists with whom we even devised joint actions. I cannot go into all the details, but there is great support and collaboration in relation to mining (shale gas in southern Algeria, or phosphates in Morocco and Tunisia), water issues (Tunisia, Morocco, and Native American tribes—in relation to Standing Rock in particular), the issue of land (the Landless Workers

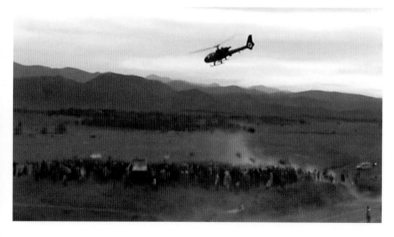

Movement in Brazil, Indigenous people from the Hawaiian islands, the Jemna oasis in southern Tunisia, and different tribes' struggles in Morocco). Questions of environment, human rights, and detention are all important issues that connect us with activists and organizations locally, in Africa, and internationally.

When you choose resistance, you must find someone who stands beside you, who resists with you, and who stands behind you and gives you provisions ... and there are also those who confront you. All these complex relationships are very important for any committed activist. The field determines everything; there you will learn what you did not expect. (See texts on pages 217–19)

MPB: How did you meet Nadir Bouhmouch? Was he accepted easily by your community?

OM: Nadir is an activist, a fighter, and a filmmaker. He initially visited the camp when I was in prison, but I remember our first meeting was at the time he came to the sit-in. He arrived at

Stills of the opening sequence of *Amussu*, re-employing a video taken by activists of the Movement, showing a police helicopter harassing the protesters on October 11, 2011

about ten at night. I was there to welcome him and another comrade to the camp. That night a long discussion took place through which I sought to understand his ideological orientation and his political affiliation (our movement has no affiliation, it is independent and deals with all ideological trends with caution, and this is a rule or perhaps a trick), paying attention to the concepts he was using. At first I was cautious with him in the discussion (as a precaution), but since the rest of the comrades knew him from before, I knew we could have a kind interaction. Nadir has an anarchist outlook,

Of Megaphones, Cameras, and Songs

which is wonderful as we agree on a number of points. Perhaps this is what made him stand in solidarity with the movement, which rejects all forms of authority or force or command. He told me that he had learned about Imider in a video (shot when we were attacked by the authorities from a helicopter on October 11, 2011) that we had posted on social media.

Still, *Amussu*, 2019. Activists Omar Moujane and Moha Tawja are writing down a statement of the Agraw, to be published on social networks.

Nadir visited us like others did. Some people visited only once. Some people voiced criticisms, others made suggestions about possible forms of struggle (for example, we carried out a Freedom Caravan in partnership with the Solidarity Committee with the Rif Detainees; we hosted members of the Tillila Association for days in the camp; there was also the Tamaynoùt convoy ...). As for Nadir, being a filmmaker, he suggested working in partnership on a film, which is what we did with the documentary *Amussu*. The movement documents events through filming and recording, while also carrying out cultural activities inside the sit-in, and all these activities are considered by the movement as forms of struggle and protest, as forms of resistance.

MPB: What was the importance of art, culture, film, and social media in your fight before his arrival?

OM: As I said before, the movement adopted many different methods to sustain the resistance, and art is one of them. Graffitti, poetry, theater, sports, and various entertainment activities are part of our lifestyle and have been adopted in the struggle and as a mechanism of protest. Creativity and art are part of the texture of our lives. The camp is a total artwork.

Art and culture constitute a receptacle for the multiplicity of representations and practices produced by the activists. They are a symbol of life first, and a symbol of resistance second, as well as a symbol of social identity. They express the movement's discourse and struggle. Art is a spirit that unites us and makes connections between the elements of the environment in which we live, in harmony with our culture. The movement is not only meant to voice protest, it is a space for popular learning and knowledge acquisition. (See text on page 219)

In the collective imagination, the camera is identified with authority—it is one of the tools of oppression in the hands of the authority. In our collective memory, cameras appeared with the French colonizers. Initially, rifle barrels were pointed at the resisters. Then they were replaced by cameras. The culture of cinema was reserved for the minority that

Nadir Bouhmouch, Omar Moujane, Marie Pierre-Bouthier

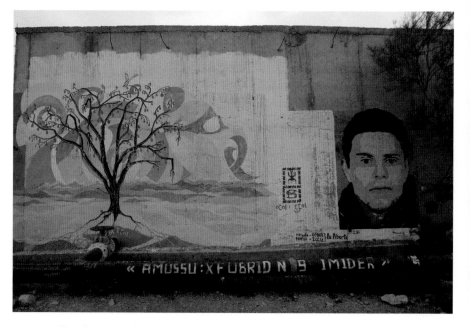

« AMUSSU:XFUBRID N 9 IMIDER »

ABOVE AND BELOW
Pictures of murals,
taken in April and
October 2018, and
in February 2019,
in Mount Albban
Protest Camp

monopolized power. This is one of their standards. But we have made the camera our weapon as well. We focus its lenses on what they consider to be marginal. We have used it to make the "invisible" visible and the margin central, and to show what they are trying to hide. Producing a documentary is like moving the resistance from the mountain into film theaters. The fact that the film was produced by the movement's own activists is a response to the problem of knowing how the marginalized can portray themselves.

MPB: How did the idea of shooting a full-length documentary film emerge? What were the steps that led to it? Were there drafts of it before, or was the film formed during the shooting? What did you expect of the shoot?

OM: The documentary film *Amussu* focuses on an important aspect of the life of the activists: how they live their resistance in Albban, how they behave every day. The film immerses us in the quotidian aspects of the movement and reveals the background within the public space of Albban,

namely Agraw—the meetings between the community members. The film did not document everything, but it shows the power relations that the movement points to in relation to space, resources, and social construction ….
 Filming *Amussu* came after long discussions, but the actual start was when the movement decided to shoot a statement bearing its position at the summit of the parties in Marrakech (I will not talk about the source of the idea as it is of no importance here). Filming this short film was an idea accepted by the

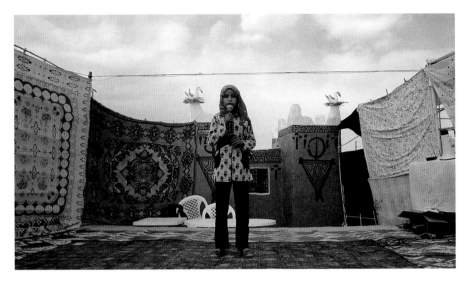

Still, *Amussu*, 2019. Mahmoud Darwich's poem, presented by a young girl during Spring festival.

director Nadir, who welcomed it and expressed his willingness to work together on it. After producing the four-minute video professionally, we published it in a very well-studied circumstance[5] and it created an unexpected impact on public opinion, but it had a positive impact on the movement in terms of its struggle strategy. This was the beginning of the work on the production of the feature film *Amussu*.

MPB: The title of this four-minute video was a hashtag, *#300kmSouth*, which indeed contributed to the advertisement of the Movement. As for *Amussu*'s shooting, how was it integrated into the everyday resistance of the community? How was the community involved in the shooting, the editing, the financing, and the circulation of the film?

OM: The film production process is not an easy thing, I was a member of the local committee assigned to the production of the film and I worked with the filming team for three years, from the beginning to the end through all production stages, from shooting to distribution. I did not study cinema and I did not have any training in the field, but learning cinema did not require registration in an institution and obtaining a certificate or diploma. It has been an important experience for me, both in front of the camera and behind it.

Still, *Amussu*, 2019. Sequences shot in April 2017, during the "Imider Spring Festival: Sport, art and entertainment, the other face of the peaceful resistance."

For the population, the idea of a documentary was not easy to accept. They are resisting mining and extractivism, so when you talk to them about cinema, they are perplexed. It is a paradox which is difficult to understand; therefore, it was hard to convince everyone of the project's usefulness ... and even more so, to

5 For the context of the COP22 conference in Marrakech, see Nadir Bouhmouch's text, pages 200–1.

convince them to take part in it. That said, there are many possible meeting points between culture and struggle, which contributed to the integration of cinema into our general strategy of struggle. In the end the film was an important experience, in terms of benefits for the cause but also for the preservation of our collective memory, and for proposing an alternative pedagogy and breaking the prevailing norms.

After everyone agreed to the idea, we did not need to draw an action plan to get people involved, as Agraw is sufficient to facilitate the process of everyone's participation. No scenario had been prepared before—we did re-shoot certain scenes, but very few.

During filming, whenever we wanted to shoot a scene, we felt like we were protesting, because we were always facing the authority, and always drawing schemes to evade the authority representatives and their assistants, which our local knowledge helped us with. It is an experience that will never be repeated. The world premiere took place in the camp, in Albban, February 2019. It was a distinctive step and the beginning of a new phase in the movement's path as a whole. It was tantamount to breaking out of invisibility (which the authority imposed on us for years) and into recognition. The authority ignored us and did not respond to our demands, but the film cut through that contempt and made the lights point again towards our long battle for existence. I was sure that the response from the authorities would be harsh.

MPB: Has the film and its circulation fulfilled all your hopes and expectations? Do you remember a particular screening? Which one was the most important for you?

OM: With the film, we transferred the resistance and struggle from the mountain to the screen. We are saying in all languages that we reject submission and domination. We will work to pressure the mining company by all means.

Nadir Bouhmouch makes visual choices and arranges the technical setup for the shoot collectively with youth members of the Movement

Of Megaphones, Cameras, and Songs

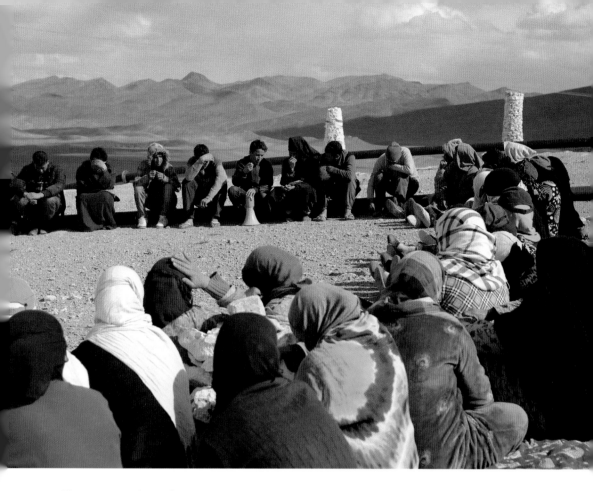

The impact of the film was especially evident after the sit-in and protests were suspended by the Movement. The film's participation in festivals, nationally and internationally, embarrassed the authorities. Poor farmers fight against barbaric capitalist companies, and they create an award-winning documentary. The film makes room for the voices of the oppressed and the marginalized.

It definitely fulfilled all our hopes. It is a continuation of our resistance, and I can say that we have built a piece of collective memory, and memory is a form of resistance. We transferred the protest to the screen in a manner that speaks to the world.

One of the first Agraws for writing, held on February 22, 2017, which decided on the principle of shooting a feature-length documentary and initiated its collective writing and shooting. Omar Moujane, with megaphone, is sitting in the center.

MPB: What are the prospects of the Movement in 2021 and for the future?

OM: Currently, the context has changed, as Morocco is going through an ambiguous period due to unrest within the Makhzen. The prospects are unclear and any move may cost great sacrifices. As for the movement, it has maintained its organizational framework despite the rise in protest forms and demonstrations. An essential aspect of the Movement's work is now the film's screenings and parallel discussions; another is the academic research carried out by social scientists specializing in social movements and social change.

I said in a previous interview with a French newspaper in December 2019, that the prospects of social movements depend on their ability to propose political alternatives while preserving their social character (as a social organization), which is something that I draw from my experience as an activist and militant, as well as from my interest in social movements. My academic discipline is sociology. I cannot talk about the horizons of the movement any further, because activists like to ask "what to do" in reference to horizons whenever there is a crisis. And I do not like such imprecise questions in terms of taking the context into consideration. However, I can say that the future prospects are related to several objective and complex conditions. It is not possible to talk about prospects without realizing, analyzing, and understanding the current concrete reality.

With regard to me as a person, I might launch into a new social experiment, through which I will try to build a model sustainable village.

Producing the documentary *Amussu* in a critical and activist context

Until 2016, there was no plan to document the movement's activities by including cinema as a tool of struggle, despite the presence of a special committee for filming and documenting marches and sit-ins since day one, by way of videos filmed in an unprofessional manner with the aim of raising awareness through social media. In general, filmmakers are rarely interested in issues like Imider, or environmental issues and protest, especially when it comes to documenting the history and resistance of the marginalized. For example, the activists of Imider consider that documentary film is a space for making their voice heard after it has been suppressed and besieged in official spaces. Therefore, the Imider activists resorted to militant cinema as a space for creativity and for expressing their resistance and opposition to control on the one hand, and on the other hand they considered the film itself to be a means and a tool for defending their rights and continuing the protest. The documentary *Amussu* is a model for militant cinema.

The film documents the patterns and ways of life of the peasants and the local inhabitants of the Imider region in southeastern Morocco, along with the forms of their resistance to extractive activities. It also presents the life and social relations that emerged in the Albban camp as a space without authority, a liberated space. The film is a reference made available to researchers and those interested in the marginalized and persecuted. It is also directed primarily to the peoples of the South to serve as a bridge between Indigenous peoples and activist forces.

Cinema is a tool of resistance. When we engage in a battle that affects our social life, art is our method of struggle. Thus, *Amussu* is considered an engine for the continuation of resistance from one generation to the next. From a generation carrying weapons in the face of colonialism to a generation who carries, through the lens of the camera, the barrels of their ancestors' guns. *Amussu* is a manifestation of resistance to all forms of

colonialism in art and cinema, and it can be considered a current answer to the social, economic, political, and historical reality.

Amussu was not the first instance of a militant film. It will be added to the list of previous experiences in committed and revolutionary cinema. There are several examples in various countries of the South (the Third World), such as the Third Cinema experience that uplifts the struggle and its various forms. The film tried to raise the causes of struggle and the motives of protest. The poor and marginalized who suffer from social misery, economic dependency, the continued plunder of local wealth, and the obliteration of identity. The film also touched on aspects of the daily resistance of the people of Imider against extractive activities and in defense of the environment. But I want to add that Amussu went beyond documenting Imider's protest experience by evoking historical events; by extension, Amussu became a part of building collective memory.

Amussu sought to reveal to us the mechanisms of the continued resistance and protest of the Ait Atta Tribes in the village of Imider. Over the course of its scenes for ninety-nine minutes, it reveals the economic, social, and environmental deterioration that drove this rural population to sit in Mount Albban for eight years. In this marginalized region, which has the largest silver mine in Africa, women, youth, the elderly, and children struggle with strong determination and will, as an expression of their refusal of control, plunder, and the destruction of the environment. Our slogan highlighted the issue of "fate" before the mining company settled on their lands. With camera and art, we tried to write our history and announce our narrative to the public after we fought the battle of existence. In my opinion, Amussu has attempted to reconsider the resistance of those who are marginalized, oppressed, and forgotten in official history. Thus, it conveyed to us the resistance of these poor Indigenous people and their defense of the land, the environment, and wealth ... and revealed to us aspects of the lives of those sitting on the mountain and of activists in the local social movement. (OM) (See text on pages 220–21)

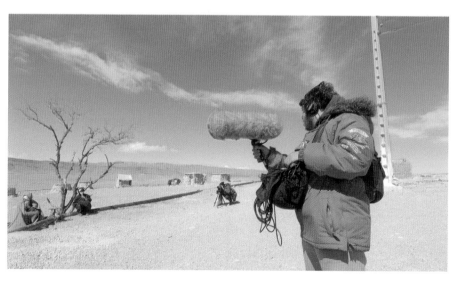

Nadir and sound recordist Jalal El Guermain filming at Albban protest camp, March 2018

Exchange with Nadir Bouhmouch, Moroccan filmmaker and activist

Nadir Bouhmouch is a Moroccan film director (born 1990), trained in UC San Diego, and based in Marrakech. His student years, which took him far away from the former colonizer's sphere of influence, prompted his interest for ethnic, racial, and gender-related minority issues, but also for Third Cinema. We first met in 2013, a few hours before a Black Lives Matter demonstration in Berkeley, California. That was a few weeks before Nadir came back to Morocco, to settle for good as a freelance filmmaker. At that time, Nadir Bouhmouch had already produced a few committed films, directed during his first and second years as a film student, as a member of the Guerrilla Cinema group formed in the wake of the February 20th Movement, the Moroccan Arab Spring. *My Makhzen and Me* (2012)[1] dealt with the Moroccan uprising of 2011, and *475* (2012)[2] with an article of the Moroccan penal code which allows rapists not to be judged if they get married to the raped woman. A few months after returning from San Diego, Nadir Bouhmouch went to Imider and met the Movement on the Road '96. (MPB)

Marie Pierre-Bouthier: Being born in Morocco's capital city, Rabat, what led you toward the countryside, the mountains, and the margins of Moroccan territory? How did you encounter the Movement on the Road '96 and its activists?

Nadir Bouhmouch: Well, even though I grew up in Rabat, my mother is actually from Ouezzane [northwest Morocco], so we spent a lot of time visiting my grandparents and extended family, many of whom are peasant farmers. Actually, my mother was herself a farmer for several years so, many childhood weekends were either spent carrying a hoe or taking art classes. But I guess what probably had the most impact on my vision of the world, and what I think ultimately led me to the countryside today, are the many, many trips she would take my sister and I on to rural areas across the country, especially the Atlas and the southeast. Since during her childhood she was punished by her older brother for sneaking out to take photographs of Ouezzane, these trips were a way to compensate for what she wasn't allowed to do before she was married, by taking hundreds of photographs of my sister and me in these regions. Actually, the first photographs I took were taken with my mother's film camera in the same regions I love and work in up until today. She was particularly enamored with the mountains, and so that love rubbed off on me. We would spend weeks, not at hotels, but rather either camping or staying with peasant families who opened their doors to us with open arms and endless generosity. I think the experiences with these families were impressed upon me ever since, and the

1 https://www.youtube.com/watch?v=zVNmMUYGnGw
2 https://www.youtube.com/watch?v=Ym07RKs-PJU

Of Megaphones, Cameras, and Songs

burning question of class struggle came with that as I observed the huge differences between the way we lived in Rabat and the way many of these families lived. I felt something was wrong, but I didn't have the analytical tools to understand it until much later.

MPB: Then, how did you get these tools? How did you become politicized? What is your training, as a filmmaker *and* an activist?

NB: Well, it depends who you ask! If you ask the state-sponsored media they will tell you I was trained by the Algerian intelligence services to provoke chaos and destabilize the state.[3] But as far as I know, or at least according to what my diploma says, I studied cinema and political science at San Diego State University in the United States. So my training as a militant was very much intertwined with historic events taking place on both sides of the Atlantic. In Morocco, the February 20th Movement and the fervor of the 2011 revolutions across North Africa in general. And in the United States, the Black Lives Matter movement and the protests that justly took place after every brutal murder of innocent Black people. As a student there, I became co-chair of the Students for Justice in Palestine chapter and helped organize for the university's divestment from corporations complicit in Israeli apartheid. We used to, for example, occupy rooms where Israeli soldiers came to spread their horrendous propaganda. But as a group, we often worked with Black, Mexican/Chicanx, Queer, migrant, and Indigenous students—and these collaborations were really something that opened my eyes to many things. You could say my decolonial worldview had a lot to do with this "south-south" solidarity I witnessed and became a part of on campus.

I was also connected (digitally, and whenever I was back to Morocco for the summer or winter, physically) to the February 20th Movement. As you know, I made a film, *My Makhzen and Me*, about the movement, and we formed the Guerrilla Cinema collective in Morocco just a year after the movement started. The collective ended up producing my second film *475*, about a law which allows rapists to escape jail if they marry their victims. Once I finished my studies, I joined the UECSE (Union des Étudiants Pour le Changement du Systeme Éducatif), now known as Tilila, and, briefly, ATTAC Maroc (which was too bureaucratic for me). With the UECSE, we organized direct actions—for example, against Morocco's complicity in the war in Yemen, against femicide and the patriarchy, in solidarity with the Hirak Rif.[4] We also organized popular universities in public spaces, and "philosophy in the street." This was even after the February 20th Movement started dying down. We believed that we had to occupy public space with

3 https://m.le360.ma/politique/sit-in-anti-arabie-saoudite-quand-un-pro-polisario-fait -son-cinema-53837 and https://fr.le360.ma/medias/quand-le-journal-de-droite-le-figaro-se -transforme-en-caisse-de-resonance-dun-appel-a-lanarchie-au-221730. These papers refer to a film Nadir Bouhmouch shot in the Sahraouis' refugee camps in Tindouf, Algeria: *The Other Dakhla* (2013).
4 A huge popular movement that has been taking place in the northern part of Morocco since October 2016, and which was triggered by the tragic death of a street fisherman after a police control. Hirak political leaders and activists are now imprisoned.

debates, learning, and culture, to defend it against increasing militariza-
tion and a culture of consumption. At the same time, I was involved with
anti-capitalist environmental circles in North Africa and, through a good
friend, Omar Radi,[5] I became especially interested in the land rights move-
ment. Now I see these two, land rights and the environment, as being
intrinsically connected. they have taken the vast majority of my atten-
tion, which is why, today, my lens is turned almost exclusively towards this
direction.

MPB: … Which leads us to the Movement on the Road '96. How did you get
accepted by the community? How did you get involved in the community,
as an activist and a filmmaker?

NB: I had been in touch with the Movement online for several weeks
before I came back from my studies in San Diego. Actually, the first
contact was established after the Ferguson protests and during Mexico's
Ayotzinapa protests, which I attended in Tijuana with a protest sign that
read: "From Ferguson to Ayotzinapa to Imider: One Struggle." Ferguson
(Missouri, USA), if you recall, is where Michael Brown, a young Black
man, was shot by the police leading to massive protests in the city; while
Ayotzinapa is where forty-nine Mexican students were killed by cartels
leading to demonstrations across the country. I drew a link between these
three historic moments in popular struggle to point out the fact that we
are living under the same global repressive system and so our struggle
is one. I had sent them the photo right away and that's how we started

5 Omar Radi is a Moroccan investigative journalist and human rights activist who, in particular,
 investigated the Hirak Movement in the Rif. He has been imprisoned since July 2020.

Of Megaphones, Cameras, and Songs

chatting online. So when I first arrived in Imider, only a month after I came back in early 2015, they already knew who I was. Actually, I organized the trip for a friend, a Black Lives Matter activist who was also working on water issues in Detroit. I thus saw my first visit as an action of solidarity which, although minute, eventually led the Movement to officially release a statement in solidarity with the BLM movement in the US. So essentially, the first contact was one between activists, between equals, not between a filmmaker and his so-called "poor" subjects.

During that visit, I took some photographs for the Movement and subsequently decided to co-write an article about it with the BLM activist Kristian Davis Bailey.[6] The Movement provided us with all their documents, manifestoes, and archives for the article, so I spent a lot of 2015 researching the Movement. At the same time, I was extremely impressed by the Movement during the first visit—the [circular] Agraws where everyone participates in the deci-

The Agraw of 2 January 2017, captioned "#NiOubliNiPardon #300KmSouth" on Facebook

sion-making, the horizontal organization, the [Mount Albban] protest camp ….

At the same time, I was disillusioned by the bureaucracy and the authoritarian tendencies of an urban left which seemed unwilling to make room for young cadres like myself to have a say or contribute. So I left the organization I was a member of back then and instead proposed my capacities to the Movement, who gladly accepted them.

6 https://www.aljazeera.com/economy/2015/12/13
 /a-moroccan-villages-long-fight-for-water-rights

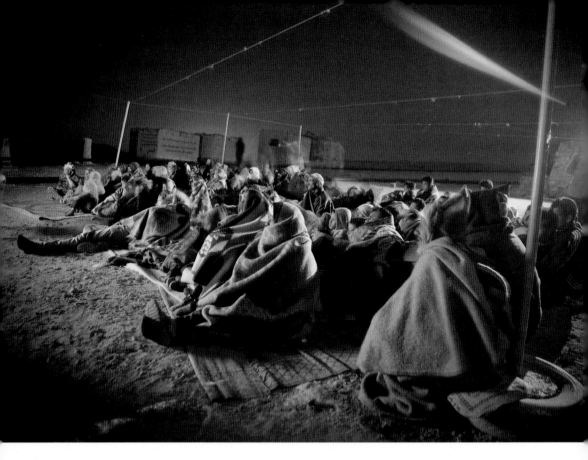

2nd Imider
Environmental Justice
Film Festival, 2017

I mainly contributed by creating social media campaigns, graphic design, memes, translating statements into English—things like that.

As a result, when the COP22 conference approached almost two years after my first visit to Imider, it was very natural for the Movement to ask me to make a short film. Its objective was to reveal the irony of the Managem corporation[7] sponsoring the conference held in Marrakech. The message was: only 300 km south of Marrakech, the conference's sponsor and the hosting state are responsible for environmental crimes against the villagers. The video's title was *#300kmSouth*.[8]

MPB: You brought to this video your professional capacity for photography and editing. Several shots were actually re-used in your feature-length *Amussu* three years later. The caption on Youtube read "Imider has a speech," claiming the idea that image should extend the reach of the Movement's traditional means of expression, such as songs.

NB: The video's title was a hashtag, *#300kmSouth*, since it was accompanied by a digital campaign that successfully put Imider on the lips of hundreds of

7 The corporation handling the silver mine that the Movement on the Road '96 is fighting against.
8 The video can be viewed at: https://www.youtube.com/watch?v=aBVhkOBAHTQ

Of Megaphones, Cameras, and Songs

activists who came from around the world:[9] Kayla DeVault of Navajo Nation, who wrote a report for The Good Men Project and was a SustainUS dele-gate; Niria Alicia Garcia Torres, a Xicana climate justice activist (SustainUS); Marouane Taharouri (Alternative Libertaire / Union Communiste Libertaire); environmental journalists and activists Morgan Curtis (New internationalist, SustainUS), Devi Lockwood (Truthout.org, Sier-raclub.org), and Ashley Braun (DeSmog); Ryan Camero, a water rights activist from California (mentioned in a report by the Global Justice Ecology Project and in a paper by Indybay.org); and Koenraad Bogaert, a lecturer at Ghent University who published a report on Jadaliyaa.com. Moroccan freelance journalists also seized this rare occasion to publish on the subject: there was an editorial piece published in the Moroccan independent online paper, LeDesk; I, myself, wrote a report for Opendemocracy.net; and as well, Ilhem Rachidi for The New Arab, and Fayrouz Yousfir for Middle East Eye.

 As a result, some of them even made the trip to Imider to attend the first edition of the Imider Environmental Justice Film Festival, which was organized at the same time as the COP22.

MPB: Indeed, films were screened in November 2016 to give to the sit-inners a new occasion, along with Agraws, to sit together and rein-force their togetherness. The festival was thought of as a new step toward "cultural liberation": Imider sit-inners learnt what cinema could bring to the comprehension of environmental justice, mass injustice, native nations persecution, and rural life. They realized that they were not alone, and that other people's fights and life and history, in Morocco, Algeria, Honduras, or Mexico, were comparable to theirs. Indeed, the festival screened their

Niria Alicia Garcia Torres (above) and Kayla DeVault (below)

9 https://www.jadaliyya.com/Details/33760; https://truthout.org/articles/standing-rock
 -morocco-indigenous-protesters-act-in-solidarity-against-corporate-polluters/; https://newint
 .org/blog/2016/11/18/cop22-why-climate-justice-must-also-be-a-struggle-for-sovereignt;
 https://ledesk.ma/encontinu/cop-22-les-villageois-dimider-rappellent-leur-lutte-au-monde
 -video/; https://globaljusticeecology.org/cop22-protest-and-die-in-for-environmental
 -justice-for-safi-and-imider-morocco/; https://www.opendemocracy.net/en/north-africa
 -west-asia/morocco-green-for-rich-grey-for-poor/; https://english.alaraby.co.uk/english
 /society/2016/11/22/a-small-moroccan-town-stands-up-to-cop22-greenwashing;
 https://goodmenproject.com/environment-2/environmental-injustice-in-morocco-just-300km
 south-of-cop22-wcz/; https://www.unioncommunistelibertaire.org/?Maroc-La-COP22-lave-plus
 -vert; https://www.middleeasteye.net/opinion/cop22-morocco-between-greenwashing-and
 -environmental-injustice; https://www.sierraclub.org/sierra/green-life/dispatches-youth
 -delegate-cop22; https://sustainus.org/2016/11/from-cop22-to-nodapl-thank-you/;
 https://www.indybay.org/newsitems/2016/11/18/18793806.php; https://www.desmogblog
 .com/2016/11/22/un-climate-talks-indigenous-activists-align-standing-rock-protesters
 -tensions-rise-and-temperatures-fall.

own short film, *#300KmSouth*, along with the Algerian-Amazigh film *Baya's Mountain* (Azzeddine Meddour, 1997), the Moroccan film about peasants' daily life, *Alyam Alyam* (Ahmed El Maanouni, 1978), as well as South American films. A second edition took place during Spring 2017 as part of the yearly Imider Spring Festival. (See text on page 219)

But if the festival was organized precisely in November 2016, it was first for the purpose of "draw[ing] the eyes of the world away from COP22," and from "the greenwashing discourse" of the regime and the COP22 sponsors (Managem, precisely, and the Office chérifien des phosphates). One of the goals was to get associated with other environmental resistance movements that were very active at the time in the USA, Morocco, and France; in particular, the Native Americans at Standing Rock who are resisting the Dakota Access Pipeline (DAPL).

NB: This also resulted in members of the Indigenous Youth Caucus and another anti-climate change group organizing a direct action inside the COP22 conference grounds in Marrakech by pretending to drop dead around Managem's corporate pavilion.

It was during this period just before and during the COP22 that I made another proposition, to make a feature length film documenting the Movement in more depth, and Agraw decided in favor of it.

MPB: And thus *Amussu* was born, as an independent clandestine collective production, participating in the Movement's cultural strategy. How was *Amussu*'s shooting integrated into the ways of resistance, and the political project, conceptions, and values, of the Movement? On what principles was it organized? How did you manage to make this shooting participatory?

BELOW AND OPPOSITE
Those who are
filmed contribute to
scriptwriting and are
consulted during the
shooting,
February 24, 2017

NB: The collective manner by which the film was produced cannot be separated from the collective manner by which decisions were made by the villagers in the Movement on Road '96—they were one and the same. To be more precise, the film was adopted by Agraw as the highest decision-making body of the Movement, which has reestablished this ancient form of Amazigh democracy.

In other words, *Amussu* was a democratic production, inspired by native democratic traditions in which major decisions regarding the film are made from below, not from above. Agraw, however—seeing that it was made up of people who have to tend to their agriculture,

Of Megaphones, Cameras, and Songs

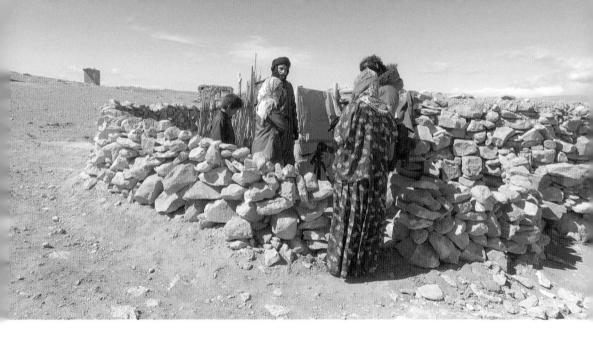

to work, or to study—cannot possibly make decisions on the day-to-day film production tasks, especially during a harvest. For this reason, Agraw elected a committee to take on these daily tasks like location management, field translation, production logistics, budget supervision, schedules, and finding volunteers. We called this committee the "Local Film Committee of Imider." The committee worked directly with me and the rest of the professional staff and crew, and regularly reported back to Agraw on everything concerning the film, from budgets to film festival updates. Agraw also had the capacity to summon me or members of the professional staff for questions. These mechanisms ensured that the film production was completely transparent vis-a-vis the community. The large Agraw was also broken down into voluntarily-attended Agraws that played a role in the creative aspect, like the "Agraw for writing" and the "Agraw for editing." This collective and transparent method maintains a high degree of trust that I think a capitalistic (company-based, profit-driven) approach can never reach. In fact, I would say it is a model that can be applied to any domain, from engineering to architecture to medical research to economics. This bottom-up, community-oriented approach is ultimately a political experiment in what genuine, democratic governance should look like.

MPB: To provide the members of those various Agraws with the theoretical, aesthetical, historical tools for film analysis, film-shooting and script-writing, you organized also film workshops, after the first step of the Environmental Justice Film Festival of November 2016: film analysis for boys, women, and girls, but also sound, cinema, and cinematography workshops.

You also conceived, jointly with the film club "Agora" from Marrakech (in the framework of a series of popular universities), a pedagogical publication that recapped for uninitiated Arabic-reading audiences, various tools of film analysis, as well as various film theories. But then, why didn't you resort to collective attribution?

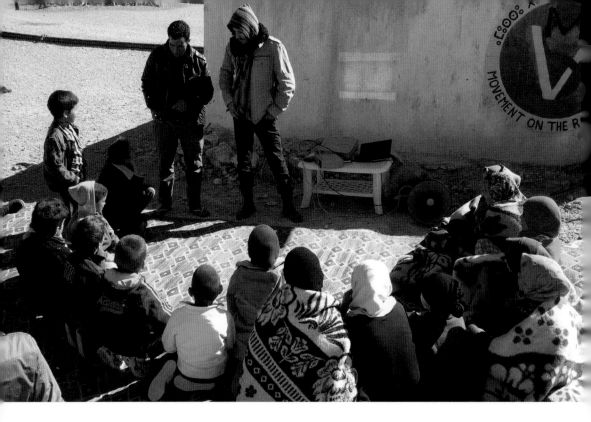

NB: Regarding the lack of collective attribution, it's important to realize that this is only limited to the role of the *réalisateur* ["film director" in French]. So when we agreed that I sign as *réalisateur*, and the Movement as producers and writers, above all, it had to do with recognizing a collaboration between myself as an individual artist and between them as a community. If, say, I was myself part of a collective of artists, then that signature could have been in the name of that artists' collective but without erasing individual contributions (the balance between collective and individual freedom is extremely delicate!).

So this attribution just means that as an individual, I was given the role of listening to the community and translating what they had to say into images and sounds. I tend to see the role of *realisateur* being closer to that of a translator than a "director," or to that of a historian or archivist rather than that of an "auteur" (especially in documentary). This function is comparable to the one played by the Amdiaz [the traditional singer and poet of the tribe in the Amazigh culture] or the griot [traditional singer and poet in Sub-Saharan Africa] who translates what a community is going through or what a community feels.[10]

10 Indeed, filmmaker Ahmed Bouanani explains: "The role of the poet in ancient Maroccan society is considerable. He is above all the chronicler, the 'historian' of his tribe. He does not only sing his loves and bad luck, but also, and mostly, the events lived by his tribe or within his tribe. [...] Respected and revered like a saint, his speech is listened to, because he owns wisdom and the secret for words that go straight to the heart. [...] His role is capital when his tribe goes to fight the enemy. [...] He is believed to be able to get in contact with nature's forces, to ease them or enrage them against someone; he speaks the language of animals, plants, and insects." "Introduction à la poésie populaire marocaine," *Souffles* 3 (1966). Translated from French by MPB.

Of Megaphones, Cameras, and Songs

MPB: Cinema was thus decided to become one of the Movement's cultural means of expression, which should reenact their ancestors' oral arts. The first images that were shot were first used for a second short film after *#300KmSouth—Timnadin N Rif*—which was released online in July 2017[11] in support of another social movement, the "Hirak." This other Movement was taking place in the northern Amazigh-speaking part of Morocco, the Rif, since November 2016. *Timnadin N Rif* aims at translating to images the ancestral oral poetic form of Timnadin. One can hear Amdiaz Yassin Madri's song, telling about the Imider people's solidarity with the Rifans, while silent faces of Imider villagers are edited in slow motion, conveying the patience, resistance, and permanence of Berber people. (See text on page 222)

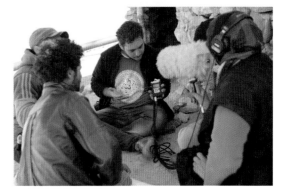

 Amussu, just like *Timnadin N Rif* and *#300KmSouth*, was self-produced and self-financed by the community. But *Amussu* was to

11 https://www.facebook.com/Amussu.96Imider
 /videos/1803315123018276/; https://vimeo
 .com/225104985

Still, *Amussu*, 2019. The plateau above which Mount Albban stands and above which the Amdiaz sings.

be a feature-length film, and, around 2018, the community realized that it would be very difficult to complete the shooting, and above all the editing and post-production of the film, with so little money. Funding was usually selected in a resolutely de-colonial manner: no French funding was applied for. But Agraw voted for an application to the Doha Film Institute. They were aware of its implications,[12] but this option was preferred to the risk of seeing the film remain incomplete. *Amussu*, the result of such a collective way of writing and producing a film, is thus thoroughly different from your first documentary *My Makhzen and Me*. Now that you look back on this first film, what do you think about it? In what way does *Amussu* emerge from this experience, and in what way does it differ from it?

NB: As you know, I was quite young when I made *My Makzhen and Me*, only nineteen when I started ... so I was quite naive, politically-speaking, and had still not developed my own cinematographic language. I was still affected by American films and, as the title indirectly suggests, Michael Moore's documentaries in particular. It is on this issue of language that I base most of my critique of the film, and this in two ways: first, the spoken language of the film, of the narration, being in English and thus inaccessible to a large part of the North African public; second, the cinematographic language which, although appreciated by Moroccan urbanites who were accustomed to it, fell into the mimetic trap many contemporary films from the colonized countries find themselves in. One aspect of this borrowed cinematographic language is its tendency to center individuals (in this case myself and two other young activists) in historic situations which are in fact molded by communities or peoples. Ideologically, this gives the film a liberal worldview which, as time passed and as I encountered various anti-capitalist and decolonial ideas, appeared to become more and more disconnected with our social reality.

12 The film became bi-national (Moroccan and Qatari).

By the time I started making *Amussu*, I had already rejected the conception of cinema as a "universal language," since I think it is a language codified and standardized in a manner that favors a Eurocentric perspective. Instead I adopted the notions of pluralism, diversity, spontaneity, and decentralization—cinematic multilingualism, if you will. This conception is not too dissimilar from Chomksy's premise on language and his critique of states that attempt to standardize how we speak and write. This is why we tried to develop a film whose language is based neither on Eurocentric nor national culture, but on a very specific local Indigenous culture. This was accomplished most notably by studying local cultural expressions, especially the oral arts that are dialectical and polyphonous by nature. This means they quite easily lend themselves to elaborating a collective protagonist. This helped resolve the individualist narrative we find in *My Makhzen and Me*, by removing the classical "voice-of-god" narrator who speaks to us from above and replacing it with a multitude of voices who speak to us from below.

MPB: With *Amussu*, you reach a film form that is at once activist (or artivist), and sheer beauty and poetry, deeply rooted in the cultural and political ways of the people you film. Can you explain poetry's role in the Movement, in your reflection as a filmmaker, and in the composition of the film?

NB: This question has a lot to do with the point I made earlier when I spoke of the necessity of developing a plurality of cinematographic languages as opposed to a single universal language. Perhaps here it is useful to compare cinema to agriculture: in the same manner that agribusiness has destroyed biodiversity by imposing monoculture, GMOs, and uniform agricultural techniques that are incompatible with local ecosystems, one could also say that nationalism, and (what Richard Falk calls) "globalization from above" have tended to push for a "monoculturalization" of otherwise very "biodiverse" and complex cultures.

So on the one hand, we have this art that is defined and imposed from above, a commodified art and culture that is driven less by social and environmental needs than by market needs, profit, and the consolidation of economic, political, and cultural hegemony, whether racial, gendered, or class-based. An art that has its roots in state-making and colonialism. An art that is classified, measured, regulated, and planned in a quasi-industrial process dissociated from local contexts while disingenuously claiming universal or at least national appeal. But on the other hand, we continue to be surrounded by art that is collectively constructed and spontaneously organized from below, through the accumulation or aggregation of millions of individual contributions and improvisations ... unplanned organic art, if you will. In many cases, this type of art is linked to egalitarian social practices, and in some cases it is attuned to specific communities as well as the ecosystems they inhabit. It is this type of art that has inspired *Amussu* specifically and my filmmaking practice more generally.

To be more specific, I am attracted by our oral tradition, especially Izlan (being a term which encompasses the entire range of Amazigh oral

poetic forms: Timnadin, Agouri, Aayta, Tamawayt, Tamdiazt, etc.). What I think makes most oral art exceptional is its unconstrained, participatory form. For example, many Izlan often come in the form of a non-linear mosaic of self-contained Izli. They neither have to be sung together nor recited in a specific order, allowing a high degree of participation, improvisation, and formal fluidity during performances. One can think of Izlan as a spontaneous network of poems rather than a rigid or fixed structure. In this sense, Izlan is a strong basis for a collective or communal model of artistic creation. It is driven forward by the multiplication and aggregation of individual creativities and improvisations over many generations. This open structure, if you will, allows each physical (as opposed to imagined) community to elaborate their own specific culture, thus making room for a highly "biodiverse" and democratic cultural landscape.[13]

TOP
Still, *#300KmSouth*, 2016, with Amdiaz Yassin Madri singing

BOTTOM
Recording the women's song for *Amussu*, November 2018

I believe this not only reflects a decentralized approach to art, but also an ideological worldview that sees local autonomy and social participation as primordial to both human and environmental welfare in general. This is why I think we cannot separate the oral arts from neither ancestral democratic practices like Agraw (popular general assembly), nor egalitarian socio-economic practices like Tiwiza (mutual aid),[14] nor ecological practices like Agdals (collective pastures or forests collectively handled and preserved).[15] In fact, oral art acts as a kind of a living, decentralized, immaterial archive, spread out across the many minds that make up a given community, and whose role is, among other things: to preserve Indigenous memory and history from a collective, bottom-up perspective; to encourage communal participation, democratic practices, and solidarity; and to guard local knowledge (i.e., the names of creeks, when floods come, when to plant, when to graft, etc.). It is no coincidence that these are also some of *Amussu*'s main objectives.

13 "A tale is only the way it is said. [...] Each storyteller has his own style [...]. Improvisation is capital to achieve his goal. [...] Because telling a story is not only relating it the way it was conceived by the ancients, it is mostly enriching it with new elements. This is the reason why a storyteller is also a poet. [...] [And yet] historians and classical biographers despise all that was not composed in classical literary Arabic and relagate into oblivion those "vulgar and illiterate poets," who, nevertheless, expressed the deepest feelings of our people. [...] Those ambulant singers became prominent during the fight again colonialist forces at beginning of the 20th century and under the Protectorate. [...] Many songs deal with the French penetration, the fight of the tribes, the Caids' and civil controllers' exactions; anonymous songs that anyone could make their own because they are said with simple words and a man's heart." Ahmed Bouanani, "Introduction à la poésie populaire marocaine," *Souffles* 3 (1966): 3. Translated from French by MPB.
14 During a harvest, for example, the community will unite "in Tiwiza" to help each other, or if an irrigation system needs reparation it will be repaired with the community's "Tiwiza."
15 Collective pastures or forests are used for wood and for pastoral activities, but their use is limited by the community based on a collective decision to preserve the wellbeing of the ecosystem.

Of Megaphones, Cameras, and Songs

MPB: Indeed, *Amussu* borrows its slow rhythm from the songs and poems scattered on its soundtrack. During one of the opening sequences of the film, one can hear the beautiful voice of the Amdiaz rising above the plateau, the village, and the mine in the back-

ground. The voice asks for God's benevolence, then claims that the singer is going to relate what the singer saw and what he experienced. This is a way of claiming that the film is going to *translate* into images the poet's songs, that the filmmaker takes on the role of the tradi-tional poet, and that the film is going to be a new contemporary form of song of resistance— indeed, it is going to tell about *one* episode of this resistance. This resistance is that of a collective hero, a community of peasants and farmers—it is thus made of and sustained by an infinite number of daily practical actions (the caretaking of almond trees, carpet weaving, etc.). These characteristics directed some of *Amussu*'s narrative and visual choices. (See texts on pages 222–25)

But beyond traditional Amazigh poetry or carpet weaving, what were your models, as far as films and film theories are concerned, for such research?

NB: It's difficult to trace *Amussu* to any single model as it draws from a variety of sources, experiences and philosophies. You could place *Amussu* in the Third Cinema tradition, but at the same time it neither adopts the didactic approach applied by Octavio Getino and Fernando Solanas in *La Hora de los Hornos*, nor the avant-gardist model of production proposed

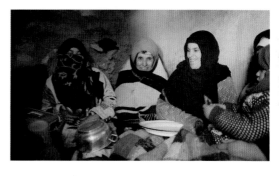

Stills, *Amussu*, 2019. Women working in the fields in spring, and singing in winter.

in *Towards a Third Cinema*.[16] Actually, out of all the Latin American expe-riences I've studied, I think our model of production most closely resem-bles Jorge Sanjines' experiences with Quechua communities in Bolivia, most notably in *Ukamau* and *El Coraje del Pueblo*. Both of these films were collective productions created through a participatory process. In fact, I have found "Problems of Form and Content in Revolutionary Cinema," Sanjines' article describing and theorizing this participatory process, to be more practical in the field than the Third Cinema manifesto itself. But overall, we could say that the new Latin American cinema, in a more general sense, has had a significant impact on my theoretical approach,

16 Fernando Solanas and Octavio Getino, "Towards a Third Cinema" in *Movies and Methods: An Anthology*, ed. Bill Nichols (Berkeley, CA: University of California Press, 1976), 44–64. First published in Spanish in the Cuban journal *Tricontinental* in 1969.

whether we are talking about Third Cinema, Cinema Novo, or Tropicalismo. I mean, for me, it makes sense to look at these as models, considering how closely the colonial histories and the neocolonial realities of Latin America resemble those we have in our region. But I am far from being the first to look in this direction; many before me across the colonized world have done the same, and so it has been just as interesting for me to learn from filmmakers like Sembene Ousmane in Senegal as it is to look at my predecessors in Morocco or Algeria and how they interacted with and applied these ideas and aesthetics in our region. In this regard, I am particularly fond of Assia Djebar (Algerian female writer and filmmaker) and Ahmed Bouanani (Moroccan editor, filmmaker, and writer),[17] to whom we can retrace our orality-based approach in Amussu. Actually, I see Amussu as a continuation of their work—a prolongation of this trend. It has become very important for me to build on and develop their ideas. Amussu has already made important steps in this direction; I think it does open new paths, but it is far from sufficient.[18] A lot more research, theorizing, and practice is needed. It is in this regard that I hope the modest interest some young Moroccan documentary filmmakers and film students have shown towards this mission can yield concrete projects in the near future. As for the "new urban cinema" generation,[19] it's difficult for me to imagine them shifting directions at this point, they are far too materially invested in the export-oriented model.

MPB: Has the film and its circulation fulfilled all your hopes and expectations?

NB: To be honest, I am actually quite disappointed with how the film has circulated so far. Of course, I am grateful that the film has been screened at major festivals, but these festivals were only meant as strategic points. First, they were meant to provide us with the credibility we needed to be taken seriously. Since people's minds are still colonized in Morocco, they need to see that you've been validated by the West's gatekeepers. Our project especially needed this credibility since we had no production company behind us. Many had initially ridiculed our participatory approach ... so getting into festivals was to say: "Look! It is possible for a community to produce a film and even compete on the international

17 Especially: *La Zerda ou les chants de l'oubli* and *La Nouba des femmes du mont Chenoua* by Assia Djebar, which attempt to visually translate Algerian female singing traditions; and *Memoire 14, Les Quatre Sources* and *Tarfaya* by Bouanani, which attempt to visually translate Moroccan oral tales.
18 Ideas explained in particular by Ahmed Bouanani in a roundtable published in *Souffles 2* (1966): "Bouanani: 'If we want our cinema to be a means of culture, information, a mirror of Moroccan civilization, it should have its characteristics. [...] Let's take a Moroccan epic: what should it be? Simply a long story, stretched over several films, which should relate the Moroccan people's history, since the most antique periods until nowadays. [...] There is no hero in an epic. There is a collective hero, which is the people. [...] It has everything to do with oral tradition. Moroccan tradition makes a huge use of epic.' Laâbi: 'The filmmaker may then make use of [...] the techniques of the halqa, or that of [oral] tales. [...] There may be, then, an oral transposition into an artistically-aware creation.'" Translated from French by MPB.
19 See Jamal Bahmad's papers and books on the subject: https://www.researchgate.net /publication/255717443_Casablanca_Unbound_The_New_Urban_Cinema_in_Morocco.

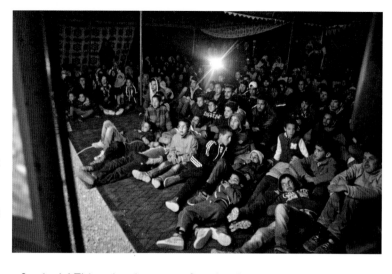

level!" And second, the festivals were supposed to attract distributors and help generate funding that can help us reach and organize screenings for a working-class audience. We were especially hoping to put together a mobile cinema caravan for the film to be screened in rural areas across the southeast and Atlas. This never happened because no distributor was interested in our film, despite its success at festivals! This rejection was often justified by claiming that the film "does not fit into their repertoire" or that it would be "difficult to sell." But I think it's because the film doesn't cater to Western audiences, neither through its cinematographic language, nor by deploying the stereotypical subjects-of-interest in our region that appeal to the West: gender, Islam, or terrorism, amongst others. As Assia Djebar put it in the documentary *Zerda* (1982), what they really want from us is to film ourselves "le ventre vide et les pieds nus, pour leurs belles dames et beaux messieurs!" [empty-stomached and bare-footed, for the sake of their pretty ladies and handsome gentlemen]. But this is not to say that subjects like gender aren't issues we need to deal with; on the contrary, they absolutely need to be handled ... but I refuse to treat them in a way that maintains imperialist sentiments and racism in Europe while failing to spark any genuine debate around these issues here.

Amussu's world premiere on top of Mount Albban, February 2019

MPB: In fact, when I screened *Amussu* in France, during the "Rendez-vous de l'histoire de Blois" in October 2020 (the one and only screening that has taken place in France in 2020, partly due to the Covid-19 restrictions, but also due to the lack of distributor), the reaction of the audience was quite the opposite of what distributors seem to fear, and radically different from many other screenings of Moroccan films I had already organized. The characters of the film were for once not perceived as instances of radical "otherness" or "objects of curiosity"—on the contrary, some people in the audience claimed that the film, and in particular the characters' resistance against political repression and environmental aggression and crisis, helped them understand something of their own condition and of the way things were going on and being dealt with lately in France, including the environmental crisis and police violence issues. So the film fulfills its purpose when confronted by an audience, but the difficulty is to overcome the reluctance of distributors, festival programmers, and venue managers.

NB: I am so glad to hear this! But international circulation was also supposed to provide us with the means to organize grassroots screenings in Morocco. That's not to say that we didn't. The world pemiere, for

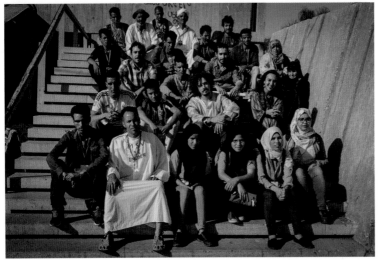

example, was organized at the protest camp. It was an unforgettable experience. The villagers put up a huge tent, built a screen, and ran a solar panel to power the projector, and in this way we made a makeshift cinema in the middle of the brush. The screening was attended by a couple of hundred people, the villagers of Imider, but also from other communities. Student "solidarity caravans" came from as far away as Errachidia; even some nomads who were passing by came to watch

MPB: Though *Amussu* intends to inform the world about the Movement, its cause, its cultural traditions, and its political experiment as a movement and collective film production, it was primarily intended for the community itself—to re-form or perform one's self when seeing one's self on screen. Something of this kind happened after *Amussu*'s second screening in Morocco, in June 2019 in Agadir (Fidadoc film festival): many among the audience chanted Amazigh slogans and raised the three fingers of the Amazigh salute, which was all the more moving as an important number of female, male, and child militants from Imider were present, revealing the extent to which *Amussu* is a powerfully vital, political, and aesthetical experiment.

The next day, a Q&A session with students revealed that young Moroccan filmmakers-to-be were as much impressed by this collective and culturally-rooted experiment, as by the political proposal of the Movement. For example, young Amazigh women from Agadir were impressed by the freedom of speech and political participation of women in those remote mountainous regions that they naively believed to be Morocco's most archaic and conservative parts.

NB: After Agadir, we also managed to organize several other screenings in collaboration with student syndicates in the public universities that have been economically shunned by the state, and culturally shunned by Moroccan filmmakers who prefer to show their films at private business schools instead.

MPB: The film was also shown in cultural centers and by French cultural institutes. Have you kept in contact and collaborated again with the community and the Movement since then? (See text on page 226)

NB: Certainly! Of course not with every member of the community (that would be impossible), but many remain my friends ... and when the camp

was dissolved [in September 2019] some of them came to live with me for a couple of months in Marrakech to take a break from the harsh reality in Imider, even if temporarily.

Besides this, we do continue to collaborate as the film still circulates and as producers they must be informed of its distribution and attend screenings when possible. I also continue to collaborate with some members of the Movement in my ongoing research on the oral arts, particularly through AWAL ("the word"), an oral arts program I co-founded with my partner Soumeya Ait Ahmed in Marrakech.[20]

MPB: Two years later, how do you judge *Amussu*'s experiment? What are your personal prospects and future projects as an activist and a filmmaker?

NB: I think it has been, generally speaking, quite successful. I mean, just the fact that we are starting to have more and more young people in both the activist and cultural spheres speak about Agraw as a model is something of a victory. But of course the experiment does have weaknesses, and I think the most significant one is that it is a mode of production that heavily depends on what I've in the past called "liberated zones"—that is, communities or spaces which have gained a certain level of autonomy from the state. As we can see now with what has happened to the Movement, as soon as it was dissolved, so too with the Agraws, the protest camp (as a liberated zone)—everything which allowed our model to thrive. Now we are left with a film produced by a community that no longer has neither the organizational nor practical structures, nor the morale, nor the energy to carry it forward as collective producers. People are tired and carry a lot of fear for what will happen in the future, and I understand that because that's what I am going through myself. Considering the current context, with a growing police state and increasing repression, it has become far more difficult to repeat the same experience since even the smallest resistance is so violently quashed.

So, for now, I have taken on the mission of working on and archiving our popular memory, more particularly our oral traditions, whether poetry, songs, legends, or folktales. If Bouanani was already warning us in 1966, in his "Introduction à la poésie populaire,"[21] that this needed to be done as soon as possible, you can imagine how much more urgent it is for us to do it now. This is why my partner Soumeya Ait Ahmed and I started this program called AWAL ("the word" in Tamazight), through which we hope to establish an audiovisual archive of the popular oral arts. This certainly means that I have less time to think about or make films, but I see it as a necessary and urgent work because a whole generation is about to leave us and take with them, a large part of our collective memory. I see it as work for the future of our cinema and our art in general, for future filmmakers and artists who I hope can find their inspiration on this land, from our Timnadin poetry and our legends, instead of only looking for it in Europe or the United States.

20 https://le18marrakech.com/awal/
21 Ahmed Bouanani, "Introduction à la poésie populaire marocaine," *Souffles* 3 (1966): 3–9.

I see it as groundwork for the construction of a cinematographic language which is no longer dependent on aesthetics and narratives that were introduced to us through unequal power relations and cultural imperialism.

I also see it as a way of doing justice to the regions that have been excluded from the official historical narrative, the regions where history was recited in poetry (as the proverb goes, "Tar Izli Urtamou" [an event without its poem is an event which never happened]) and not written by notables. So it's not just for artistic purposes, but also for research ... for linguists, anthropologists, historians, and even biologists! These oralities are not only art, they are also carriers of Indigenous knowledge: how we organized our environment, how we planted, how we organized our communities. For example, when the poetess, Mririda says (in "Bab Tagant," a poem describing a forest guard who punished some villagers for cutting wood to build and warm their homes): "Et pour cent perches (de bois), don de la nature généreuse, / Tu t'arroges le droit de nier cette bénédiction de Dieu! / Comme si la forêt était bien du Makhzen / Et non propriété immémoriale des gens de Tasselli!" [And for a hundred wooden rods, gift of generous nature, / you reserve yourself the right to deny this blessing of God! / As if the forest belonged to the Makhzen / And was not the immemorial property of the people of Tasselli!]—does this not reveal a certain ideological vision that many of our ancestors had? Does it not show that the so-called "savages" who lived in "Bled Siba" [the country of anarchy, as were called the rebellious Berber margins disobedient to the Sultan's rule] were not so savage after all? That they believed in social equality? That they resisted the idea of any external institution controlling the nature in which they lived and that they have come to know for centuries? They were not perfect, but they have much to teach us and we have a responsibility to document what they said

Acknowledgements

• The exchanges between Nadir Bouhmouch, Omar Moujame, and Marie Pierre-Bouthier took place from July 2020 – June 2021 between Paris, Marrakech, and Imider.
• This contribution contains a section with texts and words by Nadir Bouhmouch, Comité médias et Communication of Movement on the Road '96, Yassin Madri, and other activists of the Movement.
• The English versions of Omar Moujane's texts were revised by Omar Berrada.
• Photos and reproductions are courtesy of Amussu (2019), Comité médias et Communication of the Movement on the Road '96, Hicham Fallah (FIDADOC) and Elise Cortiou-Campion, John Englart (rights reserved), and Bethany Hindmarsh (rights reserved).
• Marie Pierre-Bouthier's acknowledgments: My warmest gratitude goes to Nadir Bouhmouch and Omar Moujane, for their trust, their beautiful words, and their patience in this long process of exchange. My gratitude also goes to Mohamed Ed-Daoudy (Tawja), another figure of the Movement on the Road '96, for his incredible generosity and in particualr for sharing countless pictures, links, and additional information. I am also thankful to Hicham Fallah and Sarah Ouazzani for the pictures they provided. I am deeply thankful to Omar Berrada for his enthusiastic, dedicated, and meticulous reading and revision of the English version of Omar Moujane's texts. Finally, this chapter would not exist without Jonathan Larcher and Alo Paistik's interest for a cause and a film that sadly interested too few people on this side of the Mediterranean: thank you for your openness, your patience, your precise reading of the contribution, and your stimulating and kind advice.

This chapter is dedicated to all the brave, resilient, and generous souls of the Movement on the Road '96 and of the village of Imider, as well as to all the political prisoners currently imprisoned in Morocco (#FreeKoulchi).

Speeches given during Agraws

The speeches, chants and slogans were presented at Agraws in Tamazight. These particular speeches are drawn from *Amussu*'s English subtitles.

A woman's speech
Peace be upon you, people of my land.

As the comrade said before … If other places benefit from the mining company, we don't care! But here they take silver and water, arrest us and compensate us with cyanide. If they're humane as they claim, they'll prioritise us. Those who pillage our land are left alone while our sons are jailed for speaking up.

I pity these thieves. What will they become in the afterlife?

We won't compromise on our rights any longer. We will no longer buy their lies. The mine syndicate had a 6-month strike and got "hereditary jobs".

We protested for 6 years And got plenty of jail time!

The police have invaded our villages.

They say we only die once. But when they've stolen our land and water. And given us cyanide; is this not another type of death?

They say we reject solutions. They say they gave us 50 jobs!

But 50 jobs in exchange for what? Is it for the cyanide? Or is it for all the wealth they took from '69 until 2017? Is it for the water? Is it for the misery? Is it for the prisoners?

Meanwhile, the miner's union undermines us. They say we'll never get anything from the mine.

But stay strong people! Our occupation is the only way to victory. Empower yourselves! Do not fall in despair! Never say "we have no chance." This is what they want. This is why they've dragged this out. They want us to lose hope. To turn against each other. To be divided. So that we never taste victory even if we get our rights. Be strong people! Be patient! Let's come to each other's aid. It's the way to beat these thieves!

Anyone who has stolen from this land will suffer the consequences later. For all the suffering we've been through. For all the thirst, tears, and fear. May God punish them. Whether they're locals or foreigners.

May we escape their heavy hands like the prophets did. May God keep us on the just path. May our miseries never be futile. Those who break us will be left to God.

Peace be upon you.

I'm sorry if I've said anything wrongful.

A child's speech
I salute the militants, and all people present in this Agraw. May our prisoners be released safe and sound. Thank you!

Amdiaz Yassin Madri's speech
Thanks to the comrade for these words.

I salute these militants for their resistance and all free people wherever they may be. I salute the independent and honest press.

In our demands we have to push for guarantees. That they will not go back to using water like before.

We need alternatives. The scope statement must be respected. Article no. 10/94 of the penal code gives the priority of water use to people first, then animals, agriculture, and last for industrial use.

The company is breaking this law, along with many others. […]

Because the state does not want people to be conscious. It doesn't want unity. As we reopen the debate about our list of demands, we have to understand that it's like planting a tree. If we plant an almond tree now, it will take 7 to 8 years for it to give its first harvest. The more we are resilient, the bigger the rewards. Eventually the harvests will get larger and larger. This is the kind of patience and resilience our cause needs. Thank you.

Slogans chanted during demonstrations

ⵓⵛⵉⵙⵙⵉⵙ ⵓⵛⵉⵙⵙⵉⵙ ...	Movement, Movement …
ⵅ ⵣⵀⵓⵌⵗ⵿ ⵉ ⵗⵔⵀⵀⵉⵓ	On the road of the martyr!
ⵜⴰⵉⵞⵎ ⵜⵓⵅⵓⵜⵓⵓⵜ ⵥⵓⵓⵅⵞⵓⵉ ⵥⵞⵣⵉⵓⵓⵉ	The biggest school for militants!

ⵓⵦⵉⵙ ⵅ ⵙⵦⵉⵙ	Hand in hand …
ⵓⵏ ⵉⵙⵥ ⵥⵔⵓⵙⵦⵉ	We'll break the chains!
ⵔⵙⵏⵏⵙ ⵓⵌ ⵚⵓⵉ ⵙⵦⵉⵙ	We're all one hand …
ⵥ ⵜⵓⵞⵙⵉⵜ ⵉ ⵓⵚⵜ ⵥⵞⵣⵇ	For the unity of Imider!

ⵙⵅⵞⵣⵇ ⵙⵅⵞⵣⵇ	Imider, Imider …
ⵅ ⵙⵙⵌⵣⵙⵜ ⵓⵙ ⵓⵏⵏⵓⵉ	Is struggling in the Southeast
ⵅⵦ ⵍⵓⵞⵓⵉ ⵌ ⵍⵓⵔⵓⵎ ⵌ ⵜⵙⵌⵓⵜ ⵥⵅⵙⵙⵓⵉ	For water, land, and a dignified life.

إميضر يا جوهرة	Imider, oh Jewel!
خرجو عليك الشفارة	The thieves have ruined you!

"Letter of solidarity to our sisters and brothers American Natives in their fight for water, land and culture."

Support letter from the Movement on the Road '96 ahead of COP22, distributed by email and published on September 11, 2016, on the Movement's Facebook page. The text is reproduced retaining its original style and formatting.

September 8, 2016

We, Amussu xf Ubrid 96 (Movement on Road 96) at Imider stand in unwavering solidarity with our brothers and sisters at Standing Rock in their struggle against environmental destruction and cultural desecration by the North Dakota Access Pipeline (DAPL), Energy Transfer Inc. and other invested owners, as well as the United States government.

Amussu xf Ubrid 96 condemns the construction of the DAPL as a predator enterprise that threatens the Sioux people's right to water and subsistence, right to health, right to a clean environment and right of self-determination.

We also support the appeal by Standing Rock to the United Nations, demanding that the United States government "impose an immediate moratorium on all pipeline construction until the Treaty Rights and Human Rights of the Standing Rock Tribe can be ensured and their free, prior and informed consent is obtained."

Furthermore, we are indignated by the heinous and violent acts of Energy Transfer Inc. and their mercenaries who, sanctioned by state authorities, have illegally desecrated ancestral burial grounds and attacked peaceful protesters with dogs and gas. We recognize these acts as a provocation and a form of psychological warfare on a non-violent protest camp.

On a different note, to our Sioux brothers and sisters: our solidarity with you does not merely find its source in anger and outrage at these most recent events. It is also comes from a profound sense of relation and understanding which emerges from the sentiment that we are suffering similar oppressions: both historic and current.

Like you, we are part of a confederation of native tribes, the Ait Atta. Like you, we have come under attack by a colonial power. Like you, we resisted bravely. Like you, we historically suffered and continue to suffer from land expropriations. Like you, our land has seen environmental destruction and our water has been polluted. Like you, we face a large corporation that acts without our consent. And like you, we have built a protest camp in order to shut down its penetration into our land and resources.

Five years later, the tents of our protest camp have now become permanent clay and stone dwellings as we continue to stand, sleep, eat, sing, create and live in the way of a mining corporation that has polluted our water and soil. We would say that we hope that your camp will flourish like ours, but it seems it already has. We wish you victory, inchallah.

In Solidarity,
Amussu xf Ubrid 96

P.S. If Standing Rock is sending a delegation or representative to (or in protest of) COP22 in Morocco this November, we would like to invite you to come further south to visit our protest camp on top of Mount Alleban.

Statement of the Movement on the Road '96, published after COP22

Published on November 23, 2016, in French and English on the Movement's Facebook page. The text is reproduced retaining its original style and formatting.

IMIDER STATEMENT
Azul …
Greetings of glory to the soul of the martyr of Imider fair and just cause Lahcen Osebdan, greeting of resistance to Imider residents and freedom for all prisoners of the cause detained in 1986, 1996 and 2011/2016, a tribute to all those who deserve gratitude throughout the world.

In parallel with the 22nd Conference of the Parties to the UN Framework Convention on Climate Change (COP22) held in Marrakech a few days ago, the Movement on the road 96 organized several forms of protest and activities related to the environment during 8–9–13–14 and 20 November 2016, between Alebban protest camp and Marrakech.

The movement has begun its program with two training workshops on 8 and 9 November, first on extractive activities, then about eco-feminism facilitated by activists related to the Movement and with the presence of a group of militants from Tunisia, Algeria, Kenya and the United States, as well as militants from Imider. There has been a thorough exchange of struggle experiences from different parts of the globe, before the launch of Imider Environmental Justice Film Festival, which presented the films "Mount Baya" from Kabylia, "Resistencia" from Honduras, and #300kmsouth produced by residents of Imider together with the interim Committee of the Imider Environmental Justice Film Festival. In addition to this, a number of short films were displayed for the benefit of children of Imider.

In Marrakech, the movement resumed its activities on 13 November by displaying the above-mentioned films before an audience including Marrakech's residents and some foreigners, followed by a press conference on the next day in collaboration with Redacop.

In addition to this, the movement has been part of the World March for Climate on the same evening, where banners, placards and slogans were raised in protest against environmental crimes committed by Managem company which sponsors the COP22. During these days, activists and human rights defenders affiliated with the movement have participated in a variety of meetings and seminars on water issues, women and the environment, the resistance of indigenous peoples to climate change, etc.

To conclude these various activities parallel to the COP22, Imider residents organized a protest march towards the silver mine that is being exploited by "Managem" since 1969, however the oppressive forces prevented the demonstrators from heading towards the mine. Dozens of armed police officers, elements of the Rapid Intervention and forces troops were present following an order of the Caid chief of Tinghir to besiege the peaceful march. Moreover, mocking and humiliating peaceful protestors were used as a provocation and a threat of participants in this struggle by the Caid chief of Tinghir "Ahmed Ikmakh" and a member of authority, "Ibrahim Mokhliss."

Through these multiple activities parallel to the COP22, the Movement on the road 96 aimed at bringing the attention of state officials and members of Managem, as well as the public opinion and international community to see the reality of the appalling conditions faced by the neighboring residents of Imider silver mine because of environmental crimes committed during 46 years by the official sponsor of COP22 including extorting and deteriorating our natural resources, polluting our environment with remnants of silver rejected on our lands without any treatment or processing operations, inter alia. All of these unlawful actions are done under the protection of the

public authority which protects the interests of a private company. The arrests occurred in 1986, 1996 and 2011–2016 can be considered as a proof, with more than 40 detainees (2–4 years imprisonment) and the martyr of Imider "Lahcen Ourahma" in 1998, etc.

In consideration of the above-mentioned, the Movement on the road 96 declares the following to the public opinion:

*Emphasising on:
– Justice and legitimacy of our demands and our cause, which derives from the roots of Imider collective living memory;
– Legitimacy and independence from any civil or political entity (associations, unions, political parties …).

*Our commitment to:
– The innocence of Imider detainees, the ones that are released and four who are still languishing in the prisons of injustice;
– Continue the peaceful struggle until our rights are attained;
– An official and serious dialogue as a means toward solving justice for residents of Imider.

*Refusing:
– Policies contributing to the pillage of our natural resources and polluting our environment by SMI/MANAGEM;
– Presence of security forces during our peaceful protests, as well as policies of negligence and attempt to circumvent our human rights dossier;
– Misleading the public opinion about what is occuring in Imider and systematic media blackout about it;
– Any compromise in our legitimate rights in exchange for certain concessions for the benefit of the company exploiting Imider's mine.

*Solidarity with:
– Detainees of Imider cause and their families;
– Free all prisoners of conscience and fair causes across the world;
– All social movements of humanist and fair issues (#Standingrock, #ZAD #NDDL, #NOTAV, Al Hoceima, Safi, social movements of south-east, …).

Movement on the road 96—Imider
Alebban protest camp, 22 November 2016

Mahmoud Darwich's poem "On This Land," presented by a young girl during Spring festival

We have on this land what makes life worth living
The hesitance of April
The scent of bread at dawn
An amulet made by a woman for men
The beginnings of love
Moss on a stone
The mothers standing on the thinness of a flute
We have on this earth what makes life worth living.

عَلَى هَذِهِ الأَرْض مَا يَسْتَحِقُّ الحَيَاة: تَرَدُّدُ إبريلَ, رَائِحَةُ الخُبْزِ في الفجْرِ, آراءُ امْرَأَةٍ في الرّجالِ, كِتَابَاتُ أَسْخِيلِيوس, أَوَّلُ الحُبِّ, عُشْبٌ عَلَى حجرٍ, أُمّهاتٌ تَقِفْنَ عَلَى خَيْطِ ناي, وخوفُ الغُزَاةِ مِنَ الذِّكْرِياتْ.

عَلَى هَذِهِ الأَرْض ما يَسْتَحِقُّ الحَيَاةْ

Statement of the Movement on the Road '96 concerning *Amussu*

Published on January 29, 2019, in French, Tamazight, and English on the Movement's Facebook page. The text is reproduced retaining its original style and formatting.

Through the ancient Amazigh proverb "Tar Izli Ur tamu" (an event without its poem is an event which never happened), our ancestors have affirmed the importance of poetry and art and their fundamental role in the documentation of our history and the wealth of collective memory. Today, the means of communication have developed considerably. Yet, this does not mean that we will substitute the poetry of our ancestors with cinema. But rather that we will combine the two arts to strengthen our cultural heritage and the legacy of resistance.

This idea has been applied to our upcoming documentary film, "Amussu," whose creation is a form of resistance in itself. The film tells the story of our continued struggle as the community of Imider, a village located in south-eastern Morocco. For the past few decades, we have faced the abusive exploitation of the biggest silver mine in Africa, owned by Managem corporation, a subsidiary of the royal investment holding. Our struggle is about the right to water, land and a decent life.

Since the summer of 2011, we have protested against mining activities which have depleted our natural resources and destroyed the environment in our region. But also against the Makhzenist state's marginalisation and impoverishment of our region. It is for these reasons that our social movement, which we have called "On the Road '96" has seen the light. Its name commemorates our community's last peaceful uprising, repressed violently in 1996. The Movement on the Road '96 brings together the people of the Imider tribe, men and women, young and old, students and peasants, through Agraw—the general assembly of the community. Agraw is an ancient Amazigh democratic system inherited from our ancestors after the founding of the confederation of the Ait Atta tribes, before the establishment of the modern central state. With Agraw, we make collective decisions through direct democracy.

After the fifth year of our protest, we decided to make a feature film with the help of one of the many militants for our cause: Nadir Bouhmouch, a young and ambitious Moroccan filmmaker with whom we have already collaborated with on two short films, and thanks to whom we have been able to give the right value to this artistic work. Launched in 2016, the production of this film is also made through Agraw whose decisions are enacted by the "Local Film Committee of Imider." This unique community-based production method is far from the typical one used in cinematographic production nowadays.

The thousands of people who expressed solidarity with the cause of Imider around the world often understood our struggle through the lens of its resistance, human rights, its demands, water rights and the protest camp on top of Mt. Alebban. However, this time, Amussu will reveal a world previously invisible to many; it will delve into the details of protestors' daily lives, their sacrifices and the achievements of the protest camp. Through this work which blends the seventh art with our rich tradition of Amazigh poetry, we will explore human stories to which few have been exposed. We will unveil the different practices that govern indigenous communities' relationship to the land, their local knowledge rooted in those historic democratic customs which testify to the strength of indigenous Amazigh social and political systems. These stand as an opposite to what we witness today: colonialist laws which maintain injustice and exploitation (especially the laws related to land, water and mining).

Yet, as rich as this experience was, it was certainly not easy. Here we are referring to the fact that this film was produced autonomously,

independently from any other entity. As such, the entire filming process had to be secured by the community, as we chose the right times and places to film to avoid the authorities. In addition to difficulties of filming in a repressive state, are the divergences of ideas between ourselves and between us and the filmmaker. These are discussed in Agraw with the objective of reaching a consensus that satisfies us all, particularly during the post-production stage. Outside of the filming process, we have organised cinema workshops which benefit the youth and children of the camp, under the guidance of the film crew and with the same equipment used to produce Amussu. In fact, some scenes in the documentary have been filmed by these trained youth, an illustration of our firm conviction to our right to practice art and culture without any restriction. Thus, in this manner we have directly used cinema, an art which is by no means exclusive to a certain social category or to those with money and authority.

None of us could have imagined how long our occupation of the pipeline would take, or that one day we will produce a long film about our struggle. We always hoped that a day would come when our problems would be settled and our normal lives restored with dignity. At the same time, we strengthen our resistance to adapt to the worst possibilities we might face one day, including the continued indifference of the Makhzenist state or a return to the arbitrary arrest of our youth. Throughout these years, we were forced to turn our resistance into a way of life and to adopt sustainable and long-term forms of resistance, with a conviction that change is imminent sooner or later.

The experience of filming Amussu is inscribed into this long-term form of resistance. It is a project not only for and about us, the current activists of Movement on the Road 96, but also for the timeless cause and ideas we defend since it ensures continuity and communication with future generations, and challenges all attempts to erase our history. This erasure has happened before, as we see today with the misleading dominant narratives about the Ait Atta tribe's resistance against colonialism in

1933, and during the uprisings of Imider against the Managem destructive actions in 1986, 1996 and 2004. Hence, Amussu also acts as an archive document for the generations to come, serving to preserve a significant part of the collective memory of our tribe's struggle.

Furthermore, it is noteworthy to add that Amussu is a unique filmic experience since it is the collective product of a social protest movement, and not a production company. This is a rare achievement, the first of its kind in Africa. Perhaps, the closest to it are some indigenous Latin American and Aboriginal-Australian experiences. This is something we are proud of, and hope our experience can provide a model for any social movement looking to make itself heard. We are also proud to contribute to the filmography of Assamr (the southeast) and to provide a new reference for the world to understand the struggle of our besieged village. We see this film as a voice of all the victims of the mine industry in Morocco (Tafraout, Askawn Taliwin, Bouazer, Akka Tata, Tighanimine, Tiwitt Iknioun, Oumjrane, Jerrada, etc.) and the voice of all those struggling against extractivist industries (like those in the mining basins of southern Tunisia and Algeria). We encourage all of these communities to demonstrate more interest for the art of resistance, the art of defending causes which concern us all. And in particular, those of indigenous communities, considering their attachment to land and water, and their experiences in defending these sources of life. Amussu is not only a film but an experiment in peaceful resistance, we submit it to all activists of social and environmental causes.

Today, we celebrate the Amazigh new year 2969. After 90 months of the existence of our protest camp, and 2 years since we have launched the production of this film, Amussu sees the light. Today, our resistance continues and we keep in our memory El Haj Mellioui, one of the characters of our film who has left us after a long struggle with disease. We hope the birth of this film will generate new lives filled with love and hope. The premiere of Amussu will take place here at the Imider protest camp.

Statement of the Movement on the Road '96 concerning the short film *Timnadin N Rif*

Published on July 13, 2017, on the Movement's Facebook page. The text is reproduced retaining its original style and formatting.

"Timnadin" for the Rif—a film in solidarity with our siblings in the Rif

Despite all the efforts by democratic organizations and social movements in defending the rights of Moroccans since the retreat of the imperialist colonial power, despite all the pompous slogans destined to mask the Makhzenist state's despotism, the human rights situation in Morocco is rapidly degrading on all levels—subjected to more violations than the period preceding the 2011 constitution.

What the people of Imider have undergone during the last 6 years, and what the people of the Rif have undergone since the murder of Mouhsin Fikri in Al Hoceima, demonstrates perfectly the relapse of human rights situation in our country.

The security approach with which the authorities are attacking the Rif's peaceful Hirak movement is a crime that has left deep injuries in the hearts of all those who fear for this country. They are events that will haunt our collective memory for a long time.

The militants of the Movement on Road '96, in addition to many other organizations and people of conscience in general—both inside and outside the country—stand in solidarity with the Rif and support its rightful demands. Demands which we believe, are not much different than ours as they touch on the people's socio-economic, environmental and cultural rights. Rights that we believe are a necessary prerequisite for living in dignity in our motherland.

Today we express our solidarity with our Riffian brothers and sisters through a visual poem, a short film produced by our Movement: "Timnadin for the Rif", meaning "Verses for the Rif." It is a collective production which saw the participation of numerous militants in the ranks of Imider's social movement.

By blending the art of Timnadine with the art of cinema, we wish to refresh Morocco's indigenous culture and to revive the legacy of the ancient poets who travelled from village to village, spreading the news of the resistance against colonialism and the Makhzen.

It is also a way of taking back the arts of our grandparents from the state which has promoted their degradation through their censorship, folklorization* and cooptation. In some places, the state has tamed the rebellious narratives that ran through indigenous culture. In others, it has completely marginalized and censored it. Both, the Rif and Asamer, are part of the latter group of places.

By addressing this poem to the Rif, we hope it could be of help in boosting the morale of the free souls fighting for the cause, and strengthening the Rif's spirit of resistance until victory.

Long live the Rif and down with its traitors

Long live Imider and down with its traitors

Imider-Alebban protest camp, July 12, 2017, Imider, Tinghir

* See Kenza Sefrioui, *La revue* Souffles *1966–1973: Espoirs de révolution culturelle au Maroc* (Casablanca: Éditions du Sirocco, 2013), 171, 175–76.

Excerpts from "Amussu, from theory to practive—Notes to the editor," Nadir Bouhmouch's personal notes

One of the fascinating aspects about the struggle of Imider is its capacity to not only raise consciousness amongst the community, but in the process, to also restore some of the dying cultural traits that once used to mark most of Amazigh society. Ever since the beginning of the struggle in Imider, the socio-political role of Imdiazen has made an extraordinary comeback after several decades of disappearance. For example, Uncle Tuness, an Amdiaz from Imider, has been documenting the entire history of their struggle against the mine since 1996. Here are four of his many Timnadin; these ones in particular recount the initial phases of the 1996 intifada in Imider:

We brought our donkey, loaded with blankets
And took to the road, armed with patience!
We moved next to you, Oh Albban!
That's where the water we speak about can be
 found.
We saw the youth climb the hills,
Escaping the soldiers' attack, escaping arrest!
Tea became bitter and water hardened
The day the forces came, to arrest us.

With each new event, a new Tamnadt is added—the Timnadin lasts as long as their struggle lasts. It is literally an epic tale of their struggle, down to the number of soldiers deployed, names of generals, and ministers involved. Using oral forms like these to document their history and call for resistance against a new invader, the villagers of Imider have given contemporary meaning to their ancient rebel-poet culture. […]

 Weaving, studying, feeding animals, plowing, typing, photographing, singing, harvesting and walking—all of these actions should accumulate throughout our film, laying out our "Azetta ." Woven together, it is the multiplication of these seemingly "mundane" acts performed by a great multitude of seemingly "mundane"

people which transforms history. Hopefully, this approach will also empower the viewer who may find that the smallest gestures in their daily life can be extraordinary and transformative. […]

 The importance of "movements" or gestures as I have outlined above is not merely a theoretical question. Sure, it does resonate with Marx's theoretical conception of history, what he called "material dialecticism"—but what I am proposing is also very much rooted in the community's own self-perceptions. Before filming *Amussu*, an Agraw n Kitaba (General Assembly for Writing) was held with around sixty members of the community. In it, people patiently took turns to express what they believed was important, what they believed should be filmed. Not coincidentally, all the suggestions were actually movements—gestures or daily forms of labor. Taking their suggestions, we set out to try to capture as many of them as we could over the last couple years. In the process of filming, I began to realize that these movements could be categorized into two principal types: movements of production and movements of militancy. Movements of production are the actions related to agricultural production or other labor. These include a variety of gestures ranging from harvesting to feeding chickens to building a new part of a house. Movements of militancy, on the other hand, are the gestures related to militant action. These include things like watching a film or even eating at the camp, painting a banner or marching in a protest. They are both movements that drive history, and they can both be considered movements of resistance. They are both deeply interconnected, one cannot exist without the other: collective militant actions are what allow collective productive actions to take place, and vice versa. This interrelationship can also be understood or visualized geographically between two central locations in our film: the protest camp and the oasis. The protest camp exists to protect the oasis, and the oasis sustains

the protest camp. The oasis gives the wheat for bread and olives for oil, which literally keep the people at the protest camp alive. And conversely, if harvests have been successful in recent years, it is thanks to the existence of the camp which has closed the valve and sustained water to the oasis. Hence, this Tamnadt written in prison by Yassin, one of the movement's former political prisoners:

Isurigh la vanne, ngess atghoni Ay-aman tag-holm-dak ighreminaw
I closed the valve, shut it down Water has returned to my ighrem (village)

This is precisely what makes the Movement on Road '96 victorious. It has managed to restore life to the oasis, making every harvest a tangible, edible victory! Thus, in our editing, we should try to somehow emphasize this linkage between the movements of militancy and movements of production, and their visualization through the two central geographic locations. […]

If movement represents life, the lack of it represents death. While the actors of the movement are constantly moving and changing, the pipeline and the mine remain static. […] In this sense, the mine as a counter-historic, anti-environmental force—even if it is very powerful—has been confronted by move-ments of resistance. The pipelines have been re-appropriated by these movements performed by people who are full of life. Through their many small, "mundane" historic acts, it is this enormous, powerful object which becomes mundane and useless. People perform theater on top of it, children play on it, uncle Said sits on it to feeds dogs, sheep cross it as if it isn't there, and life continues despite of it. […]

As Bouanani states, the Amdiaz "peut rentrer en contact avec les forces de la nature, les apaiser ou les déclencher contre quelqu'un; il parle le langage des animaux, des plantes et des insectes." [the Amdiaz can enter in contact with the forces of nature, soothe them or make them storm against someone; he speaks the language of animals, of plants and of insects]. Indeed, if we analyse the temporality and rhythm of *Izlan* [traditional poetry] we can notice that nature is often an accompanying instrument in itself. One need only listen to a *Tamawayt* performed in natural surroundings: unaccompanied by any instruments, the long pauses between one verse and the next allow us the time to hear the sounds of nature (streams, wind, animals, mountainous echoes, etc.). These silences are powerful, effectively play a role within the poetry, giving it a timeless and grandiose *ampleur*.

In the same way, *Amussu* should also make use of natural sounds. These sounds can help carry us from one scene to another. It can also help us define certain places. After all, nature is powerful. If climate can define the colours of a carpet and if water can define the shape of a mountain—then surely, nature can also define our film and how our audience experiences it. But not only that, we can also construct a diegesis around the natural seasons with which our characters constantly interact. However, our seasons should not be typical (i.e. spring, sum-mer, fall, winter). Instead the structure should be defined by the actual seasons we encountered in reality. This is related to the fact that seasons in the southeast, like in most of the world, have become irregular. As a consequence of climate change, some seasons simply never took place while others took too long. Our structure should reflect that. For example, we could move almost directly from summer to winter, since almond trees were never allowed the time to even shed their leaves. By winter they remained perplexedly green, suddenly finding themselves snowed down without warning. In conflict with humanity and itself, nature is itself a character in our film.

Selected songs and poems of resistance heard in *Amussu*

Yassin Amdiaz's opening song
 Qⵊⵟⵉ ₒⵏⵉ ⵔⵉⵕ ⵏⵒⵔⵉⵏ ₒ⋀ ⵉⵜⵜⵊₒⵏ ₒⵊₒ
I entrusted my affair to the Divine

ₒ⋀ ⵉⵜⵜⵊₒⵏ ₒⵊₒ
To the Divine only …

ⵏⵣⵣₒQ ⵜⵏⵉⵉⵜ ₒ ⵏⵋⵊⵟ ⵟⵊⵟₒⵊ ₒ⋀ ⵋⵟⵉⵊ ₒⵊₒ
Despite prison, time passes …

ₒ⋀ ⵋⵟⵉⵊ ₒⵊₒ
Time passes …

ⵟⵉⵙ ₒ⋀ ⵉⵟₒⵊₒⵏ ₒ⋀ ⵉⵊⵉⵙ ⵣₒ ⵉⵊQₒⵊ ₒⵊₒ
I want to tell what I saw …

ⵣₒ ⵉⵊQₒⵊ ₒⵊ
And what happened …

Improvised poetry battle on top of Mount Albban
Oh, people of Albban,
Oh resistance fighters!
Hear, hear!
One ate until full, and threw a bone beside me!
In the end, I was the one they accused.
Make tea and blow the embers!
But careful you get burnt,
A teapot can feel treachery!

Women's song
Oh mother! I am in prison
Guards surrounding me and the door locked!
Oh, I am locked inside! I cannot see the light!
My only hope is divine! Oh mother!
Tell them I have set up camp on top of Albban.

Women's song
Oh Divine, help us in our struggle.
Oh Titsa waters, you are named by our ancestors,
and you've defied the traitors.
The Movement has called the world to help us
shed the false accusations.
Oh traitors, Cyanide has made us sick. We will
never forgive you.
The Divine is witness of the mine's lies.
We came to the movement for justice, and found
a helicopter threatening us.
And the Caid, threatening mothers with a gun,
See what a man of the law looks like!
I thought Mt. Albban was infertile, until I came to
build a shed on it.
The valve is heavier now with the locks
we put on it. Now the enemy can say what it
wants!
Oh trees! Oh harvests! You can curse those who
have taken water from underneath you.

Amdiaz's song
In the name of the Divine whose name brings
good omen, whose name brings ease and joy to
the heart, may all the gates be opened, for there is
a rebellion in the village.

Women's final song
Oh Divine! Answer the prayers of those who
celebrate!
Unite me with Albban, where the children of
benevolence stand.
Relieve me with a sunrise.
For you didn't create us to give up.
May you rise like the moon …
Glorious among the stars!
Oh misery! Has God made you my companion?
But the Divine is capable of all,
Misery can't be everlasting.
Our sun will surely rise one day.

Two declarations published on *Amussu*'s Facebook page by Nadir Bouhmouch, following the film's world premiere at Imider protest camp

Published in Arabic on February 10, 2019, and in English on February 14, 2019. The texts are reproduced retaining their original style and formatting.

A few pictures from an extraordinary premiere last night at Imider protest camp.

We believe cinema is not limited by walls or laws, but that it is rather a space created by a gathering of people who are at one and share a collective experience, and that this space can be created in any place and time.

Hearing the laughter, the cries, the occasional "ayuz!" in the crowd at the premiere of ⵉⵎⵉⴹⵔ Amussu last night was an ecstatic moment. It was not a crowd of film professionals, artists, VIP guests or businessmen. There were peasants, unemployed youth, workers, children from the surrounding villages; there were also students who came in "solidarity caravans" from as far away as Marrakech, Errachidia, Ouarzazate or Agadir.

We often see film screenings as one-way acts: from the screen to those looking at it. Yet, what is on the screen becomes meaningless without an audience. They are what make the film materialise in the real world, what give it agency. In this sense, I could not have wished for a more magnificent audience than the one we had last night.

Perhaps it was more difficult to hold it on a mountain top where there is no running electricity, where we are susceptible to unpredictable mountain weather. But despite the obstacles, we consciously chose to go against the common tradition of holding premieres in fancy cinemas in the central metropoles. We believe a film about a struggle should launch itself from within that struggle. And for this reason, we will never regret losing the metropolitan audience for the sake of gaining this other-ed audience, one which has been denied their right to culture and to this special world of cinema.

It was an unforgettable moment in my life, the accumulation of a long period of work by many people: the community of Imider and the militants of the Movement on Road '96 who are the pillar of this film—producers, "subjects," and creators—to say the least.

But also the many friends who participated in making this film a reality despite all the difficulties we encountered along the way: sound recordist Jalal El Guermai who has shared with me the many hardships of almost 2 years of fieldwork on Mt. Albban. On production, Elias Talbi who has saved me from myself too many times and been patient with my incapacity to do math; also on production, Sophia Menni who has pushed me to think harder about each step, and whom I have almost driven crazy several times; editor, Maria Mocpat who has helped us weave a narrative from hundreds of hours of material; cinematographer, Yassir Charak who has helped us compose stunning images; sound mixer, Ghita Zouiten Elhachimi who has done magic to save us from deficient sound equipment and roaring winds; colorist, Ghali Ouazzany who has painted the final touches to give the film an aesthetic coherence; and the many many other people who have participated in realising this work …

To everyone, I express my deepest gratitude. Thank you.

— Nadir Bouhmouch, Director.

Of an Attempt to Deconstruct Landscape to a Weaving of Teachings

Etienne de France
David Harper
Jamahke Welsh
Jonathan Sims
Blackhorse Lowe

*in conversation**

edited by
Etienne de France

'Yahkwaa Pay Amat Chuumiich?
Looking for the Perfect Landscape?

Words by Etienne de France

Engaged since the beginning of my artistic practice in interrogating the notions of *nature* and *landscape*, I seek to understand how they are materialized within systems of domination and separation. How do a painting, a film, a garden, or a park embody these notions and become tools of power which, in the context of colonialism, are put to use in worldwide processes of territorial-cultural dispossession and appropriation?

Years ago, the videos and films of Hopi artist Victor Masayesva Jr. had provided me with an inspiring critique of the prevalent visual representations of the American Southwest. His works offered a powerful poetic and multilayered alternative point of view to the usual "perfect landscape" of the Southwest's visual representations, dominated by imagery produced by national parks and environmental conservation organizations, and globally relayed by airconditioned road trips, cinema, and visual culture.

These perfect landscapes are constructed by way of European American colonization and their continued US occupation, the past and ongoing genocides, dispossession, and appropriation processes. They are presented as Western Edens, drawing on the notions of wilderness, desert, frontier, and conquest, all the while alienating and erasing the Indigenous peoples and their immemorial relationship to the lands. Reverberating on a worldwide scale, the contemporary persistence of such aesthetic language still pervades many cultural forms, showing how visual art, cinema, and new media can be complicit in the processes of neocolonial extraction.

Acknowledging the Native Nations' long struggle against the incursions of extractive industries and green colonialism immediately complicates the everlasting fascination with the empty, contemplative so-called "desert" landscapes, populated by monumental industrial-architectural structures, staging modernist nostalgia and end-of-the word spectacles. The actions of a coalition of Californian Tribal Nations against the construction of a series of solar plants in Mojave Desert, including the massive Genesis Solar Energy Project, are one among these struggles.

Curator Anna Milone's invitation in 2016 to conduct a research residency at FLAX in Los Angeles the following year, offered me a unique opportunity to confront my artistic practice with these urgent and multi-layered realities.

In the months prior to this residency, articles reporting the Californian Tribal Nations' struggles against the implementation of the Genesis Solar Energy Project that had caused the destruction of archeological sites and cremation grounds, and documentaries such as the series *Tending the Wild* (co-produced by KCETLink and the Autry Museum of the American West), had led me to David Harper, at that time Mohave tribal spokesman and head of the Colorado River Indian Tribes (CRIT) Tribal Preservation Office.

All the images in this contribution are stills from the film *Looking for the Perfect Landscape*, 2017.

In May 2017, after arriving in Los Angeles, I decided to reach out to David. Following a short discussion over the phone, we agreed on a first meeting in the Californian town of Blythe, to have breakfast, to get to know each other, and to discuss my intentions and the ideas for what was to become *Looking for the Perfect Landscape*.

How to deconstruct Western homogenizing land/landscape/nature representations by establishing a space for critical dialogs with the immemorial experiences and practices of the Mohave people, and through the acknowledgement of the reciprocity tying together land, people, and language?

In a complex context of territorial and cultural conflicts over-simplified by the dominating traditional media, how could a film or an artwork have any relevance for Mohave audience and people from the Colorado River Indian Tribes?

Renouncing the monoform[1] and conservative codes of mainstream documentaries and films, how could an audiovisual poetic approach constitute a respectful and humble gesture with regards to the rich storytelling and song practices of Mohave Oral traditions?

Keeping these questions in mind, I approached the making of this film through reciprocity, beginning with patient listening, respecting the host protocols, and strived to engage in long-lasting dialogs, careful documentation, cooperation, and alliances.

After our first meeting, David agreed to continue the dialog, seeing in my proposal a possibility to create cultural and educational materials for the Mohave people.

Some two weeks passed and we met again for another breakfast in Blythe, on a sunny morning in the flat and spread-out town. We exchanged more about the structure of this film project, its possible narrative form and content, and David passed me copies of documentaries that the Colorado River Indian Tribes had been making about their history and the ongoing vital issues of protecting and managing water. In the first week of June 2017, David invited Maitê Fanchini, head of production for the film, and myself, to spend some time in Parker, Arizona, the main city of the Colorado River Indian Reservation. The idea was not to film, but rather that David, upon his kind invitation, would take us to significant areas in the region and introduce us to his own family, elders, Bird Singers, and activists. This is how I had the chance to meet first Gertrude Van Fleet, and then Jamahke Welsh, a young traditional Bird Singer then working for the CRIT Museum, both of whom would later assume central parts in the film.

These meetings and discussions, unaffected by the rush of a shooting schedule, the visits to Mohave landmarks often desecrated by industry and energy development, set in motion a process of transformation, accompanied by the experiences of waking up at dawn to encounter the presence of the Colorado river flowing by, serene and mighty, of witnessing the sun rising and then powerfully circling around people, mountains, mesas, and vegetation.

1 A notion elaborated by the filmmaker Peter Watkins.

Aware of my complex position as a white French artist planning to work on a film and an art project on Mohave lands, I spent many other breakfasts with David discussing how to bridge the Mohave's intentions to depict their own situation with a work that aims to deconstruct Western homogenizing aesthetics of *landscape*. I still remember David telling me, while driving to the Genesis solar plant: "landscape is people."

When presenting myself and the film project to the elders committee for their approval, I was asked to explain precisely what I meant by the use of fiction and poetry in a film directly addressing the questions and issues of their land and people.

My proposal consisted in using a fictional plot (the journey of a location scout working for a film production) to allow for meandering through real locations and encountering real individuals who express their own opinions. The poetic approach would lie in a particular audiovisual treatment: long and cyclical takes, repetitions of motions and situations; particular positions of people in the space of the frame; the use of a wide, layered, and ambient soundtrack.

During this period, David shared with me transcripts of Mohave myths and texts about Mohave cultural practices such as funerals, dreaming, Creation Songs, and Bird Singing, that we decided to use to structure the film: dreams foreseeing futures, the four days and the three nights, which constitute an important Mohave cycle guiding the narrative. The immemorial Mohave trails crossing desert, mesas, and rivers would join this structure to form a physical and metaphorical element innerving the film.

Back in Los Angeles after that first stay in Parker, I continued to exchange by phone and email with David and Jamahke on the various aspects of the developing story that couldn't yet really be called a script, but rather a grid of questions and themes leaving wide spaces for every-one's own expression and realities, creating a structure that allowed for improvisation and possible bifurcations.

In that sense, the writing and later the filming process are what I would call a "form in emergence," a dialogic method and approach that I try to re-question during the preparation of each new work.

During this period of development, the recommendations of the filmmaker and film programmer Adam Piron led me to invite the Navajo filmmaker Blackhorse Lowe to take charge of the cinematography of this film-in-becoming. Many of our initial discussions shaped the visual collabo-ration that would define the poetic aspects of this film.

In the last days of June, during a heatwave exceeding 45°C, we assembled a very light shooting team with Maitê Fanchini, Blackhorse Lowe, and Jonathan Sims for the sound, and traveled for a few days through Mohave lands. Guided by David and Jamahke, we also benefited from the counsel and teachings of Weldon "Jippy" Johnson, the former Tribal Historical Preservation Office expert on Mohave archeology. The advice and additional guidance of Blackhorse Lowe and Jonathan Sims, Navajo and Pueblo Acoma respectively, enriched the learning aspect of this shooting.

Along the way, our discussions and the reality of being on location led us to improvise and rewrite the structure of the film. There were oscillations between moments of reverence for the sites we were introduced to, and hesitations and self-questioning on how to bring a camera in contact with the land and the people. Fluctuations between the pleasures of spontaneous, casual, and at times deep discussions, and the necessary awareness of one's own position and situation in this context. Beyond the usual stress of a film shoot, doubts, tensions, and questions continuously inhabited me during the filming process, calling me to constantly reckon with my being an outsider and reconsider my expectations.

Filmmaking or artmaking couldn't be otherwise—a state of constant learning, of polyphony, of openness, and of fragility.

Polyphony and fragility also determined the process of editing and post-production between August and October 2017. Through careful editing by Aloyse Leledy in France, and consultations with Jamahke and David on the other side of the Atlantic, the voices of each participant were woven together, all the while deconstructing positions of authority in the course of storytelling.

The soundtrack and the collaboration with French musicians Setter (Xavier Gignoux and Marc-Antoine Perrio) and Vincent Ballestrino constitute an important aspect of this film. Their music tries not to dramatize and aestheticize, but rather to reverberate the multi-layered meanings, the presences, and the marks of intrusions contained in these lands; it attempts to reflect the poetry of the cinematography. Instead of imposing a "perfect" soundscape on Mohave lands, the soundtrack lets breathe the land and people that we encounter, leaving also a crucial space for the Bird Song of Jamahke, central to his persona, and central to Mohave culture, language, and lands.

In the film that was thus created, we follow Jamahke Welsh, Bird Singer, who is hired by a production company to scout shooting locations for a period film about the first encounters between the Mohave people and Spanish conquistadors. Through this work, he meets members and elders of his Mohave community, and travels to different places and sites on the reservation as well as on their aboriginal lands. Soon, the process of searching for filming locations reveals the need to portray other realities—of struggles against urban and energy development.

The act of looking for a location, a site, for a perfect landscape, dissolves into the living land, its language, and its people.

From an attempt to deconstruct the notion of landscape, the making of this film became a journey of personal and collective learning, weaving together the teachings of Jamahke Welsh, her elder Gertrude Van Fleet, Weldon "Jippy" Johnson, and David Harper.

The infinite interdependent relationships tying together land, people, and language explode the capitalistic and colonial endeavors to produce homogenous perfect landscapes. Mohave Creation Songs are epic song cycles telling of trails that connect places among river, mountain, and desert; in effect, they are spiritual maps of the land performed in mourning

and ceremonials that break down the notion that nature is a separate entity from culture.

In a world entangled in acute ecological and political crises, acknowledging and reflecting on the realities of the Mohave and the Colorado River Indian Tribes' struggles against neo-colonization and the intrusion of industrial-urban developments on traditional lands indeed allows us to reimagine critical and multi-layered representations of lands necessary for current and future political alliances. More profoundly, the places and lands, the people and all the dialogs that compose this film, address the transmission of Mohave knowledge, and the ongoing challenges of sustaining Mohave language and culture.

Looking for the Perfect Landscape is a forty-five-minute film, accompanied by a series of interviews and audiovisual archives. All dialogs in the film are excerpts of video and audio interviews that have also been separately edited as documents and archives. This whole series of works is now part of the Colorado River Indian Tribes' Library and Archive Center.

Along with the screened version of the forty-five-minute film, *Looking for the Perfect Landscape* is also exhibited as a multi-channel video installation.

The film premiered in November 2017, both at the Echo Park Film Center in Los Angeles, and in Parker, Arizona, during the Fall Gathering of the Colorado River Indian Tribes. At the same time, the audiovisual archives were exhibited and projected at the Colorado River Indian Tribes' Library and Archive.

From this first collaboration a new research and creative project has emerged, currently in development with David Harper and Valerie Welsh Tahbo, the director of the CRIT Museum in Parker. This project aims to create a dialog between the work that the French ethnopsychiatrist and anthropologist Georges Devereux conducted between 1932 and 1985 among the Mohave people, and the past and current archeological research and surveys carried out by the Colorado River Indian Tribes. The intention is to revisit Georges Devereux's research through the Mohave people's perspective. This work will lead to a film, a video installation, and the archiving of a series of previously unpublished and newly produced documents.

For the purpose of this publication, I asked David Harper and Jamahke Welsh to look back and reflect on the making of the film. These texts are followed by a series of conversations with filmmakers and producers Blackhorse Lowe and Jonathan Sims, who collaborated on *Looking for the Perfect Landscape* as cinematographer and sound engineer, respectively.

'Ahavir—The River

Words by David Harper

The river has many facets to the Mohave people. The word "Mohave" originates from 'Aha Makav meaning the people along the river, 'Aha being the river in Mohave.

In the creation stories, our creator Mastamho made the river out of a staff. He stuck that staff in the ground, made a hole, and when he pulled it out, the river started and came out. The river being made by the creator, it holds special sacred and spiritual content to Mohave people.

When you are bothered by the outside world of dark sides, you have spiritual unrest. And in that moment, you would go to the river to cleanse yourself. You go before the sun comes up, before dawn, because you want to welcome that day, pure and clean from bad thoughts and spirits. And when you do that, you start a new clear day.

When you are struggling or when you have a funeral for someone that had passed away, every day for four days, you wake up in the morning before the sun comes up, and you cleanse yourself.

In Mohave lore, we talk about crystals that you would find in the desert. We don't like to keep them, because regular Mohave people don't delve in the black magic of the crystals.

When you find these crystals in the desert, it is said at night, that they dance in the moonlight, beings coming alive. If you get that crystal, you will have great luck, great fortune in all your thoughts and desires, find the woman or the man you want. But you will have a short life and a quick death, because these crystals sap the energy. The only way to get rid of that crystal power is to put it in the river.

The river has that sacredness of the ability to cleanse and clean the impurities of life. Not just in this life, but also in the afterlife.

If you are swimming in the river and that there are holes in the river, vortex or whirlpools, these are babies that are gone on to the next world that live in the river. It is said to always be careful when swimming at night, because the river babies will pull you down by your feet. If one of those babies get you, you should just let yourself go with the current. They will pull you in and you will go down a few feet, but that vortex will shoot you back up. You just don't panic. We were taught at a young age, between four and seven about how to swim in the river.

Because you don't fear the river, you respect the river.

We stand in solidarity with the fight against the Dakota pipeline, and it's important to develop the concepts of "Water is Sacred" or "Water is Life," and what it means to be a River Keeper. The river has its own content, its own spiritual life. There are good things, and not so good things about the river, as the river does spawn life but also spawn death. If you don't respect it, and if you're not careful with it, it can take you.

We call ourselves the "River Keepers," "the keepers of the West of the river." We maintain the ability to work with the river, it's concept of spiritual content, and how we have worked, lived together, and used it for its purpose of farming, nourishing the body, cleansing. But you also have to maintain that spiritual belief of how deceptive it can be and how there were other sides of the belief of the river, such as the water babies.

You always make sure that you maintain that balance of respect and understanding.

The sacredness is that it is the giver of life and the taker of life if you are not careful. The same as today, as we live, there is life and there is death. For Mohave people, life and death are together, there is no difference. We live of our life of honor and gratitude, and as all living beings, we have to go through death, to reach the next world, where we are supposed to be.

You see this vein of lifeline meandering through the river, that water affecting all livelihood of Mohave people, who would interact with all the elements of the river, from the banks to the roots, to the animal and the plants.

The runners who could do up to a hundred miles a day knew where the springs were, and that is how they were able to run the trails and get water as they moved along and crossed these desert areas. The aquifers, the springs, the water that fed in the river made life sustainable at the time. And they would use these trails, and run sometimes at night, when the temperature eases, following as guides the quartz bricks reflected by stars and moonlight.

It is said that in the past, many people would push a very large cottonwood tree into the river, and that's how they went down the river to the other villages along the water. On a tree wide and long enough to hold up to twenty people. They would ride on the cottonwood tree down the river to the different areas they were going. The trees were so large that they would even cook on them. Granted that they had to walk back up, they had an easy ride. They had to have the knowledge and skill about how to navigate the river, to understand the sand bars, the quicksand, and the elements of the area. But they knew enough to know how to manoeuver these trees.

Of an Attempt to Deconstruct Landscape to a Weaving of Teachings

I am saying this to Mohave people, you may not have heard this. You may have heard a story that was similar but different, but we do this so you have a starting point to find yourself and what you are looking for. So you can tell your children. The whole purpose is to start the movement of the curiosity of who you are, and where do you come from. And if you say "you're not telling the story right." well, find the story and educate yourself or correct me. We are not above being corrected.

The story may not always be the same, but the element is of being of who we are and that you know I can tell you a story of Mohave creation. If you want to know more, research it and come to your own understanding. This is just the starting point of what we are talking about.

And that's just how we are, because our clans are different. What can happen on the southern end of the reservation, and how they perceive and look at things could be a lot different in the north. The base of the concept is the same, but the story may be a little different. It could be a rabbit, versus over here could be a coyote. There could be variations, but the storyline is always the same. Even from us here, to Fort Mojave or down to the Quechan. We may have a different perspective on how presentation occurs, but it still has the same storyline of thought.

Etienne de France: Would you say then that story-telling is not about truth or fiction, it is rather an invitation to reflect on layers of possibilities?

David Harper: Yes, that is part of it. It is the true story trying to sustain, and the other part is the inquisitive person who wants to know more.
Someone who comes and asks:
 – You know, I want to know more ...
 – What do you want to know more about?
 – Tell me about the tree, or tell me about something.
Then, I always tell the story. And I ask, well, what do you think?
 – I don't know, is it true?
 – That's for you to determine.
 – How do I determine that?
 – Well, look it up! You know, find out what you can look for. Come back and tell us what you found, so there is a full circle. And that's how things work. And sometimes, I'll come back wrong, and sometimes I'll come back right, but that's not important. What matters *is* that the person fact-finding the information makes their own conscious decision about what they want.

Ich Kunaav Chuu'ee Amat Chuumich
Two Storytellers and Teachers of the Land

Gertrude Van Fleet (1926–2021)

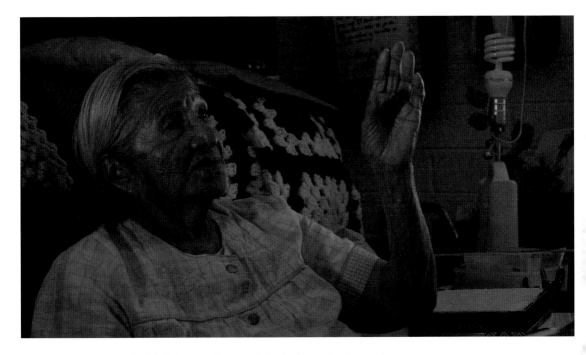

In the early years of 1900, it was Gertrude's father who brought
Christianity to the Colorado River Indian Reservation, and he set up the
first church. Today, many people don't realize that being the first preacher
went against the whole set of cultural values of the Mohave people and
he didn't have an easy time, he had a rough life. He was admonished by
the elders who practiced traditional ways at the time. When he set up this
new foundation of religion that was practiced in the boarding schools, it
brought a lot of hostility out of the people. At this period, Mohave culture
was alive and well, there were the four-days-long cremation rites, there
were shamans and medicine people, people who also practiced the life
on the dark side. There were still many rituals and traditions that were
practiced, there were runners that still ran the runs and the spirit runs.
The United States Government and its Army had their hard heavy hand
on Mohave people and our culture. It is little known maybe, but there had
been also a lot of blame on Christianity and white settlers for the spread
of smallpox. And there you have a Mohave man proclaiming himself as a
messenger from God, a God from the outside world, while you have had
these atrocities happening where many hundreds of Mohave people died
from smallpox. This must have been a tremendous pressure for her and her
family to even exist within the tribal community, and it was tough her for to
grow up as a child in that era. Gertrude is able to tell us what it was like in
the thirties, forties, and fifties, and the whole transition to where we are at

Gertrude Van Fleet

today. She can explain the story of the reservation: about how we moved forward to become less dependent on the government, more independent, and then on to our sovereignty; and about the traditions and cultural aspects that have occurred on the reservation. Because, even though she was in the church and her father a preacher, she and her friends still interacted a lot in the social dancing and the native Mohave culture on the reservation. And now being ninety-six years old and looking back to what her parents had to go through to establish this church on the reservation and going against the stream. So with Gertrude, you sit and you look at her, and her face is like a roadmap of life in Mohave ways.

She would tell me about these landmarks, about these oases that were in the desert where they would go swim and play all day, going home at night. They were used to walking or running six or seven miles, so free, the heat didn't bother them, they were so adapted to the environment.

Gertrude was alive before the dams, remembering when they were built. She talks about salmons that had run in the river and the ice that would flow in the river. Traditionally before the dams, Mohave people would go up on the mesas during the snowmelt. The river would become so wide and at some times three, four, five miles wide, and during the annual flow they would go sit on the top of the mesas until the water subsided. That's when they would come back, plant their crops, and that is how the cycles went. She knew the diversity of rivers from it being wild to it being dammed and the impact it had on the environment, the riverbed, and on the people and their culture. No more salmons, no more possibility to plant these crops. And so those ways of life were taken once the dams came in.

She would remember those aspects of the development of the reservation and the effects of some things we lost forever, and would defend some things we are clinging to, the language and our clan systems. She was very well aware of how the younger people, the forty-to-sixty-year-old people have lost their language, warning us that the potential of losing the language in our life time is very well upon our shoulder. Gertrude is as a resource, a book of knowledge. Her presence reminds us of our existence in the past, of our present and future perspective.

David Harper, Parker, December 2020.

Weldon "Jippy" Johnson (1959–2018)

I first met Jippy while being a Tribal Historic Preservation monitor. Being with Jippy is like having a teacher of the land. One of the most unique characters that I have ever met. Just learning from him, it was something I enjoyed. The pleasure to spend time with Jippy and to learn many of the cultural meanings of the land. The short duration that I had, Jippy was one of the most unique and significant parts of my life.

Jamahke Welsh, Parker, February 2021.

Jamahke Welsh and
Jippy Johnson

Jippy was working for the CRIT Museum at an early age, in the 1980s. It is really in 1981–82 that we started interacting. Jippy kept taking me out to cultural sites and asking me many questions about these areas. I replied then that I didn't know anything about them, and later I would go home ask my elders, my mother, my grandmother about these areas that we saw. And they would tell me that there are certain areas you can go and some not. Archeologically inclined, we would go to the forbidden areas because they had to document and archive these areas, but it wasn't safe for Mohave people to go to there because of traditional beliefs.

And so we started learning about Mohave ways early, always fact-checking each other about what we saw or heard, wondering about an elder's song. Going to these sites, sacred places evoking creation stories, talking about what they meant to Mohave people, about the avenues of death, of where the spirit goes once a person dies. And we would ask ourselves these questions, "do you believe the soul takes this route?" I remember being in those areas, where Chemehuevi people were put in the past, looking through petroglyphs and intaglios.

It was interesting because we both looked at each other as if to ask "do you really believe these things or are they just archeological findings that we are just archiving?" As you get older and become more mature in relation to what you are looking at and seeing, you start to develop keen

senses of what the true meanings are by people, elders, interviews, teachings, and by just being out there.

Weldon had an important archeological career, becoming one of the foremost experts in Mohave traditional culture, a man of so much knowledge of the land. When I was a Mohave traditional spokesman and going to federal court, talking publicly or presenting a local perspective to the council, I had to research a lot of the culture. I would run to Jippy and we had a full circle, sharing what we knew and submitting our perspectives to the elders. Although we didn't see each other some years, at other times we interacted on a daily basis hand in hand, fighting at federal court, or fighting the state about traditional Mohave perspective.

In 1998–99, we were part of the movement in Ward Valley opposing the nuclear dumpsite. Meeting with elders to determinate the traditional meanings of this site, we had to fact-check the area, and we found it was profoundly sacred. Jippy had to personally take a stand for ourselves, to go against this facility being proposed on a sacred site. Therefore, we had to rely on each other. During the occupation, there even had been sixty people carrying weapons to drag us out and take us to federal prisons. Jippy brought then twenty people to support the elders and take care of them. As one of the traditional leaders, I was targeted and relied on him for my safety, because so many things were happening, so many people, so many interactions, and a traditional and spiritual warfare of people against the US government. We could have been easily picked off, dragged out, subjected to threats of physical violence and harm, so we had to rely on each other up there for the whole 113 days during that occupation. We learnt then the spiritual content of the saying, "would you put your life on the line?"

Looking at each other in counsel, Jippy was protecting me in order that I could tell people the whole story if anything would go wrong. And so we created these different avenues to get me out of that area, and there were four or five people with me at all times to make sure that nothing happened to me. Elders were saying that warriors don't fight out of anger and hate, but out of survival. The first issue is to survive, because you can't help anybody when you are dead, so your whole main objective is for you and your people to survive, and if you have to hurt somebody or be hurt, that is part of the survival life. But when you hate or are angry, you are going to make mistakes, hurt somebody, or be hurt yourself.

When we were in North Dakota at Standing Rock with Jippy, we felt the same as we did in Ward Valley, seeing what we saw. The different kind of fights: the physical fight, the young people chasing bulldozers in North Dakota, and the spiritual confrontation, the type of fight that it was now our role to make. And we saw the same atrocities, the same things. Throughout political and spiritual struggles, Jippy remains also a man who was one of the foremost experts in Mohave traditional culture, a man with so much knowledge of the land. We could not learn enough from him, but what we retain from him will stay in ourselves, and sustain our knowledge and ability as Mohave people.

David Harper, Parker, December 2020

Of an Attempt to Deconstruct Landscape to a Weaving of Teachings

Anyoo Vidii
Opposing Instrusions

A conversation between David Harper and Etienne de France

Following the major land dispossession enforced by the US military and the relocation of a part of Mohave people in the Colorado River Indian Reservation in 1865,[1] Mohave/Mojave traditional territories and culture have been dramatically affected by colonization, mining, the building of railways, roads, and industry, while people were stripped of their culture and language via the boarding school system.

As with the Hoover Dam, large parts of their ancestral lands were flooded. The Parker Dam (built by the Bureau of Reclamation between 1934 and 1938) and its associated reservoirs and canals have deeply transformed the river, affected and modified lands and sites profoundly interwoven with traditional Mohave/Mojave narrative and spirituality.

Located at the border of California and Arizona, Parker Dam has shaped the reservoir of Lake Havasu, a very strategic area. Water is extracted and pumped for both the Colorado River Aqueduct (CRA) and the canal of Central Arizona Project (CAP),[2] providing water on one side to Southern California, including cities such as Los Angeles, San Bernardino, and San Diego, and irrigating on the other side Central and Southern Arizona, including its metropolitan areas of Phoenix and Tucson.

Holding significant water rights on the Colorado River since 1963, profound changes are occurring for the Colorado River Indian Tribes, as droughts intensify each year and water reservoirs such as Lake Mead are shrinking. It is also essential to remember that roads and irrigation canals were built with the forced participation of interned Japanese American labor during World War II. In 1942, more than 120,000 Japanese Americans were relocated and incarcerated. On the Colorado River Indian Reservation, the small community of Poston, not far from Parker, was the site of one of the largest Japanese American internment camps. More than 17,000 Japanese Americans were held there in camps and barracks during a three-year period.

Transforming traditional ecological practices such as agriculture and fishing, these water facilities have imposed intensive agricultural practices in Mohave/Mojave and Chemehuevi lands. Up to the present day, these developments have structurally shaped the economies and geographies of Fort Mojave Indian Reservation and Colorado River Indian Reservation, where Mohave people live along with Chemehuevi, Hopi and Navajo people.[3] (EDF)

1 The other part remained in the Fort Mojave area, where the Fort Mojave Indian Tribe is now located.
2 The Colorado River Aqueduct operated by the Metropolitan Water District of Southern California and the Central Arizona Project is managed and operated by the Central Arizona Water Conservation District (CAWCD).
3 The imposition of the United States settler colonial extractive economies on the Mohave/Mojave and the Colorado River Indian Tribes is echoed in the experiences of many other Native Nations. See for instance Nick Estes's (Lower Brule Sioux Tribe) *Our History Is the Future: Standing Rock Versus the Dakota Access Pipeline, and the Long Tradition of Resistance* (London: Verso, 2019).

Etienne de France: David, during the making of the film you took us to Mohave sites and landmarks affected by the intrusion of industry and individuals. The destruction in past years of the Intaglio in 'Avii-Thaampo, following decades of desecration of Mystic Maze and of the petroglyphs of 'Avii-Kwa'ame, the recent destruction of archeological sites and cremation sites grounds during the implementation of Desert Genesis Solar Plant or at the electric transmission line at Palo Verde-Devers II, all reflect a history of structural dispossession and devastation through the abuse of eminent domain and expropriation of lands. Continuing the transformation and destruction of the Mohave footprint, the building of plants such as Desert Genesis Solar Plant, McCoy Solar Plant, Palen Solar Electric Generating System, and Blythe Solar Power Project 1, 2, 3, without real government-to-government consultation, continues the legacy of past invasion and then colonization. Cultural appropriation through tourism, cinema, arts, and media also affects these lands.

By maybe coming back to the Genesis Plant case, could you tell us the current and future challenges that face the Colorado River Indian Tribes and Mohave ancestral lands, specifically in relation to water and energy?

252

David Harper: We have current and future challenges that are eminently now. What we are realizing is that we don't have enough educated people of culture, or people who have the sincerity and background to understand the Mohave culture perspective of land, water, people, and sacred sites. A song is a song and a mountain is a mountain unless you learn the traditional values of what it is.

You can't sing a song without knowing the language, you can't know the language without knowing and *singing the sacred area*. And you can't do that without knowing the story. You can't know without knowing who your people are, and so its purpose is all interlocked, and when you don't have that you're either mimicking or following as a sheep a leader who may not understand or know the complexities of what Mohave culture is.

And there are sacred areas that still are intact, but who is going to tell the story, because the story-tellers are almost gone? Being alienated by the health system, the governments, or drugs, violence, and alcohol. It is supposed to be balanced and equal, but it is not.

Mohave elders would always say that one would have to be mature and old enough to hold the information. But we realized that none of our

A view of the Desert Genesis Solar Plant from afar

Etienne de France, David Harper, Jamahke Welsh, Jonathan Sims, Blackhorse Lowe 253

people were making it to that age or maturity because they would die early. The keepers of the knowledge who waited for people to become mature and able to hand over the traditional spiritual things and understand them, they waited too long for these people because their health never got them to that point. And we lost so much information because of that. Our people were not able to maintain that age and maturity of understanding to the next level. You set a standard so high, which has been traditionally forever, and now it's unattainable because of the society.

People pass so young, eaten up by diabetes, cirrhosis, and health factors, but you also have a lack of school or education. Getting knowledgeable, we don't mature enough to get to that point. And even if we do, how do you hold this information to make it accountable for long standing.

In the area of the Genesis Solar Plant, those were the marshlands of the river when it flooded, when it became very large. As you look around there at the landscape you see the alluvial fans, which are the landmarks you see where the water comes through, and at the end of the bottom, that is where the prehistoric lakes are. And those areas around the lake are where they found a lot of remains of Mohave people, campements and several cremations sites, dated up to 10,000 years old. The geographical history of this area shows, that it was a swampland. There was an ice-age/prehistoric lake created from the rain of the mountain. Some of these lakes were very large and would go to the Colorado River, and they were part of the river that fed into it. Under them, the aquifers, the underground lakes were even larger, under the water tables. That's how Mohave people knew about the water tables, the springs and sources, or where to live, or where the water was high.

The intrusions we know are there, and we know the impact of the intrusions, but our due responsibility of learning our culture and traditions so we have the perspective to understand why we fight about what we fight over is being lost, and we have to rely on history books by non-Indian people to subject our ability to stand before oppression, and that is the problem.

That is the issue, because when we go to federal court, the judge asks you, "why are you here? What is the purpose?" And if we don't know our language, the songs, the history, and the people, we're like any other idiot in the world trying to claim a piece of land that we have no understanding of—the relationship that we should know by heart. In today's world, how do we sustain our cultural identities to the land?

That has probably been the most frustrating, because we may see our language die in our lifetime, and that worries a lot of people, but it doesn't worry them enough to move to have sustainability in our culture.

EDF: And on the Genesis case, you created a policy for reburial practices. Can you some say something about that?

DH: During the time of the building of Genesis Solar Plant, we created a burial policy for isolates and some of the cultural items that we found in the desert. The reason why that was done is because 3,000 artefacts were

A canal diverting water from the Colorado river in Parker

damaged and removed from the desert while they were building the plant. And once they're removed, they become property of the United States government, then it becomes the determination of the USA where they are placed and stored. These 3,000 artefacts including manos, metates, flakes, funerary items, cultural and ceremonial items, are placed in the San Bernardino County Museum in boxes in warehouses. Our position is that they should not have pulled them out.

As far as I know, this where they were last placed and so that's where they sit, and the Colorado River India Tribes' position is to have them brought back and repatriated back into the desert floor. But that hasn't happened because we are lacking people who understand why it is so important and significant that the items go back. And as we wait, elders are passing with the knowledge of why they need to go back, so we kick ourselves in the foot because we don't have the jump to get up and go to move these things to be re-placed back. It becomes just another chapter in our history of our inability to move things forward, to get things done, for whatever reasons. I don't know why people don't have an interest, don't understand; it is not their priority.

But, in the traditional world, there is imbalance amongst the tribes, imbalance amongst people, death, and this pandemic. Elders and traditional people would say, "this is why we need these artefacts back and to be put back in the ground," to create balance in our community, because we haven't solved this problem and it has affected our people.

EDF: And concerning the water and the future, how do you see the situation? The Colorado River Indian Tribes being an extensive water rights holder in the area, do you think states, companies, or other private entities are going to put more pressure on the use of resources now and in the future as the climate is warming, and with all the factors we know?

DH: Water is its own issue of either progression or regression for the tribe. I say that because within our tribal people you hear different points of view on whether or not to lease our water. And yet the water that went through our reservation is picked up by other states and used without compensation.

So it's important there to have an understanding the sacredness of the water. Define the sacredness to Mohave people, to the animals, to the plants. How is it balanced? How does it create an ecosystem of balance for everybody? Because that's how we look at the river and the water. And if it is sacred, can we create water sustainability for all people and try at the same time to maintain our cultural identity? We don't know how to do that, we are confused, because you can say water is sacred and has purposeful spiritual value, but we are leasing the water for golf courses, for other things than sustaining life.

I don't know, maybe somewhere down the road there will be a legal clause saying "recreational," or the tribes can put it for "human needs" rather than for sport. I don't know for sure also because the water world is evolving so fast and powerfully, and people want this water so bad. And we

are caught in this world of corporate values, which itself creates confusion because in order for the tribal people to have a good position, you have to open the eyes of the corporate world on how it relates to the water.

As with water, we know the impact of the intrusions on the land, but within the tribe itself what did it do? Jobs are jobs, money is money. But more exactly, what did it do, did it really help us, did we really gain anything? Did we live off any of that, or was it just intrusive and we lost what we lost? The river in all its glory is still alive today, still breathing, and still part of our life. For how long we don't know, because I am making assumptions.

We, people who are the keepers of the river and are the relative of water, are supposed to know the balance of that. And that's something we have a hard time understanding in today's age. What's the value of money versus the value of life? Today, we need to bring tribes to the table, to say what we want. We have to develop economic plans, talk about mitigations, and ask ourselves if we want this or that, not just for today but for the next fifty years and the next seven generations.

We can learn from what went wrong in the Blythe Solar Plant or Genesis Solar Plant in order to bring the tribes to the forefront. We need to have power to change things and give our opinions. We can't sit at the back and expect things to happen and let people do whatever. The North Dakota Pipeline is the best example. You do nothing and they are going to run you right over.

By the same token, tribal leaders have to open their eyes to the value water has in daily traditional and spiritual life. A lot of them might say "we're not there no more, we don't have that ceremony, we don't have that tradition, we don't that culture, we don't have that person." But that doesn't take away the traditions of who we are and there is some confusion on the value of water from a spiritual and cultural point of view.

And how do you prioritize that message to your tribal community, to understand this type of perspective that affects our livelihood and our way of life? It's an ever-evolving question, that can change this afternoon or tomorrow. And so the tribe has put the vote to the people on the water lease in 2019, but it doesn't lessen the value or take away the corporate need to have this water. All it does it gives it a different perspective: either we sit and wait and lose our resources, or we become competitive in the corporate world, have self-determination on water rights, and maybe lose our identity.

That's a vast and complex question, and I don't know all the infra-structure of the water leasing plans, or what the Tribal council is moving towards. But I know the inner infrastructure of our people, I know the spiri-tual meanings and the content of the water.

The environment in which I self-express my individuality is personal. I can take any path towards nothing and it makes sense. The connection I have with my skateboard and myself is undefinable, I can express and let myself be liberated. I've had good and bad times skateboarding which I can now use in life, they were lessons learned from my board. To pick yourself up, dust yourself off and keep moving.

You're going to fall and it's going to hurt but you keep pursuing onward.

Of an Attempt to Deconstruct Landscape to a Weaving of Teachings

Singing has been a part of my life since I was a young boy, I grew up around my father, uncles, and their friend's singing tradition Mohave Bird Songs. I was fortunate to have learned my Mohave culture and be able to sustain my traditions. I hold my Mohave Traditions close to my heart. I come from a long line of traditionalists, and when I sing Bird Songs it brings me closer to my ancestors.

Jamahke Welsh

Kuunaach Anyakura'oo
Notes on Filmmaking and Visual Art Practices

An exchange between Etienne de France, Jonathan Sims,
Blackhorse Lowe, and David Harper

What does it mean and imply for a white French artist to work on a film and art project on Mohave lands, and within the context of their struggles? Is it possible in artistic practice to bridge a work that aims to deconstruct Western homogeneizing aesthetics with the Mohave's intentions to depict their own situation? We reflect on these questions, and on filmmaking more generally, with David Harper, the cultural adviser of this project, as well as with filmmakers and producers Blackhorse Lowe (Navajo Nation) and Jonathan Sims (Pueblo Acoma), who were responsible for the cinematography and sound engineering work, respectively.

Etienne de France: Jon, on social networks, you posted an interesting article some time ago about how, since January 22, 2021, the National Park Service is no longer collecting application or location fees, or cost recovery for filming in national parks.[1] Is this an open gate to another type of endless image extraction? In a moment of lockdown, when we are overloaded with television series and advertising, does it mean filming more commercials, films, and videos without having an understanding of or relation to the land?

Jonathan Sims: It's interesting because it opens up the National Park Services to production without paying for permission. Prior to that, there was a specific price per day, and an administrative delay to go through. I think that in some cases what's going to happen is that you are going to see a lot of National Park Service imagery being put on stock image websites, and that is sad. But in the meantime, being public sites, picturing them should be public! It might create imagery we have never seen before. The advantageous part is that we will be seeing unknown images of lands, especially considering the creativity of some people on their drone footage— and that is exciting somehow.

 Are we projecting people down the path of creating without understanding the land? Yes. There, you have opened a wide open door for people who don't care about the environment or have any relations to the land. They are going to come in and shoot. I can imagine now that big productions will be using the national parks. My own experience working for larger productions is that we always left a huge carbon footprint, and we always left places different to how we found them, unfortunately. And that is the difficulty of working with big crews and a major motion picture company,

1 This legal decision has since been reversed and starting from October 28, 2023, the permits, fees, and "longstanding laws and regulations governing commercial filming in parks" have returned. See https://www.nps.gov/aboutus/news/commercial-film-and-photo-permits.htm

or a commercial agency. That the least of their concern. I believe that it is going to be rough. The Park Services will have to manage this a lot more than I believe they think they will. I think it will create exactly what you are saying. People are going to show up and use the land, not really caring about whether or not the land is left as they found it. But for the little guys, independent filmmakers, it's a chance to be able to shoot in unique places. If you don't leave a footprint, and a have a freewheeling run-and-gun approach to filmmaking, if you're taking care of the land and you're small and nimble, the national parks can become new possibilities. I can't even imagine some of the stuff that is going to come out of that. There are so many places so close to my place that I wanted to shoot using photography or video that I never could. And now it's wide open. It will make a big difference.

EDF: As a filmmaker and former Acoma Tribal Secretary, how do you approach creating an image of a tribal land, especially today with the over-saturating presence of cameras?

JS: A lot of times, we get fantasized image of what a tribal community looks like. That changes from place to place. But often you get this idea of poverty or barren lands. In places like my home, the Pueblos, you get the barren lands, but you don't get a lot of this kind of notion of poverty. When I was Tribal Secretary, I fought with a television crew from France. They had been doing a "This Is America" sort of television show, and they showed up unexpectedly to the Pueblos and were upset not to be allowed to film. I was telling them, "this is not just open public land, this is private, this is another, older country that you're in now." We went back and forth, and then this person asks me, "well, we're looking for images of poverty, where are your poor people?" I was devastated and we eventually ended up kicking them out of the Pueblos. But they came in, using their cameras to find imagery that work for the narrative that they wanted to tell. You have to be very careful in the process of looking for the imagery of the story you are trying to tell. In some cases, we do have some cameras coming up to Acoma, and they are there to portray the landscapes of a very ancient village that is isolated without running water, without electricity. We are the oldest continuously-inhabited community next to Taos and Oraibi (Hopi). There is that possibility to show this land that hasn't changed very much, but at the same time within that land you find today's peoples who of course have adapted, and so you've got to show that, the juxtaposition. One of my favorite images I have is of a sister-in-law: she is fifteen, in her contemporary dress in the middle of the old Pueblo, and she's taking a selfie of herself with her cellphone. There is nothing better to show that complex juxtaposition of old and past, and media, and all that intertwined. It can be a hard process, but I think when you create that image today it's more about what your intent is.

EDF: You do have pretty restricting rules about filming the Pueblo as well as for drones in certain areas. I find it crucial because these rules shows that a land is much more a landscape. In this project, I was trying to decon-

Of an Attempt to Deconstruct Landscape to a Weaving of Teachings

struct the notion of a location or landscape in art and cinema through a dialog with the depths and layers of what a place or land means for Mohave people. How do you perceive such collaborations, and is "reciprocal film-making" possible?

JS: Collaboration between Indigenous people and an outsider artist is one that is beneficial to both. On the filmmaker side you learnt a lot, I am sure. That's how I feel when I go to any of the communities I work with. It's always a mindblowing process when you're being brought into the middle of a community, one that is not often seen by others, or is privy to others. That is when and where the interplay is important, because you can't capture this time and place and not allow the people's voices to be heard. One of my priorities as a working filmmaker for the last fifteen years has been the crucial importance of that presence. To make sure that communities like ours have that ability to be heard. Often, in the communities they don't have that person inside [who can make the commmunity heard and seen]. Then, sometimes it's beneficial to have someone from the outside looking in because you get different perspectives. Not a lot of people agree with this, because they think it should be Native people telling Native stories. And that is very true. But at the same time, inviting someone with a totally different background to come, and trying to find that common ground, or finding an understanding, is important. Then, when you're looking at and questioning the landscape as a notion of art, what's important is to define what you are trying to achieve, what exactly you will use that footage for, what is the intention behind showing it? It just has to be a collaborative effort. Is it to show the modern and the past together, or separated? The regulations of the use of drones vary by community. Our restrictions have foremost to do with the effort to control how hunters use them to monitor game. Drones can be a great means of showing landscapes and lands. Often in my own tribal community I have tried to educate people about the uses of drones. Drones are very important pieces of storytelling nowadays.

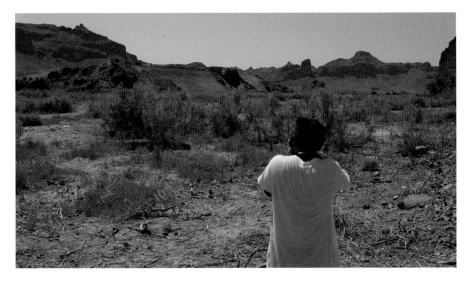

Jamahke Welsh, along Parker Dam Road photographing a quarry across the Colorado River

EDF: After the first screening of *Looking for the Perfect Landscape*, I started to regret the final image of the film with Jamahke standing alone on top of a small ridge looking down at the valley. My intention was somehow an attempt to break down some Western types of landscape representation or composition, and there I was often doing it again, with that an aesthetic of a character alone in front of a landscape. Blackhorse, remembering your short film *Shimásáni* (2009), and your work with often wide compositions and how you position your protagonists in them, I was thinking about this tension between deconstructing the classical type of composition in cinematography, and sometimes being pulled back to it. How do you manage this tension in your work?

Blackhorse Lowe: There is not even one film, and this is especially true of *Shimásáni*, where I don't regret the images and choices that I made looking afterwards. I always want to reshoot and re-edit everything, but you just kind of have to let it go.

In these independent productions, the film takes on a life of its own once you start making it, and what the images allowed you to capture, the situation it puts you in, the emotions that it throws you into, and the different challenges … it's all part of the overall process. It is the life that the film took on, and then it moves us, pushes us in those ways. Once you get that final edit done, you see and reflect on where it took you, what kind of knowledge and emotions you gained from that experience. But relative to the first conversations I remembered we had before filming, I think it accomplished the goals we had set for it in terms of the story, even though it is of course from a Western perspective. But even for me, a lot of my film education and the films I love are European and made by white directors. I am taking them, fusing them with my eye, which is Navajo, but all my training comes from these people, who are basically Western film directors. Michelangelo Antonioni had a very large influence on my work on composition. For the places and sites that we were filming, we were combining the vast spaces of the lands with the kind of naturalistic cinema characteristics typical of the 1970s cinema. Our shared cinema influences mean that most of the images are composed in this way, they are shot in a very specific way, with an emphasis on lines, mountains, and skies cutting across the land.

So, European-educated in terms of cinema, but Navajo in terms of shooting on Mohave land and having to translate that into this new kind of hybrid cinema. All this is sort of cyclical in a weird way, where all things are strangely connected. At our point in history, there is no separation from one to another, it's a global artform now. Especially when you look at the way Indigenous people have been a part of cinema—as far as back as the Lumière brothers or any of the first Georges Eastman films and all those who built early cinema cameras, many of the first images they shot were Native Tribes. Since the beginning, we have been associated with motion pictures. First we were the subject matter, then at different points we picked up the camera and started shooting ourselves. It is a very complex relation we have, then, with the moving images. It is hard thing to dissect

and say what goes where, because it became a new art form that kind of meshes all these different elements at one point.

To reflect on this using an example from the film's cinematography, we were often trying to express the many different levels of narrative taking place: the valley and the different mountains in the background what they signify to Mohave people, and what they were telling us, of what their creation stories meant. I wanted to express how these combinations of the traditional way of seeing the land met with the solar plant—this technology imposing itself on their sacred site.

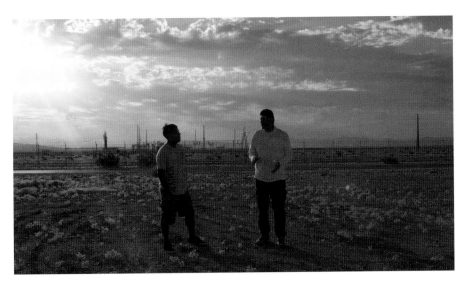

David Harper (right) and Jamahke Welsh (left) in front of a solar plant complex outside the city of Blythe, California

Many different narratives were happening there, with David telling Jamahke the history of the land, and Jamahke taking in the whole place [of where the scene was filmed]. I felt that this spoke a lot about what the film was going to contain, being a younger finding about his lands, himself, and his roots, where he comes from, where he presently is, and what he's going to do with all this knowledge. Another example would be the sequence where we filmed Jamahke skateboarding towards this highway off in the distance, along with the electrical power lines and the mountains. Other combinations include the loneliness of the character in vast spaces, a very contemporary Indigenous Mohave person influenced by Western culture with a traditional tattoo on his face. Skateboarding along this road, crossing a sacred site, he's making the best of it in his own landscape and amongst his own people. I used to skateboard, and somehow that culture fuses with the desert. Growing up on the reservation, it's hard to find a place for skateboarding. But there he's got a road, and it's open, he can do whatever tricks that he wants and make it happen.

EDF: The element of time and the length of shots can also challenge the notion of landscape. Time to make up your own mind, to wonder—a displacement. How do you perceive this notion of time in relationship to our discussion on photography?

BL: Letting the shots hang makes you feel what time does to you, and how it affects your thinking; reflect on it on a spiritual level. We could refer also to another common reference we share, Andrei Tarkovsky. The essence of his poetry, weaving morals, ethics, spirit, and using religious iconography infused, for example, *Andrei Rublev*, where monks are out in the land-scape, speaking and questioning God and existence, interrogating what we are doing here and how we deal with these different challenges. As a Navajo, that is what I got from being on Mohave lands where you feel these connections between family members and the land. It echoes our rever-ence for nature and for everything that surrounds elements that compose all of humanity, that are all materials from the stars, matter that are we made of.

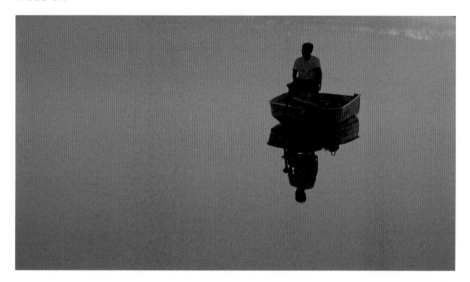

There was this shot at dawn. It feels that Jamahke is floating with his thoughts in another world, on a piece of glass. And yet, he is there on the boat floating on the water, on an arm of the river that is a spiritual place, to cleanse. It relates of this very holy time of the morning. For Navajo people, it is the time that the holy people are out, when you do your prayers. It has the same type of resonance to me. A source of living and a place to make offerings.

EDF: This image represents to me a fruitful meshing of our discussions during the filming. At the same time, in these moments I was very aware of my external position as a foreigner in Mohave lands, yet wanted to confront the questions underlying this film through an aesthetic and political dialog, if that is possible?

BL: As far as myself and Jonathan Sims (Acoma Pueblo) are concerned, we were also foreigners to that area too. Culturally speaking, three extremely different people—different thoughts and ways of believing. All Native Tribes are not the same, so we don't know the protocols, how to interact with other nations. For example, our relationships to death are very different.

Navajo want absolutely nothing to do with death, while we have specific rites. Mohave have a very different relationship to dying and very important rites for the body and the spirit to move to the next world. Western people tend to consider death as being the moment it physically occurs, but for Navajo there is a residue, a reverberation that will affect the rest of your life if you don't approach things properly, with the proper songs and prayers that go along with those moments, to bring you back in harmony and balance. If those things are not done, it will affect you further down the line, maybe something mentally, physically, in your physical space, your job—you don't know. These are things to always consider when you explore them, how to properly approach them and to be respectful to them. Within this context of several nations and cultures meeting, different systems and values meeting, and ways of seeing things, it made for an interesting film and a different experience.

One point I always have to consider when making a film or shooting somewhere, especially going through such locations which were at times actually Mohave sacred sites, is: how it will affect me in the long run? Will it come back on me? Did I do the proper prayers? Did I show the proper respect? What will happen to me because of it? That thought is always there. It's not just for one specific location, it's in all the film I make.

Filmmaking is a process in which you have to impose yourself and your goals on everyone in order to make the images you want—in which we forego this pushing attitude and become more gentle. They were very complex and sensitive moments when we were working together, always having to walk on eggshells, and in the meantime having to make many decisions. I love filmmaking because you have to constantly try to figure out a way to weave a way through chaos.

EDF: Weaving through chaos is a great angle to approach the idea of a location, often sought for in the arts and especially cinema. The title of this film is very ambiguous, *Looking for the Perfect Landscape*, or in other words, "looking for the perfect location." Because, what does it mean to go to a location and to be filming there a scene? How much time should we be in one place and how will this space influence you later on? How to relate to this place and the multilayered meanings it has for the people of this land? Confronting the capitalistic and extractivist approach of cinema and the arts to the land, it is crucial to address these notions of location, of site, that are also living spaces!

BL: Yes, because a site, a place, a landscape, is definitely a character that you can't separate from the narrative and the emotions you're trying to compose. The sites are the foundations out of which you compose your story. I was talking recently to our production manager about this next project, and I was insisting on having locations in Four Corners Area, in White Sands, because these scenes I have written speak for those specific landscapes—those landscapes are tied to the narrative, to the meanings they have to the character. And these landscape are tied to the overall essence of the piece I am writing and making. Those elements are crucial,

Etienne de France, David Harper, Jamahke Welsh, Jonathan Sims, Blackhorse Lowe 267

but it is often a struggle, especially with industrial cinema or corporate and commercial filmmaking, where you are only looking at financial means. This is why working on that film with Mohave people was another approach, because we didn't have the constraints of those types of productions. We were actually constantly brought by David, Jippy, and Jamahke to various sites and places, taking the time to compose and being immersed. You then free yourself from the shackles of filmmaking.

EDF: David, considering your experience in conflicts such as Ward Valley, Genesis, and your long work as Tribal Spokesman and Tribal Historic Preservation Office (THPO) director, could you consider film or video as another tool of resistance alongside legal, political struggles or physical resistance? Could we consider those forms a sort of educational resistance?

David Harper: This question brings me back to when I talked with members of the American Indian Movement during the struggle at Ward Valley. Their leader, Dennis Banks told me: "We are in a different time. Maybe in old days we used bows and arrows and then guns, but in today's modern world, we have to use the media and documentation of films as weapons of resistance, because our elders are leaving us. When we record our elders, it is documentation of events, of time and place, and it proves that our elders spoke, and revalidate our elders' speech to film and movie, that what is, is." And he explained that, how we look at our perspective of archiving our lives, traditions, and culture is not for us today, or for me tomorrow, to use in a movie, but it's for the next seven generations. Seven generations of culture sustainability. And then who is to say that it is not the resistance against the government or the industry coming to take our land? Who is to say that these documents and films and movies aren't our testimony?

Since then, I have always made a point documenting, archiving, filming, writing, taking pictures, to somehow create a moment and suspend it in time. Not for today, but for later on in life. The whole purpose of me doing this book or a movie isn't for me, it is for my great-great-grandkids. So that one day, they can identify or have an understanding where they come from and who they are. Or, for example, a lawyer, a tribal member, who needs information about our people, our territory, or our perspectives.

And in terms of resistance, I see film as having several different points of importance. First, it shields us from the outside, and also even within our own selves, our own tribes. Then, it is education—of belonging, of people looking for their plight in life, or where they belong and who they belong to. Thus, I think that films and books have value because often today we use them in different projects because our elders are gone. The people that we imagined would be here forever are forever gone to the next world.

Unless we have the greatest memory and can sit and think and dream about these things, we have a hard time piecing back together the events— even looking at Ward Valley, for example. Almost everybody from that event is gone, passed away.

I know that all the elders are gone, except one or two. My mother talked about this impression of watching the films of the struggle at Ward

Valley. It was as if being in a dream, feeling again to be safe together, against this hostile environment. It was like a dream of remembering again people trying to harm us or get to us. But yet, we were able to stay inside that circle. How do you articulate that over time? Films are living documents that are suspended in time forever, and you can go back to them. That's the power of resistance and shielding. Memory, and the trigger within yourself that it gives, is powerful.

EDF: Often the movie industry imposes its rhythm. How do you see the conflict between the rhythm and the commercial goals of the cinema industry, and the time needed to understand all these deep stories and emotions layered in the land?

DH: I think that a person can be very selective in that process. You don't want to be producing just to make movies for your own self. I am about sustainability, archiving, holding information, so we look further down the road. If someone gets to me and tells me "I want to make this movie, what do you think?" As a Mohave person who is supposed to have some integrity and thoughtfulness, I might look into it and if I disagree I may then say: "you know what, I am not going to do that."

I want to look at the content and the means. This is the change I have been talking about. Native people want a seat at the table, and we want to be in control of that table as it relates to ourselves. So many times, movie people have come and filmed as an intrusion, not as an invitation. As we start moving in these directions, we want to say: this is what we want to talk about, this is what we feel is important, and this is why we want to do it, so we have an educated process for sustainability.

Things can be exploited and discredit the value of cultural purposes. That's dangerous for Native people because one can re-write history or reduce the meanings of cultural perspectives. I try then to look at a proposal and understand what is its core value and purpose? How is that going to reflect years later? Am I diluting the culture, or creating animosity, uncertainty, and confusion?

With the elders, it was our decision to engage in this film with you, that reflects a cultural duty of creating narratives, documents, and archives that foster the sustainability of our people. Films can be educational opportunities, inviting our people not to fact-find in order to ridicule somebody else, but to fact-find for themselves. I always tell people: you can take this film or this book, you can listen to it, use it, fact-find it, but is to stir the curiosity to understand more, to become more inquisitive.

The whole purpose is to start the movement—of curiosity about who you are and where you come from. Go find out what that is. Do you think it is wrong?

Then look for what it means. Because if you put a concerted effort into researching and finding out what that is, it is going to stay with you forever.

Inyeech Idiik'avath
Returning Home

Words by David Harper

You can't sing a song without knowing the words to your language, without knowing what you're singing about, the landmarks, cultural, spiritual landmarks and pathways. Because you sing it, you have to know Mohave life, how Mohave creation and death are both woven in the same fabric.

I should then know the meanings of the words, so I can interpret the songs that are mostly related to the landmarks and the stories of our land. When Bureau of Land Management requested a map of traditional areas, Mojave from Fort Mojave sang to them. Mountains and locations are talked about in the songs. The songs are the maps of identified landmarks, and of the spiritual content of our people.

When you pass away and you take a last walk on earth, you follow the footsteps of your life. And you go to these areas that are sacred to Mohave and Mojave one more time before you leave this earth. That was the map they were singing.

'Avii'Achii is Fish Mountain and gives reverence to the fish that has always sustained us. 'Avii-Hakwahel is Red-Tail Hawk Mountain, referring to the warrior clan. Avii-Haly'a, is Moon Mountain, the moon providing guidance and direction at night for the runners and the people who were in the world that move at night. Each of these sacred points has significance not just to the life in the past but also in life itself. They create balance for who we are as Mohave people, and for our spirit.

Spirit is balanced by the way of life. You get up in the morning before the sun comes up. We wash, we cleanse in the river, and we welcome the day. And at the end of the day, you wash to clean away from the day that has ended: it may have been a good day or a bad day. Bird Singers have this song: "The day is over, we are welcoming the next day. And the next day is the new beginning of the end of the day."

The beginning of the day is the ending of yesterday. Life and death are the same concept, there is no fear and no difference between life and death. It is the cycle of life, how we live. And those references, those points of sacredness in our beliefs, or in our ability to practice or understand, comes at a time when we are seeking our own self-existence, of who we are as a human being. Imagine that you live your whole life, and at the end you look back on how life was. And you can see all the relationships and the kinships you developed with people, but also with all our non-human relatives. That is how life is supposed to be.

From the beginning to the end. Because the end begins your new life in the next world.

Caught up in power, politics, and today's world of fast self-gratification, we fail to look at the existence of our people who used to sustain themselves in the culture, how balance was maintained and created. We want things now, we don't want to earn our perspective, our livelihood

of who we are. We just want to be given things. Alcohol, drugs, sugar, and entertainment keep us from struggling in our spirituality of seeking, because these are the fast remedies of our people, since we lost this ability of being patient and respectful.

In life today we are lacking the ability to take time and understand content, be serene, with reverence to our culture. It takes patience to go out to Mohave landmarks. Mohave culture had always incorporated this ability of patience, by going out to this mountain or that site. You run around and then you sit and talk about oral tradition. It is almost impossible now for a young person to sit down because they want to see, look, and touch everything. It is good to be so curious, but we encourage patience also, to sit and to listen to the stories. To teach the reverence of what sacredness is.

Educating our young people about where they come from and who they are creates a center of certainty of our culture, allowing us to understand perspectives and become keepers of our culture. The reverence of our people to our traditional culture and landmarks, it encompasses everything of the human being in a Mohave person. You can't have the language without learning the landmarks, you can't know the landmarks without knowing the songs and their meanings. Being Mohave is inclusive, based on who we are, and all these elements are part of our reverence of our existence in our culture.

When you go the mountains, which mountains are you going to? When you go to teach to children, what is your perspective of that mountain? What is the word for that, the traditional meaning?

"Camera Is My Machete."

Promedios and the Construction of Zapatista Alternative Media

Francisco Vázquez Mota

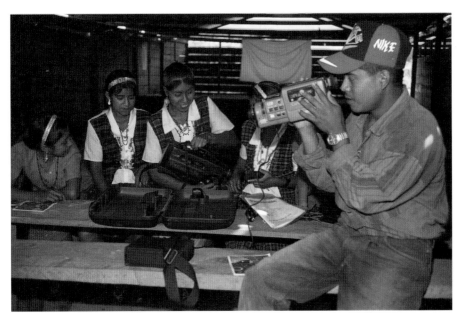

First workshop in La Garrucha, 1998.
We came down to the community of La Garrucha to hold
a training session for the members of the community,
selected by the assembly, to be responsible for
documenting and producing audiovisual materials.

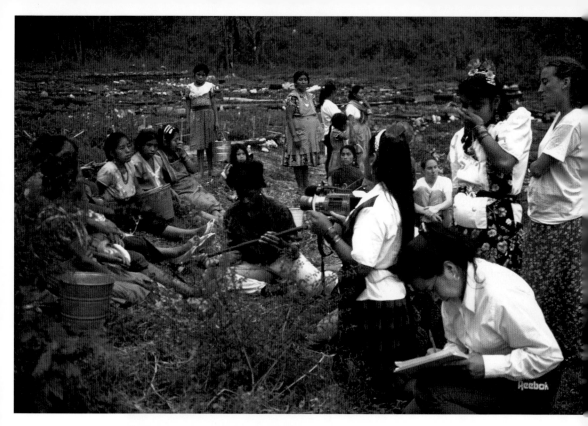

Recording interviews in Morelia, 1998.
The women of the delegation of the Chiapas
Media Project workshop interview the women
of Morelia who participated in the workshop.

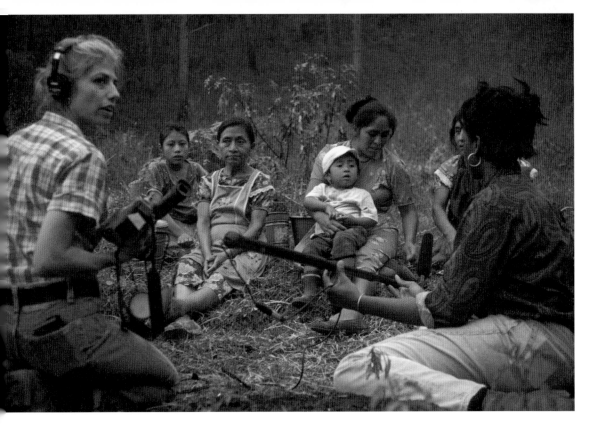

Recording interviews in Morelia, 1998.
Alexandra Halkin Interviewing the women
from the community during the first
workshop at the Aguascalientes of Morelia.

NEXT SPREAD
Workshop for women in the Aguascalientes of Morelia, 1999.
Three women attending a workshop who, after a lesson in
framing and composition, practice among themselves with
video cameras.

Francisco Vázquez Mota 279

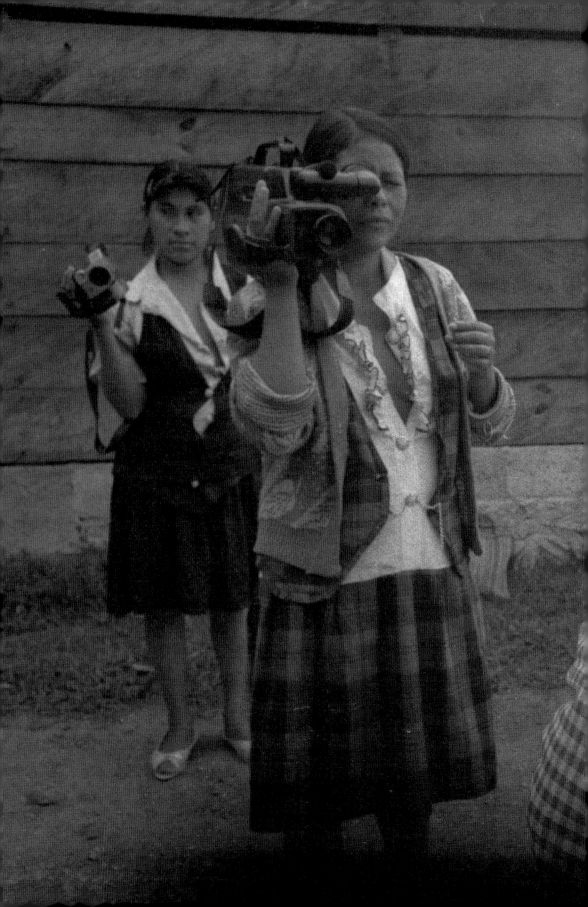

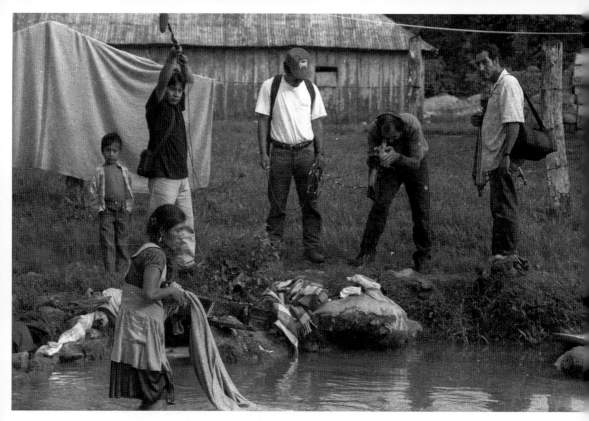

Daily life in La Realidad, 1999.
The team of trainers and filmmakers from Oaxaca CVI
(Centro de Video Indígena) document the daily life of
the community despite the close presence of the military
camp.

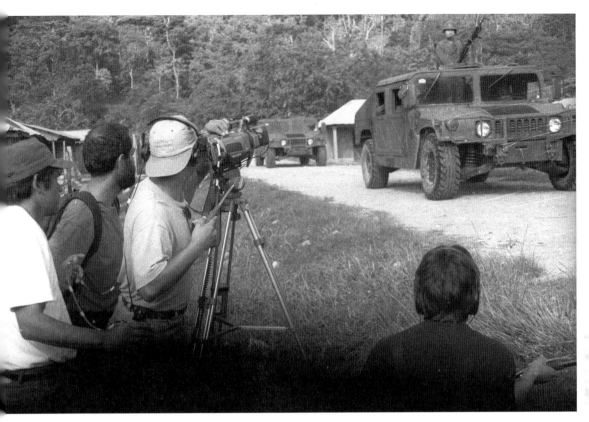

Documenting militarization, 1999.
During a workshop in the community of La Realidad, the crew from Oaxaca CVI documents the military convoy driving through the community. Constant harassment was a strategy well-implemented at the time.

NEXT SPREAD
Interviewing Zapatista delegates coming back from the Consulta (The National Consultation for Indigenous rights), a national referendum organized by the Zapatistas, 1999.
After a workshop was conducted in the community of La Garrucha, delegates from the EZLN (Ejército Zapatista de Liberación Nacional / Zapatista Army of National Liberation), who were travelling to multiple municipalities throughout the country, were interviewed by a newly trained communication team.

Francisco Vázquez Mota

Autonomous School in San Nicolás, La Garrucha, 2000.
During the production of *Education and Resistance* (2000),
the children from the community pose inside their school
alongside their drawings on the walls.

"Camera Is My Machete." Promedios and the Construction of Zapatista Alternative Media

Mixed crew producing *Education and Resistance*, 2000.
A film crew formed by La Garrucha's communication team and cinema students from New York producing the film *Education and Resistance* (2000). This was the first occasion for two groups of Mexicans with radically different life experiences—the descendants of the Maya, and of Mexican migrants—to exchange and collaborate in a video production for the Zapatista movement.

The ceremony of keeping the light, Morelia, 1999. For the celebration of New Year's Eve and the anniversary of the uprising of January 1, 1994, Tzeltal elders perform the ceremony of keeping the light live during the transition between years. They are helped by children and other members of the community.

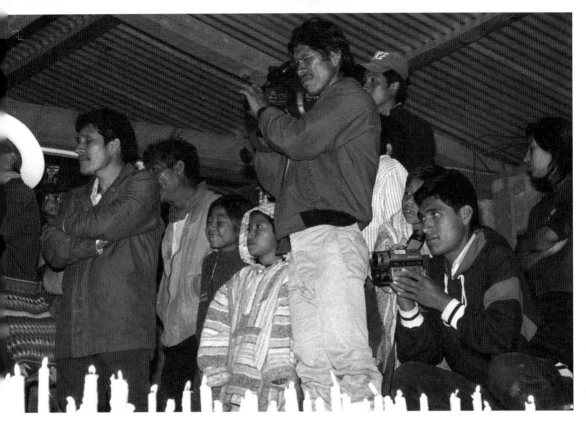

New filmmakers document New Year's Eve, 1999.
Members of the communication team from the
Aguascalientes of Oventic and Morelia document the
celebration of New Year's Eve and the anniversary of the
uprising.

NEXT SPREAD
Documenting the procession, Roberto Barrios, 1998.
Members of the community who were in the process of
being trained in the use of video, document a religious
celebration in the town of Roberto Barrios.

Francisco Vázquez Mota

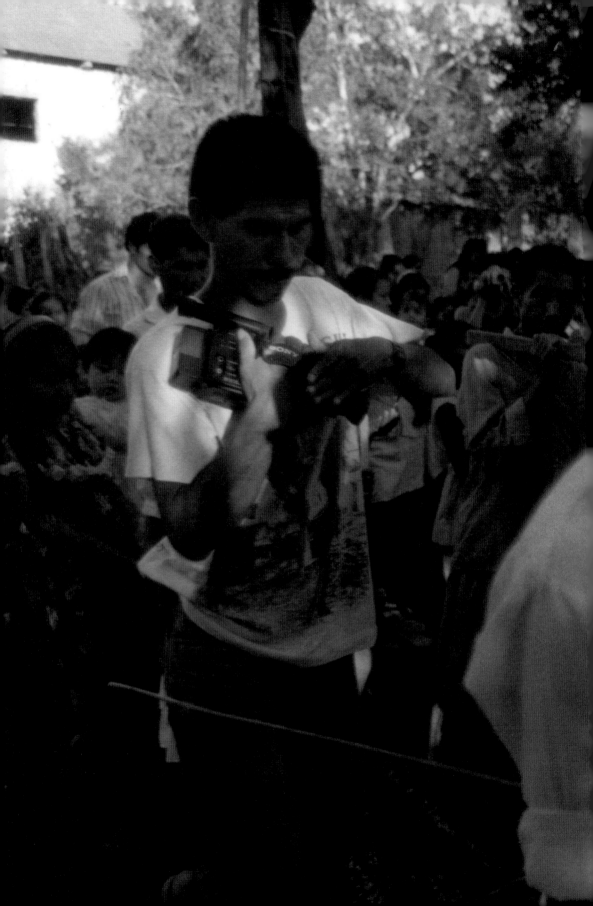

Games and balloons, Morelia, 1998.
In the *ejido* Morelia, children are chasing
each other and playing around with
balloons, while the army patrols the
community.

Tired but curious, Morelia, 1998.
In the *ejido* Morelia, sick and malnourished
children are still curious about the visitors
who play with them and take pictures.

The little gang, La Garrucha, 2001.
Three kids pose in front of the camera,
looking with disregard at the visitors from
the city. The leader of this little gang has
embarrassed multiple visitors with his
incredible chess skills.

Three kids from San Benito, 2000.
Kids from the displaced community of San
Benito pose in front of their shack, the
oldest holding his self-made guitar.

Collecting wood (*leñadoras*), La Realidad, 2001.
Two women struggle to walk across a muddy trail holding
a load of wood for their kitchen.

Alimentar patate, 2000.
A woman married to a *promotores de educación* (education promoter) prepares food for the entire family with her daughter.

"Camera Is My Machete." Promedios and the Construction of Zapatista Alternative Media

Promotor de educación's house, New San Nicolás, 2000.
A view of the *promotor de educación*
family's entire house.

A sketch to remember the challenges, 1999.
Members of the community of Morelia perform a sketch
representing the dangers of alcoholism in the community, and the
related violence against women.

Francisco Vázquez Mota in conversation with Jonathan Larcher

Jonathan Larcher: Promedios de Comunicación Comunitaria (initially created by Alexandra Halkin as the Chiapas Media Project) is a media and political organization active in the creation of alternative media infrastructure in the state of Chiapas, Mexico, that has been supporting social movements since 1998. The inventory and digitization of their video archives, which began in 2021, shows that Promedios was part of an ecology of communication involving a multitude of actors: the Zapatista movement, alternative media organization such as Indymedia Chiapas, international NGOs, and political and religious organizations. Promedios is well known for providing video and computer equipment and training to the members of autonomous Zapatista communities between 1998 and 2014, four years after the uprising of January 1, 1994. Your photographs present a key period in the Autochthonous and peasant struggles in Chiapas: the years 1998–2000, marked by the army's policy of "low intensity warfare" and, as a response, the organization of a concerted media campaign by the *bases de apoyo* (civil bases of support) of the Zapatista movement. Immediately prior to that, in 1995, two events laid the groundwork for Promedios—could you say a few words about it?

Francisco Vázquez Mota: The Chiapas Media Project, or Proyecto de Medios en Chiapas, was the first name given to the initiative established by Alexandra Halkin with the support of Tom Hansen and Guillermo Monteforte. At the time, Tom Hansen was the director of Pastors for Peace, and Guillermo Monteforte was the founder of Ojo de Agua Comunicación and director of the CVI (Centro de Video Indígena) in Oaxaca). The project has also benefited from the support of Manuel Pintado from Mexico City (director of ILCE, Instituto Latinoamericano de Comunicación Educativa), and many others. The purpose of this initiative was to bring training and equipment to the Zapatista communities. It was an attempt to respond, as members of the civil society, to the Zapatista's need for access to communication tools.

Alexandra Halkin was engaged in the solidarity movement with Cuba through the NGO Pastors for Peace network. In 1995, it organized a solidarity Caravan, with loaded trucks leaving from the US, traveling through Mexico, joining at Mexico City with the Mexican Caravan, and delivering aid to the community of Guadalupe Tepeyac in Chiapas. The Caravan also included international human rights activists, Mexican scholars, and a couple of PRD (Partido de la Revolución Democrática) congressmen who tried to hold a meeting in the community of Guadalupe Tepeyac while a military encampment was installed there. Guadalupe Tepeyac was, at the time, the community that hosted the first Aguascalientes meeting. The Aguascalientes were the regional community centers, which acted as both rally points and platforms between Zapatista communities and actors from the civil society or international NGOs. They were replaced in 2003 by the Caracoles. During that Caravan with Pastors for Peace, Alexandra Halkin documented the repressive actions of the government and the army, and

This exchange took place via email and chat, between San Cristóbal de las Casas and Paris, in November and December 2022.

the joint effort of the civil society and the communities to resist them. This also made it possible for Alexandra to understand the dynamic between the international press and the communities. Her own experience as a non-Spanish speaker probably made clear the importance for members of the communities to actually have media tools in their hands.

There's a passage on one of the videotapes we have in our archive that shows delegates and advisors, who were invited to assist the Zapatistas, presenting and structuring the demands of the movement to the government. This event was held in the cathedral of San Cristóbal de Las Casas in 1995. At one point, Jose Manuel Pintado is filmed coming out of the cathedral with the conclusion of one of the discussion sessions, regarding the demand of the Zapatistas to have access to tools of communication. His reading of the declaration presents the relevance of constructing Indigenous autonomous media in Chiapas and in the communities.

JL: Throughout 1998, the first workshops were organized in several Zapatista Aguascalientes (renamed Caracoles in 2003). In what context and how were these workshops organized?

FVM: During 1998, there was a severe drought in the region of Chiapas and Guatemala, causing numerous fires in the forest and on agricultural lands. Traveling to the communities at the end of that decade involved moving around under the cover of night because of the presence of both the army and migration officers who attempted to gather information about the people involved in the acts of solidarity towards the Zapatista communities. The army and the migration officers were particularly keen on applying immigration policies against internationalists in an attempt to isolate the movement. Given this context, it was often necessary to travel through the mountains that were literally on fire. We encountered on many occasions people from the communities striving to contain the fires.

The so-called low intensity warfare was a strategy that attempted to react to a popular insurrection whereby the military component was closely integrated within the communities, becoming almost indistinguishable from them. The first stage is to control the territory and limit the mobilization of insurgents. While controlling the communities, the army isolates them from each other in order to prevent the expansion of the social movement. The second stage is to use the state services to gain the population's sympathy with social programs, focusing in particular on places where the influence of the movement is growing.

In this context, arriving in the communities with training and equipment was difficult. It implied certain risks—first of harassment, but also potential military action against the Mexican participants in the workshops. The strategy was then to bring delegations of human rights observers to accompany the workshops and training sessions. The participation of Pastors for Peace was crucial in order to organize our stay within the communities, regarding both the logistics of bringing in the equipment, and the coordination between all the human rights observers.

JL: What were the primary objectives of the workshops? And what uses of the video cameras were most urgent for the members of the civil bases of support?

FVM: The primary objective of the workshops at the beginning of the project was to allow the communities to document the conditions they were facing, and to give them basic resources, both in video and computer use, to produce the information that they considered most urgent. Video as a tool was chosen for its simplicity, allowing people to participate without limitations stemming from their level of literacy, and because the audiovisual medium is a very powerful resource in showing the lived experiences of the communities. Those who participated in the first workshops were initially under the impression that they would be able to document all of the military's actions. While in some cases this did happen, it proved to be difficult. On the other hand, they quickly realized the potential of using multimedia to educate themselves and promote their programs—on the autonomy of health and education—and traditional knowledge within the movement. The versatility of video as a tool was recognized early on. At the end of a workshop held in early 1999, Bernal, a member of the La Realidad community said: "I get it now, the camera is like my machete, I can use it to harvest food, but also to defend myself."

JL: You arrived in Chiapas in 1998, having already been active as a community organizer and photographer in your home community, San Pablo Oztotepec, to the south of Mexico City. Can you tell us a little about this experience that preceded your involvement in Promedios?

FVM: Yes, I'm originally from San Pablo Oztotepec, in the region of Milpa Alta, which is inhabited by a pre-Mexican population—living in the Mexico valley before the Aztec Empire: Toltecs and afterwards Chichimecas, with their present identity being Nahua-Momochca or Malacachtepec Momochco.

The people from this ancestral territory have always been defending their traditional land against the Mexicas, the Spaniards and, more recently, against the spreading of Mexico City itself. It is a region that actively participated in the 1910 revolution, during the first Zapatista movement, and therefore has a strong tradition of self-organizing and self-government.

During my childhood, I learned from my parents the stories of my grandparents participating in the revolution and—based on the principles of the *tequio*, the community workshop—self-organizing to build basic community resources such as roads and water pipelines. Both in secular life as well as in the church—my relatives exercise their religious practices in the Presbyterian Church—the community participation was the norm for any individual in my family. Trained as a photographer, I was asked by the community environmental protection commission to produce documentation as well as educational materials for children, and to raise awareness about the protection of the environment and the territory. The Tepeyahualco Community Forest Nursery Project (Vivero Comunitario

Tepeyahualco) has become very visible, nationally, especially through its activities to introduce children into the process of tree production and reincorporation into the forest. This process of restauration and reforestation has been made possible by the participation of communities working voluntarily throughout the year. In 2006, this project was awarded the first prize for environmental protection by the National Youth Institute.

During the years I was involved in this project I went through different roles starting with documenting the initiatives of education with the help of a film-based photo camera. I was responsible for producing slide shows to motivate the children to participate in the activities, and for educating the public in general. Then, I became part of the general coordination of the project, within a committee of several people elected by the assembly. Because of this work, our organization was well known among the circles of Mexico City related to Indigenous issues, and it was the reason why I was invited to participate in the first initiative that the Chiapas Media Project organized for the Zapatista communities in the Aguascalientes of Morelia in 1998. This first encounter was designed to invite activists and photographers to share their experiences with the workshop's local participants, so they could imagine different ways of using of the video tools, adapted to their own needs.

JL: What have been the outcomes of these workshops?

FVM: As a result of these first workshops held in 1998 and 1999, the communities were able to organize municipal commissions to deal with communication. Several short films were also produced on these occasions, allowing us to raise funds in support of these workshops. These communication commissions have been useful both locally, for municipal needs, and more globally within the movement, to provide service and support to the authorities organized in the Juntas de Buen Gobierno (Good Government Councils). Through the establishment of communication centers in each of the Aguascalientes (and later the Caracoles), these commissions directly served the autonomous development of branches of the Zapatista movement and, of course, any other issues or problems that needed to be communicated within the movement, or to the civil society.

JL: Why did you decide to abandon color photography (on reversal film) to concentrate on black-and-white photography?

FVM: Originally in my photography practice, I always had to negotiate between what was my personal work, and the professional work or service to the community. For the slides or negatives in color, I used the laboratory of my own family, which was easily accessible when I started out. It was quite useful and fast enough for most of my professional projects and services. At the same time, I conceived black-and-white film my medium of choice for my personal projects. I always related to black-and-white film as a medium that naturally abstracts the images from the so-called reality, in order to discuss, to suggest, broader issues.

Francisco Vázquez Mota

When I began to participate in the Chiapas Media Project, I started to use slide film. But it was complicated—and too risky—because of the lack of laboratories in the region. I could not send it over to my family laboratory near Mexico City. I decided to use black-and-white negative film to be able to develop it myself at our office in San Cristóbal de Las Casas. Given the need to control my own production in the context of the widespread surveillance by the police, the military, and even the paramilitary, black-and-white photography was the best solution for documenting the first stages of the Chiapas Media Project.

JL: These photographs show the diversity of activities that make up the struggle of the Zapatista support bases: from confrontations with the army to daily household activities. Was this diversity reflected in the films that were later produced by the Zapatista communities?

FVM: I don't think there is a relationship between my photographic work documenting the life of the communities, and the decisions the movement made regarding the topics of their own documentaries. My work was never intentionally shared in the communities. Its aim was mostly to promote the project outside the movement, as well as documenting its process. I would say that these photographs did not have any impact on the recordings and films that were made by the communities. The potential connection or mirroring of the topics could rely on the shared context that both they and I were experiencing.

First workshop in
La Garrucha, 1998, detail

Zapatista Cinema

Nicolas Défossé

The title of this essay, "Zapatista Cinema," is the title of a documentary project I wrote and began shooting between 2003 and 2005 about the work of the Zapatista videographers trained by the association Promedios in Chiapas. In the end, I never made the film, but here is the first paragraph of its script, inspired by my experience on the ground.

Chiapas, south-eastern Mexico. The dense vegetation of a tropical forest. Afternoon sun shines through the foliage. The environment is filled with the sounds of local fauna. We follow two men walking, machete in hand, ready to clear possible obstacles on the path. They advance with alertness and carry shoulder bags, sometimes exchanging a few words.

Still, unreleased film material shot by Nicolas Défossé in 2005

Around the bend we discover a small village located in a clearing. Near a chapel, the Indigenous peasants arrive from all over, gathering for the evening's event. The excitement in the air is palpable. The two men who just arrived discuss with the village leaders, take out of their bags a video recorder, speakers and a projector which they install facing the chapel's wall. A white sheet is hung on the wall to serve as a screen. The men inquire if there is electricity in the community or if they have to install a generator for the screening. As people get settled, they give a short presentation in Tseltal, the local Indigenous language. It's just after 7 p.m., the sun is disappearing behind the hills, and the outdoor film screening can begin.

This essay is based on a talk given at La Fémis, Paris, on February 28, 2019, during the colloquium "Autochthonous Cinema Against Occupation," as part of a series of colloquia entitled "Filmic Forms and Practices of Autochthonous Struggles." The accompanying visual materials have been selected from the video archives of Promedios, held at their headquarters in San Cristóbal de Las Casas, by Jonathan Larcher in consultation with Nicolas Défossé.

Still, unreleased film material shot in 2005. Interview with Zapatista video promoters of the Caracol of Morelia.

Who are the people who organize these screenings? They are known locally as "communication promoters" (*promotores de comunicación*) or "video promoters" (*promotores de video*). They were appointed by the Zapatista civil authorities, the support bases of the Zapatista Army of National Liberation (Ejército Zapatista de Liberación Nacional, EZLN), to assume the function not only of filming but also of taking on a whole series of tasks related to video production and communication. For more than fifteen years, an independent association accompanied and supported this initiative: Promedios de Comunicación Comunitaria / Chiapas Media Project. The association's first video workshops with Zapatista support bases took place in early 1998. But what precedes this sequence?

Zapatista video promoters and Nicolas Défossé (center, with headphones) film an event organized by the Zapatista movement in 2007

The Zapatista uprising took place on January 1, 1994. This was the date of Mexico's signing of the North American Free Trade Agreement (NAFTA), which opened the doors to neoliberalism in Mexico even wider. In the preceding years, Mexico had to adapt some of its laws and its constitution in order to be able to sign this treaty. Since the Mexican revolution, land had been regularly requested by groups of peasants who had no access to it. Each president allocated land by decree, which then became *ejidos* in most cases. The *ejido* is a specific juridical structure in Mexico where land

Zapatista Cinema

is a collective social property, which avoids the tendency for land to be concentrated in the hands of a few large landowners—which was precisely the troublesome situation prior to the Mexican Revolution and one of the causes that provoked it. In Mexico, as in other countries where the neoliberal turn occurred in the 1980s, the message that was sent not only to the Indigenous people but to the peasants in general was that the decades-long period during which the state regularly granted land was over. Moreover, programs were set up to facilitate transfers of land tenure, so that people

who occupied an *ejido*, that is, a collective social property, could sell their land as if it were a private property. I say this because the Zapatistas have intensely opposed the reform of article 27 of the Mexican constitution. The article, which since 1917 had given the government the authority to redistribute land to *ejidos* and benefitted Indigenous communities, was deleted in 1991—a reform that was supported by the majority of the Mexican political class in order to be able to sign NAFTA. This reform is seen as an unequiv-

ocal sign of a blocked outlook: the main legal avenue of access to land inherited from the Mexican revolution, which does not involve money or the capitalist system, is no longer available. And access to land, the right to land, the protection of land, is a central motivation of the Zapatista movement, one of its *raisons d'être*.

Still, Promedios, *Chul stes bil Lum qui, nal (Tierra Sagrada; The Sacred Land)*, 2000

Ten years passed between the clandestine founding of the EZLN on November 17, 1983, and the armed uprising of January 1, 1994. The experiences of this decade would lead it to the decision to take up arms with the battle cry of "¡Ya Basta!" The war itself, the armed confrontations between the Zapatista guerrillas and the Mexican army, lasted only about ten days, mainly because Mexican civil society mobilized extensively and put pressure on both parties—the Zapatistas and the government—to stop the fighting.

Between 1994 and 1998, there were several attempts by the Mexican government to negotiate with the EZLN. At first the government insisted on negotiating only with the EZLN, but the Zapatistas took the opposite position: they refused to negotiate only for their own interests. They proposed to invite representatives of other Indigenous peoples in Mexico, as well as members of civil society, including scholars of political autonomy, so that from this space for collective reflection could emerge proposals that would benefit all Indigenous peoples in the country, not just

Still, archival film images shot in the late 1990s, at the peak of the low-intensity warfare in Chiapas Highlands

the EZLN's support bases in Chiapas. Among the recurring demands of the Zapatistas was the desire to no longer be treated as second-class citizens, and to constitutionally establish a form of autonomy that would allow the Indigenous peoples of the country to have true legal decision-making power, especially with regard to the mega-projects that were being carried out on their lands and that often had dramatic social, cultural, and ecological consequences. So, there were discussions and negotiations with numerous people invited by the Zapatistas, at the end of which the famous San Andres Accords were signed in February of 1996, but which would remain unimplemented in the sense that they would not be applied in the country's constitution. This is one of the reasons why the Zapatistas have never given up their arms: even though the war itself lasted ten days, they still consider themselves at war with the Mexican state. The state has repeatedly tried to get the EZLN to perform the symbolic act of surrendering their arms, but the Zapatistas have never done so. For this reason, there continue to be troops of Zapatista insurgents who train underground and who can intervene at any moment if the Zapatistas decide to do so. This is part of the balance of power between the EZLN and the Mexican state, as long as the country's constitution does not fully recognize the rights of the Indigenous peoples and their culture, thus endowing them with the means of collective legal defense.

During this period of negotiations, the government also attempted to capture Zapatista commanders, in particular the media-savvy Subcomandante Marcos, in February 1995, just two months after the inauguration of the new president Ernesto Zedillo. They did not succeed in this, but it was above all the strategy of low-intensity warfare that prevailed: it consisted of using armed groups, implanted in rural areas, to make the overall political and military conflict between the EZLN and the state look like multiple local, intra-community conflicts instead. The government's strategy was to avoid as much as possible the direct intervention of the Mexican army, thus making the state's repression of the Zapatista movement less visible, since such visibility had the effect of fueling international solidarity with the rebels. The low-intensity warfare also rested on economic development and anti-poverty programs, which were directed at the populations of the areas where there were many Zapatista support bases, and which served to deepen the social divide in the communities. In fact, one of the conditions for being part of the Zapatista movement is to refuse state aid.

These benefits are considered by the Zapatistas to be breadcrumbs, an indignity that reproduces an unjust and paternalistic system instead of contributing to changing it, to overturning it. In order to form a Zapatista base of support for the EZLN, it is necessary to accept that one does not receive such aid from the state: often this does not involve much money, but in an often-complicated economic context the temptation to accept "breadcrumbs" from the state is a source of tension in families and communities. For this reason, among others, there are Zapatista sympathizers who are not Zapatistas—in the strict sense of being a support base for the EZLN— because being a Zapatista implies respecting very precise rules: there is the advantage of receiving the benefits of the autonomous system (health, education, etc.), but it also implies, for example, taking turns on guard duty, participating in collective work of general

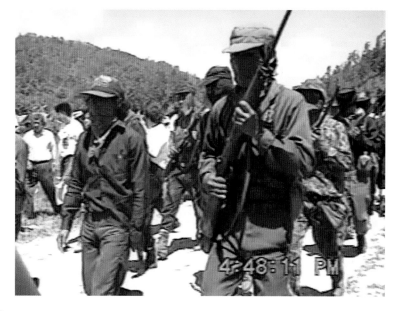

interest, and refusing to receive state aid for oneself and one's family, among other things. Compliance with these rules is strict. Anyone in the organization who does not comply with them will be at least warned, or even temporarily excluded from the Zapatista organization.

In this context of low-intensity warfare, tragedies and spikes in violence become frequent. In December 1997, the infamous Actéal massacre occurred in the Altos region of the Chiapas highlands: forty-five people, mostly women and children, were massacred by a paramilitary group. In 1998, many foreigners in solidarity with the Zapatista movement were apprehended in Chiapas and expelled from Mexico. Over the years, international solidarity has been established with people who have come to Chiapas, often as human rights observers, to bear witness to the abuses of the army or paramilitary groups.

Stills, Promedios, *Chul stes bil Lum qui, nal (Tierra Sagrada; The Sacred Land)*, 2000

NEXT TWO SPREADS
Stills, FrayBa and Promedios, *Caminando hacia el amanecer*, 2001

Nicolas Défossé

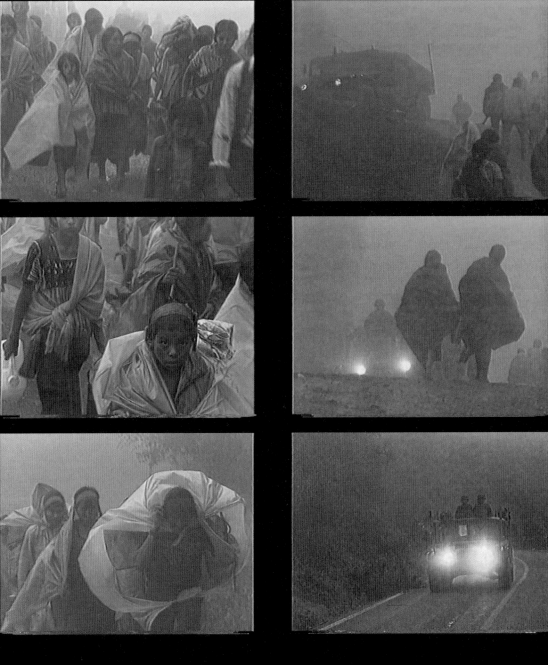

Caminando hacia el amanecer, co-produced by Promedios and the Fray Bartolomé de las Casas human rights center (FrayBa), presents the experience of the Tzotzil (Chiapas Highlands) and, to a lesser extent, Ch'ol Maya (North of the Lacandon Jungle) communities, who were the victims of paramilitary violence and forced displacement in the late 1990s. The victims' stories, told at workshops organized by FrayBa, are interwoven with interviews with several of the organization's key players (including Bishop Samuel Ruiz, who was its founder and president). The film begins with images of the forced displacements (TOP) and ends with images of the return of some of the displaced to their communities of origin (OPPOSITE).

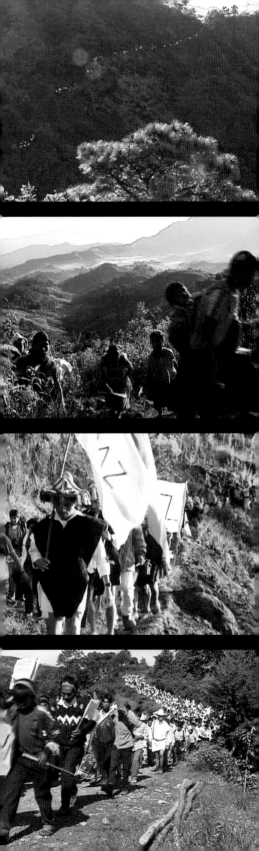

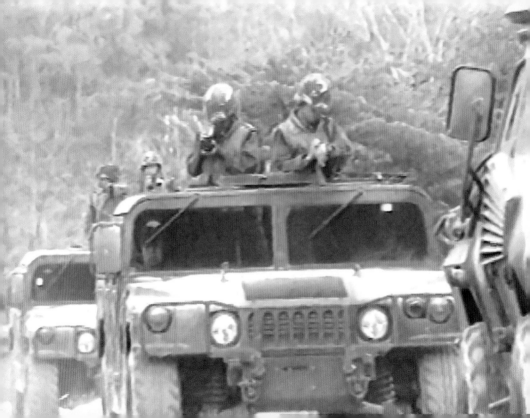

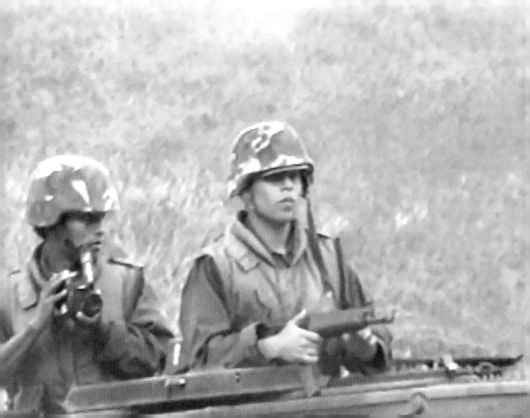

LEFT AND OPPOSITE
Stills, Promedios,
Proyecto de Medios
de Comunicación en
Chiapas (Chiapas
Media Project), 1998

It was with the background of this great tension that, in February 1998, the first video workshop of what was then called the Chiapas Media Project took place in Zapatista territory, in Chiapas. It is important to remember that since their uprising in 1994, the Zapatistas have been refusing all state aid, and building solidarity with national and international civil society. In this appeal of the Zapatistas to civil society, there is an invitation to collaborate in the development of health and education, as well as access to information and means of communication. It was in this context that an American filmmaker named Alexandra Halkin made a documentary about a solidarity caravan that went to Chiapas. During the filming, she realized that the Zapatista communities were clearly interested in having access to these video tools. Once back in the United States, she set up a project, sought funding and looked for possible allies, intermedi-

aries and collaborators in Mexico, particularly in Mexico City and Oaxaca. In Oaxaca, a neighboring state of Chiapas in the south of the country, there was already a legacy of the transfer of media know-how. In fact, in the 1980s, the National Indigenous Institute had set up a project of this type: a state initiative to provide Indigenous communities with video tools and training in order that they themselves could document their traditions and ways of life. There was a group of people in Oaxaca who had received this training, who had appropriated the tools and who were forming organizations independent of government institutions, such as the association Ojo de Agua. These individuals from Oaxaca participated in the first workshops in the Zapatista communities in Chiapas, because they had direct knowledge of the context of the Indigenous communities, and it was precisely this type of profile that Alexandra Halkin was looking for. Another key

LEFT AND OPPOSITE
Stills, Promedios, *Te Nop Jun Yu'un
Pobrehetic* (*Education en resistencia*;
Education in Resistance), 2000.
The film shows the development of an
autonomous education system that
encourages the use of Indigenous
languages, and the teaching of the
communities' own history and customs
(opposite). Teachers are trained by
promotores de educaccion (left).

contact was Francisco Vázquez, who was one of the founding members of
the media project in Chiapas. He came from the Indigenous Nahuatl region
of Milpa Alta, a borough of Mexico City, and was therefore used to commu-
nity decision-making mechanisms involving traditional Indigenous authori-
ties, customs, and traditions.[1]

Alexandra Halkin relied on organizations that were already estab-
lished and people who already had knowledge of the Indigenous community
context, and set up a series of initial workshops. The aim was a "transfer
of media": that is to say, to transfer cameras, equipment and training, so
that the members of the community could learn how to use them and, at
some point, become autonomous. There was no precise timetable, but the
long-term goal was for the community to no longer need the association to
operate the equipment.

In the first few years, there was a clear priority given to video over
other communication tools. This is probably due to the fact that Alexandra
Halkin comes from a documentary background, which put more emphasis

1 Francisco "Paco" Vázquez, author of a contribution in this volume, is now president of
 Promedios de Comunicación Comunitaria, based in San Cristóbal de las Casas.

on video, as did the collectives in Oaxaca who had greater familiarity with it. Meanwhile, the Zapatistas were already developing radio with other allies in civil society. As a result of the first video workshops with the Zapatistas, a series of short documentaries were produced and quickly distributed in the United States and Mexico. This was part of Alexandra's strategy to generate the funds necessary to both acquire equipment and continue to offer training. Volunteer work in this area was also an important part of the program. Screening tours including several of these short films were organized, especially in the universities in the US, which have specific resources allocated for this type of activity.

At the beginning of the project, the first short films documented festivities or moments of collective struggle. For example, *Recuperación de la presidencia Autónoma de San Andrés Sacamchén* (*Resumption of the Autonomous Presidency of San Andrés Sacamchén*, 1999, 11 min.) documents a situation in the Altos region (the Chiapas Highlands) where thousands of Zapatista support bases carried out a large, peaceful collective action to reinstall their autonomous civil authorities, despite the presence of the police and the army, who had destroyed the headquarters of the autonomous government the day before. The productions made use of journalistic practices, which in turn shaped the audiovisual language. The films frequently included talking-head interviews, intercut with relevant images. For example, in the short film *Educación en resistencia* (*Education in Resistance*, 2000, 21 min.), which deals with autonomous Zapatista education, education promoters and Zapatista authorities explain the principles of Zapatista education as well as the context. Why is there a need for autonomous education? What are the problems and limitations of official state education? In state schools, teachers are often absent, the role of Indigenous peoples in Mexican history tends to be grossly undervalued, and students from Indigenous communities are often discriminated against. Through interviews, this short film provides several contextual elements that help us understand the creation of the autonomous Zapatista schools, as well as their operating principles.

Nicolas Défossé

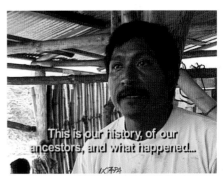

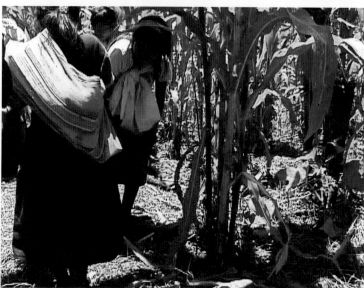

LEFT AND OPPOSITE
Stills, Promedios, *Chul
stes bil Lum qui, nal
(Tierra Sagrada; The
Sacred Land)*, 2000

The short film *Tierra Sagrada* (*Sacred Land*, 2000, 20 min.) deals with the relationship to the land, and in particular with the struggle of the Indigenous peasants for access to the land that is at the root of the Zapatista uprising. On a formal and technical level, the films are increasingly better composed. *Tierra Sagrada* and a selection of other short documentaries were screened at the Sundance Film Festival in the US, and this type of symbolic recognition further helped to open the doors of some American foundations so that the Media Project in Chiapas could consolidate. There was a constant need for video equipment in Chiapas in the Zapatista communities. When we speak of the Zapatista territory, we are talking about five regions, incorporating several autonomous Zapatista municipalities, and that together encompass more than 24,000 km². The Zapatistas have superimposed their own territorial division on the existing state administrative division, and each of their five regions has a cultural and political center where the training workshops are usually held. Within each region, the autonomous Zapatista communities coordinate with each other, and the idea was to provide each community with a minimum number of cameras. At that time, there were about thirty autonomous Zapatista rebel communities. In the regions with a tropical climate—which are the majority—the humid conditions meant that the equipment was likely to deteriorate quite quickly. There was also a need for videotapes,

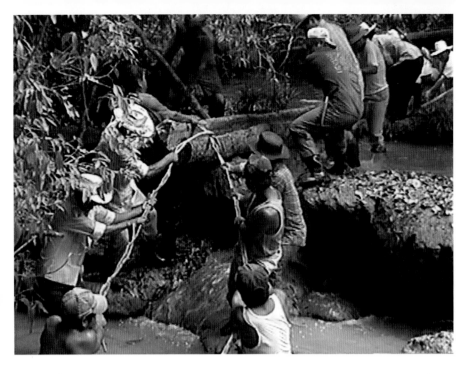

and the question of editing benches—first linear and then virtual—arose. It is precisely at the end of the 1990s that the first portable computers equipped with editing programs appear.

The video workshops were usually held in the regional centers, which at the time were called Aguascalientes, one in each of the five Zapatista regions. The video promoters from each region gathered there to attend workshops. Then, starting in 2000, another initiative was put in place which consisted of residency grants: the Zapatista video coordinators from each region took turns coming to San Cristóbal de las Casas, a city of 200,000 inhabitants which is one of the most important in Chiapas, where the offices of the Promedios are located. The promoters took turns attending training sessions there, which lasted two or three weeks. Often they would bring unedited rushes and edit them on site, in the organization's offices, with the help of an editing table and assistants.

I'd like to clarify the meaning of the terms "*promotor de comunicación*" (communication promoter) and "*promotor de video*" (video promoter). They were not created by Promedios, but were being used by the Zapatistas at the time. When the association proposes these workshops and the equipment that goes with them, it meets with the Zapatista civil authorities. Communication is one of the areas assigned in the system of Zapatista autonomy under construction. Just as there are health promoters, education promoters and agro-ecology promoters, there are also communication promoters and video promoters. These roles are rarely carried out by volunteers, but are more often than not assigned by the assembly and/ or the Zapatista authorities. As this is a *cargo* (a charge), it is unpaid. The people involved are always peasants, and working the land remains their main activity. Just because they're shooting video doesn't mean they stop being farmers since they don't get paid to make videos. However, no less

important, this is one of the many responsibilities of Zapatista organization members. They have both the privilege and the duty of training themselves to use these tools and produce short films that serve to communicate the construction of autonomy, inform about education and health projects, document major Zapatista public initiatives, bear witness to the exactions of the army or paramilitary groups, and document the festive moments when the community gathers—particularly important events in the Zapatista calendar such as the uprising on January 1, 1994, the anniversary of the creation of the EZLN on November 17, the death of Emiliano Zapata on April 10, and so on.

2001 was the year of major change in Mexico. After more than seventy years with a single party in power—the PRI, Partido Revolucionario Institucional, which had ruled since the Mexican Revolution—a political changeover took place at the top of the state, with the election of Vicente Fox of the PAN (Partido Acción Nacional). Against this backdrop, the Zapatistas launched an initiative, a caravan march—*Marcha del color de la tierra, Marcha de la dignidad indígena*—during which twenty-three commanders and Subcomandante Marcos traveled from Chiapas to Mexico City, holding large meetings in several major cities. The aim was to bring pressure to bear on the political class to put the famous San Andrés Accords, signed in 1996 but never implemented, on the agenda, which implied a constitutional reform to be voted on by senators and deputies. The caravan march received a great deal of media coverage at the time, and several international left-wing figures, such as José Bové and José Sarramago, traveled to Mexico City for the occasion. However, the initiative failed to secure constitutional reform, and the EZLN saw the behavior of Mexico's progressive left as a betrayal. When it came time to vote for or against constitutional reform, the senators of the PRD (Partido de la Revolución Democrática), the left-wing political party which had consistently declared its sympathy and solidarity with the Zapatista movement, voted along with the other political parties, thereby helping to gut the constitutional reform so long hoped for by the Zapatistas and many other Indigenous peoples (*pueblos originarios*) throughout the country. In the wake of this failure, the Zapatistas concluded that they could no longer expect anything from "above," i.e., from political parties, even if they were left-wing, and that it would be better to concentrate on strengthening autonomy from below, in the autonomous communities. A more viable path was seen in building autonomy "in practice" rather than waiting for the state to authorize it, since this was unlikely to ever come to pass.

In 2003, the path taken by the Zapatistas towards autonomy became more radical with the establishment of the Caracoles. These are the five regional centers that already existed in the form of Aguascalientes, with a slight change in status, since each Caracol, each regional political center, was henceforth to be the seat of a Council of Good Governance (*Junta de Buen Gobierno*) made up of a rotating body of Zapatista civil authorities. Regularly renewed, their task was to help govern the autonomous life of the Zapatista communities inhabiting a particular territory. In the film

NEXT SPREAD
Stills, Promedios,
*Caracoles: los
nuevos caminos de la
resistencia*, 2003

Nicolas Défossé

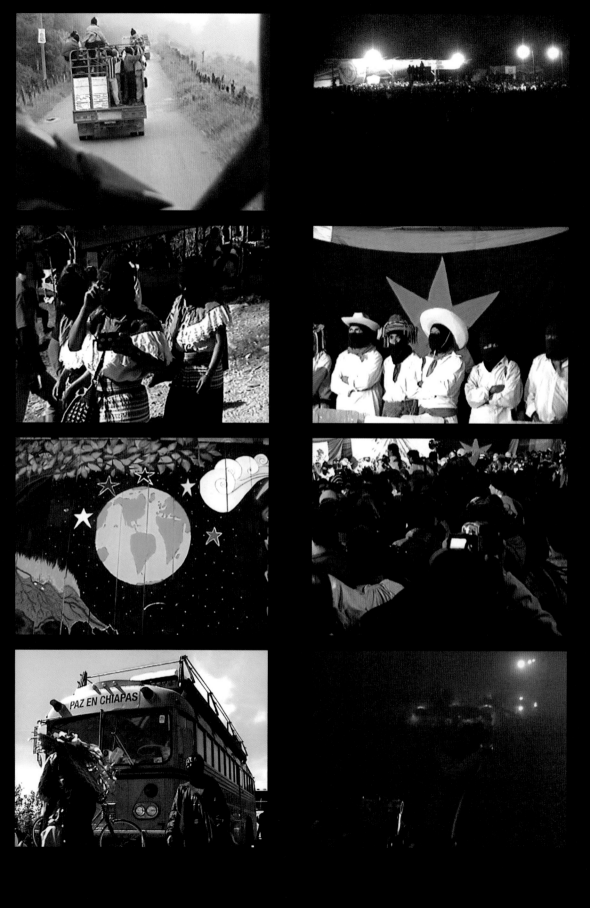

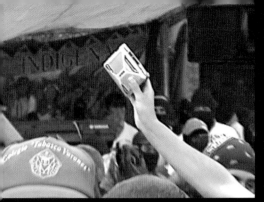
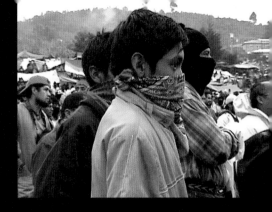

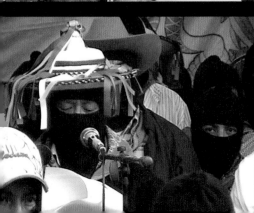
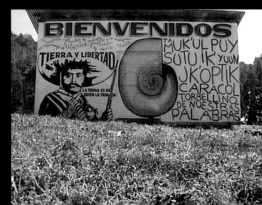

Caracoles, los nuevos caminos de la resistencia (*Caracoles: New Paths of Resistance*, 2003, 42 min.), we can see images filmed at the time of the creation of the Caracoles—members of the Zapatista movement and of national and international civil society gathered in the Caracoles of the Altos region in Oventic, Chiapas. On this occasion, Zapatista men and women came from all over Chiapas to celebrate the founding of the regional center, a historic date for the Zapatista organization. As not everyone was able to attend, the role of the Zapatista video promoters from all five regions was foremost to bear witness to the event and pass it on to those who couldn't be present. A first quick edit of the film lasting around two hours was compiled from a selection of rushes filmed by the various cameramen, copies of which were sent to as many autonomous communities as possible.

Films of this kind, covering important moments in current Zapatista history, have an archival function and help build collective memory. When Zapatista video promoters screen films showing the great caravan march of 2001 or the foundation of the Caracoles in 2003, they are not necessarily shown only in villages or hamlets wholly under Zapatista governance, but also in communities where Zapatista support bases are a minority. As the screenings are also attended by non-Zapatistas, this helps to stem the potential disinformation that sometimes denies the existence of the large-scale Zapatista mobilizations and the strength of the movement that goes with them. In villages where Zapatista support bases are in the minority, the screening of these films conveys the collective strength of the movement, which can potentially help to change the balance of power and respect within a village or hamlet.

Films that report on a protest campaign organized by the Zapatistas are thus one of the types of films produced by video promoters. In the case of *Caracoles, los nuevos caminos de la resistencia*, a dozen Zapatista cameramen produced the footage, supplemented by additional images shot by members of civil society, all of which was incorporated into the editing process. As far as the use of the footage is concerned, a certain amount is broadcast outside the communities, but this is the tip of the iceberg; the vast majority remains for internal use only, as an archive.

For example, when there are altercations or tensions with people who are not members of the Zapatistas, this is filmed and analyzed by the Zapatistas but not intended for wider distribution. On the other hand, the various autonomy projects (concerning health, education, collective work on the land, etc.) can be filmed in one of the five Zapatista regions and then shown in others, thus reinforcing communication between the regions and communities.

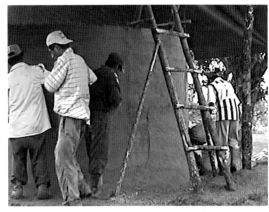

In parallel with the inauguration of the Caracoles, the Zapatistas are clearly demonstrating their desire to move even further towards autonomy with the establishment of Good Governance Councils. The Promedios association had anticipated this step by working on the idea of building and equipping a media center in each Zapatista regional center, from which four out of the five centers will eventually materialize. The construction and equipment of these media centers took place between 2003 and 2004, in step with the consolidation of Zapatista autonomy and the creation of the Caracoles and Good Governance Councils. These media centers are sites where communication and video promoters from each Zapatista region come together for training workshops and to stay and work on their editing. These workshops are not only run by members of the Promedios association and the external instructors it invites; the most experienced Zapatista communication promoters train a new generation of promoters in turn, most often directly in their Indigenous language (the most prevalent being Tzotzil, Tzeltal, and Ch'ol). The creation of these centers is thus directly in line with the drive towards autonomy.

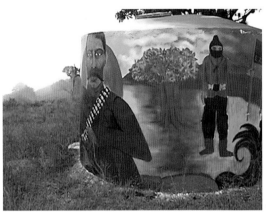

A number of the short documentaries produced by Zapatista video promoters are also spurred by certain civil society groups who work with Zapatista communities to improve specific community services. This is the case, for example, with *La lucha del agua* (*The Struggle for Water*, 2003, 14 min.), which focuses on improving the supply of running water by building pipes to save residents, especially women, from having to carry water over long distances; *Letritas para nuestras palabras* (*Little Letters for Our Words*, 2005, 13 min.) shows the use of a textbook to help Zapatista elementary school pupils learn to write in their Indigenous language; and *El huerto de Zapata* (*Zapata's Vegetable Garden*, 2002, 19 min.) looks at the experience of a collective vegetable garden in a Zapatista village.

NEXT SPREAD
Stills, Promedios,
*El Camino de la
nueva salud*, 2007

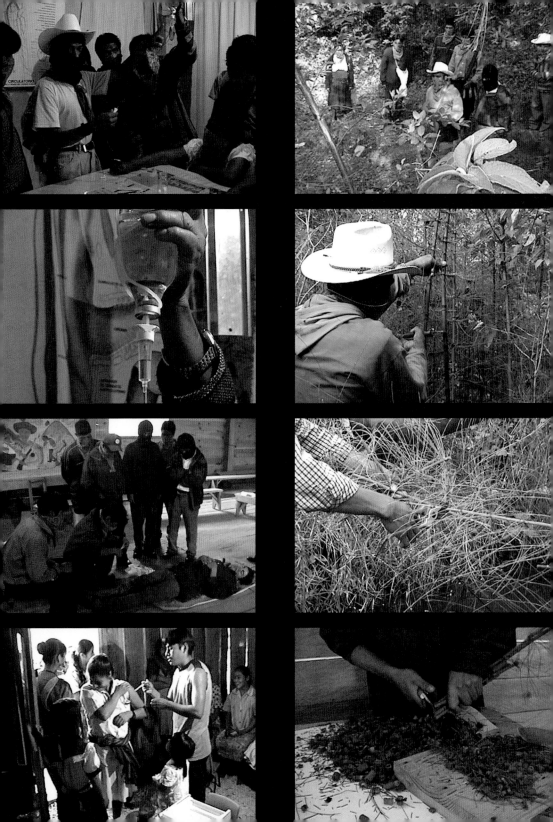

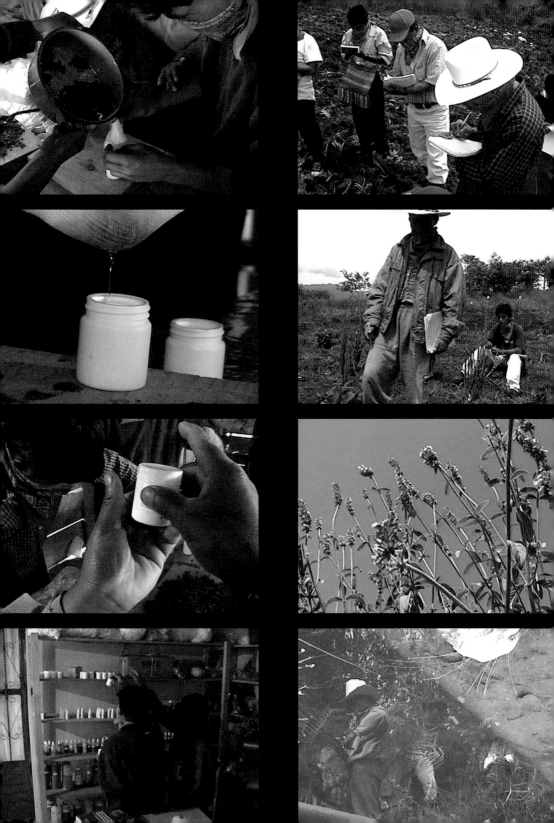

What these films have in common is that they were initiated by solidarity groups working in Zapatista communities who want these concrete works of self-reliance under construction to be known in other communities and beyond. But rather than inviting outsiders to make the films, they turned to the Zapatista communication promoters, thus ensuring a consistent approach while helping to strengthen the communities' audiovisual self-reliance.

There are also films made by individual Zapatista video-makers that would be quite normal elsewhere, but are the exception in this particular context. Films such as *Son de la Tierra* (*Song of the Earth*, 2002, 16 min.), about traditional Tzotzil music, *La guerra del miedo* (*The War of Fear*, 2002, 26 min.), which chronicles acts of paramilitary intimidation and provocation in a Zapatista region, and *Xulum' Chon* (2002, 16 min.), named after a crafts cooperative whose work and symbolism are explored in the film, were all originally spearheaded by a specific video promoter, albeit always in agreement with the Zapatista civil authorities.

While some films have certainly been initiated by individual Zapatista video-makers, the dominant trend has been for the Zapatista authorities that represent the community to decide when to make a film on a given subject. Take for example the autonomous health system under development in the Zapatista autonomous regions: in the film *El camino de la nueva salud* (*The Path to New Health*, 2008, 42 min.), Zapatista health promoters and their civil authorities explain that the aim is to recover ancestral knowledge while training in allopathic medicine and modern laboratory techniques. *Los cargos*—involving offices, mandates, and responsibilities, including that of video/communication promoter—have a collective dimension, and the prevailing logic is one of collective decision-making. During the editing of this film, there were intense discussions between Tzotzil, Tzeltal, and Tojolabal promoters from different regions on the question of how to treat the figure of the *curandero* (healer, shaman): should he be mentioned in the film, and if so, how? Everyone had a different point of view on the subject. Nevertheless, one of the promoters gradually took on a leading role in the decisions, due in part to the fact that he had been a health promoter and therefore often had a more assertive, sharper point of view on the issue. He was, as it were, the captain of the ship, the one who steered the course. But that doesn't mean his name would have been included in the film's credits as the filmmaker. There is an ideological decision to present the collective first, refusing to attribute a given film to a single author, and avoiding placing anyone's name any higher than any one else's in the credits. To underscore the tension between the individual and collective character, it should also be noted that some of the promoters are there in the first place because the Zapatista organization appointed them. They are therefore there first and foremost out of duty, certainly trying to do the job as well as possible on a technical level, but not all of them are necessarily going to invest as much as a comrade who had been a health promoter for several years and who saw in this film about autonomous health a dimension that was not only informative but also expressive.

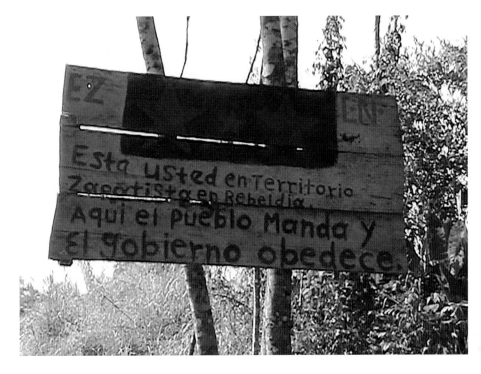

Still, Promedios, *La Tierra es de quien la trabaja*, 2004

I'd now like to focus on a film whose origins lie essentially in the collective mechanism set up by the autonomous Good Governance Councils and communication/video promoters. This is the case of *La tierra es de quien la trabaja* (*The Earth Belongs to Those Who Work It*, 2004, 15 min.). The process of making this started when the Good Governance Council of the Caracol of Roberto Barrios, in the northern part of Chiapas, learned that a government delegation made up of civil servants and plain-clothes policemen was coming to pay an impromptu visit to a Zapatista community that had settled on land close to the Agua Azul waterfalls, a well-known tourist site, without requesting permission from the state. The aim of the delegation's visit was to persuade the Zapatista Indigenous peasants to leave the land before the state would resort to force to evict them. The Good Governance Council of this Zapatista region, having learned of this visit by government representatives—which was supposed to be a surprise visit—decided to send a video promoter and Zapatista organization members, who were trained in dialog with Mexican state authorities, to the community the day before, so as to be ready to receive the delegation and surprise the visitors instead. The video promoter conducted interviews with local members of the Zapatista community ahead of the meeting. When the state representatives arrived in the community the next day, with some delay, the relationship of domination was completely reversed: the camera was part of a mechanism that reversed the usual balance of power. First, the state authorities were ordered to stand under the sun instead of being received in the shade or in a house, and were surrounded by the entire community. Rather than delegating the discussion to the chiefs and author-ities, as would be the usual practice during negotiations, the community stayed for the entire discussion. One by one, the visitors were also obliged to declare their identity, and to defend themselves with arguments, bearing

NEXT SPREAD
Stills, Promedios, *La Tierra es de quien la trabaja*, 2004

in mind that it was the Zapatista representatives who guided the dialog and said when it would start and end. Being able to decide such matters is generally the privilege of the other camp, the dominant camp. Through this inversion of the dominant-dominated relationship, the government's authority was undermined, laid bare. The film is all the more interesting in that, like many others, it wasn't born of an external impulse, whether from a civil society group or the Promedios association. At the time, I was visiting the various Caracoles to hold editing workshops, and I remember arriving at the Caracol of Roberto Barrios, where the coordinating communication promoter showed me what he had filmed while telling me about the filming process. It's possible that these images and sounds would have never been edited or made into a film. But as it happened, Moisés, the communication promoter and coordinator of the promoters in this Zapatista region, had good relations with the authorities in his area. He also had his own thoughts on the purpose of video productions. For him, it was interesting to show this type of situation to the outside world because it could help people understand what was happening on the ground, in the communities, and the situations they were facing. Thinking and saying this is not self-evident because in other cases neither the Zapatista authorities nor the video-makers themselves necessarily hold the conviction that distributing these types of images and situations serves a particular purpose. What we see in this film is therefore quite exceptional. It has been shown in Mexico and elsewhere, and has been very well received by viewers, because it shows how, in very concrete terms, a Zapatista village is resisting state pressure with the help of Zapatista authorities and video promoters. It shows the use of video not as something external to the Zapatistas' mechanism of orga-nization and collective resistance, but as an integral part of its autonomous regional structure. While the representatives of the state wanted to take this peasant community by surprise, this little film shows how it's the other camp that masters time, space, and the production mechanism—a possi-bility that wasn't necessarily visible in the early years of the video-making project in Chiapas. That's why, for me, it's a highly symbolic film, rich in lessons about the stakes and scope of the act of filming in the context of Indigenous struggle.

In the years that followed, from 2005–10, a number of films were still made and distributed outside Zapatista territory. But little by little, they became fewer in number. This is partly due to the position held by the Zapatistas, who perhaps accorded less weight to the usefulness of such films. The working group formed in 1998 to work with the American asso-ciation the Chiapas Media Project, created by Alexandra Halkin, became a legally-constituted association in Mexico in 2002, and little by little the Mexican branch of the association became more and more independent of the American parent association, particularly in terms of its ability to seek and obtain funding from foreign foundations and institutions. Over the years, Halkin's presence in Chiapas has also diminished. Yet she had always been the driving force behind the use of video, given her background in documentary filmmaking. In addition, other collaborators or members of the Mexican association Promedios, which also had a taste for documentary

and even narrative filmmaking, such as Carlos Efraín, a video-maker from Oaxaca, left or became a small minority within the association. The vision that gradually took hold within the association was known as "popular communication." If popular communication is a toolbox, video is a tool to be mastered among others, with less stringent requirements, since the aim is above all to learn how to use all the tools without specializing too much or developing one to the detriment of the others. Learning how to manage satellite internet access, surf the web to select information, and produce wall newspapers to transmit this information to the communities, appear to have gradually become higher priority tasks for communication promoters and Zapatista authorities.

This is just one example to show that, on the one hand, the tasks of communication promoters are increasing, and on the other, the people who are part of the association probably have less desire than in the early years to drive the production of films. All this contributes to the gradual decline in the number of films produced. A regular effort is still made to record, film, and archive, but these images remain within the Zapatista regions and are considered less and less as a part of the assembly of films intended for distribution outside the Zapatista communities. In 2010, the association published an anniversary compilation DVD featuring a selection of films made by Zapatista promoters from the start of the project in 1998 to 2008. This compilation was very successful internationally, with subtitles in several languages (English, French, German, Italian, etc.). Over the years, these films have become increasingly well known, particularly in Europe, in Zapatista solidarity networks, and sometimes beyond. These films also help to supply the Promedios association in Chiapas with volunteers and foreign students, who have often discovered the existence of the association by seeing in their respective countries the films made by Zapatista promoters with the support of Promedios. The paradox is that the films are gaining in distribution at the same time as the production of short documentaries is gradually dying out in Chiapas, with productions becoming more rudimentary and no longer destined for circulation outside the communities.

A significant detail: in the first films made by Zapatista promoters in the late 1990s and early 2000s, most of the Zapatistas filmed in their daily activities do not have their faces masked by a headscarf or balaclava, except in the case of symbolic public acts carried out by the organization (the inauguration of the Caracoles, for example). Over the years, however, the Zapatista authorities seem to have issued increasingly strict instructions to avoid making films for external distribution in which the participants— Indigenous peasants, Zapatista support bases—do not wear masks; an instruction which applies equally to external film crews and Zapatista video promoters. An example of the radicalization/systematization of this instruction can be seen in the production process of the short documentary *La vida de la mujer en resistencia* (*The Life of the Woman in Resistance*, 2004, 18 min.) made in the Caracol of La Garrucha. In the first edit, the film included interviews with Zapatista women speaking openly. However, these interviews had to be subsequently edited so that all the women wore balaclavas. A priori, the order came from the Zapatista Good Governance

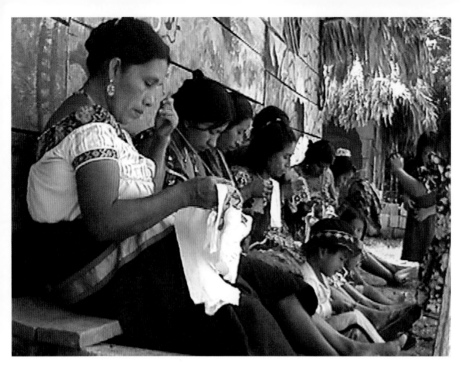

Still, Promedios, *Trabajos colectivos*, 2000

Council of the region in question, a civilian body which likely followed the directives of the commanders of the EZLN, the political-military branch of the organization. In the film *Educación en resistencia*, made in the same region of La Garrucha a few years earlier, the instruction to mask the faces of all participants was not followed. The same observation could be made about other films made by video promoters. Although the timing is not necessarily the same from one region to the next, there is nevertheless now a strong tendency to apply the instruction to conceal all faces, at least for any short film intended for distribution outside Zapatista territory. How are we to interpret these increasingly strict instructions? The argument of protecting the identity of those involved for security reasons has certain limits given that villages are very rarely entirely Zapatista, and that this therefore implies the day-to-day coexistence of communities where everyone knows who is Zapatista and who is not. As such, state services, relying on local sources, have little difficulty in knowing who is a Zapatista. Another reason may lie in the fact that Zapatista leaders are more concerned about controlling the image of their movement that is disseminated abroad. The symbolic collective action carried out in San Cristóbal de las Casas on December 21, 2012 may provide a clue. On the symbolic date of the change of era in the Mayan calendar, thousands of masked Zapatista columns invaded the city, as they had done on other occasions, notably during the uprising of January 1, 1994. But at the end of 2012, they were unarmed and no speeches were made. A small stage was set up near the San Cristóbal cathedral, where all the masked Zapatistas, one by one, column by column, climbed up, raising their fists in silence. This impressive collective choreography thus resembles a great artistic performance, conveying a clear political message: in the Zapatista movement what counts is organized collective strength, not any one individual.

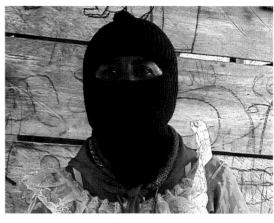

Stills, Promedios,
*La Vida la mujer en
resistencia*, 2004

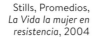

In fact, this is a message constantly repeated by the Zapatistas, and sometimes in relative contradiction to the over-mediatization of the figure of Subcomandante Marcos. In fact, he has become less present in the media over the past decade, often ceding his role as spokesperson for the movement to other Zapatista commanders, and even declaring the symbolic death of the Subcomandante Marcos persona, renamed Subcomandante Galeano in 2014. The masked face has become a rule that tolerates fewer and fewer exceptions, as part of a communications strategy that emphasizes the strength of the collective organization and the desire not to single out any particular individual.

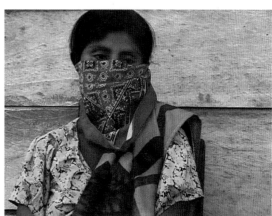

In parallel with this development, on the part of both the Zapatistas and the Promedios association, filmmaking became a marginal activity, and eventually almost non-existent. In 2014, the Promedios association in Chiapas stopped working with Zapatista communities, while continuing to offer audiovisual training to people involved in social organizations close to the Zapatista spirit of autonomy. The association is also responsible for managing an archive, largely the fruit of a collaboration with Zapatista communities spanning more than

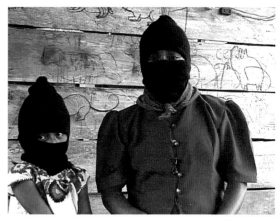

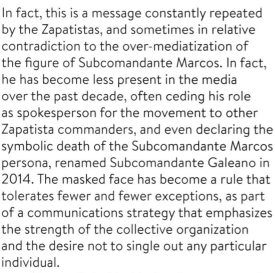

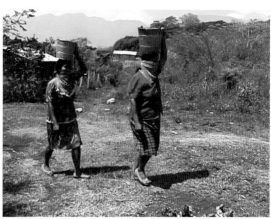

Nicolas Défossé

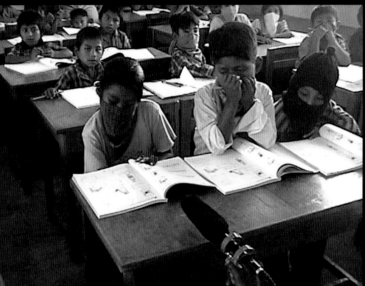

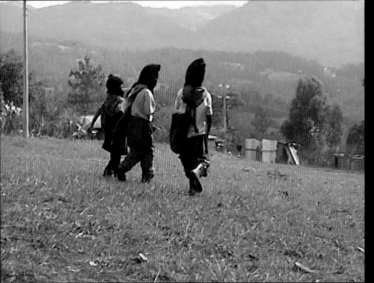

Stills, Promedios,
Letritas para nuestras
palabras, 2005

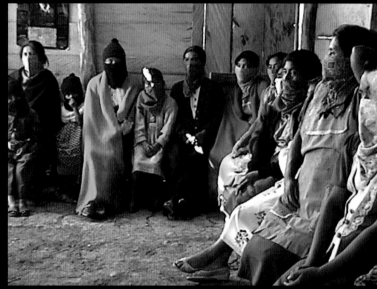

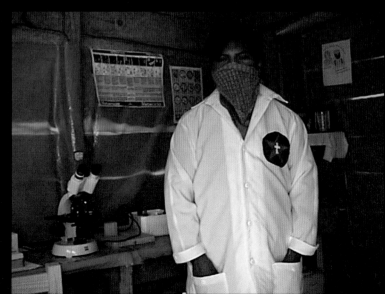

Stills, Promedios, *El Camino de la nueva salud*, 2007

fifteen years, with the task of preserving this heritage and making it accessible to future generations. The largest part of the archive covering the collaboration between Promedios and the Zapatista movement concerns the ten-year period between 1998 and 2007.

Since 2014, a new generation of Zapatistas who wield the video tool has emerged in the Zapatista regions. The term video promoter or communication promoter has given way to the expression "los tercios compas" in reference to the fact that they are neither the official media of press agencies nor alternative or independent media, but "the third media," originating from Zapatista communities. They are in their twenties or sometimes younger, and while there seems to be a desire to make films among some of them, the current audiovisual productions are unlikely to materialize as fully-developed films. Few of the films that *are* being made are intended for the outside world, and the majority of audiovisual pieces produced primarily serve an informative and educational function. Above all, the link and transmission between the first generation of Zapatista video-makers trained by Promedios and the current generation is not obvious, as if there has been a break. Hence the redoubled relevance of the question of archive preservation, which concerns not only an external audience but also the transmission of this history within the new Zapatista generations.

Still, Promedios,
*Caracoles: los
nuevos caminos de
la resistencia*, 2003,
detail

Zapatista Cinema

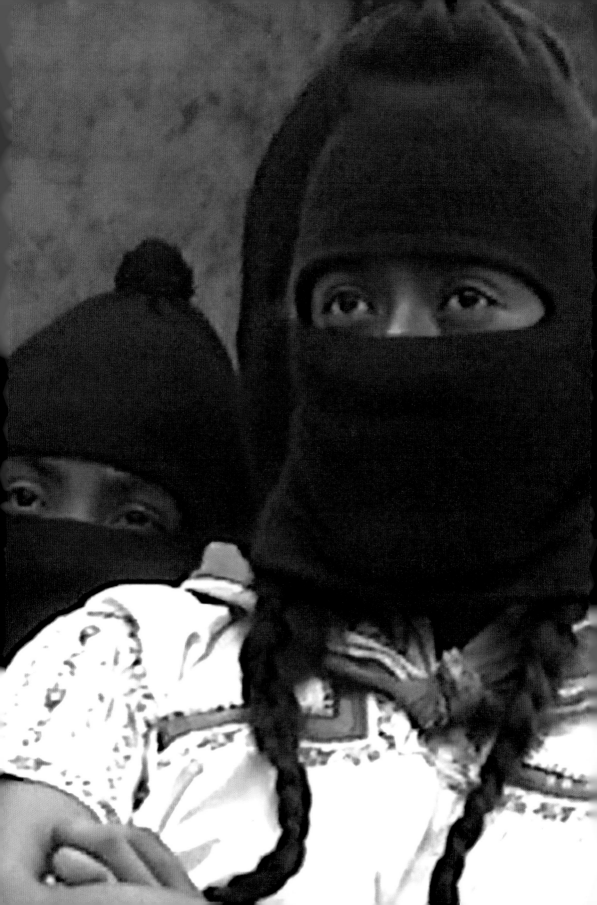

Intertwining Indigenous Resistance in Cauca

Ariel Arango Prada
Laura Langa Martínez

in conversation

*¡Tierra para la Gente. Gente para la Tierra!** [*]

Sangre y Tierra, Resistencia Indígena del Norte del Cauca (Blood and Earth: Indigenous Resistance in Northern Cauca) is the first documentary by Entrelazando, an independent and itinerant audiovisual and editorial production company that was born in 2012 in Argentina. Our aim was to document different contexts in Latin America from a mobile home— a Volkswagen Combi '84—together with colleagues from different disciplines who focus on documentation based on artistic and investigative work. Eventually this journey on wheels ended, giving way to a new stage of Entrelazando in which the cartographies continue to be traversed, now installed on a more permanent, yet not fixed, basis in Colombia.

This is how Entrelazando was constituted as a meeting space destined to create, communicate and intervene in reality with different artistic expressions; with the intention of contributing from the political communication that our bodies, visions, and voices allow; and aspiring to contribute towards transformative collective action, always seeking the astonishment that grants the possibility of narration.[1]

We first arrived in the Indigenous communities of Northern Cauca in Colombia, where *Sangre y Tierra* is set, in February 2015. In those days, the community was celebrating the 44th Anniversary of the Consejo Regional Indígena del Cauca (Regional Indigenous Council of Cauca), CRIC, one of the first organized Indigenous movements in Latin America that emerged in the midst of violence and subjugation of the peoples of southwestern Colombia in 1971. Under the postulates of *Unity, Land, Culture* and later *Autonomy*, CRIC continued the struggle for the recovery of the lands of the Resguardos[2] and the non-payment of *terraje*[3] (leased land), the defense of Indigenous history,

1 To learn more: www.entrelazando.com.
2 Resguardos are legally recognized territories of Indigenous communities, with inalienable, collective or communal property titles, governed by a special autonomous statute that was institutionalized during the Spanish colonization.—Trans.
3 This refers to a payment in labor force that had to be made on the land appropriated (usurped) by the landowners in exchange or compensation for being able to cultivate a small piece of land to live on—thus becoming a widespread practice of modern slavery. Usually the whole family was under obligation to to "pay the terraje" for several days a week.

[*] "Land for the People. People for the Land!"

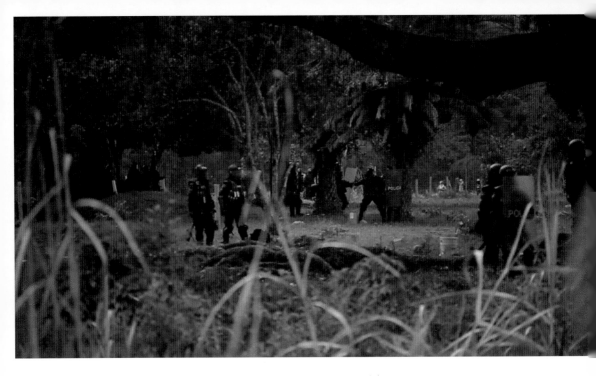

language, and customs, information about laws concerning the Indigenous communities, and the demand for justice generally.

And the fact is that since the time of the genocide, of the so-called "Spanish conquest," the lands of these communities were usurped, passing into the hands of settlers, the Catholic Church, and landowners. Because that is how the large estates grew, with fire and blood—erasing the map of these lands as they were before the grievances, before exploitation and expropriation, when someone said that this land was no man's land, wasteland.

This is what happened in northern Cauca, and in the flat area of Valle, where those families with power inherited from colonial surnames began to impose themselves on the land and its peoples, maintaining slavery, managing to destroy a significant number of the ecosystems of this region, monopolizing what is today a green horizon of sugar cane that extends between the western and central mountain range, with all its violence and dispossession. For this reason, many of the blood stories of the Afro, Indigenous and peasant communities lie in the memory of these lands, as well as the resistances that have been maintained with human costs over time.

One of these resistances is the ongoing struggle for the recovery of land that began in the 1960s, which gained strength in the 1970s and 1980s, and continues to this day. The people entered, armed with picks and shovels, to work the land, their land. To sow it, to cultivate it and thus, little by little, to return to live on it. The state had to recognize the rights of these communities, which the law itself already protected, and begin, through the Colombian Institute of Agrarian Reform (INCORA) at that time, to buy these lands in order to return them. This was not without tension and violence, as the protesters were often detained, tortured, persecuted, and many of them were murdered.

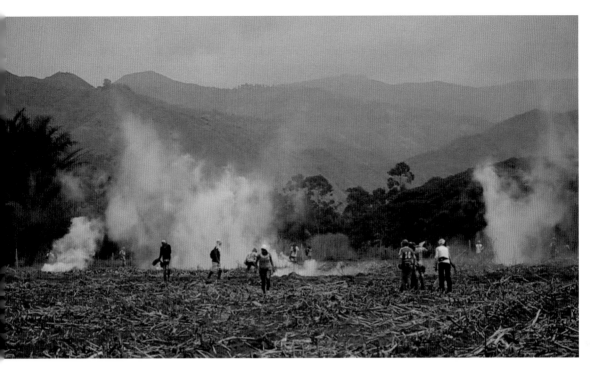

This is what happened in most of the territory where *Sangre y Tierra* was filmed.

And in all this history of dispossession and violence, on December 16, 1991, a massacre took place known as the Nilo Massacre, in Caloto, Cauca, in which twenty Indigenous people of the Nasa Nation were murdered— people who had been recovering those lands and others nearby for several years. They were about to harvest their crops when narco-paramilitaries, with the complicity of the state,[4] entered to shoot and set fire to their houses.

It was a massacre foretold, because the community had given notice of the threats they were receiving, as well as the existing risks.

The massacre occurred just after a process of laying down arms initiated by several guerrilla groups, such as the M-19, which was joined by the Quintín Lame Armed Movement, an armed Indigenous group that had emerged to defend itself from violence and persecution by the state, by paramilitaries, and some guerrillas. That political agreement resulted in the drafting of a new political Constitution that recognized the Indigenous

Still, *Sangre y Tierra*, 2016. Voiceover, Liberator of Mother Earth: "How is it that men, women, children, the elderly, are going to be subjected to the full combat force as if they were in a heavy battle, as if they were in a war? When there are helicopters, airplanes, tanks, trucks, trained horses, weapons to persecute people. [...] It is a very violent form of aggression by this government."

4 Major Jorge Enrique Durán, commander of the 2nd Police District of Santander de Quilichao, and Captain Fabio Alejandro Castañeda, at the time Anti-Narcotics Chief, are accused of being responsible for the massacre, along with drug trafficker Alberto Bernal Seijas, in charge of trafficking arms for the United Self-Defense Forces of Colombia to the Urabá region, and the pilot of drug trafficker Gonzalo Rodríguez Gacha. Currently, Bernal Seijas has requested his entry into the Special Justice for Peace, JEP, which was created within the framework of the so-called Peace Accords, which will imply his release, despite the fact that in 2002 the sentence by the Supreme Court of Justice ratified his twenty-six-year prison sentence. With respect to Duran and Castañeda, following a long process of judicial delays, the Council of State and the Supreme Court of Justice reaffirmed the responsibility of the state, revoking the action of the military criminal justice that had kept them free. The trial against them is currently in process.

peoples as being the subjects of rights in Colombia; or, in the words of the Liberators of Mother Earth of Cauca: "a political pact with which they were the only ones winning, while we had to be content with the corner to which they had destined us, with the crumbs of a state that little by little would be handed over to the masters of the world."[5]

After the massacre, impunity for the perpetrators followed and, in turn, unfulfilled agreements with the state in terms of land restitution continued. At the same time, social movements started proposing a "possible and necessary" world. This was the case in 2005, when the streets were filled with protests to prevent the implementation of the Free Trade Agreement with the US, which would have a negative impact on the country's food sovereignty. That same year, in September, the Nasa Indigenous community decided to recover the lands of La Emperatriz, the farm where the Nilo Massacre had been planned. Eleven days later, after much tension, the state officially agreed to budget twenty billion pesos for the purchase of land as "reparation" for its responsibility in the massacre—a responsibility that had been judicially recognized by the Inter-American Court five years earlier, condemning the Colombian state and requesting an investigation to prosecute those responsible.[6]

This promise was just one of many that are agreed upon by the bureaucracies that result in long waiting periods, impunity, and oblivion. Meanwhile, in 2007 and 2008, large mobilizations took place that led the Indigenous movement across the country to the capital, Bogotá, to share their dignity, their resistance, and their political project as an alternative for the peoples, and to continue demanding compliance at least with the signed agreements.

In 2014, this wait was exhausted and a group of Indigenous people decided to "liberate" four farms at the service of the sugar mills who had been grabbing the land in this region, leaving the state as an interlocutor in the past and directly attacking the economic interests of the companies, the same ones that have been determining the economic and political destiny of the country. Thus began what was self-described as the Process of The Liberation of Mother Earth (Proceso de La Liberación de la Madre Tierra). The process consists of cutting sugar cane and planting food on lands that the agroindustry appropriated for the benefit of a few, in order to create new models of community life and secure the preservation of these lands.

It was an interest in this process, which was gaining huge momentum in those days when we arrived in Northern Cauca, that led us to arrive there, albeit without really understanding what it might imply in creative and personal terms.

5 https://www.cric-colombia.org/portal/libertad-y-alegria-con-uma-kiwe-palabra-del
 -proceso-de-liberacion-de-la-madre-tierra/.
6 Case 11.1101 April 13, 2000. "In view of the information gathered during these proceedings, the acknowledgement of responsibility by the Republic of Colombia, and its response, the Commission reiterates its conclusion that agents of the state together with a group of civilians violated the right to life of the 20 Indigenous persons killed. […] The state has partially failed in its obligation to guarantee these rights and has failed in its duty to take the necessary measures to prevent their violation." Full ruling: https://www.cidh.oas.org/indigenas/colombia.11.101.htm.

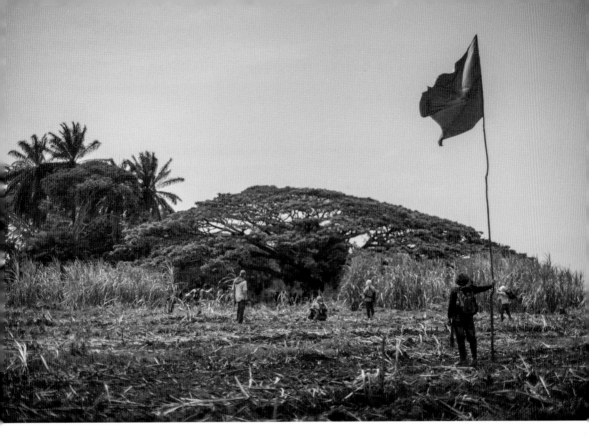

That was how *Sangre y Tierra* began: wanting to know what was happening there at that moment, a research exercise with a camera, but without script or hypothesis, nor calendar or timeline. We were a very small, austere team of one, two, or maximum three people on some occasions, with few economic resources, full of interest and commitment, just like the resistance itself.

And in that sense, the documentary is also a form of resistance, a way of putting body and gaze at the service of collective memory, but above all of the transformation of imaginaries through the critical revision of history. It is an ethical-political exercise, both individual and collective, that can have a positive impact on people's lives—sometimes it can even transform them, and even if this sounds a little utopian, it at least changes the destiny of those who make the film, and that is a shockwave.

"Creation is the movement of life," said the writer Alfredo Molano, which is why all "efforts aimed at knowledge must aspire to create, not to discover. To create is, after all, an ethical act."

That is why we must pay close attention to the type of creative processes with which we engage, because it is very likely that we end up rooted, deeply linked to those with whom we share experiences; and on many occasions the fertility of these creative processes also influences new ones. It is a spiral that goes outward and inward, like the memory of the peoples. This is what happened to us with *Sangre y Tierra*, and this is the reason we are writing these lines.

Minga of Cane Cutting at Finca la Emperatriz

How was *Sangre y Tierra* made?
What were the decisions that precipitated its realization?

Magic in the flow of the color of the earth.

One day, like many others, accompanying a community exercise, an assembly of the Indigenous Cabildos of Northern Cauca, a particular event occurred that definitively marked the creative path of *Sangre y Tierra*. We were returning from a sugar cane cutting *minga*[7] at the farm La Emperatriz, where for several hours there were confrontations with the police's mobile anti-riot squad ESMAD who were trying to evict them. Nearby, the community was gathered in assembly, the traditional healers were sitting around the fire—the *tulpa*. We arrived and I sat down with them, they gave me coca leaves and several plants, and we stayed like that for a long time until one of them got up and came to give me the scarf of the Indigenous movement, with its red and green colors, commenting that "the sign marked that I could carry the message of the people."

I received the scarf and I was confronted—undoubtedly it was a welcoming gesture, a gesture of acceptance without even really knowing me and without my having said a single word. There was much to understand and learn from this gesture, and I had several plans at that time that included taking other directions outside Colombia. This specific situation made us rethink the way we choose our paths, or how they choose us; the implications of arriving at a place and how these determine our ways. And also accepting that there are orders of another nature that have great relevance within the communities, such as the practice of spirituality.

The decision was undoubtedly to stay and assume the destiny that the coca leaf had marked. And as it could not be otherwise, the documentary had to carry in its name the meaning of that scarf, *Sangre y Tierra*, Blood and Earth.

Eight years have passed since that night and we are still walking hand in hand with the communities of Cauca, with new creative processes including a documentary film and two editorial projects that are in the development stage, *Ofrenda* (*Offering*) and *Tumba la caña* (*Cut the Cane*). It is a time in which we from Entrelazando have been involved in other creative processes that have led us to converge between diverse forms of knowledge, and paths, to begin to create handcrafted books woven from multiple languages and which maintain our need to narrate the resistances in other parts of the country.[8]

When I now remember that night by the fire and the coca leaf, I think of the experience of Jorge Sanjinés and the Ukamau Group in Bolivia while filming *Yawar Malku* (*Blood of the Condor*) in an Indigenous community called Kaata at the end of the 1960s. They say that they had an invitation

7 The *minga* is community work, in which the community is called to come together to achieve a common goal—in this case to cut the sugar cane planted by the sugar mills, to "free" the land and put it to another use.
8 http://entrelazando.com/sincesar/.

from the chief of the community, but when they got there realized that the invitation did not guarantee any permission to shoot. The community was very distrustful of the outsiders, to the point of generating a high level of tension that sought to expel them entirely. In addition, the mayor of the neighboring town apparently provoked even more distrust by saying that they were "dangerous communists who came to rob and murder."[9]

In the middle of a long conversation between the film crew, a phrase came up, very commonly used in Bolivia, to refer to strange situations that are difficult to resolve: "*esto no se ve ni en coca*"[10] (not even the coca will reveal this). It was precisely this phrase that became a revelation, and they asked the community chief if the Yatiri (clairvoyant and guide of the ceremonies) could consult through the coca ritual whether their presence was positive or not. The result was positive, and since then the community radically changed their attitude towards them, deciding to actively collaborate in the process of the film. This fact, anecdotal if you will, highlights on the one hand that

Coca leaves and tobacco

many times an approach to the communities is attempted through their best-known leaders or their authorities—effectively a colonial approach that constructs hierarchies above the social bases without understanding that they are elected by community assemblies, and that they frequently rotate their positions.

This, together spirituality and its rituals, is what has maintained the resistance that has endured for so long, despite the fact that the capitalist model has managed to destroy it little by little, and it is also what keeps us with the heart and the commitment to continue walking, listening, and learning hand in hand with the social bases. Building solid ties with those who ultimately make the organizational process possible and collectively sustain all decisions.

What happened to us that night with the traditional Nasa healers is just one example of the effects that this way of walking and understanding creation has had on us, whether by way of film or other manners of expression, which has led us to reaffirm the power of the encounter as a gesture of joint creation that strengthens inwardly and outwardly.

9 Jorge Sanjinés and Grupo Ukamau, *Teoría y práctica de un cine junto al pueblo* (Mexico City: Siglo Veintiuno Editores, 1979), 29.
10 Sanjinés and Grupo Ukamau, *Teoría y práctica*, 29.

What if, by methodology, we really meant timeline?

Recovering the Land to recover everything!

The surprise of what is to come. Urgent cinema.

It is said that the awareness of the unfinished is the awareness of constant transformation, which invites a willingness to sow doubts and suspicions about what we see, and thus be attentive to the doors that the same path and the same intuition are offering us. Therefore, it is essential not to place too many limits on creation, because the creative process itself will mark them for us and it is only a matter of being alert. It is a way of allowing the path to be the one that walks us, until ethical and political decisions, and even technical ones in some cases, lead us to set certain limits.

In our case, we did not have a determined work schedule; the deadline for the completion of the documentary was marked by a decision that had to do with a necessary criticism we wanted to make within the framework of the "Peace Dialogs" that were taking place at that time in Havana between the FARC-EP and the government of Juan Manuel Santos. A dialog behind closed doors between the government and another armed actor of the "internal conflict," as they decided to call it, because talking about war in a "democracy" was nothing less than scandalous.

While we were shooting *Sangre y Tierra*, we felt that the conditions of injustice and social and economic emergency that the state and the companies had brought to the social sectors were impossible to imagine being resolved peacefully; and much less with only one of the armed groups, knowing that many others were acting in the territory. In fact, one of the "red lines" of the negotiation forbade touching the military doctrine that had protected so many crimes, including the state's responsibility for the Nilo Massacre.

Furthermore, these "Dialogs" were being held without questioning the country's economic and political model. This amounts to another "red line," and the cause of the direct difficulties regarding access to land, which instead becomes destined to looting, extractivism and dispossession through mining titles and agroindustry by large landowners, cattle ranchers, and businessmen, as was and continues happening in this area of southwestern Colombia.

That is to say, they were not seeking to solve the causes of the barbarity, but rather to slightly and deceptively palliate its consequences. This opened the door to end up accepting, suddenly, that the person responsible for the catastrophe would be the one who would solve it. Meanwhile in the territories, the repression by the state continued through its public forces as well as the systematic and structural violence of its political and economic measures, which are directly affecting the communities while benefiting, in this case, the large sugar mills.

This is why we took the decision that the documentary should be released before the signing of the "Peace Agreements" (*Acuerdos de Paz*, 2016), to generate dialogs and debate this situation that was not being

Intertwining Indigenous Resistance in Cauca

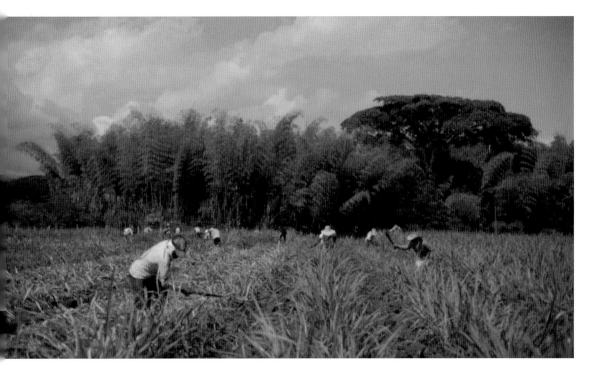

publicized by the official media—the same media who had been responsible for building the story of the public enemy, in which the responsibility for everything bad that happens in the country is down to "the guerrillas," and who have also stigmatized all the actions of the Indigenous movement.

For this reason, *Sangre y Tierra* became an exercise in "urgent cinema"—in the sense that we shared parts of the film before completing the documentary.

From a first teaser—involving some photographs and graphic pieces produced together with other artistic collectives and some members of the Indigenous communities of Cauca—we began to generate meetings in different Cultural Centers of the city of Bogotá in order to disseminate, reflect, and open the debate; but also to find resources that would allow us to make a donation of materials to support the Process of the Liberation of Mother Earth, always promoting the exchange. All this material, which included tools for working the land, camping sites, hoses for crops, kitchen utensils, paints, and other items, we delivered to Cauca, to be useful at two points of the Liberation.

In this way, the photographic and audio-visual records served not only to summon reflection, but also create an alchemy in the cities that generated solidary support. They contributed in a practical, reciprocal way—because we know that filming is not enough. If cinema is good for anything, it is to create bridges within society and across distant geographies, promoting the critical gaze and exercising reflective contemplation.

In short, the goal is to produce a piece of communication that mobilizes. That is what we believe the documentary is: encounter and movement.

The decision to circulate the material before it was completely finished allowed us to show the audio-visual material to the communities

Still, *Sangre y Tierra*, 2016. Voiceover, Liberator of Mother Earth: "The Minga for the Indigenous peoples has represented the most pedagogical space, the most practical one in terms of unity, in terms of understanding. But above all, it was the integration of many families, of many communities."

and people close to the process, and from there consolidate decisions of style and content. After all, the documentary sought to become another tool for the community, helping to show to a wider public what was happening there.

This was the great challenge we faced. It was no longer only the challenge of representing the communities, recognizing the mosaic of hierarchies and otherness, but also an ethical one: how to deal with the contradictions that every movement has aspects that sometimes we do not want to show?

This is what the documentary is—each shot implies a choice. What are the intentions of those choices? What makes us focus on one story and not on another? To which imaginaries do we want to contribute?

The decision, although questionable, was relatively simple for us when we tried to answer this question: What were the implications and consequences of showing a story with all of its contradictions concerning the multiplicity of opinions and experiences involved in understanding the political governance of Indigenous peoples? Was that what we were looking for with *Sangre y Tierra*?

The answer could have been yes, and it would be legitimate. But it would be another documentary. The sense of *Sangre y Tierra* was to show an alternative of an actual struggle, of resistance, that could inspire other processes even beyond the geography of Cauca. And that was our choice in a precise and historical moment of the country.

Those exercises of sharing the material, which generally worked as a video forum, generated many extremely enriching, emotional, self-reflective conversations that, through their comments and suggestions helped us to understand more deeply the meaning of what we had decided to show, the Indigenous resistance. This process was very touching;

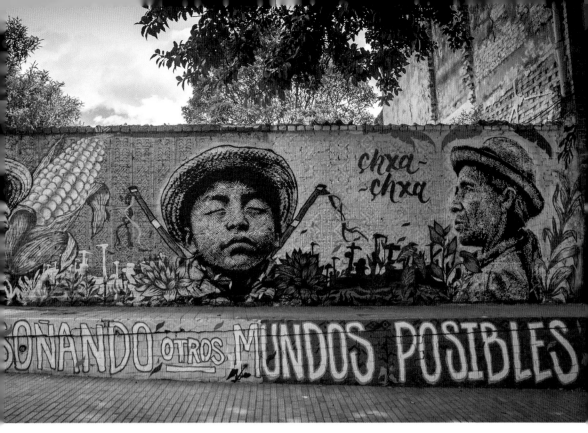

it allowed us to witness together many of the communities documenting their own process, and to learn what they wished and expected to happen with the documentary. In this sense, many expressed pride in seeing themselves marching there, in seeing their hope and their struggle represented, which could then reach many viewers and remain deposited in a document that could last over time; that is to say, in memory.

After a few months, the finished documentary reached the hands of the communities.

From this process prior to the premiere of the documentary, other possibilities arose that allowed us to put the material produced to further use, weaving with other collectives, artists, and communities. Thus, some of the images were turned into large-format murals and gigantographies intervening in a number of social spaces. We also jointly published reports in the Nasa people's own media, as well as in the national and international media. In addition, some of the photographs were made available for use in books and postcards published by the Liberation of Mother Earth to raise funds. And it generated a group of young communicators from the communities who were was trained in video editing and photography.

Undoubtedly, the documentary ended up being a pretext to generate other projects which resulted in very enriching and creative human relationships that continue to this day.

Artistic intervention produced by Entrelazando, Colectivo Dexpierte, and the Guardia Indígena in Bogotá

So who decides the narrative?

The journey of the community always marks the destiny.

In documentary filmmaking it is very convenient to find a character and, through their tracking and dramatic transformation, describe the elements of a specific context and thus develop a narrative with a denouement from the point of view of a personal story. But in the case of *Sangre y Tierra*, since it was a collective process, the narrative could not be limited to a few protagonists; instead the community had to lead the story. That is why, precisely because it is a community process, it was necessary to address the different historical and contextual elements that make possible its organization and resistance beyond the specific instance of the Liberation of Mother Earth.

Still, *Sangre y Tierra*, 2016. CRIC elder Blanca Andrade: "The indigenous movement in '71 began for what was needed and that is why the platform of struggle was formed and there it is very clear what we wanted and what we have been building and what we have been winning through the struggle. This is the peace process of the indigenous movement that we have managed to achieve and that the youth will continue to achieve if they keep on fighting."

With this in mind, we decided to refer to the struggles of the past, the rituality, and other aspects of Nasa Indigenous culture with different levels of depth. The same approach was brought to bear on the Indigenous Jurisdiction that was being questioned at that time (one of the victories of the 1991 Constitution), social mobilization in Cauca and Bogotá, and the organizational processes of the Álvaro Ulcué youth movement—a seed that fosters the continuity and development of community life. In combination, such elements offer a broad perspective of the values, causes, and motivations that lead a community to change the destiny of its history.

By narrating together all these elements we were encountering, we believe it allows both ourselves and the viewer to identify the values and awaken in them a certain empathy and understanding, finding common places and shared struggles. This was especially charged during those months because official media channels were generating a campaign that stigmatized and discredited these Indigenous communities, especially the process of the Liberation of Mother Earth. Such channels completely decontextualized their historical and legitimate claims, presenting them as "usurpers of land linked to armed groups."

Intertwining Indigenous Resistance in Cauca

And all this, how does it influence the technical decisions?

As we were filming and understanding the elements that ought to appear, we realized that the editing process had to happen much faster, so we decided to edit the material as it was being filmed, thus composing different sequences that worked independently in advance of eventually finding an order that would allow them to enhance each other.

There is a method I knew from an Argentinean filmmaker I admire, Jorge Prelorán. It was the '60s, a time when filming was very recursive; Jorge had a sound recorder that was not synchronized and a 16mm Bolex camera that, besides being noisy, only allowed him to film takes of up to thirty seconds. So his gamble was to record the sound first the interviews and conversations, and from

Still, *Sangre y Tierra*, 2016. Indigenous protesters, mainly Nasa, heading to Bogotá during Minga Social y Comunitaria por la Defensa de la Vida, el Derecho a la Protesta Social y la Jurisdicción Especial Indígena— J.E.I. (Social and Community Minga for the Defense of Life, the Right to Social Protest and the Special Indigenous Jurisdiction). November 22–27, 2015.

that material develop the script that he would later film. In this manner, with images of short duration, the narrative flows easily. Something similar happened with the editing of *Sangre y Tierra*.

For me, sound is the soul of cinema and the body is the image. You can have a film with excellent images, but if the sound does not work it is very difficult for the viewer to endure it; on the contrary, if the sound is very good, it could work even if the image quality is poor. In that sense, the way to edit *Sangre y Tierra* was to first create the sound mix, with the testimonies, the ambient sounds, and the music, which in this documentary is fundamental because for the Nasa people music is always present. Flutes and drums accompany the daily scenes of resistance. The most popular songs are full of struggle, denunciation, demands, hope, and joy, that is, they are a faithful reflection of their resistance—just like the radio, another fundamental element always playing in the kitchens.

In this sense, it is worth mentioning that the Indigenous movement of Cauca has managed to generate its own processes of community radio stations, which are very practical when it comes to convening, informing, and accompanying—that is to say, a format that mobilizes, and which for us was also a channel of learning. The language, the tone, the irony, the laughter, the way of narrating, of choosing the contents, the order in the stories or their rhythm, were all aspects we applied to the editing of *Sangre y Tierra*, especially in emotional terms.

Punto de Liberación in the Finca la Emperatriz

The daily process of resistance in the communities of Cauca is full of unexpected incidents; each day brings its own event, its urgency, its mobilization. Many things happen all the time, and that was a feeling we also wanted to transmit through the documentary. That is why the editing had to have a dynamic rhythm, moving from one side to another, the way the community reacts immediately to each problem. That is why there are many contrasts between one sequence and another.

In this diversity of moments that the past invokes, it was also necessary to make use of multiple registers, so the archival material that we were able to integrate into the documentary was of enormous help. Because in the sense that in this documentary the protagonist is the community, a collective, the perspectives have to be collective as well. In short, cinema is always a collective work, and having the possibility of combining images of the past in dialog with those of the present is an exercise of memory that commits us all, provoking expectations relative to the future and filling us with questions.

Intertwining Indigenous Resistance in Cauca

How did the dissemination start? What have the repercussions been?

Taking the message of the people to the world.

Finding an audience has always been one of the great concerns of documentary filmmaking. Beyond theaters and film festivals and despite the rise of countless platforms that make it easier to find diverse content, this does not always guarantee that documentaries will find their place, especially if accessing these spaces involves a fee or being part of certain social groups that such platforms can reach more easily. In short, it is inevitable that many people miss out, especially when it comes to documentaries with a political commitment; within certain exhibition spaces there are even regulations against screening contentious material. It is certainly important that the work can be seen by all types of audiences; paradoxically, however, it is often in very local or otherwise small venues that such work can have a greater impact—especially if accompanied by an event that generates a debate, which is often not possible in commercial movie theaters.

In the case of *Sangre y Tierra*, we decided to begin screening it within the Nasa Indigenous community—on occasions such as the forty-sixth anniversary of the CRIC, where more than 300 people gathered. Then it was taken to the various Resguardos where parts had been filmed; and it was also presented to the CRIC Councilors and some leaders of the Indigenous movement. These first screenings also served to ensure the communities' approval, and to enter into dialog with the rest of the citizenry. It was officially premiered in the capital of Cauca, Popayán, in an emblematic auditorium of the University of Cauca, the Paraninfo.

The decision to use this venue was not casual, as it contains some of the most conservative symbols of slavery and the Spanish colony, including a large 6 × 9 m painting by Efraím Martínez, *The Apotheosis of Popayán*, which depicts the families that exterminated the Indigenous communities and made their great fortune from the imposition of slavery, destroying the ecosystems of Valle del Cauca. This oil painting was covered by a large white screen on which *Sangre y Tierra* was presented. It was a deliberately provocative, symbolic gesture.

The room was so full that some people had to stay outside. Thus began the screening process; next it was taken to the Centro de Memoria in Bogotá, where 400 spectators filled the center's three rooms; and then it began to circulate in the film clubs of several universities, in independent cultural centers, and little by little people began to ask for it in other Latin American countries. It was a success, with a large number of spectators, all outside the traditional screening venues, and always free of charge. Word of mouth helped a lot, and, as the screenings happened to coincide with significant mobilizations of the Indigenous movement in Cauca, the film helped audiences understand some of their problems. In a way it was becoming the tool we always wanted it to be.

In this sense, we were able to share our work in other contexts where resistance processes were taking place over land issues and claims for the rights of Indigenous communities, such as in Mexico, Chile, and Australia.

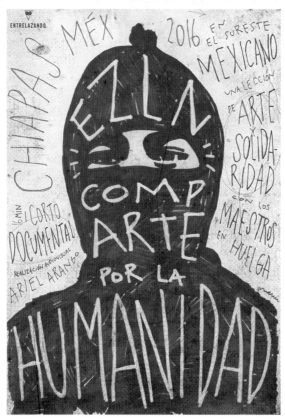

This is how in mid-2016 we came to travel to Mexico, to the EZLN art festival in Chiapas—the CompARTE for Humanity, a festival that invited artists from around the world to share their art with the Zapatista communities.

In those days when the festival was held, the teachers were on strike throughout the country against the Education Reform proposed by the government of Enrique Peña Nieto. One of the strongest mobilizations was concentrated in the Mexican Southeast, where there were many blockades on the main roads with large camps of

Poster for the documentary *EZLN CompArte por la Humanidad*, 2016, Mexico

teachers. The EZLN proposed that part of the festival take place at these points in support of the striking teachers, and also shared with them the food they had prepared for the festival in solidarity with the struggle—about eleven tons in total (110,000 corn tortillas).

After watching *Sangre y Tierra* at one of those screenings at a blockade on the outskirts of Chiapas, I was approached by an Indigenous man from the region who was very moved. He told us that his community were experiencing a very serious situation of labor exploitation and humiliation in the sugar cane crops, perpetrated by the landowners in the area, and that he would like to show the documentary in his community to motivate his peers to do something similar. We gave him a copy without a second thought; clearly our documentary had found its way into the right hands. In recent years Chiapas has increased sugar cane cultivation to the point of becoming the fourth largest producing region in Mexico.

We also took the documentary to several other places linked to the teachers' strike, and left copies in the Zapatista Rebel Autonomous Municipalities, which generated interesting conversations. In the end, this experience led us to also shoot a short documentary about the strike, the art festival, and the support of the Zapatistas.[11]

More recently, in 2019 we toured Greece, exchanging ideas with environmental movements who fight against burning toxic waste, gold mining, and for the protection of water sources. In this way, *Sangre y Tierra*

11 https://entrelazando.com/portfolio-item/ezln-comparte-por-la-humanidad/.

Intertwining Indigenous Resistance in Cauca

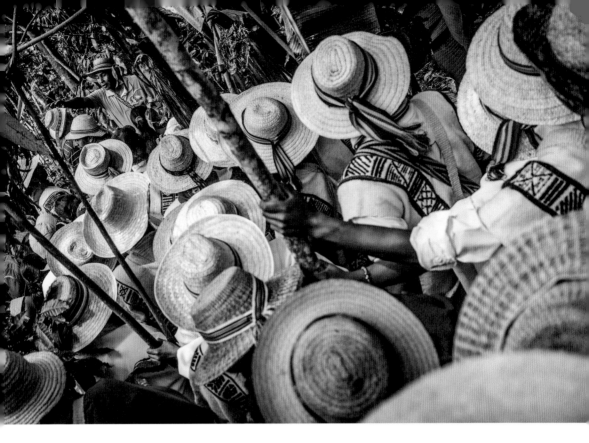

is enabling us to generate links of great human richness, creating connections with collectives from other countries; exchanges that in solidarity also served to translate the documentary into English, French, Italian, Portuguese, and Greek. Over time we also began to receive some voluntary financial contributions, as well as a few awards, which allows us to finance part of Entrelazando's other creative processes, continue supporting the resistances, and also finance the circulation of the documentary itself. Throughout all this time, we have also participated in a number of documentary film festivals—some very large, others quite small. The documentary is freely available on several online platforms as well as our own website.[12]

We can positively say that since its premiere we have had at least 45,000 viewers, who have been able to see and hear the message of resistance of the communities of Northern Cauca. This means that we can secure wide audiences without the need of a distribution company.

Saakhelu Kiwe Kame, community ritual of the Nasa people

12 https://entrelazando.com/portfolio-item/sangreytierra/.

Why make *Sangre y Tierra*?

To avoid inheriting hopelessness.

From the beginning, the purpose of *Sangre y Tierra* was to show that "another world is already possible." This is how we experienced it in the Indigenous communities of this region of Northern Cauca, which were and are proposing an alternative way of life applicable to any global context, even though it is a very local experience.

 The alternative is clear: to enter those lands that have been usurped and stripped of their original nature in order to free them from an extractive and predatory destiny. And through this, to expand the plans of community life, against monoculture: planting organic food on those lands, both for the people who live there and for those who come from elsewhere; and to distribute it in the peripheries of nearby cities where hunger has become a daily occurrence. This became known as the Food March.

 In a way, what they are proposing is an agrarian reform, communal and self-convened—of self-justice outside the logics and laws of the state and the companies. It is also a space for meeting and learning, where all those who identify with this journey have a place, and where other initiatives from different latitudes converge to be discussed and shared. The Liberation of Mother Earth is a process that considers not only those who are here now, but also those to come—a way to break geographical and temporal boundaries, and that seeks to avoid inheriting hopelessness.

Still, *Sangre y Tierra*, 2016. Television news reporting on the demands of the Indigenous peoples during the Minga de Resistencia por la Vida, el Territorio, la Dignidad, la Paz y el Cumplimiento de Acuerdos (Minga of Resistance for Life, Territory, Dignity, Peace and the Fulfillment of Agreements). June 2016.

 Intertwining Indigenous Resistance in Cauca

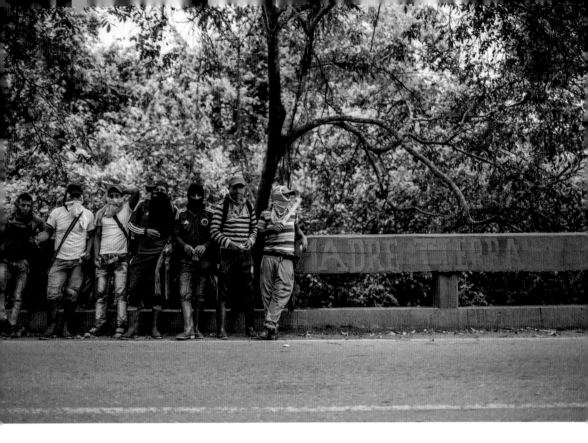

Why make documentary films? Isn't everything already filmed?

"Calling for unity"—heirs of a long history.

One night in front of the bonfire during the filming of *Sangre y Tierra*, an older man from the community who was chewing coca leaves asked: "How do you think of yourself in two hundred years from now?" This is a question that even today, through every creative gesture, we seek to answer in the cinematographic and editorial process of Entrelazando.

 Because in this question there is a sense of legacy and commitment to the future with the collectivity or collectivities that concern us—the response to which assumes the certainty that our actions affect the way we prolong life. Cinema has this characteristic: the virtue of transcending time and geography, beyond our vital permanence, to influence those who relate to it in some way.

 Because each creation has its own path that exceeds our control, which we cannot reach because we do not know its final destination. It is what people call "the social life of movies," full of possibilities and surprises, where chance works its magic.

 This is what happened with the "New Latin American Cinema" in the 1960s, where the films of Fernando Birri and Fernando Solanas in Argentina, Jorge Sanjines and the Ukamau Group in Bolivia, Patricio Guzmán in Chile, Glauber Rocha and Nelson Pereira Dos Santos in Brazil, Tomás Gutiérrez Alea in Cuba, and of course Jorge Silva and Marta Rodríguez in Colombia,

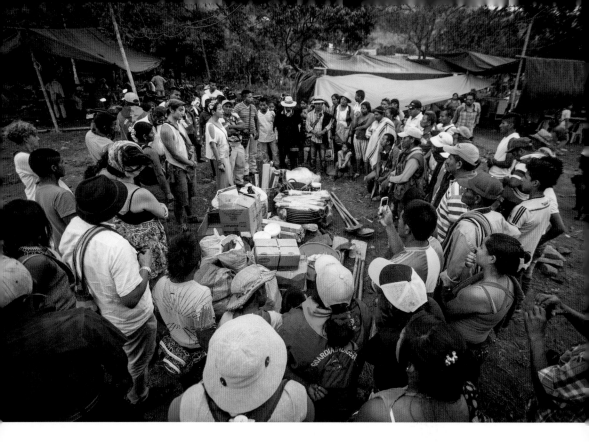

Donation and support
for the Process of the
Liberation of Mother
Earth

among others, transcended their time. More than six decades later, they
continue to be the key reference point in the quest for an identity of Latin
American documentary cinema. The critical gaze that this generation
showed us through their filmmaking is our legacy today, and it is up to us to
continue and contribute to what they achieved, via other theoretical frame-
works and technological innovations that afford us new possibilities in film
production. Every point of arrival is a point of departure.

That is why we like to understand film production as an exercise
in dialog, as conversations between creators; that is to say, to conceive
oneself as a creator within a framework of collective creation as opposed
to an individual one where often authorial narcissism prevails, prompting
competition and other values that characterize our increasingly commer-
cialized societies. This collective recognition is precisely what the
Indigenous communities have been working on: building community
thinking, learning from the memories of the past. One does not create or
think from scratch; we follow the steps of what has been suggested before-
hand, because nothing we do would be possible without what those who
have gone before have left.

We mention Marta Rodríguez and Jorge Silva as our filmmaker refer-
ences since some of the archival images in *Sangre y Tierra* were originally
produced by them. They were the ones who documented the emergence
of the Indigenous movement in Cauca in the 1970s in the documentary
Nuestra Voz de Tierra, Memoria y Futuro—an essential portrait of the peasant
and Indigenous struggles of those times. Jorge passed away in 1987, while

Marta continues to make films. Their work remains a central chapter in the filmic memory of the social processes in Colombia, both in terms of their uncompromising approach to political filmmaking, and the trenchant commentary of their films about the cooptation of the state by capitalist and undemocratic agendas.

The premiere of *Sangre y Tierra* in Popayán in February 2016

It was through this social life of a documentary that the encounter with Marta Rodríguez, who attended the premiere of *Sangre y Tierra* in Bogotá in 2016, took place. Marta maintains the interest and commitment to continue investigating the reality of Cauca, accompanied by an intergenerational team with whom, since Entrelazando, a friendship has been forged in which conversations allow us to continue learning from each other, building community.

That night at the bonfire we continued talking and that same Major asked another question: "Do you know what a project is?" "What is it?," I asked, and he answered: "A dossier that generally expires after six months comes with a chronometer. Here in our towns we speak rather of processes, because they have no conditions or limits, everything is to be written, and the path of those who are leaving are marking the way for those who are coming."

Fernando Birri used to say "there is no true revolution if there is no renewal of language." And that is why it makes sense to continue making films.

The Process of the Liberation of Mother Earth continues the legacy of the recuperators of the last century, of those who formed the

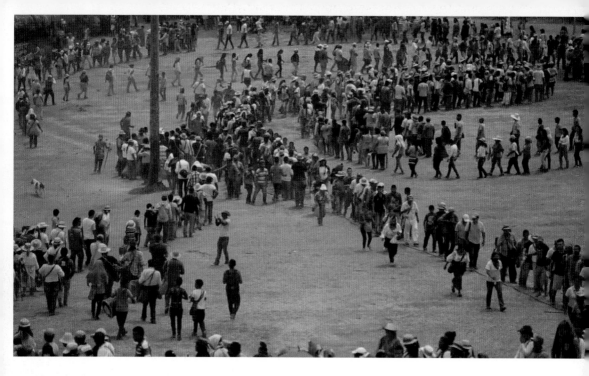

Still, *Sangre y Tierra*, 2016. Saakhelu Kiwe Kame ritual, Páez de Corinto reservation, August 27–30, 2015.

Indigenous movement, bursting with force in our historical context with a new language. And it was this process of resistance that summoned us, through which we found a way of working based not on what we have in excess, but from what we lack; to create from discomfort, in a recursive manner, and from an uncertainty that is always full of surprises—as is also true of the resistance. It's akin to entering the lands of the sugar mills and, in very difficult and complex conditions, to begin to sow and to build a ranch to inhabit, without light, without water, knowing that at any moment the public forces can attack, destroy, and burn everything; but also knowing that, risking everything, we can harvest great ways and joys—in short, a Plan for Communal Living.

Indigenous Guards on liberated land

Intertwining Indigenous Resistance in Cauca

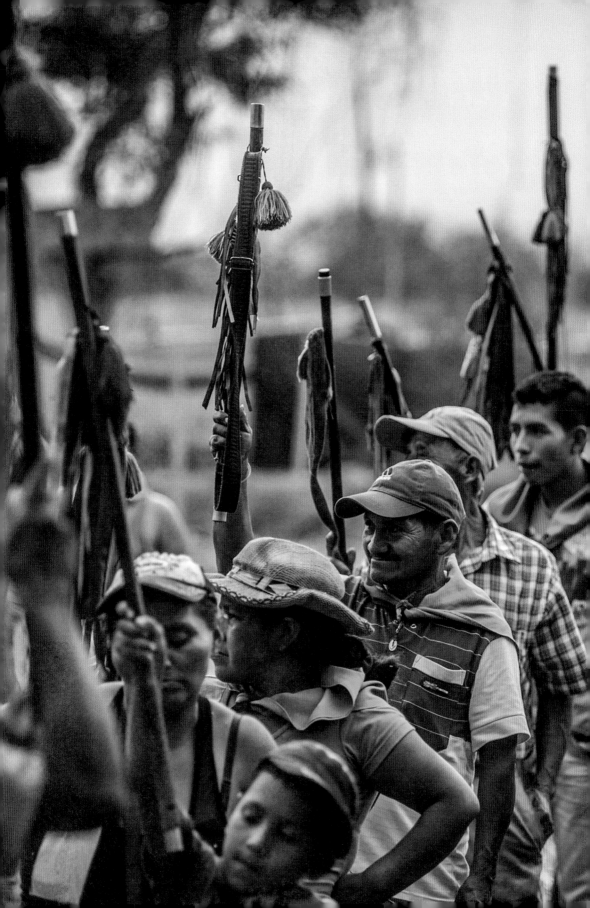

Nũhũ Yãgmũ Yõg Hãm: This Land is Our Land!

A Travel Journal

Isael Maxakali
Sueli Maxakali
Carolina Canguçu
Roberto Romero*

Mimnox xup yãiy
Mimnox xup yãiy
Saudades das árvores cumpridas
Saudades das árvores cumpridas

*Canto do Mõgmõka (Gavião-espírito).***

We met in Belo Horizonte in 2007, in the midst of meetings at forumdoc.bh—the city's Documentary and Ethnographic Film Festival—and at the Federal University of Minas Gerais (UFMG). The turn of the twenty-first century marked the beginning of Indigenous peoples' access into Brazilian universities as well as the implementation of a nationwide cultural policy (the so-called "cultural points"), based on a comprehensive and diverse concept of "culture." For the first time, there was federal public investment to fund historically marginalized cultural manifestations, especially among Black and Indigenous groups across the country. It was in this context that pioneering audiovisual training initiatives among Indigenous peoples such as the Vídeo nas Aldeias (VNA) project[1] expanded its reach and inspired similar movements throughout Brazil.

At the turn of the century, Sueli and Isael Maxakali were two young leaders of their people.[2] Born in the village of Água Boa to some of the main local political and spiritual leaders, they were raised from an early

1 Founded in 1986, Vídeo nas Aldeias (Video in the Villages) is a pioneering project in the field of Indigenous audiovisual production in Brazil. Over the last few decades, it was responsible for holding dozens of workshops among different Indigenous peoples in the country, and for training some of the main Native filmmakers currently active. In 2000, VNA became an independent NGO. VNA's history facilitated the creation of an important collection of images with and about Indigenous peoples in Brazil—more than seventy films, many of which have received national and international awards, that are now a key reference in the field.

2 Currently, the Tikmũ'ũn people number about 2,500 individuals living in four territories located in the districts of Santa Helena de Minas, Bertópolis, Teófilo Otoni, and Ladainha, in the northeast region of the state of Minas Gerais in southeastern Brazil. Although "Maxakali" is their ethnonym, they refer to themselves as Tikmũ'ũn (us, our people). They speak the Maxakali language, the last language of its language family spoken today, which belongs to the Macro-Jê linguistic branch.

* Essay written by Roberto Romero and Carolina Canguçu; journal entries by Isael and Sueli Maxakali.

** "How we miss the long trees." Chant of the Hawk-spirit.

PAGES 366–73
Stills, Isael Maxakali,
Sueli Maxakali,
Carolina Canguçu,
and Roberto Romero,
*Nũhũ Yãgmũ Yõg Hãm:
This Land Is Our Land!*,
2021

ABOVE
Isael Maxakali,
voiceover: "These
drawings were
made by a white
man a long time
ago. The Tikmũ'ũn
people lived here on
their big land. Then
the white people
came and occupied
the houses of the
Tikmũ'ũn. They killed
many Tikmũ'ũn and
so they ran away in
fear."

age to defend their rights. While still young, they became teachers at the village's Indigenous school and began to travel to assemblies and meetings outside the limits of their territory, gradually learning to move between different languages, places, and cultures. Together, the couple began to frequent the city, the university, and movie theaters, where they discovered the films produced by other "relatives" (*parentes*), as Indigenous people in Brazil refer to Indigenous people of other ethnicities. It was in this context that they decided that they wanted to do the same; to "bring their people out of the dark," as they say. In 2006, Isael became one of the first teachers of his people to attend university, through the recently created intercultural training course for Indigenous educators at UFMG. At that time, Carolina Canguçu was a Communication Studies student, a member of forumdoc.bh, and an audiovisual professor at the research group Literaterras in the Faculty of Letters, which co-coordinated the university's pilot Indigenous degree program (FIEI-ProLind) and published textbooks intended for schools in Indigenous educators' villages. Isael and Sueli Maxakali circulated in all these spaces, working on the publication of books, such as *Hitupmã'ax—Curar* (2008), aimed at health professionals practising in Tikmũ'ũn villages, and also on the production and editing of documentary films. Shortly after, Roberto Romero joined the Social Sciences course at the same university and soon became involved with forumdoc.bh activities. The Indigenous presence in those spaces represented an important novelty in the political, intellectual, and cultural scenario of the country. The encounters that emerged in that context would give rise to literary, cinematographic, and artistic productions of which our work represents only a small fraction.

In 2004, Isael took part in a first audiovisual workshop at forumdoc.bh, led by filmmaker Divino Tserewahu from the Xavante people, one of the first to graduate from VNA. A few years later, with a borrowed camera,

he would make his first film, *Tatakox* (2007). Filmed almost entirely in one single-take continuous shot, the medium-length film, a beautiful record of the initiation ritual of young boys, was acclaimed by the audience of the Documentary and Ethnographic Film Festival of Belo Horizonte, where it premiered, receiving the Glauber Rocha Award. The film also inaugurated a style of filming that would become one of the hallmarks of Isael and Sueli Maxakali's work: the hand-held camera, the long single-take shots, and the narration made *in loco* (*on the spot*) at the very moment of filming.

Shortly thereafter, the project "Image-body-truth: transit of Tikmũ'ũn-Maxakali knowledge" began. Coordinated by ethnomusicologist and professor at the UFMG School of Music, Rosângela de Tugny, and carried out by Associação Filmes de Quintal,[3] the project culminated in the publication of the books *Yãmĩyxop xũnĩm yõg kutex xi hãm ãgtux: Chants and Tales of the Bat-spirit* (2009) and *Yãmĩyxop mõgmõka yõg kutex xi hãm ãgtux: Chants and Tales of the Hawk-spirit* (2009), the photo book *Koxuk Xop: Image* (2009), the traveling exhibition "Chant-shine Tikmũ'ũn: On the Edge of the Fertile Country" (2009), and the first audiovisual workshop

Archival footage of the region. Isael Maxakali, voiceover: "The Tikmũ'ũn wondered: 'How can the white people multiply so fast? White people multiply like ants or bees, but we, the Tikmũ'ũn don't multiply ourselves that fast …. White people are angry like bees and ants. They cut down many trees and spoil the crops, like ants.'"

3 Created in 1999, Associação Filmes de Quintal brings together a collective of filmmakers, anthropologists, producers, and researchers with extensive experience working with traditional communities in the production of cinematographic exhibitions, publications, training processes, and research. It has hosted forumdoc.bh since 1997.

Isael Maxakali, voiceover: "Look this grass is not ours, it's from the white people. It's farmers grass. The grass of the Tikmũ'ũn is different, It's real grass, like the one we use to make houses."

held in the Tikmũ'ũn territory. The workshop was coordinated by Mari Corrêa, one of the directors of VNA at the time, and assisted by Carolina Canguçu, who also edited the audiovisual records of the two books' creative processes, a very rich material of ritual teaching by the shamans of Água Boa and Pradinho. This first audiovisual workshop in the Tikmũ'ũn villages resulted in the films *Kuxakux Xak: Caçando Capivara* (*Hunting Capybara*, 2009), *Ãyok Mõka'ok: Acordar do dia* (*At Daybreak*, 2009), and *Tatakox Vila Nova* (2008).[4]

A few years later, in 2010, the first audiovisual production workshop would take place in Aldeia Verde, this time coordinated by anthropologist Renata Otto Diniz and filmmaker Carolina Canguçu. The village had been created just over three years before and was then beginning to structure itself. In 2004, a serious conflict caused the departure of two groups from the demarcated Indigenous land, inaugurating a new phase of the Tikmũ'ũn's struggle for their ancestral territory. After leaving the reserve, in 2005 the dissident groups got together and started a *retomada* (the process of taking back the historical land) in the surroundings of the reserve, specifically in the area of an old village known as Tehakohit, presently situated in the district of Santa Helena de Minas (Minas Gerais, Brazil). The movement aroused the ire of local farmers who took advantage of the conflict among the Tikmũ'ũn people to incite a massacre. Faced with growing tension and an imminent war, a court decision forced the removal of the families from the site. Initially transferred to a soccer field in the municipality itself, the Tikmũ'ũn were moved to a place rented by the local Indigenist agency and then transferred to a state-owned land in the municipality of Campanário, where they lived for almost two years awaiting

4 These and other films made by Tikmũ'ũn filmmakers in recent years are available online at the *Cinemas Tikmũ'ũn* exhibition, on the website www.amerindias.art.br.

the acquisition of a new land by the Federal Government. Finally, in 2007 the group moved to Ladainha, where they created Aldeia Verde.

Their involvement with cinema took place, therefore, from the very beginning, in a context of struggle for territory, even though this was not the main theme in the first works of the Tikmũ'ũn filmmakers. Since their first experiences with the camera, Isael and Sueli Maxakali's main interest has been to film the passages of the *yãmĩyxop* spirits through their villages: a multitude of animal- and plant-spirit peoples with whom the Tikmũ'ũn have lived since time immemorial, and who always visit their villages to sing, dance, eat, and heal. During the eleven days of the workshop in Aldeia Verde, we watched several of these spirit-peoples pass through the central courtyard of the community. The workshop was organized as follows: initially, minimal instructions on the use of the mini-DV camera were given to the participants. Then, they went out to film freely, without the accompaniment of non-Indigenous instructors. Finally, all the filmed material was shown collectively in the workshop room, in the presence of the filmmakers, the shamans of the community, and whoever else happened to be there. The material was then commented on by the workshop conductors, the shamans, and the filmmakers themselves; and this same process was repeated day after day. As specialists in the ritual, the shamans were responsible for evaluating how the filming was conducted by the young filmmakers especially what could or could not be shown to a wider audience. The non-Indigenous instructors pointed out small suggestions for filming, cutting, and framing of the images, which were discussed with the participants.

For the second part of the project, we traveled to Brasília to translate all the material filmed in Aldeia Verde, which would result in the feature *When the Yãmiy Come to Dance with Us* (2011). Brasília is the federal capital, the political and administrative center of the country, where the

headquarters of the presidency of the National Indian Foundation (FUNAI), the official Indigenist agency, is located. At the time, the project's coordinator Renata Otto was an employee of the institution, and she invited Sueli and Isael to visit the foundation's headquarters. Together we visited the building and entered one of the archives where documentation related to demarcated Indigenous territories in Brazil is kept. Isael and Sueli, who took the camera with them, recorded some of the documents concerning the Tikmŭ'ŭn territory they found at the site. However, the news reached the FUNAI's presidential office, which ordered security to ban the filming and demanded the tapes back. That night, when we got home, Sueli and Isael recorded a long statement about the history of the dispossession of their lands and their revolt at the attitude of the Indigenist agency. From that statement, we decided that our next project would be to film their travels through the territory, visiting the sites of old villages that were never demarcated. The project was written that same year and submitted to a public call for proposals in the state of Minas Gerais, but it was not selected and remained archived.

In the meantime, Isael and Sueli continued filming. In partnership with researcher Charles Bicalho, founder of the NGO Pajé Filmes in Belo Horizonte, the couple made several short and medium-length films, including *Yiax Kaax—Fim do Resguardo* (*The End of the Lying-in*, 2010), *Xupapõynãg* (2011), *Kotkuphi* (2011), *Yãmîy* (2011), and *Mîmãnãm* (2011). In the same period, whenever he was passing through Belo Horizonte, Isael used to bring the mini-DV tapes he recorded in the village to Carolina Canguçu. The resulting film, *Kakxop pit hãmkoxuk xop te yŭmŭgãhã: Initiation of the Children of the Earth Spirits* (2015), was completely self-funded. Shortly thereafter, together we created the project *Yãmîyhex: The Women-Spirit*, which was completed in 2019. The film follows the five-day farewell ritual of the *yãmîyhex*, a female spirit-people, who, after a long stay in the village, return to their distant abodes. Already quite familiar with the camera, Sueli and Isael took over the filming. During the translation stage, carried out in the village itself, we decided to film the reenactment of the myth of origin of the *yãmîyhex*, mythical women who abandoned their husbands and turned into red-tailed boas, disappearing into the river's waterfalls. While filming *Yãmîyhex*, we finally managed to get approval for the old film project about the travels through ancestral territory.

Millennial inhabitants of the Atlantic Forest that once covered the entire region currently divided into the states of Minas Gerais, Bahia, and Espírito Santo (precisely the region where the Portuguese invasion began in the sixteenth century), the Tikmŭ'ŭn's first land was only recognized by the Brazilian state in 1940. The territory corresponded to a total area of 2,000 hectares, insufficient even for the group of about 120 survivors estimated by the census at the time. Only in 1956 would a second portion of land be demarcated for the group that had been excluded from the first demarcation, after the commotion generated by the murder of Antônio Cascorado Maxakali, killed and burned by local farmers for leading the struggle for land. Following the redemocratization of the country, the two territories

Tikmũ'ũn leaders and shamans visiting locations where their kin were killed

were still divided by a corridor of farms until 1996, when the land was finally unified. Despite the unification, the total of 5,035 hectares officially recognized by the state excluded from the demarcation all the surroundings of the reserve, a site of ancient and not-so-ancient villages, most of them expropriated by officials of the Brazilian government itself, who divided and devastated the territory throughout the twentieth century, selling most of it to third parties and giving rise to a conflict that drags on to the present day.

The violations of rights and the dispossession of traditional lands perpetrated by former state officials were never recognized or repaired. Despite the Tikmũ'ũn leaders' repeated appeals for the revision of the limits of their territories, no formal process of recognition and delimitation of Indigenous lands has been introduced by FUNAI in recent years. In short, there has never been a study that establishes and allocates lands to the Tikmũ'ũn under the conditions guaranteed by the Brazilian Constitution of 1988, namely, lands "on which they live on a permanent basis, those used for their productive activities, those indispensable to the preservation of the environmental resources necessary for their well-being and for their physical and cultural reproduction, according to their uses, customs and traditions," (Article 231; §1).

In this wasteland where they were "fenced off," as they say, there is practically no more forest, no water or animals. The Umburanas River which

cuts through the demarcated territory is increasingly dry, and its water unsuitable for consumption, bathing, or fishing. Many villages spend entire months without access to clean water. During droughts, the fire spreads through the grass desert, covering the territory with smoke and causing various respiratory diseases. Mortality rates in all age groups far exceed those of non-Indigenous neighbors. The social benefits inaugurated by the Federal Government's income transfer programs[5] do not reach many of the families, as their cards are withheld by local merchants who maintain a system of perpetual indebtedness, threatening anyone who tries to to challenge such financial exploitation. When they leave the limits of their land to hunt, fish, or simply walk, they are attacked with insults or gunshots.

But despite all this, anyone who expects to find only wasteland in Tikmũ'ũn villages is mistaken. These men and women are cheerful, vibrant, and pride themselves on their strength and beauty. They are great artists, master singers, owners of a vast repertoire of songs and stories of the yãmĩyxop spirits, "those who strengthen us." All that was lost, all that was stolen from them, their spirits recorded in these songs and tales. And, through singing, the shamans revisit all the diversity of the fauna and flora of the forests of yore, which the young people of today only know by "listening to singing." Their chants emerged from the earth, they were literally *taken out of* the earth during the wanderings of the ancients through the woods. In fact, there is practically no event narrated by the Tikmũ'ũn from which their ancestors did not "take chants" (*kutex xut*). "This story has a chant," or "this place has a chant, it has history," the shamans usually say whenever they refer to specific places, such as a waterfall, a rock, a mountain, the source of a river At the limit, it is as if its entire territory were an immense musical score.

Such an immense score was precisely the "script" of our long walk through the ancestral territory during the filming of *Nũhũ yãgmũ yõg hãm: This Land Is Our Land!* For twenty days of May 2019 we traveled together with some of the main Tikmũ'ũn leaders and masters through the portions of their territory that were never recognized and demarcated by the state. Unlike the previous films, Isael and Sueli decided to inscribe themselves in the image, appearing in front of the cameras. For the first time, Carolina Canguçu took over the cinematography during most of the filming. Here too, for the first time, we left the limits of the villages and the courtyard of rituals, turning the camera, so to speak, to the reverse shot of history; that is, to the contact with whites and the devastating consequences of colonialism, actualized in the forms of daily violence and surveillance imposed on the Tikmũ'ũn.

Guided by the songs and stories of the ancients, we visited ancestral sites, such as the "home of bats," a cave where the ancients hid from

5 Established in 2003 by president Luiz Inácio Lula da Silva, Bolsa Família was a successful national welfare program granting financial aid to impoverished families. Initially based on former social welfare programs, Bolsa Família's goal was to end hunger and to reduce poverty by guaranteeing the right to food and securing children access to public education. In the far-right government of Jair Bolsonaro, Bolsa Família was reviewed and replaced by "Auxílio Brasil" in 2021.

the whites; the tomb of Osmino Maxakali, murdered by farmers on his way back from the city; the *Mĩkax Papnok* stone, where the tapir fell into the trap and "fell apart"; the streets of the city of Batinga, where so many other relatives were killed by whites; the lands of the old village of *Katamak Xit*, where children would hang on the vines of *gameleiras* (*Ficus*) to play. At each stop, the film-walk revealed a reunion with happy memories of a time when the land, the forest, and the rivers were big and the *yãmĩyxop* walked free hunting and singing, but also very sad memories of entire families killed by the hands of those who took those same lands, but never the joy of living and singing with the *yãmĩyxop*.

During the days of filming *Nũhũ yãgmũ yõg hãm*, Isael recorded his "travel journal" on the ruled sheets of a notebook. The journal was originally written in the Maxakali language and later translated into Portuguese by Roberto Romero. In the extracts published here in the following pages, along with some additional comments by Sueli, we can follow some details of the film's trajectory through the eyes of the couple. The encounters with the ancestral territories were loaded with emotion, songs, and memories of joy and pain. Let there be no doubt, therefore: this land belongs to the children of the earth, to those who have arisen in this earth and who have resisted for centuries on it. It is high time we recognized this inalienable, original right and returned the land to those who belong to it. To stay with the words of the shaman Vitorino Maxakali, uttered during the recordings: "May the earth come alive again for us! May it be great again for our children! So that we can spread out again in these lands where the whites killed us!"

Tikmũ'ũn leaders and shamans on the former location of Katamak Xit hamlet and a Kuxex (chant house)

Isael Maxakali, Sueli Maxakali, Carolina Canguçu, Roberto Romero

373

pote hõnhã hãm tup xohi te 11

hõnhã nũtex moxakta potẽ tu
tu no nõm tu yãymox koxuk
xip tu kutex mãy kepmãy kutex
ax tu mãy mũg kutex kux tuta
takto yĩ kopit yãymox xop yĩy ax
tu ha no yĩy xopxop ãxet ax
hã yĩy hã mõg hãmgãy ãxet tapta
kutut xop. mũgmãy ãxet ox tuta homix
mũgmãy ũxeha

hõnhã hãm tup xohi te 12 mãyxõ
hãm te kaxiy hã nũtex moxcha mãy
maxakani. tuhõnkãy mũg ham agtux
maxakani xo kopa hãm agtux
takto te tu hõm ag terxte ax tu
ta homixex mõg puxap hex mũg
ha mã mã hep tu tu ha
no te kute mãy tex nõm
tu xupep tu puxap hep tãmmãy

hak mõg tu penchã ũxeha
tu xe hã note kutex tixmãy
kiupak tu nõm xupqa tuta homix
mũgmõg ma pno minlu xe
hano te hãm agtux nõmtuk
mãy tu mũg nũn tuk pet
mãy ha xo te hãm agtux hu
hãm agtux kux yita ãte
hãm agtux nõmpãyenet
tex mũã tu mãm nõm tuk
mũ xuk tux hãg yãyhi ĩhã
õm nũn ayuhuk tu motonix
yĩ kopel tepmũn mãyhã mãm
ha ãxa mõtonix te hãm
koxuk xut ha ayuhuk te

Axaha ayuhuk te hãmã
pãp hã mãm nũte ha tanipix
tammãy ũ mõnhã kaxiy tu ha
no te hãm agtux nãn tuta
xe homix mũgmõg yimkox mep
tu tu xe ha toa hãm agtux nõm
tu tix mũin yõg yakkup mãm
yĩy tu ha mõg hamõg hã mãm hu
ta mep. tu tak mũg nũn pat pu
xata nãn hã tu xat tuk xit
nũte. tuk xit kux tu ta mot
mõyõn ax tuk mũg mõg tu xe
ha no te xut xi xuk tux mot
mõyõn ax nõm kopak mũg
xohi payã xe ayuhuk xop te
ũymãy mũtix hãm agtux tu

tuta xe homix mũgmõg apne
konãg mai tu tuk mũg mõg hã
xonmitet kak he min koxuk taxuptu
tak otkoxuk tu xe ha note tatu
hãm agtux tu tak pet te hãm ag
tu tatu tu xuktux kux tuta
tatu kutex mãy ũ yõg putuxop
kutex ax. tu homik mũgmõg
tuta tu xe mion tuta yip xa
tu mĩmkax pap nok xux xut
pa tikmũ ũn tatpãp ũ

yõg hip nox kumuk hakmũ no ãyãn
tuk mũgmõg tu konãg mai tuk
mõxahã tu mãy meniano yõg apne
tu moxcha pap ti ax nãy payãy tõxxop
mũn tihi tu ap tia mãyxop
xata nãn tu mõg yã nũn nõy
ax

Pages from Isael and Sueli Maxakali's journal

Isael and Sueli Maxakali's travel journal

Today is May 12, 2019

Yesterday we arrived here in the town of Machacalis and today we are going to film inside the city. My uncle Totó told stories and then, when he finished, we went to Puxap Hep (Lake of the Ducks) and Mãmã Hep (Lake of the Frogs), where we sang the songs that emerged there. *Yãyã* (uncle) also said that there was a place where there was a village in the past. From there they

moved to the village of Kopuk Ta'ax. The community never lived in one place. Kopuk Ta'ax was the place where whites took axes to our ancient relatives. The word for "axe" is *Kopu'uk*. After that, we went to the land of Valdomiro, where we told the stories of when we came and built houses here. Sueli told the stories, and then I told them about the day the farmers shot us. We were walking and telling stories, when a white man came and

Isael Maxakali writing his travel journal, Santa Helena de Minas, May 2019

asked the production driver what we were doing there. The driver said that we were filming and the white man told him that a few years ago, when we moved there, it was difficult to get us out of there. We continue walking to where the remaining jackfruit trees are, because the whites cut down almost all of them. Then we went back to Santa Helena and had lunch. When we finished lunch, we went to film the soccer field where we stayed when they took us from Valdomiro's land. Then we went to the village of Água Boa. On the way, we stopped at my uncle Osmino's grave, where a tree trunk is. There, my uncle Pinheiro told his brother's story and, at the end, we sang the song of his *Putuxop* (Parrot-spirit). On the road, we stopped the car to film from afar the stone of *Mĩkax Papnok* (White Stone). Suddenly, some Tikmũ'ũn passed by on the road and we gave them a ride because their bus had broken down. We arrived in the village of Mãe Vereadora in Água Boa. She wasn't there at the time. Her children said that she had gone to Santa Helena and was on her way back. When it was late afternoon, we recorded the interviews of Mãe Vereadora and my *compadre* (comrade) until nightfall. When we finished filming, we went to the *kuxex* where *Mõgmõka* (the Hawk-spirit) sang. When it was over, we went home to rest.

Today is May 13, 2019

We had breakfast at 7 a.m. While we were having breakfast, Manuel Kelé arrived and joined us. Today we are going to film in the *barreiro* (mud pit) and in the bat cave. The village leaders had to travel to attend a public health meeting, but their children stayed in the village and are working with us. Today is Monday. Good Morning!

Now in the afternoon I am writing here on this paper. It was 9 a.m. when we arrived at the village of my brother-in-law Terval and my cousin Vanusa, where the shamans gathered to talk and sing. After the chants were over, we went down to the *barreiro*. We went there to talk about our clay. Because we wanted to show why the earth is our mother. In the past, we used clay to make *panelas* (pots). To extract the clay, we talked to the clay [for it to allow us] to make a pot, to be able to make food. That's why the owner of the clay pit went in front of us—she wanted to

Isael Maxakali sings at his uncle Osmino's tomb, Santa Helena de Minas, May 2019

talk to the clay first. We followed her when my brother-in-law Terval asked the other shamans to wait there and only those who were filming to enter. So only us who were filming walked in. The owner of the clay pit was there digging and talking to the clay. My mother also talked to the clay. There in the *barreiro* there was a hole that the old *mõnãyxop* (ancient people) made as well as a newer one. My cousin said: "This hole here was dug by the ancients and this one, the recent one, was dug by me." The oldest was filled with water and belonged to her grandmother. My cousin dug the newest hole and put the clay in a bag. Then she covered the hole and we hit the road. When we arrived, the shamans were all there. We put the bag in an utility cart and took it to the village, where the shamans told stories and sang. My cousin also took us to the house where she makes ceramics. There were a lot of ceramics there that she made with her students. We sang again until about 10 a.m. On the way back, we headed to my uncle Joviel's village to talk to him. But we were very hungry so we left. Tomorrow we agreed to go back there.

We are here in my *compadre*'s village, the Ãmãxux (Tapir) village, but everyone is very worried because a relative has fallen ill. They took her to the hospital at the town of Machacalis earlier today.

Today is May 15, 2019

Yesterday we went to the bat house, where there is a small waterfall. I asked my uncle Joviel about the olden days for me to learn. He told stories inside the school and after we finished we all went to the bat house. The grass was very tall and we walked through it. The grass cut our skin and one of the women who was with us, the one who carried the sloth stick (the boom mic), ended up slipping and falling. When we arrived, some of us opened the way with machetes and called out to the rest of us: "Come! This way, come!" So we all went inside the cave. There were a lot of bats in there! The shamans sang the bats' chants and talked with them. It was really nice to know the cave where our ancient relatives hid. There we saw a stone on which they used to make *beijú* (a flat bread made with cassava flour). They used to light fires there and hid when the whites came. Inside the cave, a small stream cuts the stones, and the bats drink from its water. That's why there were so many bats inside.

After we finished filming, we came back around noon and in the afternoon we went to Mĩkax Papnok (White Stone), crossing the signalgrass path. Once there, we filmed and told stories. This place has three names: Mĩkax Papnok, Ãmãxux yãy pot ax (Where the tapir broke) and Ovo Grande (Big Egg). We remembered the stories of yesteryear, of the places where the chants originated. That was because we were passing through the places where the chants originated. Until a white man came on a motor-cycle and said: "*Opa!*" I took my cell phone and started filming. My mother was scared and said: "Uh oh! He must be angry!" But he drove away and we went to the mountain, where my mother told the story of that site. When we were on our way back, the man came again with his motorcycle and asked: "What did you come here for?" Then Roberto said: "We are working." We walked past and Roberto climbed up and shouted: "Get away from the bike! Are you crazy?" Roberto was scared. Then the motorcycle man's dog came towards us and the girls ran away. And so we walked until we arrived at our car, in the afternoon, and we went back to the village of Ãmãxux. The cowhands put pressure on us, but at no time did we give up on our filming.

The other day, early in the morning, we went to Santa Helena and paid for the hotel where our driver stayed. On the way back, we stopped at the Jaqueira village and did some filming. We asked my uncle Totó to tell us about the time of the soldiers.[1] He told the stories and imitated the soldiers. Then we went to my uncle Manuel Damázio's village. We left our things inside the school and went to have lunch in Batinga. After we

1 "The time of the soldiers" refers to the period of the Rural Indigenous Guard (GRIN) (1969–72). During the Brazilian military dictatorship (1964–85), the GRIN was created by Captain Manoel dos Santos Pinheiro in the region of Minas Gerais as an Indigenous branch of the army. Its model was first established with the Maxakali and then expanded to the Krahô, Karajá, Gavião, and Xerente ethnic groups. The purpose of the Guard was to control the movements and activities of the Autochthonous communities, as well as to disarticulate resistance and opposition to state extractivist projects. Two Indigenous prisons were also created: the Krenak Indigenous Correctional Institution (Reformatório Indígena Krenak), and the Guarani Farm. Uncle Totó took part in the Guard. As he affirms in the film *GRIN* (Isael Maxakali, Roney Freitas, 2016) during this time, he took the skin of a soldier.—Trans.

finished lunch, we went looking for a place for the driver to spend the night in town. Then we went back to the village where we were staying.

Katamak Xit (Cipó da Gameleira, Gameleira's Vine)

We arrived in Katamak Xit. Our van couldn't go up, because of the rain and mud. We left the van parked down there and walked up slowly to be able to escort the elders. Arriving there they showed us the place. They remembered that *yãyã* Totoca, my grandmother's grandfather, was buried there, close to that stone.

In Katamak Xit there came to be the song that tells about the first time they saw the cow crossing the waterfall. Dona Delcida remembered that there was a vine from which they used to swing. My uncle Dozinho also remembered the moment he fell into the marsh, swinging from the vine. There was a *kuxex* (house of songs) there and all around there was that kind of papaya from the bush. But after the non-Indigenous people arrived, they cut down all the papaya trees. We only knew these places by name, but today we actually saw them. It was a moment of happiness for me. The shamans told us about the village that once existed there, showed us where the *kuxex* was, where they fished and collected *tracajás* (yellow-spotted turtles) in the river and sang the cow song. Then we went back up the hill. On the way, the car stopped again for us to film. The shamans told us that this land used to be ours, but the whites opened a road by cutting it in half and to this day they continue to cut down the forest. "Look, they're bringing it down again," they said as I filmed. One of the shamans went ahead with his wife and waited for us there where the sign of our demarcated territory is. We went there and he showed us where the sign actually used to be, but the whites took it off and stuck it elsewhere, reducing the limit of our land. We went down to where the sign was, but when we arrived a white man was standing there and started yelling at the shamans: "What are you filming here?" Then my brother-in-law Tiago called me to film the white man, but when I got there he stopped talking. The shamans got into the van and we followed. We arrived at 3 p.m. and we were starving. We had lunch and rested.

Vanusa Maxakali removing clay from her grandmother's clay pit, Aldeia de Água Boa, May 2019

NEXT SPREAD
The leaders and shamans Arnalda Maxakali, Mamed Maxakali, Israel Maxakali, Pinheiro Maxakali, Alexandre Maxakali, Manoel Damásio Maxakali, Delcida Maxakali, Toto Maxakali, Nozinho Maxakali, Vitorino Maxakali, and Sueli Maxakali during the film shoot in Katamak Xit, Batinga, May 2019

Isael Maxakali, Sueli Maxakali, Carolina Canguçu, Roberto Romero

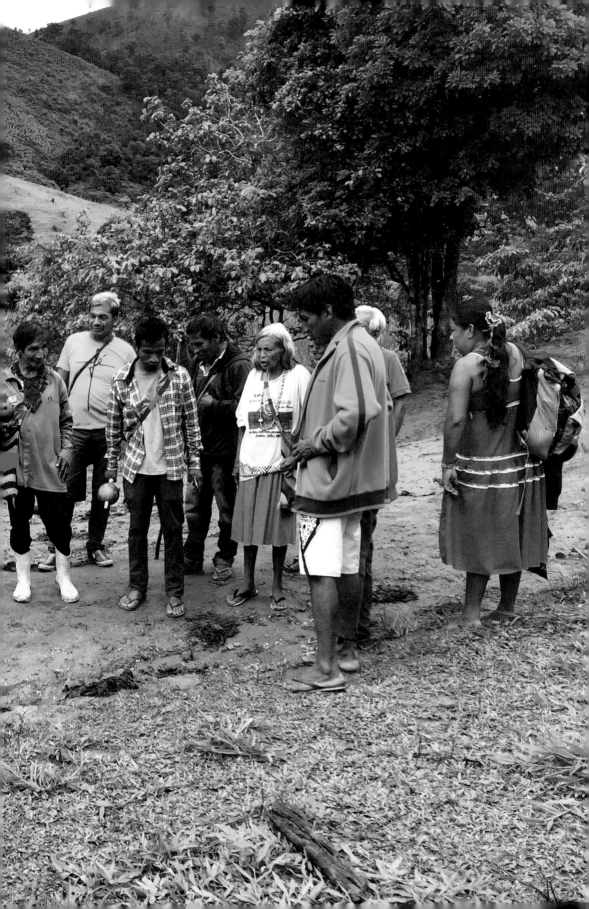

Today is May 17, 2019

Today we didn't go out. We didn't go to the waterfall where the capybara fell. The day dawned raining, so we worked right here at the school. The shamans told the names of those of us who were killed by the whites.[1] Today we are going to tell the names of the farmers who killed our relatives. We will tell them very well so you know them too. The whites killed our relatives. My mother told the stories and my uncle Pinheiro too. My cousin Vitorino also told the story of the murder of his father and of other

relatives that the whites also killed. I told him about my cousin Daldina, who the whites ran over on a motorcycle, and her son Rominho who died when a bus hit the health truck, which was transporting him and his family, but only he died. My cousin Vitorino told the story of the murder of his father and brother too.

Inside Batinga, we repeated: "This land is our land!" We arrived at 4 p.m. in Batinga, where we went to show the places where

Natalino Maxakali writes the names of relatives killed by whites on the school board, Aldeia Nova Vila, May 2019

our relatives were killed. We saw the place where my cousin Reinaldo was killed and a little later, while we were filming, a white man called us and said: "You have to film this and show it to Funai! What is Virgílio doing?" He showed us a lamp and said that Virgílio was stealing it and that we were supposed to film it and show it to Funai. My cousin Vitorino then argued with him and he said: "[contrary to that Indian] you guys are good." Sueli also said: "A lamp is not worth anything! You are killing our relatives here inside this city and justice has never been made!" After we finished arguing with him, we continued on our way until we reached the place where the truck ran over my brother-in-law. The shamans told the story and I painted on a concrete wall: *Nũhũ yãgmũ yõg hãm!* This land is our land!

OPPOSITE
Isael and Sueli Maxakali after painting the wall with the words: "This land is our land!," Batinga, May 2019

1 In the Portuguese version of the text, Isael and Sueli employ the verb *contar*—to tell. Here, they "tell" their names like they tell their tales.—Trans.

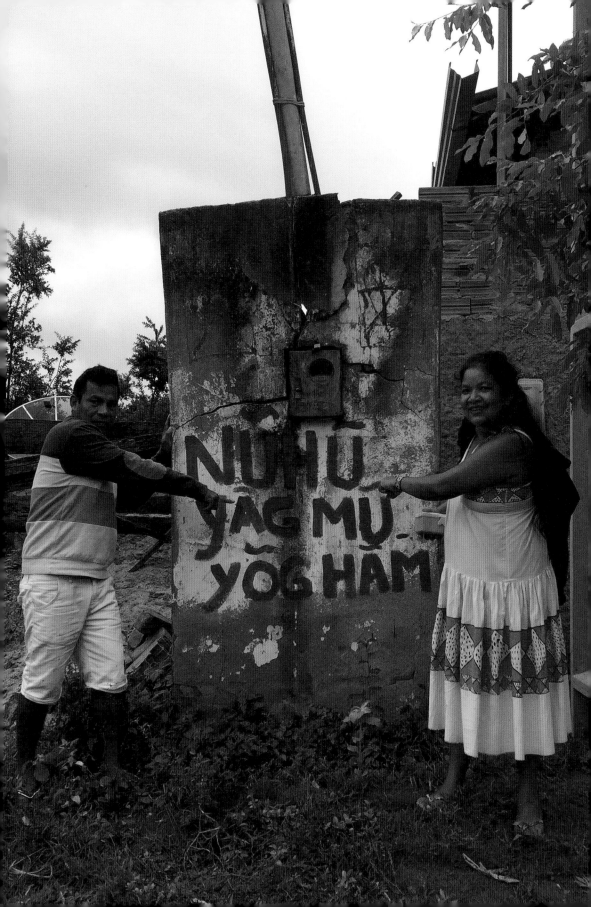

Part II

Reverberations

Returning Images: The Trajectory of Vídeo nas Aldeias and the Political Role of Cinema in the Context of Cultural Resistance

Amaranta Cesar

"What is being an Indian for you?" Carved into a big ceramic knife, this question by the visual artist of the Pataxó ethnic group, Arissana Braz Bonfim, materializes the colonial incision that expropriated Amerindian land, causing scissions that were not only territorial but also cultural, onto-logical, and related to identity. As a call to the colonized imagination, the sculpture *Mikay*, by Arissana Pataxó, as the artist is known, also recalls the constraining situations that she says she experienced while doing her under-graduate degree in Visual Arts at the Federal University of Bahia, when she made this work. Arissana Pataxó is at once a witness and a contester of the persistence among academic
circles, and even more so
in the general population,
of "a static perception of
the cultures of Indigenous
peoples." According to
her, "changes, borrowings,
creations and inventions,
even within the Brazilian
historical context, seem to

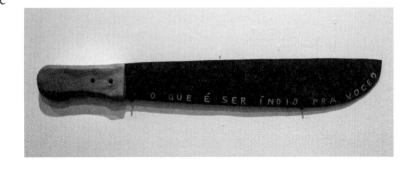

Arissana Pataxó,
Mikay, 2009

still not fit into the minds of people in relation to Indigenous peoples."[1]
It is not only her paintings and sculptures but also her trajectory, as artist, professor, and researcher, that are a live contestation of this ethnocentric perspective that had apparently been overcome yet persists, even in the twenty-first century. Arissana Pataxó is part of one of the first generations of Indigenous people who entered Brazilian universities. In her Master's thesis (2012), she describes and analyzes the significant cultural relationship that makes traditional Pataxó art a complex and continuous process of inter-section of past, present, and future. When she incorporates technologies,

1 Braz Bonfim Arissana Souza, "Arte e identidade: adornos corporais Pataxó" (Master's thesis, Federal University of Bahia, 2012), 43.

procedures and epistemologies through intense intercultural negotiations with the aim of politically strengthening Indigenous peoples and cultures, she is participating in a movement that is common among the various ethnic groups in Brazil.

The way that this movement has come to the heart of the longest-running project to train Indigenous filmmakers in Brazil, Vídeo nas Aldeias (Video in the Villages), is the subject of this text. I propose to consider the strategies of returning the images—as a method of collectivization of film production and a politic of restitution—that it puts into action so

Arissana Pataxó,
Amerindians in Focus,
2016

that cinema may be added to the traditional Indigenous practices that participate in the struggle for territorial rights and in the cultural resistance of the Indigenous peoples of Brazil. Understood as an intercultural space, Vídeo nas Aldeias (VNA) is a film and audio-visual project in Brazilian Indigenous villages that has existed for the past thirty-five years. In this time, it has produced more than eighty films, half of which are authored by Indigenous filmmakers, and its archive includes close to 3,000 hours of footage by sixty different Brazilian Indigenous peoples.[2]

Presently in Brazil,[3] there are over 305 Indigenous groups, totaling 896,000 people who speak close to 160 Indigenous languages. Their struggle for recognition and territorial rights has been marked by an alternation between progress and regression, and had its first positive development in the 1980s, in the context of the post-dictatorship constitution of 1988. The Vídeo nas Aldeias project began in this same period, in 1986. The project

2 In this essay, I attempt to analyze the VNA trajectory through two temporalities. At first, I describe and investigate the effects of the method of returning images at the very moment of film production and during the workshops held over the first decades of the project. This is something close to "filmic feedback," a strategy developed by Robert Flaherty and re-elaborated by Jean Rouch. As stated by Steven Feld, "by developing and printing rushes on location and screening them with Nanook and other Inuit, Flaherty initiated filmic feedback as a form of stimulation and rapport." Flaherty developed, though, a filmic ethnographic field method to engage community with the film. That is why "Rouch views the film as a celebration of a relationship" (Steven Feld, *Jean Rouch: Ciné-Ethnography* [Minneapolis, MN: University of Minnesota Press, 2003], 12). For VNA, community screenings are a method of self-image appropriation that comes into play in the structure of films, in order to celebrate not a filmic relationship, but a collective practice of cultural resistance. This is why I would rather think of it as a strategy of collectivization of film production (as per André Brasil's argument: "Cineastas-guardiões: hipótese sobre a autoria no cinema indígena," in *Anais do 30° Encontro Anual da Compós* [Campinas: Galoá, 2021], 1–19). Then, I analyze the return of images to the Indigenous communities with the passage of time, by investigating the restitution to the Indigenous communities of the audiovisual records accumulated over more than three decades of the VNA project. In both cases, in the performative time of the production of images or in the future of these images, it seems to me that we can speak of a return.
3 Data from the 2010 Census of the Brazilian Institute of Geography and Statistics (IBGE: Instituto Brasileira de Geografia e Estatística), available on the website Povos Indígenas do Brasil of the Instituto Socioambiental: https://pib.socioambiental.org/pt/P%C3%A1gina _principal.

Returning Images

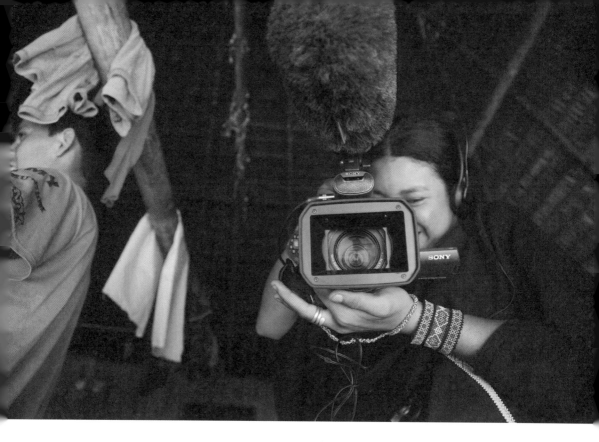

followed a good number of the various struggles spread across what was agreed upon as Brazil, witnessed and interacted with the specificities of each ethnic group in contact with whites and Brazilian institutions. There are constant, specific local tensions between the various Indigenous groups and large landowners, illegal gold miners, or large state or corporate extractivism that has an environmental impact. Land disputes and slaughters did not cease after the legislative and social gains of the end of the 1980s. Currently, the Brazilian state under Jair Bolsonaro's ultraright government has presented legal threats against the land demarcation processes underway or already concluded, which has contributed to the increase of violence inside and outside traditional territory. In contrast, the Indigenous movement has displayed great political and mobilizing power, in resistance against what they deem the moment of greatest threat in Brazil's recent history.[4]

In August 2021, during the Covid-19[5] pandemic, more than 6,000 Indigenous people from 176 different ethnic groups from all regions of the country gathered in Brasilia at the "Fight for Life" camp, which

Eirishi Piãkom during filming workshop in Ashaninka territory, 2010

4 Written between 2021 and 2022, this text does not address the subsequent transformations in the Brazilian political context for Indigenous peoples and VNA, starting with Luís Inácio Lula da Silva's third presidential term, which began in January 2023 following his electoral victory over Jair Bolsonaro.
5 Over 1900 Indigenous people had been fatally struck with the coronavirus by August 2021, a date when 163 ethnic groups had been affected according to records.

was the largest Indigenous mobilization since the 1988 Constituent Assembly. Fighting against the anti-Indigenous agenda under way in the national congress and federal government, the movement is organized by The Articulation of Indigenous Peoples of Brazil (Articulação de Povos Indígenas do Brasil—Apib), an association headed by Sônia Guajajara[6] (Socialism and Liberty Party's [PSOL] 2018 candidate for the vice-presidency). The "Fight for Life" camp especially seeks a Federal Supreme Court ruling on the repossession suit filed against the Xokleng people, sustained by the Milestone Thesis according to which Indigenous peoples would only have had the rights to the demarcation of land that had already been in their possession on October 5, 1988, the date of the enactment of the constitution.[7] "Our history does not begin in 1988. Our history does not begin in 1500. Brazil Indigenous land": the watchwords that have fed the Indigenous resistance in 2021 not only contest the legal apparatus mobilized by large landowners to remove Indigenous peoples from history, but also shift the colonizing historical perspective linked to land demarcation and expand the horizons of epistemologies of time and land, and fundamentally contest the very idea of a Brazilian nation as a parameter of justice.

As for VNA, right from the beginning its aim has been to put audiovisual technology and documentary-making practice at the service of Indigenous leadership to defend land and cultural heritage, to ensure life and ways of living in all their specificities. Under Vincent Carelli's coordination, the project was born inside the Indigenous Labor Center (Centro de Trabalho Indigenista, CTI), with the aspiration of making the most of video to carry out Indigenous activism, and it then went on to become a proper non-governmental organization specifically aimed at audiovisual production and workshops on Indigenous territory. Through the young filmmakers' training workshops, the project has become part of the strategies of cultural resistance for many of the peoples with which it allied itself.

During its first two decades of existence, the VNA received funding exclusively through international cooperation with the governments of the Netherlands and Norway. Vincent Carelli believes that, during this period, the project would hardly have been institutionally viable had it only had funding for film production. The great "turning point," according to his analysis, occurred with the mandate of Luís Inácio da Silva, when the organization started to receive funding from the Brazilian government through the programs aimed at promoting cultural diversity which were implemented by Gilberto Gil's ministry, and through funding systems with public tenders for

6 Sônia Guajajara is Brazil's first Minister for Indigenous Peoples. Since January 2023, she has headed the ministry created by Lula's current government in response to the struggle of Indigenous peoples and their role in combating Brazil's far right.
7 To learn more about this case: https://apiboficial.org/2021/06/29/entenda-porque-o-caso-de-repercussao-geral-no-stf-pode-definir-o-futuro-das-terras-indigenas/.

the entire film and audiovisual production chain, which started at this time and marked an unprecedented expansion of Brazilian cinema in general. It was at this time that VNA ensured its sustainability with film production projects. However, the wind blew in a different direction in Brazilian politics and with Bolsonarism's frontal attack on culture, VNA has been facing strong difficulties in maintaining its viability, as was the case with many other projects, organizations, production companies, and associations. Recently, a series of workshops and five films were produced through an agreement with Vale, the private company that caused unprecedented environmental damage in Brazil, and which tried to control the content of the works, thus revealing the impossibility of a partnership under those terms. Presently, Vincent Carelli is dedicated to raising funds among public and private institutions, with the aim of ensuring the preservation of the archive of more than three decades of image and sound production, and its restitution to the peoples that it portrayed.

The preservation and restitution of audiovisual archives, which has become the focus of VNA's efforts in recent years, is directly related to the project's origins and its wish to cast a spiraling gaze at time and its processes. From the beginning, in his partnerships with Indigenous leaders and peoples, what interested Carelli in audiovisual media "was the possibility to immediately show what was being filmed and to allow for the Indigenous appropriation of their own image."[8] The methodology of incorporating into the actual filmmaking process the playback of raw footage as it is being produced is something that is at the very foundation of VNA. It speaks to the chance provided by video to immediately restitute images to the people who have been filmed, in the sense of materializing a practice that is in fact "interactive or shared," as explained by Vincent Carelli and Dominique Gallois, his partner in founding the project, when they speak of its initial objectives while it was still hosted by the CTI.

> Return, feed-back, interactive or shared anthropology, as preached
> by Jean Rouch, are often declared principles, which are rarely made
> concrete. What the studied, photographed and filmed communities
> expect from the interaction established with anthropologists is not just
> the photos, edited films or concluded theses. However, it is this mechan-
> ical form of feedback that most ethnographers conceive of and practice.
> The CTI video project intends to invert and enrich this relationship.
> Instead of simply appropriating the image of these peoples for research
> purposes or large-scale distribution, this project aims to promote the
> appropriation and manipulation of their image by the Indigenous people

8 Ana Carvalho, Ernesto Ignacio de Carvalho, and Vincent Carelli, eds., *Vídeo nas Aldeias: 25 anos, 1986–2011* (Olinda: Vídeo nas Aldeias, 2011), 46.

themselves. This experience, which is essential for the communities that go through it, also represents a field of research that reveals the processes of identity construction, of the transformation and transmission of knowledge, and of new forms of self-representation.[9]

Thus, at the heart of the audiovisual mechanism constructed by VNA is not only the recording of images for future memory, but also the viewing of these images in the present by the communities, which provoke other images and, simultaneously, the actions to be recorded by them, thus creating movements for a redevelopment of identity, as well as negotiations, updates, and recovery of tradition, as can be noted in the first experience of the project, a video with the Nambikwara people, *A Festa da Moça* (*Girl's Celebration*, Vincent Carelli, 1987), whose release is agreed upon as the foundational point of VNA.

Narrated in a distant voiceover and through explanatory language (a recourse that was later overcome in VNA's filmography), *A Festa da Moça* is described as "an encounter of the Nambikwara with their own image." Inhabitants of the forests of the Guaporé River Valley and of the grasslands of the Chapada dos Pareci, at the borders of the states of Mato Grosso, Rondônia, and Bolivia, the Nambikwara numbered 10,000 at the beginning of

ABOVE AND OPPOSITE Stills, Vincent Carelli, *A Festa da Moça* (*Girl's Celebration*), 1987

the twentieth century but were reduced to a population of 600 people in their twenty villages at the time of the video's shooting. It was a moment of euphoria, when they were taking over their lands again and reconnecting with their traditions. This energy traverses the video: it is in the political discussions about recovering land that permeate the parties, as well as in looking at and taking up again their own rituals. Guided by Cacique Pedro Mamaindé, Vincent Carelli accompanied two ceremonies of celebration at the end of the period of seclusion of adolescents after menarche. The point, however, is not to explain the ritual from a descriptive and ethnographic

9 Vincent Carelli and Dominique Gallois, "Vídeo e diálogo cultural—experiência do projeto Vídeo nas Aldeias," *Horizontes Antropológicos* 1, no. 2 (July–September 1995): 61–72.

Returning Images

perspective, but rather to make it the backstage for a wider issue: the way in which the Nambikwara respond to history, and to a constant reconfiguration of their violence and trauma, in order to continue existing.

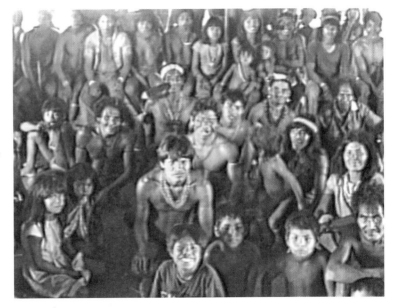

The community screenings of the films of parties take part precisely in this collective development of ways of interceding in one's own history. After watching the images of the first recording of the party, the Nambikwara criticized the excess of clothes and the absence of body paints and traditional ornaments. The second party, then, already presented some differences: less clothing and more paint.

As told by Carelli: "This mirror-play generated enthusiasm, and with the possibility of seeing themselves in the little screen, the Nambikwara are thrilled, and us with them. And suddenly, under the leadership of Pedro

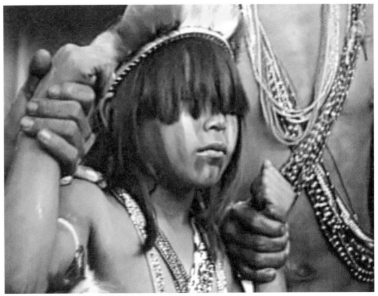

Māmāindê, they pierced the lips of thirty young men in a ceremony abandoned for more than twenty years."[10] It is one of the eldest men who explains what was at stake in the recovery of the ritual: "If you don't have piercings in the lips or ears, nobody is going to believe that you are an Indigenous person. There is no way for you to prove it." The performative effect of the audiovisual dispositif created at the very beginning of VNA thus appears to reside in the power of the image as operator of cultural resistance, in its capacity to perform resistance. The documentary can thus be seen as a communal practice and it becomes incorporated as an active political instrument in the cultural differentiation process.

10 Discourse in Vincent Carelli's *Corumbiara* (2009).

If in the production of colonial and neocolonial ethnographic images one may note a referential impulse anchored in the assumption of the disappearance of Native people or of their cultural erasure, what can be observed in the appropriation of audio-visual technology by Indigenous peoples, in the context of VNA, is the reverse: the constitution of a memory that is alive, which is connected to the movements that defend the survival and sovereignty of peoples. Things are recorded not only in order not to forget but also to remain, to resist. In this sense, the most acute movement to reverse the classic ethnographic gaze and its initiatives seems to be the performative role of audiovisual practice and its relation to history and tradition.

In this sense, we can observe a recurring aesthetic and political aspect of the VNA films: the "re-enactment of tradition"[11] through which documentary practice takes on the role of mediator in a process of cultural resistance. The re-enactment of tradition[12] refers to the articulation of film practice and the historical-political movements that generate a re-elaboration or eventually a recovery of traditional practices. The re-enactment of tradition presents itself, then, as a means to access memory and as a tool to foster its transmission, but it constitutes itself, above all, as a gesture for the activation of community practices of a performative dimension. It is about a movement of political resistance not only because it enacts a "recovery" or a "returning" but because it allows for, in the corporeal passage between times, a "becoming" or "turning into."

If this aesthetic-political resource, which is intrinsically linked to the return of images as a method, strongly traverses the first decade of VNA, it is also present in the later periods, together with the various formal and historical-political specificities of the films produced by different peoples and filmmakers, including Pi'õnhitsi—Mulheres Xavante sem Nome (Xavante Women with No Name, 2009), Bicicletas de Nhanderú (Nhanderú Bicycles, 2011) and As hiper mulheres (Itão Kuegü [Kuikuro]; The Hyper Women, 2011), to cite but a few of these titles.

The recovery of Jamurikumalu, a Kuikuro ritual, which is the major feminine ritual of the Alto do Xingo, featured in As hiper mulheres, is a vivid example. Released in 2011, the film, whose authors are Takumã Kuikuro (Indigenous filmmaker), Carlos Fausto (anthropologist) and Leonardo Sette (editor), narrates the process of preparation and performance of the Jamurukumalu, which, at the time when the film was being produced, had

11 Amaranta Cesar, "Tradição (re) encenada: o documentário e o chamado da diferença," Devires: Cinema e Humanidades 9 (January–July 2012): 88–97.
12 As this tradition itself is constituted as a set of performances, or enactments, in constant renovation, when we are dealing with performances that were provoked or acted out through and for the filming artifact, we will use the term "(re)enactment."

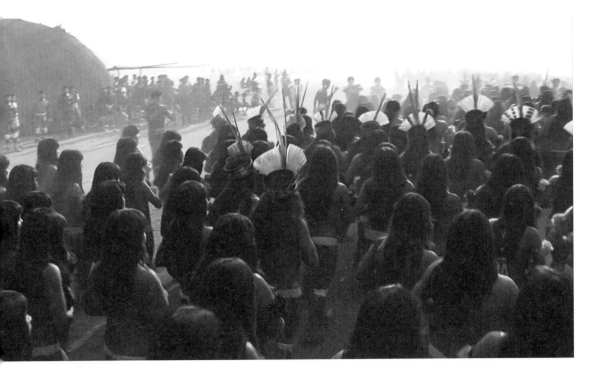

not been performed in close to thirty years. Kanu, the only singer who knows all of the ritual songs, is seriously ill and cannot sing nor teach the other women. This dilemma and the overcoming of it, which constitute the main plot of the film, synthesize the conflicts surrounding audiovisual transmission and its fundamental role in the survival of tradition. And the film approaches the issue in different ways.

The film was scripted, prepared, and enacted according to the procedures of fictional tradition. However, its practice is marked by desires of intervention in the community and conducted as an action in reality as an engaged documentary. During the production process, as both event and practice, the film spurred the village's people to mobilize so that the ritual and its celebration could take place, bringing together over 600 people, along with other communities—something which had not happened for a long time. Thus, there is in *As hiper mulheres* a formal hybridism which combines a documentary approach in the way it relates directly to the bodies in ritual, together with a fictionalization of the preparations for the ritual. But it must be noted that both—the documenting as well as the dramatization that surround the recovery of the ritual—take part in the same process in relation to tradition. The fictional mise-en-scène that is present in *As hiper mulheres* is connected to the control of self-image in order to materialize tradition. In this sense, the fictional enactment, like the recovery of the ritual provoked by the shooting of the documentary, is articulated by the necessity to construct, for others and for themselves, a traditional image, and can be understood as a mode of elaborating intercultural

Still, Takumã Kuikuro, Carlos Fausto, and Leonardo Sette, *As hiper mulheres (Itão Kuegü, The Hyper Women)*, 2011: Kuikuro women performing the recovered Jamurikumalu ritual

NEXT SPREAD, Aky, Panará leader, paints his body for the cover photo of the DVD compiling the work of Panará Indigenous filmmakers

Amaranta Cesar

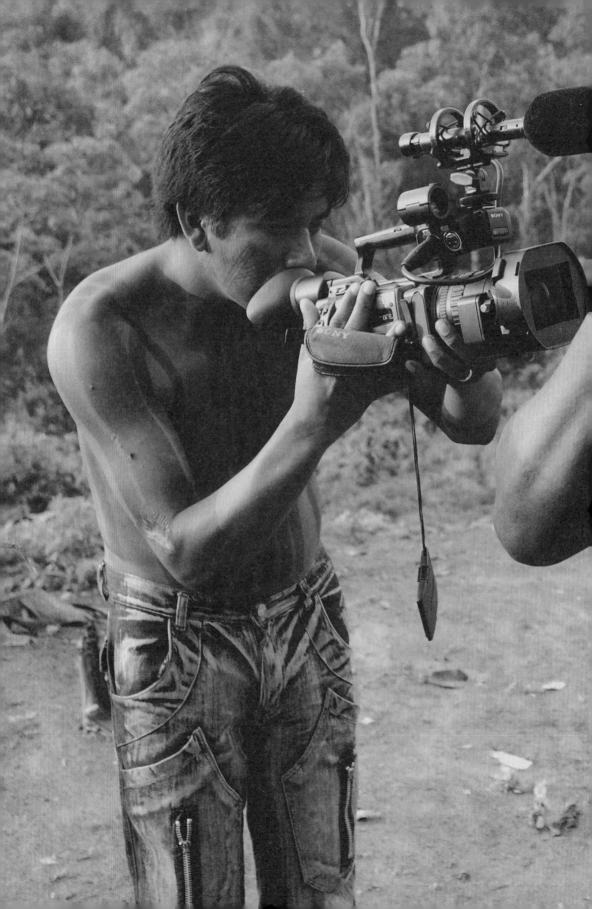

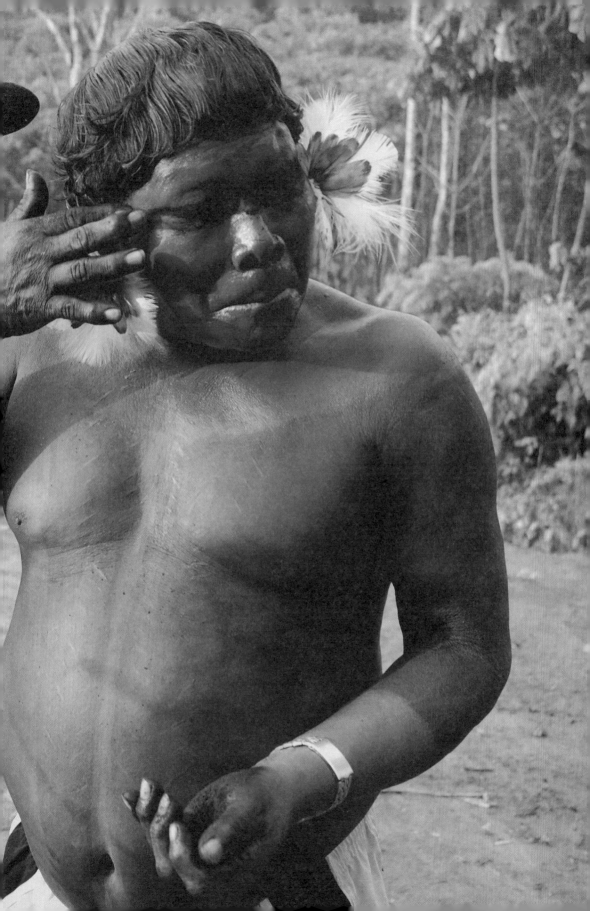

difference.[13] Therefore, the result of the enactment, as much from the fictional plot as from the ritual itself, has a performative dimension rather than a mimetic one. That is, the ritual that the film revives is not truly a spectacle for the Other, nor a fiction, but it is a form of *wing the self* and ensuring a future for the community. As Carlos Fausto states, "ritual also serves to avoid another definitive transformation, since it is the only place where the Indians are not 'becoming white.' Perhaps this is why it has also converted into an activity in which they can 'become Indian' again."[14]

After thirty-five years of producing films and organizing training programs aimed at Indigenous communities, the Indigenous filmmaking practices have gone through significant transformations and their outlook today is far brighter than in the 1980s. As André Brasil states:

> [...] the work of Vídeo nas Aldeias (Video in the Villages) has contributed to an extraordinary increase in the number of films by Indigenous filmmakers and collectives. Currently, there are filmographies closely linked to the specific demands of each ethnic group. Some of the filmmakers and collectives have acquired more and more autonomy to produce films which are increasingly making their way into festivals and showcases in Brazil and abroad (for example, Divino Tserewahú, Zezinho Yube, Ariel Ortega and Patrícia Ferreira, Takuma Kuikuro, Isael and Sueli Maxakali, among many others). Recently, the production of films by Amerindian groups has proliferated, either connected with or moving beyond the experience of Vídeo nas Aldeias. Ritual-films, fictions created from mythic narratives, activist documentaries, and records of situations of vulnerability: all of those images compose a diffuse and heterogeneous collection that contributes to the affirmation of the historical and cultural experience of Amerindians in Brazil.[15]

In this context of impressive effervescence, in which increasingly autonomous and diverse cinematic experiences and trajectories among Indigenous filmmakers in Brazil are consolidated, it appears significant that the efforts of VNA are at present focused on the preservation and digitization of its collections of images and sounds so that these may be given back to the communities where they were produced. It is safe to assume that it is the return of the images—whether at the moment the footage was taken or a

13 A futher analysis of *As hiper mulheres* is developed in Cesar, "Tradição (re) encenada" 88–97.
14 Carlos Fausto, "Registering Culture: The Smell of the Whites and the Cinema of the Indians," in *Vídeo nas Aldeias: 25 anos, 1986-2011*, eds. Ana Carvalho, Ernesto Ignacio de Carvalho, and Vincent Carelli (Olinda: Vídeo nas Aldeias, 2011), 237; see this essay for the use of the term "Indians."
15 André Brasil, "Tikmü'ün Caterpillar-Cinema: Off-Screen Space and Cosmopolitics in Amerindian Film," in *Space and Subjectivity in Contemporary Brazilian Cinema*, eds. Antônio Márcio da Silva and Mariana Cunha (New York: Palgrave Macmillan, 2017), 24.

long time afterwards—that makes it possible to think about the Indigenous cinemas as a repertoire of collective practices, in which those images facilitate the passage between times, bodies, and subjects in processes of cultural resistance.

At present, VNA maintains an audio-visual archive composed of more than 4,000 hours of analog and 3,000 hours of Native digital sounds and images (Hi-8, VHS/S-VHS, Betacam, mini DV/HDV), and 20,000 photographs, connected to over sixty Indigenous peoples, produced over the last thirty-five years. With an understanding of the cultural dynamics being experienced by the Amerindians, and considering the resulting political relationship with their identity, history, and traditions, the patrimonial significance of the audiovisual archives of VNA should be seen as invaluable. If, as argued here, the production of audiovisual materials in Indigenous territories can be thought of from the perspective of cultural resistance, all that has accumulated over more than three decades of intense work in this sense constitutes historic heritage that requires an acute effort in order to preserve it. This does not only concern initiatives of material safeguarding, the physical maintenance of the images, but entails a set of actions in order to return these images to the peoples that inhabit them; a kind of "repatriation," as Carelli calls it, a passage that occurs between territories as well as temporalities. This is precisely the mission to which VNA is dedicated at the moment: to digitize, preserve, and host this voluminous archive, with the aim of returning these images and sounds to the peoples therein portrayed, and to ensure the longevity of their access to them. A part of this restitution process is a reactivation of these archival images through the organization of training workshops. The VNA's audio-visual heritage serves here as a point of departure for the production of new images. This process can be seen as "a kind of cinema with no end," as observed by André Brasil: it is a cinema that "will always be put back in context, that will be stopped from standing out from the networks of sociability which traverse and constitute it."[16]

Yaōkwá, Imagem e Memória (*Yaōkwá: Image and Memory*, 2020), VNA's most recent film directed by Vincent Carelli and his daughter, Rita Carelli, is precisely the result of a project funded by the cultural institute of a Brazilian bank which enabled the digitization of archives and the organization of an expedition for their restitution to the Enawenê-Nawê, as well as the donation of filming, editing, and projecting equipment, and to assure workshops that "ensure the autonomy in the management of archives and the chance to continue filming," as mentioned in the opening titles. The short feature film reveals the restitution of film records produced between 1989 and 1995 of the Yaōjwa, a long ceremony in which "during seven months each year, the masters of ceremony lead myriad chants in an

16 Brasil, "Cineastas-guardiões," 11.

extensive mythological narrative." The archives have become a reference for a generation of young people who no longer know some of these chants.

In the first film sequences, which take place during the approaching sunset, we see a film projection being set up at the center of the village. In the middle of a semi-circle formed by dwellings covered with buriti straw, a white screen stands out. As the evening falls, a non-Indigenous member of VNA surrounded by young Enawenê-Nawê is teaching them how to turn on the projector, connecting it to a computer, and showing moving images to a few dozen men and women, young and old, as well as children.

It is night, and illuminated by the light of the projection, with their bodies clinging to each other and vibrant eyes, the Enawenê-Nawê watch the images, as if diving into a crack in time. Deceased relatives, forgotten chants, and transformed customs return to the village, spurring a range of emotions, which are revealed to the camera on the following day, as is the case in Lolawenakwaenê's testimony:

> I think it's right to return with images of the Yaõkwa now. I think it's good, but I also feel sad. We have lost some Yaõkwa chants already, that is why I feel sad. We have lost them because the elders departed too fast, and with them, the chants. [...] Yesterday, as I was watching, I heard a song that had disappeared. We realized that it was missing from the Yaõkwa. But now we have brought the chant back. That is why I think it's good.

Traditionally, during the Yaõkwa, the Enawenê-Nawê fed fish, manioc, and salt to the *Yakairiti*—spirits with whom they maintain alliances. Part of the ritual's traditional protocols are long fishing outings with small temporary dams on the Iquê river, which is an affluent of the Juruena located near the village in the northeast of Mato Grosso in the Amazônia Legal. Since the beginning of the 2000s, life and the life forms that are produced and reproduced in the waters and on the banks of the Juruena river have been greatly threatened by small hydroelectric power plants (PCHs). They curtail the movements of fish during breeding season, which has drastically reduced the amount of fish and thus affected the Enawenê-Nawê's lives.

The preservation of the Yaõkwa started to depend not only on the maintenance of knowledge transmission processes, but also on safeguarding the region's biodiversity. Environmental damage has made the ritual also a political issue, with some struggles that have included protests calling for an end to the construction of hydroelectric power plants, pressure on FUNAI (National Indigenous Foundation) and the Federal Public Prosecution Office to fund the purchase of farmed fish, legal negotiations to suspend construction authorizations and the implementation of funds for damages and compensation, and the national heritage listing of the ceremony,

recognized in 2009 as Brazilian intangible heritage and listed in 2011 by UNESCO as being in urgent need of protection.

Still, Vincent Carelli, *Yaõkwá, Imagem e Memória* (*Yaõkwa: Image and Memory*), 2020

In the short film *Yaõkwá: Image and Memory*, the archival images of the great traditional fishing, recorded in 1991, are projected at the center of the village for the whole community. This procedure is not patrimonialist, nor does it sustain a mummified vision of history according to which peoples need to safeguard their tradition so as not to lose their identities. In a parallel montage, we see, for example, images of playful spirits in the Salumã at two different times, 1991 and 2020. The overlapping, in which the historical transformations of the ceremony become evident (the manioc has been replaced by salty pastries, the presence of SUVs, etc.), does not provoke melancholy or participate in a denouncing utterance. In this act of returning, videos and photographs appear to reestablish, besides memory, within these historical images an opening to the gaze of the other and of another time: an opening that would justly permit a political acting out of images in the processes of cultural resistance.

The recovery of tradition, through and with the records that were returned to the communities, seems to be connected to the reflective attitude towards culture that corresponds to what Manuela Carneiro da Cunha calls "culture with quotation marks." According to her, "various peoples are more than ever reclaiming the celebration of their 'culture' and using it successfully to obtain reparations for political damages."[17] But aside from safeguarding knowledge, ensuring its transmission and celebrating "culture," the giving back of archives also activates historical perception, it makes

17 Manuela Carneiro da Cunha, *Cultura com aspas* (São Paulo: Cosac Naify, 2009), 313.

history vibrate. Through the action of the images in time, it is made evident that the identity/difference that demarcates the territory is permanently negotiated and traversed by antagonistic, heterogenous forces. By returning them to their subjects, these images and sounds display not only historic and reference value but, as they operate in between times, spaces, and bodies, activate forces that can sustain their struggles to ensure the continuation of their territory and lives.

In this sense, beyond acting as a recording instrument for future memory, the documentary, following the trajectory of VNA, has proven to be an action, a live practice, that, in the interaction with other practices in the communities, has become capable of making available that which is on its way to becoming part of the past to men and women in the present, so that the future may reinvent itself. As observed by James Clifford, through memories and selective connections, tradition articulates past and present. And the past "in Indigenous epistemologies is from where we look at the future."[18] This finding is articulated with an important observation by Eduardo Viveiros de Castro: "[...] Amerindian is not a concept that solely alludes to, or even principally, the past—one is Amerindian because one was Amerindian—, but also a concept that alludes to the future—it is possible to be Amerindian again, it is possible to become Amerindian. Indianness is a project of the future, not a memory of the past."[19]

From their very creation, the images and sounds of the vast VNA archive seem to address the future. Watching a film projection with startled eyes, Enawenê-Nawê children turn to elders for reassurance, "was that us?" Kolalienê, one of the eldest, aware of and zealous about this seed of future, asks the VNA team: "Will our great-grandchildren be able to see us when we die? Won't these machines lose the images?" In the country where the National Museum and the Brazilian Cinemateca were consumed by a fire borne out of negligence and abandonment, this question resonates and invites a wider response.

18 James Clifford, *Returns: Becoming Indigenous in the Twenty-first Century* (Cambridge, MA: Harvard University Press, 2013), 57.
19 Eduardo Viveiros de Castro, "A indianidade é um projeto de futuro e não uma memória do passado," *Prisma Jurídico* 10, no. 2 (July–December 2011): 265.

Bibliography

Brasil, André. "Tikmũ'ũn Caterpillar-Cinema: Off-Screen Space and Cosmopolitics in Amerindian Film." In *Space and Subjectivity in Contemporary Brazilian Cinema*, edited by Antônio Márcio da Silva and Mariana Cunha, 23–40. New York: Palgrave Macmillan, 2017.

Brasil, André. "Cineastas-guardiões: hipótese sobre a autoria no cinema indígena." In *Anais do 30º Encontro Anual da Compós*, 1–19. Campinas: Galoá, 2021. https://proceedings.science/compos/compos-2021/trabalhos /cineastas-guardioes-hipotese-sobre-a-autoria-no-cinema -indigena?lang=pt-br>

Carelli, Vincent, and Dominique Gallois. "Vídeo e diálogo cultural—experiência do projeto Vídeo nas Aldeias." *Horizontes Antropológicos* 1, no. 2 (July–September 1995): 61–72.

Carvalho, Ana, Ernesto Ignacio de Carvalho, and Vincent Carelli, eds. *Vídeo nas Aldeias: 25 anos, 1986–2011*. Olinda: Vídeo nas Aldeias, 2011.

Cesar, Amaranta. "Tradição (re) encenada: o documentário e o chamado da diferença." *Devires: Cinema e Humanidades* 9 (January–July 2012): 88–97.

Clifford, James. *Returns: Becoming Indigenous in the Twenty-First Century*. Cambridge, MA: Harvard University Press, 2013.

Cunha, Manuela Carneiro da. *Cultura com aspas*. São Paulo: Cosac Naify, 2009.

Fausto, Carlos. "Registering Culture: The Smell of the Whites and the Cinema of the Indians." In *Vídeo nas Aldeias: 25 anos, 1986–2011*, edited by Ana Carvalho, Ernesto Ignacio de Carvalho, and Vincent Carelli, 234–38. Olinda: Vídeo nas Aldeias, 2011.

Feld, Steven, ed. *Jean Rouch: Ciné-Ethnography*. Minneapolis, MN: University of Minnesota Press, 2003.

Souza, Braz Bonfim Arissana. "Arte e identidade: adornos corporais Pataxó." Master's thesis, Federal University of Bahia, 2012.

Viveiros de Castro, Eduardo. "A indianidade é um projeto de futuro e não uma memória do passado." *Prisma Jurídico* 10, no. 2 (July–December 2011): 265.

On Visual Sovereignty and the Formal Explorations of Indigenous Futurisms

Sophie Gergaud

Downtown Tkaronto/Toronto

It is pitch black. All around me. As tiny beams of light appear, I see the word "Tkaronto" just in front of my eyes. Wait, I think I remember! It is a Kanien'kéha word meaning "where there are trees standing in the water." It is also the ancient name of the colonial place now known as Toronto, the city I have been visiting for two weeks now.

I thought I was all alone, but I hear a woman say: "Änen shayo'tron' Shonywäa'tihchia'ih sentiohkwa? Where did the creator put your people?" I am not sure where and who she is exactly but even though the tone of her voice is gentle, I do not dare to ask. I turn around but I am still standing in the dark and I don't really feel her presence next to me. This is weird. While waiting for something to happen, I reflect on the question she just asked me. And on its deeper meaning. My thoughts bounce back and forth. I am a French white woman, originally from Brittany but exiled and—weirdly enough—happily diluted in the big capital city of Paris. I am also only truly myself when on the move, traveling the world, trying to adapt to ways of life that are different from mine, always enjoying new encounters. So her question troubles me. Where did the creator put my people? And why there? To be honest, I often wonder who is "my" people, really: the people I was born to? The peoples I have met along the way and learned to love? The people I feel most at home with?

While still processing, I realize that daylight now permeates the place around me. Or maybe my eyes just got used to the dark? No ... I still cannot see anything behind me and I have a hard time deciphering the subway map on that pole, next to me. It is in such a state of advanced decomposition that it seems about to disintegrate, but that is not the only reason it is hard to read. Looking left, I can finally see the sunlight coming through a gaping hole in the ceiling. It strikes me how the subway platform I stand on looks so deserted and, quite frankly, abandoned. *I* feel abandoned too. Where is everybody? At this hour, the crowd waiting on the platform is usually

unbearable. All of a sudden I shiver. A draft lifts the detritus at my feet. I feel cold. I always feel cold waiting for the subway. Wait! I can hear something from a distance, a mechanical and squeaky sound—is the subway finally on its way? I approach the edge of the platform and, looking down, I realize the tracks are underwater. It seems stagnant and at first, I tell myself that the station must have become a vast sewer. It makes sense now that the walls and the ceiling are completely covered with moss. But after a closer look, the water looks actually very clear and there is a current gently animating it. I marvel at the sight of a tiny tree growing through a crack of concrete—I have always been amazed by the capacity of natural elements to counter human obstacles and do whatever they please.

A few minutes ago, I could almost smell humid rot and thought death was the only thing to expect next. Now it is the complete opposite and it seems like demonstrations of life are indeed timid, and yet everywhere. I look down again at the detritus at my feet: someone left their copy of the *Toronto Star* on the floor. I hate when people do that. At least it wasn't long ago: the front page is today's. Maybe it is the same person who docked the canoe I see over there? The paddles next to it do not look that old. Someone was obviously just here. I am still not totally reassured but the excitement of an encounter is slowly taking over.

I like the calm sound of dusk. Now that I am outside and have left the underground station, I can clearly hear some croaking frogs. Even though that surprises me (some frogs around here, really?), everything looks so peaceful that I do not feel scared anymore. But the sight of Nathan Phillips Square being completely flooded reminds me that I should remain on my guard. I wonder what happened—and when? I came here not too long ago and it was all dry, packed with people, and bursting with life. Now I once again have the impression of being the only one around. I notice a turtle further away, and it adds to the numbing impression that everything is moving smoothly and slowly around me. Her presence is a soothing sign. I grin at her as ancient stories told by different Native Elders resurface in my mind—stories about turtles, and especially about Turtle Island, the name given by Indigenous peoples to North America—, and I like that.

I realize now that the place is actually not flooded; it is more like a pond or a river branch with reeds growing here and there. And the water does not look invasive nor destructive; rather like a natural resource made available for the flora and fauna whose gentle sounds permeate the space all around me.

The iconic city hall, courthouses, shops … everything is here and yet looks different. The city's infrastructure seems to have recently collapsed. I can see trees growing on the roofs now, or cutting their way through cracks in the asphalt. Vegetation covers the walls of the crumbling buildings. I still have no clue what happened and am not sure how

I should feel. There is no sense of chaos nor loss, as landscapes are far from being empty and void. Nature just seems to have taken over its rights. Looking at my feet, I see the pavement slabs that used to be Nathan Phillips Square and which now form the bank of the river where I spot another canoe upside down—someone else has come this way. There are multiple signs of human presence: a fire pit close to me, a garden table too, and some chairs nearby, positioned in a welcoming way. People were obviously socializing here, not so long ago. I am disappointed to have missed them. Shall I wait for them to come back? Where have they gone?

It is all very quiet and peaceful out here—apart from the nocturnal animals that are slowly taking over. Though they are still hiding and remain out of sight, I can certainly hear them getting louder and louder, more confident as the night is gradually falling on us. I remain still.

And then I see her. In a white dress, digging in the soil. As she looks up towards the sky, I look up too and see a raven flying overhead. I don't know what she is digging for and she is quite far from me but she seems busy so I decide to leave her alone. I just can't stop staring at her though. Once again she looks up and I notice the giant and mighty moon rising. Here comes the raven again, the sound of his wings brushing my ears as he passes by and startles me a bit. Is he trying to play tricks on me? He suddenly reminds me of the many stories a quirky Tlingit friend in Alaska used to tell me about ravens and eagles, about clans and extended families, about rules he was supposed to follow but constantly got around and played with …. We haven't seen each other for a long while and it now dawns on me how I miss his storytelling, his way of always mixing facts and figments of his overflowing imagination.

Lost in my train of thought, I suddenly realize that I am now on the roof of the building. I can tell the night is almost here. Intrigued, my eyes are caught by a dome, similar to a traditional wigwam, glowing from the inside. I am curious, I want to get in. The structure is made out of branches, fragile-looking, and yet strong enough to hold the fabric that is stretched taut all over it. I move over towards the lining. As I extend my arm, to touch it and figure out what kind of material can reflect light in such a mysterious way, I get distracted by a hole in the ceiling and dive into the celestial vault above me. There is a numbing feeling to it, as I listen to every single spark of life entering my ears and reverberating in my body. Magic is in the air as little spots of light, like lively fireflies, float all around me. There are more and more of them, competing with the millions of stars that have popped up in the endless sky.

I take a deep breath. It feels nice and warm inside.

I am at peace.

First, his voice surprises me. It is so close to me. All around me. Not even trying to move an inch, I remain attentive. His words enter my ears and float in front of my eyes as they appear in the sky. I don't know that language so I have no clue what he is saying but looking at the written words hanging above me, I find myself thinking that they harmoniously fit in the landscape— they seem to be woven into the fabric of the world. I know this man is talking to me because just when I am done reading the long words full of those unusual letters weirdly associated together, they morph into English so I can grasp their meaning. The meaning of his poem. Then they suddenly disintegrate into the air, flaking into small particles of white dust, joining the fireflies and the stars, as if returning where they belong. As part of the universe.

Sophie Gergaud

In a state of near-weightlessness, I patiently admire everything that beautifully surrounds me. I realize that I had a blissful smile on my face the whole time, looking ridiculously happy—but I could not care less. I just want to stay here, motionless, softly floating among the fireflies still sparkling and tirelessly dancing. I have been here for what seems an eternity: dawn is almost upon us and the gentle light now enables me to soak up the astonishing view. I slowly and cautiously approach the roof edge. Kind of dizzy,

 I nevertheless feel attracted to the vertiginous city below me. Like a powerful magnet, it sucks me in—makes me want to fly over its new and mysterious appearance. Embracing the landscape that stretches before me towards the horizon, I realize that the radical change I have been experiencing so far is not specific to the neighborhood I find myself in: Tkaronto/Toronto proudly affirming its lushness is now entirely revegetated with bulky trees growing everywhere. Concrete buildings and infrastructure may be falling apart, damaged by still unknown forces, but they are now covered with greenery that gives them an innate sense of life.

Yes, life is everywhere! I am undoubtedly surrounded by its mighty presence.

More voices emerge. Overlapping. Speaking a language that I do not understand—but I am not really trying to, not like I used to anyway. Forcing and rushing things. Instead, I let those foreign and mysterious words gently rock and cradle me into the new day.

And suddenly it is all black again. I feel myself falling into the abyss, then seized and pulled back by a text appearing just in front of me:

The central prayer of the Haudenosaunee is "The Thanksgiving Address."
They are the words that come before all else.

Biidaaban is an Anishinaabe word. It refers to the past and the future
collapsing in on the present. It is the moment of first light before dawn.

The languages of Wendat, Anishinaabemowin, and Kanyen'keha
have been here for thousands of years.
They have things to tell us about this place—and our future.

Situating oneself within the iNdigital Space

When the rolling credits come to an end, I refuse to face the truth. A soft voice breaks the silence. It tells me I can now safely remove the headset and asks me to move to the side so that other people can come in and enjoy the show too. I do not oppose and docilely obey. I feel dazed and it takes me some time to become accustomed to the room again, to the lights, the space, and the people around me, to the slight noises their conversations are making in the background. I am in the iNdigital Space, a curated space on the main floor of the TIFF Bell Lightbox in Toronto, Canada. Dedicated to Indigenous VR and video games, it is part of the nineteenth edition of the imagineNATIVE Film + Media Arts Festival, taking place from October 17 – 21, 2018. imagineNATIVE is known as the world's largest event showcasing Indigenous-made content (film, video, audio, digital and interactive works), and the eight-minute VR piece I just watched, *Biidaaban: First Light*, is part of this year's selection of digital and interactive media works. In the festival catalog it is presented as a "remarkable Anishinaabe view of the future," where "people have found a reconnection to the past. *Biidaaban: First Light* illuminates how the original languages of this land—Wendat, Kanien'kehá:ka (Mohawk), and Anishinaabemowin— can provide a framework for understanding our place in a reconciled version of Canada's largest urban environment."

All the images in this contribution, unless otherwise indicated, are screen grabs from the interactive VR work *Biidaaban: First Light*, 2018, by Lisa Jackson, Mathew Borrett, and Jam3.

Biidaaban's Canadian premiere took place in September 2018, a few weeks before imagineNATIVE, in a custom-built installation featuring five individual stations with VR headsets, located on the actual Nathan Phillips Square in Tkaronto/ Toronto—on the exact same spot represented in the second part of the film. It was the first time that the National Film Board of Canada, who produced it, had presented an installation both in the open air and on the city's landmark square. During this week-long event it became the center stage of this unique project, both in virtual and real life.

Canadian premiere of *Biidaaban: First Light* in Nathan Philips Square, Toronto, 2018

I did not have the chance to discover *Biidaaban* outdoors, in these spectacular conditions, but stepping out of the room-scale experience at

imagineNATIVE, I nevertheless felt deeply impressed and puzzled. And I knew right away that I would include it in the selection of Indigenous VR works[1] I have been curating as part of a special event dedicated to Indigenous Futurisms, a movement that stands in response to the colonial imagination that only views Indigenous peoples as relics of the past, frozen in time and on the verge of extinction. The term "Indigenous Futurisms" was coined by Anishinaabe scholar Grace Dillon when she edited the first anthology of Indigenous science fiction, *Walking the Clouds*, in 2012.[2] Informed by Afrofuturism, it is intended to be open to interpretation by all Indigenous creatives: the book indeed included contributions by Native Americans, First Nations, Aboriginal Australians, and New Zealand Māori authors. But as Anishinaabe artist and researcher Elizabeth LaPensée specifies, "[Dillon] does share that, from an Anishinaabe perspective, her interest is in work that doesn't seek to imagine futures in which we leave Aki (Earth), but rather always relates back to the wellbeing of Aki and reinforcing nationhood."[3] Hence the anthology provided a "deconstructive critique of conventional science fiction with its traditional colonialist emphasis on conquering 'alien' territories while highlighting the speculative and time-traveling traditions that had always informed Indigenous legends and oral storytelling."[4] Moreover, Indigenous Futurisms are a glaring proof that contemporary Indigenous artists are no outsiders to the technological world and that they have long appropriated and mastered the tools of futuristic storytelling. imagineNATIVE is one of the few avant-garde events to have made room for special screenings and gatherings promoting Indigenous artists' visions and imagination of the future.

I am a French film curator and an art event organizer. As the co-founder, director, and head programmer of the Festival Ciné Alter'Natif since its first edition in 2009, I have specialized in Indigenous-made films

1 Indigenous artists throughout the world have produced VR works since technology first emerged. As the presentation section of the online FourthVR.com database states, "throughout the development of Virtual Reality (VR), Indigenous creatives have found ways to access, adapt and innovate VR technology," thus giving birth to a vast and ever-growing body of Indigenous VR works. FourthVR.com is a database and interactive map created by researchers Keziah Wallis (Kāi Tahu) and Miriam Ross from the Victoria University of Wellington in New Zealand, who wish to capture the rich array of VR works that maintain Indigenous visual sovereignty. FourthVR spans all the major platforms, displaying a variety of genre forms from VR games to non-narrative experimental artworks to cinematic VR experiences. It spans the globe with production locations extending from Inuit lands in the far north to Aotearoa New Zealand in the south. Overall, this database clearly demonstrates the capacity of Indigenous creatives to produce their own narratives using the medium of VR. For more information, see FourthVR database at https://fourthvr.com.
2 Grace L. Dillon, ed., *Walking the Clouds: An Anthology of Indigenous Science Fiction* (Tucson, AZ: University of Arizona Press, 2012).
3 Darren Lone Fight, "Interview with Elizabeth LaPensée on Indigenous Futures, Video Games, and Art as Resistance," 2019, https://www.darrenlonefight.com/news/2019/10/23/interview-with-elizabeth-lapense-on-indigenous-futures-video-games-and-art-as-resistance.
4 Brenda Longfellow, "Indigenous Futurism and the Immersive Worlding of *Inherent Rights/Vision Rights, 2167* and *Biidaaban: First Light*" (paper presented at the FSAC Annual Conference, Department of Cinema and Media Arts, York University, Toronto, 2019), 14.

and visual art. I first attended the imagineNATIVE film festival in 2014, and have to admit that I became instantly addicted to it, and have made sure not to miss a single edition ever since. I have always been a festival buff: I make endless lists of films to watch every day, I run from one event or industry panel to the next, I totally immerse myself in the atmosphere and always try to take it all in. But among all the great festivals in the world, imagineNATIVE is the place that inspires me the most, and it always makes my brain spin even faster than it usually does. While watching a film or experiencing an art piece I love, I immediately start to imagine events and screenings as opportunities to share with French audiences all the exciting discoveries I just made in this very special space entirely dedicated to narrative sovereignty and a thriving Indigenous visual creativity.

If most of the time the first spark of interest gets ignited by my own personal taste along with a sort of instinct guiding my curating choices, a second stage finds me in dire need to understand, intellectualize, analyze, and go beyond mere emotions and sensibility. In the case of *Biidaaban*, a large variety of feelings emerged during its eight minutes—from a hint of fear to reassuring appeasement; from being startled to letting go completely, along with an intermediate stage spent unsuccessfully trying to decipher the unfamiliar words and world surrounding me. As a visual anthropologist, I am used to being challenged and taken out of my comfort zones—this is precisely why I am so passionate about Indigenous cinemas, as they invite non-Indigenous viewers to experience a reversal of perspective—a de-centering of our own perception, requiring that we step aside and move away from our habits and our certainties, welcoming other ways of looking at, understanding, and simply being in the world. Another part of the experience is the need to confront my own interpretation with the artists' intentions and desires. This can take a while, as processing emotions and instant reactions can be an intense and complicated journey.

At first I really did not feel like talking after handing my headset back to the festival volunteer, despite her engaging smile and genuine wish to know what I had thought of *Biidaaban*. All I wanted was to be left alone and given time to process this disconcerting experience, to reflect on what I had just seen: a world that is both beautiful and disturbing, as well as surprisingly complex. As a film curator, I also could not help but wonder in which French venue this singular and revolutionary piece would fit, and how a French audience would react to it. French viewers are, still today, mainly exposed to films that fall under what I have started to categorize as the "films d'Indiens" supra-genre[5]—films, whatever the genre, that are built upon the same narrative structure within which Indians[6] are helpless and/or doomed to disappear. Seen as belonging to a permanent state of primitivism, Indians in the "films d'Indiens" supra-genre seem "stuck" in the past; they are hardly ever represented as contributing to the present time. Defined by their tragic past, largely denied a thriving present, Indigenous people are thus absent from non-Indigenous present-day worlds and imagined futures. What a huge leap forward French viewers would have to make, from the usual films entangled in the traditional narrative structure of the "films d'Indiens" to the Indigenous visual sovereignty embodied by the innovative world of *Biidaaban*, combining decaying Western civilization infrastructure and decrepit reminders of a consumerist lifestyle (concrete roads and buildings, retail centers, bridges, and foot-walks) with a thriving natural life redefining the city's look and outlines. Convinced that it would nevertheless be very well received in France, I had to strengthen my intuition by doing some research, and by hearing the filmmaker herself talk about her work and artistic vision.

5 Drawing upon works and analyses by Indigenous scholars and art critics such as Jaquelyn Kilpatrick (Choctaw/Cherokee) and Beverly Singer (Tewa/Diné), in *Cinéastes autochtones. La souveraineté culturelle en action*, I proposed the "films d'Indiens" supra-genre as a theoretical tool. The "films d'Indiens" supra-genre is characterized by a set of semantic elements that constitute a sort of narrative spinal column that would be recycled endlessly, except for a few vertebrae, yet concealed under coverings (plots and characters as flesh and muscles) that give it the appearance of change. It is worth noting here that this recurring narrative backbone can be found in any film genre, not just Westerns. The semantic elements of the "films d'Indiens" supra-genre can be summarized and grouped in six main categories: 1) a temporality mainly frozen in the past, imbued with nostalgia and a fascination for the conquest of the West; 2) the Vanishing Indian ideology; 3) a generic representation of Indians with characters who fall into two main categories—on the one hand, a uniform group with indistinct personalities who do not speak or utter frightening war cries and, on the other, an isolated and one-dimensional individual whose role is to value the real hero, the white savior; 4) a relative absence of female characters who, when they do exist, are portrayed primarily as victims; 5) Indians are usually a pretext for highlighting (or denouncing) Western values but have no existence by themselves; 6) finally, a tendency towards drama and tragedy, including in the few films with a contemporary plot. Of course, there are exceptions that may weaken this proposed analysis grid. Although there are films that contradict one or more of these main elements, none break free from all of them simultaneously. For a more detailed analysis of the "films d'Indiens" supra-genre, see Gergaud, *Cinéastes autochtones*, 2019.

6 I have deliberately chosen the term "Indians" here to refer to stereotypical representations that deserve to be deconstructed. The terms "Native Americans," "First Nations," or "Indigenous peoples," on the other hand, are used when referring to the Indigenous nations and peoples of North America. "Indigenous" is capitalized to clearly point to its more recent definition that accounts for political and historical realities (Christine Weeber, "Why Capitalize 'Indigenous'?" Sapiens, May 19, 2020, https://www.sapiens.org/language/capitalize-indigenous/).

A reclaimed Indigenous city

> Given that half of Canada's population that's Indigenous lives within cities—
> and *I've* always lived within cities—I was just like:
> "Well, why don't we think of cities as Indigenous?"
> Cities are totally Indigenous!
> And cities are full of vibrant Indigenous cultures.
> And so I've centered *Biidaaban* in the middle of a city
> and sort of claimed space in that way.[7]
> – Lisa Jackson

Biidaaban: First Light was co-created by Canadian/Anishinaabe filmmaker Lisa Jackson and Canadian environmental designer Mathew Borrett, together with Toronto-based studio Jam3 and the National Film Board of Canada. During the different imagineNATIVE panels and Q&As Jackson participated in, she explained how Mathew Borrett's previous work, "Hypnagogic City," inspired her vision of a future Toronto reclaimed by nature. As soon as I saw his designs, they reminded me of an art exhibition called *Il était une fois demain* (*Once Upon a Time Tomorrow*) by Chris Morin-Eitner, a French architect, photographer, and filmmaker I worked with a long time ago as an assistant editor on one of his short fiction films. We have lost touch since then, but I happened to come upon his exhibition in Paris and discov-

ered his distinctive hybrid creations. His photo-montages are a mix of pictures he took while traveling abroad and graphic elements he then added digitally. Each piece shows a historic or contemporary architectural landmark, symbolic of a well-known megalopolis (Dubai, Shanghai, New York, Rome, Paris, London …) in a state of sublimated ruins, invaded by a welcoming virgin forest, some peaceful wild animals, and majestic birds. His representations of famous cities and iconic places saturated with nature, in which greenery and wildlife repopulate the abandoned urban sites, are a post-apocalyptic and surreal world where humans—who thought they

Chris Morin-Eitner, *Paris#MakeOurPlanet-GreatAgain*, 2017

7 CBC Arts, "Imagine if Toronto were reclaimed by nature," September 20, 2018.

had conquered the world with their grandiose monuments and infrastructures—have now completely vanished. In Morin-Eitner's creations, there are no clues as to what happened to humankind, but this is not the focus of his work: what really interests him is to imagine how nature can reclaim places that have long been deserted by human presence.

 Biidaaban is different. Much like in *Il était une fois demain*, fauna is growing out of the city's collapsed infrastructure. But in Jackson's vision of Toronto, long after the world as we know it now in all its excesses has ended, the absence of humans is not a *sine qua non* for nature's success at reclaiming the space—the abandonment of their unsustainable way of life, however, is. In *Biidaaban*, the whole world has not collapsed but Western civilization has. And if nature has overtaken its rights, humans have not fled from the city; they are not banned from it and neither have they disappeared: they are simply not the main characters of the story. Not in the center, they do not dictate where action should be or how it should unfold but they seem to co-exist with the other elements of the environment, integrated into the landscape. We only see a woman in one sequence, farther away from us. In all the other shots, humans are not seen directly through their physicality but their presence is delicately suggested through visible signs of their discreet activity and visual signifiers of indigeneity—such as homegrown corn on skyscraper roofs, tobacco leaves drying on a traditional wooden rack, canoes docked at the subway platform, a dome reminiscent of Indigenous living and ceremonial structures. Humans are not central but they are definitely part of a well-balanced and living world.

In *Biidaaban*, futurist landscapes take on new aesthetics as Indigenous presence (human *and* nonhuman) can be found in every nook and cranny, reclaiming every bit of space. Where Morin-Eitner photoshopped onto its Parisian landscapes wild animals from the African savannas as well as lush vegetation coming straight out of the Amazon rainforest, Jackson and Borrett researched indigenous flora and fauna that populated the Toronto area before colonization (or which are still to be found today despite galloping contemporary urbanization) and brought them back into their natural habitat. *Biidaaban* suggests that even in cities, survival can be sought thanks to ancient knowledge, indigenous to the area and still relevant for the future. But there again, while the warm and sometimes garish colors of Morin-Eitner's flamboyant safari-type creations are reassuring, Jackson's bluish atmosphere feels a little chilly. It seems like nothing can be taken for granted, and when *Biidaaban* ends uncertainty is still looming in the air. It is dawn after dusk, morning as a revival from the night, anything is possible but everything is yet still to be done. Jackson indeed questions us, as human beings placed at the heart of this experience: What are we going to do? Will we be able to listen, observe, and learn from the world around us?

In *Bidaabaan*, humans do not *make use* of the landscape but they *fit in*, they are part of it. Through this VR experience, Jackson attempts to reconcile the different elements of the landscape, human and nonhuman alike. The land itself is not portrayed as a number of empty spaces waiting to be filled or transformed by man's hands and will, it appears as what Dillon calls "deeply situated social and ecological environments," "a self-sustaining vessel" requiring "participation from all its interwoven inhabitants," a "common pot" to be shared.[8] Watching the futurist land-scape unfold through a VR headset, experiencing this deep immersion into a reconciled universe, one cannot help but think that the "egosys-temic" culture of modern industrialized nations as theorized by writer Louis Owen (Choctaw/Cherokee) has finally been replaced by what he calls the "ecosystemic" culture of Native peoples who feel neither removed from nor superior to nature, recognizing themselves as an essential "part of that complex of relationships we call the environment."[9] If Jackson chose to locate her VR piece in Nathan Phillips Square it is because, as she explains, it is "sort of the center of our systems of governance, a kind of reflection on the systems that we govern ourselves by and a bit of ques-tioning of it."[10] In the futurist world of *Biidaaban*, institutional buildings can thus crack and crumble: we understand there is no need for them anymore if "humans are living in keeping with the knowledge systems of

8 Dillon, *Walking the Clouds*, 6–7.
9 Dillon, *Walking the Clouds*, 150–51.
10 CBC Arts.

the original people of the territory."[11] And that is when another reclaimed Indigenous space comes into play: part of this new aesthetics of futurist landscape is contained in the sound space, filled with nature's vibrations and sonorities, but also with words in Indigenous languages. There is no English spoken in *Biidaaban* at all we instead hear Wendat, Anishinaabe-mowin, and Kanyen'keha (Mohawk), three Indigenous languages that were once the only human words heard on these territories. The order in which we hear them matters: it respects the order in which these Nations lived in Tkaronto/Toronto.[12] And according to Jackson, the way they describe the territories is highly refined as these languages have been growing "on this land in the same way that plants do. The languages have been spoken here for thousands of years; they capture this land more than any other languages."[13]

"A rising tide of Indigenous Futurism":[14]
Towards a decolonization of the Anthropocene

> Outer space, perhaps because of its appeal to our sense of endless possibility, has become the imaginative site for re-envisioning how black, indigenous and other oppressed people can relate to each other outside of and despite the colonial gaze.[15]
> – Lou Cornum

If, according to anthropologists Heather Davis and Zoe Todd (Métis/Otipemisiwak), colonialism is a "severing of relations,"[16] *Biidaaban* offers a reconciled vision of the world we all share, with restored relationships to one another. And regarding the question of what happens once Western civilization and present-day society have disappeared, it answers that far from being the end of the world, it is on the contrary a beginning with new possibilities to be imagined. This flourishing envisioned future is clearly embedded within the timeframe of Indigenous Futurisms which, according to LaPensée, "reflects not merely the future from a linear worldview, but rather non-linear past/present/future spacetime."[17] And it is precisely what led Jackson to choose this title: *Biidaaban* is the Anishinaabemowin word

11 Elisabeth Jackson, "Biidaaban: First Light" (Master's thesis, York University, 2019), ii.
12 Jackson, "Biidaaban: First Light," 31.
13 Rhiannon Johnson, "Anishinaabe Artist's New vr Experience Takes an Indigenous Futurist Look at Toronto," CBC, April 14, 2018, https://www.cbc.ca/news/indigenous/lisa-jackson-biidaaban -vr-future-toronto-1.4619041.
14 Jackson used this expression several times during presentations of *Biidaaban*.
15 Lou Cornum, "The Space NDN's Star Map," *The New Inquiry*, January 26, 2015, https://thenewinquiry.com/the-space-ndns-star-map/.
16 Heather Davis and Zoe Todd, "On the Importance of a Date, or Decolonizing the Anthropocene," *ACME: An International Journal for Critical Geographies* 16, no. 4 (2017): 770.
17 Lone Fight, "Interview with Elizabeth LaPensée."

for "dawn," but in its very structure it also refers to the idea of "the past and future collapsing in on the present."[18] The first light refers to that specific moment when the night is still palpable and yet the new day is already coming: "This is a way to say that there can be a new way of looking at it and without saying what the new day would look like, it's just saying here's a moment, let's pause to reflect on what else may be possible."[19] This different temporality also asserts a sense of Indigenous continuity where Indigenous peoples can draw on former events to inform their present-day survivance[20] and find ways to ensure a better and sustainable future.

Indeed, while mainstream society tends to think about dystopian worlds only in the future, Indigenous Futurisms remind us that apocalypse already occurred in most Indigenous pasts. As survivors, Indigenous creatives have long been imagining more balanced, thriving futures. Jackson's enthralling futurist artwork is one of those Indigenous Futurism art pieces that make space for discussions about the Anthropocene and its impacts from an Indigenous point of view. "Implicit in the piece," she says "is the question of whether the 'apocalypse' may have already occurred, if you are Indigenous or of the tree nation, animal nations, etc."[21] Indigenous scholars and environmental activists have called for a widening of the concept of the Anthropocene beyond its current Western and Eurocentric framing that does not significantly differentiate between peoples, ideologies, and ways of life. They question the reference to "anthropos," the generic human being, which implies a universally-shared responsibility, whereas the changes observed can largely be attributed to the Western world and its socioeconomic system. Davis and Todd also argue that "a start date coincident with colonization of the Americas would more adequately open up these [contemporary conversations of the Anthropocene]," adding that, to most Indigenous peoples,

> the Anthropocene is not a new event, but is rather the continuation of practices of dispossession and genocide, coupled with a literal transformation of the environment, that have been at work for the last five hundred years. […] [T]he ecocidal logics that now govern our world are not inevitable or "human nature," but are the result of a series of decisions that have their origins and reverberations in colonization.[22]

18 Jackson, "Biidaaban: First Light," 4.
19 Jackson, "Biidaaban: First Light," 4.
20 According to Gerald Vizenor (Anishnabe), "more than survival, more than endurance or mere response [...], survivance is an active repudiation of dominance, tragedy, and victimry." Gerald Vizenor, *Fugitive Poses: Native American Indian Scenes of Absence and Presence* (Lincoln, NE: University of Nebraska Press, 1998), 15.
21 Jackson, "Biidaaban: First Light," 2.
22 Davis and Todd, "On the Importance of a Date, or Decolonizing the Anthropocene": 761–63.

Hence if the Anthropocene is defined by a visible and massive impact of humans' activities on earth, deeply affecting its ecosystems, for most Indigenous peoples it started with the severing of their relation to their environment—induced several centuries ago by settler colonialism, which "was always about changing the land, transforming the earth itself, [as] colonizers did not only seek to overcome unfamiliar and harsh climatic conditions, but rather to transform them."[23] This specific moment in history, when Indigenous communities experienced the end of their worlds as they had previously known them before colonization started, is referred to by some authors working within the Indigenous Futurism movement as the "Native Apocalypse." It extends beyond the usual scenarios of the Apocalypse stemming from the Euro-Western biblical tradition as, for Indigenous peoples, the apocalypse has historically already occurred and, maybe more importantly, because they were able to survive this ordeal and are still working on overcoming its consequences.[24] Indigenous peoples have already faced the end of their worlds, apocalyptic annihilation in the form of mass dispossession, genocide, and ecological upheaval, and this experience conditions all Indigenous approaches to the future with the generational knowledge that, despite overwhelming odds, Indigenous people have survived and they possess the resilience, wisdom, and skill to survive future apocalyptic iterations.[25] Hence, contrary to many non-Indigenous science fiction works that predominantly envision the end of the world as a tragic event *yet to come*, scenarios imagined by Indigenous Futurisms mainly focus on an optimistic reversal of a situation that *has already happened*, a reversal that implies mending previously severed relationships with the environment, including languages, laws, and livelihoods that are deeply intertwined. And while futurist works in general are regularly depicted as post-apocalyptic and terrifying worlds, Indigenous Futurisms call our attention to the "utopic flowering within dystopia."[26]

VR as a decolonizing tool for a more engaged spectatorship

"*Biidaaban* endeavors to enliven the non-human elements of the world and puts us in relationship to them in a visceral way."[27] While Jackson has

23 Davis and Zoe Todd, "On the Importance of a Date, or Decolonizing the Anthropocene": 770.
24 Dillon, *Walking the Clouds*, 8–10, 149.
25 Longfellow, "Indigenous Futurism and the Immersive Worlding of *Inherent Rights/Vision Rights, 2167* and *Biidaaban: First Light*," 16.
26 Zainab Amadahy, "*Biidaaban First Light*: Seeing with Renewed Eyes," *Muskrat Magazine*, October 21, 2018, http://muskratmagazine.com/biidaaban-first-light/. To read more about a decolonized Anthropocene, see Sophie Gergaud, "Indigenous Cinemas and Futurisms: How Indigenous Visual Arts Are Shifting the Narratives and Offering a New Relationship to Space and Landscapes," in "Landscapes and aesthetic spatialities in the Anthropocene," ed. Sandrine Baudry, Special issue, *RANAM*, no. 51 (2021): 151–69.
27 Jackson, "Biidaaban: First Light," 2. In this section, all the citations and analyses are from the same source, 28–41.

addressed this crucial point during numerous Q&As and interviews, I found the "Production" section of her thesis for a Master of Fine Arts degree the most informative. Jackson indeed explains that she realized early on that a conventional documentary would not be the right form for capturing such a radically different worldview, as it would be an intellectual explanation when what she was really looking for was "a form that could convey a different way of being." She wanted to eschew dialog in favor of felt experience, as she did with her previous films. I have been following Jackson's career for many years and have had the opportunity to showcase her work in France, in particular her shorts *Savage* (2009) and *The Visit* (2009) which I included in previous Festival Ciné Alter'Natif selections. I can only agree with her assertion that throughout her films, "the creation of tone and place has

Biidaaban: First Light in Nathan Philips Square, Toronto, 2018

always been strongly tied to sound," and that she has often utilized an approach "that mixes music and sound design to create moods that are evocative but not prescriptive." In *Biidaaban*, we feel included, deeply immersed, focused, and far from being passive. Jackson voluntarily used VR technology to build relationships between the subject and object of the action. She wanted to highlight relationships and make us feel interconnected with what is unfolding in front of us as viewers, as a way to reflect on a "worldview that is embedded in languages," a society that is deeply "embodied in the land." Her goal was to create an experience of "embeddedness in the world."

To do so, she used different VR techniques and devices. She made sure "the audio was always an equal to the visual world, its design conceived in tandem with it, never as a secondary consideration." Her sound design is largely natural: we constantly hear non-human life which is abundant with crickets, ravens, and owls. Voices are nothing like voiceover commentaries but rather what I would call an intimate conversation—and which Jackson describes as a bedtime story shared by the speaker. Our reactions as viewers are thus guided by what we hear as much as what we see. Jackson adapted Borrett's initial 2D graphic work in different ways. While Borrett's designs are "high overhead omniscient views of a landscape," Jackson wanted *Biidaaban* to be at a human scale, plunging the viewer in the midst of the urban landscape. As a room-scale VR experience, *Biidaaban*'s setup allows us to move around within about a ten-foot-square space, which is meant to heighten our sense of realism and "our feeling of embodiment or agency in the piece."

Jackson wanted the interaction to function differently to how video game environments usually work with hand controllers. Instead, as the technical specifications added at the end of her thesis indicates, *Biidaaban* requires a space of 10 × 10 feet and three sensors that need to be approximately at a height of seven feet to enable the full room-scale experience. We (our bodies) are therefore fully immersed in the experience, nothing separating us from the space that unfolds before our eyes and all around us. We are physically present but without any corporeality. That is what disturbed me a little at first, as I felt a sense of disembodiment through this absence of physical human incarnation. But as *Biidaaban* unfolds, an inner sensation sets in and we then feel fully immersed and present.

Beyond mere movements, our interaction with the environment is channeled through different visual elements: for instance, the front page of the *Toronto Star* newspapers among other detritus on the subway platform is updated via the internet with the actual front page of the day, thus directly connecting the viewer's experience to the present. According to Jackson's understanding, it is the first time such a live updating of a VR piece via the Internet has been done. Other elements are subtly gaze-triggered. For example, the length of time we spend in the scene with the digging woman is based on our gaze interaction with the area where she is standing, and thus increases our chances of seeing her. Likewise, when we stand on the rooftop, the pace with which we move to the next scene is linked to our visual interaction with the glowing dome. Once inside, the translation of the three stanzas into English is triggered by our gaze, which indicates when we have read each of them.

Of course, we are not conscious of any of these processes and other "technical maneuvers" during the viewing. It is only by reading Jackson's explanation in her Master's thesis that what appeared as subtly natural suddenly becomes explicitly directive. I already had the opportunity to appreciate Jackson's talented imagination as a filmmaker when she presented her first VR documentary at imagineNATIVE in 2016. In *Highway of Tears*, a four-minute 360° video commissioned by the CBC's *The Current*, she explored the unsolved murder cases of countless (and mostly Indigenous) women in British Columbia along the 450-mile corridor of Highway 16.[28] She decided to focus on one of them, Ramona Wilson, who disappeared in June 1994 at the age of sixteen. One of the things Jackson really wanted to show was the stunning beauty of the territory, using drones for shots of the highway from way above the treeline, showing the mountain ridges in the

28 For more on the Missing and Murdered Indigenous Women, see *Reclaiming Power and Place: The Final Report of the National Inquiry into Missing and Murdered Indigenous Women and Girls* (National Inquiry into Missing and Murdered Indigenous Women and Girls, 2019); *Missing and Murdered Indigenous Women in British Columbia* (Inter-American Commission on Human Rights, 2014); *Those Who Take Us Away: Abusive Policing and Failures in Protection of Indigenous Women and Girls in Northern British Columbia* (Human Rights Watch, 2013). See also the official website of the National Inquiry into Missing and Murdered Indigenous Women and Girls, https://www.mmiwg-ffada.ca, and a dedicated page on the CBC website, http://www.cbc.ca/missingandmurdered/.

distance. Her goal was to disconnect the territory from the violence experienced by Indigenous women. According to her, "it's a city-centric view that paints remote parts of the province as an inherently dangerous places [sic] for women." Instead, "it's systemic issues of poverty, racism and policing that leave Indigenous women vulnerable to abuse. […] The problem isn't that these Indigenous communities are in the middle of nowhere—they're actually in the middle of their territory."[29]

But grasping the beauty of the landscape to give us a sense of the highway itself is not the only tool Jackson used in her 360° piece in order to answer the creative challenge she had to face. When exploring such a subject with not much "action" to show, film-makers are often condemned to fictionalize and reenact past events and/or film people talking, sharing their testimony or expertise. In *Highway of Tears*, while the first option could have turned out to be quite inappropriate given the context of the missing and murdered Indigenous women, Jackson reinterpreted the "talking heads" interview style and crafted a real and "direct experience" with Ramona's mother instead, as well as with the land itself. The setting of her film constantly moves back and forth between wide-angle road shots and the intimacy of Matilda Wilson's living room. Her direct eye-contact, looking straight at us while we are sitting in front of her, is deeply moving. We listen to her as she tells us about the circumstances surrounding her daughter's disappearance: with very few transportation options in the area, Ramona was on her way to visit a friend of hers but never arrived. When Matilda tried to file a missing person's report, the police suspected her daughter had simply run away and recommended that she wait. Over a year later, Ramona's body was found along the highway. Her story is, unfortunately, one of many unsolved cases that are still pending today, due to a mix of causes including underfunded institutions, neglect, indifference on the part of local police forces, and systemic racism—to only name a few. Experiencing such intimate interaction with the mother of one of the murdered and missing Indigenous women undoubtedly generates reactions and emotions as we really feel her presence through the virtual reality setting. Even though the film is short (four minutes), the 360° image and sound really enable us to dive into Matilda's living room and intimacy, to take the time to look around and explore all the details—such as pictures on the walls, or simply the way the furniture is laid out. We feel invited, welcomed, and we engage with her as she generously shares her story. According to Jackson, "In a sense we all feel this is our community, and to be in Matilda's space, and to listen to her, it really shows her full humanity—it doesn't just make her a statistic."[30]

29 Sarah Berman, "Why an Indigenous Filmmaker Directed a VR Documentary About the Highway of Tears," *Vice*, January 29, 2017, https://www.vice.com/en/article/5353gd/why-an-indigenous-filmmaker-directed-a-vr-documentary-about-the-highway-of-tears.
30 Sarah Berman, "Why an Indigenous Filmmaker Directed a VR Documentary About the Highway of Tears."

Indigenous film festivals as a place of visual activism

The poster of the imagineNATIVE Film + Video Media Art Festival 2019

Being able to experience creative VR environments at the iNdigital space is one of the many ways the imagineNATIVE film festival enables a more engaged spectatorship to emerge, where viewers are invited to go beyond a mostly passive and sometimes consumerist behavior of "simply" watching films. As a major Indigenous art venue, it promotes new filmic forms within Indigenous struggles: we do not only *see* those struggles on a screen, but as those innovative filmic forms embody the struggles themselves, they invite us to *feel* and *experience* parts of them.

In 2019, while walking through the corridors of the TIFF Bell Lightbox during the twentieth edition of the imagineNATIVE festival, I was reflecting on a book I had just read: *Activist Film Festivals: Towards a Political Subject*.[31] In their introduction, Sonia Tascón and Tyson Wils recall that films and film festivals are some of the oldest of the modern forms of visual activism. But they also ask how effective festivals are at producing politically engaged spectators and at being more than a privileged site for the consumption of "images of the suffering," challenging "distant spectatorship, unidimensional experiences of suffering and other features of what [Tascón] refers to as the 'humanitarian gaze,'" a gaze inscribed in "humanitarianism" that she describes as an activity which "implies a passive victim

31 Sonia Tascón and Tyson Wils, eds., *Activist Film Festivals: Towards a Political Subject* (Bristol: Intellect, 2017).

who needs to be protected and assisted."[32] As they aptly recall, "watching others' troubles" is not a neutral activity; it is, on the contrary, "subsumed within an economy of local and global power that can construct bodies as having agency or as failing to have it. [...] [B]y continually reifying the relationship of image consumption from an assumed binary of power—victim/saviour for example—even while attempting to interrupt and make salient its features, it continues to assume and support 'the logic of a global morality market that privileges Westerners as world citizens.'"[33] However, the book's various contributors reveal that, in certain contexts, consuming images that motivate people to help change the lives of others can be tackled differently if new modes of viewing are put in place, taking us out of the shackles of the "victim-savior mentality" and allowing for visual activism and activist spectatorship.

As Tascón and Wils assert, both the context of image consumption and the site of the festival itself matter and make a difference. I contend that imagineNATIVE attaches great importance to ensuring that the ways of engaging with the films and artworks being showcased allow for something other than simply "witnessing" "suffering strangers."[34] According to Davinia Thornley, one of the contributors to *Activist Film Festivals*, imagineNATIVE acts as a working laboratory for what she calls "collaborative criticism," a form of audience engagement that requires the non-Indigenous spectator to become comfortable with the unfamiliar and engage with Indigenous worldviews and knowledge they may not recognize. The goal of the festival is "not simply to encourage a cross-cultural encounter between Indigenous and non-Indigenous ways of knowing but also to ask non-Indigenous people to practice self-reflectivity in terms of the *limits* of their understanding of what they watch."[35] Thornley shows how imagineNATIVE facilitates collaborative criticism in order to force spectators "to not only confront the differences between themselves and others but [also] acknowledge and live with those differences." Of the utmost importance in this process is learning how to disconnect the notion of difference from the notion of superiority, and to question our own position and values within the system of power in place. As Thornley again appropriately puts it: "Perhaps the most radical position of all is not even in acknowledging difference and embracing what it has to offer, but simply to know you will, in fact, never know—and to accept *that* as

32 Tascón and Wils, *Activist Film Festivals*, 6–7.
33 Tascón and Wils, *Activist Film Festivals*, 4–5, quoting Lilie Chouliaraki, *The Ironic Spectator: Solidarity in the Age of Post-Humanitarianism* (Cambridge: Polity Press, 2012).
34 Tascón and Wils, *Activist Film Festivals*, 4.
35 All the quotes in this paragraph are from Davinia Thornley, "imagineNATIVE Film + Media Art Festival: Collaborative Criticism through Curatorship," in Tascón and Wils, *Activist Film Festivals*, 204 (emphasis in original). I quote Thornley extensively here because her analysis of collaborative criticism applied to imagineNATIVE perfectly theorizes my own personal experience as a non-Indigenous participant and spectator at this festival over the years. It has also informed and enriched my professional experience as a visual anthropologist and a film curator organizing events dedicated to Indigenous cinemas and visual content in France.

exactly the means, and the ends, of your critique." However, she also makes it clear that "[n]ot knowing is never an excuse for ignorance or simplistic dismissal. Instead it requires courage and a constant reaching-out from the critic."

Indigenous Futurisms as new filmic forms within the Indigenous struggles for sovereignty

Hence, while traditional criticism emphasizes "cinematic objectivity, narrative coherency, technical excellence and realism,"[36] expecting the critic to be both omniscient and distant, collaborative criticism as Thornley advocates for is, in contrast, "immersive, relational and ongoing, requiring a level of commitment and even discomfort from critics as they accept and foreground *not knowing*." She recalls that being "in relationship" is the first step required in any collaborative criticism, the viewer being willing to engage with the film shown and to enter into discussion with it, as part of a dialogic process rather than a divisive one, unlike traditional criticism that "does not so much engage with films as pass judgment on them." *Biidaaban: First Light* is an example of one of the innovative ways that raw emotions can be explored through intimate visual poetry, seeking to establish a dialog, to move us, to make us feel concerned and part of the solution instead of trying to simply inform, educate and/or lecture us. When watching *Biidaaban*, the viewer is not given all the clues to understand what is unfolding in front of and around them. What happened to the city? When? Why? Why is the woman in the white dress digging the earth? Whose are those voices? In which language are they talking and what exactly are they saying? Even when their words are translated for us, do we really understand their deeper meaning? And how does this experience translate into our everyday life? What is expected from us exactly in this day and age of the Anthropocene? What do Indigenous worldviews teach us, and what are they suggesting we should do?

Biidaaban is not educational in the usual didactic sense. Non-Indigenous viewers are not at the heart of the director's concerns; they are not central, nor are they the only target audience—though they are not excluded either. The spiritual or historical significance of Indigenous elements (such as wild tobacco, corn, ravens, turtles, the moon, and so on) are not over-explained: they are present on screen but not "over-shown." Instead, they are subtly and discreetly framed, easily noticeable by those in the know, and simply part of the decor for those who aren't. Different layers of understanding are offered by the filmmaker, and it is up to the viewers

36 All the quotes in this paragraph are from Thornley, "imagineNATIVE Film + Media Art Festival: Collaborative Criticism through Curatorship," 201, 207.

to do their homework and sharpen their interpretation of the different segments that might remain unclear to them. As Jackson clearly states, her initial intention was not to seek a form that would amount to an intellectual explanation, but rather something "that could convey a different way of being," through an approach that would be "evocative but not prescriptive," suggesting perspectives rather than preaching alternatives.[37] By showcasing Indigenous works such as *Biidaaban*, imagineNATIVE wishes to remain inclusive but not at the expense of, as Thornley puts it, "dumbing down" Indigenous content or creativity. If non-Indigenous audiences are indeed very welcome, they are expected to "meet the Indigenous challenges presented onscreen through respectful listening, ongoing discussions and even further research."[38] Indigenous filmmakers like Jackson, and many others who gather annually at imagineNATIVE, offload the diktat of the anthropological cultural explanation that systematically establishes a distance by creating and imposing the status of "the Other." Indigenous creatives are reclaiming narrative sovereignty by freeing themselves from the obligation of constantly having to explain everything. Activist film festivals like imagineNATIVE are sites dedicated to visual sovereignty, where it can be nurtured and thrive. They are not only a platform for Indigenous struggles: they embody those struggles in form as well as content, favoring those filmic forms that push for new ways of reaching a more engaged spectatorship.

An increasingly vast body of works has been emerging, offering creative visual art pieces that focus more on innovation and imagination, and are less concerned with a head-on deconstruction of century-old cinematographic misrepresentations of Indigenous peoples. Decolonized cinematographic practices in support of Indigenous struggles no longer feel constrained to work within didactic filmic forms aimed at making Indigenous cultures and worldviews intelligible to Western audiences, with detailed rites, ceremonies, practices, and meanings. This deep desire to favor an artistic experience that would first appeal to the senses, freed from the demonstrative obligation that prioritizes the comfort of non-Indigenous viewers, is not a recent phenomenon. (As early as the 1980s, Victor Masayesva Jr's (Hopi) filmmaking, for instance, already challenged Western narrative and discursive logic. Departing from the traditional documentary form, he often used perspectives framed within a more cyclical Hopi worldview, which the Euro-centric perception of time and space had trouble adapting to.)[39] But as art and film festivals like imagineNATIVE and others

37 Jackson, "Biidaaban: First Light," 6, 8, 20.
38 Thornley, "imagineNATIVE Film + Media Art Festival: Collaborative Criticism through Curatorship," 207.
39 For a deeper analysis of Masayesva's groundbreaking cinematic proposal, see Beverly Singer, *Wiping the War Paint Off the Lens: Native American Film and Video* (Minneapolis, MN: University of Minnesota Press, 2001), 63–67.

around the world attest, such an approach is more frequently embraced and artworks are now more widely and proudly shared.

Indigenous narrative sovereignty, therefore, entails having the right to embrace genres and film styles that are at the antipodes of what is usually expected from Indigenous artists. The Indigenous Futurism movement strikingly shows the ability of Indigenous people to imagine themselves—and the world—in the future and to reclaim their right to self-determination. Unlike the terrifying, dystopian post-apocalyptic worlds that characterize much of Western science fiction, Indigenous Futurisms instead envision a possible blossoming in a shared future. In works such as *Biidaaban: First Light*, there is no sense of loss but rather a sense of addition and inclusion. Words, sounds, songs, and stories are informed by reclaimed Indigenous lands which are given a new aesthetic value. Past thriving stories are incarnated again and enriched through those new visual narratives. Indigenous languages, which have existed for thousands of years but have been dramatically lacking on screens for over a hundred years, are now incorporated into films and digital media works, and finally form an integral part of the landscape again. Nature and culture can be renegotiated in the context of a decolonized Anthropocene, with nature taking back its rights but not excluding humans. Indigenous Futurisms enable us to dive into artistic visions about Indigenous places and spaces in the future, and examine their role in shaping a common, collective, and diverse destiny. Indigenous Futurisms in cinema and the visual arts show how powerful, prolific, and different Indigenous imagination can be. By questioning what being Indigenous in that future space means, who Indigenous people want to be, and who they can be, Indigenous Futurisms as an artistic movement is becoming a mighty tool for Indigenous struggles, asserting visual sovereignty, the right to self-determination, and self-imagination.

Acknowledgements

I would like to thank the co-editors of this book for allowing us as authors (and actually for *asking* us) to unleash our creative spirit, allowing us to take a step aside from the usual academic formalism—while remaining faithful to scientific rigor. I would particularly like to thank Jonathan Larcher and Alo Paistik for their careful critical reading.

I would also like to thank Brenda Longfellow: her paper presented at the FSAC Annual Conference in Toronto in 2019 was the spark that shaped the first part of this article and gave it its current narrative form.

And thank you also to Lisa Jackson of course, for the power of her work which continues to inspire me.

Bibliography

Amadahy, Zainab. "*Biidaaban First Light*: Seeing with Renewed Eyes." *Muskrat Magazine*, 2018. http://muskratmagazine.com/biidaaban-first-light.

Berman, Sarah. "Why an Indigenous Filmmaker Directed a VR Documentary About the Highway of Tears. A short piece now touring Canada lets you sit with a mom who lost her daughter." *Vice*, 2017. https://www.vice.com/en/article/5353gd/why-an-indigenous-filmmaker-directed-a-vr-documentary-about-the-highway-of-tears.

Cornum, Lou. "The Space NDN's Star Map." *The New Inquiry*, January 26, 2015. https://thenewinquiry.com/the-space-ndns-star-map/.

Davis, Heather, and Zoe Todd. "On the Importance of a Date, or Decolonizing the Anthropocene." *ACME: An International Journal for Critical Geographies* 16, no. 4 (2017): 761–80.

Dillon, Grace, ed. *Walking the Clouds: An Anthology of Indigenous Science Fiction.* Tucson, AZ: University of Arizona Press, 2012.

Gergaud, Sophie. "Indigenous Cinemas and Futurisms: How Indigenous Visual Arts Are Shifting the Narratives and Offering a New Relationship to Space and Landscapes." In "Landscapes and aesthetic spatialities in the Anthropocene," edited by Sandrine Baudry, Special issue, *RANAM* 51 (2021): 151–69.

Gergaud, Sophie. "Femmes autochtones disparues et assassinées au Canada." *Différences*, no. 315 (October 2020): 10–11.

Gergaud, Sophie. *Cinéastes autochtones. La souveraineté culturelle en action.* Laval: Éditions WARM, 2019.

Hardawar, Devindra. "The Surprising Beauty of Nature Reclaiming Toronto In VR." Engadget, 2018. https://www.engadget.com/2018/04/20/biidaaban-vr-tribeca/?guccounter=1.

Jackson, Elisabeth. *Biidaaban: First Light.* Master's thesis, York University, 2019.

Johnson, Rhiannon. "Anishinaabe Artist's New VR Experience Takes an Indigenous Futurist Look at Toronto." CBC, 2018. https://www.cbc.ca/news/indigenous/lisa-jackson-biidaaban-vr-future-toronto-1.4619041.

Kilpatrick, Jacquelyn. *Celluloid Indians: Native American and Film.* Lincoln, NE: University of Nebraska Press, 1999.

Knight, Chris. "How *Biidaaban* Imagines a Future in Which the First Peoples Have Reclaimed Their Territory." *National Post*, September 21, 2018. https://nationalpost.com/entertainment/movies/how-biidaaban-imagines-a-future-in-which-the-first-peoples-have-reclaimed-their-territory.

Lone Fight, Darren. "Interview with Elizabeth LaPensée on Indigenous Futures, Video Games, and Art as Resistance." Darren Lone Fight's website, 2019. https://www.darrenlonefight.com/news/2019/10/23/interview-with-elizabeth-lapense-on-indigenous-futures-video-games-and-art-as-resistance.

Longfellow, Brenda. "Indigenous Futurism and the Immersive Worlding of *Inherent Rights/Vision Rights, 2167* and *Biidaaban: First Light.*" Paper presented at the FSAC Annual Conference, Department of Cinema and Media Arts, York University, Toronto, 2019.

Singer, Beverly. *Wiping the War Paint Off the Lens: Native American Film and Video.* Minneapolis, MN: University of Minnesota Press, 2001.

Tascón, Sonia, and Tyson Wils, eds. *Activist Film Festivals: Towards a Political Subject.* Bristol: Intellect, 2017.

Vizenor, Gerald. *Fugitive Poses: Native American Indian Scenes of Absence and Presence.* Lincoln, NE: University of Nebraska Press, 1998.

Weeber, Christine. "Why Capitalize 'Indigenous'?" *SAPIENS*, September 19, 2020. https://www.sapiens.org/language/capitalize-indigenous/.

Films & Videos

Jackson, Lisa. *Biidaaban: First Light.* Produced by NFB, 2018, 8'.

Jackson, Lisa. *Highway of Tears.* Produced by CBC, 2016, 4'.

"Imagine if Toronto were reclaimed by nature." CBC Arts, September 20, 2018.

Reports

Reclaiming Power and Place: The Final Report of the National Inquiry into Missing and Murdered Indigenous Women and Girls. National Inquiry into Missing and Murdered Indigenous Women and Girls, 2019.

Missing and Murdered Indigenous Women in British Columbia. Inter-American Commission on Human Rights, 2014.

Those Who Take Us Away: Abusive Policing and Failures in Protection of Indigenous Women and Girls in Northern British Columbia. Human Rights Watch, 2013.

A Little Matter of Feminicide.
Quiet Killing
by Kim O'Bomsawin

Aurélie Journée-Duez

September 2017. Traveling through the US for my PhD research, I decide to cross the North-West border. I want to visit British-Columbia, Canada, meet Indigenous Peoples' representatives, and immerse myself in Native arts and cultures from this area. I ride a bus from Seattle, Washington, to Vancouver City.[1] Four hours traveling, dreaming of this land and territory. Finally arrived, Downtown Vancouver is awful. The hostel where I stay is ugly. I have never seen so much poverty. Even in Los Angeles, known for its scandalous rate of homeless people. Here, poverty has a face, mostly Indigenous. The report *Red Women Rising* explains that "Indigenous women represent forty-five percent of homeless women in the Metro Vancouver region, and all Indigenous members of DEWC (Downtown Eastside Women's Centre) have been homeless at some point in their lives. Indigenous women with children are the most likely to experience "invisible homelessness," such as staying temporarily with a family member or friend. Indigenous women often have to make the impossible decision between staying in an abusive relationship, or becoming homeless and having their children apprehended. Indigenous trans youth are also particularly vulnerable to homelessness with one-third of trans youth reporting rejection from shelters as a result of policies that police gender presentation. Finally, single Indigenous women elders are a fast-growing demographic amongst Metro Vancouver's homeless, with all seniors representing twenty-three percent of the homeless population."[2]

The documentary *Quiet Killing* (*Ce silence qui tue*) was written and directed in 2015–16 by Kim O'Bomsawin (Abenaki, Canada), who graduated with a master's degree in sociology before turning to filmmaking. Released in 2018, the film's primary location is Vancouver's Downtown Eastside, one of the poorest districts in Canada that has sadly marked many Indigenous lives. The making of the documentary coincided with the publication of

1 The city of Vancouver has the third-largest population of Indigenous Peoples in Canada.
2 *Red Women Rising Report: Indigenous Women Survivors in Vancouver's Downtown Eastside* (Downtown Eastside Women's Centre, 2019), 20. https://dewc.ca/wp-content /uploads/2019/03/MMIW-Report-Final-March-10-WEB.pdf.

All the images in this contribution are stills from Kim O'Bomsawin's film *Quiet Killing* (*Ce silence qui tue*), 2018.

Truth and Reconciliation Commission of Canada's final report in 2015, and the establishment of the National Inquiry into Missing and Murdered Indigenous Women and Girls in 2016, whose report was published in 2019. The violence and trauma framed in these reports traverse the lives and shape the experiences of the Indigenous women and men whom the film meets— the dark history of residential schools, sexual abuse, homelessness, drug and alcohol addiction. A terrifying circle.

The first portrait in the film opens on the back of a woman looking at a window. Upon first seeing the film, I suddenly realized that the hotel where she stays is two blocks away from the one I stayed a year prior. When my organization, the CSIA (Comité de Solidarité avec les Indiens des Amériques—Nitassinan), showed it for the first time in France in 2019, with Kim O'Bomsawin as guest presenting her work, my memories returned as ghosts.

This issue documentary is specific for at least two reasons: it deals with a reality through the portraits of Indigenous women and men that have been directly impacted by the violence Kim O'Bomsawin works on. Secondly, each person is interviewed in the intimacy of their daily lives. The film *Quiet Killing* takes mostly place in Vancouver, British-Columbia, and also in parts of Quebec.

Other films have previously tried to raise the issue of femicides impacting Indigenous communities.[3] Fifteen years ago, Métis filmmaker Christine Welsh directed the documentary *Finding Dawn* (2006) to talk about this topic. The film opens with the case of Robert Pickton, a serial killer active in the Vancouver area who confessed to murdering almost fifty women, of whom more than half were Indigenous.[4] Kim O'Bomsawin also mentions these events but does not make them the focus of her film. Ten years later, Matthew Smiley (a non-Indigenous filmmaker) directed *Highway of Tears* (2014), a name given to a section of the Trans-Canada Highway (Highway 16) along which many Indigenous women disappeared.

Humanizing the stories of victims with personal testimonies of Indigenous survivors and activists, *Quiet Killing* was named Best Social or Political Documentary Program at the Canadian Screen Awards in 2020. Because each portrait is at once different and similar due to the individual

3 It is necessary to define the words "femicide," "feminicide" and also the acronym "MMIW." "Femicide" qualifies the murder of a woman because she is a woman; it is also a way to underline the fact that the use of the word "homicide" permits to refer to the murder of a human being and not only of a man. The prevalent use of "homicide" doesn't permit to understand the particular logics that underlie the killing of a woman. The word "feminicide" starts to be used in order to qualify the pandemic proportions of the number of murdered women and to stress that these are not simply isolated events. The murder of Indigenous women represents a significant part of this phenomenon. The acronym MMIW stands for Murdered and Missing Indigenous Women, a movement that appeared in 2015 in Canada and in 2016 in the US.
4 In 2002, the remains or DNA of more than thrity-three women were discovered on Pickton's pig farm in Port Coquitlam, British-Columbia, about 25 km east of Vancouver. Pickton was convicted in 2007 of six counts of second-degree murder.

experiences and the larger historical trauma they reveal, I find it important to follow step by step the story that Kim O'Bomsawin tells us with great care and thoughtfulness. The different persons portrayed talk with Kim O'Bomsawin directly—we can see her sometimes on the edge of the picture—and she creates scenes of dialog between family members in which victims can talk to each other in a safe and secure context.

In Canada, femicides are an epidemic, one shared with the United States of America. The word femicide itself is not new. Used and described by the independent journalist Emmanuelle Walter, in her 2014 book *Sœurs volées* (stolen sisters), she explains that, "When hundreds of women die for the only reason that they are women, and that the violence against them is not only the result of their murderers, but also of a system, when this violence is also due to the governmental carelessness, this is a feminicide."[5] According to a Royal Canadian Mounted Police report from 2014, nearly 1,200 Indigenous women have been murdered or missing in Canada since 1981, considered to be an underestimation. Proportionally, this would represent 36,000 murdered or missing white women within Canada's population of 38 million.

In *Sœurs volées*, Emmanuelle Walter touches upon the case of a young Indigenous woman whose body was found in Red River, Winnipeg. Her name was Tina Fontaine. A picture of this young woman also appears in

Dave Dickson, retired police officer and outreach worker's voiceover: "A lot of people in the past have called [Vancouver's Downtown Eastside] the largest reserve in Canada. The trend is to run away from a reserve back East and come to Vancouver because the weather is a bit warmer or they're looking for somebody, and get stuck down here. [...] The women seem to take the brunt of the violence."

5 Emmanuelle Walter, *Sœurs volées: enquête sur un féminicide au Canada* (Montréal: Lux Éditeur, 2014), 13: "Quand des femmes meurent par centaines pour l'unique raison qu'elles sont des femmes et que la violence qui s'exerce contre elles n'est pas seulement le fait de leurs assassins mais aussi d'un système; lorsque cette violence relève aussi de la négligence gouvernementale, on appelle ça un féminicide." Translated from French by the author.

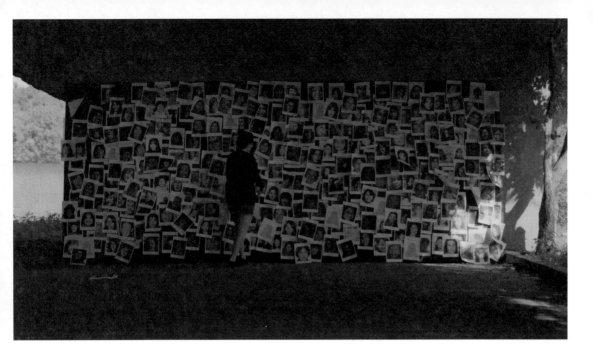

Quiet Killing, which insists on the fact that "she was a child." Portraits are indeed the center of the film, through interviews, or photographs. The idea of *mise-en-abyme* underlies the film—one of its most visually striking sequences depicts Kim O'Bomsawin fixing pictures on a wall. One picture, first, and then, in a time-lapse, she fixes several pictures, many pictures, hundreds and thousands. Each of the photographs shows a woman or a girl, murdered or missing. Some images are in color, others are in black-and-white. All of the portraits shown on the screen represent a spirit; a spirit and a body that each affected family has been searching for decades. I see this wall as the crystallization of the epidemic femicides.

Angel Gates (Haida Nation) is the first woman in the film testifying from her own experience with Kim O'Bomsawin. The scene opens on pictures fixed on the wall of her apartment. Angel's aunt, Gul Kiit Jaad, from the same nation, shares a story of loneliness. Angel is forty years old and defines herself as "a prostitute for more than thirty years," almost her entire life. The filmmaker shows the viewers the complexity of a woman who didn't have the chance to live a real childhood. She focuses on Angel's extravagant pink shoes. She also shows close shots on what surrounds her: some shoes, Japanese dolls, religious figurines, and an object with a Haida traditional symbol on it. I think that these elements can be a link to what Gloria Anzaldúa named the "mestiza."[6] According to her: "Indigenous like corn, the mestiza is a product of crossbreeding […]. Like an ear of corn—a female seed-bearing organ—the mestiza is tenacious, tightly wrapped in the

6 Gloria Anzaldúa, *Borderlands / La Frontera: The New Mestiza* (San Francisco, CA: Aunt Lute Books, 1987).

husks of her culture. Like kernels she clings to the cob; with thick stalks and strong brace roots, she holds tight to the earth—she will survive the cross-roads."[7] All the objects around Angel highlight the complexity of Indigenous identities in colonized societies, especially when people are far from their community. Angel's mother was killed by her partner. Victim of a femicide, she died at the age of thirty-four.

Gul Kiit Jaad and Angel Gates (both Haida Nation). Angel Gates, voiceover: "I am telling my story because a lot of people still can't tell theirs and my story is everybody's story."

 In Canada, and more generally in North America, the historical trauma mostly refers to the attempt of genocide committed against Indigenous Peoples. From 1830–1996, Indigenous children in Canada were sent to residential schools. Administered by Christian churches, these schools were dedicated to one goal: "killing the Indian inside the child."[8] In other words, their purpose was to transform Indigenous children seen as "savages" into "civilized" people. This by all available means, including physical and psychological violence. Indigenous girls and boys were forced to not speak their languages, to not dance their own traditional dances, to not practice their own personal and community ceremonies. Their traditional long hair was cut, and they were dressed in western outfits. Residential schools were sites of a racist and assimilationist system, intent on erasing Indigenous cultures and attempting to disrupt, break, and replace Indigenous epistemologies that were not conforming to Westerner binary distinctions. In terms of sex and gender paradigms, it means that the role and status of Indigenous girls and boys were totally disrupted. For a long time, violence and sexual assaults they suffered from in these schools were not publicly discussed.

7 Anzaldúa, *Borderlands*, 104.
8 Incorrectly attributed to Duncan Campbell Scott, head of the Department of Indian Affairs from 1913–32, who oversaw the operation of the residential schools.

Rose-Anna McDougall and Marguerite Wylde (both Anishinaabe Nation) at the former site of Saint-Marc-de-Figuery residential school. Marguerite Wylde on her experience of the arrival at the residential school as a child: "C'est comme un blackout" ("It's like a blackout").

Indigenous families report that it was simply impossible to share with their own relatives what they were confronted with. It is important to stress that violence against Indigenous children is larger than the issues of sexual violence and gender discrimination. It also concerns colonization and the way lands and territories were stolen from their first inhabitants. By building schools on the traditional Indigenous lands, the residential school system was a means to appropriate these lands in order to truly colonize Indigenous bodies.[9]

The title of the film, "Quiet Killing," refers to this idea: the silence of what happened in residential schools and what is currently happening to Indigenous women, perpetuating the violence and murders. McDougall family members interviewed in the film also suffered from sexual assaults by the priest in the residential school they were sent to. It took a long time for them to rebuild themselves. This very affecting scene takes place on the site of an old residential school building that doesn't exist anymore. Men and women from different generations of the McDougall family share their memories and experiences. In 2008, Prime Minister Stephen Harper apologized for the residential school system and its consequences. He recognized that these institutions have been destroying Indigenous families since they were created. In addition, he admitted that boarding schools were places where many Indigenous children died or disappeared. Some of them never came back home. On July 8, 2021, Canadian Members of Parliament Mumilaaq Qaqqaq (Inuit) and Charlie Angus held a press conference to call on Justice Minister David Lametti to investigate crimes committed against Indigenous children in residential schools in Canada. On the same day, the

9 Jacqueline Fear-Segal and Rebecca Tillett, eds., *Indigenous Bodies: Reviewing, Relocating, Reclaiming* (Albany, NY: SUNY Press, 2013).

Penelakut First Nation announced that it had discovered nearly 160 undocumented and unmarked graves at the Kuper Island Catholic residential school off Vancouver Island. A few weeks earlier, 215 graves of Indigenous children were found in Kamloops, at one of the Catholic residential schools in the area. In addition, a mass grave of more than 751 bodies was discovered at the Marieval residential school in Saskatchewan.

Nowadays, because of this historical trauma that disrupts many Indigenous families, women and children are still the main victims. For some people, like Angel's aunt, the social services of Canada reproduce what residential schools did to children: they take children from their families and place them with ones that are mostly not Indigenous. Indigenous women working as prostitutes have a high risk of having their children removed by social services. Authorities don't take into account the economic and social issues that force Indigenous women to resort to prostitution; they don't take into account systemic racism in Canadian society. In reservations, the rate of unemployment is so high that people have to go to the closest city to find work. For Indigenous women, it means traveling over long distances, alone, often having to hitchhike. Most of the murdered and missing Indigenous women are killed or disappeared along the highway they use to go to work or to go grocery shopping. When they make it to Downtown Vancouver, Indigenous women have many difficulties finding a place to live. Often, the only available options are cheap hotel rooms, at places such as Balmoral Hotel, located in dangerous neighborhoods. That's what Angel and her aunt, but also judge Mary Ellen Turpel-Lafond (Cri Nation), remind us in the film.

In *Quiet Killing*, Kim O'Bomsawin meets another Indigenous woman who survived from an extreme precariousness, Lorelei Williams, from Skatin and Sts'ailes Nation. "Just being Indigenous, I am at risk," she says. This other portrait reveals to the viewer something important: the violence

Lorelei Williams (Skatin and Sts'ailes Nations): "I grew up in East Van and so that's where my childhood was and that's where a lot of bad things happened. [...] My mom chose Vancouver because she didn't want to raise us in Mission, where a residential school is, or on a reserve where a lot of abuse was happening. So, my mom chose Vancouver, but it still happened."

that Indigenous women are suffering from in Canada is not only coming from the outside. Domestic violence is a veritable disease. There is a direct link between this reality and Catholic residential schools, where Indigenous children were sent by force.[10] This strategy to "assimilate" them as "Westerners" disrupted several generations of Indigenous families. Men and women didn't have the same role and place that they had in their communities. In residential schools, Indigenous children suffered from extreme violence coming from missionaries and priests. Later, as the children grew up and formed their own families, they reproduced the violence they had suffered. The trauma is thus a complex process and the violence against Indigenous women is not only an issue about racism. Moreover, it also deals with vulnerability stemming from poverty and alcoholism. As Julie Perreault highlights: "the vulnerability of women of color seems necessary to the functioning of the colonial social system and the patriarchal policies that keep it in place."[11] In 1977, Marie Sanchez, chief tribal judge on the Northern Cheyenne Reservation, first asked the UN to recognize that sterilization was a form of genocide. During the 1970s, following the passage of the Family Planning Services and Population Research Act, physicians sterilized almost twenty-five percent of Native American women. Many sterilizations happened under pressure or under the false pretext that they were undergoing appendectomy. The worst part of this chapter is that the law subsidized sterilizations for patients who received their healthcare through the Indian Health Service.[12] In Canada, a Senate report released in June 2021, concludes that "Indigenous women were still forced and coerced into sterilization"[13] from 2005–10, some cases dating to as recently as 2019. For a long time, these surgeries were protected by law, thanks to the passing of the Sexual Sterilization Act in Alberta (1928) and in British Columbia (1933) that allowed for the sterilization of individuals with mental health issues.

Lorelei Williams had to face sexual assaults coming from her aunt's partner when she was a child. Lorelei doesn't say if he was Indigenous or not. But the fact is that these acts of violence happened within the family circle. Lorelei speaks about the residential school in Mission, British Columbia, where she was living with her family in her childhood. Her mother didn't want her to stay there because of all the violence. That's why they moved to Vancouver. Through her film, Kim O'Bomsawin insists on the difficulty that Indigenous Peoples are facing in finding a place in the

10 David Wallace Adams, *Education for Extinction: American Indians and the Boarding School Experience 1875–1928* (Lawrence, KS: University Press of Kansas, 1995).
11 Julie Perreault, "La violence intersectionnelle de la pensée féministe autochtone," *Recherches féministes* 28, no. 2 (2015): 40.
12 Jane Lawrence, "The Indian Health Service and the Sterilization of Native American Women," *American Indian Quarterly* 24, no. 3 (2000): 400–19.
13 *Forced and Coerced Sterilization of Persons in Canada* (Standing Senate Committee on Human Rights, 2021). https://sencanada.ca/content/sen/committee/432/RIDR/Reports/2021-06-03_ForcedSterilization_E.pdf.

colonial society that was created without them. "In Canada the migration to urban areas is historically connected to the Indian Act legislation under which Indian women who married non-Indian men (and non-status Indian men) lost their Indian status and the right to live on reserves […]. This gendered discrimination within the Indian Act pushed generations of Indian women and their children off reserve and into urban areas. Likewise, many Métis communities were dispossessed of traditional territory and lacked formal reserves, leaving many Métis individuals to migrate to urban areas seeking housing and employment. Once off-reserve, Aboriginal people lost access to social services—that is, healthcare, education, housing—and access to cultural events and seasonal activities was sometimes difficult."[14]

We speak about a society that was founded on the belief that Indigenous Peoples were not humans, and that if they wanted to be so, they had to transform themselves into something they were not: members of the majority society. In *Quiet Killing*, Indigenous jewelry emphasizes the hybridity of Indigenous identities nowadays. The emphasis on these objects, and the knowledge and stories associated with them, shows that they are not "acculturated." Almost each portrait focuses on a piece of jewelry that the woman or the man interviewed is wearing.

Violence that Indigenous Peoples are suffering from is not only an issue touching women. Specifically, domestic violence concerns both women and men. Kim O'Bomsawin shows us through a sequence of

portraits that this domestic violence is a circle, linked to an original trauma. The portrait of Fridaline Papatie and her domestic partner Réjean-Luc Gunn (both of Anishinabeg Nation) remind us of this. In their relationship, Fridaline Papatie was bitten on several occasions by Réjean-Luc Gunn. The domestic violence that Fridaline was a victim of,

however, cannot be analyzed in a Manichean way. Indeed, Réjean-Luc didn't have a loving childhood, his parents never expressed any tender feelings for him. He also suffered from domestic violence in the hands of his parents

Fridaline Papatie and Réjean-Luc Gunn (both Anishinaabe Nation)

14 Kristin Dowell, *Sovereign Screens: Aboriginal Media on the Canadian West Coast* (Lincoln, NE: University of Nebraska Press, 2013), 7–8. Reservations were created by the *Indian Act* and adopted by the Canadian government in 1876. Its goal was to settle down and assimilate the so-called "Indians." According to the law, still in force, this guardianship regime gives them the status of minors.

Aurélie Journée-Duez

when he was a child. To get their attention, he became a drug user, but the violence worsened. This violence is of course amplified by alcohol and drug use, but it is also amplified by the fact of living in and with a community where every member knows each other. Then, when victims of violence decide to talk, they are confronted with police officers who are also violent against them. In 2015, an investigation carried out by Radio Canada for the show "Enquête" showed that at least six Indigenous women were victims of physical violence and sexual assault by eight police officers in Val d'Or, Quebec. Following the broadcast of this report, these officers were administratively relieved of their duties. The Ministère de la Sécurité publique referred the investigation to another police force, the Service de la police de la Ville de Montréal (SPVM). While systemic racism was recognized inside the police institution, the police officers accused of these acts were only temporarily forbidden to work and were never recognized as being responsible or accountable for their acts. Béatrice Vaugrante, Amnesty International Canada Francophone director, explains that a UN report published in 2015 recognized that Canada was not doing what it was supposed to in order to protect Indigenous women or guarantee their safety.[15]

In the streets of Vancouver, street art expresses messages of support and solidarity, sometimes combined with pictures of missing relatives. On one of them, shown in the film, we can read "Justice pour les femmes autochtones disparues et assassinées" ("Justice for murdered and missing Indigenous women"); on another, "End Violence against Women in Sahota Hotels." Sahota is the name of the family that owns a number of buildings in Vancouver.[16]

Different strategies are used in Canada to stand against feminicide. Some Indigenous women empower themselves by practicing self-defense thanks to organizations like *Arming Sisters*. The idea is to stop being a victim and become a powerful human being. This group also collaborates with artists, for example in the comic book *Deer Woman: A Vignette* (2019), by Elizabeth LaPensée (Anishinaabe) and Jonathan R. Thunder (Red Lake Ojibwe). This work tells the story of a traditional mythical creature, both woman and deer. She became an animal after being sexually attacked. Deer Woman is now able to fight against acts of male violence and defend other women. At the end of the book, *Arming Sisters* presents several images of technical moves that can help female targets of assaults. In Vancouver, other organizations are also helping Indigenous women. This is the case of the Pacific Association of First Nations Women and "Urban Butterflies." This program helps young Indigenous girls and women to heal themselves

15 Victoria Tauli Corpuz, *Report of the Special Rapporteur on the Rights of Indigenous Peoples*, United Nations Human Rights Council, 2015.
16 Belle Puri, "Court Denies Class-Action Lawsuit Against Sahota Family, Landlords of Decrepit Hotels," CBC, October 12, 2018. https://www.cbc.ca/news/canada/british-columbia/court-denies-class-action-lawsuit-against-sahota-family-landlords-of-decrepit-hotels-1.4861576.

through community cultural and artistic projects. Other Indigenous women work on healing through art, such as Rebecca Belmore (Anishinaabe) with her performance *Vigil* (2002). In this video piece, the artist wears a red rose between her teeth and then puts on a red dress. As explained by the art historian Charlotte Townsend-Gault, "In the performance, crimes against the body, the native body, the woman's body, are embodied in, enacted by, or inscribed on her own body, as if in an act of atonement."[17]

It is important to give more visibility to Indigenous women and the violence they face. To date, no reliable list of murdered and missing Indigenous women and girls has been compiled. The attempts have run against the underreporting of cases, the police's failure to investigate them, and the lack of centralized databases and comprehensive statistics in both Canada and the United States. The Royal Canadian Mounted Police report in 2014 cited a figure of 1,017 Indigenous women killed and 164 disappeared between 1980 and 2012. The Native Women's Association of Canada has put the figure closer to 4,000. Across North America, the National Inquiry into Missing and Murdered Indigenous Women and Girls in Canada, which published its report in 2019, and civil and grassroots organizations have worked to shed light on systemic roots of violence against Indigenous women and girls.[18]

17 Charlotte Townsend-Gault, "Have We Ever Been Good?," in *Rebecca Belmore: The Named and the Unnamed*, ed. Scott Watson (Vancouver: The Morris and Helen Belkin Art Gallery), 18.

18 In 2011, the Indian Law Resource Center participated with its partners, the National Congress of American Indians' Task Force on Violence Against Native Women as well as the National Indigenous Women's Resource Center, in the first thematic hearing on violence against Indigenous women in the United States, ahead of the Inter-American Commission on Human Rights.

Audrey Sigel (Musqueam Nation): "First Nations peoples are portrayed by the media and society in general as being angry. And my response to that is: you're damn right, we're angry. We've had our women murdered, our men murdered, our children murdered, residential schools, Sixties Scoop, our land has been stolen and occupied and destroyed, our cultures have been completely decimated"

What Kim O'Bomsawin shows us is that Indigenous Peoples really can move forward and rebuild themselves drawing on Indigenous ways of life. The residential schools were highly disruptive precisely because their purpose was to eradicate Indigenous cultures that were connected to their ancestral lands. These schools stole parts of these lands that were and are still sacred to Indigenous communities that live there. Kim O'Bomsawin honors the existential link between Indigenous peoples and their ancestral lands: she shows her film in the communities where it was made. She gives back the messages that Indigenous women and men share with her. Her most recent film, *Call Me Human* (2020), about the poet Josephine Bacon, follows a strong Indigenous woman who survived the residential school system and shows her life in a big city. The filmmaker shows us that all this tragedy can be shared and overcome through the preservation of Indigenous cultures and arts.

Bibliography

Adams, David Wallace. *Education for Extinction: American Indians and the Boarding School Experience 1875–1928*. Lawrence, KS: University Press of Kansas, 1995.

Anzaldúa, Gloria. *Borderlands / La Frontera: The New Mestiza*. San Francisco, CA: Aunt Lute Books, 1987.

Crenshaw, Kimberlé. "Mapping the Margins: Intersectionality, Identity Politics, and Violence against Women of Color." *Stanford Law Review* 43, no. 6 (1991): 1241–99.

Dowell, Kristin. *Sovereign Screens: Aboriginal Media on the Canadian West Coast*. Lincoln, NE: University of Nebraska Press, 2013.

Fear-Segal, Jacqueline, and Rebecca Tillett. *Indigenous Bodies: Reviewing, Relocating, Reclaiming*. Albany, NY: State University of New York Press, 2013.

"Femmes et filles disparues et assassinées." *Revue Liberté*, no. 321 (2018): 6–12.

Lawrence, Jane. "The Indian Health Service and the Sterilization of Native American Women." *American Indian Quaterly* 24, no. 3 (2000): 400–19.

Perreault, Julie. "La violence intersectionnelle de la pensée féministe autochtone." *Recherches féministes* 28, no. 2 (2015): 33–52.

Red Women Rising Report: Indigenous Women Survivors in Vancouver's Downtown Eastside. Downtown Eastside Women's Centre, 2019.

Townsend-Gault, Charlotte. "Have We Ever Been Good?" In *Rebecca Belmore: The Named and the Unnamed*, edited by Scott Watson, 9–50. Vancouver: The Morris and Helen Belkin Art Gallery, 2002.

Walter, Emmanuelle. *Sœurs volées: Enquête sur un féminicide au Canada*. Montréal: Lux Editeur, 2014.

Media in Environmental Activism on the Borders of Arkhangelsk Oblast and Komi Republic. Fieldwork as Video Curation

Perrine Poupin

In 2018, a section of the gigantic taiga in Northwest Russia, in the south-west of the Arkhangelsk's region, was chosen by the Moscow authorities to accommodate a domestic waste landfill. For twenty years, the site—located in a former train station called Shies—was to receive millions of tons of waste, transported by train from Moscow, 1,200 km away. Shies would have become the biggest landfill of Europe. Starting from summer 2018, villagers close to the site, and later the inhabitants of the Arkhangelsk region and from the neighboring Komi Republic, carried out protest initiatives—establishing a camp (a sort of occupation or ZAD[1]), monitoring stations around the construction site, and organizing around thirty daily meetings in cities and villages. Following two years of conflict, the inhabitants won: the project was abandoned after Putin gave in to the political pressure.

Since 2017, waste treatment has become a significant and controversial public issue in Russia. It is at the center of many development and environmental conflicts in around thirty regions of the country. The controversy emerged around environmental and sanitary scandals regarding the overload of landfills and incineration plants on the outskirts of Moscow, a part of which was inherited from the Soviet era, leading to the intoxication of children by the gases from these sites. The controversy continued around the decision by Moscow authorities to export waste from the capital to other regions. In Russia, 90% of the waste is sent to landfills, 2% is burnt, and 8% is recycled. The landfills around Moscow are saturated and rejected by the population, as the capital and its region produce 20% of the country's waste. The popular environmental actions regarding the equipment dealing with waste in Russia belongs to a larger national and historical context. Indeed, the many fights against major development projects in Russia target, among other things, the

1 ZAD in French stands for *zone à défendre*, "zone to defend," a militant occupation of a territory to block its development project, usually in view of its ecological impact. The most notable ZAD is at Notre-Dame-des-Landes, covering agricultural lands outside Nantes, formed in the late 2000s in resistance to a proposed airport project.

Chronology of events

2018

Late July — Discovery by hunters of a part of the forest that was destroyed around the old station of Shies, and alert by the inhabitants on social media.

Late August — First gatherings in Urdoma, the village closest to the construction site, and in the surrounding villages.

October — Beginning of blockage of roads leading to the construction site by inhabitants.

October 6 — Orthodox procession and erection of a cross commemorating the former village of Shies.

October — Launching of a campaign in favor of the project on social medial by the contractor and the Arkhangelsk and Moscow regions.

November — The Urdoma administration files a lawsuit against the railway company, the Technopark company and the Federal Agency for the Management of State Property of the Arkhangelsk region to demand the end of the construction. Request denied.

December 14 — First official presentation of the project to the inhabitants of the Lensky district, of which Shies is part, by representatives of the Regional Board of the Arkhangelsk region and Technopark.

December 20 — Set up of a monitoring post (wagon) equipped with a WiFi hotspot to monitor the construction and document the illegal activities.

2019

January 29 — "Fictitious" public audition (with no invitation to the inhabitants) organized in Urdoma, with representatives of the Ministry of Natural Resources of the Arkhangelsk region and Technopark and a paid audience.

February — The Urdoma administration files another lawsuit against the project leaders.

February — Implementation of checkpoints by the inhabitants on the roads that connect Shies, Madmas, and Urdoma. From February 22, blockage of fuel delivery trucks.

Mid-March — Set up of a camp and monitoring posts near the construction site by the inhabitants.

March 14–15 — Construction workers force their way through a checkpoint, wounding one demonstrator. A legal procedure is launched against inhabitants for attempted homicide.

April 1 — Seizure by law enforcement of audio, video, and computer material on the Shies camp.

April 5 — Governor Igor Orlov reaffirms the strategic character of the project and defines its opponents as "scoundrels." The term causes outrage across the whole region.

Mid-April — Beginning of occupations of around thirty public places in the Arkhangelsk region and in the Komi Republic against the project.

April 19 — Seizure of the wagon with the WiFi hotspot.

April — Journalists from national democrat-liberal media go on site and share stories on the mobilisation.

May 16 — Call to order by President Putin to the governors of the Moscow and
 Arkhangelsk regions to ask the inhabitants' opinion around Shies.
June 10 — Installation of an information tent for the public by Technopark near the site, in
 the middle of the forest.
June 15 — The Moscow Region decides to interrupt the construction.
June 23 — Symbolic funerals of the landfill project in Shies by the protesters.
June — Publication of a documentary about Shies on the Radio Svoboda website, a
 national online media close to the democrat-liberal opposition.
August 27 — The tire of a delivery truck is punctured during a roadblock. A lawsuit is filed
 against an inhabitant.
October 23 — Blockage of the village and voluntary electricity and internet disconnection
 by law enforcement to ensure the passage of trucks near the construction site.
December — Publication of a news report by the famous Moscow-based blogger Ilya
 Varlamov on the mobilization against the landfill project.

2020
January — The Regional Tribunal of Arkhangelsk rejects the project and forces the
 constructor to dismantle the illegal construction site.
October 26 — The 14th Court of Appeal of Vologda confirms the decision of the arbitration
 Court of the Arkhangelsk region. The Technopark company dismantles the site over
 several months.

Video corpus

Video 1 — Dimitri Povolokin, "4 июня 2019г. Разговор с министерством (June 4, 2019. Conversation with the Ministry)," YouTube, June 4, 2019, 8:22, https://youtu .be/5ZDJ_1a-mFU (6,800 views as of March 2023; reposted on June 5, 2019, on the URDOMA Online page: https://vk.com/wall-29913030_237134).

Video 2 — Ljudmila Ivanova, "22 сентября 2019 Демонстрация в Урдоме (22 September 2019 Demonstration at Urdoma)," VK, September 22, 2019, 2:27, https://vk.com/video271856003_456240824 (47,000 views as of July 2021).

Video 3 — Aleksei Veprev, "Митинг в Котласе 19 05 2019 (Meeting in Kotlas, May 19, 2019)," YouTube, May 20, 2019, 2:57, https://youtu.be/5ZDJ_1a-mFU (8,100 views as of March 2023; reposted on May 20, 2019, on the "Pomorie—Not a Dump" page: https://vk.com/wall-180464391_45837).

Video 4 — A.P. Chekhov, "Урдома, Шлагбаум 27.04.2019 (Urdoma. Checkpoint. 27.04.2019)," YouTube, April 28, 2019, 40:25, https://youtu.be/ok-nB5mq1F4 (5,400 views as of March 2023).

Video 5 — Pavlik Morozov, "Шиес 1 МАЯ. Интервью - прогулка 'в тылу врага!' (Shies 1 MAY. Interview—Walk 'Behind Enemy Lines!')," YouTube, May 5, 2019, 28:54, https://youtu.be/zGkkywlbmzA (52,000 views as of March 2023; reposted on May 5, 2019, on the URDOMA Online page: https://vk.com/wall-29913030_188865).

Video 6 — СтопМусор (StopMusor), "Шиес 23 июня 2019г. Концерт Марата Шатского (Shies June 23, 2019. Concert by Marat Shatsky)," YouTube, June 29, 2019, 18:49, https://youtu.be/joOicrpw8Vs (1,600 views as of March 2023; reposted on July 24, 2019, on the URDOMA Online page: https://vk.com/wall-29913030_301714).

Video 7 — Ljudmila Ivanova, "Станция Шиес. В городе Урдома установлен придорожный крест (Shies Station. The City of Urdoma Has Set up a Wayside Cross)," VK, October 22, 2018, 28:04, https://vk.com/video198064554_456239375 (49,000 views as of July 2021).

Video 8 — Svobodny Elektron, "'Похороны' Технопарка ('Burial' of Technopark)," VK, July 31, 2019, https://vk.com/wall-29913030_299801 (14,000 views as of March 2023).

Video 9 — Nikolaj Viktorov, "(Discovery of a Coral Tooth Mushroom Near Shies)," VK, July 7, 2019, 1:16, https://vk.com/wall-29913030_289867 (40,000 views as of March 2023).

Video 10 — Andrey Larionov, "Ложь пропаганды: На станции Шиес нет болот? (Propaganda Lies: Is There No Marsh in the Shies Station?)," YouTube, June 11, 2019, 5:50, https://youtu.be/c1If3_BzRhs (7,700 views as of March 2023; reposted on June 12, 2019, on the URDOMA Online page: https://vk.com/wall-29913030_251414).

Video 11 — "ВИДЕООБРАЩЕНИЕ АРХАНГЕЛЬСКОЙ БЕССРОЧКИ (Video Address of the Bessrochka of Arkhangelsk)," VK, October 7, 2019, 3:24, https://vk.com/wall-180464391_123014 (16,700 views as of March 2023).

Video 12 — Ljudmila Ivanova, "Презентация полигона ТБО - первая часть - поселок Урдома 14.12.2018 (Presentation of the Landfill—First Part—Urdoma Village,

December 14, 2018)," VK, December 14, 2018, https://vk.com
/video198064554_456239438 (89,000 views as of July 2021).

Video 13 — Andrej Chekmarjov (inhabitant of Koriajma, a city 150km away from Shies).
Andrej Chekmarjov, "Обращение к Путину! (Appeal to Putin!)," YouTube, June
14, 2019, 2:12, https://youtu.be/8ilzIPioxXI (800,000 views as of March 2023;
reposted on June 15, 2019, on the URDOMA Online page: https://vk.com
/wall-29913030_255125).

Video 14 — "Экоактивисты о губернаторе (Eco-Activists About the Governor)," VK,
June 13, 2019, 0:31, https://vk.com/wall-67055297_250220 (394,000 views as of
March 2023).

Video 15 — Pavlik Morozov, "Шиес - Урдома. Диалог с полицией 28.04.19 (Shies—
Urdoma. Dialog With the Police, April 24, 2019)," YouTube, April 28, 2019, 33:01,
https://youtu.be/rk1FZJJx87s (56,000 views as of March 2023).

Video 16 — Natalia Bryzhan (inhabitant of Iarensk). Natalia Bryzhan, (Marina Dziouba's
release), VK, June 26, 2018, 3:02, https://vk.com/video145847957_456239218
(35,000 views as of March 2023).

Video 17 — Ириша (Irisha, Irina Vladimirova), "Шиес: прорыв техники, люди ни что,
давят техникой! (Shies: Breakthrough Technology, People Are Nothing, Crushed
by Machinery!)," YouTube, March 15, 2019, 2:10, https://youtu.be/V6LyxCeeWCI
(19,000 views as of March 2023).

Video 18 — Ernest Mezak, "НАРОДНЫЙ СХОД НА КПП 'ПЕРЕПРАВА' 27 АВГУСТА
2019 ГОДА (People's Gathering at the Checkpoint on August 27, 2019)," YouTube,
October 8, 2019, 1:43, https://youtu.be/J989T9Encxo (1,700 views as of March 2023;
reposted on the author's VKontakte page: https://vk.com/wall3627653_7286).

Video 19 — Vladimir Shnjakov (inhabitant of Koriajma). Vladimir Shnjakov,
"VID_20190604_095200," VK, June 4, 2019, 0:45, https://vk.com
/video-29913030_456240782 (32,000 views as of March 2023).

Video 20 — Identity checks by the local police, accompanied by the regional OMON, the
armed riot police. Evgeny Tropin, "ОМОН в Шиесе. 1-ое мая 2019г. 5 часов утра
(OMON in Shies. May 1, 2019. 5 O'Clock in the Morning)," VK, May 1, 2019, 7:12,
https://vk.com/video10459096_456239213 (204,000 views as of March 2023).

Video 21 — Sergej Alyshev, "Шиес. 27.05.2019 (Shies. May 27, 2019)," VK, May 28, 2019,
6:55, https://vk.com/video70745244_456239305 (519,000 views as of March 2023;
reposted on URDOMA Online: https://vk.com/wall-29913030_218718).

Video 22 — Vera Goncharenko-Sedricheva (inhabitant of Urdoma). Vera Goncharenko-
Sedricheva, "Video by Vera Goncharenko-Sedricheva," VK, May 11, 2019, 8:12,
https://vk.com/video-29913030_456240359 (16,000 views as of March 2023).

Video 23 — Uragan 29rus, "Шиес влог часть 1. Прибытие на станцию. Первая встреча
с ОМОНом, ЧОП и полицией. (Shies Vlog Part 1. Arrival at the Station. First
Meeting With the Riot Police, the Security Guards and the Police)," YouTube, June
11, 2019, 10:02, https://youtu.be/8m9yGq6sCUQ (26,000 views as of March 2023).

polluting exploitation of oils, industries and dams.[2] They have similarities and differences with the USSR environmental movement from the late 1980s.[3]

Shies, while situated in the traditional Komi lands, also straddles two administrative regions that for centuries have been destinations of internal migration. Since at least the Middle Age, populations escaping from repression, particularly religious, or relocated by force, have set up in these inhospitable territories. The communities formed small, isolated groups living along the rivers and their estuaries on the edge of the Arctic, and rarely within the forest. The state policy of forced displacement, recruitment of workers and administrators from other ethnic groups, compulsory dispatch of Indigenous men to wars of conquest and occupation abroad, and assimilationist language and education policies—techniques that are still being implemented by the Kremlin throughout the country and the territories occupied during the war with Ukraine—has had the effect of suppressing ethnic identities, cultural practices, and the ability to speak minority or Indigenous languages. As a result, the inhabitants of these regions have diverse social and cultural backgrounds. However, the inhabitants who rallied against the landfill also rely on strong regional identities and often bring up their little-known ancestors, two local Native groups—the Komi of the neighboring region (making up twenty-five percent of the population), and the Pomors (inhabitants of Pomorie, in the north of the Arkhangelsk region, made up of several thousand people living on the edge of the Arctic).[4] During the protest, several participants openly declared themselves to be of Komi ethnicity and spoke the language. They told me that the names of the villages Shies, Urdoma, and Madmas were Komi place names. In the early 1920s, the Soviet government had officially recognized the Komi Republic but transferred the territories around Shies (Lensky district) from the former administrative entity of the Vologda government to the Arkangelsk region (much of the Komi territory was given over to other regions). In other words, Shies is an Indigenous Komi territory and many people recognize the heritage and identity of their reclaimed ancestors, even if the colonization policies of both the Russian Empire and the Soviet Union, along with the current nationalism in the Russian Federation, have been doing their utmost to erase the culture for the past 550 years. This asserted ethnic identity is coupled with a positive

2 Gregory Vilchek and Arkady Tishkov, "Usinsk Oil Spill: Environmental Catastrophe or Routine Event," in *Disturbance and Recovery in Arctic Lands: An Ecological Perspective*, ed. Robert Crawford (Dordrecht: Kluwer, 1997), 411–20.

3 See: Laurent Coumel and Marc Elie, "A Belated and Tragic Ecological Revolution: Nature, Disasters, and Green Activists in the Soviet Union and the Post-Soviet States, 1960s–2010s," *The Soviet and Post-Soviet Review* 40, no. 2 (2014): 157–65; and Jean-Robert Raviot, "L'écologie et les forces profondes de la perestroika," *Diogène* 194, no. 2 (2001): 152–59.

4 For more information on the history and news about these two groups, see: Jurij Šabaev, "Les Komis de l'Ižma et les Pomors," *Études finno-ougriennes* 43 (2011), http://journals.openedition .org/efo/165; and Sébastien Cagnoli, "Le sentiment national komi: vers une identité républic-aine extralinguistique?," *Regards sur l'Est* 51 (2009), http://regard-est.com/le-sentiment -national-komi-vers-une-identite-republicaine-extralinguistique.

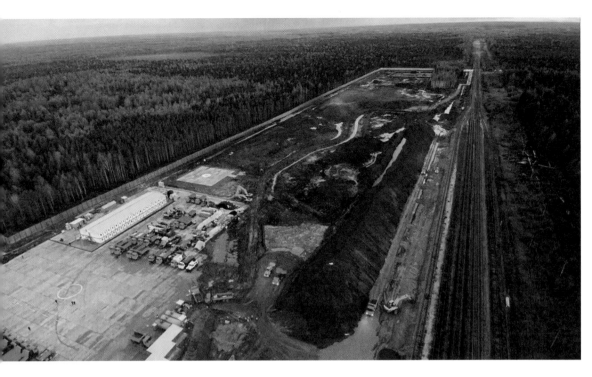

Video 1

perception concerning the northernness of the inhabitants: the people of the north (Северяне) are known as brave, committed, and free. Given the background of this historical and cultural context, the mobilization in Shies stands up against a power dynamic that the inhabitants consider as colonial, sometimes making use of the term. This critical position has in part also been advanced by national (regionalist) movements of the Komi Republic—some of them are environmentalist and have supported the struggle in Shies. Specifically, this colonial dynamic is at play in Moscow's monopolizing of local resources in Russia's regions, as part of the state centralization and economic submission policies that have been carried out for more than a decade. The Shies's project is seen as encapsulating the larger history of the two regions. According to the rallied locals, Moscow reaps the riches of the far north—the inhabitants do not benefit from it but are forced to pay the ecological and sanitary price. Indeed, the ore and oil mining pollute greatly.[5] In the Komi Republic, the exploitation and transport of oil leads to major pollution and health problems.[6] Moreover, the Russian boreal forests, threatened by large-scale development projects like mega-landfills and forest exploitation, represent one fourth of the world's forest surface. The project consisting in trans-

5 See: Yvette Vaguet, "Pollution en Arctique," in *Géographie et géopolitique des énergies*, eds. Annette Ciattoni and Yvette Veyret (Paris: Hatier, 2007), 123–31; and Sophie Hou, "Conflits environnementaux et instrumentalisation dans le secteur des hydrocarbures en Russie orientale," *L'Espace Politique* 23, no. 2 (2014), http://journals.openedition.org/espacepolitique/3134.
6 See: Julia Loginova, "Achieving Human and Societal Security in Oil Producing Regions: A Komi-Izhma Community Perspective From Pripechor'e, Russia," in *Human and Societal Security in the Circumpolar Arctic: Local and Indigenous Communities*, eds. Kamrul Hossain, Jose Miguel Roncero Martin, and Anna Petrétei (Leiden: Koninklijke Brill, 2018), 191–211.

porting Moscow's waste to Shies is thus seen as direct provocation: one more humiliation, an insult to the dignity of local populations. On the other hand, the colonial qualification refers, more generally, to a new relationship to waste and pollution that has been developing since the 1990s globally, embodied in the term "waste colonialism," which refers to the transfer of waste, the sacrifice and the pollution of the receiving territories, and the effects of the domination of one group over another between two countries or within a single one.[7]

In December 2018, I started an extensive investigation about the Yellow Vests movement in France. Each week, I participated in the Saturday demonstrations in Paris and other regional capitals, including those on roundabouts and other events, in particular in Île-de-France.[8] In January 2019, while I was still involved in this human and political adventure, I started a postdoctoral research work in which I had the opportunity to do fieldwork in Russia.[9] My doctoral thesis, defended in May 2016, had analyzed the protests carried out in Moscow by civic platforms supported by human rights activists, democrat and left-wing movements, against police brutality and political violence. One of these platforms had emerged during the repression against activists involved in the protest of a highway project crossing a periurban forest in Khimki, in the north of Moscow. After this thesis, I had analyzed the occupation of the central place of Maidan in 2013–14, in Kyiv, then the itinerary of abducted then released women during the armed conflict in the east of Ukraine supported by Russia. The research work within the Yellow Vests movement confirmed some intuitions on trends that I had already come across on previous work fields: nowadays, large-scale mobilizations are not carried out by seasoned activists, but rather by ordinary citizens. Said mobilizations were characterized by occupations with strong territorial attachments in diverse spaces: urban (the Maidan place in Kyiv, the Yellow Vests demonstrations in powerful neighborhoods of Paris and regional capitals), peri-urban, and rural (roundabouts during the Yellow Vests movement).

In January 2019, I looked up "Yellow Vests" in Russian (Жёлтые жилеты) in a search engine. I discovered protesters wearing said yellow jackets—a nod to the French Yellow Vests—in the Arkhangelsk region, against the Shies' landfill project.

7 For a presentation of this research movement, see: https://discardstudies.com/2018/11/01/waste-colonialism/.
8 Two articles were published about this investigation. The first deals with the experience of police brutality against the Yellow Vests, and the second focuses on the street medic work, volunteer medics during the demonstrations: Perrine Poupin, "'On est plus chaud! Plus chaud! Plus chaud qu'le lacrymo!' Expérience du maintien de l'ordre dans le mouvement des Gilets Jaunes," Sociologie et sociétés 51, no. 1–2 (2019): 177–200; and Perrine Poupin, "Prendre soin des manifestants. Les street-medics dans le mouvement des Gilets jaunes," Techniques & Culture 74 (2020): 160–73.
9 As part of a project: "ResisTIC–Les résistants du net. Critique et évasion face à la coercition numérique en Russie," funded by the French Agence Nationale de la Recherche (https://www.resistic.fr).

Sacrificed territories and regional fights against the colonial policy of the federal center

Since the 1930s, the Russian North (Русский/Российский Север)[10] has been known for having created a pioneer fringe where several hundreds of thousand people (called "specially displaced," then "labor settlers") were sent to exploit the natural resources of this hostile territory. It is also where the Gulag prisoners built great industrial projects.[11] The two villages at the heart of the fight against the landfill project in Shies (Шиес)—Urdoma (Урдома; 4,068 inhabitants as of 2021), the largest village of the Lensky district in the Arkhangelsk region, and Madmas (Мадмас; 790 inhabitants), in the Komi Republic—have been deeply affected by this history. Both acquired official village status in the 1930s. The great wooden barracks of that time were kept unchanged around the Urdoma station. The inhabitants are proud of their family histories and their mixed origins (Ukrainian, Belarusian, German, etc.). According to them, this heritage feeds their actions and survives in their fighting and tolerance qualities, necessary to hold the front. This local history fascinates several inhabitants of Urdoma, called *kraevedi* (краеведы), volunteer amateur ethnographers who preserve the memory of local territories in Russia by carrying out inventories, by advocating for the conservation of traces and monuments, and by publishing leaflets. Their investigation and description skills were successfully transferred to the mobilization.

As part of the fight, Urdoma villagers meet every afternoon near the station and an old food shop and barracks from the 1930s. Others relay to one another at a permanent checkpoint located on the one road that connects Urdoma to Shies. On the other side of the Vychegda (Вычегда) River, towards Syktyvkar (Сыктывкар), inhabitants of Madmas and surrounding villages occupy day and night a monitoring station next to the jetty of the ferry that crosses the river, close to the railway. These monitoring stations mostly bring retired villagers together, whereas the younger ones travel to the site of Shies, accessible via difficult roads and by foot. On site, the inhabitants share their experiences regarding the history of their villages and their elders. Some also mention the Soviet past, with its violent management of nature and humankind. The Soviet experiment indeed built, one could say, a paradigmatic example of Western modernity and its eventful industrial and environmental history: rare were the governments who did not try their hardest to appropriate resources, to centralize, to exploit and transform nature, in arduous climates and biomes such as steppe, taiga, and tundra.[12] The station near the

10 "Русский" refers to the (main) ethnicity or "nationality." A number of the inhabitants of the regions prefer the term "российский," which corresponds to the multicultural territory or country.

11 See: Hélène Mondon, "Le Grand Nord des 'dékoulakisés,'" *Revue des Deux Mondes* (October–November 2010): 135–45.

12 See: Paul Josephson, et al., *An Environmental History of Russia* (Cambridge: Cambridge University Press, 2013).

ferry, close to Madmas, is located facing a cemetery, which was presented to me as a mirror of the history—deportees who died at work were buried there—by an inhabitant of Madmas, the child of Soviet Germans who were displaced by Stalin to the North and who were key activists. Regarding Soviet history, the inhabitants sometimes mention another event that affected their lives: the Chernobyl catastrophe. The current site is called the "exclusion area" in reference to it.

The mobilization effort also focused on the occupation of the site near the construction, in Shies. Rooted into the territory, it became visible and public due to the participation of inhabitants of both regions and others from other parts of the country. These participants took many pictures, widely shared via social media.

A territory full of native images

During summer 2019 I went to Shies, in the Urdoma village and in the capital of the Komi, Syktyvkar. My Russian friends and colleagues in France and Moscow had told me that I was about to travel to the end of the world. I would struggle to receive the internet, a few hours a day, near the main shop of the village. Reality offered a different scene: most of the protesters were continuously taking pictures and filming the demonstration sites. A WiFi hotspot had been set up within the camp since the beginning of the occupation. In the surrounding villages, inhabitants gathered and met every day in public places. Retirees showed me their smartphones with YouTube videos documenting their action, as well as videos of recipes for pickled gherkins and others criticizing the social and economic policy of the federal government. A massive number of images of the conflict were produced and shared daily. The present essay offers an analysis of this production by the community that emerged during the mobilization. Indeed, I wished to present the inhabitants' formidable film production about their fight. For the researcher, presenting and reviving these works means taking care of them and the inhabitants. The latter are active producers and interpreters of images, and the lines are blurred between the ones who are acting, those who are filming, and others who are watching. The film adventures redesign the relations to oneself and to the inhabitants' world. They empower the narrative forms of media conventions. They build a community power. However, for the most part, these images remain anonymous and end up being forgotten. By presenting them in the present essay and other places (in articles, in academic conferences, on websites, and on social media, etc.), I aim to commit to a "film curation," a type of work that research has rarely described as part of political conflicts.[13]

Since the beginning of the conflict in summer 2018, a wide range of digital animated images has been produced. They come from various

13 Roger Sansi, ed., *The Anthropologist as Curator* (London: Bloomsbury Academic, 2020).

sources: web videos, filmed testimonies, documentaries, artists' videos, etc. There were only few professionals, Russian or foreign, who went to Shies, and their presence was short-lived. Most of the images were produced by the rallied inhabitants, some local journalists (some having national outreach, like Elena Solovieva), and a cinema student from Moscow who did not make his film public. The inhabitants post their images on the Russian digital platform VKontakte, others on their YouTube channels. Said images, produced by the inhabitants as amateur video makers, were meant for immediate use. Some inhabitants' YouTube channels became popular, such as that of Evgeny Tropin, an inhabitant of Velsk, a small town of the Arkhangelsk's oblast located 600 km west of Shies. Tropin has produced around 270 videos (from 1 to 190 minutes) on the mobilization since March 2019.[14]

The protesters were permanently on the Shies site. They could thus document in real time the construction's progress, the different aspects of their fight, and their experiences, on platforms like VKontakte and YouTube. The independent journalists, the regional inhabitants, and politicians got information from the individual and collective pages of the rallied inhabitants. This production situation by the frontline inhabitants was mocked by journalists and politicians who were learning about the events on social media platforms. The narration and images of the mobilization by the inhabitants on social media turned them into participants in the fight for their own rights and fostered freedom of speech. They shared their words about the fight directly, instead of being its object.

Images are key elements of conflicts. To study them, I developed a visual ethnography approach through my various field studies.[15] This approach combines a film observation experience, and a reflection on the reception of images in the recorded communities. Three levels of film experiences are highlighted: the experience of the recorded people, that of the researcher-film-maker, and that of the images' audiences (online and during real-life interactions). For the last few years, I have been developing an analysis method for social media in order to understand the massive production, dissemination, and use of media content generated during the mobilizations. The images exist and act in different contexts, as part of an ecology of relations between images, people, and communities. The approach then considers the pictures

14 Evgeny Tropin's YouTube channel: https://www.youtube.com/channel /UCAmQCKhCsovPHA8_l_buz6w.
15 See: Perrine Poupin, "Quand les manifestants s'emparent de la vidéo à Moscou: communiquer ou faire participer?," *Participations* 7 (2013): 73–96; Perrine Poupin, "Filmer les actions protestataires à Moscou. Enquêter depuis une pratique et relation documentaire," *Anthrovision* 3, no. 2 (2015), http://anthrovision.revues.org/1886; and Perrine Poupin, "Caméra au poing: enquêter sur l'action politique par la vidéo. Une expérimentation pragmatiste à Moscou," *Pragmata, revue d'études pragmatistes* 1 (2018), https://revuepragmata.wordpress .com/2018/09/26/camera-au-poing-enqueter-sur-laction-politique-par-la-video-une -experimentation-pragmatiste-a-moscou-par-perrine-poupin/.

and videos as crucial elements of a visual performativity on digital platforms: taking pictures, selecting, editing, marking, and posting them are both a first-person creation, based on the narrative, and powerful tools to build a community. In other words, the visual material can illustrate lived and embodied situations, and, at the same time, community lives—in our case, rallied villages and occupied sites. Lastly, every exchange produced on the digital platforms around the images is recorded on the network: they can be reproduced and accessed by other people at any given time. These network characteristics give the protesting inhabitants the means to investigate the project.

Videos that feed the citizen investigation

In late July 2018, two hunters discovered areas of forest that had been destroyed near the old station of Shies, along with construction work in progress. Building workers told them that they were building a massive landfill that would receive Moscow's waste by train. According to the workers' explanations as reported by the villagers, the waste—not sorted—would be pressed into bundles and wrapped up in non-recyclable plastic. On the way back to the nearest village, Urdoma—34 km away from the site—workers from the railway company confirmed the news. Shocked, the village community warned by the hunters found itself facing what pragmatist philosopher John Dewey called a "problematic situation."[16] The emergence of a development project threatening a sensitive natural space and the living environment of the villagers was a moment that disturbed their understanding of the world and their everyday life. With this experience, and to solve the problem, the inhabitants started investigating and reorganizing their operations.[17] They carried out an investigation, which we can define, following pragmatist-inspired philosopher Joëlle Zask, as a "mechanism following the trial of a discontinuity within experiences and meant to overcome it."[18] They collaborated, distinguished the causes of their problems, and articulated their interests. All these events and activities reconfigured their understanding of politics.

On the night of July 26, 2018, some inhabitants wrote messages on the "URDOMA Online" (УРДОМА Online) group wall, which was created in 2011 to focus on the life of the village on VKontakte social media. The news spread in both regions via the internet.

Groups dedicated to the problem emerged in real life and online.[19] Following the alert, the inhabitants and a portion of the municipal

16 John Dewey, *The Public and its Problems* (New York, NY: Henry Holt & Company, 1927).
17 John Dewey, *Experience and Education* (Indianapolis, IN: Kappa Delta Pi, 1938).
18 Joëlle Zask, "Situation ou contexte? Une lecture de Dewey," *Revue internationale de philosophie* 3, no. 245 (2008): 315–16.
19 See: Perrine Poupin, "Government Responses to Online Activities of Waste Protest: The Case of VKontakte and the Shies Uprising in Far Northern Russia," *First Monday* (May 2021), https://firstmonday.org/ojs/index.php/fm/article/download/11711/10135.

administration became involved in activities regarding the interpretation and evaluation of the undetermined situation, in a "process of investigation":[20] they stated a primary problem (the landfill project), gathered data and images, and denounced the status quo. They discovered that the construction had started illegally, i.e., without state environmental, technical, and sanitary expertise, without public hearings nor legislative decree. For a long time, the state and legal institutions remained silent regarding the lawfulness of the process surrounding the project. In Russia, market-based mechanisms apply in the highest state modes of action. The interlocking of the public and private sectors shapes the content and outlines of the waste treatment policy. The state gives the private sector free rein, except when the situation turns conflictual. In that case, as in Shies, police and judiciary repression comes down on the opponents.[21] The mobilization against the landfill led to multiple repressive actions. On one hand, these actions were familiar to the Russian context (intimidations, violence, arrests, raids, trials), while another form of repression took place online.[22] In the face of this mobilization, the media reactions were manifold. The pro-state local and regional media praised the project and undermined the protesters. Some regional and national pro-opposition media accounted for the mobilizations and repression.

The processes for the flow of information, alert and criticism, denunciation and advocacy on social media created "digital public arenas,"[23] which strengthened the advocating communities and created a network of people and groups. The "investigation community"[24] grew quickly in the Arkhangelsk region and the Komi Republic. In Russia and elsewhere, the internet had deeply transformed the modes of "visibility" of public environmental problems, as well as the scope and flow of arguments—in particular during public controversies. Videos nurtured the investigation process: these animated images reproduced or accounted for the inhabitants' approaches towards the authorities (letters, phone calls, meetings) and the evolution of the construction (videos, drone images). The inhabitants wrote the case of Shies into a national context: they shared videos about other landfill projects in Russia and the situation of waste treatment in the country. In Video 1, an inhabitant proposed a montage of moving images, incorporating footage and photos of the construction site from different angles, along with images of social mobilization around the project. The soundtrack is a conversation that the author had with an elected representative of the Ministry of Natural Resources of the Arkhangelsk region, in

20 Dewey, *Experience and Education*.
21 See: Perrine Poupin, "L'État face aux contestations des projets d'équipements en Russie. Le cas du projet de décharge à Shies," *Revue française d'administration publique* 178, no. 2 (2021): 295–309.
22 See: Poupin, "Government Responses to Online Activities of Waste Protest."
23 Dominique Cardon, *Culture numérique* (Paris: Presses de Sciences Po, 2019).
24 Dewey, *The Public and its Problems*.

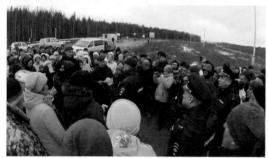

Videos 1, 2, 3, and 4

which he asks her about the illegal construction site (Video 1).

Showing up in numbers, showing strength

From late August 2018, many gatherings against the project were organized in Urdoma, in which a third of the village participated, then in cities of the two regions. The events were announced early on the pages of local groups and by common calls via video. VKontakte was used to prepare the gatherings (such as asking to borrow a drone to film, recording a video with one's motivations to join the gathering, showing the location as it was being prepared, etc.). Then, the inhabitants documented the gatherings live with pictures, videos, and texts. An inhabitant from Urdoma thus recorded the demonstration against the project in her village (Video 2). Another from a village near Kotlas (Котлас, 61,821 inhabitants, 200 km away from Shies, with most of the road leading to it without asphalt), a photography operator, did the same in his city (Video 3). The pictures from these events resounded with one another across the large territory of the two regions. Some gatherings took place in remote villages yet became events on a regional scale thanks to the posting of the pictures and their dissemination via VKontakte. Actions of solidarity were also organized and recorded, and their images shared by local environmental movements in other regions of Russia. For example, such was the case of the Movement for the Defense of the Khoper (Хопёр) River, against nickel mining in the Voronezh region.[25]

Since October 2018, inhabitants from Urdoma and Madmas have been blocking dirt roads leading to Shies, officially prohibiting circulation, as they are close to gas pipelines. On December 20, 2018, they set up a wagon with a WiFi hotspot, near the construction site in order to continuously monitor the progress of the works, document the violations, and make them public on the

25 "Солидарность Воронежа с Шиесов: поморье не помойка, Против Добычи Никеля в Воронежской области (Solidarity of Voronezeh with Shies: Pomorie is not a landfill. Against nickel mining in the Voronezh region)," June 27, 2019 manifestation, Свободные Люди Воронежа (Free people of Voronezh) YouTube channel, https://youtu.be/ro_pBZwJFYY.

internet. From February 2019, several checkpoints became permanently active on roads connecting Shies, Madmas, and Urdoma, and the inhabitants blocked the path of the trucks. Roadblocks managed to slow down the construction. The fuel deliveries then took place sporadically, via helicopter or railway, hidden in luggage. Videos documented the blocking of deliveries (Video 4).

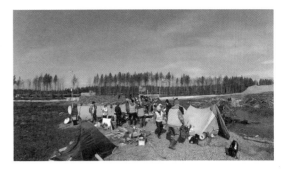

Images that strengthen the fighting community

A camp with several posts, including one called "Leningrad" and another "Stalingrad," was set up close to the construction site from mid-March 2019. A call for participation was sent on social media by Urdoma inhabitants. The camp and the checkpoints were established, and wooden barracks were added over time. The inhabitants' videos allow us to follow the evolution of the site a posteriori. They also account for the camp's and checkpoints' everyday life, in all seasons (Video 5). Inhabitants from the Arkhangelsk, Vologda, and Kirov regions, and from the Komi Republic often came on site, ensuring a continuous turnover and provisions. The images show the camp's kitchen, the preparation of meals and tea on campfires with pure water from the rivers, a vegetable garden, meals, etc. On camera, the protesters would open deliveries with donations (food, mattresses, clothes, pins from the mobilized cities, etc.), letters, and postcards. They would turn and greet each passing train with their hands. The drivers usually answered with a whistle, sometimes long, which delighted the demonstrators. Passengers also waved back. This ritual brought great joy to the participants. The protesters relayed to one another at checkpoints every two hours, day and night. Communication was ensured via walkie-talkies. A WiFi hotspot was set up in the central camp. In the camp and on the images, music performances were central (Video 6). Religious events and plays also took place. The inhabitants organized an orthodox procession and raised a cross to commemorate the old village of Shies, which was inhabited until 2002 (Video 7). They staged symbolic funerals for the landfill project (Video 8). Oftentimes, the protesters

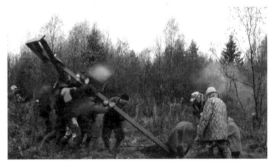

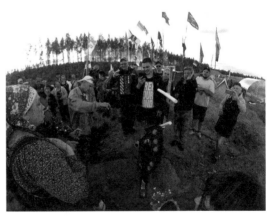

Videos 5, 6, 7, and 8

Videos 9, 10, and 11

raised flags on sand piles: flags from mobilized cities, activist flags (from any political affiliation, except the party in power), flags of the elite airborne troops (VDV), and so on. Every event created images.

The occupations represented an opportunity to create various meetings between different political, territorial, gender-related, and generational cultures that tolerated one another with a common goal at heart. The videos show us the occupations as places to learn, share and reactivate practical knowledge. They made us see the spaces of a participatory democracy under construction. With the occupation of Shies, the periphery experienced new political forms of action. In Russia, as I showed in my thesis, the traditional form of action is a gathering that is urban, static, and negotiated with the prefecture.[26] The relations of communities with their natural environments and their naturalistic knowledge are also visible in the videos. By occupying the site and by monitoring its surroundings, the demonstrators were exploring their environment. They discovered rare biological species, such as the coral tooth mushroom (*Hericium coralloídes*), documented in the Russian Red Data Book, an indicator of a healthy natural environment, as explained by a biologist on site (Video 9). Several videos show the forest, and in particular that the site is located in a marsh, ill-advised for a landfill (Video 10). Ecologists questioned the Shies site's information center employee about this particular issue as it opened in June 2019.[27]

Concurrently with the Shies occupation, some inhabitants gathered every day in around thirty public places in cities and villages of the two regions, starting in mid-April 2019. People would meet, bring food and recyclable waste (to be given to a recycling company) (Video 11). They celebrated birthdays, weddings, and national holidays there. A part of these occupations continues to exist. The "Bessrochka" (Бессрочка, which means "with no time limit") is a form of occupation of public space, without authorization requested at the prefecture, and without clear hierarchy nor leaders. It emerged after the demonstrations against the pension reform in September

26 Perrine Poupin, *Action de rue et expérience politique à Moscou. Une enquête filmique* (PhD diss., École des Hautes Études en Sciences Sociales, 2016).
27 "ШИЕС. ЭКОЛОГИ РАЗОБЛАЧИЛИ ГОВНОПАРК (SHIES. ECOLOGISTS UNVEILED A SHITTY PARK)," Evgeny Tropin's YouTube channel, https://youtu.be/iQiUZiNAxoA.

2018 in Moscow and St. Petersburg, and later in other regions. As part of the mobilization against the Shies project, this form of action became popular in around thirty public places of the two regions. Each group created its own page on VKontakte, with as many communities present at the same time both in public places and online. The communities established themselves through personal connections and in localized places of inter-knowledge—they also brought together people who did not know one another before.

Images in an online field of conflicts

The videos show the evolution of the project, the execution of the construction, and the reactions that it created in the different groups. Some footage, produced by the project's supporters, reinforces the invisibilization of the sacrificed territories in favor of the landfill. Others, like the videos we have already mentioned, criticize the project, bring the problem of the landfill to the attention of the general public, and challenge the authorities. In autumn 2018, the inhabitants of the Arkhangelsk region discovered, on their television screens and on social media, videos showing the landfill project in a positive light by the general contractor, Technopark.[28] The Moscow Region had indeed launched a promotional campaign in favor of the project on television and social media in the Arkhangelsk region, via the Moscow Information Technologies company, whose mission is to pay newspapers to publish articles and users to write messages and comments on social media to advertise the action of the municipality of the capital. An Eco-Technopark Shies group appeared on VKontakte in mid-October 2018, and promotional messages about it emerged on the timeline of the social media accounts of the Arkhangelsk region's inhabitants.[29] The videos showed waste bundles wrapped up in plastic, which could survive, according to the campaign, for thirty years.[30] In European countries, this plastic is only used for the short-term transport and storage of waste.

In early April 2019, during a peak in the mobilization, Governor Igor Orlov reaffirmed the strategic character of the investment project, he described its opponents as "scoundrels" (шелупонь) in a meeting with union representatives in Severodvinsk. His declaration was recorded by a local television channel and shared on social media.[31] The word caused general outrage and "awoke the Russian bear," according to the inhabitants and the journalists. Dozens of thousands of people demonstrated in the two

28 "Экологичный и современный подход к мусору. Что и как будет в Экотехнопарке 'Шиес' (An ecological and modern approach to waste. What we will find in the 'Shies' ecotechnopark)," Shies Ecotechnopark's contractor's YouTube Channel, https://youtu.be /ZYN4hJqGqqg.
29 https://vk.com/ecotechnopark_shies
30 "Проект Экотехнопарк (Eco-technopark project)," Roman Sokolov's YouTube channel, https://youtu.be/E_h7i8QblTw.
31 "Губернатор в Северодвинске (про Шелупонь) (The governor of Severodvinsk [about Scoundrels])," STV Severodvinsk, TV channel, https://vk.com/video-12213578_456248790.

regions. 7,000 people walked in Arkhangelsk without authorization from the prefecture and occupied the Lenin square at night in the center of the city. This form of action is rare in the country. From this date onward, groups occupied public places in around thirty cities and villages of the region for several hours every day.

Video 12 On December 14, 2018, the landfill project was first exposed to the inhabitants of the Lensky district, of which Shies is a part, at the Palace of Culture of Iarensk and that of Urdoma, by the vice-president of the regional board of the Arkhangelsk region, Yevgeni Fomenko, and Technopark director, Oleg Pankratov. The conference rooms were packed, and several inhabitants live-streamed the session on VKontakte. The vice-president of the regional board presented the project as a blessing for the district and the region. After the event, the press office of the regional board stated in the media that the session had been a success and that the inhabitants were in favor of the project. On the other hand, the videos of the inhabitants, which were shared live throughout the session or in the following days, showed the true reactions of the public: "Shame! Lies! Fraud!," "Where is the expertise?," "Where are the legal documents?," and "This is our land! Grab your bags, go to the station and go back to Moscow!" (Video 12) In Urdoma, following the presentation of the Technopark's director, the inhabitants turned away from the speakers. On their backs, they had written: "Urdoma is against this!" The speakers' expressions of surprise were also recorded and shared online by the inhabitants.

The villagers sent several petitions and calls to President Putin, asking him to take action against the project. These requests were both analog and digital. The mobilized inhabitants posted "video-letters" to President Putin (Video 13). This mode of action has become popular since 2009, when Alexei Dymovsky, a police officer from Novorossiysk, shared a video in which he denounced the corruption within law enforcement.[32] Other "video-letters" were sent by the protesters between the various groups of the mobilized cities, calling for the help of the region's inhabitants or to encourage one another.

The inhabitants also filmed situations during which the protesters challenged political officials in the streets. In one video, someone used these words to call out the governor of the region: "Igor Anatolyevich, tell me, do you have no shame before your citizens? You betrayed us, you sold us. You decided to import the waste of another place into our marsh, from where our clean rivers come. We sort our waste. We recycle. Why did you decide

32 Dymovsky's video was watched more than 725,000 times on YouTube. Two days after posting the video, he was fired.

to poison us? Do you realize that cancer rates are going to skyrocket? Babies will be born sick! Why would we need your eight billion dollars? You sold us!" The video was then shared on social media (Video 14). Protesters also filmed most of their interactions with law enforcement officials, for example near the gas pipeline between Shies and Urdoma, while the inhabitants were blocking the path of trucks delivering fuel to the construction site (Video 15).

The videos regarding police and legal repression were central to the mobilization. They did not only show repressive actions, arrests, and trials, but also the visits to the victims, and the release of prisoners, such as Marina Dziouba, an Urdoma inhabitant, following five years in prison for having allegedly struck one of the landfill's security guards (Video 16). These videos documenting every step of the repression strengthened the community of protesters.

Images of the acts of repression, surveillance, and counter-surveillance

The mobilization against the landfill entailed several acts of repression. The inhabitants' most visible action was to block the fuel supply by stopping the trucks that drove in or out of the construction site. Around these actions, conflicts with the site's guards often took place. The protesters received beatings, injuries; they were arrested and sued. For example, during the night of March 14–15, 2019, some inhabitants tried to block the path of an excavator. The vehicle drove

over a wagon set up on the side of the road by the inhabitants and injured one of them. They recorded the scene (Video 17). According to the villagers' testimonies, the excavator stalled, the driver got out, and, visibly drunk, fell on a tree. The first person wounded was hospitalized, while the second refused any aid. The police arrived several hours after the incident, despite repeated calls by the inhabitants. The next day, fake accounts on VKontakte accused the inhabitants of beating up the excavator driver and of breaking his spine. The pro-government newspaper *Echo Severa* stated that the

Videos 13, 14, 15, and 16

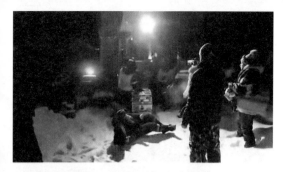

villagers had thrown Molotov cocktails.[33] Over the following days, inhabitants were arrested. A court action was started against inhabitants of the region, including Valeri Dziouba, a villager from Urdoma accused of attempted homicide even though he was not on the scene (according to the villagers and their videos). In June 2020, over a year later, the court cleared the inhabitants. The trials incorporated material found online.[34] The practice of using visual material in such contexts occurs in authoritative and liberal countries across the world.[35] Via certain appointed lawyers, the public ministry pressured people to obtain the inhabitants' images (in particular to ensure, according to the villagers, that the faces of police officers could not be seen).

Another trial against the mobilized inhabitants also made use of the images. On August 27, 2019, someone punctured the tire of a tanker truck containing eleven tons of fuel for the construction site during a roadblock near the "Pereprava" (Переправа) checkpoint, located near the ferry used to cross the Vychegda River. In a video recorded from a police car, a non-identifiable man is seen puncturing the tire and the police reacting slowly. The video was used in the trial to incriminate one inhabitant, Oleg Lyzhine. His lawyer, Ernest Mezak, posted the police officers' video, included in the case, on his VKontakte pages to prove that it was impossible to identify the perpetrator (Video 18).

During the entire mobilization, the inhabitants have documented the police officers, and security guards' actions. They thus carried out citizen "sousveillance," or reversed surveillance, as a counter-power to the institutional surveillance.[36] Indeed, the guards recorded the comings and goings of the camp's visitors. On the other hand, the inhabitants recorded the police officers, and guards' movements and violent actions on the construction site in the Urdoma village and in other cities. The fuel deliveries were particularly tense. Law enforcement officers protected these deliveries even though the construction was illegal (Video 19). The inhabitants were

33 https://www.echosevera.ru/2019/03/15/5c8b6795eac91238e44b2ff3.html.
34 See: Poupin, "Government Responses to Online Activities of Waste Protest."
35 See: Freek Van der Vet, "Imprisoned for a 'Like': The Criminal Prosecution of Social Media Users Under Authoritarianism In Wijermars," in *Freedom of Expression in Russia's New Mediasphere*, eds. Mariëlle Wijermars and Katja Lehtisaari (London: Routledge, 2019), 119–35.
36 See: Steve Mann, Jason Nolan, and Barry Wellman. "Sousveillance: Inventing and Using Wearable Computing Devices for Data Collection in Surveillance Environments," *Surveillance & Society* 1, no. 3 (2003): 331–55.

threatened, had their identities checked, and were raided in the camp (Video 20). Sometimes, the law enforcement officers used force (Video 21). The inhabitants recorded the evacuation of victims in the heart of the forest, relying on their own means (Video 22). They also counter-documented the riot police agents who recorded the activities of protesters (Video 23). With the help of applications that allowed them to find someone's profile on VKontakte (such as FindFace), they were able to identify the guards and police officers on social media. For their part, the authorities seized the material infrastructure used by the inhabitants to access the internet several times.

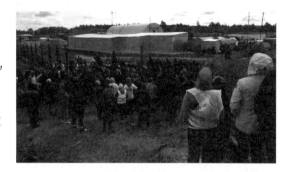

The mobilization of media professionals

Some documentarians, particularly journalists, relayed the inhabitatns' activities and showed the fight against the Shies project in other civic arenas. However, few filmmakers traveled all the way to Shies. And when they did come to the heart of the taiga, they only stayed between a few hours and a few days. They remained strangers to the local community. In April 2019, Moscow jour-

Video 19.
Riot police officers (OMON) blocking the protesters' path. In the bottom still, an OMON agent can be seen filming the protesters.

nalists from the independent online media SOTAvision came to Shies and, from then on, recorded around fifteen videos (between 1 min. and 124 min.) there, in Shies, as well as in Moscow and St. Petersburg, during supporting actions.[37] During the same month, Alexei Navalny's team, the opponents to Kremlin's regime, posted a video about the mobilization.[38] In May, BBC News Russia produced a documentary.[39] It follows a narrative thread embodied by Shies inhabitant, Viktor Juralvev, a hunter and worker in the oil sector. In it he presents a checkpoint, the construction site, and then the protesters' main camp. He explains the reasons behind the mobilization and the practical organization of the camp. Some images show tense moments,

37 For example: "СРОЧНО! ЗАЩИТНИКИ ШИЕСА БЛОКИРУЮТ возобновление строительства полигона (URGENT! The DEFENDERS of SHIES block the continuation of the landfill construction)," SOTAvision's YouTube channel, https://youtu.be/3iF-HGdOU78.
38 "Навальный: Архангельск протестует против мусорной мафии (Navalny: Arkhangelsk demonstrations against the waste mafia)," Navalny LIVE's YouTube channel, https://youtu.be/L5WV-rrdRvw. A second video was published in December 2019.
39 "Как живет Шиес – одна из самых скандальных строек России (How does Shies live, one of the most scandalous construction sites of Russia)," BBC News Russian Service's YouTube channel, https://youtu.be/sq2TLVsrGg8.

Video 20.
Police officers checking the protesters' identity at 5 a.m., for no stated reason, and searching their tent. The police officers are accompanied by OMON agents, armed with machine guns, and filming.

Video 21.
Protesters trying to block the path of a truck are being prevented by the security agents. A protester injured by a security agent is evacuated by his comrades.

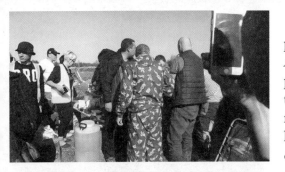

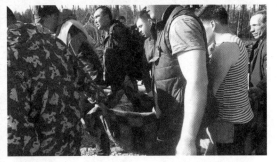

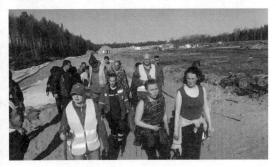

Video 22. Transporting a wounded protester from the main camp to the train station.

posted on VKontakte groups during the events. At this time, in April–May 2019, fights between protesters and security guards or police officers took place every week. The documentary also focuses on the construction site workers, both local and from other regions. It tries to reproduce the point of view of the regional power, using images from Severodvinsk television with Igor Orlov's words during the April 2019 meeting with the union representatives. It also shows Urdoma, the closest village to the site, whose inhabitants are truly committed to the fight. Lastly, it shows images of the excavator case of March 14–15 (Video 17), introduced by Valeri Dziouba's wife, whose husband was accused of homicide. Also in May, a France Télévisions team broadcasted the roadblocks of the fuel deliveries and the repression against the protesters.[40] In June 2019, Moscow-based director and journalist Yulia Vishnevets recorded and posted a documentary for Radio Svoboda, an online media channel close to the liberal democrat opposition.[41] The images were captured a few days after June 4, during which the inhabitants tried to stop the workers from setting up a fence around the construction site. Nine people were arrested. At the time Vishnevets is filming, many allies from surroundings cities and villages are coming to the camp in support. The images reuse SOTA footage from June 4 showing exchanges with law enforcement officers, some slices of life at the camp, and interviews with Svetlana Babenko, a well-known retired engineer from Urdoma involved in the fight. These journalistic accounts are usually centered around the leaders, or those they see as such. In December 2019, the famous Muscovite blogger Ilya Varlamov posted a news story on the mobilization.[42]

40 "Moscou: les ordures de la colère [Moscow: the waste of wrath]," Télé Matin's YouTube channel, https://youtu.be/ZaNLgHamQKc.

41 "Шиес. Осада. Как север борется с московским мусором [Shies. The siege. How the North fights against Moscow's waste]," Radio Svoboda's YouTube channel, https://youtu.be/QKm8gNx3RJQ.

42 "Shiyes, Russia: how people defend their homeland," Varlamov's YouTube channel, https://youtu.be/Ws2Px9LviA4.

Conclusion: Experiences of conflict and sharing

As part of the mobilization against the landfill project in Shies, the communities in opposition to the political and economic elite produced and shared images, information, documents, experiences, and stories on VKontakte social media platforms. In doing so, they broadened and enriched experiences, improved knowledge, and documented individual and collective practices of conflict. They propose a set of tools and means of addressing concrete tasks (such as organizing a gathering, creating rich content posts, or reacting to police and legal repression). They had a remarkable echo throughout the country, where protests are rarely victorious. Networks of protest met and mutually strengthened each other in the conflict of Shies. Some groups from remote villages were also fighting at the same time for other causes.

The groups and personal pages on VKontakte are digital traces of this long process of accumulation, mobilization, and networking that contributed to the movement's force. In a broader context, these groups hold a certain position in the ecology of media. Some contents are imported from websites and other platforms; the inhabitants learnt about other environmental fights in the country and connected with other activists. Like Facebook, VKontakte suggests similar groups to users. In very little time, thanks to social media, the users were able to connect, interact, and collaborate with a large number of people.

The resistance in Shies questioned the phenomenon of relegation within a rarely studied territory in the Russian North. It developed new political tools for future social movements in Russia. The critique of environmental injustice by rural and Indigenous communities, often smothered and blocked from view, managed to break through to the national stage and exert pressure on the highest political levels. New modes of mobilization including site-specific occupations, inhabitants' film productions, and social media networks, allowed for the expression of these issues in the Shies protests, before the country's total political and civic shutdown during the Covid pandemic and Russia's war in Ukraine.

Video 23. Arrival of protesters in the Shies station. The OMON riot police are omnipresent and some of their agents are filming the protesters' interactions and faces.

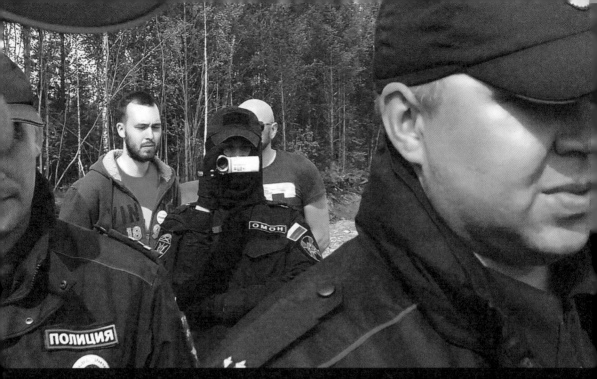

Video 23.
Documentation and counter-documentation.
OMON riot police agents with video cameras are
being filmed by the protesters.

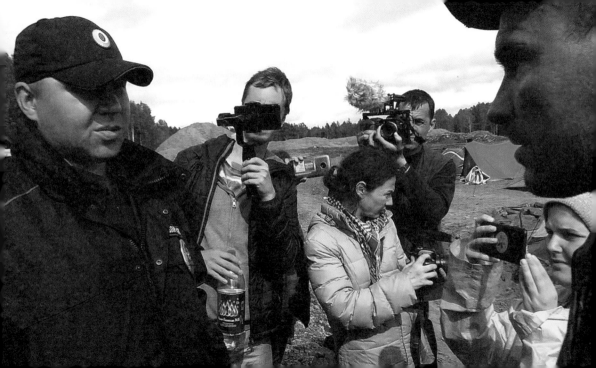

Bibliography

Cagnoli, Sébastien. "Le sentiment national komi: vers une identité républicaine extralinguistique?" *Regards sur l'Est* 51 (2009). http://regard-est.com /le-sentiment-national-komi-vers-une-identite-republicaine -extralinguistique.

Cardon, Dominique. *Culture numérique*. Paris: Presses de Sciences Po, 2019.

Coumel, Laurent, and Marc Elie. "A Belated and Tragic Ecological Revolution: Nature, Disasters, and Green Activists in the Soviet Union and the Post-Soviet States, 1960s–2010s." *The Soviet and Post-Soviet Review* 40, no. 2 (2014): 157–65.

Dewey, John. *The Public and its Problems*. New York, NY: Henry Holt & Company, 1927.

Dewey, John. *Experience and Education*. Indianapolis, IN: Kappa Delta Pi, 1938.

Hou, Sophie. "Conflits environnementaux et instrumentalisation dans le secteur des hydrocarbures en Russie orientale." *L'Espace Politique* 23, no. 2 (2014). http://journals.openedition.org/espacepolitique/3134.

Josephson, Paul, Nicolai Dronin, Aleh Cherp, Ruben Mnatsakanian, Dmitry Efremenko, and Vladislav Larin. *An Environmental History of Russia*. Cambridge: Cambridge University Press, 2013.

Loginova, Julia. "Achieving Human and Societal Security in Oil Producing Regions: A Komi-Izhma Community Perspective From Pripechor'e, Russia." In *Human and Societal Security in the Circumpolar Arctic: Local and Indigenous Communities*, edited by Kamrul Hossain, Jose Miguel Roncero Martin, and Anna Petrétei, 191–211. Leiden: Koninklijke Brill, 2018.

Mann, Steve, Jason Nolan, and Barry Wellman. "Sousveillance: Inventing and Using Wearable Computing Devices for Data Collection in Surveillance Environments." *Surveillance & Society* 1, no. 3 (2003): 331–55.

Mondon, Hélène. "Le Grand Nord des 'dékoulakisés.'" *Revue des Deux Mondes* (October–November 2010): 135–45.

Poupin, Perrine. "L'État face aux contestations des projets d'équipements en Russie. Le cas du projet de décharge à Shies." *Revue française d'administration publique* 178, no. 2 (2021): 295–309.

Poupin, Perrine. "Government Responses to Online Activities of Waste Protest: The Case of VKontakte and the Shies Uprising in Far Northern Russia." *First Monday* (May 2021). https://firstmonday.org/ojs/index.php/fm /article/download/11711/10135.

Poupin, Perrine. "Prendre soin des manifestants. Les street-medics dans le mouvement des Gilets jaunes." *Techniques & Culture* 74 (2020): 160–73.

Poupin, Perrine. "'On est plus chaud! Plus chaud! Plus chaud qu'le lacrymo!' Expérience du maintien de l'ordre dans le mouvement des Gilets Jaunes." *Sociologie et sociétés* 51, no. 1–2 (2019): 177–200.

Poupin, Perrine. "Caméra au poing: enquêter sur l'action politique par la vidéo. Une expérimentation pragmatiste à Moscou." *Pragmata, revue d'études*

pragmatistes 1 (2018). https://revuepragmata.wordpress.com/2018/09/26
/camera-au-poing-enqueter-sur-laction-politique-par-la-video-une
-experimentation-pragmatiste-a-moscou-par-perrine-poupin/.

Poupin, Perrine. *Action de rue et expérience politique à Moscou: Une enquête filmique*,
PhD diss., École des Hautes Études en Sciences Sociales, 2016.

Poupin, Perrine. "Filmer les actions protestataires à Moscou. Enquêter depuis une
pratique et relation documentaire." *Anthrovision* 3, no. 2 (2015).
http://anthrovision.revues.org/1886.

Poupin, Perrine. "Quand les manifestants s'emparent de la vidéo à Moscou:
communiquer ou faire participer?" *Participations* 7 (2013): 73–96.

Raviot, Jean-Robert. "L'écologie et les forces profondes de la perestroika." *Diogène*
194, no. 2 (2001): 152–59.

Šabaev, Jurij. "Les Komis de l'Ižma et les Pomors." *Études finno-ougriennes* 43 (2011).
http://journals.openedition.org/efo/165.

Sansi, Roger, ed. *The Anthropologist as Curator*. London: Bloomsbury Academic,
2020.

Van der Vet, Freek. "Imprisoned for a 'Like': The Criminal Prosecution of Social
Media Users Under Authoritarianism In Wijermars." In *Freedom of
Expression in Russia's New Mediasphere*, edited by Mariëlle Wijermars and
Katja Lehtisaari, 119–35. London: Routledge, 2019.

Vaguet, Yvette. "Pollution en Arctique." In *Géographie et géopolitique des énergies*,
edited by Annette Ciattoni and Yvette Veyret, 123–31. Paris: Hatier, 2007.

Vilchek, Gregory, and Arkady Tishkov. "Usinsk Oil Spill: Environmental
Catastrophe or Routine Event," in *Disturbance and Recovery in Arctic Lands:
An Ecological Perspective*, edited by Robert Crawford, 411–20. Dordrecht:
Kluwer, 1997.

Zask, Joëlle. "Situation ou contexte? Une lecture de Dewey." *Revue internationale de
philosophie* 3, no. 245 (2008): 313–28.

Back to the People / Restoring History: Political Cinema and Fourth Cinema in Aotearoa New Zealand

Mercedes Vicente

Māori scholar and activist Ranginui Walker, writing in 1982, conveys the condemnations by the New Zealand media and Prime Minister Robert Muldoon of Māori activists, alleging their public demonstrations to be "not the Māori way." When the socially acceptable activist strategies of lobbying, making submissions and petitions failed, Māori resorted to more vigorous tactics like demonstrations, marches, and occupations in the pursuit of social justice.[1] The Treaty of Waitangi, the constitutional document of Aotearoa New Zealand (hereafter referred to as "New Zealand") signed in 1840 by representatives of the British Crown and Māori chiefs, frames the political relations between the government and Māori within the discourse of partnership. Māori began to challenge and resist the constitution and hegemony of the nation-state and to call for political and constitutional autonomy. The early 1970s saw the formation of groups such as Ngā Tamatoa (young warriors), a "new wave" of Māori radicals influenced by the civil rights movement in the United States and decolonizing discourses internationally— what Walker referred to as "Neo-Māori Activists." These groups shared the liberation struggles against racism, sexism, capitalism, and government oppression.[2] This period was characterized by mass dissent in New Zealand, with demonstrations against the Vietnam War, Apartheid in South Africa, and France's nuclear testing in the Pacific. Many Pākehā (of European descent) were in solidarity with Māori self-determination, seen as an extension of their anti-capitalist and anti-colonialist positions. Indeed, as New Zealand historian Toby Boraman acknowledges, "support for Māori sovereignty became the default Pākehā leftist view by the early 1980s onwards."[3]

1 R. J. Walker, "The Genesis of Māori Activism," *The Journal of the Polynesian Society* 93, no. 3 (September 1984): 267.
2 R. J. Walker, *Ka Whawhai Tonu Mātou: Struggle Without End* (Auckland: Penguin Books, 1990), 220. Walker mentions social movement groups such as Ngā Tamatoa, MOOHR (Māori Organisation on Human Rights), WAC (Waitangi Action Committee), *He Tauā* ("a war party"), Māori People's Liberation Movement of New Zealand, Polynesian Panthers (representing Māori and Pacific Islanders living in New Zealand), and Black Women.
3 Toby Boraman, "The Independent Left Press and the Rise and Fall of Mass Dissent in Aotearoa since the 1970s," *Counterfutures*, no. 1 (2016): 53.

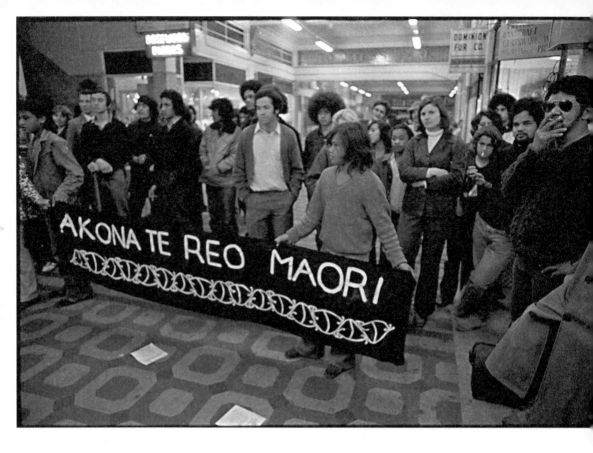

John Miller,
*Māori Language
Day*, 1972

A political cinema aligned with a socialist and decolonizing impulse and committed to emancipation contributed to the political and cultural transformations in New Zealand in the 1970s and 1980s. Although it comprised only a handful of documentaries, this modest production is, however, relevant for capturing the political climate of a period of significant radical change for Māori and the nation as it was being redefined—a Māori Renaissance with the revival of Māori culture, customs, and language—as well as for raising political awareness and mobilizing agency.

Films including Barry Barclay's television series *Tangata Whenua* (1974), Leon Narbey and Geoff Steven's *Te Matakite o Aotearoa / The Māori Land March* (1975), Merata Mita, Narbey, and Gerd Pohlmann's *Bastion Point: Day 507* (1980), Darcy Lange's *Māori Land Project* (1980), and Mita's *Patu!* (1983) harnessed film as a tool for advocacy and activism, and for the revitalization of Māori cultural identity and community building. These films represent Māori visual sovereignty by providing a Māori perspective on Māori struggles that contested the accounts of Pākehā-controlled media at the time.

By the 1970s, increased migration of Māori to urban centers that started after WWII and continued through manual labor training schemes for Māori in the 1960s, meant that three out of four Māori lived in cities, severing their identity ties to their *iwi* (tribe/peoples), *hapu* (subtribe/clan),

and *whanau* (family). The urbanization of Māori and housing policies such as "pepper potting" (placing Māori families within Pākehā neighbourhoods) were assimilationist, alienating Māori from their social structures linked to the guardianship of their land.[4] Further, with the banning of *te reo* Māori (Māori language) in schools under the "Native Schools' Code" introduced in 1870, the language had become nearly extinct.[5]

Brendan Hokowhitu and Vijay Devadas argue that the state's plans to assimilate and "modernize" Māori led instead to the formation of "new subjectivities of radical urban indigeneity [that] posed the greatest threat to the nation-state"—in Homi Bhabha's terms, "unsettling neoformations."[6] They write, "Urban Māori culture was heavily influenced by the immediate engagement with neocolonial methods of subjugation, and interaction with an increasingly politically informed academic metropolitan culture, leading to what became popularized as a process of 'conscientization' and, later, 'decolonization.'"[7]

Focusing on the historical violations of the Treaty, Ngā Tamatoa became the "public face", according to Walker, of a "rising political consciousness among urban Māori."[8] Further, because Māori resistance contesting the government and the Treaty became highly visible through protests covered by media, these contributed to a paradigm shift in how the nation was conceived.[9]

The Māori Land March in 1975, the "occupation" of Bastion Point for 506 days during 1977 and 1978, and Ngā Tamatoa's annual protests started in 1971 on Waitangi Day (commemorating the Treaty), offered highly mediated images of Māori resistance and became milestones in the politicization and growing political consciousness of Māori. It led to the establishment of the Waitangi Tribunal in 1975, a permanent commission for land claims regarding legislation, policies, actions, or omissions of the Crown that are alleged to breach the promises made by the Treaty, which guaranteed Māori *tino rangātiratanga* (absolute sovereignty) over all resources.[10] According to Indigenous education scholar Linda Tuhiwai Smith (Ngāti Awa and Ngāti Porou), the Waitangi Tribunal became also

4 Brendan Hokowhitu and Vijay Devadas, "Introduction: The Indigenous Mediascape in Aotearoa/ New Zealand," in *The Fourth Eye: Māori Media in Aotearoa New Zealand* (Minneapolis, MN: University of Minnesota Press, 2013), xxiii.
5 Hokowhitu and Devadas, "Introduction," xxii.
6 Hokowhitu and Devadas, "Introduction," xxiii.
7 Hokowhitu and Devadas, "Introduction," xxiii.
8 Walker, *Ka Whawhai Tonu Mātou*, 210.
9 Hokowhitu and Devadas, "Introduction," xxiii.
10 https://waitangitribunal.govt.nz/about-waitangi-tribunal/. Further, the establishment of the Waitangi Tribunal in 1975, which led to land claims and settlements starting in 1992, continues today. Reforms supporting biculturalism also resulted in policy changes such as the revival of *te reo Māori* (Māori language), culminating with the passing of the Māori Language Act in 1987, and in the education system with the formation of *kōhanga reo* (Māori-language pre-schools), *kura* (schools) and *wānanga* (universities). See *Te Ara—The Encyclopedia of New Zealand*, available at http://www.teara.govt.nz/en/Māori-Pākehā-relations/page-6.

significant "for recovering and/or representing Māori versions of colonial history, and for situating the impact of colonialism in Māori world views and value systems."[11]

The term *tangata whenua* (people of the land), prominent in the 1970s, would become increasingly significant to the identity politics of the 1990s onwards, for it denotes the interconnectedness of various *whanau*, *hapu*, and *iwi* with the land, but also in the increasing significance of indigeneity, as a place-based politics, to Māori rights. Hokowhitu and Devadas write,

> *tangata whenua* became the imagined united Indigenous polity that formed the Māori Other in the partnership with the state […] the advancement of '*tangata whenua*' as the tool designed to nationalised Indigenous political agency was later subsumed within the prominent discourse of biculturalism in New Zealand; an extremely problematic notion not merely because it excludes all those people who are not Māori nor descendent of European settlers, but more importantly, because 'biculturalism' came to tacitly refer to the incorporation of Māori culture within the dominant neocolonial system; or what [Glen] Coulthard refers to as the 'politics of recognition.'[12]

The land was key in the sense of addressing the process of dispossession, but also the political and legal mechanisms through which Māori sought to redress the loss of land.

A collaborative ethos characterized this early film production, with Pākehā filmmakers working alongside Māori activists and filmmakers. Two emerging Māori pioneer filmmakers, Barry Barclay and Merata Mita, would lead the way for Māori filmmaking, demanding Māori self-determination and control over their image production. Their early films represent the foundation of what Barclay later referred to as "Fourth Cinema," a cinema made by Indigenous peoples reflecting *te Ao* Māori (Māori worldview), *kaupapa* Māori (Māori principles), and *tikanga* Māori (Māori customs). Technically speaking, not all the films discussed here qualify as part of the Fourth Cinema canon, as not all were made by Māori filmmakers, but all these films were committed to social and cultural emancipation and in solidarity with Māori liberation struggles. The changes in Māori culture and politics and the increasing intensification of the politics of representation, argue Hokowhitu and Devadas, would be "symbiotic with the development of Indigenous media in New Zealand."[13]

11 Linda Tuhiwai Smith, *Decolonising Methodologies: Research and Indigenous Peoples* (London: Zed Books, 2004), 168.
12 Hokowhitu and Devadas, "Introduction," xx.
13 Hokowhitu and Devadas, "Introduction," xvii

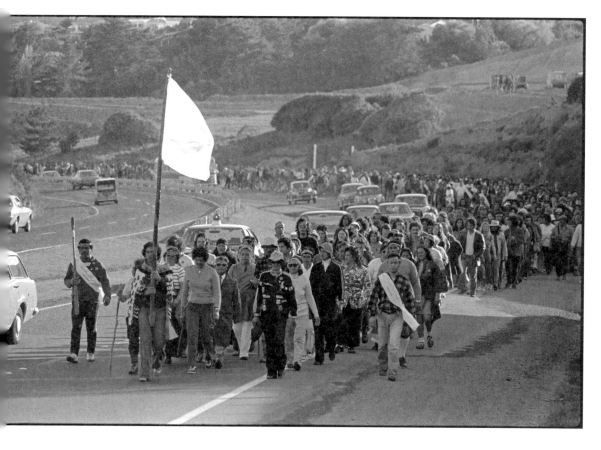

Political concerns around Māori governance and self-determination, and the need for Māori to take control over their own image, underpinned Barclay's filmmaking principles captured in his book *Our Own Image* (1990) and later essays. He coined and defined Fourth Cinema in 2002, as a cinema that applies Māori core values to filmmaking and maintains cultural integrity, in content reflecting *te Ao* Māori, the production process and reception, and in privileging the Māori gaze and Māori audiences.[14] Fourth Cinema is inherently critical of ethnographic perspectives fixed on "surface features: the rituals, the language, the posturing, the decor, the use of elders, the presence of children, attitudes to land, the rituals of a spirit world." Rather, "in Fourth Cinema, at its best, something else is being asserted which is not easy to access."[15]

For Barclay, film is an instrument for political change, aimed first and foremost at the cultures it portrays as its audiences. Barclay made great efforts to establish close links and reciprocity with the communities he filmed. He cared about how images could be read and used, and ensured ethical guardianship over their representations. Māori film scholar Jo Smith remarks how for Barclay it was imperative "to understand the processes

John Miller, *Te Matakite o Aotearoa / The Land March*, 1975

14 Barry Barclay, "Celebrating Fourth Cinema," *Illusions* 35 (2003): 7–11.
15 Barry Barclay, "Celebrating Fourth Cinema," 7.

surrounding Indigenous cultural representations—not only their conditions of production, but also the critical readings made possible by these productions—on their own terms."[16]

Barclay differentiated between "talking in"—speaking to those with an intimate knowledge of culture, therefore not having to synthesize or compromise cultural integrity for the benefit of Western audiences' understanding—and "talking out"—speaking to outside audiences and therefore having to explain to and be complicit with them. In "talking out," one is educating Pākehā, who are willing to assimilate but not to learn. He introduced the notion in film of the "invisible *marae*." In the *marae* (Māori communal meeting place to discuss matters of concern), stories are told the Māori way and for Māori. A Māori filmmaker is able to control images in the *marae*, but outside the control over their distribution and reception is lost. For him, "talking in" was the more effective strategy for political activism. "Talking in" also to Pākehā, by bringing them in the "invisible *marae*" and operating not discursively, but through experience and affective stimuli, inhabiting and expanding the invisible *marae*.[17]

Stuart Murray claims that Barclay's notion of Fourth Cinema, although conceived in the early twenty-first century, derives from and is essentially linked to Third Cinema, the radical political cinema of colonial resistance coming out of Latin America and Africa in the late 1960s through to the 1980s, which at the time were referred to as the "Third World" countries. Coined by the Argentinian filmmakers Fernando Solanas and Octavio Getino, Third Cinema was an alternative to First Cinema (Hollywood) and Second Cinema (European auteur film).[18] African cinema scholar Teshome H. Gabriel developed a theoretical critical framework for Third Cinema, anchored in the notions of struggle and resistance and inspired by the postcolonial theories of Frantz Fanon. It eschewed authorial conventions, took a collective dimension, and solicited mass participation—principles and methods shared by Fourth Cinema. Paul Willemen was critical of the Latin American Third Cinema as being a cinema made by socialist intellectuals who sought "to achieve through their work the production of social intelligibility."[19] Murray argues that by the time Barclay came to conceive Fourth Cinema, however, "the place of the 'socialist intellectual' carried far less weight than it did some thirty years earlier." This implies an inherent anachronism, as Barclay's conception of a global Indigenous cinema does

16 Jo Smith, "Barry Barclay: A Thinker of Our Time," *Journal of New Zealand Literature*, no. 26 (2008): 168

17 Barry Barclay, *Our Own Image: A Story of a Māori Filmmaker* (Auckland: Longman Paul, 1990), 76–79.

18 Stuart Murray, *Images of Dignity: Barry Barclay and Fourth Cinema* (Wellington: Huia Publishers, 2008), 22.

19 Paul Willemen, "The Third Cinema Question: Notes and Reflections," in *Questions of Third Cinema*, eds. Jim Pines and Paul Willemen (London: British Film Institute 1989), 27, quoted in Murray, *Images of Dignity*, 22.

not reflect "the kind of contemporary Indigenous sociology practised by Tuhiwai Smith and [Makere] Stewart-Harawira [that] draws more on ideas of culture than on the political frame of Marxism." Further,

> Viewed through this frame, Third Cinema, with its stress on the importance of socialist politics, its emphasis on the place of nationalism, and its particular articulation of 1970s cultural theory, seems to belong to a different historical period, one associated with the end of political decolonisation and the rise of resistance to newly independent neocolonial regimes.[20]

Indigenous activism in the 1960s and 1970s, argues Tuhiwai Smith, shared affinities with Marxist politics in their challenge of the liberal theories of modernization and development and their participation in the anti-colonial struggles and for colonial independence, but failed to understand concerns vital to Indigenous communities. The issues raised by critical theory around knowledge, power and emancipation were also raised by Māori on the ground, as these films document; but Tuhiwai Smith finds it imperative to differentiate between Marxist and Māori politics, and for Māori to propose their own terms and critical frameworks reflecting *te Ao* Māori.[21] Tuhiwai Smith has emphasized the effect of colonization on Indigenous knowledge, and filmmaking, being a Western instrument, inherently represents Western worldviews, thus the need for Fourth Cinema.

The initial intention of this essay was to examine Darcy Lange's *Māori Land Project* (1980) within the context of concurrent political documentaries, Fourth Cinema, and Māori activism. While Lange's background was the visual arts rather than film, in *Māori Land Project* he worked closely with filmmakers and Māori activists espousing the political aims of the aforementioned films. What emerged from my research on these films was a structural shift—"de-centering" Lange's project to "center" the attention on Māori film production, whereby Lange's is seen *alongside* these films—, mirroring the shifting politics of representation. A self-reflected shift that also demanded my own positionality in writing this essay. My engagement lies with Lange's legacy, here in particular with his *Māori Land Project*, seeking an understanding of Lange's intentions, political agency, and the kind of complex dynamics and contextual and historical conditions at the time of its making, as well as from current perspectives.

20 Murray, *Images of Dignity*, 22–23.
21 Tuhiwai Smith, *Decolonising Methodologies*, 167.

Barry Barclay's *Tangata Whenua* (1974, six episodes, 38 min. each)

The seminal *Tangata Whenua* became the first television series that offered an intimate look at Māori traditions and histories from a Māori perspective for a national audience that was largely ignorant at the time. It was produced by Pākehā John O'Shea at Pacific Films, with Pākehā historian Michael King as scriptwriter and front person, and filmmaker Barry Barclay (Ngāti Apa and Pākehā) as director and network contact to the Māori communities. The primetime series was broadcasted on Sunday evenings in November and December of 1974.

Each of the six episodes of the series was devoted to a different *iwi* and place, involving extensive consultation with the *Kaumātua* (male elders) and the communities depicted, and eighteen months of research and filming. It explored themes such as *mana* (spiritual power/authority), *tūrangawaewae* (a place to stand), and *tino rangatiratanga* (absolute sovereignty), and offered a view of the diversity and specificity of each *iwi* customs and ways of life that contested the notion of a national *Māoritanga* (Māori culture). *Māoritanga* was seen as a construct uniting all *iwi* for the purposes of Governmental ruling—Captain and first New Zealand Governor William Hobson's infamous *"He iwi tahi tātou"* ("We are now one people") mentioned in the Treaty.

Te reo Māori features prominently in the series (with a voiceover translation rather than subtitles) with elders mainly speaking in their native language, which recognizes and supports the political dimension of cultural sovereignty through language.[22] Barclay was affiliated to the Ngā Tamatoa, the Māori activist group that emerged in 1971 out of Auckland University, inspired by the academic Ranginui Walker. They were urban and university students influenced by international liberation and Indigenous movements such as the Black Panthers and the American Indian Movement, and the New Left. They fought for Māori rights, promoted *te reo* Māori in schools, and made the Government accountable for the Treaty's violations, leading the protests on Waitangi Day since 1971. The fifth episode features Ngā Tamatoa, but their political principles and demands for cultural sovereignty at every level can be felt throughout the series.[23] Barclay claimed "that's possibly why it [*Tangata Whenua*] had a lot of political vitality then, and why, almost two decades on, a lot feel its message is as relevant now as it ever was."[24]

22 The Māori Language Petition led by Ngā Tamatoa and Victoria University's *Te Reo* Māori Society, which demanded *te reo* Māori to be taught in schools, had been presented to Parliament in 1972. https://nzhistory.govt.nz/culture/Māori-language-week/history-of-the -Māori-language.
23 Barclay wrote, "Through Nga Tamatoa, I was shaken out of a smug view of the Māori situation. [...] The subtext of the Tangata Whenua series is straight from Nga Tamatoa. [...] The message is, of course, that people must have cultural sovereignty at every level." Barry Barclay, "Amongst Landscapes," in *Film in Aotearoa New Zealand*, eds. Jonathan Dennis and Jan Bieringa (Wellington: Victoria University Press, 1992), 123–24.
24 Barclay quoted in Paul Diamond, "Tangata Whenua: A Gift to the Future," NZ On Screen website, https://www.nzonscreen.com/title/tangata-whenua-1974/series/background.

Writing about *Tangata Whenua*, Stuart Murray argues that the series could have ended with the fifth episode, offering a historical trajectory with the previous ones concerning the Waikato King Movement, Te Kooti, and Apirana Ngata stories that led to the contemporary demands of the Māori urban communities in the 1970s. Instead, Barclay introduces the notion of citizenship in the final episode, which for Murray is "a provocation in its questioning of the ideas of national unity and cohesion that would have been commonplace in much Pākehā political discourse in the 1970s." He writes,

> [T]he episode offers a constitutional challenge [...] Indigenous pres-
> ence is, in and of itself, a challenge to the organisation of those societies
> where such presence has now become an ethnic minority. As *Tangata
> Whenua* ends, it does so with a direct *wero* towards the institutions of
> the state that would attempt to construct citizenship without due recog-
> nition of the historical legacies and contemporary claims of its Māori
> population.[25]

Murray concludes that the final episode "seems to forcibly reassert *iwi* structures and an idea of cultural heritage as the base of citizenship", not in a conservative way. Culture has a strategic purpose for the present and demonstrates that it is real and lasting.[26]

Christina Milligan remarked that Barclay privileged the Indigenous gaze and the Indigenous audience, and applied Māori core values to film-making.[27] Barclay understood filmmaking as a form of *hui* (a Māori meeting that gathers people together to discuss matters of importance), with the camera acting "with dignity at a *hui*" and "a certain restraint, a feeling of being comfortable with sitting back a little and listening."[28] Barclay wrote, "as a Māori technician, the filmmaker is faced with the challenge of how to respect [the] age-old process of discussion and decision-making while using the technology within a climate which so often demands precision and answers."[29] He thus preferred conversations instead of interviews and voice-overs to enable people to speak for themselves, with King serving less as an active interlocutor than an active listener, to mirror the intended listening from a Pākehā audience. To minimize the presence of the production crew and be less ubiquitous in his filming, he carefully chose camera positions. He favored long zoom lenses (300 mm and 600 mm lenses), so the camera

25 Murray, *Images of Dignity*, 44.
26 Murray, *Images of Dignity*, 45.
27 Christina Milligan, "Sites of Exuberance: Barry Barclay and Fourth Cinema, Ten Years On,"
 International Journal of Media & Cultural Politics 11, no. 3 (2015): 237.
28 Barclay, *Our Own Image*, 18.
29 Barclay, *Our Own Image*, 9.

could be placed at some distance.[30] In the Waikato episode, the master carver Piri Poutapu and elder Te Uira Manihera talk to King on the porch of the Māhinārangi meeting house at Tūrangawaewae Marae, with the camera crew placed several meters away.

Barclay's emphasis on *talking* reflects Māori oral traditions, and the recording also plays an archival function, but it also has more significant implications. Murray claims that privileging *talking* over people *in action*, especially enacting cultural practices, is partly because of "the stress the series has on the abstracted ideas (leadership, citizenship, etc.)." It also reflects a refusal of "the logic of ethnographic film with its emphasis on the surface features of cultural *practice* as being indicative of a communal totality" and a recognition of "the value of talk and speech as the conveyors of meaning."[31] Furthermore, that "the images that result eschew a clear realism because they become mediated through talk, and subsequently it is speech that carries the truth of social and cultural detail."[32] Vital to his working practice is to listen and record, and the trust in the inherent value of what is being said and shown.[33]

Today, the prominence of Michael King's voiceover and, even more, his presence when interviewing Māori overpowers the screen, even as he exhibits a personal demeanor and genuine respect for Māori. In a documentary made about him, King acknowledged the change in the political climate since he first became engaged in Māori affairs during his early journalism in the 1970s. At the time, his engagement filled a gap in the lack of serious journalism on Māori affairs. With a rising demand for self-determination— in Barclay's words, the control of their "image destiny"[34]—being a Pākehā, King recognized the need to step down.

Tangata Whenua gave Māori visibility, presenting Māori in their own terms to a national audience largely ignorant of their histories, customs, and ways of life. It redressed this absence and rectified racist perceptions of Māori by offering a dignified portrait. In the fourth episode, a Tuhoe elder speaks of the value of modesty among Tuhoe, but that he could not demand all Māori to partake in it if modesty was not part of their tribal core values; thus, he should speak of *Tuhoetanga* rather than *Māoritanga*. Barclay's underlying emphasis on the cultural richness and specificity of the different *iwi* throughout the series critically challenged the notion of *Māoritanga* and the government's cohesion of all Māori through assimilation.

30 Describing his documentary-making in the 1970s, Barclay wrote: "Perhaps the challenge is to seek out techniques that can put people back on the screen. I believe one of the first steps is to get rid of the camera. [...] On my documentaries we have used the long zoom a great deal, and more recently we have turned to the 300mm and 600mm lenses, which can put the camera 15 to 50 metres from the subject. We have organised simple, inexpensive sound rigs so that the cameraman, director and, when needed, a translator can hear the conversation from a distance. [...] The crew is invisible and people are left free to chat." Barclay, *Our Own Image*, 15–16.
31 Murray, *Images of Dignity*, 39.
32 Murray, *Images of Dignity*, 39.
33 Murray, *Images of Dignity*, 35.
34 Barry Barclay, "Housing Our Image Destiny," *Illusions* 17 (Spring 1991): 39–42.

Leon Narbey and Geoff Steven's *Te Matakite o Aotearoa / The Māori Land March* (1975, 60 min.)

Considered one of the most significant *hikoi* (march) in history against the continuing alienation of Māori land, the Māori Land March in 1975 was organized by the protest movement group Te Rōpū Matakite (Those with Foresight). Led by its leader, Whina Cooper (Ngāpuhi), the 1,000 km march started in Te Hāpua in the far north and ended in Parliament in Wellington. It grew considerably in support as people joined on the journey, raising public interest and national media attention.

Pākehā film director Geoff Steven approached TVNZ 2 to make a documentary about the March, with a small Pākehā crew—Leon Narbey (cameraman), Phil Dadson (sound), and Australian filmmaker Gil Scrine (assistant/editor). He sought further funds with the support of Ngā Tamatoa, and Polynesian Panthers and governmental funding, becoming the first NZ documentary to be shown on TVNZ 2.

At the start of the film, a voiceover announces, "man comes and goes, but the land is permanent," while a small group departs with the sea behind them, marching towards the camera. In a frontal close-up, activist Tuaiwa Hautai Eva Rickard[35] explains the meaning of *tangata whenua*—*tangata* means people, *whenua* means land, and also placenta. "When you are born, your placenta is buried in the land, the land supports you, provides food, and the land is where you return after you have been gone, and where you will be buried." This opening scene powerfully delivers the political message on Māori terms.

The film, edited chronologically, alternates scenes of the march on the road with interviews and intimate scenes of communal living and activities. The march lasted a month, with marchers staying in *maraes* along the way. With the film crew travelling with the march and also staying in the *maraes*, they had intimate access and fostered a close relationship with the people. The film captures marchers conveying their experiences, views and hopes for the march, as well as the voices of elders and other prominent figures who host them along the way. Being prepared to undergo the march's physical hardships, comments one of their participants, "shows the anger we feel and the strength of our convictions, with each day that passes feeling stronger." Scenes of communal efforts convey a joyous camaraderie and a growing sense of purpose: night meetings going over the planning in a non-hierarchical assembly manner; a Pākehā doctor curing the blisters of the walkers while everyone cheerfully takes turns giving each other leg massages.

35 Eva Rickard became a prominent activist on land rights and was best known for leading the protests and occupying the Raglan golf course set on Māori land. She was a member of Māori Women's Welfare League founded in 1951 to support Māori in areas such as housing, health, and education, and in fighting also for land rights and to revitalize *te reo* Māori. See: https://teara.govt.nz/en/te-mana-o-te-wahine-Māori-women/page-6.

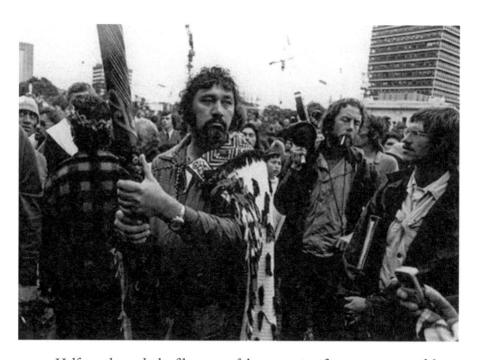

John Miller, *Te Matakite o Aotearoa / The Land March*, 1975. Left to right: Seaman's Union member Dave Clark (holding the *powhenua*), Leon Narbey, and camera assistant and the film's editor Gil Scrine.

Halfway through the film, one of the most significant moments of the march that galvanized the protesters was crossing the iconic Auckland Harbor Bridge. The highly mediated image became an emblem of Māori resistance in New Zealand. Joe Hawke speaks of the emotion he felt leading the March and holding the *pouwhenua* (a carved wooden post to mark territorial boundaries), and carrying the flag when entering the harbor, the land of his Ngāti Whatua. Hawke would later lead the "occupation" of Bastion Point in 1977–78. During the March he had high hopes of helping to bring recognition of the Ngāti Whatua's rights over their land. A master carver, holding the *pouwheneua* in his hands, and caressing its markings, explains its symbols and rank. A post used to mark places of significance, the *pouwheneua* is built and placed to designate who owns the land, the carved symbols representing each *iwi*.

As the March reaches Waikato, the center of the Māori King Movement, it pays ceremonial respect to the memorial to the Māori fighting chief Rewi Maniapoto, who led *Kīngitanga* forces against the invasion of Waikato during the New Zealand Wars in the nineteenth century. With a welcoming ceremony, the march is received at the *marae*, where the elders sign the petition to be taken to the parliament.

History is invoked through a firm link to the land, but hopes lie in the future as Cooper foresees these young marchers becoming leaders in the future. She highlights the great sacrifices of the marchers for the benefit of all Māori. In an interview with Cooper, she conveys the political aims of the march and the need to galvanize the young. She explains, "The young people are changing. They are finding now that perhaps to go along without the support of the old people, they will not reach the goals they would be

likely to reach, so they follow the old people to get their knowledge of the past to stand as a kind of an instrument for the future." The story goes that Cooper symbolically took the first steps of the march holding the hand of her *mokopuna* (granddaughter).

The seventy-nine-year-old Cooper had been the first president of the Māori Women's Welfare League, established in 1951 to support Māori in housing, health, and education. She had the *mana* among Māori and political shrewdness with the government (she was later honored as a Dame), as well as the oratory skills to mobilize people. In focusing on Cooper and Rickard, the film gives prominence to two of the most outspoken land-rights campaigners, recognizing the active role of women at the forefront of the Māori protest movement. Influenced by the women's liberation movement, Māori feminists contested the patriarchal Māori leadership, defending their rights to speak on the *marae*, which is traditionally reserved for men. In 1978 Rickard would lead the protests that occupied the Raglan golf course built on Māori ancestral land.

Stressing the level of national media attention raised by the March, we hear Radio New Zealand's morning news announcing the March's arrival at Parliament. With 2,000 marchers departing from Porirua, as they approach the capital they are joined by mass support, including many Pākehā with an emergent political consciousness. A Māori representative speaking on the radio highlights the significance of the March at an international level, comparing their struggles to other Third World struggles in the Americas, and those of the American Indians or Aboriginals in Australia. Like them, after being suppressed for so long they are now striking back. Another participant emphasizes the impact of the March in asserting Māori identity, uniting all Māori towards a common goal, the right over their lands, and calls for young Māori to stand up with pride.

The film ends at the steps of the Parliament with formal speeches and a presentation of their Memorial of Right to Prime Minister Bill Rowling. The petition, signed by the elders of all tribes with over 60,000 signatures in protest over their land alienation, demanded that the government recognize their rights and governance of their remaining tribal lands in perpetuity. The success of the March contributed to the widespread politicization of Māori and the formation of the Waitangi Tribunal to investigate Crown breaches of the Treaty.

Merata Mita, Leon Narbey, and Gerd Pohlmann's *Bastion Point: Day 507* (1980, 27 min.)

In Auckland, Bastion Point, or Takaparawha, was ancestral land belonging to the Ngāti Whātua tribe that the Crown had confiscated in the 1850s. The Ngāti Whātua had pressed claims for the land to be returned. In 1976, the

City Council planned to turn the last acres remaining of Māori land into high-end housing subdivisions in this prime coastal location overlooking the Waitematā Harbour. This prompted Ngāti Whātua activist Joe Hawke and the Ōrākei Māori Action Committee to lead the "occupation" of Bastion Point, which lasted 506 days, to stop the subdivision. The occupation attracted national media coverage and the support of Māori and their sympathisers, among them members of the Communist Party and Trade Unions. As eviction was becoming imminent, Merata Mita (Te Arawa, Ngāti Pikiao) was approached to make a film from the Māori perspective, and was the only film crew sanctioned by the Ngāti Whātua to be present. The need to take control over their representation led to Mita's first film, *Bastion Point: Day 507*, co-directed with cameraman Leon Narbey and producer Gerd Pohlman.[36] Trained as a teacher, she had begun using a Super-8 camera with her Māori students and later worked with foreign film crews as a liaison to Māori, but grew uncomfortable in that role.[37] She wrote, "From those first years, it became obvious that the camera was an instrument held by an alien hand, a Pākehā instrument [...] It is clear that as early as 1930 the screen was already colonized, and had itself become a powerful colonizing influence [...]"[38]

One of the most iconic events in the history of Māori protest actions, the film captures the last day's dramatic events: the eviction of pacifist occupiers, with helicopter shots showing the camp cordoned by 600 police and the army, ending with the bulldozing of the *marae*, buildings, and gardens, and the mass arrests of over two hundred people. Described by Walker as "the most powerful show of state force against Māori people since the dismemberment of Parihaka in 1881."[39] In an interview in 2003, Mita explains,

> I shot this kind of dreaming space, because it was such an intense
> documentary, so that the big wide shot there, shows the overall thing,
> 600 police surrounding 350 Māori land occupation people and the New
> Zealand Army with its trucks and its jeeps and its personnel destroying
> the occupation site and so on, Nightmarish. [...] So the film was actually
> structured for the impact of those events. It's not just a factual way of
> telling a story as I was told a documentary should be. It's structured

36 Mita co-directed with Pohlmann several films, such as *Karanga, Hokian ga ki o Tamariki* (1979) documenting the Hokianga's Catholic Māori community, *The Hammer and the Anvil* (1980) about the trade union movement, and *The Bridge* (1982) chronicling the Mangere Bridge industrial dispute, which reflected Pohlman's Marxist political filmmaking coming out of his recent film studies at DFFB in Berlin.

37 In 1986, Mita stated, "I agreed to do research and liaison but I was no longer happy about it. I felt like a sell-out. I was leading these people into some very sacred spaces and exposing Māori people, and it would end up as a film of how some other person saw Māori people and not how we saw ourselves." Mita, quoted in Chloe Cull, "Considering Merata Mita's Legacy," in "Love Feminisms," eds. Alice Tappenden and Ann Shelton, *The Occasional Journal* (November 2015), https://enjoy.org.nz/publishing/the-occasional-journal/love-feminisms/considering-merata-mitas-legacy-2#article.

38 Mita, quoted in Jonathan Dennis, "Restoring History," *Film History* 6, no. 1 (Spring 1994): 119.

39 Walker, "The Genesis of Māori Activism," 277.

the way that fiction is. The way you construct a story you know with its peaks and its ending that is meant to never leave you, those last shots."[40]

The film's emotional impact relies on its compelling Māori perspective—"the film is made by how it affects me, not how it affects the majority viewing audience" and "told from my viewpoint and the viewpoint of Māori people who have lost land."[41] Mita deliberately structured the film, "as if you're sitting around the campfire and my grandfather or uncle or cousin is telling a story, and in that story they tell us the truth about our history."[42]

There is a sense of a bonding struggle and people "becoming part of something greater." There are scenes of Joe Hawke's speech stating their rights and walking arm in arm towards the police to demand face to face their land back. A *kaumātua* asserts their pacifist but firm stand by their ancestral land, remaining still in response to chief police's reiterated demands to leave and threats of eviction. A demonstrator asks, "We've been bloody passive for over a hundred bloody years! This is the way we get bloody treated? How much longer must we talk, must we ask? How much bloody longer?" Roger Rameka and the protesters peacefully sing hymns and prayers. Matiu Tarawa and others perform the *haka* as a ceremonial gesture and are later arrested and removed by the police, one by one. A female voice sings a *moteatea* (lament). A distressed Aunty Hopey, escorted by Māori, leaves the grounds. These scenes represent Māori and their cause with dignity, countering the monocultural white view on Māori affairs, demonized by a Pākehā-controlled mass media. Framed in this context, reporter Graham Osborne's voiceover speaks about this historic day for New Zealand on the ten o'clock news. By announcing that the massive army was moving in to remove the Māori land protesters, he exposes the political media bias.

Mita saw *Bastion Point: Day 507* as a film of resistance; in her words, "the total opposite of how a television documentary is made. It has a partisan viewpoint, is short of commentary, and emphasizes the overkill aspect of the combined police/military operation. It is a style of documentary that I have never deviated from because it best expresses a Māori approach to film."[43]

Mita recognized the value of the film as a historical document. Interviewed by her son, the filmmaker Hepi Mita for his documentary *Merata: How Mum Decolonised the Screen* (2018), she says of *Bastion Point: Day 507*: "The most important part of this history is happening here, while we can record it, and be witness to it. And hundreds of other people would

40 Mita, quoted in Peter Britos, "Conversation with Merata Mita," *Spectator* 23, no. 1 (Spring 2003): 58.
41 Britos, "Conversation with Merata Mita," 58.
42 Britos, "Conversation with Merata Mita," 58.
43 Mita, in New Zealand Film Archive, *Land Wars Film Programme* (Wellington: New Zealand Film Archive, 2008), 1.

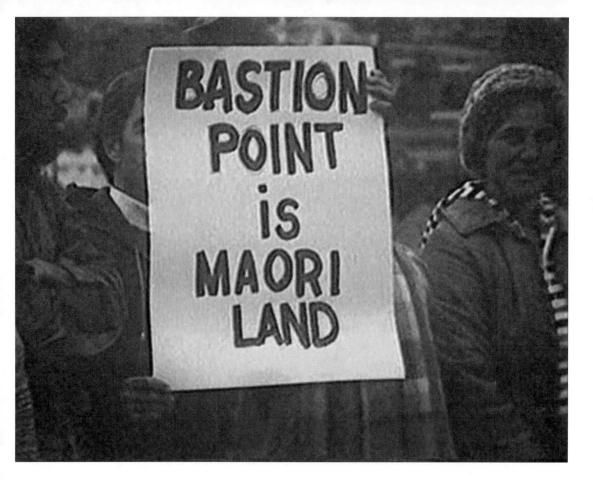

be witness to it. And it won't be just something that children will read in history books; it's something they'll be able to see on the screen."[44] Like Barclay, Mita advocated ethical protocols around the representation and archiving of images of Māori; in her words, "back to the people, where, as I like to express as a filmmaker, 'the image taken from the people has been restored.'"[45] The film was not televised for more than a decade, yet it remains one of the most significant records of Māori land struggles.

Darcy Lange's *Māori Land Project* (1980)

Shot between 1977 and 1979, Pākehā video artist Darcy Lange's *Māori Land Project* also documented Bastion Point / Takaparawha and another land alienation case, the Ngāti Hine land block, near Kawakawa, Tai Tokerau, north of Auckland. The latter involved a legal dispute about stopping the land from being leased by a forestry corporation, which argued that Māori owners had left their land underdeveloped.

44 Mita, in *Merata by Hepi Mita*, film script, 29.
45 Mita, quoted in Dennis, "Restoring History," 124.

Living in London for nearly a decade, Lange recalls arriving in New Zealand and meeting people involved in the Māori protest movement through one of *Te Matakite o Aotearoa* filmmakers. He established close relations with Joe Hawke and Colin Clark of the Orakei Action Committee, and most significantly, with photographer and Ngāpuhi land rights activist John Miller. Miller introduced him to the Ngāti Hine case, travelled with him, and even shot material. Lange gathered interviews with influential Māori activists, politicians, and members of parliament that captured contrasting perspectives. In addition to Hawke, Clark, and Miller, they included Taura Eruera, anthropologist and Nga Tamatoa activist; Duncan MacIntyre, Minister of Māori Affairs of the National Party; Matiu Rata, former Minister of Māori Affairs of the Labour Party; Matiu Tarawa, land rights campaigner; Tim Horopapera, Tasman Mill site pulp and paper worker and unionist; and finally Virginia Shaw, a reporter with TVNZ 1 who brought some of these contacts with key politicians and media individuals.

Lacking the funding support in New Zealand, Lange took the footage to the Netherlands and edited the project with Dutch collaborators. He worked with René Coelho, a former television producer and founding director of MonteVideo gallery in Amsterdam; sociologist and filmmaker Leonard Henny at the Sociology Institute in Utrecht University: and the Victor Hara film collective. On account of these collaborations and drawing on Lange's footage, three films were produced:[46] *The Māoris*, a 30-minute version produced by Coelho for NOS television (the Dutch Broadcasting Foundation); *The Māori Land Struggle*, directed by Henny and produced in two different versions, twenty-three and twenty-six minutes long, that respectively conveyed partisan and bipartisan views, used as part of his research conducted with secondary-school children to investigate the effects of media in forming their opinions; and lastly, *Bastion Point*, a more personal 140-minute study edited by Lange. These films were commissioned and shown as part of the exhibition "Māori Land Project" at Stedelijk Van Abbemuseum in Eindhoven and the Internationaal Cultureel Centrum (ICC) in Antwerp in 1980. While the notion of media politics and manipulation became the focus of the exhibition, Lange and his collaborators prevailed in their wish to draw international attention to Māori struggles.

Influenced by Paulo Freire and Bertolt Brecht's radical notions of radio, Henny's research was engaged with the use of media in political

46 In addition to thirty hours of ¾in. Lo-Band U-matic video, 16 mm film, and slides recorded by Lange over the course of three trips to New Zealand during 1977–78, there were also extracts from Leon Narbey and Geoff Steven's *Te Matakite o Aotearoa / The Māori Land March* (1975), and Chris Strewe's *Waitangi: The Story of A Treaty and Its Inheritors* (1977); newsreel footage depicting the eviction of Bastion Point; sound from Barry Barclay's television series *Tangata Whenua* (1974); and 16 mm film footage by Murry Saviden. *Darcy Lange: Māori Land Project* (Antwerp: Stedelijk Van Abbemuseum and Internationaal Cultureel Centrum, 1980), 41.

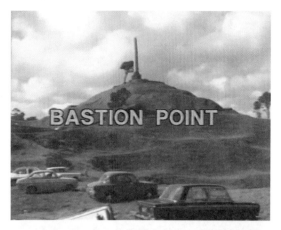

BASTION POINT

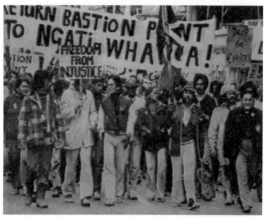

ABOVE AND OPPOSITE
Stills, Darcy Lange,
Māori Land Project,
1980

education to help raise awareness about the problems faced by the minorities living in the Netherlands.[47] Key to raising consciousness was for pupils to understand the social forces that might determine their situations. He experimented with the effectiveness of partisan and bipartisan formats in generating discussion among pupils and translating the problems in the film—Māori struggles in New Zealand—to their own realities; Freire called this a "generative moment."[48]

Seen side-by-side, Henny's two versions of *The Māori Land Struggle* and Coelho's *The Māoris* feel rather close in pace, style, and length. All three use practically the same footage and many edited sequences, and their script and editing have the stamp of Ray Krill and Gloria Lowe, members of the Victor Jara Collective.[49] *The Māori Land Struggle* and *The Māoris* were edited by Krill, the latter with Lange's assistance. Both of their scripts were written by Lowe, the former together with Cris Kooiman. The selection of shots and sequences is dictated by each film's respective emphasis, geared to different audiences and purposes (education and television), and in Henny's films to support partisan and bipartisan perspectives. *The Māoris* does not have a distinct broadcast value, as it did not follow the conventional commercial guidelines for television. For instance, the opening sets off with a sequence of the *haka* and *waiata* (Māori songs) performed as part of the Waitangi Day

47 See: Leonard Henny, *Action Research with Film and Video* (Utrecht: Media Studies Program at the Sociological Institute, University of Utrecht, 1978), and Leonard Henny, *Raising Consciousness Through Film: Audio-visual Media and International Development Education* (Utrecht: Media Studies Program at the Sociological Institute, University of Utrecht, 1980).

48 Paulo Freire, *Pedagogy of the Oppressed*, trans. Myra Bergman Ramos (London: Continuum, 1970).

49 The Victor Jara Collective, named after the Chilean musician and dissident Victor Jara, were from Guyana, formed out of a Marxist study group at Cornell University. The collective had just finished their documentary *The Terror and the Time* (1978), about British colonial rule over Guyana during the 1950s, and the Guyanese people's struggle for independence. They were influenced by the New Latin American and Third Cinema movements, as well as the theories of Soviet montage and the European avant-garde.

Back to the People / Restoring History

at Waitangi, attended by Governor-General Sir Dennis Blundell. Conversely, in *The Māori Land Struggle*, the opening sequence depicts the sea, the land, and the mountain, while we hear a *kuia* performing a *karanga*—a greeting call to guests signaling them to start entering in the *marae*. In Henny's films, the script is the same. However, in the one-sided version, Māori activist Taura Eruera speaks of the processes of colonialism, relating his history and on camera, allowing audiences to establish an empathy with him and his cause. Conversely, in the two-sided version, a female voiceover, off-camera, has the effect of neutralizing their message.

From the start, *The Māoris* anchors Māori's spiritual value to the land with a frontal shot of Eva Rickard speaking of the meaning of *tangata whenua*, as people of the land (the excerpt from *Te Matakite o Aotearoa / The Māori Land March*). Subsequently, the film introduces the conflicting differences between Māori's spiritual and communal relationship to the land, and self-determination demands over their land amid the government's plans to harness it for capital gain. In front of the map of the Northern Island, John Miller offers a detailed analysis of the present situation, pointing out which areas have been affected. He denounces foreign companies, partially funded by Japan, for bringing their laborers and taking the jobs from Māori. Ex-captain of the WWII Māori Battalion, Dick Kaki, speaks at a meeting with land share-holders of the Ngāti Hine Block and supporters of various political parties—environmentalists,

union leaders, and members of other Polynesian groups. With all other channels failing, he proclaims, the time has arrived for Nga Tamatoa to come forward, and plans are made for the court hearing to prevent the leasing of the land by the forestry company.

A scene with MacIntyre, the Minister of Māori Affairs of the National Party, appears approximately halfway through both versions. However, by the time it features in *The Māoris*, his statement falls flat and feels demagogic, on account of the eloquently strong statements previously

made by Māori, and with an empathy towards them already established. MacIntyre is further *defeated* by Miller and Eruera's contrasting allegations, along with shots of Māori working in low-paid factory jobs and living in urban centers due to having lost their land, and further statements made by Matiu Rata, former Minister of Māori Affairs for the Labor party. In *The Māoris*, the editing strategy introduces the Māori's statements first, followed by MacIntyre's interview, whose poised demeanor and cagey words make Māori look trustworthy. Conversely, MacIntyre's scene in Henny's film is backed up by the street interviews with Pākehā, which, however contentious, strengthen the Pākehā point of view, establishing a dialectical tension.

The respective editorial decisions made in *The Māoris* and *The Māori Land Struggle* are evident when carefully watching the three versions together. Henny's didactic approach would have helped viewers look for these editorial nuances, offering an exercise in viewing media. These become apparent even more so when viewing Lange's *Bastion Point*, a lengthier, freer, and more personal film. *Bastion Point* is distinct from the other films in that it does not rush through a storyline of events, nor present a political argument. His long takes (of five to fifteen minutes) with a static camera or otherwise very limited movement, and unedited or sparsely edited sequences, lends a documentary integrity to the image as the reality it portrays unfolds in real time. In his words, this presents a "documentary quality of scientific research" in the "attempt to produce a legal proof."[50] It also gives this work a sense of immediacy.

Lange missed the final eviction that made headline news. Newsreel footage of it appears in Lange's *Bastion Point* and Coelho and Henny's films; but more to the point, Lange's film moves through a series of scenes collecting moments in the occupants' daily lives living in Bastion Point during the quiet months he was there (September through December of 1977). In one scene inside the *wharenui* (meeting house) at night, with Hawke and family gathered resting on mattresses on the floor, the camera moves fluidly around the room in realtime, intimately zooming in on each individual. They speak, some in *te reo* Māori, about their personal experiences during the occupation. Lange strives to convey the sense of *experiencing with the camera*—in his words, "the feeling that you are actually there"—rather than *narrating* the scene, leaving a vivid impression of Māori and their customs, language, and communal living. Here, Barclay's notion of filmmaking as a form of *hui*, with the camera acting "with dignity, restraint, sitting back a little and listening," comes to mind. Lange understood this temporality and let people speak without editorial imposition, allowing conversations to begin organically, and preferred talking heads

50 Lange, "Interview Darcy Lange," in *Darcy Lange: Māori Land Project*, 34.

to voiceovers. Lange stays back, as much as possible while still holding the camera, becoming a witness to their history.

Bastion Point makes more evident the others' respective agendas, whether these are informative for television, or educational and political, as in Henny's experiments. Lange's non-abbreviated temporality challenges the reified endings and instrumental identifications of his peers' versions. Without a defined point of view or ideological message, neither informative nor analytical but rather open-ended, *Bastion Point* has a degree of irresolution and, one might consider, a failed potentiality. However, it conveys an intimacy that Lange established with Māori not found in the other two versions, which empathetically appeals to the viewer.

Lange's long takes also have a significant political implication, with the subjectivity and singularity of Māori portrayed through such extended duration. It contributes to the subjectivation rather than objectivation of his subjects, and again establishes a sympathetic relationship with them. This affective and empathic effect of Lange's video is constitutive in the mediation of the political. Further, his account reflects the intimate time spent with the occupants of Bastion Point over the quiet months. Based on the intimacy of these shots, John Miller and Geraldene Peters argue, Lange established with Hawke and his family "a relationship of trust" in this initial stage.[51]

However, as the project was developed overseas, no Māori representatives were involved in the editing process. Unable to articulate their own history at this level denied Māori self-determination and control over their own image. Unwittingly, the project perpetuated the uneven hegemonic power that it sought to redress.[52]

Merata Mita's *Patu!* (1983)

Mita's remarkable film follows the protests to stop the 1981 Springbok rugby team tour to New Zealand, in view of the government's support of South Africa's apartheid. The tour fervently split the nation and ultimately revealed the racial divide, with those defending it arguing not to mix politics with sport. When the appeals to the New Zealand Rugby Football Union and the National Government under Prime Minister Muldoon to cancel the tour failed, the protesters directed their efforts at boycotting the games in each city, resulting in violent police retaliation escalating during the two months

51 John Miller and Geraldene Peters, "Darcy Lange: Māori Land Project," in *Darcy Lange: Study of an Artist at Work*, ed. Mercedes Vicente (New Plymouth: Govett–Brewster Art Gallery; Birmingham: Ikon Gallery, 2008), 146.

52 Miller and Peters write, "From today's standpoint, the lack of informed consultation at the crucial editing stage and the decision to proceed with the film despite this, denied Ngāti Whātua o Ōrākei the opportunity of self-determination through visual representation—although unintentional, this was effectively another form of colonisation." Miller and Peters, "Darcy Lange," 150.

of the tour. Mass demonstrations around the country voicing their anger against the tour drew increased media attention.

Initially conceived for TVNZ as a twenty-five-minute documentary on the anti-apartheid movement's campaign, Mita felt the need to "raise awareness of the racial aspect of the tour" and left the TVNZ project to make the feature film. With a small crew comprised of editor Annie Collins and producer Gerd Pohlmann, *Patu!* (Māori weapon made of stone or bone) became a collaborative effort, with many filmmakers and press cameramen offering their recordings to the making of the film.

A dialectical montage of still images depicting killings in South Africa and rugby players opens *Patu!* with a tangible political message. The following scene presents Pākehā grassroots HART's (Halt All Racist Tours) anti-racist campaign efforts in the streets of Auckland, giving out leaflets and asking people to sign a petition against the Tour to put pressure on the government and the Rugby Union. Their aim was to educate the public about what was happening in South Africa and build support for their anti-apartheid movement. The film progresses, giving voice to others who were against the tour—the coalitions of rugby players, sports groups, women's groups, churches, trade unions, students, and Māori. High school Pākehā students enact scenes of confrontation between the protesters and the police, which are dialectically intercut with photographs showing the

Maori land fight— it's all on film!

By ROBERT JONES

AN AVANT garde film which the makers claim will "blow the whistle" on Maori land deals in New Zealand is being offered abroad.

The movie focusses on Maori land rights issues—from the Maori view.

It is being offered to documentary film-makers for distribution in both Europe and the United States.

The make is designed to have both a human and a shock political impact, emphasises one of the producers, Mr John Miller.

"There's never been anything like it done in New Zealand," he said.

Mr Miller rates it as the New Zealand equivalent to radical documentaries on land issues involving the Red Indians in America, the aborigines in their uranium-rich territory, and even on conflict between black and white in South Africa.

Says Mr Miller:

"What we're doing is blowing the whistle on big forestry companies and the way they operate by leasing Maori land into perpetuity . . . thus alienating the people," says Mr Miller.

"It throws light on a subject which must be looked into. The whole system of control through Maori Affairs and the Maori Land Court is antiquated."

erations as Maori workers see them.

It also contains clips of the Maori land march on Parliament.

Mr Lange has taken the film overseas for what he hopes will become international viewing.

A second copy is being held here for editing and the addition of commentary.

"It's a very serious, honest look at the issues in a way never before attempted in this country," says Mr Miller.

When processed, other copies of the film will be offered to universities, educational institutes, trade unions, the Federation of Labour, and Federated Farmers.

"Any profit will be used to fight Maori land issues." The Auckland Trades

Council has endorsed the green ban placed on the Ngatihine Maori land block in Northland — and has referred the issue to the Federation of Labour.

Whangarei's trades council applied the original green ban.

Fresh legal moves have been launched in the Auckland Supreme Court in an attempt to nullify a controversial leasing of the 5,514 ha. to Carter Holt forestry company.

And Ngatihine representatives have been invited to attend an open field day near Warkworth on the farm forestry property of Mr Michael Malloy, under the auspices of the North Farm Forest Association, on January 14.

Mr Malloy, an Auckland solicitor, has called for a commission of inquiry into the Maori Affairs Act and procedures of the Maori Land Court.

"It will give other ideas to people overseas who think of New Zealand as a truly multi-racial society."

Netherlands-based expatriate New Zealand artist and film-maker Darcy Lange started filming segments of Maori land protest activity some months ago.

He has been assisted chiefly by Mr Miller, liaison and research officer, Te Matakite O Aotearoa; and former junior lecturer in anthropology at Auckland University, Mr Taura Eroera.

The film, which has a running potential of up to three hours, looks at:
● A drawn-out wrangle over Maori owners' refusal to endorse a 75-year lease of 5514ha of Ngatihine land in Northland.
● Bastion Point and the stand made by Joe Hawke and followers.
● The east coast of the North Island, and the actions of major forestry interests in winning control of Maori land there.
● Kaweran pulp mill op-

DARCY LANGE and Motatau Shortland (foreground) on Ngatihine land in Northland with the camera used for filming a Maori land issues documentary.

Newspaper article by Auckland journalist Robert Jones in *8 o'clock*, December 23, 1977

killings of Blacks in South Africa and the sound of a Māori female wailing. The popular Reggae band Herbs plays in a concert in support of the campaign. There is no coercive voiceover commentary; rather, the film relies on "the style of the oral storyteller" and the dialectical montage of sound and image, lacking a conventional narrative structure.[53]

The first half of the film depicts these coalitions' massive efforts, along with the building dissent of social movements and a youth counter-culture joining in with genuine solidarity and idealism. We see the rallies growing bigger and louder as campaigners succeed in raising awareness, capturing the support of people never before involved in political action,

John Miller, *Darcy Lange with Motatau Shortland at Matawaia Marae*, 1977

53 Mita, in Pascale Lamche and Merata Mita, "Interview with Merata Mita," *Framework: The Journal of Cinema and Media*, no. 25 (1984): 6. Further, Mita adds: "Oral storytelling is often storytelling in pictures. [...] None of the Polynesian races, including the Maori people, come from a literary heritage. So it suits me to make pictures on celluloid that were formerly pictures in the mind, memory pictures, pictures of the imagination, that the storyteller uses all the time to make his stories more interesting and exciting. With the invention of film, the fact that you are able to transpose these pictures of memory, imagination and reality, mix them all up and make a story from them that you can see with your eye rather than with the mind's eye, is, I think, merely a continuation of the oral tradition. That's how I see my work. Whakapapa is a form of genealogy in the picture sense. Whoever, wherever you came from, whatever your ancestral line is, it's very closely associated with the land and with the events of that person's life. It's a whole history and it's told to you in pictures. So I've got these cultural, historical and ancestral links to storytelling through picture, which naturally gravitate towards film and are an enormous advantage to me as a film-maker." Lamche and Mita, "Interview with Merata Mita," 3.

and succeeding in capturing further public attention. All of which sets the dramatic stage for the second half of the film, when the pacifist protesters' attempts at boycotting the games clash with police violence. Hectic rampageous scenes are intercut with sound, dramatically enacting the protesters' emotional chaos, shock at the police violence, and clashes with rugby supporters—their idealism batoned with brutality, capturing "a visceral sense of 'being there' in the midst of the action."[54] The closing credits tell us that thousands of people were arrested, and some were maimed for life.

Initially portrayed as a middle-class campaign joined by mostly politically naive groups, the film's narrative progression shifts "inwardly," bringing the issue of race home. We then see a representative of the Māori Women's Welfare League speaking of their opposition to the Tour as strong campaigners against the apartheid. Tūhoe activist and Ngā Tamatoa member Tame Iti is briefly interviewed in *te reo* Māori, without subtitles. Three-quarters of the way through film, a *kuia* (female elder) in a *marae hui* reminds the campaigners that their fight against racism in South Africa and the repressive forces of the state they are now experiencing are no different from what Māori and Pacific Islanders are undergoing in New Zealand. Mita says,

> [Y]ou go out there and you fight racism as it happens in South Africa [...] and they abstract it totally from themselves and their own experience and the fact that they oppress Māori people in New Zealand. So the movement sort of turned inwards, but not in a negative sense, they had to make some critical self-analysis, they had to realise they were part of that whole oppressive system that oppresses Māori and Pacific Island people within New Zealand.[55]

Some criticized the Māori focus in the film. Reflecting on accusations of her bias, Mita remarked:

> Yes, *Patu!* has a Māori perspective, but it does not override the mass mobilisation of New Zealand's white middle class, neither does it take credit from those who rightly deserve it, everyone who put themselves on the line. My perspective encourages people to look at themselves and examine the ground they stand on.[56]

Geraldene Peters highlights that *Patu!* represents "a particular historical conjuncture that saw a coincidence of Māori political and cultural

54 Geraldene Peters, "Patu!," in *Making Film and Television Histories: Australia and New Zealand*, eds. James Bennett and Rebecca Beirne (London: IB Tauris, 2011), 46–51.
55 Lamche and Mita, "Interview with Merata Mita," 6–7.
56 Mita, quoted in https://www.nzonscreen.com/title/patu-1983.

renaissance, with an emergent middle class Pākehā political conscious-ness and the activist energies of already established social movements."[57] And further, that the shared political view among the Left recognized that the issue of race in the film had "to be understood against a context of anti-colonialism as there are many ways in which the story of the Tour could have been told."[58] The left-wing collective Vanguard Films intended to make a documentary about the Springbok Tour, explains Peters, "with a united front (the coalition of a range of interests) emphasis," working collabora-tively by using other filmmakers' footage of the protests. However, aware of Mita and Pohlman's preliminary filming, "the two groups decided to pool resources for one film that Mita would direct, implicitly an endorsement of the need for a Māori perspective."[59]

Moreover, the film's narrative structure is itself representative of these cross-pollinations, Peters remarks, with "the dual dialectical and whakapapa narrative strands" standing for Pākehā and Māori experiences of history.[60] These cross-cultural relations between Māori and Pākehā is, for Peters, what gives the film contemporary relevance. While the Springbok Tour received broad media attention, *Patu!* was not shown in cinemas. Its release was postponed until the legal prosecution against protesters ended, to protect those appearing in the film—Mita claims that the police tried to get hold of the footage to prosecute the protesters.[61] The film was shown at international festivals, and in 2012 was listed on the New Zealand section of UNESCO's Memory of the World project.

Conclusion

In watching these films, one recognizes the documentary urgency at the moment of capturing "history." In Merata Mita's words, "history as is happening here, while we can record it, and be witness to it." She also had an eye on the future; their story may not have been written in history books, but future generations will see it on the screen. The film is harnessed as a storytelling tool for resistance and for restoring history, redressing the absence of Māori in film, or worse, their misrepresentation, by giving voice to Māori views concerning their colonial history and its impacts, and through that process strengthening Māori cultural identity and community building.

Today these films play an archival role, but one that insists on being a living archive. Mita firmly believed that "material divorced from the people

57 Peters, "Patu!," 46–51.
58 Peters, "Patu!," 46.
59 Peters, "Patu!," 46.
60 Peters, "Patu!," 46.
61 Lamche and Mita, "Interview with Merata Mita," 5.

loses its value, the people keep it alive. No Archive can justify keeping people away from their images."[62] Jonathan Dennis, the founder of the New Zealand Film Archive in 1981, writes in his 1994 essay "Restoring History" that "if the archive was to take seriously the concepts embodied in its Māori name: *Ngā Kaitiaki O Ngā Taonga Whitiāhua*, the guardians of treasures of shining light," it had to recognize that even in films shot by Pākehā about Māori, the material ultimately remains Māori and has a spiritual significance to them.[63] Films are seen by Māori as *taonga* (cultural treasures), as living objects with their own *wairua* (spirit, soul) and *mana* (authority, prestige, power).

Ngāti Porou photographer Natalie Robertson highlights the similar role that photography plays in cultural history within Māori performative and oral culture. Photography, says Robertson, quoting Māori language activist Huirangi Waikerepuru, "is like writing stories, recording stories, recording history." Waikerepuru sees photography as "a contemporary expression of *mana rangatiratanga* (roughly translated as authority, trusteeship, and self-determination)", whereby *rangatiratanga* is understood as a "dynamic non-static concept emphasizing the reciprocity between human, material and non-material worlds."[64] Robertson remarks how, in making contact with a photograph, all kinds of "interconnecting relational networks" manifest, "uniting the viewer with *tīpuna* (ancestors), places and stories in a time-space collapse," and this is where *kōrero* (conversation, discussion) is pivotal "in maintaining tribal narratives vital to cultural survival."[65] The material and immaterial vitality of photographs are activated by *kōrero*, which calls into being their *mana, wairua*, and *mauri* (life force or essence), the spiritual values in photographs of people, things, and places important to Māori.[66] Robertson describes Māori protocols around photography as "hongi (sharing breath), touching, kissing and speaking with the photographs, [which] all express connections with the incarnate ancestral presence in the image."[67]

Sharon Dell emphasizes, too, "the direct communication which the films open up between the living and the dead."[68] This is why Mita asserted the responsibility of giving the images "back to the people," and the significance for those Māori audiences *experiencing* films depicting Māori life. She wrote,

62 Mita, quoted in Dennis, "Restoring History," 121.
63 Mita, quoted in Dennis, "Restoring History," 121.
64 Natalie Robertson, "Activating Photographic Mana Rangatiratanga Through Kōrero," in *Animism in Art and Performance*, ed. Christopher Braddock (London: Palgrave McMillan, 2017), 47.
65 Robertson, "Activating Photographic Mana Rangatiratanga Through Kōrero," 48.
66 Robertson, "Activating Photographic Mana Rangatiratanga Through Kōrero," 48.
67 Robertson, "Activating Photographic Mana Rangatiratanga Through Kōrero," 48.
68 Sharon Dell, "Te Hokinga Mai Ki Whanganui," *The New Zealand Film Archive Newsletter / He Panui* 16 (February 1987), quoted in Dennis, "Restoring History," 123.

To be present at showings of these early films [ethnographic films of Māori life by James McDonald in 1907] on the *marae* among the people who are descendants of those appearing in them is a unique experience. These showings demonstrate a process of retrieving and restoring history, heritage, pride, consciousness and Māori identity. Hence there is enormous respect and outpouring of emotion at every screening, particularly in the tribal areas to which the film material is especially relevant.

It is not uncommon for archival screenings to be complemented by an appreciative living soundtrack of laughter, exclamations of recognition, crying, calling out and greetings […]. Because what the audience sees are resurrections taking place, a past life lives again, wisdom is shared, and something from the heart and spirit responds to that short but inspiring on-screen journey from darkness to light.[69]

In 2016, commemorating the thirty-eighth anniversary of Bastion Point's eviction, Leon Narbey worked with Nga Taonga Sound and Vision (formerly New Zealand Film Archive) on the preservation of *Bastion Point: Day 507*, and a restored film print was gifted to the Ngāti Whātua at Ōrākei, as a gesture honoring Mita's reciprocity. Restoring here takes on a double meaning: the material physical preservation of film, and a metaphysical one—the repair of the tie that was breached between Māori and their images. As Mita proclaimed, "back to the people, where, as I like to express as a filmmaker, 'the image taken from the people has been restored.'"[70]

69 Mita, quoted in Dennis, "Restoring History," 121.
70 Mita, quoted in Dennis, "Restoring History," 124.

"We Serve up Your Image": Autochthonous Détournement in *100 Tikis*

Beatriz Rodovalho

Can Autochthonous practices of reuse decolonize hegemonic cine-
matic forms and discourses? In the film *100 Tikis: An Appropriation Video*
(2016), the Samoan artist, writer, and filmmaker Dan Taulapapa McMullin
constructs a *détourned* visual cartography of the representation of Pacific
Indigenous peoples in Western mass culture. The film is part of Taulapapa's
larger project on cultural appropriation and on Tiki Kitsch, which includes
collage pieces and video installations. Tiki Kitsch, having originated in the
1930s in bars like Don the Beachcomber in Los Angeles or Trader Vic's
in Oakland, grew into a mass culture construction after World War II.
According to the artist, it is "often mistaken for Polynesian art, but is a
European American visual art form [...] based on appropriation of religious
sculptures of Tiki, a Polynesian deity and ancestor figure."[1]

In *100 Tikis*, from Hollywood classic films to YouTube tutorials, from
colonial illustrations to images of souvenirs, from newsreels to pop art and
pop culture, the film questions the Tiki Kitsch aesthetics and the power
to colonize and possess through images. Images of primitivism, exoticism,
bestialisation, and sexual objectification, as well as other neocolonial
fantasies about Native peoples, are turned against themselves. They are also
confronted with images of Autochthonous struggles in the Pacific, produced
by the Indigenous social movements themselves.

Uncharted territories

100 Tikis employs different formal strategies of *détournement* and subver-
sion. Among these displacements—these processes of decomposition
and recomposition (*démontage–remontage*)—which submit these images
to another gaze, are the operations of deterritorialization and subsequent
reterritorialization, of which, according to Nicole Brenez's categorization,

1 Dan McMullin, "Tiki Kitsch, American Appropriation, and the Disappearance of the Pacific
 Islander Body," *LUX: A Journal of Transdisciplinary Writing and Research from Claremont Graduate
 University* 2, no. 1, article 21 (2013): 1.

the critical and analytical forms of reuse of anamnesis and plaited montage (*montage croisé*) constitute a structuring aspect.[2]

First, the deterritorialization of the images corresponds to their migration from their original contexts of production and reception. From classic or contemporary Hollywood cinema, for example, or from YouTube—that is, from mass media—these images migrate to the territory of experimental cinema, or that of contemporary art in the case of Taulapapa's collages and installations. These images are then reterritorialized from an Autochthonous perspective. This political and aesthetic shift provoked by an Autochthonous gaze allows for the subjectification of a subaltern subject that claims and takes the right to representation.

Unlike the ethnopoetic gaze in, for example, Sky Hopinka's films,[3] Taulapapa chooses a cannibalistic one: a gaze that consumes, appropriates, transforms, and reverses the colonizers' representation through an esthetically and politically violent process. This process responds to the violence of the *original* appropriation. It can equally be found in other Autochthonous experimental practices such as the work of Adam Khalil, Zack Khalil, and Jackson Polys of the New Red Order collective (NRO),[4] which has used video as a transgressive medium to erode structures of power in art, history, and contemporary society. In films like *INAATE/SE/ [it shines a certain way. to a certain place/it flies. falls./]* (Adam and Zack Khalil, 2016) or *The Violence of a Civilization Without Secrets* (Adam and Zack Khalil in collaboration with Jackson Polys, 2017), the filmmakers question the violence within the archive of the settlers' archeology and ethnography, confronting it with the living and resistant archive of Indigenous communities (the Ojibway people, and the Khalils' Native people, in the case of *INAATE/SE/*).

Considering practices of reuse, this violent gesture can be identified in, for example, some of the short films of the *Souvenir* series produced by the National Film Board of Canada, such as *Sisters and Brothers* (*Sœurs et frères*, Kent Monkman, 2015), and *Etlinisigu'niet* (*Bleed Down/Vidés de leur sang*, Jeff Barnaby, 2015). In the series, commissioned Autochthonous filmmakers explore the NFB's archives—mostly non-fiction collections comprising almost 700 hours of footage.[5] Through a critical gaze, they

2 Or a cartography of reuse forms; see: Nicole Brenez, "Montage intertextuel et formes contemporaines du remploi dans le cinéma expérimental," *Cinémas: Journal of Film Studies* 13, no. 1–2 (2002): 49–67. I employ Brenez's terminology throughout this text.
3 See Almudena Escobar López, "Ethnopoetics of Reality: The Work of Sky Hopinka," *Afterimage* 45, no. 2–3 (2017): 27–31.
4 See The New Red Order, "Join the informants!," *Triple Canopy* 25 (2019), https://www.canopycanopycanopy.com/contents/join-the-informants.
5 The series, produced by the NFB with Anita Lee in collaboration with Rhéanne Chartrand, is not without contradiction. It was firstly destined to be screened in the Aboriginal Pavilion of the Pan American Games of Toronto in 2015. Authors including Isabella Huberman have recently questioned the institutional appropriation and instrumentalisation of Autochthonous art in this context. See: Isabella Huberman, "Les Archives à l'épreuve du temps: les recadrements temporels des courts métrages de la série Souvenir," *Revue Canadienne d'Études Cinématographiques / Canadian Journal of Film Studies* 29, no. 1 (2020): 90–109.

interrogate the official archive as a technology of power. In both Monkman's and Barnaby's films, the montage of images of children in residential schools, of Christian missionaries, or medical workers handling First Peoples women and children in precarious conditions, for example, signify and reveal genocidal and ethnocidal processes.

However, the reuse of archival material as found footage or recycled cinema[6] is not a widespread practice across Fourth Cinema. Reappropriation forms appear more in essay films or documentaries. In films such as *Puberty* (1975) and *When All the Leaves Are Gone* (2010)—which crosses autoethnography and fable—Alanis Obomsawin often uses archival images with historical purposes, yet without any violent gesture that would question their status as archive. Other documentaries such as *Reel Injun* (Neil Diamond and Catherine Bainbridge, 2009) deconstruct official historiography as well as Indigenous representation throughout history, specially film history, through a critical revision of hegemonic images. Although the film employs classic documentary forms, it affirms the emergence of an Autochthonous filmic historiography.

Through another form of reuse, the oppression of the archive is violently reappropriated in the documentary *Pirinop, My First Contact* (Mari Corrêa and Karané Ikpeng, Vídeo nas Aldeias, Brazil, 2007). Vídeo nas Aldeias, created by Vincent Carelli and his comrades of the Centro de Trabalho Indigenista at the end of the 1980s, is at the origins of Autochthonous cinema in Brazil. Using video as a political and representational tool, with the goal of *giving the image back*[7] to Indigenous communities, the project is mostly based on audiovisual workshops. Its production is the result of an encounter between Autochthonous subjects and *allies*, which structures its aesthetical paradigm. In *Pirinop*, this encounter between the Ikpeng participants, especially Karané Ikpeng, and Mari Corrêa—who directed Vídeo nas Aldeias for ten years and is now responsible for Instituto Catitu—motivated the encounter with archival footage of the Ikpeng first contact. Its inherent violence is revealed by the confrontation with the archive. The opening of the film, for example, shows the arrival of the expeditioners in charge of the contact[8] as "mad masters"[9] coming from the sky as new and violent gods of a civilization of catastrophe. The reappropriation of the archive—both as montage and as the experience of projecting the archive to the community—serves as a

6 Brenez, "Montage intertextuel," 52.
7 Anita Leandro, Amaranta Cesar, André Brasil, and Cláudia Mesquita, "Nomear o genocídio: uma conversa sobre Martírio, com Vincent Carelli," *Revista Eco-Pós* 20, no. 2 (2017): 232–57.
8 The first contact with the Ikpeng happened in 1964 by an official expedition headed by the Villas-Boas brothers. In 1967, the Ikpeng were displaced to the Xingu Park. For an analysis of the film, see for example Gustavo Procopio Furtado, *Documentary Filmmaking in Contemporary Brazil Cinematic Archives of the Present* (Oxford: Oxford University Press, 2019).
9 In an analysis of the film, I refer to Jean Rouch's *Les maîtres fous* (1958).

Beatriz Rodovalho

catalyst for a larger reappropriation movement in the present—a reappropriation of the visual representation, of history, and of the original land from where they were displaced three years after the first contact. In the *Souvenir* series as well as in Taulapapa's film, the violent act of reappropriation is a radically liberating one. It liberates filmic forms and gazes as well as Autochthonous subjects.

In the case of *100 Tikis*, this art of taking images by force corresponds to piracy. The act of audiovisual artistic piracy defies the notion of property and hegemony over the mass circulation of film and video artefacts. Artistic piracy deterritorializes because it ruptures a structure of power over images. By reappropriating through illegal means, Taulapapa McMullin claims "his right to piracy, to borrowing, to the artistic disrespect" defended by Yann Beauvais and Jean-Michel Bouhours:[10] a right to resist the commodification of culture and alterity.

Who do the images circulating on the internet belong to? Who do Tiki Kitsch images belong to? Who is the rightful owner of the images of Autochthonous peoples? Isn't the right to piracy an anti-imperialistic as well as an anti-capitalist fundamental right? In *100 Tikis*, the artistic pirating or robbing of Hollywood films, of TV shows, of news broadcasts, and of YouTube amateur videos, is a gesture that defies the technologies of power themselves. The amateur, precarious aesthetics of the artist's reuse does not conceal the marks of this gesture: as this analysis aims to show, it becomes a political visual form.

Kitsch chronicles

In *100 Tikis*, the first form of this violent appropriation is anamnesis, which can be defined, according to Nicole Brenez, as the assemblage "of images of the same nature in such a way as to make them signify not something else than what they say, but rather exactly what they show and which we do not want to see."[11] The film accumulates, juxtaposes, and superimposes numerous videos of heterogeneous origins which mobilize the same ideological discourse.

In this flow of images, there is no possibility of contemplation, only the saturation caused by the discharge of the images produced by mass media. Tiki Kitsch is exposed as a capitalistic aesthetics, that is, it is perpetuated through mass-consumption in the form of numerous artefacts: souvenirs, decoration pieces, T-shirts, costumes, and ultimately, audiovisual cultural products (movies, TV shows, advertisement spots, user-generated content, etc.). With the emergence of virtual platforms for the circulation of

10 Yann Beauvais and Jean-Michel Bouhours, eds., *Monter/Sampler. L'échantillonage généralisé* (Paris: Scratch / Centre Pompidou, 2000), 34.
11 Brenez, "Montage intertextuel," 53.

videos such as YouTube, even amateur videos become kitsch artefacts when they imitate, reproduce, or convey industrial motifs and codes.

The film introduces, for instance, a series of fragments of video advertisements for resorts in Hawaii and other islands, followed by photographs and videos of white people performing kitsch touristic rituals. These images are then followed by stills of Disney films such as *Moana* (Ron Clements and John Musker, 2016) and *Lilo & Stitch* (Dean DeBlois, Chris Sanders, 2002), as well as *Avatar* (James Cameron, 2009) and animated postcards. An excerpt from *Toy Story 3* (Lee Unkrich, 2010) dubbed in Arabic shows Barbie and Ken on a "Hawaiian vacation" in Bonnie's bedroom. Finally, the film cuts to a YouTube video of an Australian guru-like man sitting in the lotus position lecturing the spectator on the "Aloha spirit." "A-lo-ha," he says slowly, as the film intercuts with an excerpt of another resort advertisement and the Moai scene from *Night at the Museum* (Shawn Levy, 2006), where the monolithic statue of the Rapa Nui people asks Ben Stiller's character for gum. This montage, which lasts almost two minutes, places these disparate images at the same level, exposing by anamnesis their rhetorical similarity as well as their belonging to the same imperialistic cultural gesture. First peoples are associated with a sort of spectacle of vandal tourism.[12] In this sense, it is this visual saturation that uncovers the representational violence of Tiki Kitsch and of neocolonial images. It reveals the image as a territory of conflict and dispute.

The other main form of reuse is plaited montage, which, according to Brenez, consists in "enlightening certain images by recourse to others."[13] Through their interval, this operation produces new meanings. *100 Tikis* also explores the intervals between images through the use of superimposition or split screen.

One of the sequences of the film cross-cuts scenes from the short film *Twilight of the Gods* (Stewart Main, 1996) with a *Lord of the Rings* sequence between Frodo and the creature Sméagol/Gollum (*Lord of the Rings: The Return of the King*, Peter Jackson, 2003). Both films are made by Pākehā (non-Māori) New-Zealanders. The montage creates a parallel between the wounded European soldier in *Twilight of the Gods* and the burdened hobbit, and between the Māori warrior and Gollum. In the short film, for example, the Māori warrior catches a fish from a pond. But the montage cuts to Sméagol/Gollum eating a raw fish by the water. "Sméagol, Master is here," "you must trust Master," says Frodo as he asks the creature to follow him. The close-up of Sméagol's mistrustful eyes is interrupted by a close-up of those of the Māori warrior. The film then shows a kiss between the warrior and the soldier, transforming Frodo's and Sméagol's relationship through a

12 I borrow the term from Yervant Gianikian and Angela Ricci Lucchi's film, *Images d'Orient— Tourisme Vandale*, 2001.
13 Brenez, "Montage intertextuel," 60.

colonizer/colonized homoerotic reading. This is not the only time *100 Tikis* employs scenes from *Lord of the Rings*, a mainstream trilogy produced in New Zealand. Taulapapa's film associates bestial and violent creatures from *Lord of the Rings*, such as Orks with Indigenous subjects, as they are often portrayed by Māori actors under make-up and costume.

The cross-cutting described above belongs to a sequence exploring the homosexual tension inscribed in (neo)colonial relationships and fantasies. Images from films like *Mutiny on the Bounty* (Frank Lloyd, 1935) or *Moby Dick* (John Huston, 1956), from the US Naval film *Hello Hawaii* (1929), and a montage of US Naval photographs of American men in hula skirts, as well as White celebrities in hula or "Hawaiian costumes," reveal a strong, more or less suppressed gay desire at play. These images are cross-cut with images of *fa'afafine* photos or ballroom dance performances, celebrating divergent sexualities and gender expressions, far from Western oppressive norms.

This sequence structures the (neo)colonial gaze as a heterosexual, phallocentric, and patriarchal one, which also objectifies Autochthonous female bodies as shown by the reappropriation of amateur videos and photographs, of paintings by Gauguin and Picasso, as well as Hollywood productions: from Dorothy Arzner's *Dance, Girl, Dance!* (1940), or Mickey and Minnie's *Hawaiian Holiday* (Ben Shapsteen, 1937), to the comedy *Just Go with It* (Dennis Dugan, 2011) which includes actresses Jennifer Aniston and Nicole Kidman dancing the hula in bikinis. Later, pornographic pictures complete this visual constellation. These images of sexualized Native women, however, are opposed to images of real Autochthonous activist women raising their voices in political gestures. Their images appear displaced, rotated vertically on the left part of the screen, disturbing the succession of hegemonic representations.

In the second part of the film, "Post-post paradise or I was in the armed slaveries," the predatory gaze appears in the reuse of *Mutiny on the Bounty* (Lewis Milestones, 1962), where Tarita Teriipaia dances to Marlon Brando's voracious male gaze. Its reappropriation evokes Barry Barclay's writings on Fourth Cinema[14] and his analysis of the film. It develops the idea of possession and control—of land, of women's bodies, of visual representation. In Taulapapa's montage, the *Bounty*'s First Cinema's camera is stripped of its powers. The territory of reappropriation institutes an aesthetic and political island inside hegemonic cinema. As Barclay writes, "the Camera Ashore, the Fourth Cinema Camera, is the one held by the people for whom 'ashore' is their ancestral home. 'Ashore' for Indigenous people is not usually an island. Not literally. Rather, it is an island within a modern nation state."[15]

14 See for example: Barry Barclay, *Our Own Image: A Story of a Māori Filmmaker* (Auckland: Longman Paul, 1990).
15 Barry Barclay, "Celebrating Fourth Cinema," *Illusions* 35 (2003): 9.

In this island, women are political and historical subjects, and their bodies have agency and power, as shown by the vertical videos of activist women which again disrupt the *Bounty*'s gaze game.

Reappropriating images of struggle

By uncovering a colonizing and commodifying gaze through montage, *100 Tikis* confronts and subverts the violence this visuality perpetrates. The reappropriation of a multitude of these violent images and of the Tiki Kitsch iconography also exposes their power to erase and substitute Autochthonous images—images of their own—as well as Autochthonous bodies. Against such *othering* images, *100 Tikis* opposes them to *other* images, that is, images produced outside of hegemonic paradigms and spaces: for instance, amateur footage of political struggles from Hawaii to Papua New Guinea or New Zealand. Can these vernacular images of struggle construct another territory for Autochthonous visual and political representation?

In one sequence of the film, for example, images produced by the Occupy Hilo movement (the "99% of East Hawaii" based in the city of Hilo) are disrupted by a musical number from the Disney film *High School Musical 2* (Kenny Ortega, 2007). The amateur video, entitled *Mauna Kea Protectors arrested at the summit April 2, 2015*,[16] was published two days later on the movement's YouTube channel, and has now had over 8,000 views (which, considered globally, is not much for the platform's standards). It is a 12-minute unedited video that shows activists protesting against the construction of the Thirty Meter Telescope over the volcano Mauna Kea. Mauna Kea is the site of several observatories built from the late 1960s on, and since then it has become a site of dispute. Autochthonous movements fight to oppose the desecration of the land. The video was published along with a statement affirming that "at least 30 of our Mauna Kea ohana have been handcuffed and hauled off the mountain by county police and by state DOCARE officers of the Department of Land and Natural Resources—the very state agency that we are challenging in court." In *100 Tikis*, Taulapapa chooses to reuse the moment when the video shows women singing a sacred song beside the car where the imprisoned activists are held, while surrounded by policemen.

In Taulapapa's appropriation, their religious song is desecrated by the Tiki Kitsch Disney scene. Over their video, *High School Musical 2* erupts in the center of the screen through an audiovisual superimposition. The sequence features a musical number by a duo of rich, talented,

16 Occupy Hawaii, "Mauna Kea Protectors arrested at the summit April 2, 2015," Occupy Hawaii YouTube channel, April 5, 2015, https://www.youtube.com/watch?v=Dkw8Gv5EFKk. All links cited in this text are active as of June 2022.

Figures 1 and 2.
Stills, Dan Taulapapa
McMullin, *100 Tikis:
An Appropriation
Video*, 2016.
"A land far far away":
opaque montage and
visual confrontation.

and extravagant adolescent twins, Sharpay and Ryan Evans. In "Hawaiian costumes," in front of a volcano scenery, the Evans siblings perform "Humuhumunukunukuapua'a," a song about a "Tiki princess": "Aloha everybody, my name is Tiki!," cries Sharpay as she emerges from behind the volcano and hops over a fake surfboard: "I long to free a truly remarkable fish / My sweet prince Humuhumunukunukuapua'a / Makihiki malahini-who / Humuhumunukunukuapua'a / Ooh / Hawana waka waka waka niki pu pu pu!" As the artist notes in the *100 Tikis'* screenplay:

"Humuhumunukunukuapua'a is a kind of Hawaiian fish, the rest is ooga booga." Even if the musical number was originally meant to be absurd, revealing the excess and cluelessness of the characters who perform it, the result is the affirmation and promotion of the symbolic violence of cultural appropriation disguised as parody. Thus, *100 Tikis*' montage makes them obscene.

As the *High School Musical* sequence continues, the film interrupts the Mauna Kea protectors' video to show the beach love scene between Burt Lancaster and Deborah Kerr in *From Here to Eternity* (Fred Zinnemann, 1953). "Nobody ever kissed me the way you do," says Kerr's character as they kiss lying on the sand (figures 1 and 2). The addition of this excerpt from the classic film affirms the obscenity of cultural appropriation and colonization, exposing its depoliticization as well as the erasure of Hawaiian Indigenous existence.

The Mauna Kea protectors' images are part of a powerful movement in the original video. The amateur operator, recording with a cell phone, first films the event from outside the circle of the women singing, and behind the line of police officers. She then moves towards them and enters the circle, writing, with the women, words of struggle into the dust on the car's window. She goes to the other side and touches the window, leaving her hand over the dusty glass, but also her image, reflected on the car as we hear her breathe (figure 3). This fragile, trembling vision reveals a struggling body and its image. Through the camera, this woman both inscribes herself in the struggle and documents it. The cell phone camera produces, participates in, and witnesses the action. It is one with them.

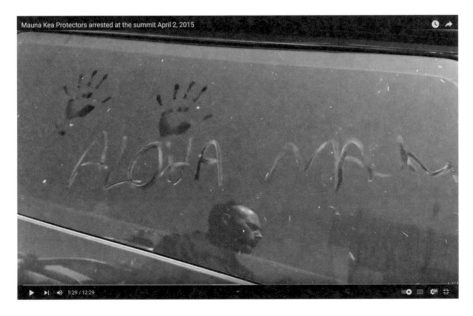

Figure 3. The potency of fragile gestures of struggle.

Paradise lost

Figures 4 and 5.
Stills, Dan Taulapapa
McMullin, *100 Tikis:
An Appropriation
Video*, 2016.
"Living free."

In *100 Tikis*, another sequence reusing amateur Autochthonous voices and images of self-affirmation and self-representation through political struggle refers to West Papua. Since the end of the Dutch colonial rule in 1962 and the Indonesian occupation the following year, the Free Papua Movement (Organisasi Papua Merdeka, OPM) carries out a guerrilla resistance for independence and self-determination. In this fight against Indonesian domination, West-Papuans have been persecuted, imprisoned, tortured, and killed. Since the 1960s, for example, over 500,000 people have been assassinated by the state's terrorism.

Towards the end of the second part, the film shows a sequence in which amateur images of the West-Papuan struggle are confronted with a travel video made by Angela Jelita Richardson, self-described on her website[17] as "a freelance journalist and editor currently based in Southeast Asia, with extensive knowledge on Indonesia." She states, "I'm passionate about human rights, travel, the environment, and photography." Richardson published the video on the January 2, 2014, on her YouTube channel.[18] The video has had about 8,000 views and is presented as

> underwater and overland fun in Raja Ampat, based out of Papua Paradise on Birie Island over a period of a week at the end of 2013. A beautiful

17 See: https://angelajelita.com. As of 2021, the description states: "I'm a seasoned journalist, photographer, and producer based in Southeast Asia. I produce and present a show on the Plant Based Network called *Feed Earth Spirit*, which bridges food, the environment, and consciousness. I'm passionate about plant-based food, wellness, human rights, travel, and the environment."

18 See Angela Richardson, "A Week in Raja Ampat, West Papua, Indonesia," Angela Richardson's YouTube channel, January 3, 2014, https://www.youtube.com/watch?v=-gliRXyLrpc.

"We Serve up Your Image": Autochthonous Détournement in *100 Tikis*

land that time forgot, thriving with life, which we all hope remains this
way. We were also very lucky to see not one, but two Wilson's Bird of
Paradise. Raja Ampat is definitely one of the most beautiful places left on
earth.

Her footage, comprising images of a group of tourists diving into an idyllic
sea, hiking in the forest, and later celebrating the new year with champagne
and fireworks, is edited together with the British band Morcheeba's song
"The Sea." Richardson's visual fantasy of island bliss is expressed through
verses like "I left my soul there/ Down by the sea/ I lost control here/
Living free/ A cool breeze flows but mind the wasp/ Some get stung it's
worth the cost."

The journalist's video is reappropriated by *100 Tikis* through
plaited montage and split-screen, along with anonymous videos shot
by West-Papuans during different political demonstrations (figures 4
and 5).[19] Their origin and circulation is as anonymous as the people who
produced them. One of the videos, for example, is already a compilation
of amateur images of police repression.[20] It was published a few days after
Angela Richardson's musical travelog (January 24, 2014) on a YouTube
channel called "Melan Nesia." The channel has only eleven videos dating
from January 13–24, 2014. They all concern the West-Papuan struggle, and
have accumulated very few views (the video in question has a little over
2,000 views today; others have no more than 100). Who were these videos

19 As Taulapapa McMullin describes them in the film's screenplay: "West Papua Indigenous
 peoples protesting Indonesian occupation of West Papua with flags and stones while being
 arrested and attacked by Indonesian military police with guns and tanks."
20 Melan Nesia, "The Brutality of Indonesian Police towards protestors in West Papua," Melan
 Nesia YouTube channel, January 24, 2014, https://www.youtube.com
 /watch?v=iifnm1uH0V4.

addressed to? They are not subtitled, but their titles briefly describe the occasion of their recording in English (in this case: *The Brutality of Indonesian Police towards protestors in West Papua*). For this user, perhaps, making these videos public was in itself a political act fueled by urgency and revolt.

It also becomes very hard to identify, to locate, and to date these images among the various images of struggle in West Papua that circulate on the internet—that is, on YouTube and Facebook, for example, where there are hundreds of short amateur videos documenting protests that end with police violence and chaos. The traces of these images are lost again and again in their wild chain of repetition and reappropriation.

The official Free West Papua YouTube channel has also had a rather limited number of views, but the videos they produce are released on their website and social media pages as well. They have a much larger reach on their Facebook page,[21] for example, with almost 390,000 followers. They also cover the different aspects of the struggle, but their videos, produced collectively by the social movement and intended for the international community, are more structured. Their strategies vary, but, in one of their clips (*Visit West Papua: Wonderful Indonesia?*, November 25, 2017), we can see a form of reuse similar to that of Taulapapa McMullin's. As the soundtrack adopts the tone of an advertisement announcing a "World of Wonders," "rich in history and ancient culture," the image counters this discourse by showing photographs of police violence towards protesters.

In this context, such discursive forms of reuse also circulate because the touristic visual rhetoric makes the struggle and the images of struggle invisible to the Western world. That is why these images are rotated vertically on the split-screen in *100 Tikis*, like the aforementioned images of female political activists, while the hegemonic ones remain horizontal. Counter to their erasure by both the touristic gaze and the hyper-visibility of violent images on mass-media, the spectator is forced to shift to another perspective to be able to really see them. This unpolished way of composing the split-screen also contributes to the radicalism of Taulapapa's provocative film, producing a chaotic confrontation between image and sound tracks. The potency of the montage emerges from its opacity.

Besides, deconstructing and disrupting this representation becomes part of the urgency of the struggle. Throughout Taulapapa's film, as well as the Free West Papua piece, the predatory touristic images of paradise are confronted in the way they operate as propaganda. This montage of confrontation exposes Richardson's video rhetoric as obscene and perverse. Following Marie-José Mondzain's question, "can these images kill?"[22]—can they oppress and colonize? In this sequence, this aspect is reinforced by the

21 Free West Papua Campaign, https://www.facebook.com/freewestpapua.
22 Marie-José Mondzain, *L'Image peut-elle tuer?* (Paris: Bayard, 2002).

song's lyrics. In the face of images of violence and torture, phrases like "I left my soul there" or "I've lost control" can evoke other meanings. Who is actually "living free" in West Papua? The struggle, in this sense, takes place inside the frame, in the field of the representation.

Another video reused by the filmmaker in this sequence shows a British television report that shows amateur footage of torture in West Papua. These videos went viral at the time of their release, but Taulapapa may have found them on another YouTube channel called "Knowing,"[23] which comprises five videos dating from 2010. The anonymous owner describes the videos as follows: "West Papuans being tortured by Indonesian TNI military/security/forces. Yesterday I also uploaded a full video but it was taken down by YouTube because of violation. Now my account has 1 warning." The video is presented with the following description:

> Will the President of the United States of America (USA), President Obama, still sign a deal to provide military training to the new reformed Indonesian armed services/forces? Will he support military that brutally tortures civilians and peaceful activists in West Papua & the Moluccas (Maluku Islands)? […] Indonesia admitted these video's which gives you a good look on how the Indonesian military try to keep order in 'Indonesia' by torturing those who are a threat to 'Indonesia'/'NKRI' are real/authentic. Uploaded on YouTube for the world to see the torture evidence and the footage of burned village! Taken from: Channel 4 News / Reporter: Kylie Morris (UK).

The channel's aim is clearly to denounce the crimes against humanity perpetrated by the occupying state. The videos circulate as evidence as they migrate from YouTube to televisual contexts and back to YouTube again. The original footage is also anonymous, but we know it belongs to another camp: it is made by the perpetrator, or *with* the perpetrator. However, here the images stand against the gaze that produced them.

In this sense, in *100 Tikis*, plaited montage demands an active position from the spectator regarding the stance of the original images, making them agents of the gaze. In general, the amateur videos shot by anonymous cameramen reused in this sequence of *100 Tikis* are images of resistance, and they represent it in the reappropriation. They raise flags while becoming flags themselves. They show bodies of equally anonymous people who clash with military power, who cry for recognition, sovereignty, justice, and freedom. They stand for the ongoing struggle against colonization and

23 See KNOWING, "UK news on Indonesia's Abu Ghraib torture West Papua," KNOWING YouTube channel, October 22, 2010, https://www.youtube.com/watch?v=smAFWyrNp7Q.

•

genocide. Like the images made by Occupy Holi, they are also fragile, trembling with the fragility of bodies at risk, trembling with the imminence of an event (destruction of the camera, police beating, arrest, death). The fragility of the body and the fragility of the apparatus align with the fragility of their aesthetics. These are precarious and unstable images, or poor images, as Hito Steyerl would put it. They have the potential to constitute counter-images, producing free and liberating visual narratives. In defying the military state's control, they point to their very existence, their very possibility. In *100 Tikis*, confronted with popular Tiki Kitsch culture, they also point to their possibility within a hegemonic context of image production. The only paradox inherent in these amateur images is that they circulate on YouTube and social media—which, belonging to capitalist conglomerates (GAFA: Google, Apple, Facebook, Amazon), are also technologies of power. But they circulate nonetheless, in their own cannibalistic aesthetic movements.

Conclusion

100 Tikis reproduces the minor aesthetics of poor internet images, claiming it as the only emancipatory form for an emancipatory art. As Hito Steyerl argues,

> The poor image is a copy in motion. Its quality is bad, its resolution substandard. […] It is a ghost of an image, a preview, a thumbnail, an errant idea, an itinerant image distributed for free, squeezed through slow digital connections, compressed, reproduced, ripped, remixed, as well as copied and pasted into other channels of distribution. [It is] a lumpen proletariat in the class society of appearances […]. The poor image has been uploaded, downloaded, shared, reformatted, and reedited. […] Poor images […] testify to the violent dislocation, transferrals, and displacement of images.[24]

For Taulapapa McMullin, the poor, radically free(d) image defies Tiki Kitsch, and his artistic gesture of reappropriation becomes Tiki.

Thus, the film's montage creates a political space of confrontation, affirmation, and liberation. It reclaims an Autochthonous right to look, as well as a right to look back at the oppressor's gaze. It dispossesses dominant visual forms and practices, and their circulation across *media*, histories, and territories. It establishes, in this sense, a new territory of aesthetic and political struggle—a territory of Tiki, and not Tiki Kitsch. As Taulapapa McMullin writes in one of his poems, this "land" has Tiki

24 Hito Steyerl, "In Defense of the Poor Image," in *The Wretched of the Screen*, Hito Steyerl (Berlin: Sternberg Press, 2012), 32.

"We Serve up Your Image": Autochthonous Détournement in *100 Tikis*

lifting the sky over Samoa, lifting the sky over Tonga
lifting the sky over Viti, lifting the sky over Rapanui
lifting the sky over Tahiti, lifting the sky over Hawai'i
lifting the sky over Aotearoa, and looking to, paying respects
to Papua, to the Chamorro, to Vanuatu, to Kiribati
lifting the ten heavens above Moana, not your Pacific, but our Moana.[25]

Through this cannibalistic *détournement*, the artist serves up the image of the West. After all, as he writes in his *100 Tikis Notes*, "what is history but possession?"[26]

Bibliography

Beauvais, Yann, and Jean-Michel Bouhours, eds. *Monter/Sampler. L'échantillonage généralisé*. Paris: Scratch / Centre Pompidou, 2000.

Barclay, Barry. "Celebrating Fourth Cinema." *Illusions* 35 (2003): 7–11.

Brenez, Nicole. "Montage intertextuel et formes contemporaines du remploi dans le cinéma expérimental." *Cinémas: Journal of Film Studies* 13, no. 1–2 (2002): 49–67.

McMullin, Dan. "Tiki Kitsch, American Appropriation, and the Disappearance of the Pacific Islander Body." *LUX: A Journal of Transdisciplinary Writing and Research from Claremont Graduate University* 2, no. 1, article 21 (2013): 1–6.

McMullin, Dan Taulapapa. "Tiki Manifesto." In *Coconut Milk*, Dan Taulapapa McMullin, 11–12. Tucson, AZ: University of Arizona Press, 2013.

McMullin, Dan Taulapapa. "100 Tikis Notes." *American Quartely* 67, no. 3 (2015): 585–94.

Mondzain, Marie-José. *L'Image peut-elle tuer?* Paris: Bayard, 2002.

Steyerl, Hito. "In Defense of the Poor Image." In *The Wretched of the Screen*, Hito Steyerl, 31–45. Berlin: Sternberg Press, 2012.

25 Dan Taulapapa McMullin, "Tiki Manifesto," in *Coconut Milk*, Dan Taulapapa McMullin (Tucson, AZ: University of Arizona Press, 2013), 12. See also Dan Taulapapa McMullin's contribution in this book, pages 107–8.
26 Dan Taulapapa McMullin, "100 Tikis Notes," *American Quartely* 67, no. 3 (2015): 586. See also Dan Taulapapa McMullin's contribution in this book, pages 109–13.

Challenging the Line:
The Forms of John Gianvito's Documentary Diptych on the American Military Bases in the Philippines

Caroline San Martin

In 2019, a series of colloquia around filmic forms and practices emerging from Autochthonous struggles was held at the French film school La Fémis. A masterclass with the filmmaker John Gianvito was organized in this context, to discuss his career and his work.[1] The event focused on his filmic diptych aimed at exposing the consequences and the aftermath of the presence of American forces in the Philippines, particularly in the Clark military base (*Vapor Trail (Clark)*, 2010) and the naval base in Subic Bay (*Wake (Subic)*, 2015). In these two films, John Gianvito reveals the vestiges of colonialism in what was an former de facto American colony, and highlights, from a cinematographic point of view, a persistent and annihilating tension between the public and the US military force.[2]

Before analyzing both films, here is a little context. The American presence in the Philippines dates from the turn of the twentieth century: the Clark Air Base was built by the United States in 1903 and the Subic Bay Base was already under consideration as early as 1868. At the time, the Spanish Empire explored the islands and considered Subic Bay as a strategic military location. In 1884, it was turned into a naval port and construction started to build out necessary facilities. After the Spanish–American War in 1898, the Philippines, together with the naval base, were ceded to the United States. Since then, via war, surveillance operation, and protection against terrorist threats, the Americans have maintained their armed presence in the Philippine lands. This archipelago, like the two bases located there, became American territory following the Philippine-American War, which began in 1899 and lasted until 1914, ending the Moro rebellion. The Philippines then remained a de facto US colony until 1946—even if its official status

1 The masterclass took place on April 8, 2019.
2 The negotiations to extend the US lease of the two bases beyond 1992, which ultimately failed, triggered "an impassioned debate in which the American military presence was assailed as a vestige of colonialism and an affront to Philippine sovereignty." David E. Sanger, "Philippines Orders U.S. to Leave Strategic Navy Base at Subic Bay," *New York Times*, December 28, 1991.

was much more complex.[3] Since the country's independence, these two installations have served as major staging bases and logistics hubs for several twentieth-century conflicts, among them the tail-end of World War II (1939–45), the Korean War (1951–53), and the Vietnam War (1955–75).

Therefore, since the beginning of the twentieth century, over decades, this American armed presence in the Philippines is held thanks to the agreement of both governments. It reached its peak during World War II, which led, in 1951, to the "Mutual Defense Treaty." This "partnership" became very important for strategic and logistical support during the Vietnam War. Even if this treaty has been challenged in the past few years, it is still more or less respected today. In fact, in 1991, the US Senate proposed a legislation to expand the presence of US military in the Philippines—transforming the previous agreement into a "Treaty of Friendship, Cooperation and Security." In reaction to this bill, supported by then United States Secretary of Defense, William Sebastian Cohen, thousands of protesters gathered outside the Filipino Senate asking the government to rule against it. This bill project was finally rejected by the Filipino Senate, followed by the US Senate, which could not impose the expansion of its armed forces without the agreement of the local government. On leaving the voting session, the President of the Filipino Senate, Jovito Salonga, declared: "September 16th, 1991, may well be the day when we, in this Senate, found the soul, the true spirit of this nation, because we mustered the courage and the will to declare the end of military presence in the Philippines."[4] However, several problems remained: the anchoring of a colonial way of thinking, the lack of memory regarding the history of the archipelago and the subordinated relationship in which the people of the Philippines are placed. Current devestations have since been added to these past sequels: an ecological disaster, and the consequences of an unsupervised military presence in both bays. Despite the withdrawal of troops after the treaty ended in 1991, in 1998, the "Visiting Forces Agreement" (or VFA) provided "a legal framework for the presence of American troops in the Philippines and for the organization of joint military exercises."[5] US Air Force troops therefore helped to facilitate patrols around the South China Sea islands. After a termination in 2020, President Duterte asked for the treaty to be reinstated in July 2021, in particular in order to fight against extremist military groups and to help with anti-terrorist surveillance.[6]

3 See: Daniel Immerwahr, "The Greater United States: Territory and Empire in U.S.," *Diplomatic History* 40, no. 3 (June 2016): 373–91, https://doi.org/10.1093/dh/dhw009.
4 Jovito Salonga's speech is referred to and quoted among the archives used in *Wake (Subic)*.
5 Michel De Grandi, "Les Philippines cassent le pacte militaire qui les liait aux Etats-Unis," *Les Échos*, February 11, 2020, https://www.lesechos.fr/monde/asie-pacifique/les-philippines -cassent-le-pacte-militaire-qui-les-liait-aux-etats-unis-1170916.
6 See: Rita Joviland, "Duterte ordered retraction of VFA termination—Lorenzana," GMA News online, July 30, 2021, https://www.gmanetwork.com/news/news/nation/797450 /duterte-ordered-retraction-of-vfa-termination-lorenzana/story/.

In *Vapor Trail (Clark)*, John Gianvito films Clark's base and the local people who live on Luzon Island. In 2015, he considers the other base, in Subic Bay, in the film *Wake (Subic)*, which we are going to study closely in this essay. Both films constitute a diptych entitled *For Example, The Philippines* that together amount to a documentary that lasts over nine hours. They also both lift the veil on the consequences of this misplaced and abusive military presence. The discourse is engaged; the films' tone is political. However, both films break away from the classic and expected dialectic filmic grammar of political films, and this is precisely what we are going to examine. Questioning the presence of American troops highlights the form of the films themselves, and in particular the use of an *organic montage*.[7] It is as if the refusal of Western narrative norms could be read as a political act of resistance: by refusing a form, the films challenge the discourse. Therefore, the organic montage which privileges the action's motricity is no longer an appropriate form. In the chapter dedicated to editing in *The Moving Image*, Deleuze points out another kind of montage, a *dialectic* one, as an alternative to the organic montage. Even if to a certain extent the latter could be considered as a substitute for the organic montage in both films, this is not exactly how the association of shots functions. In order to understand the specificity of the editing in both films, we will analyze certain sequences in order to perceive some nuances and interpret their political meanings. According to Gilles Deleuze's perspective, both types of montage are political: the first one, the *organic montage*, is conservative— even if it relies on oppositions such as rich and poor, and attempts to offer the audience a sense of unity at the end. The second one, the *dialectic montage*, is revolutionary, since oppositions always lead to new ideas.[8] The historical opposition between these two types of montage—one is put forward by Griffith, the other one by Eisenstein—is nevertheless not sufficient to underline clearly the complexity of the film's device. In fact, form is inseperable from the subject in both films. Both films invent other arrangements and reveal other forms of thinking, other ways to connect filmic elements. By working on the analysis of shots, sequences, and films, we will be able to understand the political commitment of this diptych. In order to do so, we will first explain how the *organic montage* can be problematic as far as both films are concerned.

Montage

A brief explanatory detour exposing the difference between these two forms of montage is necessary before unfolding the precise analysis. Gilles Deleuze reminds us, in the chapter entitled "Montage" in *The Mouvement-Image*,

7 Gilles Deleuze, "Montage," in *Cinema 1: The Movement-Image*, trans. Hugh Tomlinson and Barbara Habberjam (London: Athlone Press, 1986), 29–55.
8 Our choice of vocabulary is linked to Deleuze's terminology used in the chapter entitled "Montage," in *Cinema 1: The Movement-Image*.

that for Eisenstein, the process of editing is the whole film; what he calls the "Idea."[9] According to Griffith, the conception of editing is different since it is already a form of dramaturgy: at the beginning, the whole film always divides in two sections and these two sections act and react toward one another.[10] They turn into a conflict, they threaten the unity, they allow oppositions to be overcome, and they restore the situation. Finally, the editing follows a dramatic line which becomes a line in the story that has to be restored: by being challenged by a disturbing element, the initial situation generates conflicts (adventures) that threaten the balance given at the beginning of the story, until the element of resolution restores a new balance in the final situation. "It is wrong to criticize it [it being the *organic montage*, that is to say a montage whose function, whose organization is to unfold the line of the action] as being subordinate to narration; it is the reverse: for the narrativity flows form this conception of montage."[11] In other words, the narrative power is already contained in the form of editing, it is not merely an illustration: editing, therefore, is the "Idea" of the film itself. Film aesthetics is revealed through the logic of these filmic assemblage (*agencements*) and is not created by the discourse that makes it visible. Thus, this form imposes its singularity. Through editing, the discourse and the line of the story, which can be fictional or documentary, comes first, and the sequence of events becomes then mechanical. The deployment of such a logic involves finding a main dramatic line for the story either before it breaks, by anticipation, or after it has broken, by reaction. This logic pushes for the restitution of a situation, already given, by counterbalancing its possible deviations. In this formal context, we can clearly see how impossible it is for the films in question to put forward their "Idea."

Both *Vapor Trail (Clark)* and *Wake (Subic)* consider the tension caused by an unwanted occupation of the land. If, in the form of the documentary, deviations from a factual situation become impossible, then the forces of the discourse are already at work in the filmic narration and cannot find a place for expressing the people's struggle. With Griffith in particular, and in the declinations of the organic montage forms in general, the work of aesthetics consists in maintaining the direction taken by the main line of the plot contained in the initial situation (here, the American presence) by parrying and reframing all the possible bifurcations. Thus, it is not the illustration of a form of conservatism that is exposed in this montage form, but conservatism itself. Therefore, we understand much better the need for an alternative. With Eisenstein, as with Gianvito, the "Idea" of the film never occurs in a story led by the image (as occurs with the *organic montage*), but in the image of a story. In this sense, for Eisenstein, opposition is the priv-

9 Deleuze, "Montage," 32–40.
10 Deleuze, "Montage," 30.
11 Deleuze, "Montage," 31.

ileged form of aesthetics, the "Idea" of his films. Here lies the foundation of the *dialectic montage*; it marks all the progressions included within the filmic discourse, it is reflected in all the parts of the film, and it ensures they all reproduce the whole. The discourse then appears in the oppositions within the film and repeats itself in the different conflictual situations revealed. One could imagine that, in the work of constructing a discourse opposing the American presence to the Filipino resistance, such a dynamic could be instituted: the dominant discourse against the one of the oppressed—the economic interest and the military strategy *versus* the daily life of the inhabitants of the bay in which the military base is located and, in particular, the primary resources they consume. Thus would be organized the articulation between the testimonies (the discourse of the oppressed) and the voiceover that contextualizes the situation (the dominant discourse). Indeed, both films are

dealing with several storylines: the testimonies of Autochthonous people, the voiceover, the written inscriptions, the archives which are equally films or photographs, and the long shots of the bays. From the juxtaposition of these recognizable filmic segments (they all are very long—from four to twelve minutes), which are clearly set up in opposition, another image can emerge in the horror of the gaps between each of them: between the testimony and the bay, between the bay and the archive, between the archive

ABOVE AND NEXT PAGE Stills, *Wake (Subic)*, 2015. The frame-encompassing arrival of an American military vessel, juxtaposed with ...

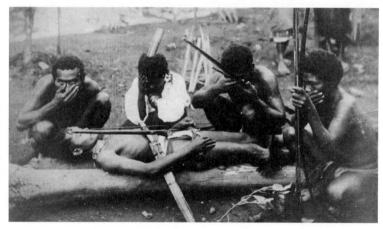

... archive photographs of the time of the Philippine–American War (1899–1913).

and the testimony. Through a series of round trips, through leaps leading in the opposite direction, rises an enlightened consciousness thanks to the shock of these absolute formal changes: the bay of Subic at dusk, in which the movement of the waves is barely perceptible; the photographs and archive films in black and white; the violence spoken of and pointed out by the Autochthonous populations in their contaminated living environment, the bruised and deformed bodies that inhabit it; and then the archive photographs along with the US Army ship occupying the entire frame. Once again, the form itself creates the discourse: the imperceptible content in the apparent cutaways is revealed by the testimonies, as if we were behind the scenes. But does the editing only put two opposite forms in tension? Are there only two in conflict (the past/present dialectic)? Is this opposition systematic to the point of becoming systemic? Is the logic of the sequence of events really found outside the images, in the birth of the absent image that links them? Is the "Idea" of the film the conflict, the opposition? Let's go back to the start.

Series of trips

What struck me the most, even before watching John Gianvito's diptych, is the length of these two films, which places them, apart from a few

Challenging the Line

exceptions, outside of a traditional distribution network. But this longform work is not only alluded to in the note that describes the films, it is also present in the length of the filming process, which took place over several years. Finally, this duration is of course present within the film since each shot, each sequence, takes its time. Thus, the chain reaction of the shots does not amount to an image of the discourse by working in favor of the narrative's linearity. The leap into the opposite[12] from one shot or from one sequence-shot to another doesn't establish a regular rhythm. An unusual duration is imposed. In *Wake (Subic)*, for instance, there are numerous still shots in which nothing seems to happen. There are many sequence shots of the bay, almost still, in which only the wind generates a little movement within the frame. The archival images are sometimes contextualized, sometimes not. The intermission unfolds the different forms that duration can take in cinema. The shots stretch, the encounters follow one another, the interventions of the voiceover recur. However, the rhythm of the film is not frenetic because the sequence shots are dominant: four minutes, ten minutes, fifteen minutes. So, even if everything repeats itself in its succession or in its composition, everything stretches and, in doing so, cancels the possibility of any regular cadence. This duration is not only internal, meaning within the frame or within the articulation from one shot to another, establishing a distance within the continuity. It is also reinforced by repetition through editing. In fact, the filmic process and the editing foster sensation over narration—or create a sensitive narration.

Let's return to the opening of *Wake (Subic)*. At first, I saw these successive cutting shots as general situation shots that present inaugural context, as they usually do in classic cinematographic grammar: a film begins with a dramatic situation anchored in a precise time and place. As such, the first shots should be large enough to show its geography, helping the audience to contextualize the action to come. The shots are not the only indications that allow the viewer to contextualize *Wake (Subic)*. The inscriptions on the black screen, before any image is shown, and the presence of the waves—thanks to the overlapping sound—tell us that we are in Subic Bay. But before learning the context of the future images and where they come from, the name of the production company appears on the black background. The succession of these two written elements (the production company and the geographical location) amounts to a first anachronism, a first request for attention to the images, a first proposal for my mental editing: the production company is in the United States, the recorded material (the sound of the waves) comes from the Philippines. The name of the production company on the black background follows the cinematographic convention of film credits, while the waves washing ashore expose another

12 Deleuze, "Montage," 35.

one, contextual, indicating the film's location. From a figurative point of view, the wording "A Travelling Light Production" contrasts with the black where it is affixed thanks to its white lettering and the inscription of the word "Light" where there is none. The following wording, "Subic Bay / Zambales Provinces / Philippines," is, on the contrary, completely associated with the sounds of the waves. Thanks to the duration of this first shot, the montage is already inherent in the image. The elements (the sound, the black background, and the words) assert themselves as fragments that can be identified and rearranged (the author of the images, their nature, etc.). The sound, at first, summons an elsewhere—the set-up of the story to come—and later, induces a spatial and temporal displacement: the missing image echoes the word "Bay," literally inscribing itself as the source and the origin of the sound of the waves given that the screen is still black at that point. In this second contextual mention, the sound ambience asserts itself as intradiegetic, whereas it was not diegetic during the single black screen and the mention of the production company. From an editing point of view, it is both a mechanical arrangement (linking a sound to its source) and a leap into the contrary (the United States and the Philippines) in the same shot: the time of the reception and the time of the narrative are co-present on the screen. These two forms of binding between the elements of the composition are caught in an infinite circulation. This associative modality is repeated: the sound of the waves is lost only to return again when the American army ship passes; later, the sound of the car's blinker resonates with the lapping sounds produced by this same ship. As for the movement, it is added and then eliminated. Movement can also circulate from one element to another: the fixed shots in which some elements are mobile contrast by formal resonance with the car in which the camera is positioned. The military ship finds itself among the weapons in the archival photographs—on both film and still images, the Western presence is shown alongside the Native population. Later, following the title sequence, the voiceover and images allow for other types of relationship between the elements: photographs appear at the moment certain words are pronounced, the editing suspending them as if the continuous flow of the film was slowing down a little, in the way that a closeup is capable of tearing the image away from the rest of the film in order to reveal a face. By returning autonomy to the elements of the composition, the film affirms that the whole is never given in advance, and elicits new forms of connection. A logic of instability is then put in place, replaying the political context of the images. For this incessant reformulation to be effective, the elements of the composition must first be presented as a form of emancipation: here lies the political aim of the film—an aspiration for decolonization as far as images, sounds, discourses, and ways of thinking are concerned. This is why the filmic associations are not systematic; they do not cease to thwart the rules they once

participated to elaborate. This is particularly the case regarding the use of the voiceover. At first, it suggests a rather classical function of commentary. It allows for contextualization. From a temporal point of view, this voice emanates from another time and another place than those of the diegetic voices—it seems logical that it should resonate with the archival images. But after a few minutes, this voiceover disappears and is replaced by photographs that slowly scroll by without a sound. Consequently, the systematic association between the archive and the voiceover is not definitive. Even more, the voiceover reappears over the images as a vestige, a reminiscence, a sound memory brought back by the very nature of the images—the name of a past personality returns on a portrait. It is secretly repeated in the silence of the soundtrack. The montage thus advocates the inconstancy of associations and, in this sense, tells the story through the image, revealing the alliances and disunions between the two countries. These constant reformulations search the possible combinations that could invent those to be experienced in order to get out of a given situation; as if watching the film, *really* watching it, was already a way of seeing the extent of the filmic and political problem; the film and the situation it depicts being both sides of an equivalent phenomenon.

Dialog

Gianvito's film's aesthetics leads to a series of changes that positions it upstream from the dominant form of discourse. From this point, it is then possible to feel the forces at stake in this dominant discourse. That is the reason why it is important to remain on the side of sensitivity. Experimenting with perpetual new assemblages indeed prevent satisfaction with the usual form of the narrative: the thread is no longer imposed from the beginning or reduced to finding the problem thanks to the formal leap into a form of opposition. I then experience a situation that refuses to continue, to perpetuate itself, to be preserved as such. Why is this dialog to be maintained on the side of sensitivity? Because being sensitive to the political situation in the Philippines does not only involve an intellectual posture or the compilation of objective data. In order to encounter the film, I must maintain a dialog with it, that is to say, make possible the meeting of two sensibilities: the one of the film, and the one of the viewer. In the cutaway shots, at the military base, in the archive images, while the inhabitants speak to the director, when they show us the extent of the ecological disaster, everywhere, the shots are stretched and the frame never slows down. As for the movements of the frame, the shots are very fluid, they never contradict those present inside the image: a boat moves, a body moves, tears are wiped from a face, arms embrace, cuddle, care. The action is not complex, only the situation is. This is the reason why the action does not

ABOVE AND OPPOSITE
Stills, *Vapor Trail
(Clark)*, 2010.
The toxic
contamination
emanating from
the former US
military bases runs
invisibly through
soil and water.

involve a preconceived set of relationships: actions take time, they are long
and dilatated. The editing, in its rhythm, does not concede to the pressure
to dive quickly into the heart of the story. It gives the images time—time for
me to watch them carefully. It forces me to observe what cinema enlightens:
the complexity of time. For the images do not frantically follow one another,
they persist, they associate themselves by formal resonances, they call upon
the *déjà-vu* (already seen) and the *déjà-entendu* (already heard), from an
extra and intra-filmic point of view. Not only is the past of the situation
present through the voiceover and the archives, but the mode of association
recalls the noises perceived in the previous sequences, the forms already
conveyed in certain shots. Therefore, not only are the elements circulating;
so are temporalities. The film dialogs with me not only because it is capable
of circulation between the intra- and extra-diegetic, but also because it keeps
me from separating the past and the present within its form.

Through duration, montage forces me to feel sensitivity toward what
is happening, since what is happening and what has happened are insep-
arable. Therefore, narrating by following a linear succession of events is
impossible. Past and present circulation is implied by their co-presence.
Consequently, by defying the line of action, duration strangely extracts me
from the confinement of the narrative: as a French person, both the Philip-
pines and the United States are far from me; here is a fight in which I am not
directly involved. Nevertheless, by extraction, by removing the effectiveness
of the gaze, here I am included in the problem despite being geographi-
cally so far from it. If the point of this duration is no longer to bring me as
quickly as possible into an objective comprehension of the sequence of

Yes, because there is no winning against sickness.

events, its stake is elsewhere. It concerns the displacement of my gaze: no longer efficient but attentive. The duration then offers me a place within the image, a journey within the frame. It demands from me an unprecedented attention in which a political requirement is lodged. "It is not only a question of subjectively watching the world through a consciousness but objectively making a consciousness sees through an image that makes the world. What matters in the image is not only what the character [here, the Filipino people] sees, but what makes an outside observer [the filmmaker] see of himself. We are not 'with' the character without also observing him 'objectively' from the outside. Everything happens as if there were two reflections in the same image, as if the image was seen from the inside with the character, but also from the outside by a narrator (a spectator)."[13] By experiencing it from my position, as a spectator, the film invites me to perform it in my life. Faced with the complexity of situations, the editing has taught me not to rush into action; to be wary of the efficiency of solutions that are only efficient on the surface. My experience as a spectator has given me the time to observe. As a member of the audience, the film has taught me to displace my expectations: if I had once considered a film to be the addition

Madapdap Resettlement, July 2007. Ruben Naguit describes his afflictions after years in the temporary resettlement area established on the former Clark Air Base territory following the eruption of Mount Pinatubo in 1991. Hundreds of people, many of them children, died of leukemia, lung disease, and other ailments due to exposure to toxic waste. Naguit suggests that his situation is worse than during the war—one can run from airplanes and gunfire but "there is no winning against sickness."

13 David Lapoujade, *Fictions du pragmatisme: William et Henry James* (Paris: Éditions de Minuit, 2008) 31. My translation. The original reads: "Il ne s'agit pas seulement de voir subjectivement le monde à travers une conscience mais de faire voir aussi objectivement une conscience à travers une image qu'elle se fait du monde. Ce qui importe dans l'image, ce n'est pas seulement ce que voit le personnage [ici, le peuple philippin], c'est ce qu'il fait voir de lui-même à un observateur extérieur [le cinéaste]. Nous ne sommes pas 'avec' le personnage sans l'observer également du dehors 'objectivement.' Tout se passe comme s'il y avait deux reflets dans la même image, comme si l'image était vue du dedans avec le personnage, mais aussi du dehors par un narrateur (spectateur)."

of pieces of information, John Gianvito's films have introduced me to a form of sensitivity that prefigures the discourse. Not only does the duration allow me to see in the image what I refuse to see in reality, but it reveals the extent of a problem lying in this gigantic American military ship that has obsessed me since the viewing of *Wake (Subic)*. This ship settles in the frame from the beginning of the film. It denies the depth of the image. It constantly returns it to its two-dimensionality, which would usually be countered by the illusion of depth. It erases the surrounding space and occupies the whole frame. And, suddenly, something asserts itself: this boat is the problem, abnormally present and continuously there. If this way of occupying space confuses me, it is because it forces me to experience its omnipresence.

The sensitive discourse defies intellectualization and proposes a form of distance: I do not recognize the situation in the Philippines as I am crossed by the forces of oppression. To deprive oneself of the effective, to find the images thanks to duration, this type of reception occurs through an operation of reduction. "Reduction is first of all an operation of cleaning. It is necessary to purify the field of the experience of all that prevents to see."[14] That is what I experienced in my dialog with the film. The regime of signs that the film mobilizes allows me to situate myself in the space that welcomes me for a while: I recognize intra- and extra-cinematographic elements (a ship for the army, the American flag for its military, cutaways, opening credits, etc.). All those signs, conventionally added up, now saturate the image and, even worse, are deprived of their causal extensions—extensions that introduce a continuity of discourse beyond the effective discontinuity of the shots. Continually in the dialog that we maintain with the film, something does not hold, something collapses. We evoked a permanent circulation between sounds and images, but it is also the case with the movement. In the two successive shots on this military ship, two movements (of the frame and within the frame) are combined in large shot that shows what surrounds it. Then, when the frame widens, the connection between the shots does not provide any additional information about the geographical situation than the previous one, and yet the shots stretch in duration so that the movement of the gaze is possible within the image. Duration is not only present in the shots that resemble cutaways; it is also present to block any chain reaction and thus proposes other modes of dialog: from one shot to another, and within the sequences themselves, such as during the care of bodies deformed by pollution—gently unfolding the contracted muscles—or the fixed frames that host the various

14 David Lapoujade, *Les Existences moindres* (Paris: Minuit, 2017), 41. My translation. The original reads: "La réduction est d'abord une opération de nettoyage. Il faut purifier le champ de l'expérience de tout ce qui empêche de voir."

testimonies. Therefore, the aim of John Gianvito's cinema is not as political as it is pedagogical, or in other words: a political pedagogy. Both films allow me to add new elements to my knowledge, to allow my learning to take place at many levels: I learn more about a context and a situation, but I also learn how to feel the invisible forces contained in the images of this situation. The logic of the editing is then no longer only mechanical or dialectical; it conveys the purpose of the film, making me feel the forces of the oppression.

Contributors

Editors

Nicole Brenez teaches Cinema Studies at the Sorbonne Nouvelle University Paris 3 and heads the department of Analysis and Cinematographic Culture at La Fémis. She is a longtime curator of avant-garde cinema at the Cinémathèque française and has extensively published on experimental and political film practices.

Jonathan Larcher is a filmmaker and an associate professor at the Paris Nanterre University, where he is the director of the master degree program Documentary Cinema and Visual Anthropology. He received his PhD in anthropology at the École des Hautes Études en Sciences Sociales. He is currently working on the preservation of the video archives of the political collective Promedios (Mexico).

Alo Paistik is active as a researcher and educator in France, Germany, and Estonia, focusing on media history and politically engaged media practices. He currently works at the Goethe University Frankfurt and at the German Film Museum (DFF), and coordinates an international cooperation project helping to preserve Nigerian film heritage.

Skaya Siku (Seejiq Truku people) received a PhD in visual anthropology at the École des Hautes Études en Sciences Sociales. She currently works as an assistant research fellow at the National Academy for Educational Research in Taiwan and contributes to the development of Indigenous cultural activism through diverse educational and artistic projects.

Authors

The Struggle of Marginalized Peoples Is the Perfect Remedy for an Ailing Nation. Okinawa, Silenced by Japan

Chie Mikami is a journalist and filmmaker. In 1995, she moved to Okinawa when Ryukyu Asahi Broadcasting Corporation was established. Concurrently with her duties as the main local news anchor, she has produced numerous documentary programs on topics such as Okinawan culture, nature, the Battle of Okinawa, and the issue of the US military bases. Her programs have won numerous broadcasting awards. Her first feature-length documentary *The Targeted Village* (2013) won both the Citizens' Prize and the Directors Guild of Japan Award at the 2013 Yamagata International Documentary Film Festival. In 2014, she departed Ryukyu Asahi Broadcasting and presently works as a freelance journalist and filmmaker. She has since made three other documentary films on the colonial history of the archipelago: *We Shall Overcome* (2015) and *The Targeted Island: A Shield Against Storms* (2017) on the resistance of the populations against the important presence of US military bases on the island of Okinawa and *Boy Soldiers: The Secret War in Okinawa* (2018) (with Hanayo Oya) on the traumas and amnesias of the Second World War. Her films are internationally distributed by Zakka Films.

Walking the Path of Resistance with My Films on My Back

Mayaw Biho, a filmmaker, lecturer, and activist, was born in 1969 to the Ceroh Tribe in Hualien, Taïwan. A graduate in film and audiovisual studies, Mayaw Biho is the author of more than thirty films. A pioneer of Indigenous cinema in Taïwan, he first explored the living conditions of the aboriginal populations confined in the slums of urban areas (*Children in Heaven*, 1997) and documented the rites and myths of the different Indigenous tribes of the island (*As Life, as Pangcah*, 1998). With the aim of participating in the revitalization of Aboriginal cultures, he denounces the historical policies of Sinicization (*What's Your "Real" Name*, 2005), becoming one of the first activists and filmmakers to encourage Indigenous families to reclaim their original names. In addition to his work as a filmmaker, he strives to make Indigenous stories visible by engaging directly with the various institutions that screen and distribute his films. To this end, he participated in various Indigenous festivals between 2000 and 2003 and offered his services on several occasions to the Taiwan Indigenous Television (created in 2005). In January 2012, he decided to run for the elections of the Indigenous representatives of the Legislative Yuan, the legislature of Taiwan. Finally, faced with the slow process of recognition of the territorial rights of Indigenous peoples, he initiated—with Panay Kusui and Nabu Husungan—the occupation of a section of a public space in the vicinity of the presidential palace in Taipei. The Ketagalan Boulevard protest, as it is called, has been ongoing since February 23, 2017. Since 2019, Mayaw Biho's has been developing an independent experimental elementary school.

Aide-Mémoire. Disinterring the Colonial Past in Service of the Present, A Conversation with John Gianvito and Myrla Baldonado

Myrla Baldonado, has over the past three decades worked as an activist in the Philippines and the United States among communities affected by political oppression and workplace harassment. From 1983–85, she was a political detainee under the Marcos regime in the Philippines, enduring interrogations and torture. Concurrently with her anti-dictatorship activism, she became increasingly involved in the social movement against the US military bases in the Philippines. As a part of her commitment to human rights activism, she co-founded the NGO People's Task Force for Bases Cleanup (PTFBC) and subsequently the Alliance for Bases Cleanup International through which she advocated at the UN-level for the cleanup and the extension of humanitarian assistance to the affected communities. After decades of commitment on-site, setting up support groups for the victims of hazardous contamination, she was forced to migrate to the United States. As the Organizing Director of Bayanihan Foundation Worldwide, she continues to address issues such as the environmental damage at the US military bases of Clark and Subic. In parallel, she has confronted the issues raised by the workplace abuse of domestic workers in the US. She is currently working with the Pilipino Workers Center in Los Angeles.

John Gianvito is a filmmaker and a professor at Emerson College. He is the author of a series of films that, over the past two decades, have documented a visual history of US imperialism and investigated the consequences of its military presence on the populations of Iraq, Afghanistan, and the Philippines. Since *The Mad Songs of Fernanda Hussein* (2001), he has shown that "the long memory is the most radical idea in America" (C. S. Loeb). This quote opens the film *Profit Motive and the Whispering Wind* (2007), which the filmmaker dedicates to the memory of struggles in the United States, from the American Indian Wars to the anarchist and unionist movements, via the revolts of African-American slaves. Through his work as a film programmer and a film historian, John Gianvito has strived, in an internationalist perspective, to shed light on the extensive links between the history of cinema, social movements, and political arts. His most recent longform documentary, *Her Socialist Smile* (2020), explores the oft-overlooked life-path of Helen Keller as a champion of workers' and women's rights.

Ricardo Matos Cabo is an independent film programmer and researcher based in London. Among other things, his work focuses on the history of documentary cinema; the intersection between cinema, the archive, and the history of social movements, with a current focus on post-war Japanese documentary; and the history of film pedagogy. He co-edited the book *Se acercan otros tiempos—Peter Nestler* (2023) with Lucía Salas. He teaches Film Exhibition Histories at the Elías Querejeta Zine Eskola in Donostia, Spain.

Rupert Cox, currently the director of the Granada Centre for Visual Anthropology at the University of Manchester, is an anthropologist and filmmaker with a long-standing interest in the intersections between art, science and anthropology that employs multimodal practices drawn from sound art, documentary, and landscape film, which are directed towards creative forms of public engagement. His regional expertise has been focused on Japan (since 1992), which has expanded since 2019 to projects in Colombia, and most recently, France. His research has explored varied topics including the Zen Arts, the idea of Japan as a copying culture, the political ecology of US military bases, and the sonic relationships between biodiversity and aesthetics. He recently completed an art book for Archive Books, a sound archive for Alexander Street Press, and is in the process of completing a monograph and a handbook on visual methods for Routledge Press.

100 Tikis Souvenir. *O upu ua lele i le matagi e*

Dan Taulapapa McMullin is a faʻafafine artist and poet from Sāmoa i Sasaʻe (American Samoa). Their artist book *The Healer's Wound: A Queer Theirstory of Polynesia* (2022) was published by Puʻuhonua Society and Tropic Editions of Honolulu for the 2022 Hawaiʻi Triennial, and is available through Printed Matter. Their book of poems *Coconut Milk* (2013) was on the American Library Association Rainbow List of Top Ten Books of the Year. Their work has been shown at the Museum of Modern Art, Museum of Contemporary Native Art, Metropolitan Museum, De Young Museum, Honolulu Museum, Kathmandu Triennial, and Venice Biennale. Their film *Sinalela* won the 2002 Honolulu Rainbow Film Festival Best Short Film Award, and their film *100 Tikis* was the opening night film of Présence Autochtone 2016 in Tiohti:áke/Montréal. Taulapapa's studio is based in Muhheaconneock lands of Hudson, New York. www.taulapapa.com

Karrabing, Filmmaking for Making the Land and Its People

Karrabing Film Collective consists of over fifty members, all but one of whom are Indigenous stakeholders for the land, with ages from newborn to elder. Forming an extended creative and filmmaking family in the midst of a social and political turmoil that touched their community in the late 2000s, the members of the collective mostly live in Australian Northern Territory. Through their films and installation works, the collective strives to invent and employ representational forms that are entirely their own, rejecting "state-mediated anthropological concepts to make sense of themselves." The work of the collective deals with the issues of the history of Indigenous disentrancement by the Australian government, and the effects of current repressive economic and social policies on the Indigenous communities (an overzealous criminal justice system, a faltering social welfare system, the pressure excreted by extractive industries), and explores the themes of alternative future (Indigenous) histories. The films are the result of collectively developed scenarios and dialogs termed "improvisational realism," while making use of pedestrian image-making technologies such as smartphones. Their films have been screened in numerous festivals and have been the subject of multiple installations. For a detailed presentation of the films and projects of the collective see: karrabing. info.

Of Megaphones, Cameras, and Songs. The Films of Nadir Bouhmouch and the Moroccan Amazigh Movement on the Road '96

Nadir Bouhmouch is a Moroccan film director. Trained in UC San Diego and based in Marrakech, he is the author of *Amussu* (2019). His student years, which took him far away from the former colonizer's sphere of influence, prompted his interest in ethnic, racial, and gender-related minority issues, but also in Third Cinema. At that time, Nadir Bouhmouch had already produced a few committed films, directed during his first and second years as a film student, and as a member of the Guerrilla Cinema group, formed in the wake of the February 20th Movement, the Moroccan Arab Spring. *My Makhzen and Me* (2012) dealt with the Moroccan uprising of 2011, and *475* (2012) with an article of the Moroccan penal code which allows rapists not to be judged if they get married to the raped woman. A few months after coming back from San Diego, Nadir Bouhmouch went to Imider and met the Movement on the Road '96.

Omar Moujane is a figure of the Movement on the Road '96. In the photos taken by the Movement's Committee for Medias and Communication, in Nadir Bouhmouch's films (*Paradises of the Earth*, 2017; *Amussu*, 2019), and at the screenings of *Amussu*, his are among the recurring faces and voices of the Movement. Omar Moujane has a precise and profound knowledge of the history

of the Movement and of the environmental and social consequences of the establishment of the silver mine on his tribe's land. An activist in Imider, Omar Moujane, is also one of its former political prisoners, as he was jailed from 2014–16. When the film project arose and its shooting started, he was a member of the local production committee for *Amussu*. He is also a research student in sociology.

Marie Pierre-Bouthier has a PhD in film history from the Paris 1 Panthéon-Sorbonne University, a degree in Cinema and Arab Studies from the École Normale Supérieure, and is associate professor in the History and Aesthetics of Documentary Film at the University of Picardie Jules Verne. She is also a film curator, and is involved in projects for the valorization and preservation of film archives in Morocco. Her interests as a researcher and programmer concern both the documentary genre and the cinema of resistance in the Maghreb. She is particularly interested in the works of Leila Kilani, Jean-Louis Comolli, Ahmed Bouanani, Ali Essafi, and Nadir Bouhmouch. In her research into the relationship between cinema, Moroccan filmmakers, and politics in an authoritarian context, she reconstructs modes of censorship, along with the strategies developed by Moroccan documentary filmmakers to circumvent it and accomplish their political and aesthetic ambitions. This research has led her in particular to tackle questions of the decolonization of the gaze, film forms, and film production, and draws attention to clandestine or alternative documentary practices. She is currently interested in the formative years of Moroccan film students in film schools in Europe and North America, and in the social intervention films of the Tunisian Federation of Amateur Filmmakers.

Of an Attempt to Deconstruct Landscape to a Weaving of Teachings

Etienne de France is a visual artist born in Paris, France, where he is currently based. He studied art history and archaeology at the Sorbonne University, and completed a bachelor's degree in visual arts at the Iceland Academy of the Arts. Known for interdisciplinary projects mixing hypothetical scenarios with reality, such as *Tales of a Sea Cow* (2012) and *Icelandtrain* (2009), Etienne de France works across media including film, photography, writing, drawing, and installation. More recently, his practice has questioned landscapes as spaces of resistance and imagination, cooperating with environmental activists, farmers, and architects to produce works including *The Green Vessel* (2015–19), *Looking for the Perfect Landscape* (2017), and *Field* (2020). Recent exhibitions and screenings in museums and at festivals include Te Tuhi Art Centre, Auckland, 2020; DocLisboa, Lisbon, 2020; Los Angeles Contemporary Exhibitions, Los Angeles, 2019; 14th Bienal de Artes Mediales, Santiago, 2019; FID Marseille, 2019; Fondation Ricard, Paris, 2019; Museu de Arte Brasileira, São Paulo, 2017; International Center of Art and Landscape of Vassivière Island, France, 2016; Reykjavik Art Museum, 2016; FIAC Hors les Murs, Paris, 2014; and Parco Arte Vivente, Torino, 2012.

David Harper has for the past twenty-five years served as the traditional spokesman for the Mohave Elders Committee. David is the author of a reburial policy for artifacts and isolates adopted by the National Congress of American Indians. As the founder and first appointed director of the Tribal Historic Preservation Office for the Colorado River Indian Tribes, he has acted as a liaison with agencies, development companies, and utilities, and established cultural monitoring programs. David is recognized by the State of California as an expert witness on traditional Mohave culture and has testified in Federal Court on the potential cultural impacts of solar energy projects in the Southwestern United States. David is also a founding board member for Greenaction for Health and Environmental Justice, a nonprofit organization based in San Francisco, and served as the chairman of the Colorado River branch of the National Association for the Advancement of Colored People (NAACP). He has written and directed several documentary films on the effects of solar projects on traditional landscapes, and participated in *The Marking of a Milestone* (2015), produced by John Wright Productions for the CRIT, and *Tending the Wild*, co-produced by the KCETLink Media Group and the Autry Museum of the American West.

Blackhorse Lowe is a filmmaker from the Navajo Nation. He is a writer, director, producer, and editor known for *5th World*, *Shimasani*, *Chasing the Light*, and *Fukry*. His films have played at Sundance, Tribeca, imagineNATIVE, Skábmagovat , Māoriland, Land InSights Montreal First Peoples Festival, and many other international film festivals, garnering numerous awards and accolades along the way. A recipient of a Re:New Media Award, Lowe is an alumni of the Sundance Institute's NativeLab, Producers Lab, and Screenwriters Lab. Lowe also curates an ongoing film series in Albuquerque, New Mexico, called CineDOOM that showcases both edgy and genre-driven Indigenous films. Currently he is a 2019–20 Tulsa Artist Fellow recipient, writing a variety of genre features and programming film screenings in the Tulsa area.

Jonathan Sims is from Acoma Pueblo, one of a handful of sites that can claim to be the oldest continuously-inhabited places in North America. He is a devoted father of two children, and a media maker. A journalism graduate from New Mexico State University, he worked in the news industry for one year, and has been a freelance media maker for over twelve years. His work has taken him around the country and the world. Jonathan has been part of major motion picture sets and one-man-band international travelogues. Most recently, he finished his Master's degree in Creative Writing, with an emphasis on Screenwriting and intends to pen more features. He has been an appointed leader within his tribe, having served as Tribal Secretary for two terms. Acoma has a storied history in filmmaking and Jonathan oftentimes managed film location requests for the Pueblo, creating its first structure for giving permissions. Jonathan ultimately wants to continue to create community stories and eventually direct his feature films.

Jamahke Welsh is a traditional Bird Singer and a former employee of Colorado River Indian Tribes Museum. He is currently a monitor for Colorado River Indian Tribes from the department of Tribal Historic Preservation Office.

"Camera Is My Machete." Promedios and the Construction of Zapatista Alternative Media

Francisco Vázquez Mota (Paco Vázquez) is an Indigenous photographer born in 1972 in the Nahua/Momoxca community of San Pablo Oztotepec, south of Mexico City. He studied at the Escuela Activa de Fotografía. He worked as a social photographer and as a photojournalist in Mexico City. In 1998, he was invited to participate in the creation of the Chiapas Media Project, which today is called Promedios de Comunicación Comunitaria A.C. Since then he has been a training coordinator, responsible for the technological localization and general coordination of Promedios. He also participated in the creation of the Central American Community Journalism Network of Popular Communication for Autonomy (Red de Periodismo Comunitario Centroamericano de Comunicación Popular por la Autonomía—COMPPA) in 2003. He currently coordinates the preservation project of the audiovisual archive of Promedios.

Zapatista Cinema

Nicolas Défossé is a producer, film editor, director, and teacher, and has devoted himself to documentary cinema since the end of the 1990s. With a Master's degree in philosophy from the Paris 1 Panthéon-Sorbonne University, he first worked in documentary cinema as a film editor in Paris. Starting from 2001, he worked with the association Promedios de Comunicación Comunitaria / Chiapas Media Project, involved in audiovisual training in Southeast Mexico. During these years, he notably directed ¡Viva México! (2009). In Chiapas, he co-founded the Mexican production house Terra Nostra Films, where he produced and edited award-winning documentaries directed by local authors, such as Negra (Medhin Tewolde, 2020), Vaychiletik (Juan Javier Pérez, 2021) and Mamá (Xun Sero, 2022). He is academic coordinator and professor at the Escuela de Cine Documental de San Cristóbal de las Casas (Chiapas). He is also one of the authors and editors of the book Cine político en México (1968–2017) (Peter Lang, 2019).

Intertwining Indigenous Resistance in Cauca

Ariel Arango Prada (Columbia) is an independent photographer and documentary filmmaker; Integral Film and Television Producer for the Centro de Investigación Cinematográfica in Buenos Aires, Argentina (2012); and founder of Entrelazando, an audiovisual and editorial production company dedicated mainly to artistic and social justice issues. His work has focused on issues of cultural identity with Afro and Indigenous communities, artistic and urban expressions, conflict, and memory, especially in Latin America.

Laura Langa Martínez (Spain) is a writer with a PhD in Social and Cultural Anthropology from the Universidad Autónoma de Madrid in collaboration with the Consejo Superior de Investigaciones Científicas (2020). She is currently a researcher in the research project "NECROPOL. Beyond the Subtierro: From the Forensic Turn to Necropolitics in the Exhumations of Mass Graves" for the Spanish Ministry of Science and Innovation. Her work has focused on researching the processes of (in) Transitional Justice, violence, and memory. She is a member of Entrelazando Audiovisual Production Company, and co-founder of Entrelazando Publishing House.

Nūhū Yãgmū Yõg Hãm: This Land Is Our Land! A travel Journal

Isael Maxakali holds a PhD in Social Communication (Notório Saber) from the Federal University of Minas Gerais (UFMG). He is a filmmaker, a teacher, and a visual artist. He has directed numerous films, including Tatakox (2007), Xokxop pet (2009), Yiax Kaax—Fim do Resguardo (The End of the Lying-In, 2010), Xupapoynãg (2011), Kotkuphi (2011), Yãmîy (2011), Mîmãnãm (2011), When the Yãmîy Come to Dance With Us (2011), Kakxop pit hãmkoxuk xop te yũmũgãhã (Initiation of the Children of the Earth Spirits, 2015), Konãgxeka: The Maxakali Deluge (2016), Yãmiyhex: The Women-Spirit (2019), and Nūhū yãgmū yõg hãm: This Land Is Our Land! (2020). In 2020, he won the PIPA Online Prize, one of the main contemporary art awards in Brazil.

Sueli Maxakali holds a PhD in Literary Studies (Notório Saber) from the Federal University of Minas Gerais (UFMG). She is a filmmaker, a teacher, and a photographer. She has co-directed the films When the Yãmîy Come to Dance With Us (2011), Yãmiyhex: The Women-Spirit (2019), and Nūhū yãgmū yõg hãm: This Land Is Our Land! (2020). In 2009, she published the photo book Koxuk Xop Imagem (Beco do Azougue Editorial), which consisted of photographs by Maxakali women of the rituals and daily life of Aldeia Verde. She was a guest artist at the 43rd São Paulo Art Biennial.

Carolina Canguçu holds a Master's degree in Social Communication from the Federal University of Minas Gerais (UFMG) and currently coordinates part of the programming of the TV Educativa in Bahia. She is an editor, a researcher, a professor of cinema, and a curator of documentary exhibitions. She also works with Autochthonous peoples in audiovisual training courses. She was a member of the collective Filmes de Quintal for twelve years, having organized forumdoc. bh—Documentary and Ethnographic Film Festival of Belo Horizonte. She is a contramestra of Capoeira Angola.

Roberto Romero holds a PhD in Social Anthropology from the Brazilian National Museum (Federal University of Rio de Janeiro—UFRJ). He is a member of Associação Filmes de Quintal, and one of the organizers of forumdoc. bh—Documentary and Ethnographic Film Festival of Belo Horizonte. He is the assistant director of the feature film Yãmiyhex: The Women-Spirit (Sueli and Isael Maxakali, 2019), and co-director of the feature Nūhū yãgmū yõg hãm: This Land Is Our Land! (2020).

Returning Images: The Trajectory of Vídeo nas Aldeias and the Political Role of Cinema in the Context of Cultural Resistance

Amaranta Cesar is professor at the department of Cinema Studies of the University Federal da Bahia, Brazil. She received her PhD in Cinema Studies from the Sorbonne Nouvelle University Paris 3 in 2008. In 2015, she carried out postdoctoral research at New York University, with a fellowship from Capes (Brazilian Federal Agency for the Support and Evaluation of

Graduate Education). She is also director and curator of the Documentaty Film Festival of Cachoeira (Bahia, Brazil): the CachoeiraDoc Film Festival (www.cachoeiradoc.com.br).

On Visual Sovereignty and the Formal Explorations of Indigenous Futurisms

Sophie Gergaud is a documentary filmmaker with a PhD in visual anthropology, as well as a translator, specialized in films, and a visual art curator. She works from a cross-disciplinary perspective, combining theoretical research, filmmaking practices, and artistic event organizing activities. Since 2005, she has devoted her research to Indigenous cinemas/visual arts and their role in asserting the right to self-determination and visual sovereignty of Indigenous peoples. A professional translator, she has subtitled nearly a hundred films, mostly directed by Indigenous filmmakers. In recent years, she published *Cinéastes autochtones: La souveraineté culturelle en action* (WARM, 2019), and co-edited the first anthology on Indigenous cinemas published in French, *Cinémas autochtones: des représentations en mouvement* (L'Harmattan, 2019), for which, along with Thora Herrmann, she gathered thirty contributions from key Indigenous filmmakers, producers, and researchers worldwide. Sophie Gergaud also works as an independent film programmer specialized in Indigenous cinemas and, since 2009, has been the director of the Festival Ciné Alter'Natif, the only festival in France entirely dedicated to Indigenous-made films.

A Little Matter of Feminicide.
Quiet Killing by Kim O'Bomsawin

Aurélie Journée-Duez holds a PhD in anthropology from the Laboratoire d'Anthropologie sociale (EHESS/CNRS), and is a teacher of visual arts. Her dissertation was entitled *Artistes femmes, queer et autochtones face à leur(s) image(s): pour une histoire intersectionnelle et décoloniale des arts contemporains autochtones aux Etats-Unis et au Canada (1969–2019)* (EHESS, 2020), soon to be published by Presses Universitaires du Septentrion. A committed curator and film programmer with the Comité de Solidarité avec les Indiens des Amériques (CSIA-Nitassinan), she has organized, in collaboration with other collectives and venues, numerous screenings and exhibitions on the works and commitments of Indigenous artists.

Media in Environmental Activism on the Borders of Arkhangelsk Oblast and Komi Republic. Fieldwork as Video Curation

Perrine Poupin is a sociologist and associate research professor at CNRS (French National Center for Scientific Research), CRESSON/AAU (Université de Grenoble). She works on local socio-environmental conflicts and war in different regions of Russia and Ukraine, and their impacts on the rural lives of Indigenous, local, or descendant communities. Her work is based on a filmic, visual, and web-pragmatist ethnography. She has carried out field research missions in visual ethnography over many years in Russia, Ukraine, and France, engaging in experimental filmic observation and applying an inductive methodological approach. This approach subsequently includes a digital ethnography of the narratives and images, especially videos, disseminated and commented on via the Internet, on digital social networks, and by the participants of the social and political mobilizations. Finally, by collecting and showing the formidable filmic production of the people and communities in struggle, she engages in a process of curation. In recent years, she has focused on the Shies protest against government plans for a massive landfill in the Arkhangelsk region in the north of Russia, which was launched by inhabitants and lasted two years. She examined this cross-regional protest within the broader landscape of popular and community contention.

Back to the People / Restoring History: Political Cinema and Fourth Cinema in Aotearoa New Zealand

Dr. Mercedes Vicente is a curator, writer, lecturer and researcher. She is a lecturer of Critical and Contextual Studies at the London Metropolitan University, UAL, and previously at the Royal College of Art. Vicente has held positions as Director of Education and Public Programmes at Whitechapel Gallery, Curator of Contemporary Art at Govett-Brewster Art Gallery in New Zealand, and Research Curatorial Assistant at the Whitney Museum of American Art in New York, among others. She has curated numerous exhibitions at institutions such as Tate Modern, Ikon Gallery, Camera Austria, and CCA NTU Singapore. Her extensive writing and editorial credits include books, exhibition catalogs, and journals. She is the editor of *Darcy Lange: Study of an Artist at Work* (2008), and the author of a forthcoming monograph on the artist (Palgrave MacMillan, 2023).

"We Serve up Your Image":
Autochthonous Détournement in *100 Tikis*

Beatriz Rodovalho holds a PhD in film studies from the Sorbonne Nouvelle University Paris 3. She is an associate researcher at the Cinema and Audiovisual Research Institute (IRCAV), where she coordinates the research group "Amateur Audiovisual Practices." Her work focuses on nonfiction cinema through an aesthetic, political, and historical perspective. She currently teaches at Sorbonne Université, Université Paris 8, and Université Panthéon Sorbonne. She is also a programmer for the Brésil en Mouvements documentary festival (Paris) and the distribution manager at Cinédoc Paris Films Coop.

Challenging the Line: The Forms of John Gianvito's Documentary Diptych on the American Military Bases in the Philippines

Caroline San Martin is an associate professor at the department of film studies at the Paris 1 Panthéon-Sorbonne University. She is a member of the research institute ACTE, the research group "La Création Collective au Cinéma" (Collective Creation in Cinema), and an associate member of the laboratory SACRe. She has taught film analysis, writing classes, and aesthetics at French universities and art schools, including at La Fémis, and in North American universities such as Université de Montréal and Wellesley College. Her research focuses on film analysis, narratology, and the links between film aesthetics and the history of the arts.

Credits

Acknowledgements

p. 10 (top) © Mary Jane Tsosie and Maxine Tsosie;
p. 10 (bottom) © Richard Chalfen, courtesy of Penn
Museum Archives; p. 11 © Francisco Vázquez Mota;
p. 13 © Jonathan Larcher; p. 16–17 © Shaney Komulainen;
p. 19 © Myaw Biho; p. 20 © Patrícia Ferreira Pará
Yxapy, photo Alo Paistik; p. 21 © Patrícia Ferreira Pará
Yxapy and Sophia Pinheiro; p. 22–23 © Promedios;
p. 24 © Pilin Yapu; p. 25 © Karrabing Film Collective;
p. 27 © Alanis Obomsawin; p. 28–29 © FrayBa and
Promedios; p. 31 © Alèssi Dell'Umbria; p. 33 © *Awake,
a Dream from Standing Rock*. Dir: Josh Fox, Myron
Dewey, James Spione; p. 34–25 © Christophe Yanuwana
Pierre; p. 36 © Nadia Myre; p. 37 © Sky Hopinka;
p. 38–41 © Christina D. King and Elizabeth A. Castle;
p. 53, 63–67 © 2015 Documentary Japan, Tofoo
Films, Chie Mikami; p. 54–56 © QAB Ryukyu Asahi
Broadcasting Corporation; p. 57 © Okinawa Prefectural
Archives; p. 58–61 © QAB Ryukyu Asahi Broadcasting
Corporation; p. 71–83 © Mayaw Biho; p. 87–95 © John
Gianvito; p. 100 Courtesy of John Gianvito; p. 102 © John
Gianvito; p. 118–43 © Dan Taulapapa McMullin;
p. 145–75 © Karrabing Film Collective; p. 178–200,
202–11 © Comité médias et Communication Movement
on the Road '96 (MSV96); p. 201 (top) © John Englart
(rights reserved); p. 201 (bottom) © Bethany Hindmarsh
(rights reserved); p. 212 © Hicham Fallah (FIDADOC)
and Elise Cortiou-Campion; p. 230–75 © Etienne
de France; p. 277–303 © Francisco Vázquez Mota;
p. 305 © Nicolas Défossé; p. 306 (top) © Alexandra
Halkin; p. 306 (bottom) © Nicolas Défossé;
p. 307 © Promedios; p. 308 Courtesy of Promedios;
p. 309–39 © Promedios; p. 342–54 © Ariel Arango and
Entrelazando; p. 356 © Entrelazando; p. 357–63 © Ariel
Arango and Entrelazando; p. 366–73 © Isael Maxakali,
Sueli Maxakali, Carolina Canguçu, and Roberto Romero;
p. 374–75 © Isael Maxakali and Sueli Maxakali; p. 376–
83 © Roberto Romero; p. 387–88 © Arissana Pataxó;
p. 389 © Ernesto de Carvalho; p. 392–93 © Vincent
Carelli; p. 395 © Takumã Kuikuro, Carlos Fausto, and
Leonardo Sette; p. 395–96, 401 © Vincent Carelli;
p. 406–12, 415, 418, 423, 433 © 2018 National Film
Board of Canada; p. 413 © 2019 Lisa Jackson – Door
number 3; p. 417 © 2017 Chris Morin-Eitner, Courtesy
of Galerie W; p. 426 © imagineNATIVE Film + Video
Media Art Festival 2019 – James Monkman; p. 437–
46 © Stéphanie Weber-Biron; p. 455–77 Courtesy of
Perrine Poupin; p. 480, 483, 490, 501 © John Miller;
p. 494–97 © Darcy Lange; p. 500 Courtesy of John
Miller Archive; p. 514, 516–17 © Dan Taulapapa McMullin;
p. 515 Courtesy of Occupy Hawaii; p. 527–33 © John
Gianvito

Every effort has been made to contact the rightful
owners with regards to copyrights and permissions.
We apologize for any inadvertent errors or omissions.

This book brings together some three dozen unique
voices and points of view to discuss how moving images
participate and emerge from a variety of forms and
situations of struggle that Autochthonous peoples
have been forced to experience in recent decades. To
talk about and show these experiences, we invited the
authors of this publication to conceive contributions
that best convey their experiences and ideas. An equally
fundamental part of the editorial concept was to allow
the form and production process of each contribution
to respect and follow the existential concerns of the
author or collective. Several of the contributions in
this book are collective works, often with one person
acting as the editor of this self-organized group and
bringing the thoughts and images into the realm
of printed matter. We are deeply grateful to all the
authors—filmmakers, artists, activists, film curators and
scholars—who ventured on this collective journey. It has
been a great pleasure to see their contributions take
shape, accompanied by insightful discussions all along
this process.

This book grows out of a research project that
took root in late 2017 and whose initial phase lasted
until 2019. With the support from PSL University's
Global Studies initiative, we were able to organize four
colloquia in the first half of 2019. Entitled "Genealogy
and Cartography of Internationalist and Autochthonous
Cinemas. Focus on Taiwan," "Autochthonous Cinema
Against Occupation," "Colonial Practices and Their
Amnesia," and "Autochthonous Futures, Our Future,"
they brought together filmmakers and activists
from Asia, Oceania, Europe, and North America. The
many discussions, organized around numerous film
screenings, offered the opportunity to directly connect
with the activist and practitioners experiencing and
representing the struggles of the Autochthonous
peoples. Besides the editors of this book, the colloquia
were also organized by Caroline San Martin, at the time
working at La Fémis. Important conversation partners
throughout that first phase of the project were Daniel
Cefaï, Sébastien Lechevalier, Barbara Turquier, and Eric
Wittersheim. During the colloquia Ricardo Matos Cabo,
Noémie Oxley, Sabrina Melenotte, Aurélie Journée,
Pascale Bonnemère, Jessica de Largy Healy, and Marko
Tocilovac offered their generous and extensive support
and advice. In addition to conversations with the
filmmakers who ultimately contributed to this book,
exchanges with the filmmakers and artists Rupert
Cox, Aléssi Dell'Umbria, Myron Dewey, Sky Hopinka,
Alanis Obomsawin, and Lisa Rave and Erik Blinderman
helped us hone the direction of the then embryonic
book project. We are equally thankful to all the other
participants in the four colloquia, who shared their
thoughts and knowledge about filmic practices in
different regions of the word.

During this initial research phase, several
Parisian academic and cultural institutions provided
administrative, logistical, and moral support. These
include La Fémis, the École des Hautes Études en
Sciences Sociales, and the Institut National d'Histoire
de l'Art. At these institutions, we are particularly
indebted to the support of Alessandro Stanziani,

Chan Langaret (PSL / Études Globales); Nathalie Coste Cerdan, Frédéric Papon, Stéphanie Pouech, Caroline San Martin, Barbara Turquier, Bernardo Cancella Nabuco, Loris Ohanian, Quentin Rioual, Hugo Chazal, and Jérôme Pocholle (La Fémis / SACRe); Adeline Loeffel-Alvarez and Bénédicte Barillé (EHESS). During the editorial phase, several French academic institutions provided generous and necessary funding to cover production costs. These include the École universitaire de recherche ArTeC, LIRA (Laboratoire International de Recherches en Arts) at the Sorbonne Nouvelle University Paris 3, CRÆ (Centre de Recherche en Arts et Esthétique) at the University of Picardy Jules Verne, Institut ACTE (Arts Créations Théories Esthétique) at the Paris 1 Panthéon-Sorbonne University, and the CNRS Sciences humaines & sociales. Most of the contacts at these institutions were established by the authors of this book. We would like to especially thank Julia Gros de Gasquet and Cécile Camart at the Sorbonne Nouvelle University Paris 3 / LIRA.

We are particularly delighted to have the opportunity to publish this book with Sternberg Press. Caroline Schneider courageously welcomed this admittedly hybrid and heterogeneous publication in its catalog and has been an attentive and patient publisher throughout its gestation period. The team at Sternberg Press has been very supportive, especially Lucy Brown, but also Ames Gerould, Rebecca Milling, and Margot O'Sullivan. Our sincere gratitude goes to Stuart Bertolotti-Bailey for his incisive copyediting and rigorous proofreading, which have helped to make the texts of this publication more cohesive.

Both Faye Ginsburg and Alanis Obomsawin read the introduction to this book, and we are very grateful for their feedback, which allowed us to articulate several of its aspects more clearly.

All along the research and editorial phases of this project, numerous individuals and organizations helped to move the various parts of the project toward reality. We are especially thankful to Kim West and Daniel Birnbaum, who offered invaluable assistance in the early stages of the book project. Ishikawa Munetaka (Tofoo Films) graciously facilitated the communications around Chie Mikami's contribution. Diane Hétu and Michael Shu at the National Film Board of Canada / Office national du film du Canada have over the years helped us communicate with Alanis Obomsawin. Francisco Vázquez Mota generously granted us access to the important video archives of the media collective Promedios de Comunicación Comunitaria. We also thank for their help and advice: Marc Allassonnière-Tang, Maria Arusoo, Confédération nationale du travail (CNT), Miguel Cruz Vera, Sara Erasmi, Gareth Evans, Olga Gonzalez, Alexandra Halkin, Vinzenz Hediger, Nadira Husain, Andreas Maag, Rodolphe Olcèse (Too Many Cowboys), Anat Pick, Eliana Ritts, Jaanus Samma, Indrek Sirkel, and Guy Westwell.

The editorial work on the publication involved several Indigenous languages and *linguae francae*, with the final publication language being American English. Although the latter was chosen for pragmatic reasons, during the editorial process we were acutely aware of the historical and political implications brought along by both English and the other regional or global *linguae francae*. Our hope is that this choice will make the book, its contents, and its ideas available to a wide public all

the while preserving the connections with the languages of origin. We are grateful to all those who have been involved in translating and editing the texts in this book, and who have given their expertise and dedication to bringing the original texts and words into a faithful English.

We are deeply grateful to all those who assisted us in gathering the extensive visual materials appearing on the pages of this book. Our gratitude goes first and foremost to the authors who were instrumental in assembling and organizing the visual worlds of their contributions. We are indebted to the many filmmakers and photographers who granted us the right to publish stills or reproductions of their works and to all those who helped to clear the publication rights: Vincent Carelli, Elizabeth A. Castle, Alèssi Dell'Umbria, Josh Fox, Sky Hopinka, Shaney Komulainen, Geneviève Lévesque and Michèle Rouleau (Wabanok Productions), Hernan Mazzeo and Christian Pfohl (Lardux Films), Christophe Yanuwana Pierre, John Miller, Nadia Myre, Alanis Obomsawin, Patrícia Ferreira Pará Yxapy, Sophia Pinheiro, Kate Pourshariati (Penn Museum Archives), Mary Jane Sanderson (Tsosie), and Pilin Yapu.

Film X Autochthonous Struggles Today

Colophon

Film X Autochthonous Struggles Today

Editors:
Nicole Brenez, Jonathan Larcher, Alo Paistik,
and Skaya Siku

Authors, in the order of publication:
Chie Mikami, Mayaw Biho, John Gianvito, Myrla
Baldonado, Ricardo Matos Cabo, Rupert Cox, Dan
Taulapapa McMullin, Karrabing Film Collective, Nadir
Bouhmouch, Omar Moujane, Marie Pierre-Bouthier,
Etienne de France, David Harper, Jamahke Welsh,
Jonathan Sims, Blackhorse Lowe, Francisco Vázquez
Mota, Nicolas Défossé, Ariel Arango Prada, Laura Langa
Martínez, Isael Maxakali, Sueli Maxakali, Carolina Canguçu,
Roberto Romero, Amaranta Cesar, Sophie Gergaud,
Aurélie Journée-Duez, Perrine Poupin, Mercedes Vicente,
Beatriz Rodovalho, Caroline San Martin

Translators, in the order of publication:
Ted Fendt (French–English for Nicole Brenez, Jonathan
 Larcher, Alo Paistik, and Skaya Siku, "What's the Point
 of Cinema?")
Jeremy Harley (Japanese–English for Chie Mikami, "The
 Struggle of Marginalized Peoples Is the Perfect Remedy
 for an Ailing Nation. Okinawa, Silenced by Japan")
Eliana Ritts, Skaya Siku, and Marc Allassonnière-Tang
 (Mandarin–English for Mayaw Biho, "Walking the Path
 of Resistance with My Films on My Back")
Omar Moujane (Arabic–English for "Exchange with Omar
 Moujane" in Nadir Bouhmouch, Omar Moujane, and
 Marie Pierre-Bouthier, "Of Megaphones, Cameras,
 and Songs. The Films of Nadir Bouhmouch and the
 Moroccan Amazigh Movement on the Road '96")
Mohamed Ed-Daoudi (Tawja) (Transcription of Tamazight in
 Amussu, appearing in Nadir Bouhmouch, Omar Moujane,
 and Marie Pierre-Bouthier, "Of Megaphones, Cameras,
 and Songs. The Films of Nadir Bouhmouch and the
 Moroccan Amazigh Movement on the Road '96")
Comité Médias et Communication of the Movement
 on the Road '96 (Tamazight–English for *Amussu*,
 appearing in Nadir Bouhmouch, Omar Moujane, and
 Marie Pierre-Bouthier, "Of Megaphones, Cameras,
 and Songs. The Films of Nadir Bouhmouch and the
 Moroccan Amazigh Movement on the Road '96")
Alo Paistik (French–English for Nicolas Défossé,
 "Zapatista Cinema")
Catarina von Wedemeyer (Spanish [Colombian]–English
 for Ariel Arango Prada and Laura Langa Martínez,
 "Intertwining Indigenous Resistance in Cauca")
Roberto Romero (Maxakali–Portuguese [Brazilian] for
 Isael Maxakali and Sueli Maxakali's Travel Journal in
 Isael Maxakali, Sueli Maxakali, Carolina Canguçu, and
 Roberto Romero, "*Nũhũ Yãgmũ Yõg Hãm: This Land Is
 Our Land!* A Travel Journal")
Beatriz Rodovalho (Portuguese [Brazilian]–English for
 Isael Maxakali, Sueli Maxakali, Carolina Canguçu, and
 Roberto Romero, "*Nũhũ Yãgmũ Yõg Hãm: This Land Is
 Our Land!* A Travel Journal")
Nathalie Stahelin (Portuguese [Brazilian]–English for
 Amaranta Cesar, "Returning Images: The Trajectory
 of Vídeo nas Aldeias and the Political Role of Cinema
 in the Context of Cultural Resistance")

Sophie Provost (French–English for Perrine Poupin,
 "Media in Environmental Activism on the Borders of
 Arkhangelsk Oblast and Komi Republic. Fieldwork as
 Video Curation")

Proofreader:
Stuart Bertolotti-Bailey

Design:
Mürt Nõmtak

Print:
Pakett AS, Tallinn, Estonia

ISBN 978 3 95679 650 0

© 2024 the editors, the authors, Sternberg Press

Distributed by:
The MIT Press, Art Data, Les presses du réel, and Idea Books

Photo credits: Karrabing Film Collective (cover)

Published by:
Sternberg Press
71–75 Shelton Street
London WC2H 9JQ
UK
https://www.sternberg-press.com

This book received generous funding from PSL University's
Global Studies initiative, École universitaire de recherche
ArTeC, LIRA (Laboratoire International de Recherches
en Arts) at the Sorbonne Nouvelle University Paris 3,
CRÆ (Centre de Recherche en Arts et Esthétique) at
the University of Picardy Jules Verne, Institut ACTE
(Arts Créations Théories Esthétique) at the Paris 1
Panthéon-Sorbonne University, CNRS Sciences humaines
& sociales, and La Butte Rouge. This work was carried out
as part of the IRIS Études Globales initiative funded by
IdEx (ANR-10-IDEX-0001-02 PSL★) and received funding
from the ANR through the program Investissement
d'avenir (ANR-17-EURE-0008).